THE PILGRIM'S GUIDE
TO SANTIAGO DE COMPOSTELA
A CRITICAL EDITION

Companion Publication

The Pilgrim's Guide to Santiago de Compostela:
A Gazetteer

by Annie Shaver-Crandell and Paula Gerson,
with the assistance of Alison Stones

580 illustrations

THE PILGRIM'S GUIDE TO SANTIAGO DE COMPOSTELA
General Editor: Paula Gerson

The Pilgrim's Guide: A Critical Edition

I
THE MANUSCRIPTS:
THEIR CREATION, PRODUCTION AND RECEPTION

by Alison Stones & Jeanne Krochalis
with Paula Gerson & Annie Shaver-Crandell

HARVEY MILLER PUBLISHERS

HARVEY MILLER PUBLISHERS
Knightsbridge House, 197 Knightsbridge, 8th Floor, London SW7 1RB

An Imprint of G + B Arts International

British Library Cataloguing in Publication Data

A catalogue record for this book
is available from the British Library

ISBN 0905203526 (2 volume set)

Composition by Jan Keller, London
Monochrome Origination and Jacket by Quantock Studios, Sidcup
Printed and bound by Pomurski tisk d.d., Murska Sobota, Slovenia

CONTENTS

For Robert and Margaret Stones and Roger Benjamin
Jeanne B. Krochalis and Robert Worth Frank, Jr.
Keith Hawley Crandell and Alice Crafts Shaver
Shepard Conn and Ida Karro Lieber

PREFACE

T HE IDEA for this book began along the pilgrimage route to Santiago. Our most valued text on that journey was Jeanne Vielliard's edition of the *Pilgrim's Guide* in Latin, based on the Compostela and Ripoll manuscripts and translated into French. Like many pilgrims, students and tourists before us, we became captivated by this book and determined to pursue further the numerous questions it raised. Whereas early pilgrims to Rome and Jerusalem had left lists of the relics and holy sites along the way, the twelfth-century text that has come to be called the *Pilgrim's Guide* is the first known account of what was to be seen and learned along the routes leading to the other great pilgrimage site of the Middle Ages, the shrine of St James the Greater in the Cathedral of Santiago de Compostela in Galicia. The *Pilgrim's Guide* describes church buildings and their decoration with a fullness of aesthetic appreciation that is rarely paralleled in the Middle Ages. Saints, their shrines, and their intervention in human lives provide a telling subtext. Miracles warned local inhabitants along the routes to treat pilgrims with respect, or beware of the consequences. Hospitals and their funding, roads and their repair, attest to a level of concern about practical issues that is complemented by useful information about distances, routes, water, wine, bread and transport across rivers. The language, customs, and dress of the local inhabitants along the routes are described in terms that combine received stereotypes with realistic observation.

The *Pilgrim's Guide* is preserved, complete or in large part, in twelve manuscripts. The earliest that survives is still at Compostela. The *Guide* is transmitted as the last part of a five-book compilation containing Liturgies, Miracles, and accounts of the Translation to Compostela of the body of St James, who was martyred in the Holy Land. The compilation is variously known as the *Liber Sancti Jacobi*, *Jacobus*, or the *Codex Calixtinus*. Book IV of this compilation is the *Pseudo-Turpin*, the popular story of Charlemagne's holy war against the Spanish Saracens, falsely ascribed in the text to the authorship of Turpin, Archbishop of Reims in the time of Charlemagne. Finding a *Pilgrim's Guide* in this company has puzzled many scholars. It seemed sensible to do what no one had yet done for the *Pilgrim's Guide*, and examine all twelve extant manuscripts. We hoped to find out who had read and used the text, and to draw inferences about its origins and purpose. When, where and why was it copied and read?

The *Pilgrim's Guide* is an account that can be read at several levels. We approach it in different ways in this two-volume study. We edit and translate the text. We also examine the context in which the *Guide* has been transmitted, with a full catalogue of each of the twelve manuscripts that contain its text complete or in part, a detailed analysis of the textual relationships of all the extant manuscripts including some observations on manuscripts which are now lost, and a full bibliography for Volumes I and II. We consider the important issues of authorship and the relation of the *Pilgrim's Guide* to the rest of the five-book compilation of which it is part. The compilation has received an enormous amount of scholarly attention, yet the texts, collectively and individually, still present many problems of interpretation. Some of them enjoyed considerable popularity during the Middle Ages: the Miracles of St James were widely read. Pseudo-Turpin's account of Charlemagne's Spanish campaigns, Book IV of the compilation, circulated in hundreds of copies. The bull of Innocent II, Aymeri Picaud's *Ad honorem* and other songs and parts of the *Guide* were attached to it in various combinations.

The *Guide* as a whole, on the other hand, stands at the opposite extreme: only twelve copies are extant, of which three contain a shortened version and one a special selection. We examine what they tell us about the text itself and what they reveal about the individuals and groups who found the text worth copying and owning. Our study of these manuscripts shows that the text of the *Guide* survived primarily as an antiquarian's book, of interest to monks, clerics, and their institutions, to bishops and archbishops, and even to popes; to historians of Spain and to a few visitors to Santiago. Each manuscript copied outside Spain can be explained by particular circumstances. Our collation shows that the manuscript tradition can never have been numerically large or geographically widespread.

Our revisionist interpretation of this text shows that, while there can be no doubt that Santiago de Compostela was one of the major goals of medieval pilgrims, it is equally certain that the *Guide* was not their pocket reading on the trip. Its audience must always have been small, and its impact relatively insignificant. Yet the text still fascinates for what its author knew and had to tell about manners and places in twelfth-century France and Spain, for what he included and for what he left unsaid. Only recently has it begun to receive the attention it deserves.

Our study contains the annotated text of the *Pilgrim's Guide* in Latin and English. Our Latin text is based on the most reliable of the surviving copies, which is also the earliest, preserved in the Archivo de la Catedral at Santiago de Compostela. We have collated the variants from the other eleven manuscripts against the Compostela copy. The facing-page translation provides an English text, with a full commentary on points of geographical, historical, social, hagiographical, linguistic and artistic interest in Volume II. We have tried to elucidate obscure passages and to guide the modern reader directly to whatever secondary sources are most pertinent to each point the author makes—or omits—and to add our own interpretations, pointing the reader towards the remaining insoluble paradoxes and difficulties inherent in the ever fascinating text of the *Guide*.

A companion volume, a Gazetteer, focuses on the monuments referred to in the *Guide*, and is designed for readers interested in the broader implications of the pilgrimage, both medieval and modern. It contains a gazetteer of monuments along the pilgrimage routes to Santiago and the English translation of the *Guide*. The gazetteer is written primarily for the modern traveller and provides detailed information about the art and architecture along the roads. When the *Pilgrim's Guide* was composed shortly before the middle of the twelfth century, many more buildings must have been standing than are mentioned or described in the *Guide*. We discuss those that are likely to be of interest to the pilgrim, student, or tourist of today, including many from the second half of the twelfth century.

Our collaborative project to edit the *Pilgrim's Guide* from all the surviving manuscripts and translate it into English took shape under the leadership of Paula Gerson. She organized the campaigns to photograph the monuments and the manuscripts, and administered the Translations Program grant from the National Endowment for the Humanities that funded part of the preliminary research. The work was divided among the participants, each taking responsibility for studying and annotating the aspects of the text that interested her most. The translation was the prime responsibility of Annie Shaver-Crandell and Paula Gerson; the photographs were mainly taken by Paula Gerson. Jeanne Krochalis and Alison Stones studied the twelve extant manuscripts at first hand, collated the Latin from them and analyzed the results. The annotations to the English translation were similarly divided. Paula Gerson worked on the historical and artistic aspects of the text; Annie Shaver-Crandell wrote the notes on the geography and sociology of the routes and on the architecture and sculpture; Jeanne Krochalis wrote the notes on classical references; Alison Stones worked primarily on the biographical, hagiographical, literary and linguistic references

and co-ordinated and edited the manuscript volume and the annotations to the English translation.

Our work on this book owes much to scholars, friends and family in the United States, England, France, Germany, Italy, Portugal and Spain. If Frisia, Denmark and Jerusalem—all mentioned in the colophon to the *Codex Calixtinus*—are absent from our list, they are more than amply compensated for by the numerous other places we have worked. For facilitating our study of the manuscripts we are particularly indebted to the curator of the Cathedral Archives, Santiago de Compostela, Illmo Sr José Díaz Fernández; to Dr Rosalia Manno Tolu and her staff at the Archivio di Stato, Pistoia; to Dr Teresa Santander at the Biblioteca Universitaria, Salamanca; and to the curators of the manuscript collections at the Arxiu de la Corona de Aragó, Barcelona; the Biblioteca Naçional, Lisbon; the British Library, London; and the Biblioteca Nacional, Madrid; to Canon Isaias da Rosa Pereira, and his staff, Lisbon; to Dr Julian Plante, Dr Thomas Amos, and Dr Jonathan Black of the Hill Monastic Manuscript Library at St John's University, Collegeville, Minnesota; to Dr A. C. de la Mare, formerly at the Bodleian Library, Oxford, and now of King's College, London; to the Librarian, Lowinger Maddison, and the Dean and Chapter of Gloucester Cathedral Library; to Dr P. A. Bulloch and Mr Alan Tadiello, Librarians at Balliol College, Oxford; to Dr Charles Ermattinger, Dr Thomas Tolles, and Barbara Cheneau and the staff of the Vatican Microfilm Collection at St Louis University; and to Father Leonard Boyle, OP, at the Biblioteca Apostolica Vaticana.

For helpful discussion of various manuscript questions we thank J. J. G. Alexander, François Avril, Larry M. Ayres, Adelaide Bennett Hagens, Elizabeth A. R. Brown, the late T. Julian Brown, Walter Cahn, Ruth Dean, Albert Derolez, Manuel C. Díaz y Díaz, Robert W. Frank, Burton B. Fredericksen, Lucia Gai, Monique-Cécile Garand, Françoise Gasparri, Marie-Madeleine Gauthier, Theodore Hausschild, Michel Huglo, George R. Keiser, F. López Alsina, José López Calo, SJ, the late Thomas Lyman, André de Mandach, Carmen Manso, Serafín Moralejo, Rae Ann Nager, Jean Preston, Robert Plötz, Eleanor Rosenberg, Richard Rouse, Gregory Sebastian, OSB, Angel Sicart Giménez, Patricia Stirnemann, Jean Vezin, Hendrik van der Werf, Daniel Williman, Craig Wright, Yolanta Zaluska. For critical readings, references and many valuable suggestions we are indebted to the late J. G. Davies, James D'Emilio, Michael Evans, Richard Fletcher, Jaroslav Folda, Marie-Madeleine Gauthier, Dorothy Glass, Klaus Herbers, Humbert Jacomet, Terryl Kinder, the late Thomas Lyman, Serafín Moralejo, Léon Pressouyre, the late D. J. A. Ross, Teofilo Ruiz, David and Sonia Simon, and Daniel Smartt. We owe special thanks to Christopher Hohler for his sustained enthusiasm for the project and for his *vigilantissimo oculo* reading of the author's text and ours, and to John Williams for generously sharing his specialized knowledge of all things Spanish and for originating and co-organizing the conference on the *Codex Calixtinus* and the Shrine of St James which took place in Pittsburgh while we were writing. Other scholars who answered specific questions are acknowledged in the appropriate footnote.

We thank the staffs of the libraries of our universities, Ray Anne Lockard, Charles Aston, W. Gerald Heverly, and their assistants at the University of Pittsburgh; Herbert Scherer at the University of Minnesota; Charles Mann, Sandra Steltz and their assistants in the Rare Book Room at the Pattee Library at the Pennsylvania State University; Peggy Seiden and Kay Harvey, both formerly of the Penn State New Kensington campus; Philip Cronenwett in Special Collections, and the staff of the Baker Library and the Bryant Collection of Spanish historical materials, Dartmouth College. Other libraries and their staffs have assisted in various ways: the Newberry Library, Chicago; the Pittsburgh Theological Seminary; the Avery Library at Columbia University, New York; the Stephen Chan Library of the Institute of Fine Arts, New York; the library of the City College of New York; the

library of the Hispanic Society of America, New York; Constance Hill at the Conway Library at the Courtauld Institute of Art, London; the Palaeography Room, Senate House, London; the Society of Antiquaries, London; the Warburg Institute, London; the University of California at Los Angeles; the Bibliothèque et Archives de la Direction du Patrimoine, Paris; the Bibliothèque Jacques Doucet, Institut d'Art et d'Archéologie, Paris; the École des Chartes, Paris; the Institut de Recherche et d'Histoire des Textes at Paris and Orléans; the library of the J. Paul Getty Center, Santa Monica, California; Carolyn Lee at the Catholic University of America, Washington, DC, and the Library of Congress, Washington, DC.

Patrick Barker, Ann Boylan, Elizabeth Peterson, Andrea Rusnock, Walter Scholl, Cora Lee Scott, and Lance Williams did indispensable work as research assistants. The preparation of this volume was made possible in part by a grant from the Translations Program of the National Endowment for the Humanities. We also acknowledge with gratitude the financial support of the Central Research Funds of the University of Minnesota and the University of Pittsburgh and a grant from the Professional Staff Congress-City University of New York. At the Pennsylvania State University, numerous offices have supported this project. Dr Joseph Michels, Dean of Liberal Arts Research, and Dr Theodore Kiffer and Dr Margaret Coté, Deans for the Humanities, have encouraged the project with grants; several Commonwealth Campus Research Development Grants have contributed travel and supply money. The New Kensington Campus lent us a MacIntosh computer and printer at crucial stages. Their contribution in paper, ribbons, and cartridges has made efficient revision possible. For technical expertise we thank Steve Umpirowicz formerly of the Pennsylvania State University, New Kensington; the Microcomputer Consulting staff at the Pennsylvania State University, University Park; John Bell, Elizabeth Peterson and Robin Rufle at the University of Pittsburgh; the staffs of the Humanities Institute, the Humanities Computing Center and the Kiewit Computing Center at Dartmouth College; Marilyn Deegan and the staff of the Humanities Computing Centre, Oxford University.

We acknowledge with thanks publication subventions from the Cockayne Fund, the Richard D. and Mary Jane Edwards Endowed Publications Fund in the Faculty of Arts and Sciences, University of Pittsburgh, and the Program for Cultural Cooperation between Spain's Ministry of Culture and United States' Universities.

To Elly and Harvey Miller we are especially indebted for their support, their many constructive suggestions and their patience. We are grateful for the clear mind and fine-tuned editorial eye of Clare Reynolds, editor for the volumes. We also thank all those who travelled the routes with us or offered hospitality along the way. *Igitur via peregrinalis res est obtima sed angusta* (Whitehill, 1944, p. 152, *Veneranda dies*).

Savignac-les-Églises, 30 December 1995

*The twelve manuscripts containing the Pilgrim's Guide are referred to throughout this book by a series of sigla. A key to these will be found on the endpapers of this volume.

INTRODUCTION

T HE BEGINNINGS of the cult of St James the Greater, the first of the Apostles to be martyred, are obscure.[1] By the early twelfth century, however, the shrine of St James in the Cathedral of Santiago de Compostela in Galicia on the north-western tip of the Iberian peninsula had developed into one of the greatest pilgrimage sites of the Middle Ages. Its splendid Cathedral was rebuilt on a huge scale beginning in the 1070s, and embellished by the 1130s with monumental sculpture and precious metalwork. Sometime in the late 1130s, a Latin book about the French routes to Santiago was compiled, and integrated into a five-part compendium about St James and his cult at Santiago. This text has come to be known as the *Pilgrim's Guide* to Santiago de Compostela.[2]

The most surprising thing about the manuscript tradition of the *Pilgrim's Guide* is that only twelve copies survive. We draw all twelve together here for the first time, and refer to them by families according to the sigla C, A, VA, P, M, T and SV (Long Version copies of the *Guide*); R, VB and Z (Short Version copies) and L (Special Version).[3] C, R and L are twelfth-century copies; A, VA, S and VB are fourteenth-century copies; T is late fifteenth century; P and M are early sixteenth century; SV is seventeenth century and Z is eighteenth century. The *Guide* was composed just about the time when the pilgrimage was reaching its apogee, yet only three of the twelve surviving copies date from the twelfth century. Our examination of the textual and historical evidence indicates that only a few copies have been lost in the intervening centuries. This is a very limited manuscript tradition. It contrasts sharply with the many hundreds of pilgrims who, during the same period of time, are assumed to have made the arduous journey from their homelands in England, Scandinavia, the Low Countries, Germany, Italy and Spain itself, to Santiago.

Even more curious are the geographical limits of the circulation of the *Guide*. Ten of the surviving manuscripts were made in the Iberian peninsula, although the earliest manuscript (the copy at Compostela) was made under strong French influence and probably in part by a Frenchman. The *Pilgrim's Guide* was certainly compiled by a Frenchman, probably writing in Compostela for French pilgrims, but it has left hardly a trace in France, and no French manuscript survives.[4] The copy at Pistoia was made in Italy in the sixteenth century, copied from a partly surviving thirteenth-century Italian manuscript probably based, itself, on a twelfth-century original sent from Compostela. If the account in P is to be believed, the North Italian city had a relic of the jawbone of St James sent by Archbishop Diego Gelmírez of Santiago to Bishop Atto of Pistoia in the late 1130s, and so had a special interest in his cult from that time on. The late fifteenth-century English copy was written by an English scribe from the Cistercian monastery of Kirkstall in Yorkshire, and possible routes of transmission are discussed under provenance in the Catalogue of Manuscripts.[5] No accounts left by French, Italian or English medieval pilgrims show any knowledge of the text of the *Guide*.

The limited manuscript tradition of the *Pilgrim's Guide* may be contrasted with the manuscript tradition of the *Pseudo-Turpin*, the account of Charlemagne's Spanish campaign falsely attributed to Turpin, Archbishop of Reims, supposedly a major participant in the campaign and eye-witness of the Battle of Roncesvalles. This was one of the companion books copied with the *Pilgrim's Guide* in all its surviving manuscripts except Z. Turpin's account was one of the most widely read texts of the Middle Ages. Close to 200 manuscript

copies survive, and it was translated into most of the vernacular languages of medieval Europe.[6]

Between *c.* 1138 and the last surviving manuscript copy made *c.* 1750, the readers of the *Guide* were largely Spanish, mainly clerics, historians or antiquarians. The international popularity of the *Guide* came only in the twentieth century. The text is widely known today thanks to the many editions of Jeanne Vielliard's French translation and edition of the Latin from the Compostela and Ripoll copies, first published in 1938 and still in print.[7] Other editions and translations have followed, together with a voluminous secondary literature.

The *Guide* still fascinates for its observations on the spiritual and the practical, the artistic and the obscene, the arcane and the obvious, the affective and the descriptive. It appeals to the modern reader as an entertaining and informative guide for pilgrims and other travellers to Santiago; it can also be read by historians of religion, language, art, and the cultures of various social classes. There is a wealth of information on regions, food, customs, languages, architecture, sculpture, and special vocabularies. But as has been remarked of the possibly related author of the *Pseudo-Turpin*, 'Whether he was always wholly serious…or whether he sometimes had his tongue in his cheek, the reader must decide for himself, according to his conception of the Middle Ages'.[8]

The 'Pilgrim's Guide' and the 'Codex Calixtinus'

In the earliest surviving manuscript, preserved in the Archivo de la Catedral at Santiago de Compostela,[9] and in most of the eleven other surviving copies,[10] the text we now call the *Pilgrim's Guide* forms Book V, the fifth and last Book, of a five-part compilation of texts relating, in one way or another, to the shrine of St James in the Cathedral of Santiago and to his cult. We use the term 'compilation' deliberately; the notion of *compilatio*, a work compiled from several sources, is coming into use at just this period.[11] The concept is particularly important in interpreting the text of the *Guide* and the five-book compilation as a whole, as it allows a much more nuanced approach to the whole question of authorship—a substantial red herring in much of the literature.[12]

The five-part compilation is known by various titles. It is commonly called the *Codex Calixtinus* after Pope Calixtus II (1119-1124), whose name and title, 'Calixtus episcopus' are the opening words of the text of Book I, accompanied, in three of the manuscripts, by a portrait initial of the pope as author (*ills. 1, 52*). Some of the sermons in Book I, some of the miracles in Book II, two sections of Book III, and several chapters of Books IV and V are also attributed to him.[13] Whether any of these texts were really written by Pope Calixtus is questionable, but the name *Codex Calixtinus* is widely used to refer to the five-part compilation. The name of Calixtus was used to identify the compilation in the few medieval inventories in which it is recorded; it also has the advantage of allowing the sub-groups to be discussed together. *Pseudo-Calixtinus Codex* would be more accurate but also inconveniently cumbersome.[14] The compilation has also been called the *Liber Sancti Jacobi* because its content focuses on St James, and because the *incipits* and *explicits* of some of the books into which it is divided use those words; the five-part compilation is also known as *Jacobus*, because four of the manuscripts name it so on their opening folios (*ills. 47, 52, 84*).[15] The oldest manuscript, and the most reliable, is the Santiago copy of the *Jacobus* sub-group, referred to here by the siglum C; this is the basis for our edition.

Book I of the *Codex Calixtinus* contains the liturgy for the mass and office of the feast days of St James on 25 July (the feast celebrated since the sixth century according to the early

martyrologies of the Roman rite), 3 October (the feast of the Miracles), and 30 December (the additional feast of the Mozarabic rite, celebrated since the late seventh or early eighth century, and known as the feast of the Translation).[16] Of special interest in relation to the *Guide* is Chapter 17 of Book I, the sermon *Veneranda dies*, whose text closely parallels the *Guide* both in content and in style, so as to suggest that the author/compiler is likely to be the same for both. Book II is an account of the 22 Miracles of St James, which range in date from 1080 to 1135.[17] Book III gives versions of the history of the Translation of St James's relics to Spain.[18] Book IV is the legendary account of Charlemagne's campaigns against the Saracens in Spain, often called *Pseudo-Turpin*.[19] Book V is generally known as the *Pilgrim's Guide*, although, as we have noted above, the earliest manuscripts simply call it 'Book V' (*ills. 50, 60, 77, 79*).[20]

The Compostela manuscript, C, also contains further material at the end, including polyphonic and monophonic songs with musical notation (*ills. 33, 35, 36*);[21] a folio containing a few lines of a liturgical text (*ill. 34*), a papal bull about the compilation, supposedly promulgated by Pope Innocent II (1130-1143), and claiming that the Codex was taken to Santiago by Aimeri Picaud of Parthenay, otherwise known as Olivier d'Asquins, and his companion Gerberga of Flanders (*ill. 34*);[22] a miracle that occurred in 1139 (*ill. 35*); and a noted *Alleluia* in Greek (*ill. 35*). This folio is followed by further miracles, including one dated 1164 and one dated 1190, and other Jacobite miracles, prayers, and hymns.[23] No other manuscript contains all the texts that follow the *Guide* in C; the other manuscripts of the *Codex Calixtinus* tradition are all selective in different ways, and no two of them preserve exactly the same selections.

The *Codex Calixtinus* as a whole has aroused an enormous amount of direct or indirect scholarly interest, as the bibliography at the end of this volume attests.[24] Some of the component Books of the *Codex Calixtinus* have been studied more than others, but the interpretation of the texts, collectively and individually, still leaves many puzzles unsolved. The important questions of who assembled the parts and created the whole, when, and for what purpose, have never been fully answered, although recent scholarship has suggested some provocative new explanations, pointing the way towards a fresh approach to the historical milieu that gave rise to the compilation as preserved in C.[25] Our study of Book V also shows that the text must be read at several levels. It contains many unstated priorities and underlying assumptions, not all of which are now clear. The new look at the manuscripts containing the *Guide* which we present here offers many more clues about the historical circumstances, the kinds of individuals who were likely to have been responsible, and the reception of the *Pilgrim's Guide*.

Our close examination of the twelve manuscripts that copy the *Guide*, in all cases with other components of the *Codex Calixtinus* compilation, leads to the conclusion that its textual tradition is almost entirely Iberian. The notable exceptions are T, copied in England (*ill. 75*); and P, copied in Italy (*ills. 76–78*). C was almost certainly produced in Spain, at Compostela, by French-trained scribes and illuminators (*ills. 1–36*). However, certain sections of the *Codex Calixtinus* enjoyed a separate circulation, predominantly in France. The miracles of Book II and parts of the Translation, Book III, were transmitted in several versions,[26] and parts of Book I formed the standard lections for the feast of St James.[27] Several versions of Book IV, the *Pseudo-Turpin*, also circulated across Europe, sometimes copied with parts of the other books and some of the supplementary material that is in C, sometimes without. Surviving in over 200 manuscripts, it was clearly one of the most popular texts of the Middle Ages, and it is the one towards which most scholarly attention has been directed.[28]

One version of the compilation has particular relevance to the *Pilgrim's Guide*. It usually includes some of the sermons of Book I, a version of the *Pseudo-Turpin*, brief passages from

Chapters VII and VIII of the *Guide,* the false bull of Pope Innocent II, the *Ad honorem* song and some of the Miracles. It is known as the *Libellus* or the 'Revised Version'.[29] It seems to have been particularly popular among the Cistercians. Our manuscript L (*ills. 42–46*), which was in Cistercian hands, makes a similar selection of passages from the *Guide,* and a *Libellus* connection has been suggested.[30] But the selections from the *Guide* in L are presented in a textual context that also includes more from the other *Codex Calixtinus* Books than other *Libellus* manuscripts.[31] The relationship between the *Guide* and the *Libellus* is a fruitful area for further work, because selections from Chapters VII and VIII are transmitted as part of the *Libellus* tradition. There is at present no list of the *Libellus* manuscripts that is complete and fully accurate, nor do we know precisely which sections of the *Codex Calixtinus* are included or how they are rubricated. Detailed collations have yet to be made. We present a sample, the 'Julius Caesar' passage from Chapter VII. For this passage, our collation suggests that L, and the other eleven manuscripts of the *Codex Calixtinus* version, are unaffected by the *Libellus* tradition.[32]

Another version of the *Pseudo-Turpin,* a lost illustrated copy, may have interesting implications for the narrative illustrations in C and S, which are problematical and may be reductions of a more extensive set of pictures, as we discuss below.[33]

The relative chronology of the various versions and copies of the *Pseudo-Turpin,* as for the other four Books of the *Codex Calixtinus* compilation and its appendages, is still a matter of debate. However, the earliest date for the assembly of the *Codex Calixtinus* compilation in the form in which the earliest manuscript, C, preserves it, lies in the period between *c.* 1137 and the mid 1140s, depending on how the arguments are weighted.[34] The internal dating evidence in the various textual components is as follows: the latest of the 22 Miracles in Book II occurred in 1135; Alfonso VII of Galicia and León, crowned *Imperator totius Hispaniae* in 1135, is mentioned as 'emperor' in the *Guide*; and the deaths of Henry I of England (1135) and Louis VI of France (1137) are mentioned in synchronisms. There are other pointers in the text of the *Guide* that indicate it was put together in the 1130s: the Kingdoms of Aragon and Navarre are not distinguished, which may mean ignorance on the part of the author, or it may mean that he wrote Chapter VII before the death of Alfonso el Batallador in 1134, after which each kingdom elected separate rulers. Similarly, there are discrepancies about which of the monuments at Roncesvalles are mentioned, which may mean that certain parts of the text were composed before 1130.[35] The earliest date at which the song writers in the song section following the *Guide* are collectively documented holding the offices given in the song *tituli* is *c.* 1136-37.[36]

The earliest date for the composition of Book I has been set at 1144 because of the attribution of one of the compositions in it to 'Cardinal Robert', on the assumption that the man in question is Robert Pullen, who became cardinal in 1144 and died in 1146.[37] However, in the absence of corroborating evidence that Robert Pullen indeed composed the song, we suggest alternative possibilities which allow the date to be pushed back to *c.* 1138. Pullen's only extant writings are unpublished sermons, the fullest collection preserved in London, Lambeth Palace, MS 458. He was a distinguished university lecturer, but is not known as a writer of hymns, and had no connection with Compostela, or any other site dedicated to St James. 'Robert' might equally, and more likely, be another cardinal, the one in office under Calixtus II, in 1121-22.[38] Or the cardinal concerned might have been a cardinal of Santiago, not of Rome. The text of the *Guide* indicates that the term 'cardinal' was used at Santiago to refer to the seven canons of the Cathedral who could celebrate mass at the high altar.[39] Although nothing can be proven, it is just conceivable that Rainerius, otherwise known in the documents as Robertus, the schoolmaster at Santiago, might be the person meant. According to the account in P, he helped arrange the transfer to Pistoia in 1138 of the relic of the jawbone of St James. He is referred to as 'cardinal' in P, though whether of Rome or

elsewhere is not specified, and corroboration in Santiago sources is lacking. The account in the *Historia Compostelana* of the activities of Gelmírez, Archbishop of Santiago, unfortunately stops in 1134, just before the earliest possible date for the compilation of the *Codex Calixtinus* and the production of C.[40] But if the 'Robertus' of the song *titulus* in Book I of the *Codex Calixtinus* is someone other than Robert Pullen, that could mean a date of composition for the song, and therefore for the assembly of Book I of the *Codex Calixtinus*, in the lifetime of the main proponent of Santiago's glory (and his own), Diego Gelmírez, whose see was elevated to an archbishopric by Pope Calixtus II himself in 1120. Gelmírez died on 6 April, which was Easter Eve, in 1140.[41]

We have argued elsewhere, on the basis of the comparative context for the decoration and illumination in C, that a date *c.* 1138-45 is also the probable date of the first campaign of work on C itself.[42] We present below the arguments from the collation of the *Pilgrim's Guide*, indicating that the text in C may well be the earliest final version, and, for the parts copied by the first scribe, could be as early as *c.* 1138.[43]

The 'Pilgrim's Guide': Text and Author

The earliest pilgrim travelling from across the Pyrenees to Santiago, a monk from the South German Abbey of Reichenau, is documented before 930.[44] About twenty years later, in 951, Bishop Godescalc of Le Puy, the earliest documented French pilgrim, followed the way of St James.[45] Throughout the Middle Ages, the shrine had a particular attraction for French pilgrims, to whom it was most directly accessible, on foot or on horseback, along the four routes through France which merged into the single route through Spain.[46] The *Pilgrim's Guide* is based, at least in part, on a Frenchman's eye-witness account of what was to be seen and learned along those routes and at Compostela itself in the 1120s-30s.[47] It tells of the pleasures of good fish, cider, bread, honey, and clean water, along the stages on the way, and where they could best be found;[48] of biting insects[49] and unscrupulous ferrymen and toll-keepers,[50] and where to avoid them. It pays tribute to the builders of the hospices and hospitals set up along the routes for the care of the pilgrims, and to those who repaired the roads.[51] It notes the names of places and peoples,[52] with details on the language and social customs of the Navarrese and Basques,[53] and recounts with relish the filth of the Gascons[54] and outrageous sexual aberrations of the Navarrese.[55] The longest chapter is devoted to the bodies of saints to be venerated along the routes, especially in France, their lives and miracles, their claims to authenticity, their churches and their shrines, some of them described in attentive and appreciative detail.[56] At the end comes a lengthy description of Santiago de Compostela, the site and its churches, and especially the architecture, sculpture and furnishings of the Cathedral itself, with its nave, aisles, transept, choir, chapels, galleries, vaults, windows and towers, its portals and their tympana and jamb figures, its altars and their relics, and, principally, the shrine of St James with its old and new altars, its silver altar-frontal, painted and sculpted ciborium and its three lamps of silver.[57] Concluding the work are two short chapters, one on the rather unexpected topic of cathedral administration and division of funds between the canons and the pilgrim hospice,[58] and one recounting three pilgrim miracles.[59]

Was the *Guide* intended to instruct pilgrims? Perhaps in part. Two comments in the text suggest the writer was addressing an audience. Once he mentions readers, and a second time he refers to listeners.[60] A further remark suggests that information is being presented with a practical intent, and there are snippets of useful information, warnings of dangers and recommendations directed to 'you' the audience.[61] There is an aesthetic appreciation

of the upper spaces of the architecture of the Cathedral and its affective powers, which again implies that the description is written for an audience of potential visitors to the same spaces.[62] Other parts of the text are full of exhortations in favour of the intercession of the saints, whose relics one should visit, and the benefits to be derived,[63] while the miracles at the end demonstrate the perils of mistreating Santiago pilgrims, about whose care and protection the writer seems particularly concerned.[64]

But the text can by no means all be read at face value. Why is so much attention devoted to St Eutropius witnessing the Life of Christ,[65] while the life and miracles of St Martial of Limoges are not included,[66] although we know of the importance of its saint in the twelfth-century liturgy of Santiago,[67] and although his Benedictine abbey church was close to that of Santiago in plan, elevation, and vault?[68] Why are some sites mentioned at the beginning, as places along the route, like Le Puy and Moissac,[69] but not again in the context of saints and relics? What about the absence of any mention of the route from Paris to Orléans?[70] Why is so little said about sites in Spain, with San Millán and Silos so close to the route?[71] Why is there nothing about Cluny, where the colophon says the Codex was primarily written, and whose abbey is one of the dedicatees to whom the book is addressed in the opening Prologue at the beginning of Book I?[72] Much is made, too, of the rival claimants to the relics of St Giles,[73] in language that strongly suggests scepticism at best on the author's part, while the similar problems surrounding the authenticity of the relics of St Mary Magdalene at Vézelay are passed over in silence; much is also made of the immoveability of the relics of Giles, Leonard, Martin and James, at just the time when, if the account in P is to be believed, negotiations were under way for a major relic of St James to be transferred to Pistoia.[74] These are just a few of many hints that the text contains hidden agendas which bear on the question of who put it together and why.

QUESTIONS OF AUTHORSHIP

Previous scholarship on the *Pilgrim's Guide* has largely been devoted to the question of its authorship[75] and has attempted to resolve the conflicts between the names of those claimed in the *tituli* as being the 'authors': 'Calixtus', for Pope Calixtus II (1119-24), in the Foreword, and in Chapters II, VI and IX; 'Aymericus' (unidentified by surname, rank or status in the *titulus* to Chapter V), and 'Aymericus the Chancellor' (the papal chancellor, fl. 1120-1141) in Chapter IX, together with Calixtus. While antiquarians, historians and scholars have for centuries been sceptical about the claim of these *tituli* that Pope Calixtus wrote parts of the text, the equally questionable 'authorship' of 'Aymericus' has met with wide acceptance, largely because of the additional claims about 'Aymericus' made in the accompanying texts that follow the *Guide* in C and most of the other copies. In its *titulus*, the *Ad honorem* song is attributed to Aymericus Picaudus, priest of Parthenay; the text of the false bull of Innocent II claims that the 'codex' was taken to Santiago by 'Aymericus Picaudus de Partiniaco Veteri' and the first of the signatories of the bull is Aimericus Cancellarius. Many scholars have leapt to the conclusion that the use of the name in the two chapters of the *Guide* implies genuine authorship by someone of that name, and some even think that the two Aimeris are one and the same person. But these are hasty conclusions, as the evidence presents many difficulties which we discuss below, expressing here views that are different from those in the Gazetteer volume.

In our own interpretation of who the compiler or compilers were, we emphasize some subtexts within the text that have so far been overlooked: the concern expressed in Chapter X about the management of the hospice at Santiago, the references to hospitals in general and to that of St-Léonard-de-Noblat in particular, and the links between Poitou, the Limousin and Santiago. We interpret our compiler's career pattern in terms of these

connections, while also allowing for the possibility of overlays or additions by another individual whose identity has only recently emerged from new studies of the Pistoian manuscript tradition—Rainerius, otherwise known (from a misexpanded R. abbreviation) as Robertus, of Pistoia, the eventual schoolmaster of Santiago, whose political connections in Paris, and perhaps also at Cluny and Vézelay, make him another attractive candidate for some kind of participation in the complex mechanism of production that resulted in the five rather disparate Books of the *Codex Calixtinus* and in the *Guide* as the last of those Books.

CALIXTUS

The person alleged to be the author of the *Codex Calixtinus* compilation is Pope Calixtus II (1119-1124).[76] His name is attached in the Prologue to the Codex as a whole. His portrait (*ills. 1, 52*) in the opening historiated initial in manuscripts C and VA, and presumably on the initial cut out in S, makes the point visually. Rubrics ascribe to him substantial portions of each of the first three books of the compilation,[77] and Chapters 24, 25 and 26 of Book IV, the *Pseudo-Turpin*, which describe the finding of the body of Archbishop Turpin, the Routes to Spain, and the letter encouraging Christians to fight against the Moslems. In the *Guide* his authorship is claimed, in the *tituli*, for Chapters I, II, VI, and IX, and in the bull of Innocent II (*ill. 34*), the Codex is described as *primitus editum* by Pope Calixtus.[78]

These claims have been rejected by all scholars since Morales and Mariana, writing in the late sixteenth and early seventeenth centuries,[79] because the authentic works of the twelfth-century pope Calixtus, printed in PL 163, cols. 1073-1338, are very different in style from the *Codex Calixtinus*. The *Guide* itself is written in various styles, further underlining the notion that it too is a compilation by more than one 'author'.[80] Only the style and content of the letter of exhortation addressed to bishops and other ecclesiastics to participate in campaigning against the Saracens in Spain, which forms the last chapter of Book IV, the *Pseudo-Turpin*, can be paralleled in Calixtus's authentic correspondence with Spanish bishops.[81] However, it is not out of the question that Pope Calixtus was involved in some way with the enterprise that C, the *Codex Calixtinus*, or a possible archetype, the *Liber Sancti Jacobi*, represent.[82] Born Guy of Burgundy, later Archbishop of Vienne (1090-1119), his family connections linked him directly with the Spanish royal court. His brother was Raymond of Burgundy (d. 1107), the first husband of Queen Urraca (ruled 1109-26).[83] This made him uncle to Urraca's son, King Alfonso VII (1126-57). As the pope responsible, according to unquestionably authentic correspondence and bulls, for elevating the see of Santiago to an archbishopric on the feast of St James, 25 July 1120,[84] at the instigation of its bishop, Diego Gelmírez,[85] his links with Santiago itself were significant. Some of his correspondence with Diego Gelmírez and other Spanish bishops survives.[86] One might surmise that he could have collected the miracles ascribed to him in Book II, and sent them to Santiago as stories of local interest. He is certainly the most important person upon whom one or both compilations could be logically foisted. The *Codex Calixtinus* or the *Liber Sancti Jacobi* might well have been a project that he encouraged, though he certainly did not live to see a completed copy of it. The use of his name, if read at face value, certainly gives the compilation an international and papal cachet, enhancing its significance for the reader, whether a Santiago local or a visiting pilgrim.

Calixtus is also credited with Chapter II of the *Guide*, on the days' journeys, and with Chapter VI, on the bitter and fresh waters along the route. There is nothing improbable about the historical Guy of Vienne, who became pope as Calixtus II, having information on the routes over which messages between himself and his brother, Raymond of Burgundy, would pass. The scurrilous remarks in this chapter about the Navarrese 'we met' are exactly the sort of stories one tells about political enemies; the Holy Roman Empire (where the

Province of Vienne lay), Burgundy, and Spain all had troubled relations with Navarre. The *Historia Compostelana*, a narrative account of the episcopal see, composed at Santiago between about 1111 and 1134, describes the 'truculent men, ignorant of language, ready for whatever evil' encountered by Girardus, Bishop of Braga, on his journey across the Pyrenees back to Portugal through the land of the Navarrese.[87]

As the last sentence in Chapter VI implies, Calixtus II may also have wished to encourage pilgrims to visit Santiago, whose Cathedral he himself was responsible for elevating to an archiepiscopal see in 1120. He presided over the Lateran Council of 1123, which granted indulgences to those crusading in Spain, as well as those fighting in Jerusalem—echoing the words of the last chapter of Book IV.[88] The colophon at the end of the *Guide* (*ill. 32*) includes a list of places where it is claimed the text was written: Rome, Jerusalem, France, Italy, Germany, Frisia and especially Cluny.[89] All are places mentioned earlier in the volume—in the various prefaces and letters attributed to Pope Calixtus. It was to Cluny that the Prologue to Book I claims he sent one of the first two copies, for correction and annotation. Its library was impressive, and its abbot, Peter the Venerable (1122-35), was one of the notable ecclesiastics of his day, although he is not mentioned by name in the compilation.[90] The other went to *Hierosolimitanis horis*—a phrase for the region of Jerusalem carefully repeated in the colophon, but not a place with which Calixtus had any known close connection.[91]

But other characteristics of the text and the author's interests fit poorly with what we know of Pope Calixtus II. Calixtus's authentic works show little interest in the kinds of specialized lists of vocabulary at which the *Guide's* author excells. The list of words in Chapter VI, which includes the names of fish in dialect, points towards an author with certain linguistic and gastronomic concerns; there are indications in the sermons of Book I that the author had specialized knowledge of medicine; and Chapter VIII includes a list of instruments of torture. None of these are in evidence in the genuine works of Calixtus.[92] Chapter VII, not attributed to Calixtus in its *titulus*, is similar in its emphasis on points of linguistic and social interest. The attribution to Calixtus of Chapter IX, with its extensive local information on the city and Cathedral, is still more problematical. We do not know that Calixtus ever actually visited Santiago; while nothing in the description of the building itself precludes a date before his death in 1124, the chronogram at the end includes mention of the deaths of Henry I of England (1135) and Louis VI, the Fat, of France (1137). The chronogram is written over an erasure, but in the original hand, and Chapter IX even concludes with the mention of Pope Calixtus 'of good and pious memory' who transferred the archbishopric to Compostela, and approved Diego Gelmírez as archbishop.[93] Perhaps he is named in the chapter heading because the compiler intended to insert his bull of 25 July 1120 into the text, rather than simply refer to it, or at any rate to remind his readers of its importance.[94] Several of these points fit better with the alternative 'authors' discussed below, one of whom may have adopted 'Calixtus' as a pseudonym of greater authority.

AYMERICUS THE CHANCELLOR AND OTHER CANDIDATES NAMED AYMERI

A second author is named in the *tituli* to the *Guide* (though not in any of the other four Books of the *Codex Calixtinus*): Aymericus the Chancellor, who is claimed in the *titulus* to Chapter IX as co-author with Calixtus. Chapter V is ascribed simply to Aymericus (*ill. 30*). Whether he was really called Aymericus or not, the name presumably refers to the person who supplied the local information for Chapter IX. Calixtus II's chancellor Aimery seems as unlikely an authentic author as the pope himself. As we have said above, the name 'Aimery' appears three more times, among the supplementary texts that follow the *Guide*

in C, and in most of the other manuscripts: in the *titulus* to the the last of the songs that complete the last quire in which the *Guide* is copied, the monophonic *Ad honorem* song, attributed to Aymeri Picaud, priest of Parthenay (*ill. 33*); and twice in the bull attributed to Innocent II that follows on a fresh bifolium and in another hand (*ill. 34*). In the text of the bull it is claimed that Aimeri Picaud of Parthenay-le-Vieux (not identified as a priest this time), otherwise known as (*qui etiam*) Oliver of Asquins, together with his Flemish companion Gerberga, gave (*dederunt*) the Codex to Santiago; and the first of the signatories at the end of the bull is Aimeri the Chancellor. Naturally there have been strenuous efforts on the part of some scholars to see all the Aimerys as one and the same, and the 'author' of the *Guide* or even of the entire *Codex Calixtinus* compilation. But there are significant differences in the contexts and placements of these references that make it extremely unlikely that the Aimerys are indeed the same or that one of them wrote the *Guide*.

Pope Calixtus actually did have a chancellor named Aymericus, a Frenchman from Bourges, whose life is relatively well documented.[95] He was related to Pierre de Castres, Archbishop of Bourges, and was a canon in Bologna, then appears as cardinal-deacon of the Roman church of Sta Maria Novella. He was named cardinal and chancellor by Calixtus II in December 1120, and is mentioned in relation to Matthew of Albano's reforms at Cluny after 1122.[96] He appears in his function as chancellor on papal bulls by (or dated) 8 May 1123.[97] Aymericus served not only Calixtus in this capacity, but also Honorius II and Innocent II,[98] which justifies his appearance as the first of the signatories in the bull that is among the added material in C and also survives in many of the copies, including the *Libellus* tradition.[99] According to the *Historia Compostelana*, Aymericus the papal chancellor seems to have acted as protector of Archbishop Gelmírez in his dealings with the Roman curia, although there is no evidence that he went to Santiago himself.[100] His death was recorded on 28 May 1141. He is unlikely to be the Aymericus who contributed to the formation of the *Pilgrim's Guide*.

The person named 'Aymericus' in the *titulus* to Chapter V (*ill. 30*), named with no title, supplied the list of road repairers for the stretch between Rabanal and Puertomarín covered by the tenth and eleventh of the thirteen days' journey between Port de Cize at the Spanish border and Santiago.[101] This section of the journey lay partly in the kingdom of León and partly in Galicia, covering territory which had suffered in the wars of the 1110s between Urraca and her second husband Alfonso el Batallador.[102] The road repairers and overseers are recorded as benefactors to the pilgrims, and therefore to the church, of Santiago itself. Who was the 'Aymericus' who supplied their names? Not a government official; these roads were repaired by private money, as an act of piety.[103] A cleric at Rabanal or Puertomarín might be able to supply names in his own locality, but not those at the other end of the route. At the upper end of the ecclesiastical hierarchy, the papal chancellor Aymericus, who never visited Spain, would have been unlikely to have access to such regional information. The person most likely to have a list of benefactors to hand would be a canon of the Cathedral of Santiago itself, since such benefactors would probably be recorded in the *Liber Memorialis*, or record of benefactors and patrons for whom masses would be celebrated. It would have been the task of a cathedral cleric, perhaps the sacristan, to keep that list up to date.[104] And if it is the Aymericus claimed as author of Chapter V, rather than the papal chancellor, who is the author of Chapter IX, who more plausibly than the sacristan, whose job it was to oversee the processions, the lights, all aspects of the building and the liturgies performed in it, to be able to describe the building as fully as in Chapter IX? Perhaps indeed, 'chancellor', like 'cardinal', was a local title, though it does not occur in the *Historia Compostelana*; but by the early fourteenth century when the Santiago Cartularies known as Tumbo B (*ill. 73*) and Tumbo C were put together, the chancellor of Archbishop Berenguer de Landoria did hold such a title—and the office was held by the

energetic Aymeri of Anteiac who also held the function of Treasurer of the Cathedral.[105] Could his twelfth-century namesake have also held the position of chancellor to the archbishop?

Several other individuals named Aymericus suggest themselves as possible authors, or models for authors, of Chapter V. An author wishing his linguistic skills to be admired might wish to invoke the memory of the grammarian Aimericus of Angoulême.[106] An historical Aimery, mentioned in the *Historia Compostelana*, with local knowledge of Santiago is the monk of Jerusalem sent *c.* 1131 with a letter from the Latin patriarch Stephen (d. 1130) to Archbishop Diego Gelmírez asking to be entrusted with the church of Nogueres and to be recognized as diocesan collector for the Holy Sites; his reception must have been cordial for the episode to have been recorded in so political a document as the *Historia Compostelana*.[107]

Another possible candidate is Aimeri, or Almerich, the Archdeacon of Antioch, author of a Spanish text, *La Fazienda de Ultra Mar*, which interpolated a vernacular bible history with information on churches and holy sites in Jerusalem.[108] According to the prefatory letter, he wrote it for his old schoolfellow Remont, the French-trained Archbishop of Toledo from 1126, who died in 1151. The Spanish text probably dates from the thirteenth century; but if, as has been suggested, it was translated from a Latin original,[109] the future archdeacon of Antioch could have begun his literary endeavours over a decade earlier at Compostela. Aimericus of Limoges, the long-lived Patriarch of Antioch (1139-1187 or, more probably, 1196), has been proposed as its author. This is improbable if the text was originally written in Spanish, and not much more likely if it was in Latin. Described by William of Tyre, as 'a gross, energetic, and almost illiterate man', the patriarch Aimericus was fully occupied as virtual ruler of the city.[110] He was, however, more learned than William allows. One letter thanks Hugh Etheriani for Greek and Latin books on the procession of the Holy Spirit, 'which we have taken to heart, with alacrity, so that we could soon take special care in reading them over studiously'.[111] The rest of the letter mentions a tract of John Chrysostom, chronicles, and the acts of a council of Nicaea.[112] His letter of 1164 to King Louis of France is a vivid account of the sufferings of Christians in the eastern kingdom—'They afflict us with unspeakable troubles'[113]—on which he elaborates for a page and a half before ending the epistle.[114] But such correspondence as survives indicates no contact with or interest in Spain, nor is his sometimes florid style reminiscent of the *Pilgrim's Guide*.[115]

That the author/compiler of the *Guide* was a Frenchman, probably a Poitevin, in origin is clear from several other passages in the *Guide*. Apart from the numerous references to 'we, the French',[116] there are more specific indications as to where he ultimately came from and where he was based before he came to Santiago. The western French route is clearly the one he knew best. He is warm in praise of Poitevins,[117] and negative about the Saintongeais and Gascons and their local dialects.[118] This is what has led to his identification with another 'Aimericus' whose name is associated with the *Codex Calixtinus*: Aimeri Picaud of Parthenay, named twice in the supplementary texts following the *Guide* in C and several of its copies.[119]

The first mention, 'Aymericus Picaudus presbiter de Partiniaco' occurs in the *titulus* to the song *Ad honorem*,[120] which in C is the last of the songs that complete the last quire of the *Guide* (*ill. 33*).[121] It is linked with the Poitevin origin of the author of the *Guide* not only because its rubric says Aymeri Picaud came from Parthenay, but also because the text of the song refers to a pilgrim from Poitiers.[122] The songs in this section of the manuscript are written by a hand whose script, we suggest, is very close to that of Hand 1 of the *Guide*, and they are decorated with initials that fall well within the range of the initials by the decorators that worked on the first phase of execution of C as a whole (*ills. 11–13, 30–31*).[123] The origins of the illumination and decoration of C are in Normandy and the central Loire

in the first third of the twelfth century,[124] and the origins of the notational style in C are entirely compatible with this, as they have been found not far from the central Loire, in Nevers.[125] The dates of the composers, in so far as they can be identified, indicate that they were flourishing by the late 1130s.[126] We find nothing incompatible with the idea of a close association between the copying of the songs and that of Books I-V by the first scribal hand in C.

But the context in which the *Ad honorem* song appears elsewhere is problematical. It is sometimes transmitted as part of the *Codex Calixtinus* tradition.[127] It is also one of the texts often copied with the selections that form the *Libellus* tradition, and there is still debate as to whether that tradition preceded C or depended on it. Only in C, however, is the song copied with accompanying music.[128]

Did Aymeri Picaud write not only the *Ad honorem* song, but also the *Guide* itself, as so many secondary commentators have claimed? And perhaps the other four Books in C? Or was he the author of the *Libellus* version? On the basis of the presence of his *Ad honorem* song in C, the case for his authorship of the *Guide* is possible—bearing in mind that the *Guide*, like the *Codex Calixtinus*, is a *compilatio*—but it is unproven, and likely to remain so.[129]

The evidence of the false bull of Innocent II weakens the case for Aimeri's authorship, rather than strengthening it. His name reappears there as 'Pictauensis Aymericus Picaudus de Partiniaco Ueteri' in the text, which, in the version copied in C, A, VA, R and L, says that Aymeri Picaud of Parthenay (without the epithet priest), alias Oliver of Asquins (Asquins is noted in the text to be a vill of Vézelay), and his Flemish companion Gerberga, gave the Codex to Santiago.[130] Could she be a joke figure? The chronicler Nithard has an account of the drowning in the Saône of Gerberga, daughter of Guillaume, Count of Toulouse and sister of Count Bernard of Septimania by Lothar at Chalon in 834. Could the author of the bull be remembering another dubious Gerberga? But such an allusion would do little to clarify the Flemish origin of Gerberga claimed here.[131] In C the bull follows the songs, on a bifolio that also includes part of a Mass for the Living and the Dead, the miracle of 1139, and the Alleluia in Greek. But on codicological and palaeographical grounds, that bifolium was not an intrinsic part of the Codex.[132] On the other hand, the text of the *Guide*, the appearance of Poitevin pilgrims in the song text, the name 'Aimeri Picaud of Parthenay' in the song *titulus* and in the bull (where it has the additional word 'ueteri'), are all factors that support a Poitevin connection of some kind.

There are also connections with Vézelay in the bull. Asquins, near Vézelay and its dependency, is mentioned as the place Oliver came from; and the positive references to Vézelay and its cult in the text of the *Guide*, coupled with the associations of C's musical style with Nevers, in whose county Vézelay is located, strengthen that association.[133] And the first of the signatories in C and in many of the copies is none other than 'Aimericus cancellarius', a figure already familiar in the *Guide* from the *titulus* to Chapter IX. Could Aimery Picaud have become the papal chancellor?

But little else about the bull is credible. It does not reflect the correct form for papal bulls,[134] and the alias claimed for Aymeri is odd, to say the least—why was he also known as Oliver of Asquins? If this Aymeri Picaud and the author of the song are the same person, his Flemish companion Gerberga is a curious consort for a priest to admit to. Scribes of some of the other manuscripts recognized these names and the grammar of the sentence as problematical. T omits the names altogether, and three Short Version copies: VB, Mariana's manuscript (now lost), and Z, rationalize the aliases (by substituting *quem* for *qui*) so that Oliver and Aimeri are two people not one.[135] The version in VB, Mariana's manuscript and Z conceivably derives from an earlier and more accurate version than C's, but it is far more likely that the scribe of VB or VB's model had altered something he (rightly) thought was

preposterous, and the correction was faithfully copied in Mariana's manuscript and in Z.

The names of the signatories may provide a clue as to who fabricated the bull. They are eminent churchmen who flourished in the 1130s and 1140s,[136] and who were in the same circle as most of the song writers in the musical supplement to C. Also in this circle were Matthew of Albano and Rainerius of Pistoia, names that appear in relation to the historical circumstances of P, which we discuss below. Was it Rainerius, whose career took him to Santiago as canon, cardinal, and schoolmaster, who fabricated and added the bull? It is conspicuously absent from the copy of the *Codex Calixtinus* that is associated with him, P. Whatever the answer, the spoof (if such it was) was fairly successful. As well as being copied (in all seriousness?) in C, A, VA, T, R, and L, and, with emendations, in VB, Mariana's manuscript and Z, the bull also enjoyed a substantial afterlife as part of the *Libellus* tradition, in which it was accorded a prominent place alongside Aimeri's *Ad honorem* song and the other short selections from the *Codex Calixtinus*.[137]

THE ROLE OF RAINERIUS

The other itinerant outsider whose impact on the cult of St James in the second quarter of the twelfth century may have been considerable, if the account in P can be trusted, was one of the schoolmasters of Santiago, Rainerius, also known in the documents as R. or Robertus.[138] He seems to have begun his career at Pistoia as a canon of the Cathedral, then studied in Paris and Winchester (depending on the precise meaning of 'studium tenere'), in the circle of Matthew of Albano, who became prior of the Parisian Cluniac house of St-Martin-des-Champs. Matthew was an eminent figure, who was called from St-Martin-des-Champs to reform Cluny itself when Peter the Venerable became abbot in 1122, and was then appointed papal legate in France. Perhaps Rainerius was with him at Cluny, one of the places the *Guide's* colophon claims it was written? Matthew was a prominent opponent of the Cistercian and other contemporary reform movements.[139] Rainerius finally became a canon at Santiago, and a cardinal there; he was instrumental in the transfer of the relic of St James's mastoid process, a part of his jaw—very possibly accompanied by a copy of the *Codex Calixtinus*—to his native Pistoia, between 1138 and 1145, if the Pistoia account is to be believed.[140]

As an associate of Matthew of Albano, Rainerius must have moved in the circles of the song-writers and bull signatories of C. He may have been responsible for the inclusion in C of the songs, or (depending on the seriousness or frivolity of his role) of the bull, or of both. Yet the account of his career in P relates that he shared the kinds of concerns of the other author figure discussed above—the welfare of the poor—and had founded a college in Paris for poor Italian students. It is tempting to suppose that this foundation of 1133, dedicated to the Blessed Virgin Mary,[141] was what had become, by the late twelfth century, the Parisian commandery of the Order of the hospital of St-Jacques-du-Haut-Pas on the Rue St-Jacques close to Port-Royal,[142] whose mother-house was in Italy at Altopascio on the Via Romea or Galicea near Lucca.[143] There was also a hospital dedicated to the Blessed Virgin Mary referred to in the commentary on Honorius III's bull of 1 December 1219 in favour of the Dominicans, that had allegedly been founded by Philippe Auguste's physician, who became his chaplain. It was apparently adjacent to a house to which the name of St James was attached.[144] Whether the function of the hospital dedicated to the Blessed Virgin Mary at that point became redundant, or transferred elsewhere, is unclear; it is tempting to assume it had been moved up the Rue St-Jacques to the site of what by 1183 had become the church of St-Jacques-du-Haut-Pas.

The beginnings of the cult of St James in Paris are equally obscure: the Rue St-Jacques was already so named when, according to the eleventh-century account in the *Liber*

miraculorum sancte Fidis, Raymond, Count of Rouergue, was killed on it in 961.[145] The *Pseudo-Turpin*, Book IV of the *Codex Calixtinus*, Ch. 5, attributes to Charlemagne the founding of a church dedicated to St James in Paris.[146] The church referred to was undoubtedly St-Jacques-de-la-Boucherie, whose flamboyant tower still marks the beginning of the Rue St-Jacques on the right bank of the Seine just north of Châtelet.[147] A church was certainly in existence there by 1119, as in that year a papal bull of Calixtus II indicates that it was given by Flohier, marshal of Philippe I (1060-1108),[148] together with its parish, to the Cluniac priory of St-Martin des Champs, on the Rue St-Martin directly north of St-Jacques-de-la-Boucherie[149]—and here is a link with Rainerius, through Matthew of Albano, his patron, who was appointed prior of St-Martin-des-Champs in 1117 and was still in that office when the acquisition of the parish of St-Jacques-de-la-Boucherie took place.[150]

The circumstantial connections between these religious establishments in Paris, Santiago and Italy offer the kind of historical context in which it would be attractive to situate the composition of more than just the false bull and the songs that follow the *Guide* in C.[151] A further hint that suggests that Rainerius may have indeed been a pivot for more of the composition of the *Codex Calixtinus* is the presence of a particularly developed liturgy of St James in two fifteenth-century manuscripts, a noted breviary (Paris, BN, lat. 1051) and a missal (Paris, BN, lat. 17315) made for a church dedicated to St James in Paris.[152] Another liturgical link between France and Pistoia is suggested by the title 'Antiphonas gallicanas' in the Pistoia Gradual of the eleventh-twelfth century (Pistoia, Bibl. Capitolare, MS C. 120) in the processions for Palm Sunday.[153] But it should be noted here that the liturgy of St James in P has little or nothing to do with Book I of C, which is surprising in view of how close P and C are in their transcriptions of the *Guide*, and is a reminder that the implications of all these tenuous links are still not quite clear.[154]

What exactly can be reconstructed from the fifteenth-century sources about the early liturgy of St James is also a matter for further investigation: it is possible that a Parisian liturgy of St James might have existed early enough for the author of Book I of the *Codex Calixtinus* to have drawn upon it or vice-versa. And the omission of Paris and the route from Paris to Orléans in the text of the *Guide* would of course be self-explanatory if the author/compiler himself had been based there: everyone would have known where the Rue St-Jacques led, and there would have been no need to comment on this section of the Orléans route. But, if Rainerius did play a significant role in the composition of the *Guide*, it is puzzling that Italy is so rarely mentioned in the text. In Chapter VI, the Italian word 'clipia' is given for 'alose';[155] and in the colophon at the end of Chapter XI, Italy and Rome are listed with Jerusalem, France, Germany, Frisia and Cluny as the places where the Codex was written (*ill. 32*).[156] The route to Rome is mentioned indirectly together with the routes to Jerusalem and Santiago in the context of the three great hospices (Ch. IV), but analogies between the three pilgrimages are not otherwise drawn in the *Guide*. Nor does Italy figure more than indirectly in the other Books of the *Codex Calixtinus*; but it is listed with Galicia, France (*Gallia*), Germany, Hungary and Dacia in Calixtus's preface to Book II as the places where he found sources; and Miracles 2, 11, 12, and 15 happen to Italians.[157]

Rainerius has been thought by some scholars to have been one of the authors of the *Historia Compostelana*.[158] Might he not also have had a hand in the composition, or the copying, of the *Codex Calixtinus* as a whole—whether C, P's ultimate model, or another copy?[159] His role as schoolmaster at Santiago, claimed in the account of his career in P, makes him an attractive candidate as part author, compiler, *remanieur*, or copyist of the *Codex Calixtinus*. As schoolmaster at Santiago, Rainerius could well have encountered another individual whose background also fits in part with the clues in the *Guide* as to who wrote it and why. The two would have shared concerns about the welfare of pilgrims and their physical and spiritual needs.

THE LIMOUSIN CONNECTION

The predilection for St-Léonard-de-Noblat, whose legends were of relatively recent origin,[160] is the most specific indication of where the Poitevin author, who was either named Aimeri (whether or not Aimeri Picaud), or used the name 'Aimericus' as a pseudonym, was based before he, like Rainerius, moved to Santiago. Chapter X provides useful clues about what his link with St-Léonard may have been. It describes the organization of the cathedral's chapter of canons, and how the cathedral monies were allocated—information that must have been privileged. It is here that a particular grievance, of enormous importance to the writer, is stated forcefully. Each of the seventy-two canons received, in turn, one week's offerings from the altar of St James on weekdays. One-third of each Sunday's offerings went to the canon who said mass that Sunday; the other two parts, added together, were again divided into three, and one-third went collectively to the canons' meal fund. The second third went to the upkeep of the Cathedral and the final third to the archbishop. The pilgrims' hospice was the beneficiary of the money from collections taken up in the week between Palm Sunday and Easter, every year; it was only as much as each canon received, though a little more frequently. On this income, the hospice had to house and feed all poor pilgrims and tend to their medical needs; and this was an author whose vocabulary indicates a specialized knowledge of medical terms.[161] The money for the hospital was not enough. 'Nay, rather, if the justice of God is to prevail, the tenth part of the offerings of the altar of Saint James' would be necessary to support the hospice properly, as was done at St-Léonard in the diocese of Limoges.[162]

Who would care more deeply about the hospice than the man in charge of it, struggling to meet the needs of the hundreds of poor pilgrims who came to Santiago? The impassioned comparison of the three major pilgrim hospices on the routes to Jerusalem, Rome, and Santiago, to churches in Chapter IV ('sacred places, houses of God, places of refreshment for holy pilgrims') and the assertion, echoing the Beatitudes ('Blessed are the pure in spirit'), that their builders 'will possess, beyond a doubt, the kingdom of God' strikes a different note from Aymericus' list of road builders in the next chapter, written in a dispassionate tone, with its conventional pious concluding wish that they (like all the faithful departed) should rest in peace. The duties of hospitality to pilgrims are reinforced in the three miracles in Chapter XI, which recount what befell those in several French towns—Nantua, Villeneuve, and Poitiers—who denied bread or shelter to Compostela pilgrims. These are the sort of stories pilgrims recounted to each other. They are not part of the collection of 22 miracles in Book II of the *Codex Calixtinus*,[163] but the hospice-keeper might well maintain a record of additional evidence of the continuing power of the shrine and saint.

We have drawn attention above to the impassioned plea in Chapter X of the *Guide* for more funds for the hospital at Santiago, based on the model of St-Léonard-de-Noblat. The connections of the author of the *Guide* both with Poitou and with the house of canons of St-Léonard are also reflected in the important pattern of historical links between the two places, extending back into the eleventh century. The house of canons at St-Nicolas, Poitiers, was founded *c.* 1050 by the Dowager Countess Agnes of Aquitaine, who, in conjunction with Bishop Itier of Limoges, fought hard in the 1060s to prevent the Cluniacs from seizing control of St-Nicolas and St-Léonard as they had at St-Martial, Limoges.[164] It was also from the schoolmaster of Poitiers that Jourdain de Laron, Bishop of Limoges (1029/30, d. 29 October 1051),[165] and former provost of St-Léonard, commissioned the earliest life of St Léonard.[166] It is the house of secular canons of St-Léonard which the author selects, in Chapter VIII, as the major shrine between Vézelay and Périgueux, to the exclusion of St-Martial, Limoges; at the same time the references to St-Léonard in Chapter X suggest that he knew it well and approved its practices.[167] Perhaps he had even held office there.

The long section on St Eutropius[168] might indicate that the author of the *Guide* was also connected in some way with Saintes, were it not for the negative comments about the local language of Saintes in Chapter VII.[169] Perhaps he had studied or worked there for a time, and disliked it. A more plausible explanation for the inclusion of this tedious passage, so often copied with Book IV of the *Codex Calixtinus* in the *Libellus* version,[170] is to see it, as Christopher Hohler has suggested, as a deliberate imitation of the life of St Martial of Limoges.[171] The shrine of St Martial is not given even a passing reference, despite the church's close architectural similarity to the Cathedral of Santiago and the other three major buildings of the 'pilgrimage church' type.[172] St Martial's legends do, however, appear indirectly in the *Guide*. They are recounted not about Martial himself, but about St Eutropius on the one hand and St Fronto on the other.[173] Martial, like Eutropius in the *Guide*'s account, was claimed by his abbey to have been an eye-witness of the events of the Life of Christ and, as in the *Guide*'s story of Eutropius, was allegedly sent by the Apostles to evangelize France.[174]

The Life of St Fronto provides another implicit parallel to the Life of St Martial. The story of St Fronto's ordination to the episcopacy by St Peter, receiving his staff from St Peter and using it to bring back to life his deceased companion George also forms part of the *Vita* of St Martial, and Fronto is another of the group of saints about whom similar claims were made.[175] Altogether, through its direct omission on the one hand, and through the indirect inference of the superiority of the rival claims to apostolic status of Eutropius and Fronto on the other, the treatment meted out to Martial in the *Guide*, as Hohler has noted, can hardly be fortuitous.[176]

Another possible instance of a rejection of St-Martial and the liturgical practices in use there, together with its music copied in Aquitanian notation, may lie in the inclusion in C of music written in Northern French neumes, close in notational style to manuscripts of Nevers, in whose county was located the Cluniac abbey of Vézelay.[177] Only in one instance does the author praise the admirable way in which the Benedictine rule is observed, and it is not at St-Martial, but at Ste-Foy, Conques.[178] The emphasis on St-Léonard-de-Noblat may also be linked to the suppression of the rival claim of Corbigny (diocese of Autun), whose abbot Hugh (1107-37) allegedly acquired the relics of St Leonard from the priory of Vendeuvre near Le Mans.[179]

It can be argued that St-Gilles is another abbey treated by the *Guide* in a less than complimentary fashion, and where a comparison is to the benefit of Vézelay.[180] The author's local knowledge of St-Gilles—the starting-place of the first road mentioned—is also detailed. The description of the shrine suggests first-hand observation, of the kind otherwise confined to the description of the Cathedral of Santiago itself, although the other sites along the southern route are treated rather more cursorily and even, in the case of Les Alyscamps, inaccurately.[181] Perhaps the author had visited St-Gilles in a context other than that of following the southern route—such as embarking by sea from a southern port to Rome or Jerusalem, both claimed in the colophon as places where the text was written.[182] Here too, comparison with the description of the Life of St Mary Magdalene is instructive: the relics at Vézelay are a case where rival relic-claims could have been made much of, but where the author treats them with circumspection.[183] Vézelay was clearly important to the author, as the fabricator of the bull also recognized. Was the author/compiler associated at some stage in his career with Vézelay, as he seems to have been with St-Léonard?

THE AUTHOR AT SANTIAGO

The *Historia Compostelana* and the contemporary cartulary, Tumbo A, reveal that French clergy were commonplace at Santiago in the early twelfth century.[184] It would be logical to

appoint a canon who knew the most common international pilgrim language, French, in charge of the hospice there. And who would be in a better position to collect Basque words for food and drink, houses and the master of a house, God, Mary and St James,[185] or the information about the eating habits of various other peoples?[186] The author's interest in language leads him to speculate about the etymology of Navarre;[187] to mention the ancient unintelligible inscriptions at Arles;[188] to include lists of interesting words, whether of fish, grains, or instruments of imprisonment;[189] and to note local vernacular words for insects, streams, costume and weapons.[190] His language suggests that he had received a formal education in the classics—he knew Ovid, and the *Veneranda dies* sermon in Book I, Ch. 17 shows he also knew Dioscurides and Basilius,[191] and was familiar with negative topoi about the Basques and Navarrese.[192] His interpretation of the sculpture of the woman holding the skull implies that he knew stories on which the image might be based.[193] On the other hand, his description of the Cathedral of Santiago is highly innovative in its use of specialist, often unattested, descriptive terminology, and also in its attempt to capture the affective aspects of the building, particularly of its interior upper spaces.[194] The author's enthusiasm for details about routes, distances, local saints, and especially water, food, and wine in the towns along the route would be helpful to pilgrims wishing to return by different routes, or making different stops. The names of the shoemaker Peyrot and Jean Gautier are recorded, not because miracles happened to them, but because they owned houses in which miracles happened.[195] Perhaps they were houses one could recommend to pilgrims on the return journey?

We suggest that the author, as a compiler, has used the names in the chapter *tituli* to identify sources of some of his information, but that he himself probably preferred anonymity. In Chapter VIII, indeed, he speaks slightingly of 'some renowned person [who] affixed his own portrait in gold…to the foot of the shrine on the altar side with golden nails' at St-Gilles.[196] Anonymity could indicate modesty, or safety. If he was working in the late 1130s, he may have assumed that material which he found with Pope Calixtus's name attached was genuine; the man had been dead for over ten years. This same individual may have been the controlling intelligence behind the whole formulation of the manuscript in the Archivo de la Catedral in Santiago de Compostela (C) as written by Hand 1, though one would expect the compiler of the extensive liturgies in Book I to say more in the *Guide* about services at Compostela and at places along the route apart from Conques, as he does in Book I.[197] Future studies of the manuscripts of the first four books may well clarify his nebulous personality further.

We shall probably never know just how the *Codex Calixtinus* or the *Pilgrim's Guide* was put together, or exactly by whom. Our Poitevin canon, coming to the hospital of Santiago via that of St-Léonard-de-Noblat, could well have contributed large parts, and the intellectual schoolmaster, trained in Italy and Paris, living in England, could have made other contributions. Like the *Codex Calixtinus*, the *Pilgrim's Guide* is clearly a compilation of information drawn together from many different sources.[198] The varying ways in which a scribe could treat his material, either copying everything exactly, or copying with additions and rearrangements, acting as editor as well as scribe, were being explored in the twelfth century. The *Pilgrim's Guide* has some material which its author/compiler is unlikely to have composed for it. The long section on Eutropius, and the brief section on Julius Caesar, have separate circulations, as material appended to the short form of Book IV, the *Libellus*. Documents of Calixtus are referred to, and Aimericus is indicated as the source of some other material on road-menders and the Cathedral itself. Some of the material about unfamiliar routes must have come from other sources, oral or written. What the compiler or compilers did was to shape this material, and add observations of his or their own on particular shrines, saints, pilgrimage, and pilgrim hospitals to make a compilation drawn

in large part from personal experience. It deserved a wider circulation in its own day than it received.

The Textual and Historical Context of the 'Pilgrim's Guide'

The text of the *Guide* has been transmitted in two versions:[199] a Long Version, copied in C, A, VA, S, P, M, T, SV, of which an excerpted version is copied in L; and a Short Version, based on selections made, according to the colophon in R, by Arnault de Munt, monk of Ripoll, in 1173, and also transmitted in two later manuscripts, VB and Z. Some of the Long Version manuscripts are incomplete. M omits Chapter V and part of Chapter VI; the English copy T stops in Chapter VII, without the final verb in the sentence. The final flourish under the last line of text which is characteristic of this scribe's work makes it practically certain that T's exemplar was also incomplete. The Seville scribe, SV, omitted the Life of St Eutropius from Chapter VIII, and had such difficulty throughout in deciphering his exemplar that he was obliged to leave many gaps in his own copy. The Lisbon manuscript, L, contains only sections of Chapters VII and VIII, and is a special version based on a Long Version exemplar. The lacunae are indicated in the Table of chapters in manuscripts of the *Pilgrim's Guide*, p. 52 below.

LONG VERSION MANUSCRIPTS

The Long Version of the *Pilgrim's Guide*, of which the earliest copy is C, our base manuscript, was also copied complete in A, VA, S and P. These four manuscripts have all of the five Books of the *Codex Calixtinus* compilation that are also in C, although in P, Books I and II are incomplete. A and VA also have the text of all the songs that complete the last quire of Book V in C (with space for the music in VA) and some of the material that follows in C, together with other items not found in C, while P has a considerable number of additional texts relating to the cult of St James and that of St Atto at Pistoia. C, A, VA and S contain substantial amounts of historiated and decorative illumination. P is undecorated, and none of the other manuscripts of the *Guide*, whether long or short, have historiation. Three of these manuscripts, C, A and VA, entitle the compilation *Jacobus* on their opening folio (see also SV, discussed below).

The remaining four of the nine Long Version manuscripts present incomplete texts of the *Guide*, in contexts that vary widely. Unlike the Short Version manuscripts discussed below, each is a special case, and they do not form a sub-group on the basis of their selections of other *Codex Calixtinus* books, or of their omissions from the *Guide*. M has selections from Books I and III; Books II and IV complete; Book V with some omissions; and the *Ad honorem* song, but none of the other texts following the *Guide* in C; M also includes additional texts about Calixtus, St James and Santiago that do not occur elsewhere. T contains only a rather eccentric version of Book IV, the *Pseudo-Turpin*, not classified with C's recension, within which is interpolated a shortened version of the bull of Innocent (among the material following the *Guide* in C) and other texts relating to Charlemagne. This is followed by an incomplete *Pilgrim's Guide*. The manuscript as a whole is an English historical compilation in different hands, but our scribe has copied a unique Latin poem about Roncesvalles later in the manuscript. SV is the fourth copy that (like C, A and VA) entitles the compilation *Jacobus* on its opening folio, but it lacks the illustrations and complete texts that characterize the other three copies; nor does it include the music of C, for which space is left in VA and

S. SV indicates the presence of notation in his exemplar by wavy lines. SV has selections from all five Books of the *Codex Calixtinus,* with many deliberate omissions and numerous gaps caused by the scribe's inability to decipher his model, and occasional omissions because printed versions were available to him and so he did not see the need to copy out certain parts of the text from his manuscript model; but it has none of the texts that follow the *Guide* in C. L has a unique set of selections from the *Codex Calixtinus,* copied in a different sequence: parts of Book I without musical notation, Books II and III complete, Book IV without Chapter 26 but with the passage about the representations of the Liberal Arts that decorated Charlemagne's palace at Aachen, parts of Chapters VII and VIII of the *Guide,* and the bull of Innocent II, the 1139 miracle and the *Ad honorem* song from the texts that follow the *Guide* in C but without notation; the *Codex Calixtinus* selections follow texts that focus on St Martin of Tours.

THE ILLUSTRATED COPIES

Among the eight Long Version manuscripts, there are four (C, A, VA and S) which contain narrative illustration, portrait initials, and a substantial amount of decoration in the form of foliate or pen-flourished initials.[200] Like the other four Books of the *Codex Calixtinus* compilation, the opening of the *Guide* in these manuscripts is marked by a particularly ornate initial for the first letter of the first word of the text, the 'Q' of 'Quatuor' (*ills. 29, 61*). Books II and III also open with decorated initials, either pen-flourished or foliate (*ills. 10, 54, 62, 64, 65*). The rest of the illumination and decoration accompanies the other two books. This illumination plays a special role in the manuscript tradition as it offers possible reasons for postulating a lost illustrated archetype, at least for Book IV of the compilation.

The portrait initial of Pope Calixtus illustrates the 'C' initial of the opening of the prologue to Book I, of which he is claimed to be the author, 'Calixtus episcopus' (*ills. 1, 52*); that of St James opens the 'I' of the Epistle of James that begins Chapter 1 of Book I (*ill. on page 50 and ills. 48, 53, 63*); and that of Archibishop Turpin of Reims, alleged author of Book IV, illustrates the 'T' initial that opens his Epistle to Leoprand that is the preface to Book IV (*ills. 21, 59, 71*).[201] It is not a little ironic—a deliberate visual parallel for the verbal irony which pervades so much of the *Codex Calixtinus* text—that these accomplished and striking portraits all represent false authors: Pope Calixtus II was not the author of Book I, nor of any other part of the *Codex Calixtinus* for which his authorship is claimed; Archbishop Turpin of Reims did not write an eye-witness account of Charlemagne's campaigns in Spain; and the Epistle of James is, of course, by St James the Less, not St James the Great.[202]

In C, the portrait initials and the foliate initials are mostly by the same painter (*ills. 1, 3, 4, 6, 7–10, 15, 21*),[203] and occur, with one exception (*ill. 23*),[204] in the work of the first scribe, who wrote, we argue, c. 1138. The stylistic and technical models for the initials derive, as has been shown elsewhere, from the regions of Normandy and the central Loire,[205] and, like the scribe of the first campaign, they were probably executed by a Frenchman.[206] The portraits in C were directly copied in the early fourteenth-century in A and VA (*ills. 48, 52, 53*),[207] a relationship that corresponds altogether to the textual links between them: they both belong to the *Jacobus* sub-group and they both include all five Books of the *Codex Calixtinus* compilation and some of the supplementary material that follows the *Guide* in C.[208] Our collation shows that neither A nor VA can depend on each other but that each independently derives from C; and A and VA are also substantially different from each other in size.[209] The illuminator of A and VA is not the same individual, nor is either set of illustrations dependent on the other (*ills. 48, 49, 52, 53, 57, 59*); but the two painters are closely related, and both are stylistically reminiscent of the illustration in the early four-teenth-century Cartulary of Santiago, Tumbo B (*ill. 73*). There are also close similarities in

scribal hand between A, VA and Tumbo B.[210] It has been argued elsewhere that the painting in A is slightly closer to Tumbo B than that of VA.[211] VA's painter adopted a considerably more antiquarian approach to his model, C: although he modified C's colour scheme, he was a slavish copier, and was at great pains to reproduce all the idiosyncratic detail of C's various foliate initials (*ills. 2, 5, 55, 56*), while A's painter replaced most of them with pen-flourished work (*ill. 47*).[212]

The fourth illustrated copy, S, was also probably made at Santiago *c.* 1325,[213] and is closely similar to A and VA in style of script, pen-flourished initials and illumination (*ills. 63–72*). Yet it presents many differences which are difficult to interpret.[214] S is not one of the *Jacobus* group,[215] nor does it include any of the supplementary texts that follow the *Guide* in C. Like C, A and VA, S also has historiated initials for St James, robed this time as a pilgrim and carrying a Tau staff (*ill. 63*), and presumably (as the initial on f. 1 is now cut out) Calixtus. But it substitutes a narrative initial for a portrait of Turpin at the beginning of Book IV (*ill. 71*), a 'T' made of foliate and dragon motifs that simulate the style of the twelfth century, showing Turpin's vision of the deaths of Roland and his followers at Roncevaux, their souls borne to heaven, and a devil flying away.[216]

Might C have originally contained this episode? Its picture-cycle cannot have included more scenes directly following the three that precede Book IV (*ills. 19, 20*), because beneath the red decoration lay originally, as can be seen in its copy VA (*ill. 58*), the opening *titulus* for the text of *Pseudo-Turpin*, and the quire structure suggests that nothing is missing here. But there is one place where such an image might be appropriately reconstructed—on f. 179 (*ill. 23*), at the beginning of Chapter 21, where a curious unfinished foliate and dragon initial is placed in text copied by Hand 2—the only one in C that is placed in the work of the second scribe. Conceivably what is there now replaced text originally copied by Scribe 1, and a historiated initial, related to the one that survives in S. There is obviously no trace of it in A and VA, because by the time these later manuscripts were copied, the foliate-dragon initial had already replaced whatever was there before.[217]

There are also differences between S on the one hand and C, A, and VA on the other in their respective treatment of the three narrative episodes illustrating Book IV, *Pseudo-Turpin*, that precede the opening initial 'T' (*ills. 19, 20, 49, 57, 58, 70*).[218] The selection of episodes is the same in all four manuscripts, but there are discrepancies between S and C, A, and VA in layout and in details. In C, A and VA, the first episode, St James appearing to Charlemagne in a Dream (*ills. 19, 49, 57, 70*)[219] is at the bottom of one folio, while the other two scenes follow on the next recto: Charlemagne and his warriors setting out, and the warriors with civilians (*ills. 20, 58, 70*);[220] in S all three miniatures are together in the same architectural frame on one page (*ill. 70*). The arrangement of the Turpin scenes in S appears to make better sense than in C, although it is curious that, unlike the Roland window at Chartres, for instance, neither of the warrior scenes represent high points in the narrative.[221] These scenes must be somehow compressed or excerpted from a more extensive narrative cycle of some kind; and the discrepancies between S and C suggest that they each drew separately from a similar, or even the same, source. What exactly that source was is hard to say, as relevant parallels in manuscripts of historical and epic narrative are scarce in this period, bible illustration offers few and not very appropriate models,[222] and wall-paintings, where one might expect to find the best sources, are imperfectly preserved.[223]

The other narrative miniature in S for which C, A, and VA offer no comparable scene is the miniature at the end, showing St James Matamoro (*ill. 72*), closely related to the miniature of the same subject in Tumbo B (*ill. 73*).[224] This connection surely implies that S, too, was made in close conjunction with Tumbo B and was also made at Compostela. The differences between S and the group C, A, and VA also suggest that its illustrations do not depend on any one of those three manuscripts but on another, more fully illustrated, source.

There is a mention of illustrations in one further copy of the *Pseudo-Turpin* that is itself now lost, but which might allow one to reconstruct a model that would provide an archetype from which to derive the illustrative traditions of C, A, and VA on the one hand, and S on the other. It is the copy that, according to a prefatory letter, was offered by Baudouin V de Hainaut to Frederick Barbarossa in 1184. Baudouin mentions the inclusion of what would appear to be a dedication miniature: *mea…yconia*.[225] It is tempting to assume, although the text does not say so explicitly, that the manuscript also had illustrations depicting the narrative of the text. If so, they might have been based on an earlier model, possibly one early enough to have been in some way related to C or to the model of S. The copy Baudouin sent is now lost but its text is known from the fourteenth-century copy in Madrid, BN, 1617, which itself is entirely unillustrated.[226] Unfortunately, therefore, one can only speculate about the place that the model for Baudouin's manuscript might have occupied in the illustrative traditions of C and S.

SHORT VERSION MANUSCRIPTS

Three of the twelve manuscripts (R, VB and Z: *ills. 37£41, 74, 86–87*) contain an abridged version of the *Guide*, in the context of a Short Version of the *Codex Calixtinus* as a whole. R and VB have excerpts from Book I, R's with musical notation (*ill. 38*), VB's without, and VB's selection of texts from Book I shorter than R's; all 22 of the Book II miracles, followed by those from Book 1, Book V (Chapter 11), and the miracles of 1139 and 1164 which are among the additions in C; selections from Book III; Book IV without Chapter 26; selections from Book V, the *Guide*; followed by the bull of Innocent II from C's added material. R also includes a short passage from Pseudo-Augustine that was not copied in VB or Z. It was added, perhaps at Ripoll, by another twelfth-century scribe. Z has many of the same selections from the *Codex Calixtinus* as R and VB, without music, but omits Book I with the exception of the two Miracles in Chapter 2,[227] leaves out Book IV altogether, and presents the compilation in the context of an antiquarian collection of material on the history of Spain drawn from various other sources in Córdoba, León, Barcelona and Toledo, consisting of copies of documents, tomb epitaphs and the like.

Commission, Production and Reception

Our account of the manuscript tradition of the *Guide* is essentially one in which each manuscript speaks primarily of its own history and particular circumstances, sometimes bearing on those of the few other manuscripts that transmit the text, at other times standing in uncertain relationship to them. The manuscripts are important pointers to those who also found the *Guide* worth copying and owning, and through whose eyes we can also read the text and respond to it. Some, particularly the copyists of the short or excerpted versions, reveal highly personal attitudes towards the text, while others show their views through the changes they made or the comments they added. Others simply copied the *Guide* as accurately as possible as part of a larger copying enterprise. The copyists form one category of readers, the one that is most easily identified; their patrons and associates are another, less firmly documented group; later owners and, in some cases, their institutions, form another cluster of readers. The vast majority of them were religious or clerics: one oblate, two Benedictine monks, two or three Cistercians, possibly a convent of Franciscan nuns, a Hieronymite, two Jesuits, an Excalced monk of the Redemptorist order, a monk or cleric of uncertain affiliation, at least two canons, three bishops, probably four archbishops, and two

popes. There are hints of possible royal patronage in two of the early fourteenth-century copies, but specific ownership cannot be proven. Not until the end of the fifteenth century is a lay reader documented—the Nuremberg physician Hieronimus Münzer, and, though he saw a copy of the *Codex Calixtinus*, one cannot be sure he read the *Guide*. From the mid eighteenth century there appears a smattering of other laymen, including one in the book trade; finally, in the twentieth century, the readership has expanded to reach proportions never remotely approached before.

We have traced the origins of the *Guide* from the 1130s with the shadowy figure of its compiler, originally from Poitou, probably at one time a canon at St-Léonard-de-Noblat, eventually at the pilgrim hospital in Santiago, perhaps named Aimeri Picaud of Parthenay-le-Vieux, more probably not. In the same decade emerges Rainerius, the educated intellectual, well-travelled and certainly well-connected: in Paris, perhaps at St-Martin-des-Champs in the time of prior Matthew of Albano, and possibly at St-Jacques du-Haut-Pas; perhaps at Cluny; probably at Vézelay as well, if he was also responsible for the music in C; in England and in Italy; moving in the circle of papal legates, bishops and abbots like the authors of the songs in the *Codex Calixtinus* and the signatories of Innocent's bull, and the protégé of some of the most eminent churchmen of his time. Yet P and its model present a Rainerius concerned enough about issues of welfare to found a college in Paris for poor Italian students, and ending his career, according to P's account, as schoolmaster at Santiago and a canon and cardinal of its cathedral in the last years of Archbishop Diego Gelmírez's rule.

We shall probably never know exactly what roles Rainerius and Aimericus played in the choice and composition of the text of the *Guide* and the *Codex Calixtinus*, and the making of the first copies of it: whether they worked alone or with others, whether they copied and illustrated, whether one added the songs or the bull, or both, or whether they were directly involved at all. But the words of the *Guide*, its textual context in C and P, and the physical appearance of C, suggest that these are the kinds of people who must have been responsible for the *Guide*, and that their careers reflect the sorts of circumstances that produced it, in one way or another. In the case of C and of P's model, the presence of an archbishop and a bishop who had done much to encourage the cult of St James—Diego Gelmírez at Santiago, Atto at Pistoia—is likely to have been a significant element, although in neither case can we prove their direct patronage or sponsorship. C and the model for P may not have been the only copies made around 1140. Archbishop Thurstan of York (1114-1140), whose election, like that of Diego Gelmírez to Archbishop, had been supported by Pope Calixtus II, could have commissioned a copy of the *Guide* towards the end of his career. The ultimate model of T, which presents close links with C and P, probably came from York.[228]

A copy of the *Codex Calixtinus* was available in Santiago in the third quarter of the twelfth century, because sections of it were copied in R, the earliest of the Short Version manuscripts, by Arnault de Munt, a monk of the Benedictine abbey of Ripoll in Catalonia.[229] We are more than usually informed about Arnault and his purpose, as his letter to his abbot, prior and community, copied at the end of the manuscript (*ill. 41*), says he found there and transcribed a volume in five Books, containing miracles of St James and writings of the church fathers; it also contained a large amount of liturgical material.[230] Arnault says he had wanted to visit the basilica of St James at Santiago not only to seek remission of his sins, but out of a desire to see places deemed worthy of veneration by others, 'propter indulgentiam peccatorum meorum et nichilominus ob desiderium visendi [sic] loci cunctis gentibus venerandi', and he had gone with his abbot's permission; since Ripoll had an altar dedicated to St James, he wanted to provide its church with a more extensive collection of the miracles of St James, 'ampliori miraculorum beati Yacobi'. Pressed for time and resources, he could only make selections rather than a complete transcript, but the contents

of the *Guide* seem to have particularly impressed him as he describes them at some length at the end of the letter. He seems to have accepted at face value Calixtus's authorship and directives for the liturgical use of the texts, as well as the authentication claimed in the false bull of Innocent II. The name Arnault de Munt does not occur again among the Ripoll manuscript holdings now in the Arxiu de la Corona de Aragó in Barcelona,[231] but the selections and omissions in R do indicate what it was he felt was important enough to copy.[232] From the *Guide*, Arnault selected Calixtus's Foreword, omitted the Chapter List, retained Chapter I on the Roads, followed it by Chapter IV, on the Hospices, and selections from Chapter VI on the rivers and clean waters. In Chapter VII he includes the lands and peoples of Gascony, Aragon, Navarre, Poitou, Saintonge, Bordelais and Landes, omits the boatmen and toll-keepers, includes the Port de Cize and Roncesvalles, together with the Navarrese and Basques, the Julius Caesar passage. After Castile, he omits the rest of the route though Spain. In Chapter VIII, he selects only seven of the 26 commemorations of saints, omitting most of the Southern French saints, but including William (Guillaume d'Orange) at Gellone. He omits the Vézelay route up to Périgueux, but includes Bishop Fronto. On the Tours route, he includes only Bishop Evortius of Orléans, and the fourth-century priest Romanus at Blaye, and Roland and his horn. At Bordeaux, he includes Roland's companions, but not Bishop Severinus. He omits Dominic of La Calzada, Isidore, and the concluding mention of St James, but includes the two third-century martyrs Facundus and Primitivus of Sahagún, whose abbey had been an important centre of Cluniac activity in Spain since the eleventh century. There is a clear concentration on epic heroes: Guillaume d'Orange, Roland and his companions. Were the other saints chosen because they were new to Arnault?[233] He condensed the architectural description of the Basilica of Compostela in Chapter IX, selecting only the descriptions of some of the altars. The one addition to the text, added perhaps by him or by another closely related hand, praises the Benedictine monastery of S. Pelayo de Anteailtares in Santiago as 'nobilis monachorum abatia', possibly indicating that he had been well received there as a guest.[234] He omitted the last paragraph of Chapter X, on the hospitality which should be accorded to pilgrims at the hospital, perhaps because he himself had not been in need of its services—although, earlier, he had included Chapter IV on the hospices. Chapter XI, the three pilgrim miracles, he had included in his Book II. And it is possible that his copying effort was somehow a factor in the decision made at Santiago itself to recopy parts of C, by the enigmatic, Santiago-trained Hand 2 at about the same time or shortly after his visit.[235] Was C already in poor condition by 1173—perhaps because it had never been bound, but kept as loose quires in a folder?[236] One passage in the text hints at a possible link between the Benedictines of Anteailtares and C,[237] but R is in fact the only copy associated with Benedictine patronage or production.[238] Arnault's copy circulated little, its two surviving copies, VB and Z coming also from the eastern part of Spain.

Less than a generation after Arnault's visit to Santiago, the Special Version, L, was made (*ills. 42–46*). Exactly who commissioned it and why, we do not know; the accompanying texts reach back to the early history of hagiography in Spain and its links with France, especially the region of Tours and possibly Paris as well. The *Codex Calixtinus* selections follow material about St Martin of Tours, drawn from Alcuin, Sulpicius Severus, Gregory of Tours and Hilary of Poitiers, followed by a list of the bishops of Tours, ending with Erbanus (d. 916). The editor of L seems to have regarded the *Guide* simply as a sourcebook for information about selected saints. He omits all information about roads, rivers, and food, and has no interest in the Navarrese or the Basques. He also omits the architectural descriptions of churches at Saint-Gilles and Compostela. From the saints listed along the southern route he selects Trophimus, Caesarius, Honoratus, Genesius of Arles, Les Alyscamps; he omits Giles, but includes the comments about the four immovable bodies; he

includes William, Tiberius, Modestus, Florentia and Saturninus. On the Le Puy route, he includes Faith and Fronto only, leaving out St Mary Magdalene, Maximus and Leonard; on the Tours route he selects Evortius, Hilary and John the Baptist, omitting Martin and Eutropius here, but inserting them elsewhere; he includes Romanus, Roland, his horn and his companions but not Severinus. He omits Dominic[239] but includes Facundus and Primitivus.

The manuscript was certainly in Portugal by the seventeenth or eighteenth century, when information about Alfonso I of Portugal (1128-85) was added to the back flyleaf.[240] But the manuscript had most likely reached Portugal much earlier. It is not insignificant that it is part of the holdings of the Cistercian monastery of Alcobaça, founded 1153; it may well have been made for Alcobaça and could even have been made at the abbey. There was a strong interest in St Martin at Alcobaça under Abbot Martin in the late twelfth century, and the historical connections between King Alfonso I in Portugal and his relatives in Spain would allow for texts destined for a newly founded monastery to be obtained in León. It was from León that King Alfonso III of León-Castile had requested material on St Martin from the monks of Tours in 906. Alfonso VI of León-Castile gave his wife's nephew Henry of Burgundy the county of Portugal. Henry married Alfonso VI's illegitimate daughter Teresa. Their son Alfonso-Henriquez became King Alfonso I of Portugal. We know that Alfonso I had a manuscript made for the Cistercian monastery of Lorvão, and he may have done the same for Alcobaça.[241] The script and decoration in L are very close to those in other Alcobaça manuscripts now preserved in the Biblioteca Nacional, Lisbon.[242] But its texts stand slightly apart from the version that the Cistercians really preferred, that of the *Libellus*.[243]

After this, interest in the *Guide* seems to wane until the making of the splendid altar-shrine of St James for the Cathedral of Pistoia in the second half of the thirteenth and the early fourteenth century gave fresh impetus to the cult of St James at Pistoia.[244] Two *Codex Calixtinus* copies are documented there by the 1260s, one partially surviving and most likely the direct model for P.[245]

The most prolific period of copying is the fourteenth century, with activity focused *c.* 1325 at Santiago, where there seems to have been an effort to reaffirm Santiago's historic importance and the cult of its patron at a time when the Inquisition was at the height of its powers. The illustrated Cartulary Tumbo B (*ill. 73*)[246] belongs to the same concentrated phase of production as the three luxury illustrated copies of the *Codex Calixtinus*: A, VA and S. These are the only other illustrated copies besides C, but S probably reflects one or more lost models. A and VA, on the other hand, were each independently copied directly from C itself.[247] Besides these formally written, illustrated copies, it is likely that there were also one or more less formally written copies produced at about the same time, with many abbreviations, one perhaps giving rise to S, another, later, to M and another to SV.[248] No scribes, artists or patrons can be attached directly to the three copies that do survive from the early fourteenth century, and their immediate history is uncertain, despite the hints of royal heraldry in A and S.[249] However, it is probably not a coincidence that they were most likely made in the time of Archbishop Berenguer de Landoria (in office 1317 to his death in 1330), who was a French Dominican, from the diocese of Rodez, and a *professor sacræ paginæ*; his wars and deeds are chronicled in the *Gesta Berengarii*, added in the fourteenth century to the ealiest surviving copy of the *Historia Compostelana*.[250] Berenguer had been the former Grand Master of the Dominicans and patron of Bernard Gui, the inquisitor at Toulouse, who became in 1323 his suffragan at the see of Tuy. This great flourish of production at Santiago itself may well reflect Berenguer's interest in combating heresy in his province, although neither his direct patronage, nor that of Gui, can be asserted for any one of the three manuscripts.[251] In the change of a key word in its colophon from 'Roma' to 'curia' (*ill.*

72), S or its immediate model may also reflect the interests of a patron in papal circles in Avignon, as Díaz y Díaz has pointed out, or of an archbishop of Santiago who was particularly concerned about the papal move, such as Berenguer's predecessor Roderick in whose rule (?1304-1316) it took place; the subsequent history of S itself would seem to indicate that it remained in Santiago until the sixteenth century.[252] None of the three surviving early fourteenth-century manuscripts gave rise to any other copies; possibly Berenguer's plans to disseminate the compilation were foiled by political unrest during his rule,[253] or perhaps, as in the case of his predecessor Diego Gelmírez, by an untimely death. All three of the early fourteenth-century copies seem to have belonged to clerics at one stage or another in their fragmentary history: S, by the early sixteenth century, to Alfonso Fonseca, Archbishop of Santiago then Toledo, and founder of a college at Salamanca, the beneficiary of his library;[254] A to Pedro de Luna (anti-pope Benedict XIII) before he became cardinal in 1375, remaining in his library at Avignon and Peñiscola until his death in 1423, when it was acquired through barter by one Magister Subirats, ending up in the possession of Fra Martín Sarmiento of Alcalá by the eighteenth century;[255] and VA to Cardinal Giordano Orsini, probably acquired in Spain during his visit as papal legate, sent to negotiate with Pedro de Luna, and bequeathed by Orsini to the basilica of St Peter's in Rome in 1438.[256]

In another part of Spain, the late fourteenth century witnessed the production of a Short Version copy, VB (*ill. 74*), partly on palimpsest parchment from Zaragoza, containing a document about the Franciscan nunnery of Sta Catalina in Zaragoza.[257] It is unclear whether or not the Franciscans had it made. Its text links it with R, but its model is unlikely to have been R itself, as there is no evidence that R ever left Ripoll.[258] VB's texts have two particular claims to distinction: it is there that the variant *quem etiam* for *qui etiam* in the false bull of Innocent II first appears, a change which circumvents the puzzling alias of Aimericus Picaudus and his still more perplexing relationship with Gerberga the Fleming, by allowing Aimericus and Oliverus separate identities and linking Gerberga with Oliver.[259] Might the sensibilities of the Franciscan nuns have hit upon this solution to the problem of Gerberga? It is also in VB that, for the first time, the *Guide* is called anything other than simply 'Book V': in the table of contents, VB lists it as *Itinerarium ad sanctum Jacobum in Galicia*. Unfortunately the circumstances of production for VB are otherwise obscure and we do not know for sure who was responsible for these interesting changes (whether the scribe of VB or an intermediary between it and R) nor why they were made. And we know nothing further about the history of VB until the end of the sixteenth century.

Almost a century elapses before the next period of fairly active copying, in the late fifteenth and early sixteenth centuries. This time the work is done in widely separated places, but it was also a time when C itself was much in use, as the annotations added between the fourteenth and seventeenth centuries attest.[260] T (*ill.75*), copied by an anonymous scribe in the last years of the fifteenth century at the Cistercian abbey of Kirkstall near Leeds in Yorkshire; M (*ills. 79–83*), copied in 1538 at Santiago by Fra Juan de Azcona; and P (*ills. 76–78*), copied in about the same period in Pistoia, by an unknown scribe, all belong to this phase, perhaps as part of a movement to re-examine the historical basis of the cult of St James during an age of growing scepticism, on the eve of the Reformation. These copies are all notable for the other texts copied with their *Codex Calixtinus* selections, all strongly historical and each reflecting the local interests of the place they were made. And a different, more sceptical, perspective is offered about this time by Hieronimus Münzer, the Nuremberg physician, who left an account of his visit to Santiago in 1495 and who has the distinction of being the first lay person we know to have looked at the *Codex Calixtinus*. Magister Subirats, assuming he was actually a Master of Arts, would have been in at least minor orders.[261]

In T (*ill. 74*), a miscellany of historical texts, an anonymous Kirkstall monk copied Book IV of the *Codex Calixtinus* and the *Guide* up to the middle of Chapter 7 between 1465-80.[262] He also copied several texts of Arthurian interest relating to Avalon and Glastonbury, and clearly knew the *Magnae Tabulae*, the large wooden tablets on display at Glastonbury abbey.[263] He preserves the only copy of the *Carmen Guenonis*, a Latin poem on the treacherous conduct of Ganelon and the death of Roland, based both on *Pseudo-Turpin* and on another version, close to the Oxford *Roland*;[264] and he added an account of the monastic career of Ogier the Dane, taken from Alexander Neckam and the story of Charlemagne's relic-collecting *Iter* to the Holy Land, from a version of Helinand de Froidemont.

Hieronimus Münzer was at Santiago in December, 1495.[265] He saw a copy of the *Codex Calixtinus*, and copied a few passages from it while he was staying with the chaplain Johannes Ramus; but his account makes no mention at all of the *Guide*, and it is probable that he did not see it; indeed, there is no copy of the *Guide* that is in any way associated with German scribes or collections.[266] Most of the text Münzer copied was from the *Pseudo-Turpin*, and he recalled those passages the following February, when seeing the horn of Roland and the graves of thousands of Christian and Saracen dead at Roncesvalles, 'ut in historia Sancti Jacobi lacius et diffusius scripsi'.[267] At Compostela, he found the services noisy and lacking in reverence, and was annoyed by not being able to see James's body: 'Sepultus autem creditur sub altari magno cum duobus suis discipulis, quorum unus a dextris et alius a sinistris. Corpus autem a nullo visum est. Etiam anno Domini 1487, dum Rex Castelle ibi esset, non vidit. Sola fide credimus, que salvat nos homines'.[268] (However, he is believed to be buried under the great altar, with his two disciples, of whom one is on the right, and the other on the left. However the body has been seen by no one. Even in the year of our Lord 1487, when the King of Castile was there, he did not see it. We believe in faith alone, which saves us men.) The text he saw, by his own account had only four books: 'Calixtus papa, singularis amator Sancti Jacobi, magnum et diffusum opus in 4 libros partitum de gestis eius et redempcione Gallicie a Karolo magno scripsit. Similiter eius multa miracula. Et sequencia brevibus, dum essem Compostelle in domo cuiusdam capellani, Johannis Rami, devotissimi hominis, ex originali eius excerpsi, ut sequitur'.[269] (Pope Calixtus, the singular lover of St James, wrote a large and diffuse work in four books, divided between his deeds and the redemption of Galicia by Charlemagne. Likewise his miracles. And I have excerpted from the original the following things in short bits, as follows, while I was at Compostela in the house of a certain chaplain, John Ramus, a most pious man.)

It is of course possible that Münzer saw a now lost copy owned by his host, which omitted the *Guide*, but included the vast and diffuse liturgy, translation, miracles and *Pseudo-Turpin*. His interest in *Turpin* suggests there was no copy in Nuremberg, and he had not seen one elsewhere in Germany.[270] He was about to travel over much of the ground described in the *Guide* and might be expected to have taken an interest in its text if Ramus' copy contained it.[271] But we can be sure he had not consulted Chapter 10, because he gives the stipend of each of 45 canons as 70 ducats, whereas Chapter 10 details a much more elaborate system of distribution of church revenues among 72 canons, a number chosen in honour of the disciples. Münzer belonged to the new generation, who preferred printed books for reading and classed manuscripts with *objets d'art*. This is the only manuscript from which he quotes in the entire account of his journey and it is just conceivable that he did look at C without reading the *Guide*.

The attitudes and interests of Fra Juan de Azcona, scribe of M (*ills. 79–83*), were quite different from those of Hieronimus Münzer. Azcona was at Santiago about a generation later, in 1538. It is unclear to which order he belonged, and whether he was based at Santiago or a visitor. The inclusion in his manuscript of a drawing of the altar of S. Payo may be an

indication that he was a Benedictine and was a guest at the abbey, as Arnault de Munt may also have been before him. His name, Azcona, suggests that he was originally a Basque.[272] He copied C, and some material from the *Historia Compostelana*; he also included local information on monuments at Iria (also known as Padrón), and a list of the bishops and archbishops of Iria and Compostela. We know that C itself was his immediate exemplar for Book I, because he copied his texts in the order now in C, with a quire which had been misbound between c. 1325, when A and VA were copied, and 1538.[273] This makes it virtually certain that he was working at Compostela itself. His copying was selective, but he made many interesting additions. He prefaced Book I with Blondo's Latin *Life of Calixtus*, and added extra miracles in Latin and Spanish to Book II. In Book III he appended the *Historia Compostelana* account of the discovery of the tomb by Bishop Theodomir in 866; in the *Guide*, he frequently noted vernacular versions of place names, such as 'Grugnum, id est logroniam' (VI-57; cf. III-35) or 'dicitur Sancti Iacobi posita a Carolo Magno vel Crux Caroli' (VII-215); 'qui vulgiter dicitur rio del archpuro' (IX-9); 'que nunc porta de azavachoria dicitur' (IX-234). Within the cathedral itself, he noted changes in the dedications of chapels and altars: 'quod nunc est altare Sancti Bartholomei' (IX-412);[274] 'nunc ibi est sacramentum et vocatur capella regis francorum' (IX-413);[275] 'nunc est sancti frutuosi' (IX-419);[276] and he added a crude drawing of the altar stone at San Payo, together with a transcription and translation of its Roman votive inscription (*ill. 83*). Unlike Ambrosio de Morales, who saw the same stone a generation later, he seems to have been unperturbed by the use of a pagan stone as a Christian altar; at any rate, he did not comment adversely on its function.[277]

The texts in P (*ills. 76–78*), also compiled in the 1530s, focus on the Pistoia-based cult of St James and St Atto—the same Bishop Atto under whom the relic of St James had been acquired—and their miracles.[278] P's selections from the *Codex Calixtinus* are intermingled with local materials, many of which also appear in a special volume made for the octave of the feast of St James in 1453, Pistoia MS Doc. vari 3; but its text of the *Guide* is extremely close to that of C. Readers of the now lost twelfth-century original compilation from which P most likely ultimately derives (like the Pisan scribe Cantarinus who allegedly compiled the account of the relic transfer from Santiago and its reception in Pistoia), must have been primarily interested in the relic itself, the new saint, and the local cult. The *Guide* includes no description of a pilgrimage route in Italy, and no Italian saint;[279] for a Pistoian, there would be no local need or interest in copying its journeys or relics. The scribe who copied the whole manuscript in the 1530s marked a different class of reader from the earlier monastic copyists, one who was interested in local history and traditions, and anxious to preserve them.

A little more than a generation later, in 1572, came Ambrosio de Morales' visit to Santiago and his examination of C, with his rejection of the authorship of Pope Calixtus and his condemnation of the contents as 'cosas tan deshonestas';[280] it was not a book he chose for Philip II's new library at El Escorial. Although Morales addressed his comments most specifically to the text of the *Guide*, it was Book IV of the *Codex Calixtinus*, the *Pseudo-Turpin*, that, in 1619, was removed from C by the canon archivist as being too embarrassing, and made into a separate volume.[281] By then, the Jesuit historian Juan de Mariana had published his adverse comments about Charlemagne and Roland as narrated in *Pseudo-Turpin*.[282] In 1606 Mariana had obtained a Short Version of the *Codex Calixtinus*, and with it the *Guide*, from Bartholomé de Morlanes, jurist of Zaragoza, himself once an oblate, whose lost manuscript contained a text close to VB.[283] Mariana valued it *auro et gemmis maius*, but gratitude did not impede his critical judgement of its contents; like Morales, he rejected the attribution to Pope Calixtus and found the *Guide totius ex fabulis et menacio compactus*.[284] His description of the manuscript sent by Morlanes shows that it must have contained a Short

Version of the *Guide*, but he included nothing from it among the *Codex Calixtinus* selections published as Chapter XII of his *Tractatus VII* in 1609.[285]

Another eminent cleric appears as an owner in the last decades of the sixteenth century. José Esteve, a student at Valencia, then teacher at Siena, probably acquired VB in Alfaro in the 1590s. He wrote his *ex libris* on it while Bishop of Viesti in Apulia (17 March 1586-March 1594).[286] Perhaps the volume stayed in Italy when he was transferred back to Spain as Bishop of Orihuela (3 March 1594 to his death on 2 November 1603), or it may have been acquired for the collection of Pope Paul V Borghese in Spain after Esteve's death.[287] From there, the trail leads to Granada in the 1630s, where Peter, the Excalced Monk of the Redemptorist Order, tried to collate his indecipherable early model with a second copy, possibly itself an early copy, but with no great measure of success, as he had to leave many gaps, recorded in the clean but very incomplete copy SV, in 1657 (*ills. 84, 85*).[288] That copy may have been made by the first lay reader of the *Guide*, who signed himself 'VS', a monogram that omits reference to any monastic or clerical status; we know nothing further about who he may have been. The manuscript would appear to have remained in lay hands until it entered the Biblioteca Nacional in 1757, as it was among the books catalogued for sale by Don Antonio López de Zúñiga, 13th Count of Miranda in 1755, and it may have been among the books he inherited from his father, Don Joaquín López de Zúñiga Chaves (d.1725).[289]

The final phase leads back to Fra Martín Sarmiento, bibliophile and monk of Alcalá and probable owner of A in the eighteenth century; to the avid Jesuit editor and antiquarian P. Andrés Marcos Burriel of Toledo, whose copy of Mariana's copy, Z (*ills. 86, 87*), made in 1750, is bound among notes on charters, tomb epitaphs, descriptions of other manuscripts, ecclesiastical histories;[290] and finally to Thomas Rodd, hispanophile and book dealer, through whom A arrived at the British Museum in 1841.[291] By then, the reception of the *Guide* was entering a new era. Fita and Vinson's edition was to appear in 1882, and thereafter, as Jeanne Vielliard has aptly remarked of the *Guide* on her opening page, 'il a connu une singulière fortune', attributable in large measure to her own efforts, but supported by the wide range of critical commentary to which our bibliography attests. The stars pointing the way to Compostela have yet to wane.

NOTES

1. As KENDRICK put it in 1960, p. 187: 'The honest beginning to any enquiry about the origin of the cult of Santiago is to admit that we know nothing about it at all'. The remark is also cited by HERWAARDEN, 1980, p. 1, to whose article we refer the reader for these questions, as to DÍAZ Y DÍAZ, 1965 and to the essays in *SANTIAGO DE COMPOSTELA*, 1985, *SANTIAGO CAMINO DE EUROPA*, 1993, and WILLIAMS/STONES, 1992, particularly the succinct historical survey by PLÖTZ (pp. 35-48); see also GAIFFIER, 1962, 1969b, 1971, 1983, 1984a.

2. The *Pilgrim's Guide* is never so called in the text or headings in the manuscripts: the title *Itinerarium ad sanctum iacobum in galicia*, copied in the late 14th century as part of a list of contents at the beginning of manuscript VB, is the first time the book is called anything other than *liber quintus*. See note 20 below and Catalogue of Manuscripts.

3. The list gives the manuscripts in approximate chronological order within families, with the two incomplete copies, T and SV, at the end of the Long Version list. The manuscripts are listed on p. 11 and on the endpapers together with the sigla by which we refer to them hereafter. Sigla used by all previous writers are listed by manuscript in the Catalogue of Manuscripts. We draw the reader's attention in particular to the differences between DÍAZ Y DÍAZ's (1988a) sigla and ours; by then we had already established our own sigla and substantially completed our collation. For discussion of the provenance and history of each manuscript, see the individual entries in the Catalogue of Manuscripts. The evidence for Lost Manuscripts is presented below, pp. $$; what is most striking is that there is no reflection of the *Guide* in other comparable medieval texts as is the case, for instance, with the *Marvels of Rome*.

4. See pp. 13-14, for a discussion of the *Libellus*, whose manuscript tradition is very largely French; for possible French links with the recensions of T and L, see the Catalogue of Manuscripts.

5. For the textual affiliations of T's *Pseudo-Turpin*, which belongs to a different recension from that of the other manuscripts which also transmit the *Guide* and from other English manuscripts of PT, see Catalogue of Manuscripts under T.

6. See p. 13 and, for editions, note 19.

7. VIELLIARD, 1938, many reprints and re-editions. The first few editions are the most reliable; reprints and re-editions from 1963 on contain a number of errors not in the first edition; they are noted in our collation of the Latin, as are the few cases where our reading differs from Vielliard's. See the first section of the bibliography for other editions and translations of the *Guide*.

8. SMYSER, 1937/1970, p. 5.

9. Our siglum for this manuscript is C. See Manuscript Introduction and Catalogue of Manuscripts. We argue below, in the chapter on the collation of the text of the *Pilgrim's Guide*, that it is also the most reliable manuscript and hence is the basis for our edition, as for those of FITA/VINSON, 1882, VIELLIARD, 1938 (many reprints),

and WHITEHILL, 1944. Whitehill is hereafter abbreviated as 'W'. The edition of the Latin in WHITEHILL, without translation (1944), includes a transcript of all the other texts in the Compostela manuscript and a series of commentary essays by other contributors. Although much criticized by HÄMEL, 1950 and HERBERS, 1984 for not including the marginalia, as well as for its errors, it is still an indispensable accompaniment to any serious study of the texts it contains, the *Guide* included. We indicate occasional disagreements on readings in our notes to the Latin text.

10. For the list see the endpapers, p. 11, and for full discussion see the Catalogue of Manuscripts.

11. See PARKES, 1976, pp. 115-141, and HATHAWAY, 1989.

12. For questions of *auctor* and *auctoritas* see note 75 below. The *Guide* draws on numerous sources, some identifiable, others not; the compiler or compilers were apparently unconcerned about imposing a unity of style on the entire text, which means that attempting to distinguish the literary personalities of different individuals on stylistic grounds is a task that is far from straightforward.

13. He is named in the *Guide* in the *tituli* to the Foreword (see English text note I-2), and in the *tituli* to Chapters II and VI, and his name appears in the *titulus* to Chapter IX together with that of Aymericus, his Chancellor; Aymericus (without the epithet 'Chancellor') is also named, alone, in the *titulus* to Chapter V. For Aymericus see English note V-1. Calixtus's authorship is also claimed for parts of the other four Books. We discuss the question further below, see pp. 17-18.

14. For descriptions of A in the inventories of Pedro de Luna, where it is ascribed to the authorship of Calixtus, see Catalogue of Manuscripts under A. Only the scribe of SV goes so far as to actually call the author Pseudo-Calixtus; see Catalogue of Manuscripts.

15. C, A, VA and SV; for the first three, see DÍAZ Y DÍAZ, 1988a, p. 328, where SV is omitted. For C, see HOHLER, 1972. The name *Jacobus* is also used in the text of the sermon *Veneranda dies* in Book I (W 145). Significantly, the other eight manuscripts of the twelve we consider here omit the *titulus* and the name *Jacobus*. The terms *Liber Sancti Jacobi* and *Codex Calixtinus* are used in different ways in the literature. The sense in which DÍAZ Y DÍAZ, 1988a uses *Codex Calixtinus* is to designate the recension of manuscripts that includes all five Books, reserving *Liber Sancti Jacobi* for the ensemble of the texts in the tradition in all the versions and different combinations: a solution that leaves open the possibility that C and other versions each depend on earlier traditions. Here we are primarily concerned with the 12 manuscripts of the *Codex Calixtinus* recension, and the concept of a possible archetypal *Liber Sancti Jacobi* can be left aside, except in relation to the discussion of the *Libellus*, which has been thought to derive, independently of the *Codex Calixtinus* recension, from the *Liber Sancti Jacobi*; on this question, see pp. 13-14. For a brief resumé of Díaz y Díaz's arguments, and for an analysis of the titles others have used for these texts, see STONES, 1991.

16. For Mozarabic feasts see AASS, Julii, VI, preliminary pagination sequence, pp. 1-112; FÉROTIN, 1904, 1912; GAIFFIER, 1983; and *Liturgia Mozarabica*, PL 85 and 86. In C and R there is notation for parts of Book I, although there are considerable differences in notational style between the two: C's style is east-central French while R's is Aquitanian; see LÓPEZ CALO, 1963; HUGLO, 1992. Space was left for notation in Book I in VA and S, and for the songs after Book V in VA; see Catalogue of Manuscripts. For a full list of editions, see DÍAZ Y DÍAZ, 1988a, pp. 129-130; the selection published in PL 163, pp. 1369-1410 (Prologue and Chapters 2, 5, 6, 19) is reprinted from MARIANA, 1609, and was also reprinted in *Magna Bibliotheca veterum Patrum*, 1622, and *Maxima Bibliotheca veterum Patrum*, 1677. A performing edition of the Mass of St James from C is HELMER, 1988; transcripts of the songs, by various musicologists, are listed in the bibliography of our Catalogue of Manuscripts under C. The sources of the liturgy of St James, as presented in Book I, have still to be fully clarified in relation to the earlier liturgy of Santiago and elsewhere in Spain on the one hand and that of France on the other. The testimony of the other 12th-century liturgical books drawn together in the exhibition *SANTIAGO CAMINO DE EUROPA*, 1993, has still to be fully analyzed in relation to what is in C, the earliest witness of the *Codex Calixtinus*; and the degree to which later liturgical books transmit earlier liturgy of St James, in Spain and France, also remains to be fully taken into account. See particularly the late 12th-century Sacramentary, León, Arch. Cat. Cód. 27, cat. no. 57; the 12th-century Sacramentary of the region of Narbonne, Avignon BM 178 (*SANTIAGO CAMINO DE EUROPA*, p. 23; LEROQUAIS, 1924, I, p. 256); the 14th-century Rituale of S. Cugat del Vallés, Barcelona, Arxiu de la Corona de Aragó 73, cat. no. 56; the 15th-century Breviario de Miranda, Santiago de Compostela, Arch. de la Catedral MS 3, cat. no. 58; the fragments of the printed breviary of Santiago of 1495 and of the Ritual of 1533-34 (*SANTIAGO CAMINO DE EUROPA*, p. 33); and the manuscripts and early printed books at the Cathedrals of Orense, Lugo, Tuy and Braga (ibid., pp. 33-34). A summary is given by Romano Rocha (ibid., pp. 18-35), with earlier bibliography, citing in particular MIQUEL ROSELL, 1937; AYUSO, 1959; DURO PEÑA, 1961; JANINI, 1977; and ODRIOZOLA, 1976-77, 1987, 1992. Three hymns from the (unspecified) 'antiguo Breviario compostelano' are transcribed in LÓPEZ FERREIRO, 1898, I, pp. 209-210; the Office for the feast from the same source on pp. 445-451, noting the variants with the few surviving fragments of the 13th-century breviary of Santiago and with the Breviary Compostelano printed in Salamanca in 1569 (pp. 451-452) and the Vespers hymn 'O dei verbum' from the mozarabic Office of Santiago reprinted from an unspecified manuscript transcribed by Florez in ES III, p. 96, on pp. 407-409; the *Magna Passio* (W 94-103), based on Pseudo-Abdias, in use in Santiago and the vicinity before and after C, is discussed on pp. 399-440. This *Passio* also appears in the selections in P and L; see Catalogue of Manuscripts and summary of the literature in STONES, 1992, pp. 139-140, n. 8, and p. 151, n. 65 for the importation of French books to Spain from the early 11th century. See also the discussion of the role of Paris below, especially note 152.
There is also debate as to whether the structure of Book I is for secular use, as maintained by HOHLER, 1972, pp. 43, 72-77, followed by DÍAZ Y DÍAZ, 1987, pp. 362-363,

and 1988a, p. 82; or for monastic use, as claimed by HUGLO, 1992, p. 107. We suggest here that the interests of the monks of the abbey of S. Payo de Antealtares, who controlled the shrine of St James until the *Concordia* of 1077 and whose building was destroyed to make way for the new cathedral, was a significant factor in the inclusion of the extra chants in C that distinguish the liturgy from a normal secular one. This solution would allow the points of view of both Hohler and Huglo to stand. See English note IX-20; FERNÁNDEZ DE LA CUESTA in *SANTIAGO CAMINO DE EUROPA*, 1993, pp. 37-53 also presents our view.

17. AASS, Julii, VI, pp. 47-58; HERBERS, 1984, pp. 108-124; MENACA, 1987, including a reprint of PL 163, pp. 1369-1376 and French translation. See also SOUTHERN, 1953, pp. 260-265, where it is suggested that the compiler met Anselm of Canterbury in Lyon and learned from him of miracles 16, 17 and 18; SOUTHERN, 1958; SOUTHERN/SCHMITT, 1969, pp. 196-209; COLKER, 1975, pp. 70-71, 114-115, and HERBERS, 1991, 1992.

18. For analyses of the variant versions see LÓPEZ FERREIRO, 1898, I, pp. 179-207, where C is compared with a 12th-century miscellany in the Escorial and the printed breviary of Evora of 1548 (pp. 179-182); López Ferreiro also gives the texts of John Beleth's late 12th-century account of the Translation from his *Rationale Divinorum Officium* (pp. 204-205) and reprints the Marchiennes manuscript version (Douai, B.M. 842) from AASS, VI, p. 12 (pp. 206-207). See also GAIFFIER, 1971 and our Catalogue of Manuscripts under P, f. 35; for a partial transcript see DÍAZ Y DÍAZ, 1988b. Hohler (private communication) has found another version in London, BL, MS Harley 4699. Other unpublished versions are in Gloucester Cathedral MS 1 and Tortosa 197; see note 26 below and Collation of Manuscripts, pp. 197-240. There is a copy in a Visigothic hand, Paris, BN, lat. 2036; a copy in a Beneventan hand is Rome, Bibl. Casanatense 1104. See GAIFFIER, 1971, p. 48.

19. Edited from VA, with variants from A, by THORON, 1934; from C, by MEREDITH-JONES, 1936/1972, a comparative edition against Paris, BN, lat. 13774; also edited from C by WHITEHILL, 1944. For editions of other versions see CIAMPI, 1822, based on Turin, BN, I.V.36; CASTETS, 1880, based on seven Montpellier manuscripts; and SMYSER, 1936/1970, based on Paris, BN, lat. 17656. The major analytical studies focusing on Book IV in the context of the *Codex Calixtinus* are HÄMEL, 1943, 1950, 1953; MANDACH, 1961; SHORT, 1969, 1972; HOHLER, 1972; HERBERS, 1984; DÍAZ Y DÍAZ, 1988a. For a list of which manuscripts containing the *Guide* are discussed by which of these authors see the Introduction to the Catalogue of Manuscripts, p. 51.

20. The title is first found in the Table of Contents in VB, in the second half of the 14th century. See Catalogue of Manuscripts. For editions of the *Guide*, see the first section of the Bibliography.

21. On the music see particularly ANGLÉS, 1931, 1935, 1961; WAGNER, 1931; PRADO, 1944; APPEL, 1949, 1953; BIRKNER, 1962; KRÜGER, 1964; REANEY, 1966; HUGLO, 1967, 1992; KARP, 1967, 1992; OSTHOFF, 1967; BESSELER/GÜLKE, 1973; LÓPEZ CALO, 1963, 1982, 1988; WERF, 1990, 1991, 1992; FERNÁNDEZ DE LA CUESTA, 1993.

Full references in the Catalogue of Manuscripts under C.

22. In VB, Z, and the now lost copy from which Mariana published excerpts in 1609, the sentence containing this information is differently structured and the two men are separate individuals; see p. 21 and Catalogue of Manuscripts. The folio containing the bull in C is not intrinsic to the manuscript, as DÍAZ Y DÍAZ, 1988a, p. 308, has shown on the basis of its place in the structure of the *Codex* and on the basis of its script.

23. The texts that follow the *Guide* in C were written by a number of scribes; see Catalogue of Manuscripts.

24. The most important textual and contextual studies of the last two decades are those by SHORT, 1969, 1970, 1972; GAIFFIER, 1971, 1972, 1976, 1981, 1983, 1984; HOHLER, 1972; WALPOLE, 1976, 1985; LÓPEZ CALO, 1982; PLÖTZ, 1982, 1984, 1992; HERBERS, 1984, 1986, 1991b, 1992; GAI, 1984; *SANTIAGO DE COMPOSTELA*, 1985; DÍAZ Y DÍAZ, 1984, 1985, 1988a, 1988b, 1992; *SANTIAGO CAMINO DE EUROPA*, 1993. Also useful, if rather more popular, is DAVIES/DAVIES, 1982. We draw attention also to the set of studies on a variety of aspects of the *Codex Calixtinus* that resulted from the conference *The Codex Calixtinus and the Shrine of St James*, held in Pittsburgh in 1988, while this book was in progress: see WILLIAMS/STONES, 1992. MOISAN, 1992, came out after our text was complete; we disagree fundamentally with his attribution, following LOUIS, 1952, of the entire *Codex Calixtinus* to the authorship of Aimeri Picaud, but we have added references to MOISAN where relevant.

25. HOHLER, 1972 sees Book IV primarily as a schoolmaster's text, composed for critical use in class, largely tongue-in-cheek, as SMYSER, 1937/1970, p. 5, had hinted, and the texts of Books I and V in similar vein. Interesting in this context is the structure of the information about rivers and towns in the opening chapters of the *Guide*, which finds a close parallel in a similar text that was written to be memorized, no doubt as a school text: the tables of universal history preceding Sigebert of Gembloux's *Chronicle* in Paris, BN, lat. 583, from Signy (O. Cist., dioc. Reims). There the lists of places are prefaced by notes on methods of learning and memorization. It is unlikely there is a direct connection between the two texts, as the list of places in Spain in the Signy manuscript (ff. 32v-33) does not include Santiago or sites on the route there, but the 'school-text' approach to this material in the *Guide* is probably a significant indicator of what this part of the text was based on, and perhaps of what its function was (see English note I-9). If the historical circumstances of the acquisition of the Pistoia relic in 1138 are to be taken seriously, as P claims they are, then Rainerius of Pistoia, the schoolmaster of Santiago, emerges as a very likely person to have had a hand not only in the transfer of the relic but also in the acquisition of a copy of the *Codex Calixtinus* or parts of it, as we show below.

26. See particularly Tortosa, Archivo de la Catedral, MS 197, Gloucester Cathedral Library, MS 1, Oxford, Balliol College MS 292 and Tortosa 106, discussed in the chapter on Lost Manuscripts below. Of these, the Gloucester manuscript is certainly not French, but associated with Reading or its cell at Leominster, and Balliol is in an English hand; see KER, 1977, and Lost Manuscripts below. For the versions of the Translation, which include copies in Visigothic and Beneventan hands, see note 18 above.

27. The *Magna Passio*, Book I, Ch. 9; see note 16 above.

28. With such a large corpus of *Pseudo-Turpin* manuscripts, the families have been charted with great difficulty (see note 19 above), and there is considerable disagreement as to the chronological sequence, to say nothing of the origin and significance of the text. As Meredith-Jones aptly wrote in 1936, at a time when only 49 manuscripts were known: 'Les hypothèses que l'on a émises pour expliquer l'origine et interpréter le sens de la Chronique du pseudo-Turpin, non seulement étonnent par leur nombre et leur diversité, mais encore laissent dans l'esprit de celui qui les étudie une très grande confusion...' (MEREDITH-JONES, 1936, p. 36). See also note 24, and the Introduction to the Catalogue of Manuscripts.

29. HÄMEL, 1950, pp. 42-51; id., 1953. A version was first published from several of the Montpellier MSS by CASTETS in his 1880 edition of the *Pseudo-Turpin*. For lists of manuscripts, see particularly MEREDITH-JONES, 1936, D group, pp. 13-17; HÄMEL, 1950, 'Libellus Gruppe', pp. 42-44, and id., 1953; MANDACH, 1961, D group, pp. 373-376. The term 'Revised Version' is preferred by DAVID, 1946, and HOHLER, 1972, pp. 58-61.

30. DÍAZ Y DÍAZ, 1988a, p. 340, suggests it is textually closer to C than to the *Libellus* group. For the opposite view see MANDACH, 1990; we note some inaccuracies of transcription in the latter; see our Catalogue of Manuscripts under L and Latin Appendix.

31. See Catalogue of Manuscripts under L.

32. See Latin Appendix.

33. This issue is also discussed in STONES, 1981, and in STONES, 1992, pp. 136-140.

34. See Catalogue of Manuscripts under C for full descriptions of the passages containing the dates, and for which scribe copied which sections of the text.

35. For Alfonso VII see English notes V-4, IX-142; for Louis VI see English notes V-8, IX-142; for Henry I see English note IX-142. For the Kingdoms of Aragon and Navarre see English note VII-17. For Roncesvalles see English notes III-10, 11, VII-31, VIII-176. Some critics (MANDACH, 1969, p. 817; id., 1990, p. 45; MENACA, 1987, pp. 229-234) have assumed that the reference in Book V, Ch. V, 'in the time of Diego, Archbishop of Santiago and Alfonso, Emperor of Spain and Galicia' (English notes V-3, 4) indicates that the individuals concerned were dead, and thus 1157, the death of Alfonso VII, provides a *terminus post quem* for the text of the *Guide*. We do not accept this reading.

36. See the list in the Catalogue of Manuscripts under C.

37. See HOHLER, 1972, p. 47, citing POOLE, 1934, p. 290; see also JL II, p. 21. For his sermons, see COURTNEY, 1950, and SMALLEY, 1973, pp. 242-246. COURTNEY, 1954, argues that Pullen was an Austin canon of Osney; SMALLEY, 1973, sees him as a secular clerk, and suggests he taught at Exeter, then at Oxford (SMALLEY, pp. 39-50).

38. JL I, p. 781; PL 163, pp. 1091-1092. MOISAN, 1985, p. 23, thought Robert Boso, cardinal of Rome and papal legate, d. 1146, was intended. But in the contemporary history of Santiago known as *Historia Compostelana* (cited in the edition by FALQUE REY, 1988), Robert Boso is referred to exclusively as Boso, Bosso or B., never as Robert; and a Boso was still in office in 1152 (JL II, p. 21).

DÍAZ Y DÍAZ, 1988a, p. 52, seems to accept Robert Pullen.

39. See English note IX-131.

40. For further discussion see Catalogue of Manuscripts under C and P, and p. 23.

41. FLETCHER, 1972, p. 47.

42. See p. 198 and STONES, 1992. DÍAZ Y DÍAZ prefers a later date than the one argued for there: *c.* 1160 (1988a, p. 81; and in *SANTIAGO CAMINO DE EUROPA*, 1993, no. 102), or slightly earlier at *c.* 1150 (1992, p. 9). For an earlier date (between 1139 and 1143) see HERBERS, 1984, p. 38.

43. See the detailed list of dating *termini* and supporting arguments in the Catalogue of Manuscripts under C.

44. HERBERS, 1991a, esp. pp. 257-258, citing KLÜPPEL, 1980, pp. 86-89 and 102-105.

45. While in Spain, Godescalc had a copy of Ildefonsus's *De virginitate*, Paris, BN, lat. 2855, written for himself by Gómez, monk of S. Martín de Albeda (dated 951); see AVRIL *et al.*, 1982, no. 22. That commission was later recorded pictorially in the famous copy of *c.* 1100, now in Parma, probably made at Cluny. See SCHAPIRO, 1964, plate facing p. 24, and *SANTIAGO CAMINO DE EUROPA*, 1993, nos. 14 and 15. For another recently discovered copy see RAIZMAN, 1987.

46. That Santiago pilgrims came from all over Europe has been shown through the presence of shells in graves (FORGEAIS, 1863; MAXE-WERLY, 1885; LAMY-LASALLE, 1967, 1968; COHEN, 1976, 1977; KÖSTER, 1983, 1984, and in SANTIAGO DE COMPOSTELA, 1985; HEERINGEN, KOLDEWIJ and GAALMAN, 1988; JACOMET, 1990; BRUNA, 1990). The earliest, in Schleswig, dates to the late 11th or early 12th century (KÖSTER, 1988, p. 122). For mentions of healing miracles associated with the shell, see Miracle 12 in Book II and the *Ad honorem* song following the *Guide* (see English note IX-63). Written accounts besides the present *Guide* are those of Nompar de Caumont (VIELLIARD, 1969, pp. 132-140), William Wey, 1857, Margery Kempe, 1940, Hieronymus Münzer, 1920, Purchas, 1625/1905, and many more cited by HOWARD, 1980; RICHARD, 1981; HERBERS, 1988; DAVIES/DAVIES, 1982, pp. 221-224; DAVIES, 1988, GANZ-BLÄTTER, 1991. See also *SANTIAGO CAMINO DE EUROPA*, 1993, nos. 75-81 and Introduction. What levels of society were represented is not altogether clear, especially before the 13th century; but see SCHMIDT, 1978 for the claim that peasants did participate. A useful review of the literature is STOPFORD, 1994. However, notions about how many pilgrims made the journey are highly subjective. Only in the case of English pilgrims of the 15th century travelling by boat do reliable statistics exist; see STALLEY, 1985, p. 123, where a figure of 5,000 over a period of a few days is suggested.

47. For the *termini* in the text, of which the mention of the death of Louis VI, in 1137, is the most significant, see Catalogue of Manuscripts under C and note 35 above.

48. Chapters VI and VII.

49. English note VII-9.

50. After English note VII-11, and at VII-15-21.

51. Chapter V.

52. Particularly Chapter VII.

53. At English note VII-35 ff. For the Basque language see note VII-42.

54. Between English notes VII-10 and 11.

55. English notes VII-48-50.

56. Chapter VIII.

57. Chapter IX. In both Chapter VIII and Chapter IX adjectives or adverbs expressing appreciation are used, although the range of terms is limited to a few much repeated words: *inmensus* (shrine of St Martin, Tours, VIII-716); *ingens* (shrine of St Giles, VIII-163; churches of St-Sernin, Toulouse, VIII-422; St-Martin, Tours, VIII-718; St-Jean-Baptiste, Angély, VIII-754; Cathedral of Santiago, IX-392; lamp at altar of St James, Cathedral of Santiago, IX-610); *ingens et pulcherrima* (church of Ste-Marie-Madeleine, Vézelay, VIII-847); *ingens et obtima* (church of St-Hilaire, Poitiers, VIII-742); *obtimus/a/um* (tomb of Modestus and Florentia, VIII-400; burial place of St Sernin, VIII-420; church of Ste-Foy, Conques, VIII-449; tomb of St James, IX-453; flowers on altar-frontal, Santiago, IX-527); *obtime cooperta* (cathedral roof, Santiago, IX-397); *decens et obtima* (altar-frontal, Santiago, IX-530); *magnae lampades...apostoli decus* (lamps at altar of St James, Santiago, IX-609); *magnus et mirabilis* (altar, Santiago, IX-475-476); *mirabilis* (fountain at Santiago, IX-175); *mirabilis magister* (Bernardus, Santiago, IX-651); *mirabiliter...sculpuntur* (south door sculpture, Santiago, IX-318); *mirabiliter sculpitur* (Transfiguration, west door, Santiago, IX-373); *mirabiliter operatur* (ciborium, Santiago, IX-546; lamp, Santiago, IX-610); *ordo mirabilis* (south door sculpture, Santiago, IX-344); *miro opere* (church of St-Martin, Tours, VIII-721; church of St-Jean-Baptiste, Angély, VIII-755); *miro opere et magnitudine* (tomb of St James, Santiago, IX-455-456); *pulchritudine miri operis* (tomb of St Front, Périgueux, VIII-654); *pulchra* (north door sculpture, Santiago, IX-267); *pulcherrima/ae* (basin of stone fountain, Santiago, IX-179; columns of altar-frontal, Santiago, IX-527); *pulchre refulget* (white marble of south door sculpture, Santiago, IX-336); *pulchritudine magnitudine et operacione alias transcendit portas* (west door, Santiago, IX-360); *ipsa maior et pulchrior...mirabilius operatur diversis modis* (west door, Santiago, IX-362, 364, 365); *ceterisque operibus pulcherrimis...basilica refulget* (Santiago, IX-391-392); *studiosissime fit* (church of St-Front, Périgueux, VIII-650). See also the famous passage about the perfection of the cathedral: *nulla scissura uel corrpucio inuenitur, mirabiliter operatur, magna, spatiosa, clara, magnitudine condecenti latitudine longitudine et altitudine congruenti, miro et ineffabili opere habetur...* (IX-127-132), and the next sentence about the affective response to the experience of the upper spaces: *Qui enim sursum per naues palacii uadit, si tristis ascendit, uisa obtima pulchritudine eiusdem templi, letus et gauius efficitur* (IX-133-135). For further comment see English note IX-46.

58. Chapter X. For the importance of this chapter in relation to the question of authorship, see p. 24.

59. Chapter XI.

60. See English notes I-3 and III-37.

61. See the last sentence in Chapters III and VI, and Ch. VII between notes 8, 9 and 10; between notes 39 and 42. In Ch. IX after note 83 and by note 116, the references are more general.

62. Possibly also a literary topos, see English note IX-46;

and see also the same phrase in the *Veneranda dies* sermon, Book I, Ch. 17 (W 149).

63. See English notes VIII-22, 23, 82, 129.

64. For the miracles see Ch. XI, noting also the emphasis on hospitals in Ch. IV and the reference to the poor funding of the Santiago hospital in comparison to that of St-Léonard-de-Noblat in Ch. X, discussed below, p. $$.

65. Chapter VIII, English notes 131-171.

66. English notes VIII-1, 83, 97.

67. Martial is in the fragment of a 12th-century missal of Santiago, Archivo de la Catedral, fragm. 1, discussed in JANINI, 1961. See also STONES, 1992, n. 94.

68. For the architecture, see English notes VIII-71, 75, 117 and especially WILLIAMS, 1984.

69. Chapter I by English note 12.

70. Chapter I between English notes 12 and 13; VIII-103.

71. Many places are named in Chapters II and III, but few of their sites discussed in detail in Chapter VIII: see English notes VIII-191-198.

72. For the colophon reference see English note XI-11. For the Prologue to Book I, see WHITEHILL, 1944, p. 1. The omission of Cluny may be explained by the fact that it was never a major site of pilgrimage, unlike the sites described in Chapter VIII.

73. Chapter VIII, English notes VIII-57-64.

74. English notes VIII-64, 87 and IX-110, and see Catalogue of Manuscripts under P.

75. On the problems of what the terms *auctor* and *auctoritas* meant in this period, and the way medieval writers and readers viewed problems of authorship, see CHENU, 1927 and MINNIS, 1984. An *auctor* is a source known by name; *auctoritas* is the concept of using such an *auctor*, allowing also the possibility of using more than one at the same time; they are authorities who can be assumed to be 'right' in a given context because they have the weight of tradition behind them.

76. See particularly ROBERT, 1891 and English note I-2.

77. Book I: Prologue and all or parts of Chs. 2, 5, 6, 7, 12, 17, 19-30 (but not 31); Book II: Prologue and Miracles 1, 2, 5-15, 18-22; Book III: Prologue, Ch. 3.

78. But that folio is not intrinsic to the Codex; see DÍAZ Y DÍAZ, 1988a, p. 308.

79. DÍAZ Y DÍAZ, 1988a, pp. 321-322; Mariana thought that the *Guide* was full of 'cosas tan deshonestas', although he was delighted to receive a copy of a Short Version manuscript; see p. 36 and Catalogue of Manuscripts under VB and Z.

80. For the significance of the term *compilatio* in the period see PARKES, 1976, cited in note 11 above.

81. He had earlier corresponded with Oldegarius, Bishop of Barcelona and then Archbishop of Tarragona, on problems of the hierarchy of Spanish bishoprics. For Calixtus's correspondence with both Oldegarius and Gelmírez, see PL 163 and HC. For Oldegarius see also our Latin Appendix in Vol. II. Might Oldegarius in some way be connected with the production of the source for the Provençalo-Catalan Sermon of St James in Tortosa MS 106? See Collation: Lost Manuscripts.

82. For the distinctions see note 15 above. As SOUTHERN, 1958, p. 206, remarked, 'There is nothing intrinsically improbable about the statement that Calixtus was responsible for a collection of material designed to do honour to St James of Compostella. It is, however, clear that the *Codex Calixtinus* contains material which cannot possibly be ascribed to Calixtus II...'.

83. For the Spanish royal family see English notes V-4, 7; IX-120, 138, 142.

84. See English notes I-2, IX-44.

85. For Diego Gelmírez see English notes V-3, IX-119, 144 and particularly BIGGS, 1949, FLETCHER, 1972, 1984.

86. For mentions of Calixtus in the *Historia Compostelana* see FALQUE REY, 1988, indices. For the correspondence, see PL 163.

87. REILLY, 1969; FALQUE REY, 1988, p. 260, HC II, xx, xxvii-xxviii, *homines truces ignote lingue ad quodlibet nefas prompti*. This negative attitude is in part a literary topos dating at least to Carolingian times; see English notes VII-43-46.

88. See note 81 above.

89. See English note XI-11.

90. On Peter the Venerable see BISHKO, 1956, BREDERO, 1974, CONSTABLE, 1976, COWDREY, 1978.

91. WHITEHILL, 1944, p. 1.

92. See English notes VI-5-8 and note 161 below. An interest in vocabulary is also shown in the terminology used to describe the architecture and sculpture of the Cathedral of Santiago in Chapter IX; and there are close parallels in the *Veneranda dies* sermon, Book I, Ch. 17 (W 149). For his specialized knowledge of medical terms, see note 161 below.

93. See English notes IX-144-146.

94. JL 6823. It is transcribed in HC II, xvi, FALQUE REY, 1988, pp. 254-255, and in the early 14th-century Santiago Cartulary, Tumbo B (see FLETCHER, 1984, p. 209, n. 36).

95. See LE CLERC, 1847 and the extensive list of references in English note V-1.

96. See COWDREY, 1978, pp. 262-263.

97. JL p. 781.

98. JL pp. 824, 841.

99. See note 22. In C, A, VA, R, VB, Z and L he is the first of the signatories. In T he is listed second. The sequence of names is one of the variables in the recension of the bull: see Latin Appendix.

100. His letters to Diego Gelmírez are in HC II, xxiv and lxxxiii, and III, v, xxvii, l (FALQUE REY, 1988).

101. See English note V-1.

102. See English note V-9.

103. Queen Urraca's donation to Peter Pilgrim is the only instance of payment cited, see English note V-9.

104. This accords with the suggestion by DÍAZ Y DÍAZ, 1988a, p. 59, n. 99, that the author had access to local information at Santiago.

105. FALQUE REY, 1988, index; DÍAZ Y DÍAZ et al., 1985, pp. 18-19.

106. fl. late 11th century, author of the Ars lectoria (CHE-VALIER, 1905, REIJNDERS, 1971, KNEEPKENS, 1980). The style of that text is not particularly close to the Pilgrim's Guide.

107. FALQUE REY, 1988, p. 463, HC III, xxvi.

108. ALMERICH, 1965, pp. 10-12.

109. DEYERMOND, 1971, pp. 84-85; see also the reviews he cites.

110. RUNCIMAN, 1952/1971, p. 221.

111. cum magna suscipimus cordis alacritate, et mox ut in perlegendis illis studii nostri curam potuimus adhibere.

112. MARTÈNE/DURAND, 1717, I, col. 480.

113. inenarrabili nos affligunt dolori.

114. It occupies three columns of text in the manuscript.

115. MARTÈNE/DURAND, 1724/1968, I, cols. 870-872.

116. See English note V-8.

117. See English note VI-6 for a Poitevin dialect word; VII-4 for praise for the region; and Poitiers and St-Jean d'Angély are stopping-places in Ch. VIII, although Parthenay is not mentioned, see notes VIII-119-130.

118. See English note VII-6. From a Poitevin point of view, the dialects of Saintonge and Gascony would be variants of the langue d'oc rather than another language altogether like Basque.

119. LE CLERC, 1847 was the first to identify Aimeri with Aimeri Picaud of Parthenay; the identification has been widely accepted by LOUIS, 1952, MOISAN, 1985, ME-NACA, 1987, pp. 205-228 and MOISAN, 1992. See also English note V-1. 'Picaud' cannot be translated 'Picardy' as in HELMER, 1988, p. 20; and DÍAZ Y DÍAZ, 1988a, p. 87, n. 203, is right that C clearly says 'picaudus' not 'picandus' as HOHLER, 1972, p. 56, prefers. If the Aimeri Picaud of Parthenay is the author, it is surely surprising that Parthenay itself is not mentioned in the text. For the medieval churches at Parthenay and Parthenay-le-Vieux see SEIDEL, 1981: St-Pierre, Parthenay-le-Vieux, pp. 2, 21, 27, 59, 62-65, 66, 68, 77, 79, figs. 8, 53, 58; Notre-Dame de la Couldre, Parthenay, pp. 42, 48, 51, 62, 68, 78, figs. 10, 30-31, 39.

120. In the manuscripts under discussion here Ad honorem is copied complete in L and VA; M omits a couplet (see note 122 below), and A omits a line; and there are several missing stanzas in C, see Catalogue of Manuscripts.

121. See Catalogue of Manuscripts under C.

122. Peregrino Pictavensi/asinumque tradidit (W 398), a couplet omitted in M, see Catalogue of Manuscripts.

123. They fit particularly within the range of initials found in the decoration of Book I: see STONES, 1992, pp. 148-150.

124. As suggested by MORALEJO, 1980, SICART, 1981, AVRIL, 1983, BURIN, 1985, 1991, pp. 243-246, and STONES, 1992, esp. pp. 138-150.

125. MACHABEY, 1959, p. 34bis, gives a table showing the relationship between the notation of C and the antiphonary of Nevers, Paris, BN, nouv. acq. lat. 1236.

HUGLO finds parallels for the forms of the climacus, clivis and cephalicus of C in the gradual and antiphonary of Nevers, Paris, BN, nouv. acq. lat. 1235 and 1236 (HUGLO, 1967, p. 129, n. 36; id., 1984, p. 170, and id., 1992). See also GROVE, under Sources, p. 651; REANEY, pp. 238-241; and, for Book I, HELMER, 1988. WERF, 1990, 1992 stresses the correspondences between the music in Book I and the musical supplement that follows the Guide in C.

126. See the list in the Catalogue of Manuscripts under C.

127. See note 120.

128. There is space left for notation in VA, which is a direct copy of C, and in S, which does not depend directly on C, but in neither manuscript was the notation copied out; S lacks the musical supplement and with it the Ad honorem song, see Catalogue of Manuscripts under VA and S. SV has no music, but its exemplar did, and the scribe has indicated where with wavy lines in the margin, but he did not include the song. No other manuscript transmits the music: the Ad honorem song was not copied in R, the only other Codex Calixtinus manuscript to include any completed notation. There is no study that indicates how many of the Libellus manuscripts also attribute the song to Aimeri, nor how many omit the Poitevin pilgrim as M does; see note 122. These are questions that warrant further investigation.

129. The opinion of MOISAN, 1985, published without the benefit of the work of the 1970s by DÍAZ Y DÍAZ and HOHLER, to say nothing of HERBERS, 1984 and GAI, 1984, 1987, seems to us an overstatement of the evidence that is, at best, inconclusive. See also MOISAN, 1992.

130. The bull is omitted in S, P, M and SV (see DÍAZ Y DÍAZ, 1988a, p. 333, for S, P and M); T copies a variant version that omits these names; and VB, Z, and Mariana's copy rationalize the grammar to give Aimeri and Oliver separate identities. For a full list of the variants, see Catalogue of Manuscripts and Latin Appendix.

131. NITHARD, 1926, pp. 20-22. We thank Amy Remensnyder for this reference.

132. See Catalogue of Manuscripts and DÍAZ Y DÍAZ, 1988a, p. 308; the quire and hand are different, and it has different limiting dates provided by the 1139 miracle.

133. See Catalogue of Manuscripts under C and HUGLO, 1992. But Asquins itself is not mentioned in the text of the Guide; for Vézelay see English note VIII-78.

134. HOHLER, 1972, p. 56, notes the lack of arenga (formula of greeting and name of addressee), and treats the bull itself as a joke.

135. MARIANA published Tractatus VII from his manuscript in 1609, and the grammar of his version (quem etiam for qui etiam) is noted by DAVID, 1946, I, pp. 24 and 31, citing ES III, p. 120 (and incomplete references to Mariana). The full reference for the bull, to Tractatus VII, 1609, pp. 22-23, is given by WARD, 1883, I, pp. 550 and 564. The variant spellings of Escani for Iscani and of the signatories Ivo and Albericus given by Mariana are also noted by WARD, pp. 550, 559 and HÄMEL, 1950, pp. 60-61. VB and Z each treat the spellings of the signatories' names differently, see Catalogue of Manuscripts. The variant quem etiam for qui etiam does not appear to be a feature of the Libellus manuscripts, though a full collation is still needed. See Catalogue of Manuscripts for VB and Z, and the

43

variant version copied in T, and the Latin Appendix.

136. See the list, with dates, in the Catalogue of Manuscripts under C.

137. See note 135 above. The change in the grammar made in VB, Mariana's manuscript, and Z does not appear to be reflected in the manuscripts of the *Libellus* version, although the order and spelling of the signatories' names do vary. Further study is warranted. See also Latin Appendix.

138. The account is based on what is said in P and its immediate model, P1, which may in turn derive from a 12th-century original; see Catalogue of Manuscripts. The name Rainerius is common in the Florence/Pisa/Lucca region in the 12th century, whereas the originally Germanic Robertus entered Italy from Normans via Sicily, and does not appear in Tuscany before the 13th century.

139. Particularly those of the Province of Reims, and probably also of Cluny, see BREDERO, 1974, 1987; CEGLAR, 1976, 1987; COWDREY, 1978, pp. 182-183, 262-263; and P in the Catalogue of Manuscripts.

140. Could the relic they gave really have been part of the jaw of St James the Less, recently acquired from Jerusalem? See AASS, Maii, I, p. 27; GUERRA CAMPOS, 1982, p. 98; English note IX-110. We caution against the dangers of over-interpretation, as the Santiago sources, particularly the *Historia Compostelana*, are silent about the affair and do not mention Rainerius at all; see the discussion of P in the Catalogue of Manuscripts.

141. According to the account in P; see Catalogue of Manuscripts.

142. St-Jacques-du-Haut-Pas appears to have been in existence by 1183 (PERDRIZET, 1933, pp. 184-186, noting that its dedication was originally to St James the Less rather than to St James the Great; MEURGEY, 1926, p. 28). We thank Christopher Hohler, Humbert Jacomet and Léon Pressouyre for their help with Paris sources on the cult of St James.

143. Founded, according to poorly documented legend, by Countess Mathilda of Tuscany *c.* 1060; its history in the 11th and 12th centuries is equally obscure, but its church was dedicated to SS. James, Giles and Christopher, and its hospital sponsored by members of the Porcari family (KEHR, 1908, III, pp. 470-472; McARDLE, 1978, p. 2, n. 4, citing Archivio di Stato di Firenze, Regie Possessioni 3767, no. 7; LERA, 1970, pp. 80, 113-114; LORENZI, 1904, pp. 61-62; see also ANDREINI GALLI, 1976, and COTURRI, 1987). The place was certainly flourishing by the mid 12th century as it is included on the itinerary to Rome of the Icelandic abbot Nikulás of Munkathvera, written around that time; and Nikulás mentions its founding by Countess Mathilda (MAGOUN, 1940, p. 342, no. 74; see also Catalogue of Manuscripts under P). In 1239 it was given the Rule of the Hospital of San Jacopo de Altopascio by Pope Gregory IX (the Italian version, *Regola*, 1864, is edited by Fanfani; the original is Lucca, Archivio di Stato Spedale e Maggiore di S. Jacopo d'Altopascio, 2, reproduced in colour in *SANTIAGO CAMINO DE EUROPA*, 1993, no. 41, pp. 308-309). What remains unclear is how early the dedication to St James is and what the connections with St-Gilles were. By 1170 there was a parish of St James outside the walls at St-Gilles which was confirmed in 1203 to the Trinitarians (NICOLAS, 1912); the presence of St-Gilles in

the *Guide* and the negative attitude of its author towards the relics of St Giles are, in this context, items of some interest (see English note VIII-21).

144. '…primo domum juxta hospitale B. Mariae virginis ante foras Parisiensis episcopi conduxerunt' and 'data est fratribus domus S. Jacobi' (DENIFLE/CHATELAIN, 1889, I, p. 94, no. 34, citation from Jordanus's *Liber principii Ord. FF. Praed.*, quoted from AASS, Aug., I, 545, no. 40; see DENIFLE/CHATELAIN, p. 94, no. 35, and BIVER, 1970, pp. 353-357). The foundation was given to the Dominicans in 1217; from the dedication of that chapel, the Dominicans came to be known as the 'Jacobins' (see BORDIER, 1856, p. 13, n. 15, where the foundation is dated 1218 and attributed to the Franciscans; JACOMET, 1993, p. 31). By the early 14th century there was also the church and hospital of the Confrérie des pèlerins de St-Jacques at St-Jacques-de-l'Hôpital, on the Rue St-Denis at the corner of the Rue Mauconseil. BORDIER, 1875, p. 190 cites a document of 1298 for the existence of the Confraternity by that date; BORDIER, 1856, p. 25, gives the beginning of construction as 1319 (see also BORDIER, 1876, p. 332); Jean de Marigny, Bishop of Beauvais, celebrated the first mass there on 18 March 1323, and performed the consecration of the building in 1327. The papal bull of John XXII of 4 May 1325 at Avignon survives at Paris, Archives d'Assistance Publique, fonds Saint-Jacques, liasse 25, no. 326, see *SANTIAGO CAMINO DE EUROPA*, no. 43. It was for this Confraternity that Jean Pucelle was paid 3 sols to 'pourtraire' the famous seal between 1319 and 1324; the payment is recorded in the accounts for those years, which survive at Paris, Archives d'Assistance Publique, fonds Saint-Jacques, liasse 73, no. 231, cc. 2248; the date of his death has also been deduced from the record in the same accounts of his legacy of 2 sols to the hospital in 1333-34; see *SANTIAGO CAMINO DE EUROPA*, no. 42. The seal matrix was found in the Seine in 1852, then disappeared again, to be reproduced as an impression and an engraving in MORAND, 1962, pl. I c, d; it is now in the Musée Carnavalet, Paris, Inv. N.S.4, see *SANTIAGO CAMINO DE EUROPA*, no. 44. It was also for this church that Robert de Launoy was paid c sols for carving each of four apostle statues, see BORDIER, 1876, pp. 346-60; and for the menus of the annual banquet, ibid., pp. 361-76. See also PERDRIZET, 1933, p. 183; and, for the painting and sculpture, BARON, 1975. On Parisian hospital archives see BORDIER/BRIELE, 1877; but the picture in the 12th century is unclear.

145. MEURGEY, 1926, p. 28, citing BOUILLET, 1897, p. 42.

146. '…et ecclesiam sancti Iacobi qui est aput urbem Parisis inter Sequanam fluuium et montem Martirium…' (W 306).

147. See L'Abbé V[ILLAN], 1758; BORDIER, 1856, pp. 23, n. 73, and 40; MEURGEY, 1926, and VIELLARD-TROIEKOUROFF *et al.*, 1960, pp. 199-202.

148. As JACOMET, 1993, p. 30, has observed, it was Philippe I who allegedly attempted, unsuccessfully, to take possession of the relics of St James; see English note VIII-65.

149. For the papal bull concerning the transfer see JL 6789 (4964) and PL 163, p. 1142, dated 27 November 1119 (not 17 November as misquoted in MEURGEY, 1926, p. 8); and DEPOIN, 1912, I, no. 157, p. 245. BORDIER, 1856, p. 23, n. 73, describes the church as a 'chapelle qu'on croit fondée

au IXe s'. Excavations carried out in 1844 and 1852-53 uncovered foundation walls of a chapel with an apsidal east end, measuring 23.30m × 9.90m. Excavation drawings by Vacquer are preserved at the Bibliothèque historique de la Ville de Paris, as série 12, Collection Théodore Vacquer, dossier 49 (MS 237), cited by Elisabeth Chatel in VIEILLARD-TROIEKOUROFF *et al.*, 1960, pp. 199-202. Vacquer attributed the building to *c.* 900; MEURGEY preferred a broader range, between *c.* 850 and 1050 (Chatel, op. cit., p. 202, citing MEURGEY, pp. 28, 195).

150. The relationship between Matthew of Albano and Rainerius of Pistoia is discussed in the Catalogue of Manuscripts under P, where full references are cited.

151. See Catalogue of Manuscripts under C. The hospital associations may also provide a significant link between the Italian Rainerius and the Poitevin canon discussed above, who was most likely connected with the hospices at St-Léonard-de-Noblat and Santiago.

152. Discussed by PLANCHART, 1976, pp. 28-29 (misquoting Paris, BN, lat. 17315 as 17351), as sources for Guillaume Dufay's Mass of St James, and attributed to the use of St-Jacques-de-la-Boucherie by analogy with the printed Office of St James published by the canons of St-Jacques-de-la-Boucherie in 1581 (PLANCHART, n. 18); see also HUGLO, 1992, p. 111 and MOISAN, 1992, p. 127, n. 27. Hohler, following transcripts made by Patricia Stirnemann, wonders whether a more likely patron for Paris, BN, lat. 17315 might not be St-Jacques-de-l'Hôpital, or St-Jacques-du-Haut-Pas; LEROQUAIS, 1934, III, p. 48, no. 510, and id., 1924, II, pp. 221-222, no. 800, gives both simply as use of Paris. The implications of these texts for the earlier liturgy of St James in Paris and elsewhere still need full analysis in relation to the other extant sources, the early printed breviaries of Braga, Jaén and Santiago, and the sources cited in note 16 above. (The appearance of *Ad consultum veritatis* [C, f. 44v] in breviaries of Cambrai is a case in point [OTTOSEN, 1993, pp. 214, 250]. The presence of a relic of St-Giles at St-Sépulcre, Cambrai [Hainaut] and the Baudouin de Hainaut manuscript are all clues that point towards Cambrai, in one way or another.) We are indebted to Christopher Hohler and Michel Huglo for their assistance with the liturgical problems posed by Book I of the *Codex Calixtinus*.

153. *Le Graduel romain*, II, 1957, p. 115. We thank Michel Huglo for this reference.

154. See Catalogue of Manuscripts and Collation.

155. English 'shad': see English note VI-6.

156. See English notes XI-9, 10, 11.

157. See W 259 and note 279 below.

158. FALQUE REY, 1988, p. xviii. VONES, 1980, p. 64, is more sceptical.

159. We have mentioned the author/compiler's predilection for lists of words (see note 92), and the didactic aspects of the structure of the information on topography, for which the closest parallel is a Signy manuscript that appears to have been used in teaching (see note 25 above and English note I-8). HOHLER, 1972, *passim*, considers the language, and the use of deliberate errors, in the 'Calixtine' sermons in Book I and the *Pseudo-Turpin* a clear indication that the 'author' was a schoolmaster and that the compilation was drawn up for teaching.

160. He was first mentioned by Adhémar de Chabannes *c.* 1028, see English note VIII-84 and note 166 below.

161. See English note X-4. DAVID, 1948, III, pp. 80-81, tp 10-11, commented on the author's specialized use of medical terms, noting his use of the word 'limpha' for 'aqua', in the adjectival form on W 159, cited by DÍAZ Y DÍAZ, 1988a, p. 75, n. 158, see English notes VI-4 and 5; and his discussion in the *Veneranda dies* sermon of the medicinal properties of the lily, drawn, as he says, from Dioscurides (W 146), noted by HOHLER, 1972, p. 44, who located the passage in KUHN Book X, ch. 102, p. 112; MOISAN, 1992, p. 129, n. 44, also noted the references to the lily but failed to draw any conclusions from them. The author's knowledge of Dioscurides could have come from a Latin translation or from an intermediary such as Gargilius Martial or Isidore; for the medieval tradition of Dioscurides see DUBLER, 1953, pp. 14-20 and 58-63. It is possible that his use of 'vulva' meaning 'vulva' rather than 'womb' may also reflect a knowledge of medical terminology; but he might equally well have learned the word in Juvenal or Persius, or Celsus or Fulgentius, or, if ADAMS, 1982, pp. 103-108 is right, in popular language (see English note VII-49, Latin VII-365). Also significant is the list of diseases in the Calixtine sermon that forms Ch. 6 of Book 1 (W 49). It is worth noting that the surviving records of Santiago hospitals are late: the earliest register of admissions of the sick to the Hospital de los Reyes Católicos is dated 3 July 1654 to 30 March 1657 (Santiago, Archivo Histórico Universitario, Fondos del Hospital de los Reyes Católicos, 1.307, see *SANTIAGO CAMINO DE EUROPA*, no. 48).

162. An important reference, although the surviving document about Limoges concerns the division of alms between the canons of St-Léonard and the Bishop of Limoges, and omits mention of the hospice. See English note X-5. The author of the *Guide* appears to have had access to additional information.

163. But these miracles are included in Book II of the compilation in R, VB, and Z; see Catalogue of Manuscripts.

164. See BECQUET, 1974/1985, VIII, pp. 77-86.

165. See GAMS.

166. BECQUET, 1974/1985, VIII, p. 78, n. 21, English note VIII-84, and note 160 above.

167. See note 162 above.

168. Chapter VIII-131-171.

169. See English note VII-6.

170. See HÄMEL, 1953, MANDACH, 1961, and above.

171. HOHLER, 1972, p. 50.

172. The three are the collegiate church of St-Martin, Tours (now largely destroyed), the abbey of Ste-Foy, Conques, and the collegiate church of St-Sernin, Toulouse. See English notes VIII-117, VIII-75 and VIII-70 respectively. See also CONANT, 1959, p. 94, fig. 28; SEDLMAYR, 1970; and WILLIAMS, 1984.

173. The apostolic claims made about Fronto, and the miracle of George's resurrection, were already recounted in the early Martyrologies when Adhémar de Chabannes made the claim in the 1030s for the apostolic mission of Martial of Limoges; see COENS, 1930, 1957 and English note VIII-97.

174. For St Martial see the full list of early textual sources by PRÉVOT, 1989, p. 70. Adhémar de Chabannes was a staunch, if during his lifetime unsuccessful, supporter of Martial's claims, and the author of forgeries in support of them. See ADHÉMAR DE CHABANNES; LASTEYRIE, 1901; SALTET, 1925, 1926; SOHN, 1989; and LANDES, 1992. This is not to deny that, as GAIFFIER, 1951a has demonstrated, the sources for Eutropius's life include Pseudo-Abdias, Abgar, and the Lives of St Denis, see English note VIII-131; but it is also significant that Eutropius's life appears here for the first time (assuming the *Libellus* tradition cannot be proven to be earlier), and in the context of other anti-Martial sentiment.

175. See THOMAS, 1894, COENS, 1930, 1957, and English note VIII-97.

176. See note 173 above. LANDES, 1992 makes similar points and refers (p. 227, n. 5) to SARGENT, 1985.

177. See note 133 above and HUGLO, 1992, p. 109, for the observation that Vézelay and Santiago shared the same dedication date of 21 April.

178. For surviving music manuscripts from Ste-Foy see English note VIII-73.

179. See English note VIII-88.

180. HOHLER, 1972 and personal communications; for examples of hyperbole and an emphasis on unseemly relic-snatching associated with St Giles, see English notes VIII-21, 23, 24, 39, 44, 57.

181. English note VIII-18.

182. English note XI-11. See also note 143 above for a possible link between St-Gilles and Altopascio, Altopascio's connection with St-Jacques-du-Haut-Pas in Paris, and Rainerius.

183. English notes VIII-78-80.

184. Two of the authors of the *Historia Compostelana*, archdeacon Hugh, and the schoolmaster Gerald are thought to have been of French origin (VONES, 1980, pp. 49-56; FALQUE REY, 1988, pp. xiv-xv), as also Bernard the Treasurer, also known for his engineering work on the fountain and water-works and possibly involved in the building of the cathedral, and as Royal Chancellor and scribe of the Santiago Cartulary Tumbo A from 1129. See English note IX-62. BARREIRO SOMOZA, 1989, p. 23, n. 4, lists four French canons cited in the Cartulary Tumbo B: Fernando Pérez Godino, Juan Fabre, Hugo de Vexin, and Bernard Gui, though their dates extend into the 14th century and are not directly relevant here. For the links between Bernard Gui and Archbishop Berenguer de Landoria, see p. 33 below.

185. English note VII-42.

186. Text by English notes VII-39-40.

187. Text by English notes VII-59-60.

188. English note VIII-17.

189. English notes VI-7-10; VII-7, 8; VIII-93.

190. English notes VII-9, 12, 36, 39, 51.

191. For Ovid see English note VII-44; for the Dioscurides reference in Book I, Ch. 17, the *Veneranda dies* sermon, see W 146 and note 92 above; for the attribution of the 'Nec veneris nec tu' poem in the same chapter (W 160) to Basilius, see HOHLER, 1972, p. 49 and n. 70, with reference to Brussels, Bibl. Royale, MS 5657, which also contains Martial. For his knowledge of medicine see also Book I, Ch. 6 (W 49) and note 161 above.

192. Probably in general currency, not necessarily dependent on a knowlege of Caesar, see English note VII-43.

193. English notes IX-84-86.

194. See particularly English notes IX-29-46. The words at IX-46 may simply be a literary topos. See also note 62 above and W 149.

195. English notes VIII-23, XI-7.

196. English note VIII-51.

197. The description of a service at Santiago in Book I, Ch. 17 emphasizes the effects of the music (Whitehill, 1944, p. 149). In the *Guide*, mention is made of the liturgy only at Ste-Foy, Conques (see note VIII-76).

198. The accounts of the saints in Chapter VIII show knowledge of the early martyrologies and various individual *Vitae*, and, occasionally, epics (VIII-68); the Life of St Eutropius is based on Pseudo-Abdias, the Legend of Abgar and the Lives of St Denis (English notes VIII-131, 132). There are also details for which no source can be traced (VIII-10).

199. The twelve manuscripts that preserve the text of the *Pilgrim's Guide* are listed on the endpapers and in the Catalogue of Manuscripts, with the sigla by which we refer to them hereafter. Sigla used by all previous writers are also listed in the Catalogue of Manuscripts at the end of each entry.

200. The major discussions are by MORALEJO, 1978; SICART, 1981; STONES, 1981; AVRIL, 1983; BURIN, 1985; AYRES, 1992; STONES, 1992, 1996; CAHN, 1996, no. 24.

201. In C, A, and VA; S offers a narrative initial instead of a portrait, see below.

202. Confusion between the two saints James and between their relics was rife, and by the early 12th century Santiago possessed relics of both. See English note IX-110.

203. Apart from those of ff. 24v and 31, see *ills. 2, 5* and STONES, 1992, p. 148.

204. The decoration accompanying the work of the second scribe consists of one foliage and dragon initial, on f. 179 (*ill. 23*) and several red and blue pen-flourished initials, between two and ten lines high (*ills. 11–13, 16*); the stylistic associations here are with Spanish manuscripts at or associated with Santiago, notably the hand of 1176 in Tumbo A and the minor initials in Arnault de Munt's manuscript of 1173, see STONES, 1992, pp. 154-156.

205. The first to point out the stylistic dependence of the St James portrait on the St Matthew-as-Michael in the Carilef Bible, Durham Cathedral Library, MS A.II.4, f. 87v, was MORALEJO, 1980, n. 102; see also SICART, 1981, STONES, 1981, AVRIL, 1983, BURIN, 1985, AYRES, 1992 and STONES, 1992; CAHN, 1996, no. 24.

206. The decoration and illumination in C is likely to have itself been done by Frenchmen, probably working at Santiago and closely associated with the Cathedral, because of the claim that the ruling pattern in the book is Spanish; see KELLER, 1990, following VEZIN, 1978.

207. The Turpin initial in A is now missing, together with the miniature of the warriors discussed below; see Catalogue of Manuscripts.

208. Both have the additional songs (including the stanzas from *Ad honorem regis summi* now missing in C), the false bull of Innocent II, and the miracle of 1139, in the same order; both A and VA lack the post-communion fragment that precedes the false bull in C, but A has part of the Mass that is not now preserved in C or in VA. VA also omits the colophon to Book V (though space is left for it) and the Alleluia in Greek which follows the miracle of 1139, both preserved in A. Neither copy includes the notation for the songs, but VA leaves two-line spaces for it and writes the accompanying text syllabically, in Book I and also after the end of the *Guide*. A includes, in a later hand, a commentary on Job in Spanish that does not reappear elsewhere in the *Codex Calixtinus* textual tradition.

209. A is smaller than C, while VA is much larger, and is in fact the largest of the extant *Codex Calixtinus* manuscripts, although its text is still copied within a single-column text block, unlike S, which, in spite of its smaller overall size, is the only manuscript to adopt a two-column layout. Comparative measurements are as follows, in mm. C: 295 × 212; A: 222 × 155; VA: 375 × 260; S: 337 × 245; P: 290 × 205; M: 210 × 155; T: 215 × 140; SV: 314 × 217; R: 286 × 185; VB: 217 × 144; Z: 317 × 217; L: 347 × 230.

210. Tumbo B is reproduced in colour in *SANTIAGO, CAMINO DE EUROPA*, 1993, no. 116; see also DÍAZ Y DÍAZ et al., 1985.

211. St James has shells on his halo in both, and the facial types are more similar to each other than either is to VA. The similarity was first noted by SICART, 1978, see also STONES, 1981, p. 202, and MORALEJO in DÍAZ Y DÍAZ et al., 1985, pp. 60-62, pl. XXIX.

212. The pen-flourished initials in A and VA, in red and mauve, are also very similar to each other and to those in Tumbo B. See particularly STONES, 1981.

213. Díaz y Díaz in *SANTIAGO CAMINO DE EUROPA*, 1993, no. 105, prefers a more general date in the first half of the 14th century for S, while putting A (no. 104) *c.* 1330 and VA (no. 103) in the second half of the 14th century. For S, see also *Guía del Peregrino*, 1994.

214. Not least of these is the inaccuracy of his text, which we discuss below.

215. DÍAZ Y DÍAZ, 1988a, p. 328. The assumption to that effect in STONES, 1981, is erroneous; that article was unwisely written without consulting S directly, a situation since remedied.

216. This treatment rather simplifies the text description of the vision, where Marsile's soul is taken to hell by a phalanx of hideous warriors, while St Michael conveys the souls of Roland and his companions to heaven (Ch. 21, W 334). The devil in S does not carry the soul of Marsile. Much closer to the text is the illustration in the French version, Paris, BN, n. a. fr. 6295, f. 29v (LEJEUNE/STIENNON, 1966, fig. 368, and STONES, 1996, pl. 30).

217. For other examples of this subject in the illustrated French Charlemagne chronicles, see LEJEUNE/STIENNON, 1969, also discussed in STONES, 1996, pp. 195-196.

218. Two of the three are missing in A, see Catalogue of Manuscripts.

219. The details are different: in S, St James points to scenes at the sides showing Christians being killed by Saracens (the reason why St James asks Charlemagne to mount the Spanish crusade) that are lacking in C, A and VA.

220. In S, Roland holds a rectangular banner that could be read as *paly or* and *gules*: the arms of Aragon? And Charlemagne holds a triangular pennant that could also be so read. See PASTOUREAU, 1980a, RIQUER, 1983, POPOFF, 1989. But below, a civilian holds a shield *fessy or* and *sable*. It seems unlikely that either of these arms were meant to reflect those of a patron from Aragon, as the book appears to have remained in Santiago until the 16th century, see below; but it is worth noting that the sainted Queen Isabelle of Portugal (1271-8 July 1336), daughter of King Peter III of Aragon, made a pilgrimage to Santiago in memory of her husband Denis in 1326 (*SANTIAGO CAMINO DE EUROPA*, pp. 99-119). MORALEJO has recently pointed to an interesting link between the iconography of St James as pilgrim, holding Tau staff, in S and Tumbo B, and Queen Isabelle's effigy on her tomb in Sta Clara, Coimbra, where she is holding the same Tau cross (MORALEJO, 1993, esp. pp. 48-50). Might the arms of Aragon be a hint that S was planned for her, or that she paid for its execution? Perhaps the other arms (so far unidentified) might be of someone in her entourage. But the manuscript appears to have remained in Spain, to be taken from there to Salamanca; see p. 34 below and Catalogue of Manuscripts.

221. STONES, 1981. For Chartres see MAINES, 1977; STONES, 1996, n. 1; NICHOLS, 1983, pp. 95-105 adds little to the discussion while obfuscating considerably; he also uses VA's illustrations to make anachronistic points about the 12th century.

222. See STONES, 1992, pp. 146-147.

223. A fascinating hint of the kind of pictorial model from which these puzzling scenes might have been drawn is the partially preserved wall-painting at Cressac, Charente, to which Frances Terpak and Christopher Hohler independently drew my attention; see DESCHAMPS and THIBOUT, 1951, pp. 132-137. The beard-pulling civilians/warriors still do not make much sense. Are they supposed to be pointing towards the portrait of Turpin on the facing page, and to the opening of his narrative, encouraging the viewer to read on, as suggested by Walter Cahn at the Pittsburgh conference in 1988? Such an explanation seems preferable, to me, to LEJEUNE and STIENNON's idea that they are commenting upon the wall-paintings of the Liberal Arts in Charlemagne's palace (LEJEUNE and STIENNON, 1966, p. 54). For the beard-pulling motif see, in addition to GJAERDAR, 1964, *Apologiae duae*, 1985, and JACOBY, 1987.

224. The subject relates to St James's legendary intervention at the 9th-century battle of Clavijo at which the Moors were defeated. The event is not recorded earlier than the 12th century, in Santiago, Archivo de la Catedral, Carp. 7, no. 1 (*SANTIAGO CAMINO DE EUROPA*, 1993, no. 112). See also the 12th-century sculpture of the same subject at the Cathedral of Santiago and the 13th-century Tumbo Menor de Castilla, Madrid, Archivo Histórico Nacional, Códices, 1046B, discussed in SÁNCHEZ ALBORNOZ, 1948 and STONES, 1981; the Tumbo was no. 113 in *SANT-*

IAGO CAMINO DE EUROPA, 1993. In the Santiago cartulary Tumbo B, the legendary companions Theodore and Anastasius who are allegedly buried with James in the Cathedral of Santiago de Compostela appear beside St James enthroned in the upper part of Tumbo B's miniature. For their legends, and for the account of how their relics were distinguished from those of James when their joint tomb was opened in 1879 (by matching the remains with James's relic from Pistoia) see AASS, Nov., I, pp. 1-16, 18-22, and our catalogue entry for P.

225. SMYSER, 1937/70, pp. 7, 110. The relevant text passage reads *Humilitatem meam, qua vobis meum presento et codicem et servitium, mea designant yconia in capite libri vestre humiliter maiestati affusa* (p. 110). 'My image, (*mea…yconia*) humbly offered to your majesty at the beginning of the book, signifies my humility, in which I present my codex and my service to you'. For other links with Cambrai see note 152 above.

226. SMYSER, pp. 6-7, 110. HÄMEL, 1953, p. 81, sees it as of mixed recension; MANDACH, 196, p. 370, classifies it as M2S. It would be interesting to see if its texts are closer to C or to S, whose illustrative programmes differ significantly from each other.

227. W 20-21. Z's table of contents includes the four sermons from Book I (Chs. 2, 5, 6, 19 of C) that are in VB; CIROT, 1905, p. 397, argues that they are absent in the manuscript because Mariana had sent them off to be published; we agree but view Z as the copy of Mariana's manuscript made for Burriel rather than being Mariana's copy itself. See Catalogue of Manuscripts under Z.

228. Thurstan died, like Diego Gelmírez, in 1140. If it ever existed, his copy of the *Codex Calixtinus* was probably made after 1139 as the surviving English copy, T, includes the false bull of Innocent II which, in C, is on the same folio as the 1139 miracle. See Catalogue of Manuscripts under C and T, and our discussion of Lost Manuscripts, p. 227.

229. DÍAZ Y DÍAZ, 1988a, pp. 134-135, expresses caution about whether R is actually Arnault's copy; previous scholars have assumed that it was. We have not found his hand among the other Ripoll manuscripts in the Arxiu de la Corona de Aragó, Barcelona. See our discussion of the relationship between VB and R below for a possible hint that two copies might have been made *c.* 1173. The Arxiu de la Corona de Aragó in Barcelona, where Ripoll books are now held, is not yet among the collections filmed by HMML at Collegeville, Minnesota. See also VIELLIARD, 1938, and our Catalogue of Manuscripts under R.

230. 'reperi volumen ibidem .V. libros continens de miraculis apostoli…et de scriptis sanctorum patrum, Augustini videlicet, Ambrosii, Yeronimi, Gregorii, Leonis, Maximi et Bede' (he does not mention Calixtus in this list, but he did transcribe some of the Calixtine sermons, and says so later in the letter). Transcribed in VIELLIARD, 1938/1968, pp. 126-127 and in our Catalogue of Manuscripts under R. The inclusion of *Pseudo-Turpin* would also have interested Ripoll monks, as Count Raymond Berenguar IV of Barcelona, who claimed descent from Charlemagne, had been buried there in 1162 (BISSON, 1986, p. 35, citing the Ripoll compilation of the *Gesta Comitum Barcinonensium c.* 1162).

231. BEER, 1908, 1910 and GARCIA, 1915. None of the other Ripoll manuscripts of the period have this script or decoration. For the closest parallels see Catalogue of Manuscripts under R.

232. See the Table of chapters in manuscripts of the *Pilgrim's Guide*, p. 52.

233. There is no 12th-century calendar of Ripoll among the abbey manuscripts now in the Arxiu de la Corona de Aragó, but the collection does include a 15th-century missal, no. 112; a 12th/13th-century *Tractatus de officiis ecclae* [sic], no. 117, which, if it indeed comments on processions and such throughout the church year, would give saints commemorated at Ripoll; a 14th-century hymnal, no. 180; see GARCIA, 1915.

234. Latin note IX-44, English note IX-20.

235. The latter is more likely as the variants between R and C occur largely in the sections recopied in C by Hand 2; see Collation of Manuscripts.

236. Most of the recopying is on outer bifolia; see Catalogue of Manuscripts under C.

237. See English note IX-20.

238. Bishop Atto of Pistoia, most likely associated in some way with the production of P's model, had formerly been abbot general of the reformed Benedictine order of Vallombrosa; but P reveals no particular link with the abbey; see Catalogue of Manuscripts under P. It is possible that Fra Juan de Azcona, scribe of M, was a Benedictine; he does not indicate to which order he belonged, but he did pay special attention to the reused Roman altar in the church of S. Payo, see Catalogue of Manuscripts under M, p. 177. A later owner of A was Fra Martín Sarmiento, monk of the Benedictine abbey of S. Martín de Alcalà, near Madrid, but he did not commission the manuscript. See below, Catalogue of Manuscripts under A, p. 109.

239. Mary Magdalene, Leonard, Giles, Severinus and Dominic are also omitted in R. R in general has few French saints. The Vézelay cults of Mary Magdalen and Leonard were still relatively new, as was Giles, and may not have been celebrated at either Ripoll or Alcobaça. Does the omission of Dominic in both indicate that his was also still a relatively local feast, not celebrated at Ripoll or in Portugal? More work on Iberian calendars is clearly needed.

240. See Catalogue of Manuscripts under L, where references for the historical background are also given.

241. ROSA PEREIRA, 1985, MS 143, pp. 133-134 and pl. 19. The Lorvão manuscript, dated 1185, had material on the relatively new cult of Thomas Becket, adopted into the Cistercian calendar in that year.

242. For precise parallels see Catalogue of Manuscripts.

243. See pp. 13-14 above.

244. Reproductions and discussion in GAI, 1984. See also Catalogue of Manuscripts under P.

245. Pistoia, Archivio di Stato, Doc. vari 1, discussed by GAI, 1984, p. 192, n. 72, and in our Catalogue of Manuscripts under P.

246. See the facsimile edition by DÍAZ Y DÍAZ *et al.*, 1985, and *SANTIAGO CAMINO DE EUROPA*, 1993, no. 116.

247. See our Collation, pp. 197-240.

248. The problem of these exemplars is discussed on pp. 204, 227, 233.

249. A possible hint of an intended patron is the presence of the emblems of Castile and León in the bottom margin of f. 1 in A: could it be an indication of royal patronage? If so, the intention would appear to have been thwarted as we know that it was acquired before 1375 by a scribe for Pedro de Luna. See Catalogue of Manuscripts under A. The presence of the arms of Aragon in S is equally inconclusive in terms of its intended patron or early ownership; see note 220 above and in the Catalogue of Manuscripts under S.

250. Salamanca, Bibl. Univ., MS 2658. Flórez, ES XX, p. 612, using the *Gesta Berengarii*. Berenguer is the first Dominican archbishop of Santiago identified by GAMS (p. 26), but Flórez also lists Archbishop Rodericus González de León, (died 1304), as Dominican. See also the biography of Berenguer by DÍAZ Y DÍAZ, 1983.

251. Tumbo B gives Bernard Gui as a canon of Santiago, see note 184 above; but French sources appear to offer no independent corroboration of this and also suggest that, although consecrated as Bishop of Tuy, he never took possession of the see (VICAIRE, 1981, with essays by AMARGIER, GUILLEMAIN, and VICAIRE; and more recently GUÉNÉE, 1987, pp. 49-85).

252. DÍAZ Y DÍAZ, 1988a, p. 13, n. 95.

253. See DÍAZ Y DÍAZ, 1983.

254. See Catalogue of Manuscripts under S.

255. See Catalogue of Manuscripts under A.

256. The donation is recorded in the hnadwritten catalogues of 1598 and 1603, see Catalogue of Manuscripts under VA.

257. See Catalogue of Manuscripts under VB.

258. See p. 32.

259. See p. 21.

260. DÍAZ Y DÍAZ, 1988a, pp. 259-260, pl. IX, X.

261. PFANDL, 1914-17; 1920, pp. 1-181; HÄMEL, 1938. The account is in Munich, Bayerische Staatsbibliothek, Cod. lat. 431, which was owned by Hartmann Schedel, author of the Nuremberg Chronicle. For German pilgrim accounts see PLÖTZ, 1984a, 1990, HERBERS, 1988, GANZ-BLÄTTER, 1991, and Herbers in *SANTIAGO CAMINO DE EUROPA*, 1993, pp. 121-139.

262. For full description of the texts in T see the Catalogue of Manuscripts.

263. The Tablets are now in Oxford, Bodl. Lib., MS Lat. hist. a. 2, edited in KROCHALIS, 1997a).

264. Translated into modern French by BOURLET, 1991.

265. HIERONIMUS MÜNZER, p. 154.

266. MANDACH, 1961, lists several copies of *Pseudo-Turpin* in different versions, in German libraries, but none has the *Guide* attached. See also KLEIN, 1986.

267. HIERONIMUS MÜNZER, p. 144.

268. Ibid., p. 98.

269. Ibid., p. 155, and see KROCHALIS, 1996.

270. MANDACH, 1961, lists no copy in Nuremberg itself. This was just the period when scepticism about the contents of *Pseudo-Turpin* was growing in Germany under the influence of the French historian Robert Gaguin, whose *Compendium de origine et gestis francorum* of 1495 was the first to condemn the *Pseudo-Turpin* and the *Descriptio*; particularly striking are the changes in Johannes Tritheim's attitudes between 1492 and 1514; see SHORT, 1972, esp. p. 129. For attitudes at Saint-Denis towards the *Pseudo-Turpin* see BROWN, 1992.

271. SHORT, 1972, assumes what Münzer saw was not C but another manuscript.

272. He may have come from the village of Azconita near San Sebastian, but Léon Pressouyre kindly informs us that the name is widespread in Basque and means 'badger'. Juan seems to have read critically the list of Basque words in Chapter VII and gives variants for most of them, see Latin notes VII-309-318, though he does not add comments on the *Guide's* text, nor take issue with its negative presentation of the Basques.

273. We thank Elizabeth Peterson for this observation.

274. Originally dedicated to St John the Evangelist, brother of St James the Great; see English note IX-100.

275. Originally dedicated to the Holy Saviour; see English note IX-101.

276. Originally dedicated to St Martin of Braga; see English note IX-104.

277. *SANTIAGO CAMINO DE EUROPA*, 1993, no. 5, with comment on the attitude of Ambrosio de Morales by Serafín Moralejo; see also PEREIRA MENAUT, 1991, I, no. 48, pp. 131-134.

278. See Catalogue of Manuscripts under P.

279. The *Guide's* author/compiler knew enough Italian to know a variant Italian name for 'shad', *clipia* (see Latin note VI-67, English note VI-8) and p. 26; and Rome was one of the places claimed in the colophon that the *Guide* was written (English notes XI-10-11). Elsewhere in the *Codex Calixtinus* compilation references to Italy are sparse, but several of the miracles in Book II, nos. 2, 11, 12, 15, happen to Italians; no. 2 is attributed (falsely) to Bede, the others (also falsely) to Calixtus; see description in Catalogue of Manuscripts under C. See notes 155 and 156 above.

280. MORALES, 1765, pp. 130-131, HÄMEL, 1943, pp. 232-233, SHORT, 1969, p. 3, DÍAZ Y DÍAZ, 1988a, pp. 321-322 and n. 62. Morales (p. 40) had also seen a copy at the Cistercian abbey of Sandoval near León; see also the note to this effect in SV. The Sandoval copy appears to be lost and it is unknown whether or not it contained the *Guide*; see Lost Manuscripts, p. 234. Another sceptic of this period is Don García de Loaysa, reported by TOLRA, 1797, cited in JACOMET, 1993, n. 135.

281. For this, rather than the usually suggested earlier date, see DÍAZ Y DÍAZ, 1988a, pp. 322-323.

282. His *História general de España* was first published in Latin in Toledo in 1592, then in Madrid in 1606, and in an expanded translation in 1608. DÍAZ Y DÍAZ, 1988a, p. 323, n. 72, cites the Spanish version of 1606, p. 342.

283. See Catalogue of Manuscripts under VB and Z, and our discussion of Lost Manuscripts, p. 225, 226, 233.

284. MARIANA, 1609, p. 21, cited by DÍAZ Y DÍAZ, 1988a, p. 323, n. 72.

285. Published in Cologne.

286. See Catalogue of Manuscripts under VB.

287. 'Of the part of the library remaining at Avignon, little is known with certainty. It is known that Martin V ordered some of the manuscripts returned to Rome in 1418. Of the part remaining at Avignon to 1594, about 400 manuscripts were taken to the Palazzo Borghese in Rome under Paul V (1605-21)', THOMPSON, p. 452. VB was not among those manuscripts. A manuscript belonging to a Bishop Esteve in the 1580s could not in any case have been still in Avignon in the 1590s. Nor was it among the manuscripts Paul V acquired from the Duke Giovanni Angelo d'Altemps in 1612: see MERCATI, 1938.

288. See Catalogue of Manuscripts under SV.

289. See ANDRES, 1898, p. 619, and Catalogue of Manuscripts under Z.

290. See Catalogue of Manuscripts under Z.

291. See Catalogue of Manuscripts under A.

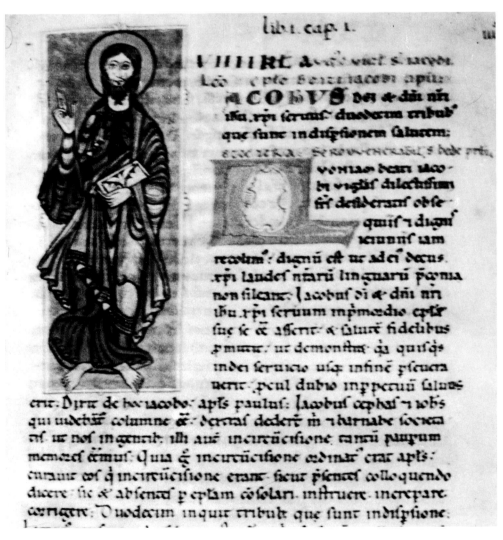

St. James. Santiago de Compostela, Archivo de la Catedral, f. 4

CATALOGUE OF MANUSCRIPTS

Table of Chapters in Manuscripts of the 'Pilgrim's Guide'

Manuscripts are listed by sigla, following the sequence in which we collate them, Long Version manuscripts first (C, A, VA, S, P, M, T, SV), then Short Version manuscripts (R, VB, Z), followed by the special selection from the Long Version in L. Beginnings of chapters are indicated by folio number. Omissions are indicated by a dash -. Z's chapter numbers, not found elsewhere, are given in footnotes. L's sequence of passages is given at the end of the table.

L's sequence of *Codex Calixtinus* texts is as follows: ff. 182-185: Introduction to Eutropius and the Passion of Eutropius (II, pp. 54-55); f. 211v: Julius Caesar (II, pp. 222-223); ff. 211v-214v: Trophimus, Caesarius, Honoratus, Genesius, Les Alyscamps, (Giles, his shrine and his immoveability are omitted), four immoveable bodies, William, Tiberius, Modestus, Florentia, Saturninus, Faith, (Mary Magdalene and Leonard are omitted), Fronto, Cross, Chalice, Evortius, Knife of the Last Supper, (Martin omitted here, inserted below), Hilary, John the Baptist, (Introduction to Eutropius and his Passion omitted here, inserted above), Romanus, Roland, Horn of Roland, (Severinus omitted), Roland's companions, (Dominic omitted), Facundus and Primitivus (II, pp. 64-65). Ff. 214v-215: *Ad honorem* (see Catalogue of Manuscripts, p. 107), Martin (omitted above); ff. 215-215v: False Bull

Chapter	Manuscripts											
	C	A	VA	S	P	M	T	SV	R	VB	Z	L
Foreword	192	159	156v	107	138v	181	41	72	80	41v	136v	-
Chapter list	192	159v	156v	107	138v	-	-	72	-	-	-	-
Ch. I Roads	192	159v	157	107	138v	181	41	72	80	41v	137	-
Ch. II Days' Journeys	192v	160	157	108v	139	181	41v	72v	-	-	-	-
Ch. III Names of Towns	192v	160	157	108v	139v	181v	41v	73	-	-	-	-
Ch. IV Three Hospices[1]	193v	161	157v	109	141	182	42	73v	80v	42	137v	-
Ch. V Names of Road Repairers	193v	161	157v	109	141	-	42	73v	-	-	-	-
Ch. VI Good and Bad Rivers[2]	193v	161	157v	109	141v	182v	42	73v	80v	42	137v	-
Ch. VII Lands and Peoples[3]	194v	162	158v	109v	143	183	42v	74v	81	42	138	-
Ch. VIII Bodies of Saints[4]	197v	165	161	111v	149v	187	-	77v	82v	43v	140v	211v
Ch. IX City and Basilica of St James[5]	207	173v	169	117	169v	199	-	84	84	44v	142v	-
Ch. X Number of Canons[6]	212v	179	173	120	180v	206	-	(-)	85	45v	144v	-
Ch. XI Two Santiago Pilgrim Miracles[7]	213	179	173v	120v	181v	207	-	(90)	49v	14v	126v	-
Explicit	213v	179v	-	121	-	207v	-	90v	-	-	-	-
Colophon	213v	179v	-	121	-	207v	-	90v	-	-	-	-
St. James Matamoro (miniature)	-	-	-	121	-	-	-	-	-	-	-	-

(Catalogue of Manuscripts and Latin Appendix, II, pp. 224-225); f. 215v Isidore, James, doxology.

1. Z entitles this Chapter II.

2. The chapter heading and first four words are omitted in L. The rivers Aragón, Arga and Runa (II, pp. 18-19) are omitted in R, VB, Z, and L. The Salty Brook, Navarrese horse skinners, River Ega, and deadly rivers are omitted in L. The lists of fish and good rivers are omitted in R, VB, Z, and L. The concluding admonition (II, pp. 20-21) is omitted in M, R, VB, Z, and L. Z entitles this Chapter III.

3. The descriptions of Gascony, Aragon, Navarre, Poitou, Saintonge, the Bordelais and the Landes (II, pp. 22-23) are omitted in L. The Gascons, boatmen and toll-keepers of St-Jean de Sorde and St-Michel Pied-de-Port (II, pp. 24-25) are omitted in R, VB, Z, and L. T ends incomplete in this section. The descriptions of the Port de

Cize and the Cross of Charlemagne, together with the Navarrese and Basques (II, pp. 28-29), are omitted in M and L. The passage about the Navarrese fornicating with animals is ommitted in Z and L. The section on Burgos and Castile (II, pp. 30-31) is omitted in L, together with the rest of the route through Spain, which R, VB, and Z also omit. Z entitles this Chapter IV.

4. R, VB, and Z omit Trophimus, Caesarius, Honoratus, Genesius and the cemetery at Les Alyscamps (II, pp. 32-35); their omission of Giles and the remarks about his immoveability are shared by L. R, VB, and Z also omit the following passage about the four immoveable bodies of Giles, Leonard, Martin and James (II, pp. 40-41), which M inserts at the end of Chapter VIII. Z entitles the section on William (II, pp. 42-43) Chapter V. R, VB, and Z omit Tiberius, Modestus, Florentia, Saturninus, and Faith. Their omission of Mary Magdalene and Leonard is shared by L. Z entitles the section following Leonard (II, pp. 44-45) Chapter VI; L omits this passage. Z entitles the section on Evortius (II, pp. 48-49) Chapter VII. L includes Martin (II, pp. 50-51) out of sequence, on f. 215. R, VB, and Z omit Hilary, John the Baptist, the Introduction to Eutropius and his Passion (II, pp. 54-55). SV also omits most of the Passion of Eutropius. Z entitles Romanus (II, pp. 62-63) Chapter VIII. R, VB, Z, and L, omit Severinus. Z entitles Roland's companions (II, pp. 64-65) Chapter IX. R, VB, Z, and L omit Dominic. Z entitles Facundus and Primitivus (II, pp. 64-65), Chapter X. L inserts the *Ad honorem* song (see Catalogue of Manuscripts under L, p. 107), Martin, omitted above, and the false Bull of Innocent II (see Catalogue of Manuscripts, p. 87), after Facundus and Primitivus. R, VB, and Z omit Isidore, James, and the doxology (II, pp. 64-65).

5. L omits the entire chapter, together with the last two chapters, explicit, colophon and Matamoro miniature. Z entitles this Chapter XI. R, VB, Z, and L omit the descriptions of Santiago's two rivers and seven gates (II, pp. 66-67). R, VB, and Z omit the description of the cathedral up to the altars, which Z entitles Chapter XII, and the body and altar of St James which Z entitles Chapter XIII. R, VB, and Z omit the descriptions of the altar furnishings, retaining the section on the authority of the church and canons, which in Z is entitled Chapter XIV. They also omit the passage on the stonemasons and dates of construction (II, pp. 84-85), retaining the second passage on the authority of the church (II, pp. 86-87). In P, the passage on the stonemasons and dates of construction precedes the authority of the church and canons. In SV, the model was illegible from shortly after the beginning of the second passage on the authority of the church to the explicit (II, pp. 90-91), and the scribe has indicated the gap with rows of dots.

6. Z entitles this Chapter XV. R, VB, and Z omit the end of the chapter, on the offerings for pilgrims (II, pp. 88-89). Chapter illegible in SV, see previous note.

7. R, VB, and Z excerpt this chapter for inclusion in Book II, the Miracles of St James. SV's model continued to be illegible.

THIS CATALOGUE describes in chronological order the physical and textual contents of the twelve extant manuscripts that contain the *Pilgrim's Guide*. In the case of C, our base manuscript, we give a detailed analysis of the textual contents in relation to the quire structure and the participation of the two major scribes; this is because C is the only manuscript in which the *Guide* was copied by more than one scribe. These scribal distinctions, which have been stressed in much recent discussion about the date and authorship of the *Codex Calixtinus*, are important to the arguments we make about the priority of the text of the *Guide* as copied by C's Hand 1.

Since none of the other eleven manuscripts has received any detailed codicological discussion in print, full information is presented for each one. The descriptions of the contents make clear the ways in which texts in each manuscript differ from those in C. The variants in the text of the *Guide* are discussed in the Collation of the *Pilgrim's Guide* that follows the Catalogue. The provenance and history of the manuscripts have been variously treated in the literature: we present the evidence as fully as possible in each catalogue entry, noting the sigla used by previous authors.

We refer to text editions by the following abbreviations:
MJ = MEREDITH-JONES, 1936
W = WHITEHILL, 1944
GP and OT = GARCÍA PIÑERO and ORO TRIGO, 1994
VIELLIARD, THORON, HÄMEL and LÓPEZ PEREIRA are spelt out in full.

Most previous discussion of these manuscripts has occurred in the context of Book IV, *Pseudo-Turpin*, which is in all of them except Z. We note that MJ, 1936 discusses 5 of our 12 manuscripts, including our C, A, S, and M in his B group, and our T in his D group; HÄMEL, 1950 and 1953, lists eleven of the twelve. In 1950 he put eight in his B group (our C, L, A, VA, S, M, T, SV) and three in his R group (our R, VB, Z). MANDACH, 1961, put six in his B group (our C, A, VA, S, M, SV), three in his R group (R, VB, Z), one in his D group (L) and one (our T) is in both his HA and his T group. The missing manuscript is our P, discussed in AASS (Maii V, pp. 194-203; Julii VI, p. 25; Nov. I, pp. 1-16, 18-21) and by FERRALI, 1979, GAI, 1984, 1987, and DÍAZ Y DÍAZ, 1988a. We alert readers that DÍAZ Y DÍAZ's L is our A, and vice-versa; his M is our Z, his Ma is our M, his V is our VA, his B is our VB; and our SV and T are omitted. We also note that DAVIES/DAVIES, 1982, p. 42, n. 7, list Paris, BN, lat. 12 as containing the *Codex Calixtinus*; this is incorrect.

We have found it worthwhile to note variations and rearrangements in the texts of the other four books, where these are significant in determining the relationships among the manuscripts that contain the *Guide*. Our descriptions are intended to stimulate others to tackle detailed collations of the other books.

C. Santiago de Compostela, Archivo de la Catedral (no shelf number)

Jacobus
c. 1138 and *c.* 1173? Santiago

Parchment, i + 225 + i folios. Two folios are numbered 97, and f. 221 (*olim* 191) is now missing. The present foliation dates from 1964-66 and incorporates in sequence ff. 163-191v, containing the *Pseudo-Turpin*, which was detached in 1619 to form a separate volume (W 301-348). 295 × 212mm, written space approximately 230/225 × 152/145 mm. Ruling in faint leadpoint with single verticals through top and bottom margins (of a type found only in Spain, according to KELLER, 1990). Text written below top line (except on ff. 181-182) in one column of 34 lines.(*Ills. 1–36*)

Quires: 1^{10} (wants 1), $2\text{-}15^8$ (quire 4 partially misbound), 16^8 + one half-leaf, $17\text{-}23^8$ (the outer leaves of quire 21 are four singletons), $23a^2$, $24\text{-}27^8$, 28^2, 30^3 singletons. For a detailed description of the structure of the volume, except the appendix, ff. 221-225, see DÍAZ Y DÍAZ, 1988a, pp. 143-157. No original catchwords.

Script: Written by 2 main scribes, whose division of labour in relation to the quire structure and the text, first recognized by HÄMEL, 1950 and refined by HERBERS, 1984, pp. 21-32, and DÍAZ Y DÍAZ, 1988a, pp. 143-157 and 271-308, is outlined below in the Table of contents. The work of the two scribes never occurs on the same bifolium. Hand 2 more usually (in quires 22, 23, 25, 26) copies outer bifolia, although in quire 20 he copies three inner bifolia and in quire 21 he copies the last two leaves which are singletons. The work of these scribes always preserves the quire structure consisting of quaternions; the divisions always occur in mid-sentence, occasionally in mid-word, and do not correspond to neat breaks in the text. It is likely, however, that their work represents two separate campaigns, the first possibly as early as *c.* 1138 and the second, which took place for reasons that are unclear, *c.* 1173 (for detailed arguments, see STONES, 1992). The scripts are difficult to date on the basis of palaeography alone; the decoration would seem to provide more substantial criteria, see below. The other scribal hands (X, 3 and 4, 1C and the scribes of the appendix) are listed in the Table of contents below but are not discussed here as they did not participate in the writing of the *Guide*. For an analysis of Scribes 3 and 4 see DÍAZ Y DÍAZ, 1988a.

DÍAZ Y DÍAZ subdivides the work of the first campaign between two closely related hands, assigning Book I to Hand 1A and the rest of the first campaign to Hand 1B. He prefers a later date than the one argued for here: *c.* 1160 (1988a, p. 81) or slightly earlier, *c.* 1150 (1992). HERBERS, 1984, p. 38, argues for a date between 1139 and 1143. The *Guide*, Book V, is copied by DÍAZ Y DÍAZ's Hand 1B and the second scribe, Hand 2. Hand 1B is extemely uneven in spacing, occasionally making corrections or adding words in the margins within outlined boxes. Characteristic letter forms include both slant-backed and upright 'd', the former often curving to the right; both ampersand and the Tironian nota for 'et', the Tironian nota with a long, slightly down-curved back; headed 'a'. Letters such as 'r' and 'f' sometimes descend very slightly below the level of the other letters (generally a feature from the first half of the 12th century). The letter 'y' is dotted; minims curve slightly towards the right. The hand has a distinctive 'g' with flat top stroke extending to the right; the shaft below the top stroke curves back to the left, as for 'c', then the lower bow is made by curving to the right like a 'c'. The lower lobe descends briefly, then curves up to the right like an 's'. The shaft of 't' does not protrude through the cross bar. The common mark of abbreviation has a small serif standing upward to right. No bitings. Both 'ct' and 'st' ligatures are used. A distinction is made between 'u' and 'v'. Round 's' is occasionally used in final position. Hooked 'e' for 'ae' occurs sporadically, not always in etymologicaly correct positions. 'Punctus elevatus' is

used for comma, 'punctus versus' for full stop. The use of 'u' and 'v', 'i' and 'j' differs between the two scribes, and may prove to be significant in localizing one of them. Such usages as 'b' for 'p' (*obtimo*, f. 193 and *passim*) and omission of initial 'h' (*abilis* for *habilis*, f. 193 and *passim*), or addition of unetymological 'h' (*hora* for *ora*, *passim*; *hopus* for *opus*) suggest that Scribe 1B may have been a Spaniard. The erratic singling of double vowels (*his* for *hiis*, near the top of f. 194) or consonants (*excomunicentur*, f. 195v) is also characteristic of—though by no means restricted to—Spanish scribes. So is the doubling of single letters, as in *peccunias* f. 195v; *immagines*, f. 198. Occasionally the division sign is used for '*est*'. Capitals are sometimes used, erratically, for proper names in Ch. VIII, so *LEONARDUS* and *LEOTARDUS*, *GEORGIUS* (but *Fronto*), *SAMSONIS* and *MARTINUS*; and *MARIE* and *WICARTUS* in Ch. IX. Rubrics are by the same scribe, written larger, with some capital forms, notably uncial 'm'. The display script in Roman capitals is in several colours: red, blue, green, yellow and mauve. The colophon is in Roman capitals with uncial forms for 'm', 'h' and sometimes 'e'. The heading on f. 163, together with its decoration, the explicit on f. 191v and the letters 'AR' in the colophon on f. 213v, are 17th-century restorations.

Hand 2 uses a quite similar but considerably more elegant script with more lateral compression within words and more regular spacing between words. His Tironian nota has a flatter top, and he has longer ascenders and descenders, finished with hairlines up to the right; the shaft of 'g' is slightly less curved; 'a' is headed; the shaft of 't' sometimes protrudes slightly through the cross stroke; when not upright, 'd' has a slanting shaft with a slight concave curve; there are still no bitings (cf. MS R, copied in 1173, which had them occasionally, usually with 'p' and sometimes 'b', but not with 'd'). There is a hairline finial on final 'e'; both long and round 's' occur in final position, more frequently than in Hand 1; long 's' is invariable elsewhere. Like Hand 1, Hand 2 uses the *punctus elevatus* for the comma, but a period, not a *punctus versus*, for full stop. Scribe 2 has certain distinctive spellings: *baselica*, *quattuor*, and a greater preponderance of '*-tio*' rather than '*-cio*' suffixes (*initio* rather than *inicio*). Rubrics in red ink.

Both scribes often use acute accent marks, particularly with *a* when used alone to mean 'from', and on words such as 'una' (cf. Ch. II); the accent mark is also used on A for *Adefonso* (Ch. V) and occasionally with other letters, as with 'O' on *Orbega* (Ch. III), or on 'e', as in *héé*, or *Andréé*, to indicate that both letters are pronounced. Like the spellings cited above, these may indicate that one or both scribes was a Spaniard.

Rubrics:	In red and other colours; see above.
Musical Notation:	In *campo aperto* on ff. 103 (W 196-197), 128 (W 239-240), 222 (W 401-402), and on a four-lined staff ruled in red between ff. 101v (W 193) and 139v (W 257), 214-219v (W 391-398), and 221v (W 401), the latter most comparable to the notational style of Nevers (HUGLO 1967 and 1992, pp. 105-124; see also KARP 1992). No other CC manuscript copies C's musical notation, though R contains notation in a different style, and spaces were left in VA and S for notation that was never copied in.
Decoration:	Coloured initials two to ten lines high, by two main decorators, corresponding to the major divisions of scribal hands. The first group of initials, that accompanies the work of the scribes identified by DÍAZ Y DÍAZ as Hands 1A and 1B, can best be paralleled in North-west France in the first half of the 12th century (see STONES, 1992); they are painted in red, green, or ochre, sometimes with blue, most usually in two colours, with bud-like tendril terminations. There is considerable variation in quality, in the forms of the initials, and in the treatment of the bud and leaf motifs. To some extent the distinctions have to do with the role of each initial in relation to a decorative hierarchy based on the function of the initials in the text, as HELMER, 1988, p. 46, has demonstrated for the initials in Book I (we note, however, that gold is not used in the manuscript, though yellow ochre is). Simpler initials, in one

colour, are used for less important sections of text. The variations within the first group of initials is such that it is possible to also include in this group, and presumably therefore in the same phase of production, the initials of the musical supplement that follows Book V (STONES, 1992). It is also likely that some of the variations in the treatment of the initials in the first group is due to the participation of more than one individual decorator.

The second group of initials accompanies the script of the scribe called by DÍAZ Y DÍAZ Hand 2. The style of these initials is distinctly protogothic, in that the initials are only coloured in red or blue with pen-flourishing in the other colour, a practice which becomes almost universal in the 13th century. They also vary from between two and ten lines in height. Although exact parallels are difficult to pinpoint, these initials (particularly the small ones) are stylistically similar to the initials in MS R, which presumably date to 1173, amd are also done in red and blue, and to those in the 1179 section of Tumbo A, the Cartulary of Santiago (in brown and red), as well as to south French minor initials of comparable period (see STONES, 1992).

The work of the third scribe is also accompanied by minor pen-flourished initials, in brown and red. We leave them aside here as they do not occur in the *Guide*.

Illustration: Eighteen foliate and dragon initials by four hands (ff. 24, 31v, 44, 48v, 53v, 55, 72, 74, 95v, 107, 118v (2), 121, 140, 141, 164, 179, 192): all except the one on f. 179 occur in the work of the first writing campaign by Scribes 1A and 1B. Most of them are highly competent in execution, with dragons and foliage outlined in brown, red and green, set against a washed background of blue, green and ochre. The red bud motifs that protrude from a dragon's mouth in the initial on f. 48v look like the motifs on the best of the minor decorated initials and suggest that the foliage and dragon initials are also by the best of the painters of the minor initials described above. As with the minor decoration, the work that can be ascribed to the first campaign and accompanies the script of Scribes 1A and 1B is by more than one participant: the initials on ff. 24v and 31v are probably by less competent, but nontheless contemporary, painters: on f. 24v the brown outline is dominant, the foliage less fleshy, drawn only in green and ochre, and set against a plain ochre background. The male head terminal has features that do not recur in the rest of the illumination. The initial on f. 31v also has forms that are less broadly treated than in the work of the main initial painter, but this time the colours of that painter reappear both on the leaf and dragon forms and also in the background.

The initial on f. 179 is coloured in the same red and blue of the minor initials in the work of Scribe 2; but its artistic level seems rough and unfinished compared with the sophistication of Hand 2's decorated initials, and parallels for it are not readily apparent. Was it done by a later imitator?

Three portrait initials: (f. 1 Calixtus, f. 4 St James, f. 163 Turpin), all by the first dragon and foliage initial painter.

Two miniatures: f. 162, Dream of Charlemagne (altered during restoration in 1964; see LEJEUNE/STIENNON, 1967, I, fig. 31, and the copies of it in MSS A and VA, for its previous condition); f. 162v, miniature in two registers: Charlemagne and his army riding out of Aachen; men holding weapons and pulling beards, standing outside a city that may possibly also be intended as Aachen. The dream miniature is by the painter of the historiated initials and the best of the dragon-foliage initials, but the two-register miniature seems to be the work of another, inferior, painter. Its iconography is problematical in that it does not seem to reflect high points in the narrative, and the meaning of the lower of the two scenes is not at all clear (STONES, 1981).

Stylistic and iconographical sources for this illumination are with manuscripts made in Normandy and the central Loire regions between *c.* 1100 and *c.* 1140, and are fully discussed in STONES, 1992. They tend to suggest that the date of execution

of the first campaign on C is compatible with the earliest possible date supported by the internal dating evidence.

The band of colour and scroll-work on f. 162v below the miniatures is 17th-century restoration work, as are the scroll-work and heading in red capitals on f. 163. A note on the front flyleaf says that the miniatures were restored by D. Carlos Asensi Garcimartine at the BN, Madrid in 1964.

Binding: Brown leather on boards, 1966.

Provenance and History: The oldest surviving copy of the CC, given the title *Jacobus* on f. 1. Limiting dates for some of the textual components of the manuscript can be established as follows: Book I: no earlier than 1130; Book II: no earlier than 1135; Book V: no earlier than 1137. The evidence is summarized below. The song writers named in the musical appendix were flourishing by 1136-37. Nothing about the physical aspects of the work of the first campaign (script by Scribes 1A, 1B, 1C and accompanying decoration and illumination) precludes a date as close as possible to the internal *termini* of the text (STONES, 1992). The possible limiting dates for P's model and the events associated with the transfer of a St James relic to Pistoia in 1138 add to the circumstantial evidence in favour of an early date (*c.* 1138-40) for the execution of the first campaign of work on MS C.

It is most likely that the manuscript was copied and decorated in Santiago. Despite the French point of view expressed in the *Guide* and its author's special predilection for St-Léonard-de-Noblat (see Introduction, p. 24), the textual tradition of the *Guide*, as of this version of the CC as a whole, has left no trace in France. French scribes were at Santiago in the right period, and KELLER, 1990 has suggested that the ruling pattern is Spanish. Against this notion is the claim made on f. 221 of the false bull attributed to Innocent II (1130-43), which says the volume was first edited by Pope Calixtus and given to Santiago by Aymericus Picaudus of Parthenay, otherwise known as Oliver of Asquins, a vill of Vézelay, and his Flemish companion Gerberga (for other readings of the passage see MSS A, VA, T, VB, Z and L, collated in the Latin Appendix, Vol. II). The bull is written on the same folio as the miracle of Alberic of Vézelay which is dated 1139, and was perhaps copied by the same hand (not a scribe who otherwise participated in the copying of the codex). Nothing precludes the idea that this section (ff. 221-222 and the rest of the Mass that is now missing, perhaps an additional full quire [HOHLER, 1972, p. 72; cf. MS A]) was added to the codex in Santiago, perhaps as an authenticating device, in or shortly after 1139. Other dated material in the appendix that follows Book V, copied by still other scribes, includes miracles dated 1164 and 1193. The links between Aimery Picaud, the composition of the *Guide*, and Vézelay's dependency, St-Jacques d'Asquins, are exploited particularly by LOUIS, 1952 and MOISAN, 1985, 1992; but DÍAZ Y DÍAZ, 1988a, pp. 304-308, proves that the bull was not an intrinsic part of C and that its claims cannot be taken as literally as Louis and Moisan would like. The musical link is not to be disregarded, however, as HUGLO, 1992 has shown.

Folio 223 was available for copying by 1173 because the miracles on f. 223, of which the first is dated 1164, were copied in R, where all the miracles from C's Book I, Book V, and the supplements, are assembled after those in Book II. The remaining texts in C, the song *Dum pater familias* and the following texts added on f. 222, and the texts on ff. 224 and 225, appear to have been composed in the late 12th or early 13th centuries, and could have been added at any time. None of them reappears in the CC manuscript tradition, so no later copy gives a *terminus ante quem*.

The work of Scribe 2 appears to have been done around 1173, because the script and minor decoration is very close to work in the 1176 section of Tumbo A, and the minor initials are like those in R (though the latter are uniformly smaller in scale). HÄMEL, 1950, pp. 21-28, argued that textually, R depended on Hand 1, not Hand 2. We think the evidence is more ambiguous than he allowed and we discuss it in

the Collation essay (pp. 197-240). Perhaps the recopying was in some way occasioned by Arnault's visit.

Additions to the text were made in the later 12th century and also in the 13th and 14th centuries. There are many annotations in later hands, fully analyzed in DÍAZ Y DÍAZ, 1988a.

By the time MS M was copied in 1538, quire 4 had become disarranged: M copies C's present arrangement for that quire. Between then and the time of the examination of C by Ambrosio de Morales in 1572, some further rearrangement of the text seems to have occurred, as his description suggests that the *Guide* came at the beginning (MORALES, 1765/1985, pp. 130-131). Book IV was removed from the codex in 1619 by the Canon Archivist Alonso Rodriguez León, following that visit (HERBERS, 1984 p. 23; DÍAZ Y DÍAZ, 1988a, p. 322) and restored to the codex between 1964 and 1966 at the BN, Madrid.

Summary of Internal Dating Evidence for C's texts: (False) Authors of Books I-V: Pope Calixtus II (1119-24), to whom are attributed parts of all five Books of CC, and the Foreword and Chapters II and VI of Book V, the *Guide*; he is named as co-author of Book V, Ch. IX (see ROBERT, 1891). Aymericus the Chancellor (fl. 1120-1141), co-author, with Calixtus, of Book V, Ch. IX (see JL, pp. 781, 824, 841). Aymericus, named without a title, and of uncertain identification, is not necessarily the same as Aymericus the Chancellor, nor necessarily to be identified with Aimericus Picaudus (on whom see below, Book V, Ch. V). For the identities of the authentic authors of other texts in Book I and the authors of the songs that follow Book V, see below.

Book I: between 1130 and 1140?
f. 1 (W 1) Prologue addressed to the Abbey of Cluny (no abbot mentioned by name), William, Patriarch of Jerusalem (1130-45; see HOHLER, 1972, p. 42) and Diego, Archbishop of Compostela (1120-40; see FLETCHER, 1972).

ff. 104v, 105v (W 199, 201) Hymns attributed to William, Patriarch of Jerusalem (1130-45)

ff. 122v-123 (W 227-228) Prosa attributed to William, Patriarch of Jerusalem (1130-45)

f. 132 (W 246-247) Conductus attributed to 'Cardinal Robert'. HOHLER, 1972, p. 47 suggested Cardinal Robert Pullen (1144/45-1145/46; JL, II, p. 21). Pullen, however, had no known connection with Santiago or the cult of St James, and is not, as Hohler thought, the only Cardinal Robert in the period. One possibility is the Cardinal Robert who signed papal documents from 1120-21 under Pope Calixtus II (from 24 September 1120 to 28 December 1121; JL, I, p. 781). MOISAN, 1985, p. 23, suggests Robert Boso, papal legate in Spain, who figures prominently in HC (but never as Robert, always by his surname; see index to FALQUE REY, 1988, and our discussion of authorship above); Moisan gives his death as 1146. A Boso is cardinal under Calixtus II in 1119-20 (JL, I, p. 780), and another is scribe between 1149 and 1152 under Pope Eugenius III (JL, II, p. 21).

Perhaps the best possibility is one of the canons of Santiago, where the term 'cardinal' was also used (see English note IX-131). In that case, the person intended might just conceivably be Rainerius, also known as Robertus, canon, schoolmaster and cardinal of Santiago, formerly of Pistoia, Paris and Winchester, fl. 1130s, according to P's account of the acquisition of the Pistoia relic between 1138 and 1144. See Catalogue of Manuscripts under P. The last option allows for a *terminus post quem* of 1130, a *terminus ante quem* of 1140 for Book I, and a possible historical link with P's ultimate model.

These references are all to text passages copied by Scribe 1A.

Book II: after 1135, before 1139.
Dated miracles cluster in the period 1080 (Miracle 4) to 1110 (Miracle 15); Miracle 13 relates an event of 1135. These miracles are all copied by Scribe 1B. The first of

the miracles at the end of the codex, copied by another hand (f. 221v, W 400-401) is dated 1139.

Book III: after 1120.

ff. 161-162 the description of the procession at Santiago in Ch. III was composed after the institution of 72 canons by Archbishop Diego Gelmírez in 1120. Passage copied by Scribe 1B.

Book IV: after 1130, before 1145?

The major arguments are those advanced by MEREDITH-JONES, 1936/1972, p. 73, SMYSER, 1937/1970, p. 25, and DAVID, 1948, III, suggesting a probable date of composition after 1130 and before 1145.

f. 168 (*olim* 6), W 309, copied by Scribe 2, Ch. 9. Characters appear whose names are based (DAVID, III, p. 43) on Almoravid chieftains of the 12th century: Texufin is the name of the first Almoravid calif Youçouf ben Texufin; his son Ali appears as Ailis, King of Morocco (1106-43), leader of the Almoravid offensive in Spain. His brother Ibrahim was Vice-regent of Spain *c.* 1116-23. Another Texufin, son of Ali, succeeded Ibrahim from 1125 to 1137 (see also HORRENT, 1975, p. 53). Fatima, King of Barbary, is identified by David with Ibn Fatima who in 1116 approached Mondego. Maimoun, King of Mecca and Avit, King of Bougie might both be based on the pirate Avit Maimoun, mentioned in Miracle 7 of Book II (in a passage copied by Scribe 1B), and otherwise documented in 1101; alternatively, Maimoun could simply reflect the names of a dynasty of Almoravid admirals documented around the Mediterranean in the first half of the 12th century, one of whom destroyed the idol of Cadiz in 1145.

f. 166 (*olim* 4), W 306, copied by Scribe 1B, Ch. 4. The idol of Cadiz is described. Its destruction in 1145, known from Averroes, is not mentioned, suggesting that the section may possibly antedate 1145.

f. 172 (*olim* 10), W 316, copied by Scribe 1B, Ch. 13. Charlemagne, in his efforts to convert Aigolant, mentions three clerical orders. For DAVID, III, p. 50, the canon about canons regular adopted at the Council of Lyon in 1130 is an important *terminus post quem*.

ff. 185v-186 (*olim* 23v-24), W 338-339, begun on f. 185v by Scribe 2 and continued on f. 186 by Scribe 3, Ch. 22. Mention of remission of sins for the contributors to St-Denis' building fund must reflect the funding collections for Suger's rebuilding of 1137-44.

Book V: after 1137.

f. 212v (*olim* 183v), W 386, copied, over erasures, by Scribe 1B. The synchronism includes the death in 1137 of Louis VI, King of France. Some scholars (MANDACH, 1969, p. 817; id., 1990, p. 45; MENACA, 1987, pp. 229-234) have inferred from the wording in Ch. V that Diego Gelmírez and Alfonso VII were both dead at the time of writing, implying a *terminus post quem* of 1157; others leave the passage without comment. We reject this interpretation.

Musical supplement: after 1136/37.

ff. 214-219 (*olim* 185-190v), W 391-398, copied by Scribe 1C.

Identifiable song-writers (French authors listed in MOISAN, 1985, p. 23, n. 4; list of authors in DÍAZ Y DÍAZ, 1988a, pp. 51-52, n. 74, and HUGLO, 1992. There is also a brief discussion of authors and schools of music in KARP, 1992, I, pp. 108-110. A complete list is given in Contents of C below) flourished in the 1130s-40s, were all in office by 1136/37:

Aimericus Picaudus, priest of Parthenay (not 'of Picardy' as in HELMER, 1988, p. 20). Mentioned also in the text of the false bull of Innocent II, without the title 'priest', with the pseudonym Oliver of Asquins, vill of Vézelay, as having, in the company of his Flemish companion Gerberga, given the codex to Santiago (for other readings of this passage see MSS VB and Z, the Introduction and Latin Appendix).

He is not otherwise attested but has been seen in much of the literature as an attractive candidate for authorship of the *Guide*, because of the pro-Poitevin sentiments in the text and because the name Aimericus appears twice in the *tituli*; and, because the text of the bull links him closely with C, he has even been taken for the author of the CC as a whole (since LE CLERC, 1847, and most recently LOUIS, 1952, MOISAN, 1985, 1992 and MENACA, 1987; see our discussion of authorship, Introduction, pp. 18-21).

Atto, Dean of Sens, Bishop of Troyes (1123-45), died at Cluny.

Alberic of Bourges, schoolmaster of Reims, Bishop of Chalons-sur-Marne and Archbishop of Bourges (1136/37-1141).

Airardus of Vézelay, possibly the same as Alberic or Aubry, originally from the diocese of Beauvais; Sub-prior of Cluny, Abbot of Vézelay 1131, cardinal in 1138, Bishop of Ostia (1138-48, GAMS; JL, I, p. 840, II, pp. 1, 20, to 1147), papal legate to England 1138-39, to Antioch 1139, to France 1144; died at Verdun. ZENKER, 1964, no. 3. DÍAZ Y DÍAZ, 1988a, p. 52, says Airardus is unidentifiable. Author of *Annua gaudia* f. 215v. A signatory of the bull of Innocent II, and possible author of the 1139 miracle.

Albert of Paris, Canon of Notre-Dame from 1127 (WRIGHT, 1988, p. 278), its cantor from 1142 to 1174/77, also connected with the Cluniac priory of St-Martin-des-Champs and with St-Victor.

Fulbert, Bishop of Chartres (1007-29).

Joscelin of Vierzy, teacher at Paris, Archdeacon of Bourges, Bishop of Soissons (1126-52), friend of Suger who dedicated to him his life of Louis the Fat.

William of Messines, Patriarch of Jerusalem 1130, d. 1145 (HOHLER, 1972, p. 72).

Signatories of the false bull of Innocent II (1130-43): 1139?
f. 221 (*olim* 192), W 399-400. Summarized by HERBERS, 1984, p. 66, using ZENKER, 1964 and MOISAN, 1985, p. 33, citing BIGGS, 1949. See also TILLMANN, 1970, 1972.

Aimericus cancellarius: originally from Bourges. A relative of Pierre de Castres, Archbishop of Bourges, he was a canon of Bologna and cardinal and chancellor from 1120 under popes Calixtus II, Honorius II and Innocent II (JL, I, pp. 781, 824, 841); died in 1141 (also claimed as co-author, with Pope Calixtus, of Book V, Ch. IX) ZENKER, 1964, no. 116.

Girardus de sancte Cruce cardinalis: born in Bologna, canon in Lucca; cardinal from 20 February 1131 to 15 December 1141 under Innocent II (JL, I, p. 840); pope as Lucius II (1144-45) ZENKER, 1964, no. 9.

Guido pissanus cardinalis: of Pisan origin, sent on missions in Spain, Southern France and Portugal (cf. the cardinals named Guido in JL, I, pp. 840-841; BIGGS, 1949, pp. 298, 308, 320, 325-7, thinks this is the Guido, the legate in Spain mentioned in HC, and that he was Bishop of Ostia 1149-50) ZENKER, 1964, no. 119.

Ivo cardinalis: Canon of St-Victor, Paris, legate in France, 1142 (cf. JL, I, p. 840) ZENKER, 1964, no. 46.

Gregorius cardinalis nepos domini papae: cf. the cardinals named Gregorius in JL, I, pp. 840-841. BIGGS, p. 342, thinks this is Gregorio Papareschi, cardinal in 1138, d. 1140; but the claim that this Gregory was nephew of the pope accords with the now lost epitaph of Gregorio di Sant'Angelo (1116-30), cited from CIACONIUS-OLDOINUS, 1677, I, p. 171, by TILLMANN, 1972, pp. 330-331. But see Tillmann's cautionary words on p. 333 about the frequency of claims to papal nephewship; and Ciaconius gives Gregory of Sta Maria in Trastevere, Bishop of Sabina (1140-62) as nephew of Anastasius IV (cited by TILLMANN, 1972, p. 343).

Guido lumbardus: born in Florence, legate in Lombardy 1139, took part in the Second Crusade (cf. the cardinals named Guido in JL, I, pp. 840-841) ZENKER, 1964, no. 35.

Gregorius ihenia cardinalis: cf. cardinals Gregorius in JL, I, pp. 840-841. BIGGS (p. 342), thinks this is cardinal of St Chrysostom, friend of Diego Gelmírez; but FALQUE REY, 1988 gives the latter as Guido, Cardinal of St Angelo (1138-40). TILLMANN, 1972, pp. 344-347 points to two such titulars giving dates of 1143-1154 for Gregorio di S. Angelo. Not 'of Jena', as in HELMER, 1988, p. 20, but 'Genoa'.

Albericus legatus presul hostiensis. See Airardus of Vézelay = Alberic, under **Musical Supplement**, p. 61 above.

Copied by another 12th-century hand, the same one as the 1139 miracle?

Dated Miracles

Miracle of 1139
f. 221v (*olim* 192v), W 400-401, attributed to Albericus, abbot of Vézelay, bishop of Ostia and legate of Rome (see above). Also the signatory of the bull and author of one of the songs?

Copied by the same scribe as the bull?

Miracle of 1164
f. 223 (*olim* 194), W 404-405

Copied by a later, unrelated, hand.

Miracle of 1190
f. 223v (*olim* 194v), W 406-407

Copied by another later, unrelated, hand.

Secundo folio: *suscipio*

Contents:
Quires and
folios, scribal
hands, text

For a complete transcript of the entire text see WHITEHILL, 1944, here cited as W; the analysis in DAVID, 1945-49; the Spanish translation by MORALEJO *et al.*, 1950; the summary in DÍAZ Y DÍAZ, 1988a, pp. 103-118; the tables in MOISAN, 1992, pp. 15-22 and 116-119. Transcripts of individual pieces are listed in the bibliography under the transcriber's name; other editions are listed at the beginning of each of the first four Books; other editions and transcripts of PG are in the Bibliography.

Quire 1^{10} (ff. 1-9, wants 1). Hand 1A.

f. 1 Title: *EX RE SIGNATUR, IACOBUS ISTE LIBER VOCATUR. IPSUM SCRIBENTI SIT GLORIA SITQUE LEGENTI.* (W 1)
Book I: Liturgy of St James
[Editions and transcripts: ROBERT, 1891; DRÈVES, 1894; LÓPEZ FERREIRO, 1898-1904, 1909; WAGNER, 1931; ANGLÉS, 1931; HÄMEL, 1933, 1936; MEREDITH-JONES, 1936; PRADO in WHITEHILL, 1944, III; DAVID, 1946; HOHLER, 1972; LÓPEZ CALO, 1982; HELMER, 1988; WERF, 1992 and forthcoming; KARP, 1992; for Calixtus's sermons, cf. PL 163, 1369-1410, reprinted from MARIANA, 1609, not based on C.]
Texts and music for the Office and Mass of the Feasts of St James on 25 July, 3 October and 30 December and the vigils and octaves.
Prologue of Calixtus:
Rubric: *Incipit Epistola Beati Calixti Pape Text inc. Calixtus episcopus…Quoniam in cunctis…* expl. (f. 2v) *cum Arrio et Sabellio sit.* (W 1-4)

f. 2v *Chapter list of 31 chapters*, inc. *Capitulum i Sermo sancti Bede presbiteri. Quoniam beati Iacobi vigilias…* expl. *Capitulum xxxi. Farsa misse sancti Iacobi cum conductis et benedicamus.* (W 4-6)
Chapters 1-20: Pericopes and Sermons.

f. 4 *Chapter 1.* Pericope and Sermon of Bede for the Vigil of St James, 24 July.

Rubric: *UIIII Kalendas Augusti. Uigilia Sancti Iacobi. Lectio epistole beati Iacobi Apostoli. Iacobus Dei...Sermo Uenerabilis sancti Bede presbiteri.* Text inc. *Quoniam beati Iacobi uigilias...*(W 6) expl. (f. 6v) *intelectus in malum* + dox. (W 11)

[PL 93, cols. 9-14; *Corpus Christianorum* 121, pp. 183-188; actually for the Feast of James the Less. See MS L, f. 110.]

f. 6v **Chapter 2.** Pericope and Sermon of Calixtus for the Vigil of St James, 24 July.

Rubric: *UIIII Kalendas Augusti. Uigilia sancti Iacobi Zebedei apostoli Gallecie, que studio ieiunii propiique diuini officii digne celebretur.* Text inc. *Lectio sancti euangelii secundum Marcum. In illo tempore, ascendens dominus Ihesus in montem...Sermo beati Calixti pape eiusdem lectionis. Uigile noctis sacratissime...*(includes hymn of Venantius Fortunatus, *Siderei proceres*) expl. (f. 18) *in sidereis sedibus coronandi* + dox. (W 35)

Quires 2-15⁸ (ff. 10-120). Hand 1A.

f. 18 **Chapter 3.** Twelve Benedictions for the lections of the Office, by Calixtus.
Rubric: *Benedictiones Calixti pape ad lectiones sancti Iacobi.* Text inc. *Adsit nobis gratia Dei...* expl. (f. 18) *uite prebuit palmam.* (W 35)

Chapter 4. Calixtus's Prologue and the Modica Passio.
Rubric: *Incipi prologus beati Calixti pape super modicam passionem sancti Iacobi Zebedei apostoli Gallecie qui UIIII Kalendas Augusti celebrat.* Text inc. *Hanc beati Iacobi ...* expl. (f. 18v) *hanc quam aliam legere. Explicit Prologus. Incipit Passio. Gaio quatuor annis nec integris...* expl. (f. 19v) *sub Claudio Cesare actis* + dox. (W 38)

f. 19v **Chapter 5.** Sermon of Calixtus for the Feast of the Passio, 25 July.
Rubric: *Sermo beate Calixti pape in passione sancti Iacobi apostoli que UIIII Kalendas Augusti celebratur.* Text inc. *Celebritatis sacratissime...* expl. (f. 24v) *gaudere possimus* + dox. (W 48)

f. 24v **Chapter 6.** Sermon of Calixtus for the Feast of the Passio, 25 July.
Rubric: *Sermo beate Calixti pape in passione sancti Iacobi apostoli que UIIII Kalendas Augusti celebratur.* Text inc. *Spiritali igitur iocunditate...* (includes two hymns of Venantius Fortunatus, *Cultoris domini toto sonus exit in orbe* and *Iacobus ex terris animam transmit*) expl. (f. 31) *adiuuari mereamur* + dox. (W 61)

[In quire 4 (ff. 26-33), the inner three bifolia (ff. 27-32) have become disarranged, as noted in W 52, n. 1, where the text is printed in the correct sequence in the order ff. 26, 29, 28, 27, 32, 31, 30, 33. See MS M for the same mis-sequence of folios.]

f. 31 **Chapter 7.** Pericope and Sermon of Calixtus for the Feast of the Passio, 25 July.
Rubric: *UIIII Kalendas Augusti. Passio sancti Iacobi Gallecie.* Text inc. *Lectio Actuum apostolorum. In diebus illus superuenerunt a Iherosolimis prophete Antiocham...Sermo beati Calixti pape eiusdem leccionis. Adest nobis...* (includes verse passage inc. *Ad consultum ueritatis adtendite qui erratis...* [OTTOSEN, 1993, pp. 214, 250]) expl. (f. 44v) *nos adiuuare et perducere dignetur* + dox. (W 87)

f. 44v **Chapter 8.** Pericope and Sermon of Bede for the Feast of the Passio, 25 July.
[cf. PL 94, cols. 228-233; *Corpus Christianorum* 122, pp. 335-341]
Rubric: *UIIII Kalendas Augusti. Passio sancti Iacobi Zebedei apostoli Gallecie.* Text inc. *Secundum Matheum. In illo tempore accessit ad dominum Ihesum mater filiorum Zebedei...Omelia uenerabilis sancti Bede presbiteri. Dominuus*

conditor ac redemptor… expl. (f. 47v) *regnum indeficiens ad possidendum* + dox. (W 93)

f. 47v **Chapter 9.** Calixtus's Prologue and the Magna Passio.
Rubric: *Incipit prologus beati Calixti pape ante sancti Iacobi magnam passionem que .UIII. Kalendas Augusti celebratur que etiam de sancto Iosia martire .UII. Kalendas Augusti potest legi.* Text inc. *Constat illos omnino errare…* expl. *et in refectoriis secure legatur. Explicit prologus. Incipit passio. Post ascensionem…* expl. (f. 53) *et Iacobe maioris* [*minoris* in DÍAZ Y DÍAZ, 1988a, p. 104, no. 18] + dox. (W 103)

f. 53 **Chapter 10.** Pericope and Sermon of Jerome for the second day in the Octave of St James and for the Feast of St Josias, 26 July.
[cf. PL 26, cols. 60-64; *Corpus Christianorum* 77, pp. 63-68]
Rubric: *UII Kalendas Augusti .II. die infra octauas sancti Iacobi colitur officium sollempnitatis sancti Iosias martiris et sancti Iacobi simul et hoc euangelium legitur.* Text inc. *Lectio sancti euangelii secundum Matheum. In illo tempore conuocatis dominus Ihesus…Sermo beati Iheronimi doctoris eiusdem lecionis. Apostolica sollempnia ueneranda…* expl. (f. 55v) *non eruat sua ineffabili clemencia* + dox. (W 107)

f. 55v **Chapter 11.** Pericope and Sermon of Jerome for the third day in the Octave of St James, 27 July.
[cf. PL 26, cols. 125-128; *Corpus Christianorum* 77, pp. 147-150]
Rubric: *UI Kalendas Augusti .III. die infra octauas sancti Iacobi.* Text inc. *Lectio sancti euangelii secundum Matheum. In illo tempore post dies sex…Sermo beati Iheronime doctoris eiusdem leccionis. Quare Petrus et Iacobus et Iohannes in quibusdam euangeliorum…* expl. (f. 57) *qui sue transfiguracionis gloriam uenerabilibus discipulis suis Petro et Iacobo et Iohanni ostendit* + dox. (W 110)

f. 57 **Chapter 12.** Pericope and Sermon of Calixtus for the fourth day in the Octave of St James, 28 July.
Rubric: *U Kalendas Augusti. Infra octauas sancti Iacobi apostoli .IU. die.* Text inc. *Lectio sancti euangelii secundum Lucam. In illo tempore Ihesus dominus faciem suam firmauit…Sermo beati Calixti pape eiusdem leccionis. Preclara sollempnitas…* expl. (f. 64) *salubriter mereamur* + dox. (W 122)

f. 64 **Chapter 13.** Pericope and Sermon of Jerome for the fifth day in the Octave of St James, 29 July.
[cf. PL 26, cols. 197-199; *Corpus Christianorum* 77, pp. 253-256]
Rubric: *IU Kalendas Augusti. Infra octauas sancti Iacobi .U. die.* Text inc. *Lectio sancti euangelii secundum Matheum. In illo tempore assumpto Petro…Sermo beati Iheronimi doctoris eiusdem leccionis. In presenti capitulo…* expl. (f. 65) *usque ad mortem* + dox. (W 125)

f. 65 **Chapter 14.** Pericope and Sermon of Pope Gregory for the sixth day of the Octave of St James, 30 July. [cf. PL 76, cols. 1263-1265]
Rubric: *III Kalendas Augusti. Infra octauas sancti Iacobi .UI. die.* Text inc. *Lectio sancti euangelii secundum Marcum. In illo tempore accesserunt ad dominum Ihesum filii Zebedei…Omelia beati Gregorii pape eiusdem leccionis. Qui natalem beati Iacobi…* expl. (f. 67) *optulatur in temptacione* + dox. (W 128)

f. 67 **Chapter 15.** (Fictitious) Sermon of Pope Leo for the seventh day in the Octave of St James, 31 July.
Rubric: *II Kalendas Augusti. Infra octauas sancti Iacobi .UIII. die.* Text inc. *Sermo beatis Leonis pape de sancto Iacobo. Exultemus in domino…* expl. (f. 71v) *suis faciet efficaces* + dox. (W 137)

f. 71v **Chapter 16.** Pericope and Sermon (fictitious) of Jerome and Bishop John for the seventh day in the Octave of St James, 31 July.

Rubric: *II Kalendas Augusti. Infra octauas sancti Iacobi apostoli .UIII. die.* Text inc. *Lectio sancti euangelii secundum Matheum. In illo tempore accessit ad dominum Ihesus mater filiorum Zebedei...Sermo beati Iheronimi doctoris atque Iohannis episcopi eiusdem lectionis, in natale sancti Iacobi apostoli, fratris Iohannis euangeliste, qui requiescit in territorio Gallecie. Sollempnitatem hodiernam...* expl. (f. 74) *iugiter gaudere faciat* + dox. (W 141)

f. 74 **Chapter 17.** Sermon of Calixtus for the Feast of the Election and Translation of St James, 30 December.

Rubric: *Sermo beati Calixti pape in sollempnitate electionis ac translacionis sancti Iacobi apostoli que .III. Kalendarum Ianuarii celebratur.* Text inc. *Ueneranda dies...* (includes poems by Sedulius: *Protinus ergo uiros ex piscatoribus aptos;* Basilius: *Nec ueneris ne tu uini teneraris amore* [also in Brussels, BR 5657; cf. HOHLER, 1972, p. 49]; and Venantius Fortunatus: *Plaudite Gallecie populi noua cantica Christo...* expl. (f. 93v) *tecum possidere celorum* + dox. (W 176)

f. 93v **Chapter 18.** Pericope and Sermon of Pope Gregory for the Feast of the Election and Translation of St James, 30 December.
[cf. PL 76, cols. 1093-1095]

Rubric: *III die Kalendas Ianuari. Translacio sancti Iacobi Zebedei a Iherosolimis ad Galleciam et electio eius, qualiter in apostolatus ordine supra mare galilee a domino electus est celebratur.* Text inc. *Lectio sancti euangelii secundum Matheum. In illo tempore ambulans Ihesus iusta mare Galilee...Omelia beati Gregorii pape eiusdem lectionis. Audistis, fratres...* expl. (f. 95) *ad propria contempnenda perducatur* + dox. (W 179)

f. 95 **Chapter 19.** Pericope and Sermon of Calixtus for the Feast of the Election and Translation of St James, 30 December.

Rubric: *III die Kalendas Ianuarii electionis et translacionis sancti Iacobi Zebedei festiuitas celebratur.* Text inc. *Lectio libri Sapiencie. Iacobus placuit Deo...Sermo beati Calixti pape eiusdem leccionis. Sollempnia sacra...* expl. (f. 98) *nos perducere dignetur* + dox. (W 186)

f. 98 **Chapter 20.** Pericope and Sermons of Jerome, Augustine, Gregory and Calixtus for the Feast of the Octave of the Translation, 5 January.
[cf. PL 76, cols. 1272, 1184]

Rubric: *Nonas Ianuari octaua translacionis sancti Iacobi coluntur.* Text inc. *Lectio sancti euangelii secundum Matheum. In illo tempore procedens Ihesus secus mare Galilee...Sermo sanctorum Iheronimi et Augustini et Gregorii et Calxti eiusdem leccionis. Festiuitatem electionis...* expl. (f. 101) *sequi possimus* + dox. (W 192)

Chapters 21-23: Chants for the Office, with notation.

f. 101 **Chapter 21.** Capitula of Calixtus for the Vigil of St James, 24 July. [Cap. = Capitulum]

Rubric: *Incipit officium festiuum sancti Iacobi a beato papa Calixto dispositum. IX. Kalendas Augusti. Uigilia sancti Iacobi.*
Text: *Cap. ad matutinas. Iacobus Dei...*
Cap. ad terciam. Iacobus in diebus suis...
Ad sextam. In uita sua...
Ad nonam cap. In omni ore...

Rubric: *UIIII kalendas Augusti.*
Text: *Cap. sancti Iacobi ad uesperas. Inmisit, inquit...*
Cap. ad matutinas. His qui obtulerat
Ad terciam. Cum ducerentur...
Cap. ad sextam. At Iacobus parumper...

Cap. ad nonam. Iacobus uicit…
Cap. ad uesperas. Uocauit Ihesus…
Item aliut. Iacobus fuit magnus…
Aliut cap. Eodem autem tempore…
Cap. Confestim autem percussit… expl. (f. 101v) *non dedisset honorem Deo.* (W 193)

f. 101v ***Chapter 22.*** Calixtus's Responsory for the Vigil of St James, 24 July.

[We abbreviate as follows: *Alla.* = *Alleluia, A* = *Antiphona, Inv.* = *Invitatorium, Off.* = *Offertorium, Or.* = *Oratio, Ps.* = *Psalmus R* = *Responsorium, V* = *Versiculum*]

Rubric: *UIIII Kalendas Augusti. Uigilia sancti Iacobi responsoria beati Iacobi a domno papa Calixto ex euangeliis edita.*
Text: [*Matins* (W 193)]
Inv. Regem regum dominum Ps. Uenite exultemus…
Ymnus sancti Iacobi a domno Fulberto Karnotensi episcopo editus
Psallat chrous celestium…Per Iacobi sugffragia. Amen.
Cantus I toni.
A O uenerande Christi apostole…Ps. Confitemini

f. 102 *Ps. Confitemini II*
Ps. Confitemini III.
V Ora pro nobis beate Iacobe.R Ut digni efficiamur…
Sermo Marci. Cantus I toni.
R Redemptor imposuit…nomen Boanerges.V Ascendens Ihesus…
Sermo Marci. Cantus II. toni.
R Uocauit Ihesus…V Sicut enim tonitrui uoces…
Oratio Calixti pape. Cantus VII toni.

f. 102v *R Clementissime Deus…V Exue nos a uiciis…*
V Imposuit Ihesus Iacobo et Iohanni.R Nomina Boanerges, Alla. Alla.
In laudibus (W 195)
Sermo Marci Cantus I toni.
A Imposuit Ihesus…Ps. Miserere…
Sermo Marci Cantus II toni.
A Uocauit Ihesus Ps. Domine refugium…
Sermo Calixti pape. Cantus III toni.
A Sicut enim tonitrui…Ps. Deus Deus meus…
Sermo Iheronimi. Cantus IV toni
A Recte filii tonitrui…Ps. Audite celi…
Sermo Iheronimi. Cantus V toni.

f. 103 *A Iacobus et Iohannes tonitruum…Ps. Laudate dominum de celis…*
Capitulum. Iacobus Dei et domini nostri, ut supra.
Ymnus sancti Iacobi a domno Fulberto Karnotensis episcopo editus Sanctissime O iacobe…Zelus Patris…
V Iacobus fuit magnusR Secundum nomen suumm, Alla.
Sermo Marci. Cantus VIII toni.
A Ascendens Ihesus in montem Ps. Benedictus…
Or. Uigiliarum sacrarum, ut supra.
<u>*Ad Primam*</u> (W 197)
A Imposuit Ihesus…
<u>*Ad Terciam*</u>
A Uocauit Ihesus…Cap. Iacobus in diebus suis…
<u>*Ad Sextam*</u>
A Sicut enim…Cap. In uita sua…ut supra
R Imposuit Ihesus…V Nomina Boanerges…
V Occidit autem Herodes Iacobum. R Fratrem Iohannes gladio, Alla.

Ad Nonam
A Recte filii…Cap. In omni ore quasi mel, ut supra.
R Occidit autem Herodes…V Fratrem Iohannis…

f. 103v *V Iacobus fuit magnus. R Secundum…*
Rubric: *Responsoria euangelica beati Iacobi apostoli a beato Calixto papa edita,*
cum suis antifonis et ymnis diebus festis, passionis scilicet et translacionis,
eiusdem sancti iacobi cantanda. UIIII Kalendas Ianuarii translacio et electio
eiusdem colitur.
Ad Vesperas (W 198)
Uerba Calixti. Cantus I toni.
A Ad sepulcrum beati Iacobi…Ps. Laudate pueri…
Uerba Calixti. Cantus II toni.
A O quanta sanctitate…Ps. Laudate dominum omnes gentes…
Uerba Calixti. Cantus III toni.

f. 104 *A Gaudeat plebs Gallecianorum…Ps. Laude animam…*
Uerba Calixti. Cantus IU toni.
A Sanctissime apostole Iacobe…Ps. Laudate dominum quoniam bonus…
Uerba Calixti. Cantus U toni.

f. 104v *A Iacobe seruorum spes…Ps. Lauda Iherusalem…*
Cap. Inmisit inquit Herodes, ut supra.
R Dum esset saluator…V Sicut enim…
Ymnus sancti Iacobi a domno Guillelmo patriarcha Ihereosolimitano editus ad
uesperas et ad laudes cantandus.

f. 105 *Felix per omnes Dei plebs ecclesias… expl. (f. 105) Qua perfruamur politica*
patria. Amen. (W 200)
V Ora pro nobis, beate Iacobe.
A Honorabilem eximii…Ps. Magnificat…
Or. Deus qui presentem, ut supra.
Ad completorium (W 200)
Uerba Gregorii. Cantus U toni.
A Alla., Iacobe sanctisime [sic]… Ps. Cum inuocarem…
Ymnus. Psallat chorus, ut supra.
Cap. Tu autem in nobis es, domine…V Custodi nos, domine…
Cantus UI toni.
A Alma perpetui luminis lux…Ps. Nunc dimittis…
Or. Deus qui hanc noctem, ut supra.

f. 105v *Ad Inuitatorium* (W 201)
Uenite omnes Cristicole…Ps. Uenite exultemus…
Ymnus sancti Iacobi a domno Guillelmo patriarcha Iherosolimitano editus, post
Uenite cantandus.
Iocundetur/Et letetur… expl. (f. 105v) Imperanti/Ac regnati/In celesti patria.
Amen (W 203)
Sermo Mathei. Cantus I toni.

f. 106 *A Ihesus dominus uidit duos fratres…Ps. Celi enarrant…*
Sermo Mathei. Cantus II toni.
A Uenite post me…Ps. Benedicam dominum…
Sermo Mathei. Cantus III toni.
A Iacobus et Iohannes statim relictis…Ps. Eructauit…
Sermo Marci. Cantus IU toni.
A Ihesus uocauit Iacobum Zebedei…Ps. Omnes gentes…
Sermo Mathei. Cantus U toni.
A Eduxit Ihesus beatum Iacobum…Ps. Exaudi Deus deprecationem…
Sermo Marci. Cantus UI toni.

A Dixerunt Iacobus et Iohannes…Ps. Exaudi Deus orationem…
Sermo Marci. Cantus UII toni.
A Ihesus autem ait Iacobo…Ps. Confitebimur…
Sermo Gregorii. Cantus UIIII toni.
A Iam uos delectat…Ps. Dominus regnauit, exultet…
Sermo Luce. Cantus I toni.
A Herodes rex misit…Ps. Dominus regnauit, irascantur…
Sermo ecclesiastice ystorie. Cantus II toni.
A Uidens Herodes quia…
Sermo ecclesiastice ystorie. Cantus III toni.
A Regis uero facinus…

f. 107 *Sermo ecclesiastice ystorie. Cantus IU toni.*
A Statim percussit Herodem…
Sermo Calixti pape. Cantus U toni.
A Iacobe magne, supplantor…
Oratio sancti Gregorii.
V Ora pro nobis beate Iacobe.R Ut digni efficiamur gratia Dei.
De euangelio Marci.
V Imposuit Ihesus Iacobo et Iohanni.R Nomina Boanerges.
De Actibus apostolorum
V Occidit autem Herodes Iacobum. R Fratrem Iohannis gladio, alla., alla.
De libro Sapiencie.
V Ipse est directus diuinitus. R In penitenciam gentibus, alla., alla.
De libro Sapiencie.
V In uita sua fecit monstra.R Et in morte mirabilia operatus est, alla., alla.
(W 205)

f. 107v **Chapter 23.** Responsory.
Rubric: *Responsoria.[Matins]*
Sermo Marci. Cantus I toni.
R Saluator progressus pusillum…V At illi, relicto patre…
Sermo Marci et Iheronime et Psalmiste. Cantus II toni.
R Dum esset Saluator in monte…V Sicut enim uox tonitrui…

f. 108 *Sermo Marci. Cantus III toni.*
R Accedentes ad Saluatorem…V Ihesus autem ait eis: Nescitis…
Sermo Luce. Cantus IU toni.

f. 108v *R Cum uidisset autem…V Et conuersus Ihesus increpauit…*
Sermo Gregorii. Cantus U toni.
R Iam locum celsitudinis…V Iam nos delectat…
Sermo Luce. Cantus UI toni.

f. 109 *R Confestim autem percussit…V Statuto autem die…*
Sermo de euangelists excerptus Cantus UII toni.

f. 109v *R Hic est Iacobus…V O quam uenerandus est…*
Sermo Luce. Cantus UIIII toni.
R Hic est Iacobus…V O quam uenerandus est…
Sermo de Matheo et Marco excerptus. Cantus I toni.

f. 110 *R Huic Iacobo condoluit…V Tristis est anima mea…*
Sermo de utraque passione excerptus. Cantus UIIII toni.
R Cum adpropinquaret beatus Iacobus…V Uiso hoc miraculo…
Sermo a domno Guillelmo patriarcha Iherosolimitano excerptus de magna passione. Cantus UIIII toni.

f. 110v *R Iacobe uirginei…V Tu prece continua…*
Prosa. Festa digne, require in fine libri.

[Hymnus] Ad honorem…
Quidam antistes a Iherosolimis rediens, ereptus per beatum Iacobum a marini periculis, in primo tono edidit hunc.

f. 111 *R O adiutor omnium seculorum…V Qui subuenis periclitantibus ad te clamantibus…*
V Iacobus fuit magnus.
<u>*In laudibus*</u> (W 208)
Sermo ecclesiastice ystorie. Cantus I toni.
A Inmisit inquit Herodes…Ps. Dominus regnauit…
Sermo ecclesiastice ystoria. Cantus II toni.
A His qui obtulerat Iacobum…Ps. Iubilate Deo…
Sermo ecclesiastice ystorie. Cantus III toni.
A Ducti sunt, inquit…Ps. Deus, Deus meus…

f. 111v *Sermo ecclesiastice ystorie. Cantus IU toni.*
A Cum ducerentur in uia…Ps. Benedicite…
Sermo ecclesiastice ystorie. Cantus U toni.
A At Iacobus parumper deliberans…Ps. Laudate dominum de celis…
Cap. His qui obtulerat…
R Ora pro nobis, beate Iacobe. V Ut digni efficiamur promissionibus Christi Gloria…
Hymnus. Felix per omnes…V Ipse est directus diuinitus.
Cantus I toni.
A Apostole Christ Iacobe…Ps. Benedictus…
Or. Gloriosissimam sollempnitatem, ut supra.

f. 112 <u>*Ad Primam*</u> (W 209)
A Inmisit, inquit…
<u>*Ad terciam*</u> (W 310)
A His qui obtulerat…
Cap. Cum ducerentur in uia, ut supra.
R Ora pro nobis, beate Iacobe, alla., alla. V Ut digni efficiamur promissionibus Christi, alla., alla. Gloria…
V Imposuit…
Aliut responsorium.
R Iacobe seruorum spes et medecina V Suscipe seruorum miserans pia tuorum, alla., alla. uota tuorum, alla. Gloria…
V Imposuit Ihesus…
<u>*Ad sextam*</u>
A Ducti sunt, inquit…
Cap. At Iacobus parumer deliberans…
R Imposuit Ihesus Iacobo et Iohanni, V Nomina Boanerges, alla., alla. alla., alla. Gloria…Imposuit.
V Occidit autem Herodes.
Aliut responsorium.
R Iacobe, pastor inclite, preces nostras V Lapsis manum porrige ut suscipe, alla., alla. queamus scandere, alla., alla. Gloria…V Occidit autem Iacubum.
<u>*Ad Nonam*</u> (W 211)
A Cum ducerentur in uia…
Cap. Iacobus uicit turbas, ut supra.

f. 112v *R Occidit autem Herodes Iacobum,V Fratrem Iohannis gladio, alla., alla., alla., alla., alla., alla., Gloria…*
V Imposuit Ihesus…
<u>*Ad Uesperas*</u>
A Inmisit, inquit…Ps. Dixit dominus…
A His qui obtulerat…Ps. Laudate pueri…

A Ducti sunt…Ps. Credidi…
A Cum duceretur…Ps. In conuertendo…
A At Iacobus parumper…Ps. Domine probasti me…
Cap. Uocauit Ihesus Iacobum…
R O adiutor omnium…
Ymnus. Felix per omnes. Dei plebs…
V Ipse est directus…
Cantus III toni.
A O lux et ducus Hyspanie…Ps. Magnificat…
Or. Deus qui diem festum, ut supra.
<u>*Ad completorium*</u> (W 212)
A Alla., Iacobe sanctissime…Ps. Cum inuocarem…
Ymnus. Psallat chorus, ut supra.V Custodi nos…

f. 113 *A Alma perpetua luminis…Ps. Nunc dimittis…*
Or. Deus qui hanc noctem…
Rubric: *Argumentum Calixti pape de matutinis sancti Iacobi.*
Text inc. *Omnes nouem psalmi transacti…* expl. *quod die octauo festi sancti Iacobi colitur.*
Rubric: *Item Calixtus papa de missis simul et matutinis sancti Iacobi.*
Text inc. *Si beati Iacobi uigilia die dominica evenerit…* expl. (f. 114) *quod accendite significat.* (W 215)
Rubric: *Finit Argumentum.*

f. 114 **Chapter 24.** Calixtus's Mass for Nones of the Vigil of St James, 24 July; as for the Vigil of Pentecost with the blessing of the fonts.
Rubric: *UIIII Kalendas Augusti. Missa a domno papa Calixto edita, in uigilia sancti Iacobi Zebedei circa nonam cantanda sicut in uigilia Pentecostes: Kyrie Eleison, Christi audi nos, Pater de celis sequatur. Hac die fontes debent benedici.*

f. 114v *[Introit] Iacobus et Iohannes dixerunt…Ps. Iam nos delectat locus…Gloria…Amen.*
Or. Uigiliarum sacrarum dilecti apostoli…
Lectio libri Sapientie. Iacobus in diebus suis… et post mortem prophetauerunt.
Marcus. Tractus. Uocavit Ihesus ad se Iacobum…
V Et imposuit eis…
[Or.] Dominus uobiscum. Presta quesumus omnipotens Deus ut sicut in hoc ieiunio…

f. 115 *Lectio epistole beati Iacobi apostoli. Iacobus Dei et domini nostri Ihesu Christi seruus…*
R Nimis honorati sunt…V Dinumerabo eos…

f. 115v *Tractus. Iacobus in uita sua…V Ipse est directus…*
Sequentia sancti euangelii secundum Marcum. In illo tempore ascendens dominus Ihesus in montem…
Gregorius. Offertorium. Certe dum filii Zebedei…

f. 116 *V Iam lucus celsitudinis querebant…*
Secreta. Hec munera, domine…
Prefactio. Uere dignum…ut qui beati Iacobi apostoli tui festa…
Communio. Ego uos elegi de mundo…

f. 116v *Postcommunio. Uotiua sacramenta tua, domine, alme Iacobi…*
Oratio ad oras. Clementissime Deus, qui nos ad beati Iacobi…
Oratio ad vesperas. Deus qui presentem sacratissimam noctem beati Iacobi…
Oratio ad completorium. Deus qui hanc noctem sollempnem beati Iacobi…
In nocte ad matutinum. Deus qui hanc serenam noctem dilecti apostoli tui Iacobi… expl. *facias coruscare, per.* (W 218)

Chapter 25. Versus for the processions of the Feasts of the Passion and Translation.
Salue festa dies Iacobi ueneranda tropheo... expl. (f. 118) *Subueniat nobis subcine cantor. Amen. Salue...* (W 219)

f. 118 *Chapter 26.* Calixtus's Mass for the Feast of St James, 25 July.
[Introit] Ihesus uocauit Iacobum...Ps. Celi enarrant...
[Or.] Gloriosissimam sollempnitatem
Lectio libri ecclesiastice ystorie. In diebus illus imnisit inquit Herodes... expl. (f. 119) *et scatens uermibus expirauit.* (W 220)

f. 119 *Lucas. R Misit Herodes...* [cf. *Misit Herodes* in Paris, BN, lat. 1086, early 13th century from St-Léonard-de-Noblat, FASSLER, 1993, p. 377]
V Occidit autem Iacobum fratrem Iohannis gladio.
Calixtus. Alla. Sanctissime apostole Iacobe...

f. 119v *Calixtus. Alla. Hic Iacobus ualde Marcus. Alla. Uocauit Ihesus Iacobum...*
Prosa sancti Iacobi Latinis Grecis et Ebraicis uerbis a domno papa Calixto abreuiata. (W 221)
Alla. Gratulemur et letemur... expl. (f. 121) *letemur in secula. Amen.* (W 224)
[cf. *Gratulemur et letemur* in Paris, BN, n. a. lat. 3126, third quarter of the 12th century from Nevers, FASSLER, 1993, p. 360, and in Paris, BN, lat. 778, late 12th–early 13th century from Narbonne; ead. p. 382]

Quire 16^9 (121-129). Hand 1A except for the added half-leaf, f. 128, written by Scribe x.

f. 121 *Sequentia sancti euangelii secundum Marcum. In illo tempore accesserunt ad dominum Ihesum Christum filii Zebedei...*
Credo in unum...

f. 121v *Marcus Offertorium. Ascendens Ihesus in montem, uocauit ad se Iacobum...*
V Etenim saggite tue, domine, transeunt uox tonitrui in rota. Quod est.
Secreta. Nobis supplicibus tuis...
Prefacio. Uere dignum... eterne Deus et in hanc preclara beati Iacobi apostoli tui celebritate...

f. 122 *Marcus. Communio. Ait Ihesus Iacobo et Iohanni: Potestis bibere calicem...*
V Si mens uestra appetit, quod demulcet, prius bibete quod dolet. Potestis bibere...
Postcommunio. Deus, cuius Filius ad bibendum calicem suum beatos filios Zebedei...
Oratio ad terciam. Omnipotens sempiterne Deus, qui hodiernam diem nobis exultabilem in beati Iacobi apostoli tui sollempnitate...
Oratio ad sextam cotidiana. Da, quesumus, omnipotens Deus, ut sicut beatus Iacobus...
Oratio ad nonam cotidiana. Presta, quesumus, omnipotens Deus, ut qui beati Iacobi apostoli tui sollempnia...
Oratio ad completorium. Deus, qui nos beati apostoli tui diei spacia letis...

f. 122v *Chapter 27.* Calixtus's Prayers for the Pilgrims' Mass, followed by Mass for the second day in the Octave of St James and the Feast of St Josias, 26 July. (W 226)
Rubric: *Missa pro peregrinis sancti Iacobi ad omnes missas sedule dicenda a domno papa Calixto edita.*
[Or.] Pateant aures misericordie tue, quesumus, domine, precibus supplicantum beati Iacobi peregrinorum...
Alia or. Omnipotens sempiterne Deus, qui naciones barbaras omnium mundi climatum ad sacrum beati Iacobi apostoli tui altare...
Secreta. Piisimis beati Iacobi apostoli tui precibus...
Postcommunio. Deus qui beati Iaocbi apostoli tui altare uenerandum...

Rubric: *UII Kalendas Augusti. Secunda die infra octauas sancti Iacobi. Missa de sancto Iosia martire et de sancto Iacobo simul.*
[Introit] Michi autem nimis...Ps. Domine probasti me...
Or. Omnipotens sempiterne Deus, que apostolo tuo Iacobo beatum Iosiam martirem...
Lectio libri ecclesiastic ystorie. In diebus illis, inmisit, inquit, ut supra.
Prosa sancti Iacobi crebro cantanda a domino Willelmo patriarcha Iherosolimitano edita.

f. 123 *Clemens seruulorum/Gemitus tuorum...* expl. (f. 123)
 Ergo laus nostrorum/Deo sit cunctorum/Iacobe uiua, Amen. (W 228)

f. 123v *Sequentia sancti euangelii secundum Matheum. In illo tempore conuocatis Iesus duodecim discipulis suis...*
 Off. Constitues eos...
 Secreta. Quesumus, omnipotens Deus, ut hec oblacio,...qui hanc sacratissimam beatorum tuorum Iacobi apostoli et Iosie martiris diem...
 Communio. Ait Ihesus, ut supra.

f. 124 *Postcommunio. Omnipotens clementissime Deus, qui apostolum tuum Iacobum, una cum beato Iosia martire suscepisti...*
 Or. Deus cuius angelus Herodem Iacobi pro morte peremit...
 Or. Deus, qui nobis beati apostoli tui magni Iacobi... expl. (f. 124) *gaudere leticia, per...* (W 230)

 Chapter 28. Masses for the third, fourth, fifth, sixth, seventh days of the Octave of St James, 27, 28, 29, 30, 31 July, and for the Mass after Prime on 1 August, the Feast of St Peter in Chains; Calixtus's Prologue to the Feast of the Miracles of St James, 3 October, and Mass for the Feast of the Miracles.
 Rubric: *UI Kalendas Augusti. Missa sancti Iacobi. III die infra Octauas.*
 Introitus. Ihesus uocauit...Ps. Celi enarrant...
 Collecta. Deus, qui beatum apostolum tuum magnum Iacobum Gallecie aduocatum...
 Lectio libri Sapientie. Iacobus fuit magnus secundum nomen suum...
 R Misit Herodes... [cf. f. 119] *V Occidit, ut supra.*
 Alla. Sanctissime apostole...
 Prosa. Boanerges qui numcuparis, require retro.
 [Sequentia sancti euangelii] secundum Matheum. In illo tempore post dies sex assumpsit dominus Ihesus Petrum et Iacobum et Iohannem...

f. 124v *Secreta. Deus qui dispensacione tua mirabili...*
 Postcommunio. Sumpsimus, domine, beati Iacobi...
 Or. Deus, qui nobis piissimi tui Iacobi festa celebrare...
 Or. Impertire, quesumus, domine ut qui beati Iacobi...
 Rubric: *U Kalendas Augusti. Missa sancti Iacobi. IU infra octauas die.* (W 231)
 [Introit] Ihesus uocauit...Ps. Celi enarrant...
 Or. Presta, quesumus, omnipotens Deus, ut qui magni apostoli tui Iacobi...
 Lectio Libri Sapientcie. Iacobus uicit turbas non uirtute corporis...
 R Misit Herodes... [cf. f. 119] *V Occidit autem...*
 Alla. Hic Iacobus, require retro.
 Prosa. Clemens seruulorum...
 Sequentia sancti euangelii secundum Lucam. In illo tempore Ihesus dominus faciem suam firmauit...
 Off. Ascendens Ihesus...
 Secreta. Hec oblacio... et pio beati Iacobi obtentu...
 Communio. Ait Ihesus...
 Postcommunio. Deus, cui et sui facile est panem et uinum... et beati Iacobi in celis societatem...
 Or. Deus Trinitas indiuisa, qui hos dies dilecti apostoli tui magni Iacobi...

Alia or. Deus cuius dilectione beatus Iacobus... expl. (f. 125v) *bis concede bonorum, per dominum...* (W 233)

f. 125v Rubric: *IU Kalendas Augusti. Missa sancti Iacobi infra octauas U die.*
[Introitus] Ihesus uocauit...Ps. Celi enarrant...
Colleta. Fac nos, quesumus, piissime Deus, una cum beato Iacobo...
Lectio libri Sapiencie. Iacobus durus debellator...
R Misit Herodes... [cf. f. 119] *V Occidit autem...*
Alla. Uocauit Ihesus
Sequentia sancti euangelii secundum Marcum. In illo tempore assumpsit dominus

f. 126 *Ihesus Petrum et Iacobum et Iohannem...*
Off. Ascendens Ihesus...
Secreta. Super has hostias ut beati Iacobi interuentibus...
Communio. Ait Ihesus...
Postcommunio. Deus qui in hoc sumpto reuerentissimi corporis Filii tui... et ad regna celestia beati Iacobi auxiliis mereamur...
Alia or. ad terciam. Concede nobis, domine quesumus ut in his sacris beati Iacobi apostoli sollempnis...
Or. Deus cuius unigenitus beatum Iacobum apostolum de ualle collium ad montem Thabor eduxit... expl. (f. 126) *perhenni polorum claritate, per eundem...* (W 235)
Rubric: *III Kalendas Augusti. Missa de sancti Iacobi. Infra octauas UI die.*
[Introitus] Ihesus uocauit...Ps. Celi enarrant.
Coll. Natalicia dilecti tui magni Iacobi apostoli...

f. 126v *Lectio libri Sapiencie. Mali hospites iuste...*
R Misit Herodes... [cf. f. 119] *V Occidit autem...*
Alla. Santissime...
Prosa. Clemens seruulorum...
Sequentia sancti euangelii sucundum Marcum. In illo tempore accesserunt ad Ihesus filii Zebedei...
Off. Ascendens Ihesus...
Secreta. Largam benedictionem tuam super has hostias tibi oblatas, quesumus... et ad beati Iacobi consortium perducant...
Communio. Ait Ihesus...
Postcommunio. Presta, quesumus, omnipotens Deus, ut...beato Iacobo intercendente...
Or. Deus qui nobis beati Iacobi apostoli tui concedis sollempnia frequentare...
Or. Celebritatem almi apostli tui magni Iacobi Zebedei deuotissime recolentes...
expl. (f. 126v) *te donante ab ea eruamur, per.* (W 236)
Rubric: *II Kalendas Augusti. Missa sancti Iacobi. Infra octauas UII die.*
[Introitus] Ihesus uocauit...Ps. Celi enarrant...
Coll. Sollempnia beati Iacobi apostoli tui celebria...

f. 127 *Lectio Actuum apostolorum. In diebus illis superuenerunt ad Ihersolimis prophete Antiocham...*
R Misit Herodes... [cf. f. 119] *V Occidit autem...*
Alla. Uocauit Ihesus...
Prosa. Gratulemur et letemur, uide supra. [cf. f. 119v]
Sequentia sancti euangelii secundum Matheum. In illo tempore, accessit ad dominum Ihesum mater filiorum Zebedei...

f. 127v *Off. Ascendens Ihesus...*
Secreta. Presencia sacrificia magestati tue nos domine quesumus his beati Iacobi festiuitatibus...
Communio. Ait Ihesus...

Postcommunio. Exultantis ecclesie tue, domine, quesumus…in hac beati Iacobi apostoli celebritate…
Or. ad terciam. Deus qui beato Iacobo apostolo tuo Filium tuum in deitate tua transformatum ostendere dignatus es…
Or. ad sextam. Nostra, quesumus, domine, clementer exaudi preconia ut qui dilecti apostoli tui magni Iacobi colimus sollempnia…
Or ad nonam. Presta nos, quesumus, mundi redemptor, apostoli tui magni Iacobi precibus…
Or. ad uesperas. Deus qui nobis beati Iacobi apostoli tui iteratam sollemptnitatem tribuis celebrare… expl. (f. 127v) *gaudia mereamur peruenire, per…* (W 238)
[there is a break in the foliation: f. 129 follows f. 127v; the added half leaf is numbered f. 128; its contents are cued on f. 129 but it has been inserted between ff. 127 and 129]

f. 127v Rubric: *Kalendas Augusti. Missa in octauas sancti Iacobi mane post primam cantanda quia maior missa hodierna sancti Petri ad Uincula post terciam hac die debet iure celebrari.*
[Introitus] Ihesus uocauit…Ps. Celi enarrant…
[Or.] Oremus. Uenerandam beati apostoli tui magni Iacobi sollempnitatem octauam domine recolentes…

f. 129 *Lectio libri ecclesiastice ystorie. Inmisit, inquit, Herodes…*
R Misit Herodes… [cf. f. 119] *V Occidit autem…*
Alla. Hic Iacobus…
Prosa. Clemens seruulorum…
Sequentia sancti euangelii secundum Marcum. In illo tempore accesserunt ad dominum Ihesum Christum filii Zebedei…
Off. Ascendens Ihesus…
Secreta. Prebe quesumus domine super has hostias… et beato Iacobo orante…
Communio. Ait Ihesus…
Postcommunio. Da quesumus, omnipotens Deus ut qui beati apostoli magni tui Iacobi octauam celebritatem colimus…
Oratio ad uesperas. Deus qui expletis sollempnitatum diebus beati Iacobi apostoli tui… expl. (f. 129) *exultantibus animis possimus peruenire, per…* (W 239)

f. 128 Rubric: *Calixtus papa de festiuitate miraculorum sancti Iacobi que U die nonarum octobris colitur.* Text inc. *Festiuitatem miraculorum sancti Iacobi qualiter uirum…* expl. (f. 128v) *nos has idem corroboramus.*
Rubric: *U die Nonarum Octobris. Missa Miraculorum sancti Iacobi.*
[Introitus] Ihesus uocauit…Ps. Celi enarrant…
Or. Deus qui beatum Iacobum apostolum tuum ad laudem tui nominis innumeris fecisti miraculis coruscare…
Lectio [libri Sapientie]. Iacobus in diebus suis non pertimuit, ut supra.
R Misit Herodes… [cf. f. 119] *V Occidit autem…*
Alla. Uocauit Ihesus…
Prosa. Clemens seruulorum…
[Sequentia sancti] euangelii [secundum Matheum]. [In illo tempore] conuocatis Ihesus duodecim…
Off. Ascendens Ihesus…

f. 128v *Secreta. Gratie tue benedictionem super has hostias… et presta beati Iaocbi apostoli tui interuentibus…*
Communio. Ait Ihesus…
Postcommunio. Deus qui dignis sacramentis tuis nos refecisti in hac beati Iacobi apostoli tui celebritate…
Or. Deus qui nobis beati Iacobi apostoli tui miraculorum sollempnia concedis celebrare…

R Saluator progressus decantentur et lectiones de miraculis sancti Iacobi legantur. expl. (f. 128v) (W 240)

f. 129 **Chapter 29.** Capitula of Calixtus for the Feast of the Translation of St James, 30 December.
Rubric: *Calixtus papa de translacione sancti Iacobi.*
Translacionem sancti Iacobi qualiter a Iherosolimis translatus est ad Gallecianos...simul colere precipimus. III kalendas Ianuarii R de euangeliis, Saluator progressus cum suis antifonis et ymnis Iocundetur et Felix per omnes hac die decantentur.
Cap. ad uesperas de libro Sapientie. Iacobus placuit Deo et translatus est in paradiso...
Cap. ad matiutinas de libro Sapientie. Magnus pater multitudinis gentcium...
Cap. ad terciam de librto Sapientie. Fuit dominus in testamento cum ipso...
Cap. ad sextam de libro Sapientie. Agnouit enim dominus in benedictionibus suis...
Cap. ad nonam de libro Sapiencie. Dilectus a Deo et hominibus beatus Iacobus...

f. 129v *Cap. ad uesperas. Iacobus placuit Deo, require retro.*
Aliut cap. de libro Sapientie. Placens Deo factus dilectus et uiuens deinter peccatores translatus est. expl. (f. 129v) (W 241)

Chapter 30. Calixtus's Mass for the Feast of the Translation and Election of St James, 30 December, followed by Calixtus's Office for the Octave of the Translation.
Rubric: *III Kalendas Ianuarii. Translacio et electio sancti Iacobi. Missa a domno Calixto papa edita.*
[Introitus] Ihesus uocauit...Ps. Celi enarrant...
Or. Deus cuius unigenitus secus mare Galilee beatum Iacobum in ordine apostolatus elegit...
Lectio libri Sapientie. Iacobus placuit Deo et translatus est in paradiso...
R Misit Herodes... [cf. f. 119] *V Occidit autem...*
Alla. Uocauit Ihesus...
Prosa. Gratulemur et letemur...
Sequentia sancti euangelii secundum Marcum. In illo tempore preteriens Ihesus...

Quires 17-18⁸ (130-145). Hand 1A ff. 130-139v. Hand 1B ff. 140-145.

f. 130 *Off. Ascendens Ihesus...*
Secreta. Preclara beati Iacobi apostoli tui sollempnia recolentes...
Prefatio. Uere dignum... eterne Deus et in hac preclara beati Iacobi...
Communio. Ait Ihesus Iacobo...
Postcommunio. Fac nos quesumus clementissime Deus dilecti apostoli tui Iacobi patrocinia sentire...
Or. Deus qui beatum Iacobum apostolum tuum miraculis signis et prodigiis decorasti in terris, fac nos quesumus eius consorcio agregari in celis per dominum... expl. (f. 130) (W 243)
Rubric: *Calixtus papa de officio octauorum translationis sancti Iacobi.*
Text inc. *Octaue translacionis et electionis...* expl. (f. 130) *et de trans Iordanem. Benedicamus sancti Iacobi a magistro Anselmo editum.*

f. 130v *Exultet celi curia. Fulget dies...* expl. (f. 131) *Amando amicicias. Fulget dies/Deo dicamus gracias. Fulget dies ista.*

f. 131 *Conductum sancti Iacobi ab antiquo episcopo Boneuentino editum. Iacobe sancte tuum repetitio tempore festum/Fac preclues celo colente (puer hoc repetat stans inter duos cantores: Fac preclues celo colentes)...* expl. *Lector lege et de rege qui regit omne dic Iube domne.*
Conductum sancti Iacobi a domno Fulberto Karnotensi episcopo editum

In hac die/laudes cum gaudio… (puer hoc repetat pergens inter duos cantores: Iacobe apostole/sanctissime/Nos a malis erue/piisime) expl. (f. 132) *Lector lege/et de rege/qui regit omne/dic Iube domne* (W 246)

f. 132 *Conductum sancti Iacobi a magistro Rotberto cardinali Romano editum. Resonet nostra domino caterua/ (Puer hoc dicat:) Corde iocundo… expl. (f. 132) Lector lege/et de rege/qui regit omne/dic Iube domne. Conductum sancti Iacobi a sancto Fortunato Pictauensi episcopo editum. Salue festa dies, ueneranda per omnia fies/ (Puer hoc repetat pergens inter duos [f. 132v] cantores:) Gaudeamus… expl. (f. 132v) Et uirtus pergit quo pede meno ualet/Gaudeamus.* (W 248)

f. 132v **Chapter 31.** Fulbert of Chartres' Farsed Mass of St James, for use on either feast as desired.

Rubric: *Farsa officii misse sancti Iacobi a domno Fulberto Karnotensi episcopo (f. 133) illustri uiro edita in utroque festo eiusdem apostoli cantanda quibus pacebit. Cantores inter quos sit presul aut presbiter infulis uestitus, dicant hoc: Ecce adest nunc Iacobus… Alii cantores respondeant: Qualis sit iste Iacobus… Alii respondeant: Hic est reuera Iacobus… Alii dicant: Alla. in gloria… expl. (f. 133v) Letare nostra turmula/Dic Deo laudum carmina.* (W 249)

[Introit] Ihesus uocauit Iacobum… (totum dicatur) Reges terre et omnes populi…quia eius Filius. Ihesus uocauit… (usque Iacobi) Quia bonum est et iocundum habitare fratres in unum Deum. Et imposuit… (usque Boanerges) Quoniam tonitruum de nube terrificum in monte Thabor audierunt: Hic est Filius meus dilectus. Quod est filii tonitrui.

f. 134 *Celi enarrant…Laudent Deum celi et terra…quoniam dominus. Ihesus uocauit…(usque Iacobi) Ut mitteret eos predicare regnum Dei. Et imposiut…(usque Boanerges) Quorum unus e celestibus intonuit: In principo erat Uerbum. Quod est filii tonitrui. Gloria Patri… Omnes gentes plaudent mentibus…rex magnus. Ihesus uocauit…(totum)* expl. (f. 134) (W 249) *[Kyrie] Fulbertus Karnotensis episcopus de sancto Iacobo.*

f. 134v *Rex immense pater pie/eleison/Kyrie eleison…* expl. *Qui Iacobum illustrasti/eleison/Kyrie eleison/ Cuius prece nobis parce/eleison/Kyrie eleison. Rex cunctorum seculorum/eleison/Kyrie eleison…* expl. (f. 134v) *Qui Iacobum lustras probum/eleison/Kyrie eleison. Gloria in excelsis Deo…Agnus Dei…tu solus altissimus Ihesu Christe.* (W 249) *Uersus Fulberti episcopi Karnotensis de sancto Iacobo. Bini cantores dicant: Qui uocasti super mare Iacobum Galilee Chorus E (Cantores) Quique illum elegisti/ apostolice uice…* expl. (f. 135v) *cum Sancto Spiritu in gloria Dei Patris. Amen.*

f. 135v *[Epistola]*

Farsa lectionis de missa sancti Iacobi edita a domno Fulberto Karnotensi episcopo illustri uiro. Lector et cantor simul iubilent: Cantemus domino cantica glorie Beate Iacobi hec festa hodie… Hinc celum Iacobus ingredi meruit.
Lector: Leccio libri ecclesiastice ystorie
Cantor: In qua Iacobi lucida
narrantur
ouanter prelia
De Herode superbo… expl. (f. 138)

f. 138 *Lector: Perfruamur leticia*
Cantor: A
Ambo simul: Amen. (W 255)
Sanctus.
Chorus: Sanctus, Sanctus, dominus Deus Sabaoth…
Cantores: Osanna
saluifica
tuum plasma
qui creasti potens omnia
Chorus:A… expl. (f. 138v)
Chorus:E. In excelsis. (W 256)

f. 138v *Agnus Dei Fulbert Karnotensis episcopi*

f. 139 *Cantores:Agnus Dei*
Chorus:Qui tollis peccata mundi…
Chorus: Dona nobis pacem.
Benedicamus sancti Iacobi a quodam doctore Galleciano editum.
Regi perhennis glorie
Sit canticum leticie… expl. (f. 139v)
Quia sedes etheras
Ascendit, Deo gracias. (W 257)

f. 139v Explicit for Book I: *FINIS CODEX PRIMUS. IPSUM SCRIBENTI SIT GLORIA SITQUE LEGENTI.* (W 257)
Book II: 22 Miracles of St James
[editions and partial transcripts: DAVID, II, 1946; GAIFFIER, 1943 (miracle 5); DÍAZ Y DÍAZ, 1985b (miracle 19); HERBERS, 1992 (miracle 4); cf. PL 163, 1369-76, printed from MARIANA, 1609; cf. MENACA, 1987, reprinted from PL; AASS Julii, VI, pp. 47-58, edited from VA and the Marchiennes copy of the Miracles, Douai, BM 842, not from C, omitting nos. 1, 9, 12, 13, 21, and adding five miracles from MS P; SOUTHERN/SCHMITT, 1969, miracles 16, 17, 18.]
Opening heading: *INCIPIT LIBER SECUNDUS SANCTI IACOBI ZEBEDEI PATRONI GALLECIE DE XXII MIRACULIS EIUS.* (W 259)

Prologue, Rubric: *Argumentum beati Calixti Pape.*

f. 140 Text inc. *Summopere precium est… expl. diligenter legatur.* (W 259)
Chapter list of 22 chapters. Rubric: *Incipiunt capitula libri secundi sancti Iacobi de XXII miraculis eius.* Chapter list inc. *Capitulum i. De uiginti uiris quos a capcione Moabitarum apostolus liberauit… expl. (f. 140v) Capitulum xxii. De uiro qui tredecim uicibus uenditur totidemque ab apostolo liberatur.* (W 259-260)

f. 140v **Chapter 1.** 20 men captured by the Moabites in the time of King Alfonso, are freed by St James. Told by Calixtus.
Rubric: *Miraculum sancti Iacobi a domno papa Calixto conscriptum.*
Text inc. *Beatus Iacobus qui sub obediencie… expl. omnibus nunciauit* + dox. (W 262)
cf. VINCENT OF BEAUVAIS, no. 1.

f. 142 *Chapter 2.* In the time of Bishop Theodomir, the sin of an Italian is erased from a scroll offered at the altar of Santiago; told by Bede (false attribution).
Rubric: *Exemplum sancti Iacobi a beato Beda presbitero et doctore conscriptum.*
Text inc. *Temporibus beati Theodemiri...* expl. (f. 142) *deletum in euum erit.* + dox (W 263)
cf. VINCENT OF BEAUVAIS, no. 2 and JACOBUS DE VORAGINE, no. 2.

f. 142v *Chapter 3.* The son of French pilgrims, conceived in answer to his father's prayer at Santiago, dies in the forest of Oca and is brought back to life by St James in answer to his mother's prayer. Dated 1108, told by Calixtus.
Rubric: *Miraculum sancti Iacobi a domno papa Calixto conscriptum.*
Text inc. *Anno dominice incarnacionis millesimo centesimo octauo in Gallie horis uir quidam spe prolis...* expl. (f. 143) *mortuum potest suscitari* + dox (W 264)
cf. VINCENT OF BEAUVAIS, no. 12.

f. 143 *Chapter 4.* A pilgrim from Lorraine and his dead companion who have been abandoned by the rest of their 28 companions are transported on horseback by St James from the Port de Cize to Santiago. Dated 1080 and told by Hubert, Canon of St Mary Magdalene, Besançon.
Rubric: *Exemplum sancti Iacobi conscriptum a magistro Huberto piissimo Bisuntie ecclesie sante Marie Magdalene canonico cuius anima requiescat in pace sempiterna. Amen.*
Text inc. *In hoc beati Iacobi Zebedei apostoli Gallecie presenti miraculo approbatur...* expl. (f. 144) *ueniam a domino consequatur.* + dox. (W 266)
cf. VINCENT OF BEAUVAIS, no. 3 and JACOBUS DE VORAGINE, no. 3.

f. 144 *Chapter 5.* The hanged youth saved: related of German pilgrims at an inn in Toulouse, where a wicked innkeeper hid vessels in the baggage of a father and son, claiming the pilgrims had stolen them; the magistrate released the father and hanged the son, whom St James held up until the return of his parents from Santiago, whereupon the wicked innkeeper was condemned and hanged in punishment. Dated 1080 and told by Calixtus.
Rubric: *Exemplum sancti Iacobi a domno papa Calixto conscriptum.*

f. 144v Text inc. *Memorie tradendum est, quosdam Theotonicos sub peregrinacionis habitu...* expl. (f. 145) *addicatum ilico suspenderunt* + dox. (W 268)
cf. VINCENT OF BEAUVAIS, no. 4 and JACOBUS DE VORAGINE, no. 4.
[For later versions of the story, involving the Chicken Miracle, see English note VIII-191; for an expanded version of this story, see the St Albans manuscript now in Dublin, under Lost Manuscripts.]

f. 145 *Chapter 6.* Related of a Poitevin family journeying to Santiago to escape the plague; at Pamplona the wife dies, a wicked inkeeper steals the goods and the donkey which had transported the two young children. St James provides another donkey for the trip to and from Santiago, explaining the miracle to the pilgrim and foretelling the death of the deceitful innkeeper who dies in a fall from the roof of his house. Dated 1100 [*sic*] in the reigns of Guillaume, Count of Poitiers (Guillaume VII, 1087-1127) and Louis, King of France (Louis VI, 1108-37). Told by Calixtus.
Rubric: *Exemplum sancti Iacobi conscriptum a domno papa Calixto.*
Text inc. *Anno incarnacionis dominice millesimo centesimo...pestis mortifera...* expl. (f. 146) *remediis fieri debent.* + dox. (W 269)
cf. VINCENT OF BEAUVAIS, no. 5 and JACOBUS DE VORAGINE, no. 7.

Quire 19^8 (146-153). Hand 1B.

f. 146 *Chapter 7.* A Frisian sailing a boatload of pilgrims to Jerusalem falls into the sea while fighting off a Saracen attack; he is rescued by St James; the Saracens' boat comes to grief; St James pilots the Christians to Jerusalem. The Frisian visits Santiago the same year. Dated 1101, told by Calixtus.
Rubric: *Miraculum sancti Iacobi a domno papa Calixto conscriptum.*
Text inc. *Anno dominice...primo cum quidam nauta nomine Frisonus...* expl. (f. 146v) *in eodem anno beatum Iacobum in Gallecia adiit.* + dox. (W 270)
cf. VINCENT OF BEAUVAIS, no. 6, dated 1091.

f. 146v *Chapter 8.* A bishop and several others returning by boat from Jerusalem are washed overboard by a wave; St James has them washed back on again, including the bishop's psalter, still open at the same page. The bishop visits Santiago and composes a responsory in the first tone, a versicle and a refrain to St James. Dated 1102, told by Calixtus.
Rubric: *Miraculum sancti Iacobi a domno papa Calixto editum.*
Text inc. *Anno incarnacionis dominice...cum quidam antistes...* expl. (f. 147) *repetuit dicens Duc nos ad salutis portum.* + dox. (W 271)
cf. VINCENT OF BEAUVAIS, no. 7, dated 1092.

f. 147 *Chapter 9.* A French crusader fighting at Tabaria near Jerusalem conquers the Turks thanks to St James, having promised to visit Santiago. Forgetting his promise, he falls ill but is cured on condition he fulfills his vow. St James calms a storm at sea between Jerusalem and Apulia; the French crusader collects thank offerings which he presents to the building fabric at the shrine of St James. Dated 1103, told by Calixtus.
Rubric: *Miraculum sancti Iacobi a domno papa Calixto editum.*
Text inc. *Anno incarnacionis...quidam inclitus genere Francorum miles nobilissimus...* expl. (f. 147v) *ad hopus ecclesie misit.* + dox. (W 272)

f. 147v *Chapter 10.* A pilgrim relieving himself over the side of a ship on his return from Jerusalem, falls in; a companion throws him a shield, on which St James transports him, holding the top of his head for three days until a port is reached. Dated 1104, told by Calixtus.
Rubric: *Miraculum sancti Iacobi a domno papa Calixto editum.*
Text inc. *Anno incarnacionis...dum peregrinus quidam a Ihersolimis rediens...* expl. (f. 147v) *cunctis enarrauit.* + dox. (W 273)
cf. VINCENT OF BEAUVAIS, no. 8.

Chapter 11. St James miraculously delivers one Bernard from prison at Corano (dioc. Modena). Dated 1105, related by Calixtus.
Rubric: *Miraculum sancti Iacobi a domno papa Calixto editum.*
Text inc. *Anno dominice incarnacionis...quidam nomine Bernardus apud castrum nomine Corzanum in Ytalia episcopatu Mutine captus...* expl. (f. 148) *celsitudine incolumis cecidit.* + dox. (W 273)
cf. VINCENT OF BEAUVAIS, no. 9 and JACOBUS DE VORAGINE, no. 1.

f. 148 *Chapter 12.* A certain knight in Apulia, cured of goitre through the imposition of a pilgrim's shell borrowed from a neighbour, sets off for Santiago in gratitude. Related by Calixtus, dated 1106.
Rubric: *Miraculum sancti Iacobi a domno papa Calixto editum*
Text inc. *Anno incarncaionis dominice...miles quidam in Apullia horis gula...* expl. (f. 148) *ad beati Iacobi limina in Galleciam proficiscitur.* + dox. (W 274)

Chapter 13. The Allobrogian (ancient inhabitants of Dauphiné and Savoie) knight Dalmace de Chavannes is restored by St James at the request of his farmer Raimbert, after receiving a debilitating blow delivered, also with the help of St James, by Raimbert. Dated 1135, related by Calixtus.

Rubric: *Miraculum sancti Iacobi a domno papa Calixto editum.*
Text inc. *Anno dominice incarnacionis…quidam Allobros mile nomine Dalmacius de Chauannis Raimbertum quendam rusticum suum…* expl. (f. 148v) *diuina clemencia operante reddidit.* + dox. (W 274)

f. 148v **Chapter 14.** A merchant on his way to the fair, treacherously robbed and imprisoned by his lord, is delivered by St James; the guards who held him prisoner are blinded; he offers his chains to St James at Santiago. Dated 1107, related by Calixtus.
Rubric: *Exemplum sancti Iacobi a domno papa Calixto conscriptum.*
Text inc. *Anno incarnacionis dominice…quidam negociator…* expl. (f. 148v) *clemencia operante reddidit.* + dox. (W 275)
cf. VINCENT OF BEAUVAIS, no. 6, dated 1106.

Chapter 15. An Italian knight and his horse are spared in combat by St James. Dated 1110, told by Calixtus.
Rubric: *Exemplum sancti Iacobi a domno papa Calixto editum.*
Text inc. *Anno dominice incarnacionis…in Ytalia ex duabus ciuitatibus inter se dissentibus milites…* expl. (f. 149) *Deo gratias egerunt.* + dox (W 274)
cf. VINCENT OF BEAUVAIS, no. 11.

f. 149 **Chapter 16.** Three knights of the château of Donzy, dioc. Lyon, one of whom agrees to carry to Santiago the scrip of a poor woman and the staff of a poor sick man; he falls ill on the way and at Santiago is tormented by devils, who strike him dumb; St James fights them off with the same staff and scrip, using the latter as a shield, so the knight can ask his companions to fetch a priest to administer the last rites so that he can die in peace. The priest announces to one of the companions the impending death of his lord Guérin the Bald. Told by Anselm, Archbishop of Canterbury (1033-1109).
Rubric: *Miraculum sancti Iacobi a sancto Anselmo Cantuariensi archiepiscopo editum.*
Text inc. *Tres milites dioceseos Lugdunensis ecclesie de oppido Dumzeii…* expl. (f. 150v) *lancea transfossus interiret.* + dox. (W 278)
cf. *Dicta Anselmi*, ch. 21 (ed. SOUTHERN/SCHMITT, 1969, pp. 196-200; see also SOUTHERN, 1953, pp. 260-264 and SOUTHERN, 1958, pp. 189-190). VINCENT OF BEAUVAIS, no. 13.

f. 150v **Chapter 17.** A young man named Gerald, from a village near Lyon, having fornicated before departing for Santiago, is persuaded by the devil (claiming to be St James) to cut off his offending member and kill himself, which he does; his soul, taken on its way to hell by the devil, passes by Labicano near Rome where St James takes charge of him, leading him before the Virgin Mary at St Peter's; she orders his soul to be returned to his body, and his wounds healed except for the offending member. Attributed in the rubric to Anselm, Archbishop of Canterbury, but in the text to Hugh, Abbot of Cluny (1024-1109), who allegedly examined the man, including his wound.
Rubric: *Miraculum grande sancti Iacobi a sancto Anselmo Cantuariensi archiepiscopo editum.*
Text inc. *Prope ciuitatem Lugdunensem est uicus in quo iuuenis quidam morabatur nomine Giraldus…* expl. (f. 152v) *dignis celebrent obsequiis.* (W 282)
cf. *Dicta Anselmi*, ch. 22 (ed. SOUTHERN/SCHMITT, 1969, pp. 200-207; see also SOUTHERN, 1953, pp. 260-264 and SOUTHERN, 1958, pp. 189-190). VINCENT OF BEAUVAIS, no. 14 and JACOBUS DE VORAGINE, no. 6.

f. 152 **Chapter 18.** Ponce, Count of St-Gilles (1037-60), forbidden to pray at night before the altar of St James, rallies a group of pilgrims to join him in

asking St James himself to unlock the gates of his chapel, which are miraculously opened by the saint. Told by Calixtus.

Rubric: *Miraculum sancti Iacobi a domno papa Calixto conscriptum.*
Text inc. *Nuper comes de sancto Egidio nomine Poncius...* expl. (f. 153v) *benignus affuit supplicacioni.* + dox. (W 283)
cf. *Dicta Anselmi*, ch. 23 (ed. SOUTHERN/SCHMITT, 1969, pp. 208-209; see also SOUTHERN, 1953, pp. 260-264 and SOUTHERN, 1958, pp. 189-190). VINCENT OF BEAUVAIS, no. 17.

f. 153v *Chapter 19.* Bishop Stephen, having abandoned his wealthy bishopric in Greece to visit Santiago, is granted a cell in the cathedral. Invoked by peasants as St James the Knight, against the admonitions of Stephen, St James appears as a mounted warrior in shining armour, holding a pair of keys and announces the raising of Coimbra (1064) which King Ferdinand (1035-65) had besieged for seven years. Related by Calixtus.

Rubric: *Miraculum sancti Iacobi a domno papa Calixto editum.*
Text inc. *Notum est omnibus iam clerici quam laicis...* expl. (f. 154) *sepulturam honorifice suscepit.* + dox. (W 285)
cf. VINCENT OF BEAUVAIS, no. 18.

Quire 20^8 (154-161). Hand 1B: outer bifolio (ff. 154 and 161). Hand 2: three inner bifolia (ff. 155-160).

f. 154 *Chapter 20.* A knight Guillaume taken prisoner by his lord, the Count of Forcalquier, whose men are unable to execute him with the sword, thanks to the intervention of St James; the saint appears to release the man from prison, whereupon he makes a pilgrimage to Santiago.

Rubric: *Miraculum sancti Iacobi a domno papa Calixto conscriptum.*
Text inc. *Multorum itaque temporum labente curriculo...* expl. (f. 154v) *omnia, ut supa diximus, ordiune enarraret.* + dox. (W 286)
cf. VINCENT OF BEAUVAIS, no. 19.

f. 154v *Chapter 21.* Gilbert, a Burgundian nobleman, handicapped for 14 years, is borne on a litter to Santiago. In a dream he is advised to kneel in prayer until St James raises him up; he spends two nights on his knees and is raised up by St James in person on the third night.

Rubric: *Miraculum sancti Iacobi a domno papa Calixto conscriptum.*
Text inc. *Nostro itaque empore quidam uir inclitus Burgundie nomine Guilbertus...* expl. (f. 155) *proprio ore cunctis reueleuit.* + dox. (W 286)

f. 155 [Hand 2 begins shortly after the beginning of Miracle 21]
Chapter 22. In 1100, a citizen of Barcelona, returned from Santiago continued his way to Sicily and was captured, sold, and chained many times. Each time the chains were broken by St James: places mentioned are Corociana, the city of Iazeram in Ysclauonia, Blasia, Turcoplia, Perside, India, Ethiopia, Alexandria, Africa, Barbaria, Beserto, Bugia, the town of Almaria. The author (Calixtus) met him between Stella and Grugnum (Estella and Logroño).

Rubric: *Miraculum sancti Iacobi a domno papa Calixto editum.*
Text inc. *Anno dominice...quemdam ciuem Barquinonensem...* expl. (f. 155v) *omnia michi enarrauit.* + dox. (W 287)
cf. VINCENT OF BEAUVAIS, no. 15 and JACOBUS DE VORAGINE, no. 10.

f. 155v Explicit for Book II: *Finis codex secundus. Ipsum scribenti sit gloria sitque legenti.* Followed by a Chi Rho monogram. (W 287)
Book III: The Translation of St James
[editions and partial transcripts: FLÓREZ, ES III, 1754, p. 407; FITA/FERNÁNDEZ GUERRA, 1880, pp. 120-121; CCHL, 1890, I, 401; 430

after Paris, BN, lat. 2036; LÓPEZ FERREIRO, 1898, I, pp. 179-207; MEYER, 1902, after Paris, BN, lat. 13775; VILA-AMIL, 1909, pp. 42-45; VELOZO, 1965; GAIFFIER, 1971; DÍAZ Y DÍAZ, 1988b]

Opening heading: *INCIPIT LIBER TERCIUS SANCTI IACOBI* (W 289)

Chapter list of 4 chapters, inc. *Capitulum i. Translatio magna…* expl. *Capitulum iv. De tubis sancti Iacobi. Traditur quod ubicumque.* (W 289) [the chapters themselves are not numbered]

Prologue. Rubric: *Incipit prologus beati Calixti pape super translationem beati Iacobi maiorem.* Prologue text inc. *Hanc beati Iacobi translationem…* expl. (f. 156v) *remunerauit muneribus. Explicit prologus.* (W 289-290)

f. 156v **Chapter 1.**

Rubric: *Incipit translatio…* expl. *translatus in Galleciam.* Text inc. *Post Saluatoris nostri passionem…* (W 290) expl. (f. 159) *suffragio patrocinaturus.* + dox (W 294)

f. 159 **Chapter 2.** Epistle of Leo

Rubric: *Incipit epistola beati Leonis pape de translatione beati Iacobe apostoli que III Kalendas Ianuarii celebratur.* Text inc. *Noscat fraternitas uestra…* expl. (f. 159v) *suffragio patrocinaturus* + dox (W 296) [cf. London, BL, MS Harley 4690, f. 110]. Version D. For a discussion of the four versions of this letter see MS R (Provenance and History) and GAIFFIER, 1971.

f. 159v **Chapter 3.**

Rubric: *Calixtus papa de tribus sollempnitatibus sancti Iacobi.* Text inc. *Beatus Luchas euangelista…* expl. (f. 161v) *tegebantur et decorabantur.* (W 299) [Hand 1B resumes on f. 161 shortly before the middle of Ch. 3 (W 297) and writes the passage discussing the dates of the Feasts of St James, continuing with the Santiago procession.]

Quire 21^8 (162-169 [*olim* 7]; first two and last two leaves are not bifolia). Hand 1B: first two leaves (ff. 162-163 [*olim* 1]) and 2 inner bifolia (ff. 164-167 [*olim* 2-5]). Hand 2: last two leaves (ff. 168-169 [*olim* 6-7]).

f. 162 **Chapter 4.**

Rubric: *De tubis sancti Iacobi.* Text inc. *Traditur quod ubicumque melodia tube marium…* expl. *prosternuntur aerie potestates.* (W 299)

Explicit for Book III: *FINIT LIBER TERCIUS.* (W 299)

Miniature: Dream of Charlemagne. St James points out to Charlemagne the Milky Way [which he is to follow to Santiago to free St James's shrine from Saracen domination]

f. 162v Miniature in 2 registers: Charlemagne and his army setting out from Aachen on horseback; warriors standing outside Aachen, holding swords and lances, cogitating and pointing; below, the original inscription has been painted out (cf. VA, where the inscription is preserved).

f. 163 **Book IV: Pseudo-Turpin**

[editions: MEREDITH-JONES, 1936/1972, edited from C and Paris, BN, lat. 13774; cf. CIAMPI, 1822, based on Turin, BN, I.V.36; CASTETS, 1880, based on six Montpellier manuscripts; THORON, 1934, edited from VA; SMYSER, 1936/1970, based on Paris, BN, lat. 17656.]

Opening heading: *Historia Turpini* (added in the 17th century). Rubric: inc. *Turpinus domini gratia archiepiscopus remensis…* expl. *salutem in Christo.* (W 301)

f. 163v ***Prologue, Epistle of Turpin to Leoprand, dean of Aachen:*** text inc. *Quoniam nuper mandastis…* expl. *ab ea discordasse. Uiuas et ualeas et domino placeas. Amen.* (W 301)

Chapter list of 26 chapters, inc. *Capitulum i. De hoc quod apostolus Karolo appariut…* Ch. 26 (f. 164) expl. *Capitulum xxvi. De itinere Yspanie.* (W 301-302)

f. 164 *Chapter 1.* St James appears to Charlemagne.
Rubric: *Incipit liber.* [no chapter number] Text inc. *Gloriosissimus namque Christi apostolus Iacobus…* (W 302) expl. (f. 165) *ad expugnandas gentes perfidas Yspaniam ingressus est.* (W 303)

f. 165 *Chapter 2.* The taking of Pampluna.
Rubric: *Capitulum II.* Text inc. *Prima urbs…* expl. (f. 165) *a mare usque ad mare.* (W 304)

f. 165v *Chapter 3.* The cities and towns conquered in Spain
Rubric: *Capitulum III.* Text inc. *Urbes et maiores uille…* expl. (f. 166) *Ventosa, Capparria, Adania.* (W 305)

f. 166 *Chapter 4.* The Idol of Mohammed at Cadiz.
[no chapter number] Text inc. *Ydola et simulacra…* expl. (f. 166v) *repositis omnes fugient.* (W 306)

f. 166v *Chapter 5.* The Churches built by Charlemagne with Spanish gold.
Rubric: *Capitulum V.* Text inc. *Ex auro quem Karolo…* expl. (f. 166v) *per mundum fecit.* (W 306)

Chapter 6. Aigoland's conquest of Spain.
Rubric: *Capitulum VI.* Text inc. *Demum reuerso Karolo ad Galliam…* expl. (f. 166v) *Et erat cum eo dux Milo de Angleris.* (W 307)

f. 167 *Chapter 7.* Offerings for the dead.
Rubric: *Capitulum VII.* Text inc. *Set quale exemplum…* expl. (f. 167v) *se dampnandos in euum.* (W 307)

f. 167v *Chapter 8.* Battle against Aigoland at Sahagún; miracle of flowering lances.
Rubric: *Capitulum VIII.* Text inc. *Postea uero ceperunt querere Aigolandum…* expl. (f. 168) *mereamur in celesti regno.* (W 309)
[Hand 2 starts in the middle of Ch. 8 (f. 168) in the description of the flowering lances at Sahagún (W 308).]

f. 168 *Chapter 9.* Aigoland captures Agen; Charlemagne lays siege to it.
Rubric: *Capitulum IX.* Text inc. *Inde Aigolandus adunauit…* expl. (f. 169) *Decem tamen milia Sarracenorum gladio perempti sunt.* (W 310)

f. 169 *Chapter 10.* Aigoland captures Saintes; Charlemagne lays siege to it; miracles of flowering lances.
Rubric: *Capitulum X.* Text inc. *Inde Aigolandus uenit Sanctonas…* expl. (f. 169v) *circiter quatuor milia.* (W 311)

f. 169v *Chapter 11.* Aigoland goes to Pampluna; Charlemagne recruits soldiers in France.
Rubric: *Capitulum XI.* Text inc. *Tunc Aigolandus transmeauit portus Cisereos…* expl. (f. 170) *Desiderabat enim uidere Karolum Aigolandus.* (W 313)

Quire 22[8] (170-177 [*olim* 8-15]). Hand 2: two outer bifolia (ff. 170-171 [*olim* 8-9], 176-177 [*olim* 14-15]). Hand 1B: two inner bifolia (ff. 172-173 [*olim* 10-11], 174-175 [*olim* 12-13]).

f. 170 *Chapter 12.* Disputatio between Charlemagne and Aigoland.
Rubric: *Capitulum XII.* Text inc. *Itaque datis inter se trebis…* expl. (f. 171v) *Quod alii concesserunt, alii renuerunt.* (W 315)

f. 171v *Chapter 13.* Aigoland refuses baptism because of the poor.

Rubric: *Capitulum XIII.* Text inc. *Crastina uero die...* expl. (f. 172v) *quia babtismi opera non inuenit.* (W 316)

[Hand 1B resumes (f. 172) just after the beginning of Ch. 13, about Aigoland and Charlemagne (W 315), continuing to half-way through Ch. 17 (f. 175, W 320), Roland's dialogue with Ferragut.]

f. 172v **Chapter 14.** Defeat and death of Aigoland.
Rubric: *Capitulum XIV.* Text inc. *Inde crastina die...* expl. (f. 173) *et ibi hospitatus est.* (W 317)

f. 173 **Chapter 15.** Christians seize booty.
Rubric: *Capitulum XV.* Text inc. *Tunc quidam Christiani...* expl. (f. 173) *et mortem perpetuam amplectuntur.* (W 318)

Chapter 16. Charlemagne defeats the Navarrese prince Furris.
Rubric: *Capitulum XVI.* Text inc. *Altera uero die...* expl. (f. 173v) *in suam totamque patriam Nauarrorum.* (W 318)

f. 173v **Chapter 17.** Disputatio and duel between Roland and the giant Ferragut.
Rubric: *Capitulum XVII.* Text inc. *Statim nunciatum est Karolo...* expl. (f. 176v) *et pugnatores a carcere eripiuntur.* (W 323)
[Hand 2 resumes f. 175, continuing through Ch. 21, around an insertion by Hand 4]

f. 176v **Chapter 18.** The battle of the masks.
Rubric: *Capitulum XVIII.* Text inc. *Post exiguum uero tempus...* expl. (f. 177v) *in Hyspania Karolum expugnare.* (W 325)

f. 177v **Chapter 19.** Charlemagne's council at Santiago.
Rubric: *Capitulum XIX.* Text inc. *Tunc dimissis marioribus exercitibus suis...* expl. (f. 178v) *in hodiernum diem in fide ortodoxa.* (W 326)

Quire 23^8 (178-185 [*olim* 16-23]). Hand 2: three outer bifolia (ff. 178-180 [*olim* 16-18], 183-184 [*olim* 21-23]). Hand 4: inner bifolium (ff. 181-182 [*olim* 19-20]).

f. 178v **Chapter 20.** Portrait of Charlemagne.
Rubric: *Capitulum XX.* Text inc. *Et erat rex Carolus capillis brunus...* expl. (f. 179) *nobis breuiter est dicendum.* (W 328)

f. 179 **Chapter 21.** The Battle of Roncesvalles and Roland's death.
Rubric: *Capitulum XXI.* Text inc. *Postquam Karolus magnus imperator famossissimus...* expl. (f. 185v) *Karolus apud Arelatem egenis dedit.* (W 338)
[Hand 4 copies the central section of Ch. 21 that includes Roland's agony, his speech to his sword, his breaking the rock with it, ending shortly before the conclusion of Roland's prayer (W 330-333); Hand 2 finishes Ch. 21, ending in Ch. 22, in the middle of the passage about the contributions to the building fund of St-Denis (W 339)]

f. 185v **Chapter 22.** Contributions to the building fund of St-Denis; the Liberal Arts; the death of Charlemagne.
Rubric: *Capitulum XXII.* Text inc. *Post hec Uiennam...* expl. (f. 188v) *edificat basilicas collocatur.* (W 343)

Quire 23a^2 (186-187 [*olim* 24-25]). Hand 3.

[Hand 3 copies a bifolium about the remission of sins for the contributors to St-Denis' building fund, the derivation of 'French' from 'franci' and the meaning of 'freemen of St-Denis', the Liberal Arts decorations at Charlemagne's palace at Aachen, ending in the middle of Turpin's vision of the death of Charlemagne (W 341)]

Quire 24^8 (188-195v [*olim* 26-29, 163-166]). Hand 1B.

> [Hand 1B copies to the end of Book IV, continuing through the first seven and a half chapters of Book V, ending just after the mention of the Crux Caroli in the Pyrenees (W 357)]

f. 188v *Chapter 23.* Roland's miracle at Gratianopolis.
Rubric: *Capitulum XXIII.* Text inc. *Set ualde dignum est...* expl. (f. 189) *Ut pietate Dei subueniatur ei. Amen.* (W 344)

f. 189 *Chapter 24.* The death of Turpin and the invention of his body.
Rubric: *Capitulum XXIV. Calixtus papa de inuencione corporis beati Turpini episcopi et martiris.* Text inc. *Beatus namque Turpinus...* expl. (f. 190) *superius legendo fas est inueniri.* (W 345)

f. 190 *Chapter 25.* The Altumaior of Cordoba.
Rubric: *Capitulum XXV. Calixtus papa.* Text inc. *Quid patrie Gallecie...* expl. (f. 190v) *celesti munere remunerabuntur.* (W 347)

f. 190v *Chapter 26.* Calixtus's bull on the Spanish Crusade.
Rubric: *Capitulum XXVI. Incipit epistola beati Calixti pape de itinere Yspanie omnibus ubique pro parlanda.* Text inc. *Calixtus episcopus...Crebro dilectissimi...* expl. (f. 191v) *legatur et exponatur...* + dox. (W 348)

f. 191v Explicit for Book IV: *FINIT CODEX* (added in the 17th century: W 348)

f. 192 **Book V: Pilgrim's Guide**
Long Version: for contents see Table of Book V above (W 349-389). Latin references given here are to notes in our Latin text. For editions see the Bibliography.
Opening heading: *Incipit liber V* (altered in the 17th century to *IIII*, changed back to *V* in 1966) *sancti Iacobi apostoli.*
Prologue. Rubric: *Argumentum beati Calixti pape.* Text inc. *Si veritas a perito lectore...* expl. *uera esse testantur.* (W 349)
Chapter list of 11 chapters, inc. *Capitulum i. De uiis sancti Iacobi...* expl. (Ch. 11) *digne recipiendis.*
Chapter 1 [no chapter heading] Text inc. *Quatuor uie sunt...* (W 349)

Quire 25^8 (196-203 [*olim* 167-174]). Hand 2: outer bifolium (ff. 196 [*olim* 167] and 203 [*olim* 174]). Hand 1B: three inner bifolia (ff. 197 [168]-202 [*olim* 173]).

> [Hand 2 starts in Ch. 7 just after Crux Caroli (Latin notes VII-216-17; W 357) and includes the mention of the hospital at Roncesvalles, the battle of Roncesvalles with the 140,000 warriors slain, the descriptions of the Basques and Navarrese, ending before the Julius Caesar passage (Latin notes VII-405-406; W 359).
> Hand 1B copies from just before the beginning of the Julius Caesar passage to the end of Ch. 7, continues with the description of sites on the first three French routes in Ch. 8, ending on the fourth route, just before Hilary's exile to Phrygia (Latin notes VII-737-38; W 369).
> Hand 2 resumes and continues through the Life of St Eutropius into the next quire.]

Quire 26^8 (204-211 [*olim* 175-182]). Hand 2: outer bifolium (ff. 204 [*olim* 175] and 211 [*olim* 182]). Hand 1B: three inner bifolia (ff. 205 [*olim* 176]-210 [*olim* 181]).

> [Hand 2 ends in the Life of St Eutropius, just before Simon and Thaddeus are sent to Persia (Latin note VIII-969-970; W 372).
> Hand 1B copies the last part of the Life of St Eutropius, the rest of Chapter 8 and most of Chapter 9, ending in the description of the altars of the basilica, just before the comment about the immoveability of the relics of St James (Latin notes 459-460; W 383).

Hand 2 copies that comment, continuing with the descriptions of the altar-cloth, altar-frontal and ciborium, stopping just before the end of the description of the ciborium (Latin note IX-605-606; W 385).]

Quire 27^8 (212-219 [*olim* 183-190]). Hand 1B: first two leaves of the first two bifolia, ff. 212-213 (*olim* 183-184). Hand 1C: rest of the quire: ff. 214-219 (*olim* 185-190).

[Hand 1B finishes Chapter 9 and copies Chapters 10 and 11 of the Guide (W 389).]

f. 213v *Book V (Ch. 11)* text expl. *diligenter procurandi* (W 389).
Explicit for Book V: *Explicit Codex Quartus* (altered in the 17th century from *Quintus*)...*legenti.* (W 389)
Colophon: inc. *Hunc codicem...* expl. *apud Cluniacum* (W 389)

f. 214 **Songs** (W 391-398)
[editions and transcripts in DRÈVES, 1894; LÓPEZ FERREIRO, 1898-1904, 1909; WAGNER, 1931 (complete); ANGLÉS, 1931; REESE, 1940; PRADO in WHITEHILL, 1944, III (complete); PARRISH, 1957; REANEY, 1966; BESSELER/GÜLKE, 1973; HOPPIN, 1987a; LÓPEZ CALO, 1982; KARP, 1992 (complete); WERF (forthcoming).]
Rubric: *Ato episcopus Trecensis.* Text inc. *Nostra phalans...* expl. *Dulces laudes domino. Angelorum* (W 391)
Rubric: *Magister Albertus Parisiensis.* Text inc. *Congaudeant catholici...* expl. *Soluamus laudis gracias. Die ista. Deo dicamus gracias.* (W 392)

f. 214v Rubric: *Magister Goslenus episcopus Suessonis.* Text inc. *Gratulantes celebremus...* expl. *Benedicat ergo plebs fidelis Domino.* (W 392)
Rubric: *Magister Albericus archiepiscopus Bituricensis.* Text inc. *Ad superni regis decus...* expl. *Ut mens nostra regi regum benedicat domino.* (W 392-393)

f. 215v Rubric: *Magister Airardus Uiziliacensis.* Text inc. *Annua gaudia...* expl. *Sunt adamanda organa.* (W 390-391)
Rubric: *Antiquus episcopus Beneuentinus.* Text inc. *Iacobe sancte tuum repetitio...* expl. *scandere celum. Fac precludes.* (W 391)

f. 216 Rubric: *Magister Gauterius de Castello Rainardi decantum fecit.* Text inc. *Regi perhennis glorie...* expl. *Quia sedes ethereas ascendit. Deo gratias.* (W 395)

f. 216v Rubric: *Magister Iohannes Legalis.* Text inc. *Uox nostra resonet...* expl. *Laudes in cantico dicamus domino.* (W 395)
Rubric: *Magister Ato episcopus Trecensis.* Text inc. *R. Dum esset. V. Sicut enim uox tonitrui...* expl. *predicacionem beati Iacobi* + dox. (W 395)

f. 217 Rubric: *Idem Ato.* Text inc. *R. Huic Iacobo. V. Tristis est anima mea usque ad mortem* + dox. (W 396)
Rubric: *Idem Ato.* Text inc. *R. Iacobe uirginei. V. Te prece continua pro nobis omnibus hora* + dox. (W 396)

f. 217v Rubric: *Idem Ato.* Text inc. *R. O adiutor. V. Qui subueneris periclitantibus...* expl. *in periculo mortis* + dox. (W 396)
217vRubric: *Idem Ato Prosa.* Text inc. *Portum in ultimo...* expl. *paradisi uoto ortum.* (W 396)

f. 218 Rubric: *Fulbertus episcopus Karnotensis.* Text inc. *Rex immense pater pie...* expl. *qui Iacobum illustrasti, eleyson, cuius prece nobis parce, eleyson.* (W 396-397)
Rubric: *Ato prefatus.* Text inc. *R. Misit Herodes.* [cf. f. 119] *V. Occidit autem Iacobum fratrem Iohannis.* (W 397)

f. 218v Rubric: *Magister Goslenus episcopus Suessonis.* Text inc. *Alleluia. Uocauit Ihesus Iacobum Zebedei et Iohannem fratrem eius et imposuit eis nomina Boanerges.* (W 397)

f. 219 Rubric: *Gauterius prefatus.* Text inc. *Cunctipotens genitor Deus...* expl. *nexus amorque eleyson.* (W 397)
Rubric: *Gauterius prefatus.* Text inc. *Benedicamus domino.* (W 397)
Rubric: *Magister Droardus Trecensis.* Text inc. *Benedicamus domino.* (W 397)

f. 219v Rubric: *Idem Droardus.* Text inc. *Benedicamus domino.* (W 398)
Monophonic song
Rubric: *Aymericus Picaudi presbiter de Partiniaco.* Text inc. *Ad honorem regis summi...* expl. *predicare studuit.* (W 398)
[f. 220 lacuna with the rest of Aymeri's song, *Ermogeni et Fileto... decantemus iugiter,* transcribed by Whitehill (W 398-399) from MS A. See also MSS VA, M, L below [lacuna also presumably included beginning of Mass for the Living and the Dead that ends on f. 221, see HOHLER, 1972, p. 72 and MS A below].

Quire 28^2 (221-222 [*olim* 192-193]).

f. 221 by a 12th-century hand that appears nowhere else in C

f. 222 by another 12th-century hand that appears nowhere else in C

f. 222v from *Hinc decus* (W 404) by still another hand

f. 221 **Postcommunion from a Mass for the Living and the Dead.**
Text: *Iacobum et Iohannem inuitatuit fac nos, quesumus sedere ad dexteram partem regni tui, quos eiusdem calicis participes fieri uoluisti, per eundem.* (W 399)
Bull of Innocent II
[for full transcription and collation with MSS A, VA, T, R, VB, Z, see also Latin Appendix, Vol. II].
Rubric: *Epistola domini pape Innocentii.* Text inc. *Innocentius episcopis...Hunc codicem a domno papa Calixto primitus editum quem Pictauensis Aymericus Picaudus de Partiniaco ueteri qui etiam Oliuerus de Iscani uilla sancte Marie Magdalene de Uiziliaco dicitur et Girberga Flandrensis sotia eius pro anumarum suarum redemptione sancto Iacobo Gallecianensi dederunt...* expl. *uel fraudauerint. Ualete. Signatories inc. Ego Aimericus cancellarius hunc librum autenticum...* expl. (f. 221) *fore predicto.* (W 399-400)

f. 221v **Miracle of 1139**
Rubric: *Miraculum sancti Iacobi a domno Alberico Uizeliacensi abbate atque episcopo Hostiense et Rome legato editum.* Text inc. *Anno dominice incarnacionis MCXXXIX Ludouico rege Francorum regnante, Innocentio papa presidente, uir quidam nomine Brunus de Uiziliaco...* expl. *panem integrum sacculo inueniebat. O admirabile...* + dox. (W 400-401)
Alleluia in Greek
Rubric: *Alleluia in Greco.* Text inc. *Alleluia. Uocauit Ihesus. Efonisen o Yssus...* expl. *o yos tis urontis. Chorus. Quod est filii. Cantor. Alleliua.* (W 401)

f. 222 **Monophonic song**
Text inc. *Dum pater familias...* expl. *Sacer est martirio.* (W 401-402)
[compared by HUGLO, 1984, p. 170, with music from Conques in Paris, BN, lat. 1240, ff. 183-189, and Sélestat, BM, 22]
Hymn, *Signa sunt nobis*, with explanatory comments on the metre and the tune
Text inc. *Intitulatur hec oda...* expl. *spondeo discurrit. Ymnus. Cantus sicut Iste confessor uel Ut queant laxis resonare fibris.* (W 402-403)

Text inc. *Signa sunt nobis sacra…* expl. (f. 222v) *Quo uiatores fragilis diete Iustificentur* + dox. expl. *Trina sit trino simul una unius. Gloria perpes. Amen.* (W 403-404)

Singletons 223, 224, 225 (olim 194, 195, 196); three singletons copied by various hands of the second half of the 12th century, not found elsewhere in C.

f. 223 **Miracle of 1164, in verse**
Rubric: *Miraculum sancti Iacobi de puero suscitato. Anno incarnationis dominice MᵒCᵒLXIIIIᵒ. Indictione XIIᵃ. Epacta XXᵃVᵃ.*
Text inc. *Est Deus in sanctis mirabilis egregiusque…* expl. *Et sudariolum detulit indicium* + dox. (W 404-405)
Miracle of St James, in verse
Rubric: *Aliud miraculum. Miraculum sancti Iacobi de facie torta filii uicecomitis notum in terra pictauorum.*
Text inc. *Est de iusticia doloromnis et ultio digna…* expl. *Deficit unda malus proficit inde bonus.* + dox. (W 405-406)
Cantat ypostas eorum propria terna trium. (W 405-406)

f. 223v **Miracle of 1190, in verse**
Rubric: *Miraculum sancti Iacobi de liberatione christianorum et fuga sarracenorum a portugalia. Hic legendus in festo miraculorum sancti Iacobi V nonas octobris.*
Text inc. *Lectio I. inc. Ecce Dei redeunt magnalia cum Machabeis…* expl. *Hyspalis ad Palmam est regis itura manus. Lectio II. inc. Ingestis legitur rex Almansor periisse…* expl. *Tu magni laudes ne taceas Iacobi. Lectio III. inc. Cum templum domini premerent. Iherosolimis hostes…* expl. *Hec uite est nouitas et nouitatis amor* + dox. *Anno incarnationis dominici MᵒCᵒXXCᵒ, sub era MCCXXVIII.* (W 406-407)

f. 224 **Prayer in verse**
Rubric: *Oratio magistri G.*
Text inc. *Adonay rex regum domine…* expl. *Ut uestiti salutis pallio salui simus cum Dei Filio* + dox. expl. *Trium splendor, trina identitas. Explicit.* (W 408-409)
Six Lessons, in verse
Rubric: *Lectiones secundum Leonem papam et magistrum Panicham.*
Text inc. *Lectio I. Ut radius solis iusticie…* expl. *Nauem intrant, corpus custodiunt. Lectio II. inc. Nauis sancte subiecta sarcine…* expl. *ubi nunc est ecclesia. Lectio III. inc. Bis riuata uocatur Hyria…* expl. *Corpus condunt piis affectibus. Lectio IV. inc. Arcis marmoreis sepulto corpore…* expl. *Ex tunc sacer nunc usque dicitur. Lectio V. inc. Et qui prius dictus Illicinus…* expl. *Sua sponte ad iuga properant. Lectio VI. inc. Post hec Dei iusta permissio…* expl. *Peccatorum datur hic uenia* + dox. (W 409-411)

f. 224v **Miracle of St James, in verse**
Text inc. *Que tua iusticia est terras celosque reformat…* expl. *Quo maculis carta munda est missa celebrata.* (W 411-413)
Miracle of St James, in verse, with explanatory postscript
Rubric: *Miraculum sancti Iacobi de contracto erecto in eius translationis festo.*
Text inc. *Cras hodie Christus legitur donare salutes…* expl. *Cui reflorenti spiritus almus adest.*
Postscript: *Factum Compostelle…* + dox. (W 413)

f. 225 **Miracle of St James, in verse**
Text inc. *Spiritus radiat tota gratia semper…* expl. *Hoc sudariolum testis et ipse Deus* + dox. (W 413-414)
Miracle of St James, in verse, ending with a prayer
Rubric: *Uisio ciusdam Fucconis peregrini sancti Iacobi duodecies et tredecies gratia.*

Text inc. *De monasteriolo dictus Fucco mare supra…* expl. *Felicior sompnus qui uidet ut uigilat.* (W 414-415)

f. 225v **Hymn (cf. f. 222)**
Text inc. *Signa sunt nobis sacra que leguntur…* expl. *Quo uiatores fragilis diete reficantur* + dox. (W 415-416)

Sigla:

Hämel: C

Meredith-Jones: B1

Mandach: B1

Díaz y Díaz: C

Select Bibliography:

Anglés, 1931, I, pp. 59-71 (p. 65, *Congaudeant*, f. 214 [*olim* 185]); III, pp. 1-6 (*Cuncti-potens genitor*, f. 219 [*olim* 190]); id., 1935, pp. 156-158; id., 1961; Appel, 1949, 1953, pp. 212-214; *L'Art Roman* (Exh. Cat.), 1961, nos. 1768-69, pp. 532-533; Avril, 1983, p. 259; Barreiro Somoza, 1987, pp. 27-28, 241; Barwick, 1904; Bédier, 1908-12; 3rd edn, 1926-29, III, pp. 41-115, 180-182, 293-360; Beer, V, 1910, pp. 332-336; Besseler/Gülke, 1973, pp. 34-35 (with substantial bibliography on the music); Birkner, 1962; Bravo Lozano, 1989; Burin, 1985, pp. 217, 220; Cahn, 1996, no. 24; Carro García, 1944; Caucci von Sauken, 1989; Christofides, 1979; Ciaconius, 1677; Conant, 1926, 1983; Cook, 1923, pp. 31-60, 85-101, fig. 37; David, 1945, 1947, 1948, 1949; Delisle, 1878; Díaz y Díaz, 1965, 1966, 1970, 1985a, 1985b, 1987, 1988a, 1988b; Díaz y Díaz et al., 1985; Domínguez Bordona, 1929, pp. 51, 53, 56, fig. 45; id., 1933, no. 226, pp. 120-121; Drèves, 1894, pp. 191-218; *Las Edades del Hombre* (Exh. Cat.), 1990, no. 76; Fassler, 1993, pp. 360, 382 (two other manuscripts containing *Gratulemur et letemur*) and p. 377 (another manuscript containing *Misit Herodes*); Fernández de la Cuesta, 1980, pp. 107-108, and 1993; Fita/Vinson, 1882, pp. 1-20, 225-270; Gaiffier, 1951a, 1956, 1971; Gastoue, 1931; Graf, 1991, pp. 60-61; Grove, I, pp. 207, 669; VII, p. 25; Hämel, 1933, 1936, 1950, 1953; Helmer, 1988; Herbers, 1984, 1986; Herwaarden, 1985; Hohler, 1972; Hoppin, 1978a, no. 31 (*Huic Jacobo*, f. 217 [*olim* 188]); no. 32 (*Nostra phalans*, f. 214 [*olim* 185]); id., 1978b, pp. 207-214; Horrent, 1975; Hughes, 1954; Huglo, 1967; id., 1992 and figs. 2-4; Hurst, 1955; Karp, 1967; Karp, 1992 (*In hac die*, ff. 130v-131, II, pp. 232-233); Keller, 1990; Krüger, 1964; Labande, 1976; Lambert, 1931; Layton, 1976; Le Clerc, 1847; Lejeune/Stiennon, 1966, I, pp. 51-60, figs. 30-33, pl. I; López Calo, 1963; id., 1982, pp. 158-160 (*Misit Herodes*, f. 218 [*olim* 189]); pp. 160-162 (*Alleluia*, ff. 119v and 218v [*olim* 189v]); id., 1988; López Ferreiro, 1898/1983, I, pp. 208-212, 392-405, 412-432, 434-451; II, pp. 45, 51; III, pp. 36, 48, 203, 278, App. 8-24; IV, 7, 24, 56, 66, 75, 78, 108, 122, 142, 160, 175, 189, 199, 216, 222, 242, 246, 247, 262, 282, 311, 331; V, pp. 96, 98, 101; López Mendizabal, 1965; López Pereira, 1994, pp. 4-20, 150-200; Louis, 1952; Mandach, 1961, p. 395; id., 1969; Meredith-Jones, 1936 (reprinted 1972), pp. 9, 42-46; Moisan, 1985, 1992; Moralejo Álvarez, 1980, 1983, 1985a, 1985f, 1987, 1991; Moralejo Laso, 1949, 1950. 1951; Moralejo et al., 1951; Osthoff, 1967; Ottosen, 1993, pp. 214, 250 (*Ad consultum veritatis*, f. 41) Parrish, 1957, pp. 68-72, pl. XXIII (*Congaudeant*, f. 214 [*olim* 185]); Pétouraud, 1949; Pfandl, 1914; Planchart, 1976, pp. 28-29; Porter, 1923, I, pp. 172-174; PL, vols. 92, 94, 163; Prado, 1944, III, pp. XLVII-LXV; Reaney, 1966, B IV 1, pp. 238-241 (substantial bibliography on the music); Reese, 1940, p. 268 (*Congaudeant*); *Los Reyes y Santiago* (Exh. Cat.), 1988, no. 2, pp. 102-104; Richard, 1953, pp. 182-185; Robert, 1890; Romero de Lecea et al., 1971; *Santiago de Compostela* (Exh. Cat.), 1985, no. 39; *Santiago Camino de Europa* (Exh. Cat.), 1993, no. 102 (cited as MS 1 in the Archivo de la Catedral; but Tumbo A, cat. no. 1, is also cited as MS 1); Schubert, 1964; Sholod, 1966, pp. 110-128; Short, 1969, 1970, 1972; Sicart, 1981, pp. 64-87, pls. VIII-X; id., 1982; Southern, 1958, pp. 189-190 (Miracles 16, 17, 18); Stones, 1981 and pls. 14.3, 14.6, 14.7, 14.11, 14.12, 14.15, 14.21, 14.23, 14.25, 14.27, 14.29, 14.31, 14.33, 14.35, 14.36; ead., 1991; ead., 1992 and figs. 1, 2, 17, 18, 21, 22, 25, 27, 28, 30, 31, 35, 36, 41, 44, 46, 48, 50, 53-70; Stones, 1996, figs. 5, 7, 11, 15, 18; Stones/Krochalis, 1995, pp. 11-17, figs. 1, 3, 4, 5; Tillmann, 1972; Vázquez de Parga, 1947a; Vega Inclán, 1927; Vielliard, 1938; 4th edn, 1981; Werf,

1990; id., 1992, figs. 1-6; Wagner, 1931, pp. 19-126; Whitehill, 1944 I (complete transcription of C: here cited as 'W'); Williams/Stones, 1992; Wright, 1989, pp. 278-281; Yarza Luaces, 1985, p. 382; *Codex Calixtinus* (facsimile), 1993.

Recordings: CD 84-85 728-15-7 Carlos Villanueva and Grupo Universitario de Cámera, La Musica medieval en Galicia, containing *Gratulantes*, f. 214v; *Deum pater familias*, f. 222; *Congaudeant*, f. 214; *Ad honorem*, f. 219v; *Jacobe sancte*, f. 215; *Rex inmense*, f. 218. Double CD by the Ensemble Venance Fortunat, director Anne-Marie Deschamps, Harmonia Mundi ED 13023, 1993, containing all the songs that follow the *Guide*; CD by Anonymous Four, Harmonia Mundi 907156, 1996, containing 21 selections from Book I and from the songs following the *Guide* (sung in a sequence that is not that of C): 1. Inv. *Venite omnes cristicole* (f. 105v); 2. Processional *Salve festa dies* (f. 116v); 3. Benedicamus trope *Vox nostra resonet* (f. 216v); 4. Inv. *Regem regum dominum* (f. 101v); 5. Benedicamus trope *Nostra phalanx* (f. 214); 6. Ant. *Ad sepulcrum beati Iacobi* (f. 103v); 7. Benedicamus trope *Ad superni regis decus* (f. 214v); 8. Resp. *Iacobe servorum* (f. 112); 9. *Benedicamus* (f. 219); 10. Conductus *In hac die laudes* (f. 131); 11. Kyrie trope *Cunctipotens genitor* (from Paris, BN, lat. 1112, cf. C f. 219); 12. Hymn *Psallat chorus celestium* (f. 101v); 13. Prosa *Alleluia, Gratulemur et letemur* (f. 119v); 14. Off. *Ascendens Ihesus in montem* (f. 121v); 15. Agnus dei trope *Qui pius ac mitis* (f. 134v); 16. Benedicamus trope *Gratulantes celebremus festum* (f. 214v); 17. Conductus *Iacobe sancte tuum* (f. 215v); 18. Resp. *O adiutor omnium seculorum* (ff. 111, 217v); 19. Prosa *Portum in ultimo* (f. 217v); 20. Benedicamus trope *Congaudeant catholici* (f. 214); 21. Prosa *Clemens servulorum* (f. 123).

R. Barcelona, Arxiu de la Corona de Aragó, Ripoll 99 *Short Version*

Short Version of the *Codex Calixtinus*, with a short passage from Pseudo-Augustine interpolated, and a letter from Arnault de Munt to the Abbot of Ripoll
Copied, according to the colophon, in 1173 by Arnault de Munt, OSB, monk of Ripoll, in Santiago

Parchment, 85 folios, numbered 1-54; 56-86. 286×185 mm; written space 212×129 mm to inner ruling. Text in one column, 26 lines. Prickings visible in outer margins, ff. 9-16. Written above top line in black ink; frame and line ruling, with double vertical frame on inner margin, but not on outer, in faint leadpoint. (*Ills. 37–41*)

Quires:	$1\text{-}3^8$ (ff. 1-24v; ff. 16v-17 lettered c and d; quires numbered vii-viiii; Book I); 4^{10} (ff. 25-34v, quire unnumbered; begins Book IV and includes the interpolated Augustine on f. 33); $5\text{-}9^8$ (ff. 35-75, quires numbered i - v; f. 55 was omitted from the numbering, so quire 7 goes from 51-59; Books II-III; part of Book IV); 10^{10} (ff. 76-85, quire unnumbered; Books IV-V); f. 86 is a singleton (containing the end of the letter of Arnault to his abbot). As the quire numbering system indicates, the volume was planned with Book II, the Miracles, at the beginning, as in VB; but the present arrangement is not a later mis-binding, as the rubric at the beginning of Book II on f. 35 is both the explicit of Book I and the opening heading for Book II and is in the original hand. So a change of plan must have occurred in the course of production. Traces of cut-off catchwords.
Script:	Copied, according to the colophon (transcribed below), by the scribe Arnaldus de Monte (OSB), monk of Ripoll. The writing becomes smaller, more cramped on f. 33v; possibly this is the work of a second hand. Arnault's script is written in a clear, well spaced, rounded textura. Ascenders and descenders are equal in height to the body of the letter-forms, or sometimes a little taller. Descenders curve slightly to the left; ascenders are wedge-shaped. Both 'f' and long 's' descend slightly below the line; 'f' extends above the line to the same height as 'b' or 'd'; 's' does not. Both round and upright 'd', occur; there are some bitings, with 'p' and 'b', but not with 'd'. Characteristic letter forms include headed 'a' and two-compartment 'g'. Round 's' is used as initial capital throughout, and sometimes finally. Tironian nota for *et* has a long flat top and a hair-line finial slanting upward to the right, written with no space between the nota and the following word. The common mark of abbreviation usually curves upwards to the right, and is sometimes flat.
Rubrics:	In red, in the hands of the scribes.
Musical Notation:	Aquitainian notation (ff. 31v-33), close to the style of St Martial, Limoges (KARP, 1992; HUGLO, 1992) on a staff ruled in drypoint in Book I (LÓPEZ CALO, 1963, pp. 117-119 and 187-189); text beneath the notation is spaced syllabically, with syllables joined by a red line. WHITEHILL, II, 1944, p. xxv, refers to ANGLÉS, 1931 (then still in press), who mistakenly describes the notation as *campo aperto*; his description is repeated by HÄMEL, 1950, p. 27. Arnault does not include the Liberal Arts section of *Pseudo-Turpin* which describes music written on a four-line staff (DAVID, 1946, p. 29).
Decoration:	Initials in red and blue, flourished in the opposite colour, by two hands. The work of the main decorator is close to that of the decorator who worked with Scribe 2 in C, and to the decorator of parts of the Cartulary of Santiago, Tumbo A. The second was responsible only for a few initials, on ff. 84 and 85; were they perhaps added at Ripoll?
Illustration:	None.
Binding:	Modern white parchment on boards.

Provenance and History: Written, according to the colophon, in 1173 at Santiago for Ripoll by Arnault de Munt. Old Ripoll shelf-marks: f. 1, bottom of page, in an 18th-century hand: Estante 2º, Cason 2º nº moderno 10; nº antiguo 87. The Ripoll MSS came to Barcelona in 1835-36 (MARTÍNEZ FERNANDO, 1944, p. 66).

DÍAZ Y DÍAZ, 1988a, pp. 134-135, expresses caution about whether R is actually Arnault's copy; previous scholars have assumed that it was. R stands out among the few extant 12th-century manuscripts of Ripoll for its larger size and for the monumentality and elegance of its script. The other Ripoll books of this period (Barcelona, ACA 117 and 124, two volumes of a devotional miscellany; 130 Sermons; 170 Sermons, 181 Medical miscellany, 206 Sermons, 217 Miscellany of Isidore and Ildefonsus) are 30 mm or more smaller and contain more lines of script per page. The hands of Arnault (if it is his) and of his collaborator do not reappear, and neither of the pen-flourishing styles of R can be matched exactly. MS 181 has very distinctive and elegant pen-flourishing in red and blue, considerably more elaborate than what is in R, and probably later than R; however, the small initial on f. 140 in the Bartolomeu de Salerno section is comparable with the less good initials in R. MS 217 has a small red pen-flourished initial on f. 129 in the Ildefonsus section that is also rather reminiscent of R's less good initials; but neither is close enough to claim the hand is the same. See our discussion of the relationship between VB and R in the Collation essay for a possible hint that two copies might have been made c. 1173.

Secundo folio: *insinuandum*; original quire sequence would give a secundo folio of *sub veritatis*.

Contents:

f. 1 **Excerpts from CC Book I: Liturgy of St James**
[Title omitted]
Opening heading and Prologue as in C (W 1) Rubric: *Incipit epistola beati calixti pape.* Text: *Calixtus episcopus servus servorum… Quoniam in cunctis…* expl. (f. 2v) *data laterani. idus iani.* (W 4)
[Chapter list of 31 chapters omitted (W 4-6)]
[Chapter 1 omitted (W 6-11)]
Chapter 2. Pericope and Sermon of Calixtus for the Vigil of the Feast of St James, 24 July.
Rubric (shorter than C, W 11): *Vigilia sancti iacobi zebedei apostoli. Lectio sancti evangelii secundum marchum.* Pericope and Sermon text as in C, inc. *Uigilie noctis…* ending incomplete (f. 7v) *prima corona datur* (W 20, line 12), followed by a cross-reference to the miracles of Book I (W 20, lines 13-21, line 9) which are included in R's Book II: Rubric: *Primum lege miracula; quam cessemus; ergo * ubi videris hoc signum in miraculis.* [The star refers to f. 48v]. The text resumes at *Cessemus ergo* (W 21, line 14) continuing complete to *olim sic cecinit dicens* (W 34, line 18) where the Fortunatus hymn is preceded by a rubric [not in C]: *Incipiunt versi apostolorum quos fecit fortunatus episcopus.* Text continues complete: *Siderei proceres…* expl. (f. 15v) *nos perducere dignetur in celis.* + dox (W 35)
[Chapters 3-4 omitted (W 35-38)]

f. 15v ***Chapter 5.*** Sermon of Calixtus for the Feast of the Passion of St James, 25 July.
Rubric (with *im passione* for *in passione*) and text, inc. *Celebritatis sacratissime…* complete as in C. (W 38-48)

f. 20v ***Chapter 6.*** Sermon of Calixtus for the Feast of the Passion of St James, 25 July.
Rubric (with *im passione* for *in passione*) and text, inc. *Spiritali igitur…* complete as in C, expl. f. 27v. (W 48-61)
[Chapters 7-18 omitted (W 61-179)]

f. 27v *Chapter 19.* Pericope and Sermon of Calixtus for the Feast of the Translation of St James, 30 December.
Rubric, pericope and sermon text as in C, inc. *Sollempnia sacra…* expl. f. 31v (W 179-186)
[Chapters 20-25 omitted (W 186-219)]

f. 31v *Chapter 26.* Calixtus's Mass for the Feast of St James, 25 July.
Rubric: *viii° l. augustus missa sancti iacobi a domino papa callixti edita.* (as in C, W 219) Additional rubric, not in C: *Officium.* Text, with notation in Aquitanian neumes on drypoint ruling: *Ihesus vocavit iacobum…tonitrui. V. Celi ennarrant gloriam.* (W 219) Rubric [not in C]: *Oratio.* Text *Gloriossimam sollempnitatem… queamus pervenire.* (W 220) [Lectio omitted]; *Misit herodes…* (noted) expl. (f. 32) *filii tonitrui.* (W 219-221)
[Prosa in Latin, Greek and Hebrew, edited by Calixtus, omitted (W 221-224); further excerpts from Chapter 26 included below].

f. 32 *Excerpt from Chapter 27.* Prosa of William, Patriarch of Jerusalem.
Rubric: *Prosa sancti iacobi crebro cantanda a domino Guillelmo patriarcha iherosolimitano edita.* Text: *Clemens servulorum,* with both a decorated and an ordinary initial c (noted)..expl. (f. 32v) *iacobe uiua. Amen.* (as in C, W 227-228).
Followed immediately by:
Further extracts from Chapter 26
Rubric: *Evangelium.* [not in C] Text, noted: *Accesserunt ad dominum ihesum filii zebedei.* [not noted in C, W 224; rest of Gospel text and Credo omitted]
Rubric: *Offertorium.* Text, noted: *Ascendens ihesus in montem…* expl. *tonitrui in rota. P. Quod est.* Rubric: *Secreta.* Text: *Nobis supplicibus…* expl. *devicit potenter, per eundem.* [Prefatio omitted] Rubric: *Combreganda.* [not in C] Text, noted: *Ait ihesus…* expl. *potest bibere.* Rubric: *Postcommunio* Text: *Deus cuius filius ad bibendum…* expl. (f. 33) *fieri voluisti. Per eundem.* (W 224-225).
[Rest of Book I, Ch. 26 omitted; most of Ch. 27 omitted (see above for the prosa of William, Patriarch of Jerusalem); Ch. 28-Ch. 29 omitted (W 225-242).]

f. 33 *Chapter 30.* Calixtus's Mass for the Feast of the Translation, 30 December.
Rubric: *iii° kl Jani Translacio et electio sancti iacobi missa domino calixto pape edita.* [Introit omitted] Rubric: *Oratio.* Text: *Deus cuius unigenitus…* expl. *in celis. dominum nostrum*
Rubric: *Lectio libri sapiencie.* Text, as in C (W 243): *Jacobus placuit domino…* expl. (f. 33v) *benedictione est.* [Response, Alleluia, Prosa, omitted] Rubric: *Evangelium.* Text [pericope only]: *In illo tempore. Preteriens ihesus…* expl. *secuti sunt eum.* [Offertorium omitted] Rubric: *Secreta.* Text: *Preclara beati iacobi…* expl. *Per eundem.* [Prefatio and communio omitted] Rubric: *Postcommunionem.* Text: *Fac nos quesumus…* expl. (f. 33v) *Per eundem.* (W 242-243)
[Rest of Chapter 30 and all of Chapter 31 omitted]

f. 33v **Excerpt attributed to St Augustine,** *De Penitentia Salomonis.* [not in C]
Rubric: *Augustinus. De Penitentia Salomonis.* Text inc. *Salomon inquid virtute sapientie, inquid nam credibile est in simulacrorum cultus…* expl. (f. 34) *Quia potior est misericordia omnibus holocaustomatibus et sacrificiis.*
DIVJAK, 1974, p. 170, cites this text, also attributed to Augustine, in Ripoll 193, ff. 2-3 (11th-12th century), but does not include this MS in his list; STEGMÜLLER, 1951, VII, no. 11086, lists the incipit among anonymous texts, citing Stockholm Kgl. Bibl., A 141, f. 2 (Pauline Epistles, 12th century); OLSEN/NORDENFALK, 1952 attribute Stockholm, KB, A 141 to Anjou (?), 1050-1100; see also STEGMÜLLER, 1954, IV, where a similar text, lacking the exact incipit, is attributed to Pseudo-Abelard, in Paris, BN, lat. 2543 (13th century). We owe this information to the kindness of Dr Thomas Amos.

f. 34v Blank

f. 35 **Explicit for Book I and Heading for Book II**
Rubric: *Finit primus liber. argumentum beati calixti pape de miraculis Beati Iacobi*
Book II: 22 Miracles of St James
Prologue, Chapter list of 22 chapters, Text as in C, inc. *Summopere precium est…* expl. f. 48v (W 259-287)

f. 48v **Miracles (Book I of C)**
Signe de renvoie *, referring back to f. 7v. Rubric: *Miraculum de illis qui non colebant festum sancti iacobi.* Text: *Hec sunt miracula que olim sancti iacobi festa non colentibus…* expl. (f. 49) *in oculis nostris.* (W 20-21)

f. 49 **Two Miracles (texts following Book V in C, one of 1164)**
Rubric: *Miraculum sancti iacobi de puero suscitato.* Text: *Anno incarnationis dominice mº.cº.lxiiii.* (C f. 223; W 404)

f. 49v Rubric: *Aliud miraculum.* Text: *Miraculum sancti iacobi de facie torta filii vicecomitis…* (C f. 223; W 405)
Three Miracles (Book V, Chapter 11 in C)
Rubric: *Qualiter peregrini sancti iacobi sunt recipiendi.* Text: *Peregrini sive pauperes sive divites…* expl. *et diligenter procurandi.* (W 388-389)

f. 50 **Alberic of Vézelay's Miracle of 1139 (following Book V in C)**
Rubric: *Miraculum sancti iacobi a domino alberico vizeliacensi abbate atque episcopo hostiensi et rome legato editum.* Text: *Anno dominice incarnationis m.c. xxx. ixº. Ludovico rege francorum…* expl. *occulis nostris.* (C f. 221v; W 400)

f. 50v **False bull of Pope Innocent II (following Book V in C, collated in the Latin Appendix)**
Rubric: *Epistola domini pape innocencius* Text inc. *Innocentius episcopus seruus seruorum dei… hunc codicem…* expl. *fore predico.* (C f. 221; W 399-400)
Few variants: *oliuerius* for *oliuerus*; *lumbardus* (mistranscribed in W).
Followed immediately (f. 50v) by:
Rubric: *Finit codex secundus. Incipit liber tercius. Incipit prolocus* [sic] *beati calixti pape Super translationem beatio iacobi maiorem.*

f. 51 **Excerpts from Book III: Translation of St James**
[No Chapter list.]
Prologue, complete as in C (W 289-290), inc. *Hanc beati Iacobi translationem a nostro codice…* expl. (f. 51v) *remunerauit muneribus. Explicit prologus.*
Followed immediately by rubric to Chapter 1.
Chapter 1
Rubric and text complete as in C, inc. *Post saluatoris…* (W 290-294).
Chapter 2
Rubric, text complete as in C, inc. *Noscat fraternitatis…* (W 294-296).
Chapter 3
Rubric, text inc. *Beatus lucas…* as in C, ending incomplete (f. 56v) at *galleciana gaudens suscepit* (W 298, line 4).
[rest of Chapter 3 and Chapter 4 omitted]

f. 56v **Book IV: Pseudo-Turpin**
Epistle to Leoprand
Rubric: *Incipit codex IIII Sancti Iacobi de expedimento et conversione yspanie et gallecie, editus a beato turpino. archiepiscopo. Epistola beati turpini episcopi ad leo prandium.* (painted out in C, missing in A, cf. VA, SV; longer version in P; variant versions in M, T; shorter version in VB). Text, inc. *Turpinus domini gratia archiepiscopus Remensis… Quoniam nuper mandastis…* expl. *et domino placeas. Amen.* (W 301)

Chapter list of 26 chapters as in C (W 301-302).
Chapters 1-21, all numbered (except for Ch. 1, also unnumbered in C) W 302-328).
Rubric: *Incipit Liber.* Text: *Gloriosissimus namque Christi…* (W 302)
Chapter 21 and subsequent chapters are subdivided and numbered differently than C:

f. 72 *Itaque peracto bello…* rubricated but not numbered (W 330; Ch. 22 in L)

f. 73 **Cap. xxii.** *Deinde proprio…* (W 331; Ch. 23 in L)

f. 73v **Cap. xxiii.** *Domine Ihesu Christe…* (W 332; Ch. 24 in L)
[*Non decet…sed tenet aula dei* omitted (W 334; Ch. 25 in L)]

f. 74v **Cap. xxiiii** *Quid plura…* (W 336; Ch. 26 in L)

f. 75 **Cap. xxv.** *Crastina namque…* (W 336; Ch. 27 in L)

f. 76v **Cap. xxi** [sic] *Postea vero ergo…* (W 338; Ch. 31 in L)
Cap. xxii. *Post hec Viennam…* (also Ch. 22 in C, W 338; Ch. 32 in L) Text from *in eo depinguntur* (W 339, line 28) to *Incipit mors anime* (W 341, line 29), describing the Liberal Arts, omitted. The text at *Post exiguum vero tempo* (W 341) R has the rubric *Qualiter mors Karoli fuit demonstrata*, not in C.

f. 78 **Cap. xxiii.** *Set valde…* (also Ch. 23 in C, W 343; not a chapter division in L), *Beatus namque Turpinus* is *Cap. xxiiii* as in C, W 344; Ch. 23 altered to 24 [*sic*] in L), *Quid patrie Gallecie* is *Cap. xxv* (as in C, W 345; not a chapter division in L); R ends Book IV at the end of Ch. 25 (the chapter list on f. 56v notwithstanding), expl. (f. 80) *munere remunerabuntur.* (W 347).

f. 80 **Explicit to Book IV and heading to Book V:** *Finit Codex quartus. argumentum beati Calixti Papa.*
Book V: Pilgrim's Guide
Short Version, as in VB and Z. For details of omissions in Short Version, see Table of Book V, p. 52 and Introduction, pp. 31-32.
[Explicit and colophon omitted (W 389)]

f. 85 **Dedicatory Letter of Arnaldus de Monte, written at Compostela, 1173.**
The letter is written in a different but contemporary, more document hand. It was probably copied into the manuscript when Arnault returned to Ripoll.
The transcription follows the conventions for editing the text of C; in the footnote discussions of questionable cases, identifiable abbreviations such as -ur and -re are indicated by underlining. The common mark of abbreviation, or a mark of whose meaning we are not certain, is indicated by an apostrophe.

f. 85 *Reverendis patribus et dominis suis, R⁰ Dei gratia Riuipullensi[1] electo, et B. maximo priori, et universo eiusdem ecclesie uenerando conuentui. Frater A. de Monte, humilis filius atque uestre sanctitatis deuotissimus seruus, salutem, et plenitudinem debiti famulatus.[2] Consistens in ecclesia Beati Iacobi apud Compostellam quem propter indulgentiam* [f. 85v] *peccatorum meorum uisitare studueram, et nichilominus ob desiderium[3] uisendi loci cunctis gentibus uenerandi, uestre beatitudinis non minus licentia fultus; reperio uolumen ibidem V libros continens de miraculis apostoli prelibati, quibus in diuersis mundi partibus tanquam micantibus[4] stellis diuinitus splendescit[5] et descriptis sanctorum patrum, Augustini uidelicet, Ambrosii,[6] Yeronimi, Gregorii, Leonis, Maximi, et[7] Bede. Continebantur in eodem uolumine scripta aliorum quorumdam sanctorum in festiuitatibus predicti apostoli et ad laudem illius per totum annum legenda cum responsoriis,[8] antiphonis, prefacionibus, et*

orationibus ad idem pertinentibus quamplurimis. Considerans igitur paternitatem uestram circa beatum apostolum deuotissimam, memoriterque retinens quod secundum consimilis deuocionis formam, felicis memorie predecessores uestri, diuini amoris intuitu, simulque apostolice ueneracioni speculacione sub sepenominandi[9] apostoli titulo, infra basilicam Riuipullensem[10] altare sacrosanctum erexerant, proposui uolumen predictum transcribere, desiderans[11] ampliori miraculorum Beati Yacobi quibus tamdiu caruerat ubertate ecclesiam nostram ditari. Verumtamen cum copiam sola uoluntas ministraret, sumptuum uero penuria et temporis me coartaret angustia, de V libris. III. transcriptos atuli, secundum scilicet et tercium, et quartum in quibus integre miracula continentur, atque translacio apostoli ab Iherosolimis ad Yspanias, et qualiter Karolus Magnus domuerit et subiugauerit iugo Christi Yspanias. De primo quidem aliqua licet pauca de dictis Calixti Secundi collegi, in presenti uolumine conscripta. Quintus liber supradicti uoluminis scribitur de diuersis ritibus et uaria consuetudine gentium, de itineribus quibus ad Sanctum Yacobum uenerunt,[12] et qualiter omnia fere ad pontem regine terminantur, de ciuitatibus, castellis, burgis, montibus, et de prauitate simul et bonitate aquarum, piscium, terrarum, hominum, et ciborum, et de sanctis qui sub precipua ueneracione coluntur per Uiam Iacobitanam, scilicet de Sancto Egidio, Sancto Martino, et ceteris. Continentur etiam in eodem libro Vᵒ. situs ciuitatis Compostellane, et nomina circumfluentium[13] aquarum, et numerus, neque preterit fontem qui dicitur de Paradiso. Comprehendit etiam sufficienter formam ecclesie Sancti Iacobi [f. 86] et institutionem[14] canonicorum quantum spectat ad distributionem oblacionum, cum numero eorumdem et[15] qualiter sedis metropolitane dignitas, auctoritate Romanorum pontificum, ab Emerita translata sit[16] ad Compostellam[17] propter predicti apostoli fauorem. Ex his omnibus excerpsi que in[18] in presenti uoluminem[19] fidelibus occulis beatitudo uestra, contueri potest si dignatur presentius. Quid autem legendum sit in ecclesia siue in refectorio[20] de suprascriptis omnibus ex epistola domini Calixti diue memorie Romani pontificis nulli fidelium contempnenda prebetur auctoritas, qui etiam predictum uolumen inter autenticos codices in ecclesia[21] legendum apostolici[22] culminis sentencia sanccire curauit, uenerando Innocentio ecclesie Romane sumo[23] pontifice semperdictam[24] scripturam postea roborante. Ceterum quando presentis uoluminis transcriptio facta fuit. M. C. lxx. iiiᵘs ab incarnatione domine numerabatur annus.

1. Riuipellensi Vielliard.

2. MS: famll'atus, *with the first 'l' expunged.*

3. MS: de *written above the line, and perhaps erased. If the erasure is intentional, the reading would be* obside uim, *'scarcely as a surety', which does not really make sense in the passage.*

4. MS: mˡcˡatibus

5. MS: spled'sc'; splendesc., *expanded to* splendescit Vielliard.

6. MS: Ambros *with the letters* 'sii' *added above the line in a script which looks a different colour, perhaps erased.*

7. MS: et *added above the punctus, in a script which looks a different colour, perhaps erased.*

8. MS: responsariis, *expunged, and corrected to* responsoriis, *in a different ink;* responsoriis Vielliard.

9. MS: sepe n'n'adi; *if the first* n *could be read as a* u, uenerandi *would be a possible, and perhaps better, reading, but the scribe's* u*'s are always open at the top, and his* n*'s are closed.* 10. Riuipellensem Vielliard.

11. MS: desideran's, *which would give* desideranns; *the mark of abbreviation must be an error.*

12. MS: uenerur, *possibly corrected from* uenitur; uenerunt *makes better sense.* venitur Vielliard.

13. MS: circumfluentium; circumfluencium Vielliard.

14. MS: i'stututioem

15. et *omitted* Vielliard.

16. sit translata Vielliard

17. MS: *erasure of 2 letters, not visible; possibly* et.

18. MS: q'i' i'p'se'ti, *which would be expanded as* que in inpresenti.

19. volumine Vielliard. *Either* in presentem voluminem *or* in presenti volumine *would be possible; the MS readings give the ablative of the adjective and the accusative of the noun.*

20. MS refectᵒrio

21. MS: *erasure of 12 letters; nothing legible*

22. MS: c'.i, *with the dot representing an erasure.*

23. summo Vielliard

24. MS: se'dictam; sepedictam Vielliard

Sigla: Hämel: R[1]
Meredith-Jones: not included
Mandach: R
Díaz y Díaz: R

Bibliography: Anglés, 1931, 1935, 1961; Bédier, 1908-13/1966; Beer, 1908, III, p. 15 ff.; id., 1910, V, pp. 332-336; emended edn in typescript available at the Arxiu de la Corona de Aragó, Barcelona; David, 1945, 1947, 1948; Delisle, 1878; Díaz y Díaz, 1987, p. 47; id., 1988a, pp. 78, 130, 134, 229, 238, 261-262, 266, 276-277, 319, 327, 335; Divjak, 1974, p. 170; D'Olwer, 1923, p. 3ff.; Faulhaber, 1987, pp. 94-95; Fernández de la Cuesta, 1980, I, p. 74; García Villada 1915, p. 53; Hämel, 1936, pp. 147-148; id., 1950, pp. 64-67; id., 1953, IV, p. 69; Herbers, 1984, pp. 22-23, 33; López Calo, 1963, pp. 181-189; Mandach, 1961, p. 393; Martínez Fernando, 1944, p. 66; Moisan, 1992, pp. 83-104; Olsen/Nordenfalk, 1952, no. 19; Stegmüller, 1954, IV, no. 6387; 1961, VII, no. 11086; *Santiago Camino de Europa*, 1993, no. 34; Stones, 1991, p. 626; ead., 1992, pp. 152-153, figs. 72, 75; Stones/Krochalis, 1995, pp. 21-23, fig. 2; Szöverffy, 1971, p. 108; Vielliard, 1938, 4th edn 1969, edition based on C and R, and edition of the Letter of Arnault, pp. 126-131.

L. Lisbon, Biblioteca Nacional, Codices Alcobaçences CCCII/(334)

Special Version: Selections from the Long Version

Miscellany of texts about St Martin of Tours and selections from the *Codex Calixtinus*. The first number in Alcobaça manuscripts, in Roman numerals, is the number of the manuscript in the monastic library, as described in the 1775 Latin *Index*. The second number, in Arabic numerals, is the number of the manuscript in the Biblioteca Nacional, as catalogued in the *Inventario* which appeared in sections in the 1930s. The *Inventario* prints the numbers like fractions, with the old number in Roman numerals on top, and the new number in Arabic numerals on the bottom. Our references follow the pattern in BLACK, 1990, with the Roman numeral first. This pattern is followed by most, but not all critics who cite Alcobaça manuscripts

Late 12th or early 13th century, Alcobaça or Lorvão (O. Cist.?); Portugal? or Spain?

Parchment, iii (paper) + 216 + i (paper) ff. Numbered 1-215 by an earlier 20th-century hand (folios counted even when not numbered); and 1(font end leaf i)-221 (rear paste-down) by a later 20th-century hand in the inner margin; we follow the latter foliation. 347 × 230 mm, written space 248 × 152 mm. Text in one column, 30-31 long lines per page, written sometimes above, sometimes below top line of ruling. Number of lines per page increases from 30 to 31 at f. 113; writing area remains same. Frame and line ruling in leadpoint; prickings visible on outer edges. The parchment is of very poor quality, full of holes, mends, and irregular folios, but well finished; the texts all follow without breaks. (*Ills. 42–46*)

Quires:	1-27⁸. signatures i-iii; catchwords for the remaining quires.
Script:	One hand, with added texts in 17th-century antiquarian humanist hands and two cursive hands. The script of the main scribe looks quite like Hand 2 of C. The e-cedilla form for 'ae' is used erratically, sometimes where no diphthong is intended. There are still 'ct' ligatures, more laterally compressed than C's Hand 2 and rather square, and no bitings. The common mark of abbreviation is a stroke with a serif at each end. The ampersand ligature is more usual than the Tironian 'et'. These features would tend to suggest a late 12th-century date.
	The lateral compression and general ductus might suggest the 13th century. Minims finish with a small hair-line to the right; descenders are wedge-shaped; round 's' is usually only for capitals, long 's' is general otherwise, initially, medially and finally (cf. C Hand 1, but not Hand 2). The shaft of 't' does not protrude through the cross-bar; headed 'a'; 'g' closed with a hair-line. Corrections and additional *tituli* in margin, and occasional interlinear glosses, by a contemporary hand. Occasional marginal glosses in a larger 13th-century hand. See f. 105 (*ill. 42*).
	In general the script is similar to, but not the same as, Lisbon, BN, Alc. 143, of uncertain origin, whose colophon was added in 1185 at Lorvão (see ROSA PEREIRA, 1985, pp. 133-134, pl. XIX), and to Alc. CCCXCII/(424), dated *c.* 1210 by BURNAM, 1912-25, pl. XI; but neither of the two evangeliaries cited in ROSA PEREIRA, 1981 is particularly close in script. See below for some links with the decorative initials in Lisbon, BN, 3681. A marginal gloss on f. 183 in a 16th-century hand mentions a *donatio Laurbarii* in the seventh year of King Ferdinand I of León (1037-65) (it was allegedly made in 1064 to the pre-Cistercian monastery at Lorvão), but no earlier evidence links this manuscript with Lorvão.
Rubrics:	In red and blue.
Musical Notation:	None, no spaces left for it.

Decoration: Coloured initials, alternating light blue and red, sometimes decorated in the alternate colour, usually 2-3 lines. Initial 'P' on f. 4 has a height of 12 lines, quite similar to, if less elaborate than, that of late 12th-century Alcobaça manuscripts, in particular Lisbon, BN, Alc. MS LXX/(153); but there are also echos of western French decoration (cf. L, f. 17v with the early 12th-century MS from Fleury, Orléans, BM 123 (reproduced in STONES, 1992, fig. 13), and a comparison can even be made with manuscripts from closer to Paris (cf. f. 40v with the initials in the Vendôme MSS associated with Paris, Bibl. Mazarine 729). The initials in L are substantially less elaborate than those in the Alcobaça Legendary of c. 1170-90, MSS Lisbon, BN, Alc. CCLXXXIV/(418), CCLXXXV/(419), CCLXXXVI/(420), CCLXXXVII/(421), CCXXXVIII/(422) (ed. DOLBEAU, 1984, no plates; CONFINS, 1993, pp. 141, 148-150, pls. 57, 54, 55); attributed to the last third of the 12th century by analogy with Lisbon 3681, written in 1170. See also ROSA PEREIRA, 1981, pp. 27-33, pl. 1, noting that some of the scroll-work on the initial on f. CLVI is not unlike L, f. 17v); and there are some similarities between the G initial on f. 1v of Alc. XIX/(332), BUR-NAM, 1912-25, pl. XLV and the initial in L, f. 108. The development of an Alcobaça style of initials in the late 12th century has not yet been clearly enough charted for an Alcobaça provenance for L to be fully supported or rejected on the basis of its initial style.

Illustration: None.

Binding: Worn, worm-eaten brown leather over thick cardboard, 18th or 19th century. Frayed along edges and spine.

Provenance and History: The selection of Martinian texts suggests that L and its model were made for a place where veneration of St Martin of Tours was of central importance. Those selections include accounts of St Martin's posthumous miracles assembled by Gregory of Tours (died c. 594). His discussion of subsequent bishops of Tours is followed (f. 103) by a list of bishops ending with Erbenus (in GAMS as Herbernus, elected 890, died 916). This is exactly the sort of material requested by King Alfonso III, of Spain, c. 906, if the document is authentic, in the course of his letter to the Abbey of Tours, offering to buy the imperial crown in their treasury. He also says that he has an account of the Life of St Martin (presumably the one by Sulpicius Severus), but would like accounts of any posthumous miracles. He would offer in return accounts of the holy men of Mérida, a volume of limited circulation which we know he owned (ed. GARVIN, 1946). He goes on to discuss St James, saying that the apostle buried in Spain is James son of Zebedee, and offering them accounts of his tomb and translation. A copy of the letter was preserved in a Tours cartulary of 1132-37 until 1793; since then only the copy made by the 17th-century antiquarian André Duchesne has survived (FLETCHER, 1984, p. 317; published by LÓPEZ FERREIRO, 1898, II, App. xxvii, pp. 57-60).

The authenticity of the document has been severely questioned, on various grounds, including its apparent use of version B of the Epistle of Pope Leo, which survives only in a 12th-century copy at the Escorial, MS L.iii. 9, f. 40 (ed. GARCÍA VILLADA, 1929-36, I, pp. 369-370). For the four recensions of the Epistle of Leo see GAIFFIER, 1971. Version A, the earliest, is copied in a 10th-century Visigothic hand in the Saint-Martial, Limoges manuscript, Paris, BN, lat. 2036; see MUNDÓ, 1952, and, for the late 11th or early 12th-century copy of version A in Madrid, see GARCÍA ALVAREZ, 1961. Versions A and B, according to Gaiffier, are closely related. Version C is Rome, Casanatense 1104, written in Beneventan script of the 12th century and (according to Gaiffier) copied in Italy (edited by GUERRA CAMPOS, 1956); version D, substantially different from the others, is in our MS C as Book III, Ch. 2, W 294-296. For a concise summary of the arguments for and against the authenticity of Alfonso's letter, see FLETCHER, 1984, pp. 316-324, with the caveat that Fletcher was unaware of Gaiffier's article and therefore cites only three versions of the Epistle of Leo.

It is possible, if the letter of Alfonso is authentic, as ERDMANN, 1951, pp. 31-33, and FLETCHER, 1984, p. 323, believe, that the Martin section of L is a copy of material sent to Alfonso III from Tours early in the 10th century. The date would be commensurate with that of the last bishop on the episcopal list in L, which L would then have copied from his model without updating. For the text of Alfonso's letter, see LÓPEZ FERREIRO, 1898, II, app. xxvii, pp. 57-60, and GARCÍA ALVAREZ, 1963-67, no. 99.

A related possibility is that L itself or L's model was put together in or near Tours, although, in that case, it is surprising that the list of bishops was not brought up to date, as HOHLER, 1972, p. 61 has observed. As DAVID, 1946, p. 33, noted, it was at Marmoutiers near Tours that Guibert, Abbot of Gembloux obtained, *c.* 1180, his copy of the Miracles of St James and the *Pseudo-Turpin* (Books II and IV of CC), which he says he copied together with material about St Martin. Guibert's copy is not extant but he mentions copying these three components in Epistle XII (vol. 1, p. 183, lines 120-138, in GUIBERT, ed. DEROLEZ, 1988). There was also a 12th-century copy of the Translation of St James at Gembloux (GAIFFIER, 1971, p. 56), added to an 11th-century copy of Lucan, Brussels, BR 5333-35, on ff. 199v-200 (BHL 4068); but Albert Derolez kindly informs us that the script of the Translation looks earlier than Guibert's, and the manuscript came late to Gembloux, so it is unlikely to be associated with Guibert. The version of the Translation in the Brussels MS is not the same version as L's; it is closer to, though not the same as, the version on f. 35 in MS P. Both L and P are themselves later than Guibert's exemplar, but these links may merit further investigation. DAVID further notes the presence in Tours of a 13th-century copy of the *Codex Calixtinus*, Books II, III and IV, which came to the Bibliothèque Municipale from the Cathedral of Tours as MS 1040 (see also HÄMEL, 1953, p. 74; MANDACH, 1961, p. 373; DÍAZ Y DÍAZ, 1988a, pp. 327-333), as well as numerous manuscripts containing the Martinian texts that are in L: Tours, BM 1019, 1020, 1021. He observed that evidence for early ownership of L by Alcobaça is non-existent: the earliest record of its presence in Portugal is the 17th-century commemoration of Blessed Alfonso I, King of Portugal (1128-85), and an account of his miraculous appearance at St Cruz, Coimbra, on the day of the capture of Ceuta (f. 219). DAVID further (pp. 36-39) cites numerous instances where L, he thinks, 'corrects' the grammar of C, largely in the texts of Books I and IV. HOHLER, 1972, p. 61 has suggested a possible link between L and the Priory of St-Martin-des-Champs, the Cluniac priory in Paris; its prior was for a time Matthew of Albano, whose links with Rainerius of Pistoia are discussed under MS P.

The other channel of transmission worth mentioning is the Cistercian network, among which the *Libellus* or 'Revised Version' of CC circulated (MEREDITH-JONES, 1936, 'D' version; HÄMEL, 1953, pp. 73-75; MANDACH, 1961, 'D' version; HOHLER, 1972, pp. 59-61); but L and C share additional text beyond what is also in the manuscripts of the 'Revised Version': notably, L includes substantially more of Books I-IV, and its *Pseudo-Turpin* includes the section on the Liberal Arts; the Cistercian copies would seem to represent, at the least, a further stage of editing beyond what is in L, or else L is an expanded version of what they present. Which way the relationship worked can only be solved by collating what is in L with the 'Libellus'. Our collation of the 'Julius Caesar' section of Chapter VII of the *Guide* with the manuscripts collated in CASTETS, 1880 and *Libellus* manuscripts in Paris does not support the relationship between L and the *Libellus,* or 'Revised Group' (see Latin Appendix).

Our collation of the *Guide* supports the direct dependency of L on C, as copied by Hands 1 and 2, and we therefore consider that HÄMEL's classification of it is right: he put it with a group entitled *Liber Sancti Jacobi,* consisting of 11 manuscripts (HÄMEL, 1953, p. 69). All except one are the manuscripts containing the *Guide* which we consider here. The eleventh is a manuscript in Tarragona which has been inaccessible for many years, but which Manuel C. Díaz y Díaz kindly informed us

does not contain the *Guide*. Our eleventh and twelfth *Guide* manuscripts are P and T, neither of which were on Hämel's 1953 list. This conclusion parallels that of DÍAZ Y DÍAZ, 1988a, p. 340, drawn on the basis of his collation of the Prologue of Calixtus to Book I. We remain sceptical about the supposed links between L and Montpellier Bibliothèque Interuniversitaire, Section Médecine, MS H 142 as against C, presented in MANDACH, 1990, pp. 48-49, particularly as we amend his readings to *Trenquetalla* in L, *Trenquatalla* in C, and *de corporibus sanctorum qui* in L. More extensive collations of other textual components would in our view be needed to substantiate a convincing case that L does not depend on C.

The *Codex Calixtinus* material in L must have emanated, ultimately, from Compostela.

In addition to having the Cathedral and shrine of St James, Compostela frequently also had the royal chancery. Here a consideration of the royal houses of Spain and Portugal may prove useful. Alfonso VI of León-Castile married Constance of Burgundy. His daughter Urraca married Raymond of Burgundy, Constance's nephew, and ruled as Queen of León-Castile 1109-26. Raymond's first cousin Henry, Constance's other nephew, came to Spain *c*. 1092. Alfonso gave Henry the county of Portugal, and gave Raymond land in Galicia/Extremadura, which included Compostela. Urraca and Raymond's son Alfonso VII became King of Galicia after his father died, in 1111, and King of León-Castile after his mother died, in 1126. He was thus a cousin to the ruler of Portugal. There was a double family tie between the two, since Henry married Alfonso VI's illegitimate daughter, Teresa. Henry died in 1112; his widow Teresa ruled until 1128. Their son, Alfonso Henriques (King Alfonso I of Portugal) ruled from 1128-85, long enough to establish a stable kingdom. It was during his reign that the Cistercian house of Alcobaça was founded, in 1153. Alfonso was a cousin of Alfonso VII of León-Castile, and might well have had access to, as well as an interest in, material about St James. For historical information, see FLETCHER, 1984, pp. 38-39; PERES, 1967, pp. 55-74; REILLY, 1968, pp. 467-483; FEIGE, 1978, pp. 110-122.

Alcobaça MS CCXC/(143), the Martyrology and Miracles of Thomas Becket (CONFINS, 1993, no. $$), commissioned by King Alfonso I and his son Sancho, has been mentioned above as written in a script similar to L. It was commissioned for the Abbey of Lorvão in 1185. (*Index 1775*, p. 228; *Inventario* III, 1930, pp. 115-116) It is tempting to think of Alfonso making similar offerings to other monasteries in his dominions.

In the absence of compelling parallels for the script and decoration of L among manuscripts securely emanating from Tours, León, Alcobaça or Lorvão, the origins of L itself, as opposed to its exemplar, must remain uncertain. But in this context it is worth remarking that in 1191 the Abbot of Alcobaça was called Martin; he signed Alc. MS CCCIII/(365) (NASCIMENTO, 1985, p. 113, n. 14; Index 1775, p. 135; *Inventario*, V, 1932, pp. 337-338). The Abbey of Lorvão which received Alcobaça 143, was in the diocese of Coimbra, to the north of Lisbon. Between 1185 and 1191, the Bishop of Coimbra was named Martin (ROSA PEREIRA, 1985, pp. 134-135).

On f. 216 in L, a 17th-century hand records a miraculous appearance of Alfonso in Coimbra.

The cult of Becket was relatively new in 1185, and the king seems to have been making sure that the monastery had the proper materials for celebrating the feast. Perhaps whatever scriptorium supplied the Becket materials was a general source of books for liturgical use in the region. Either the bishop or the abbot might well have had a special interest in St Martin of Tours. The cult of Martin of Tours seems to have been prominent in the Lisbon/Alcobaça area. There are villages called São Martinho and São Martinho do Porto not far from Alcobaça, and a fair on the Feast of St Martin (10 November) at Golegã (NAGEL, 1964, pp. 56 and 216). And the miracle of 1190 recounting the aid of St James in lifting the seven-year siege of

Coimbra added to MS C, f. 223v, is another instance of links between Portugal and Compostela in this period.

MS L came to the Biblioteca Nacional with the bulk of the Alcobaça library in 1833.

Secundo folio: *Succedente*

Contents: The following description was based initially on the microfilm at HMML, St John's University, Collegeville, Minnesota; we also acknowledge the generous assistance of Drs Thomas Amos and Jonathan Black and we thank Dr Black for permitting us access to his description of L in advance of publication.

f. 1 334/[fundo number]

f. 2 Blank

f. 3 **Table of contents in 18th-century hand**

f. 4 **Alcuin, *Vita Sancti Martini***
Rubric: *Incipit epistola magistri albini de vita sancti martini* (Note: Alcuin is frequently cited as Albinus in medieval manuscripts.) Inc. *Postquam dominus noster ihesus christus triumphator ad alta celorum ascendit...* expl. *pietates letantium, praestante domino nostro...* colophon: *Explicit epistola albini magistri collecta de vita et virtutibus beati martini.* (PL 101, cols. 657-664; DEUG-SU, 1983, pp. 167-193)

f. 6 **Sulpicius Severus, *Vita Sancti Martini***
Rubric: *Incipit epistola severi ad desiderium fratrem suum karissimum.* Inc. [Dedication, after sal.] *Ego quidem frater unanimis.* Prologue inc. *Plerique mortalium studio.* Text: *Igitur Martinus sabaria pannoniarum oppido...* expl. *non quicumque legerit sed quicumque crediderit.* Colophon: *Explicit liber primus.* (HALM, 1866, pp. 109-137; FONTAINE, 1968, pp. 240-316; L is not included among the 11 MSS cited.)

f. 17v **Sulpicius Severus, Letters to Eusebius, Aurelius, and Bassula**
Rubric: *Item epistola sulpicii severi ad eusebium tunc presbyterum postea episcopum.* Text: [Epist. 1] *Hesterna die cum ad me plerique monachi venissent...* [Epist. 2] *Postea quam a me mane digressus es...* [Epist. 3] *Si parentes vocari in ius liceret...* expl. *me haec scribentem respicit te legentem.* Colophon: *Explicit epistola sulpici severi.* (HALM, 1866, pp. 138-151; FONTAINE, 1968, pp. 316-344, not among MSS cited.)

f. 22 **Gregory of Tours, *Historia Francorum*, Book I, Ch. 48, *De Transitu Sancti Martini***
Rubric: *Incipit epistola gregorii turonensis episcopi de transitu sancti martini.* Text: *Archadio vero et honorio imperantibus, sanctus martinus turonorum episcopus plenus virtutibus...* expl. *anni quadringenti duodecim computantur.* (GREGORY OF TOURS, 1951/1965, pp. 32-34, MS not listed.) For the implications in relation to the possibly authentic letter of Alfonso III to the clergy of Tours, see Provenance above.

f. 23 **Gregory of Tours, Excerpts from *De Virtutibus Sancti Martini*, Book I, Chs. 4-6**
Rubric: *Item alia eiusdem de eodem.* Text: *Beatus severinus coloniensis episcopus vir honeste vite...* expl. *aut factum cognovimus, silere nequivimus.* (GREGORY OF TOURS, 1885/1969, pp. 140-142. MS not listed; see note on *De Virtutibus* below, ff. 51-98v.

f. 24v **Sulpicius Severus, *Dialogi***
Heading: *Incipiunt capitula in dialogis Sulpicii Severi. Capitulum primum.*

f. 25 Rubric: *Incipit liber primus dialogi severi de virtutibus sancti martini. Capitulum primum.* Text: *Cum in unum locum ego et gallus noster*

convenissemus… expl. *sed non minore ex nostris fletibus dolore disressum* (corrected to *discessum) est.* Colophon: *Explicit liber dialogorum sulpicii severi de vita sancti martini.* (HALM, 1866, pp. 152-216. MS not listed; see note on *Vita Sancti Martini.*)

f. 50v **Hilary of Poitiers,** *Confessio Sancti Martini*
Rubric: *Incipit confessio sancti martini de trinitate.* Text: *Clemens trinitas est una divinitas, ut autem per sacramentum…* expl. *in sancta eclesia nunc et per inmortalia secula seculorum.* Colophon: *Explicit.* (STEGMÜLLER, 1960, MS not listed; PL 18, cols. 11-12.)

f. 51 **Gregory of Tours,** *De Virtutibus Sancti Martini* [Books II-IV; see ff. 20-21 above for Book I, Chs. 4-6].
Heading: *Incipiunt capitula beati gregorii turonensis episcopi de virtutibo* (or *virtutibus) sancti martini post eius transitum.* Text: [Sal] *Miracula que dominus deus noster per beatum martinum antistem suum in corpore positum operari dignatus est…* expl. *et de pulvere sepulchri accepit, protinus morbo caruit.* Colophon: *Explicit liber quartus.* (GREGORY OF TOURS, 1885/1969, pp. 134-211. Edition lists 36 groups of manuscripts, not including L in any of them.)

f. 98v **Gregory of Tours, Excerpt from** *Liber in Gloria Confessorum,* **Chs. 4-14 (St Martin)**
Rubric: *Explicit liber quartus. Incipiunt capitula de miraculis beati martini que idem gregorius in libro quem de laude confessorum scripsit inseruit.* Text: *Cratianum episcopum a romanis episcopis ad urbem turonicam transmissum…* expl. *catholicos reliquos fervore suae fidei roboravit.* Colophon: *Expliciunt miracula domni martini a beato gregorio turonensi episcopo edita.* (GREGORY OF TOURS, 1885/1969, pp. 301-306.)

f. 101v **Gregory of Tours, Excerpt from** *Historia Francorum,* **Book II,** *Vita Sancti Brictii*
Rubric: *Incipit vita sancti bricii* [sic] *episcopi et confessoris. Capitulum primum.* Text: *Igitur post excessum beati martini turonicae civitatis episcopi…* expl. *magnificae sanctitatis, praestante domino nostro ihesu christo cui est…* Colophon: *Explicit vita sancti brictii episcopi et confessoris.* (GREGORY OF TOURS, 1951/1965, pp. 37-38.)

f. 103 **Gregory of Tours, Excerpt from** *Historia Francorum,* **Book X, Ch. 31**
Rubric: *De episcopis turonensibus.* Text: *Licet in superioribus libris quaedam scripsisse visus sim…* expl. *anni clxviii quorum omnis summa est anni v.dccc^{ti}.xii.* Colophon: *Explicit.* (GREGORY OF TOURS, 1951/1969, pp. 526-537.)

f. 106v **List of the bishops of Tours**
Heading: *Hec sunt nomina episcoporum turonensium.*
List, written in 6 columns of 7 names each, with *Hursmarus* on a line above:
Gratianus, Lidorius, Martinus, Brictius, Eustocius, Perpetuus, Volusianus, Verus, Licinius, Theodorus (no mention of Proculus, cf. GAMS), *Difinius, Omatius, Leo, Francilio, Iniuriosus,* (no mention of Agrestius, cf. GAMS), *Baudinus, Cuntharius, Eufronius, Gregorius,* (the list in GAMS reads Pelagius, Leopacharius, Aigiricus, Walacus, Sigilaicus, Leobaldus, Modegisilus, Latinus, Garisigius) *Latinus, Charegisilus, Madegisilus, Figelaicus, Rigobertus,* (no mention of Papolenus, cf. GAMS), *Chrodobertus, Berto,* (the list in GAMS continues with Ebartius, Palladius, Ibbo, Guntrannus II, Dido, Raganbertus, Abbertus, Eusebius, Ostaldus, Gavienus) *Guntramnus, Ivo, Gauzbertus, Dido, Ragambertus, Austaldus, Eusebius, Herlenus, Joseph, Lamdramnus, Lamdramnus, Hursmarus* (GAMS

lists Ursmarus between Landrannus I and II), *Amalricus, Herardus, Aitardus, Adalaldus, Erbenus* (died 30 October? 916, GAMS).

f. 107v **Excerpts from CC, Book I: Liturgy of St James**
[Opening heading omitted]
Prologue with rubric as in C, text inc. *Calixtus episcopus* (W 1-3), but expl. *saltim legantur.* (W 3, line 5)
[rest of Prologue omitted]
Chapter list of 19 chapters, omitting C's Ch. 3, *Benedictiones,* and numbering C's Ch. 4, *Modica Passio,* as Ch. 3.
[Rest of C's 31 chapters omitted from list]

f. 108 ***Chapter 1.*** Sermon of Bede for the Vigil of the Feast of St James, 24 July.
[C's heading and pericope omitted]
Rubric: *Sermo venerabilis Bede presbiteri.* Text as in C, inc. *Quoniam beati iacobi uigilias* (W 6-11).
Marginal gloss in 13th-century hand: *Sermo iste non est legendus de sancto iacobo Zebedei. Sed de sancto iacobo alphei.*
[Chapters 2-7 omitted here, although listed in order in the Chapter list; see below]

f. 110v ***Chapter 9 of C; L's Chapter 8.*** Magna Passio.
Rubric: *Incipit passio beati iacobi apostoli que octavo kalendas augusti celebratur* (shorter than C's, W 93).
[Prologue omitted]
Text inc. *Post ascensionem dominicam ad caelos, apostolus domini...* expl. (f. 114v) *in hodiernum diem.* (W 102) [rest of chapter omitted]
[for further selections from Book I, see below, f. 120]

f. 114v **Book III: Translation of St James**
[Opening heading and Chapter list omitted]:
Prologue of Calixtus
Rubric as in C (W 289), but with *pappe* for *pape.*
Chapters 1-4 as in C (Ch. 4 is there, *pace* HÄMEL, 1950, p. 71), ending on f. 120 (W 290-299).
[Rubric *EXPLICIT LIBER TERCIUS* omitted]

f. 120 **Further selections from Book I**
Chapter 15. Sermon of Leo [without pericope] for ferie 7. in octave of St James, 31 July.
[Heading omitted]
Rubric: *Sermo beati Leonis pape de sancto Iacobo.*
Text as in C, inc. *Exultemus in domino* (W 128) ending on f. 124v. (W 137)

f. 124v ***Chapter 16.*** Pericope and Sermon of Jerome for ferie 7. in octave of St James, 31 July.
[Heading omitted, pericope included below]
Rubric: *Sermo beati Iheronimi doctoris atque iohannis episcopi eiusdem lectionis in natale sancti Iacobi apostoli fratris iohannis evangeliste qui requiescit in territorio gallecie.* (W 137) *Lectio .ix. Lectio sancti euangelii Secundum Matheum.* [not in C]
Pericope: *In illo tempore Accessit ad ihesum mater filiorum zebedei cum filiis suis adorans et petens aliquid ab eo. Et reliqua.* (shorter than C, W 137)
Rubric: *Omelia leonis eiusdem beati ieronimi presbiteri.* (shorter than C, W 137) Text as in C, inc. *Sollemnitatem hodiernam* (W 137) ending on f. 126. (W 141).

f. 126 ***Chapter 8.*** Pericope for the Passio of St James, 25 July.
[Heading omitted] Rubric: *Secundum Marcum.* Pericope: *In illo tempore, accessit ad ihesum mater filiorum zebedei cum filiis...* as in C (W 87) but

longer, continuing (f. 126v) *Nescitis quid petatis. Potestis bibere calicem quem ego bibiturus sum? Dicunt ei Possumus. Ait illis. Calicem quidem meum bibetis, sedere autem ad dexteram meam et ad sinistram non est meum dare uobis sed quibus paratum est a patre meo.* Response: *Tedecet laus.* Collect: *CL Esto domine plebi tue sacrificator et custos ut apostoli tui iacobi munita presidiis et conuersatione tibi placeat et secura deseruiat. Per.*
[Sermon of Bede omitted, W 87-93]

f. 126v *Chapter 2.* Pericope and Sermon of Calixtus for the Feast of the Vigil of St James, 24 July, Office.
[Heading omitted] Rubric: *Secundum Marcum.* Pericope, rubric, and text complete as in C, text inc. *Vigiliæ noctis sacratissimæ* (W 11) expl. f. 138v (W 35).

f. 138v *Chapter 5.* Sermon of Calixtus for the Feast of the Passion of St James, 25 July.
Rubric: *Sermo beati Calixti Pape* (shorter than C, W 38). Text complete as in C, inc. *Celebritatis sacratissime* (W 38) expl. f. 143v (W 48).

f. 143v *Chapter 6.* Sermon of Calixtus for the Feast of the Passion of St James, 25 July.
Rubric: *Sermo beati calysti pape* (shorter than C, W 48). Text complete as in C, inc. *Spiritali igitur iocunditate* (W 48) expl. f. 150v (W 61).

f. 150v *Chapter 7.* Sermon of Calixtus for the Feast of the Passion of St James, 25 July.
[Heading and pericope omitted]
Rubric: *Sermo beati calixti pape* (shorter than C, W 61). Text complete as in C, inc. *Adest nobis* (W 61) expl. f. 164 (W 87).

f. 164 *Chapter 12.* Pericope and Sermon of Calixtus for feria 4. in octave of St James, 28 July.
[Heading and pericope omitted]
Rubric: *Sermo beati Calixti pape* (shorter than C, W 110). Text complete as in C, inc. *Preclara sollemnitas* (W 110) expl. f. 170v (W 122).
[for further selections from Book I, see below]

f. 170v **Book II: 22 Miracles of St James**
[Heading omitted]
Prologue
Rubric: *Argumentum beati calixti pape de .xii.^{cim}* [sic] *miraculis sancti iacobi.*
Text complete as in C, inc. *Summopere precium est* (W 259) expl. f. 171.

f. 171 [Rubric omitted]
List of 22 Chapters as in C (W 259-260)
Text of Miracles complete, with rubrics and without chapter numbers, as in C (W 261-287) with *conscriptum* for *editum* in the rubric for Miracle 22 (copied by Hand 2 in C); expl. f. 184v.
[Explicit for Book II omitted, no Chi Rho]

f. 184v **Miracle of Alberic of Vézelay of 1139**
Rubric and text as in C (W 400-401), expl. f. 185.

f. 185 **Excerpt from Book V, Chapter VIII: Life of St Eutropius**
Rubric and text as in C (W 370-375)
Explicit passio beati eutropii episcopi et martiris (f. 188) [not in C].
[for further selections from Book V, see ff. 214v, 218, 218v, and comparative Table]

f. 188 **Further excerpts from Book I**

Repeated Selections from Chapter 2. Calixtus's Sermon for the Vigil of the Feast of St James, 24 July, Office. (see above)
[beginning omitted, W 11-22, line 17; see above]
Rubric: *Capitulum* [not in C]. Text inc. *Imposuit dominus symoni nomen petrus* (W 22, line 17, a repeat of L, f. 131)... expl. (f. 188v) *terre limitem Gallecie* (W 23, line 5); continues (f. 188v) with *[T]homas interpretatur* (W 28, line 1, a repeat of L, f. 132)...expl. (f. 188v) *dum in india martirum gladii pro eo accepit* (W 28, line 6).
Rubric: *versus* [not in C]. Text continues (f. 188v) with *Beatus fortunatus pictauensis presul... Siderei proceres...* (W 34, line 17, a repeat of L, f. 138v, see above)...expl. (f. 188v) *patefacta poli* (W 34, last line).

f. 188v *Verses* [not in C] follow without a break:
[Rubric omitted] Text inc. *Dederit preciosa queque pro cibo...* expl. (f. 188v) *ut acciperent dederunt.* [space for rubric] Text inc. *Deum time et mandata eius obserua...* expl. (f. 188v) *mandate eius obseruat.* Rubric: *versus.* Text inc. (f. 189) *Pulchre perquendam sapientem merite dictum* est...expl. *dies illa semper clarens.* [ruled line filler] Text inc. (f. 189) *Et erit eis verbum domini manda remanda manda remanda* [sic]... expl. *et capiendus est.* [Rubric omitted] Text inc. (f. 189) *Lilii vires diascorides medicine didascalus sic defecebit dicens...* expl. (f. 189v) *et serpentis morsum curat.*

f. 189v *Selection from Book I, Chapter 25* follows without a break:
Rubric: *Versus Calixti pape.* Text: *Salue festa dies iacobi veneranda tropheo...* expl.
(f. 189v) *subcine cantor. Amen.* (W 218-219)
[rest of Book I omitted]
Book IV: Pseudo-Turpin
[Opening heading omitted]
Prologue
Rubric: *Epistola beati turpini episcopi ad leoprandum.* [painted out in C]
Text inc. *Turpinus domini gratia archiepiscopus remensis* (this is treated as a rubric in C, VA, M, R; as text in S, P, T, SV, VB), text continues *Quoniam nuper mandastis.* expl. (as in C, W 301)
Chapter list of 25 chapters (as in C but without the last chapter, W 301-302)
Chapters 1-21
Text, each chapter preceded by a numbered rubric [not all in C are numbered], inc. *Gloriosissimus namque christi apostolus iacobus.* Continues as in C to Chapter 21 (C f. 180v, W 330), after which L has a different sequence of chapter divisions, some corresponding to textual breaks in other versions, although the text is substantially closer to C than to the A6 of MEREDITH-JONES or SMYSER's short version (cf. MS M, whose breaks are different).

f. 205v *xxii. Itaque peracto bello...* (W 330; MJ 184, Ch. 22).

f. 206v *xxiii. Deinde tuba sua...* (W 331; L's text is like MJ's A6, which also begins Ch. 23 here; MJ 192).

f. 207 *xxiiii. Domine ihesu christe...* (W 332)

f. 207v *xxv. Non decet...* (W 334; MJ 200, Ch. 24)

f. 208 *xxvi. Quid plura...* (W 334; MJ 202, Ch. 25)

f. 208v *xxvii. Crastina namque...* (W 336; MJ 206, Ch. 26)

f. 209 *xxviii. Tunc defunctorum...* (W 336; MJ 210, Ch. 27)
xxix. Et erant tunc... (W 337; MJ 212, Ch. 28)

f. 209v **Capitulum xxx.** *Beatum namque...* (W 337; MJ 212, Ch. 29)

f. 210 **Capitulum xxxi.** *Postea vero...* (W 338; MJ 216)
Capitulum xxxii. *Post hec viennam...* (W 338, Ch. 22; MJ 216, Ch. 30), with a rubric *De septem artibus. De grammatica* (f. 207v) and a sub-heading for each of the Liberal Arts; *Sed ualde...* (W 343, Ch. 23; MJ 234, Ch. 33) is given the heading *Miraculum* in L f. 212v and no chapter number, although the next chapter number has been corrected to 24 [*sic*, not 34], by a later hand using black ink.

f. 213 **Capitulum xxiii** (corrected to **xxiiii**). Rubric: *Calixtus papa de inuentione corporis beati turpini episcopi & martiris.* (as in C, W 344) Text: *Beatus namque turpinus...* (W 344); *Quid patrie...* (W 345, Ch. 25) has the heading *Calixtus papa* as in C but no chapter number; expl. (f. 214v) *munere remunerabuntur.* (W 347).
[rest of Book IV omitted]

f. 214v **Excerpt from Book V, Chapter VII: Julius Caesar**
Rubric: *Capitulum .i.* [not in C] Text as in C, inc. *Iulius Caesar ut traditur...* expl. (f. 214v) *ad dominum convertit.* (W 359, lines 10-31).
[rest of Chapter VII omitted, see Table of Book V]
Excerpts from Book V, Chapter VIII
[see also f. 185 above]
Rubric and text as in C: *De corporibus sanctorum qui in itinere sancti iacobi requiescunt que a peregrinis eius sunt uisitanda.* Text: *Primitus namque his.* (W 360) expl. (f. 217v) *quorum sollemnitas .v. kalendas decembris colitur.* (W 376)
[substantial gaps: see Table of Book V; see also ff. 218 and 218v below]

f. 217v **Song:** *Ad honorem*
Rubric: *Aimericus Picaudi, presbiter de partiniaco* (as in C [W 398] but with variant spelling). Text inc. *Ad honorem regis summi...* expl. (f. 218) *Eultreia esuseia decantemus iugiter.* (complete, as in A, VA, M; minor variants: *æcclesia* for *ecclesia; viso* for *uiso; galleciæ* for *galecie; abysso* for *abisso; sollemniter* for *sollempniter* [W 398-399, transcribed from C and A]).

f. 218 **Further excerpts from Book V, Ch. VIII: St Martin**
[see also ff. 185, 214v, 218v, and Table of Book V]
Rubric: *Capitulum.* [not in C] Text inc. *Beati martini episcopi & confessoris corporis dignum visitandum est...* expl. (f. 218) *divulgatur. Cuius festivitas celebratur tertio idus Novembris.* (W 369)
False bull of Innocent II
Rubric and text as in C (W 399-400), with minor variants: *cayxto* for *calixto; socia* for *sotia; actione* for *accione; apocripha* for *apocrifa;* rubric *Cardinalis* before each signatory [not in C]; *aymericus cancellarius* for *aimericus cancellarius; lumbardus* (mistranscribed *Lombardus* in W; C has *lumbardus*) expl. f. 218v.

f. 218v **Further excerpts from Book V, Ch. VIII: SS. Isidore, James and explicit**
[see also ff. 185, 214v]
Text as in C, but with rubric *Capitulum* before each paragraph [not in C; see Table of Book V and Latin text] Text inc. *Apud urbem legionem...* expl. (f. 218v) *Hii prefati sancti cum aliis omnibus sanctis* + dox. (W 376)

f. 219 **Additions in 17th- or 18th-century hands**
The top eight lines of the recto are palimpsest; the original text looks 12th-century.
Latin prayer, inc. *Ihesus nazarensis rex judeorum...triumphalis*
Latin suffrage for King Alfonso I of Portugal (1128-85), inc. *Commemoratio Beati Regis Alfonsi Primi Portugalliæ. Antiphona. Inuictissime* Text inc. *alfonse propugnator strenue...Oratio. Deus omnium bonorum largitor melliflue...*

printed in BRITO, 3, 1632, p. 269, cited in *Index* 1775, p. 308. Cf. Alcobaça MSS CCXIII and CCXXVIII

Note on King Alfonso I of Portugal, in Portuguese, inc. *Este bom rei dom Alfonso...* (See **Provenance** above.)

f. 220 Blank

f. 221 Back pastedown

Sigla:

Meredith-Jones: not included

Hämel: C1

Mandach: D200

Díaz y Díaz: A

Bibliography:

Alcuin, see PL 101, cols. 657-664; Black, 1990, pp. 57-61; Brito, 1597-1727, repr. 1689-1752, cf. esp. 3, 1632, p. 269; Burnam, 1912, 1925; Castets, 1880; Confins, 1993; David, 1946, pp. 33-41; id., 1951, pp. 180-188; Derolez, see Guibert of Gembloux, 1988; Deug-Su, 1983, pp. 167-193; Díaz y Díaz, 1988a, pp. 139, 312, 327; Dolbeau, 1984; Duchesne, 1900; Erdmann, 1951; Feige, 1978; Fletcher, 1984; Fontaine, 1967-9; Gaiffier, 1971; García Alvarez, 1961, pp. 217-219; id., 1963-67, no. 99; García Villada, 1929-36, I, pp. 369-370; Garvin, 1946, pp. 1, 448; Gregory of Tours, 1951/1965; id., 1885/1969; *Index codicum Bibliothecae Alcobatiae*, 1775, pp. 133-134; *Inventario dos codices alcobacensis, IV* [Anselmo], intro. A.F. Ataide e Melo, 1930-32, pp. 307-309; *Commentariorum*, pp. 265-267; Guibert of Gembloux, ed. Derolez, 1988; Halm, 1866; Hämel, 1950, pp. 70-72; id., 1953, IV, pp. 67-85; Hohler, 1972, pp. 58-61; Mandach, 1961, I, pp. 124-126; id., 1990, pp. 41-57; Meredith-Jones, 1936, repr. 1972, cited here as MJ; Moisan, 1985, 1992, pp. 83-104; Mundó, 1952; Nagel, 1964; Nascimento, 1985; Peres, 1967, pp. 55-74; Reilly, 1968; Rosa Pereira, 1981, pp. 27-33, pl.l; id., 1985, pp. 133-137; Smyser, 1937, repr. 1967; Stegmüller, 1960, I, pp. 151-164; Stones, 1991, p. 625; Stones/Krochalis, 1995, pp. 23-25, fig. 7.

A. London, British Library, Additional 12213

Jacobus

Long Version

c. 1325, Spain, probably copied in Santiago

Parchment, 1 + ii +191+ 1 ff. The manuscript has been foliated twice, the first foliation (?18th century) numbered f. 107 twice, but the error was caught at f. 111; from 111 to 118 the two foliations agree; the first foliation also omits f. 119 and is off by one from f. 120 to the end. A correct foliation was added at the British Museum in 1929 (as noted on the back paper flyleaf). We follow this second foliation. 222 x 155 mm. Written space 160 x 102 mm. Text written in one column, 31-36 lines, written in light brown ink. Frame and line ruling in lead point. (*Ills. 47–51*)

Quires: 1-7 12, 8 8, 9-11 12, 12 11 (12-1 wants 5, already missing by first foliation), 13-15 12, 16-17 8. Catchwords.

Script: The main body of the text is by a single hand, not the same, but of the same period, as those of VA, S, and the Santiago Cartulary, Tumbo B (SICART, 1978, STONES, 1981, p. 202 and MORALEJO, 1985e, pp. 60-62, pl. xxix). Clear, widely spaced, rounded *textura* with no broken strokes. Minims finish with a slight curve to the right. The 'a' is slightly headed; long 's' is used initially and medially, but round 's' finally; 'g' is closed top and bottom; top flat, extending outward to the right. Bitings of 'e' and 'o' occur only with rounded letters; 2-shaped 'r' occurs only following rounded letters. The common mark of abbreviation slants downward to the right. The 9-shaped '-us' abbreviation sometimes comes on the line, sometimes above it. The uncrossed Tironian nota is used for 'et'. Ascenders and descenders have very slight wedges. Capitals at the beginnings of sentences are ornamented with double vertical strokes (cf. VA and S). The colophon on f. 183v is certainly written with a different and thinner pen, and most likely by a slightly later hand (see discussion under Provenance, below).

There are numerous marginal annotations in an 18th-century hand in the main text. The last quire, containing a Spanish commentary on Job, with biblical quotations in Latin, is in a 14th-century cursive hand; it had already been added to the codex by 1375 (see below under Provenance). The Job commentary is mentioned in WARD, 1888, but is not included in any subsequent study of Spanish biblical commentaries.

Rubrics: Rubrics, including the Chapter list, are written in red by the scribe, but using a thinner pen.

Musical Notation: None. No spaces left blank for it.

Decoration: Pen-flourished initials in red and mauve or red and blue ink, some with fish in the borders; pen-drawn lion and castle of León and Castile (but not in a shield, nor painted in full colour) on f. 1. Pen-flourished decoration closely similar to that in VA and S, and also to those in Tumbo B.

Illustration: One historiated initial, f. 3v: St James

One miniature, f. 132v: Dream of Charlemagne.

[A missing folio between ff. 132v and 133 probably accounts for the absence of the double-register warriors scenes and the Turpin initial that are in C and VA]

These illustrations are painted in line drawing with light colour wash, closely similar in style to the illustrations in VA, S, and Tumbo B (see *SANTIAGO CAMINO DE EUROPA*, 1993), p. 108 and no. 116; for MS A, see no. 104; for MS S, see no. 105. Both A and Tumbo B give St James cockle shells on his halo (STONES, 1981).

Binding: Brown leather and cloth, 1980.

Provenance and History:

There are no direct indications as to when and where the manuscript was made, though, as A's text and illustrations depend directly on C, and are closer in style to Tumbo B's miniature of *c.* 1326, A is likely to have been made in Santiago, probably under Archbishop Berenguer de Landoria, OP (1317-30). DÍAZ Y DÍAZ, 1983), has suggested that Berenguer may have been the organizing force behind the early 14th-century copies of CC: A, VA and S; and, we would add, SV's exemplar. Berenguer de Landoria was Master General of the Dominican Order and, according to the preface to Tumbo B, was interested in the cult of St James: *'de suis originalibus [relics] transferentur et translata in uno libro quasi in uno corpore comprehenderentur...'* (cited by LOPEZ FERREIRO, 1903, repr. 1983, App. p. 74). In addition to assuring the preservation of the *'uno libro'* which recorded the Translation, he got his kinsman, the treasurer Aimericus of Antioch, to compile a cartulary of the subsequent cathedral documents, Tumbo B. Tumbo B, according to its preface, was completed in 1326; Berenguer died in 1330 after a rather stormy reign. Once more, an energetic archbishop died before a grandiose scheme of dissemination of Jacobean manuscripts could be fully implemented. The presence of the arms of León and Castile in the bottom border of f. 1 might lead one to suppose that the book was made for the King; but we show here that, a little more than a generation later, before 1375, MS A had been acquired by Pedro de Luna, the future Pope Benedict XIII. A colophon (fully transcribed below) was added by a scribe who seems to claim to have personally copied the text (which must have been done a generation earlier) for Luna, as it ends, *Et a domino petro donum piissimum non admittat.* The wording also suggests that the prelate had not yet become a cardinal.

That is confirmed by the presence of MS A in the inventory of Luna's books, made when he did become a cardinal in 1375. It is simply described: 1556. *Item epistola beati Calixti pape, cooperte de viridi, incipit in secundo folio magna, et finit in penultimo: sepulchro* (EHRLE, 1890, p. 553, Lun 1556). Not only does the secundo folio reference match MS A, but the last word on the penultimate folio does as well: it is part of the Job commentary, for which the date of the inventory therefore provides a *terminus ante quem.* After Pedro de Luna became (anti)pope as Benedict XIII in 1394, MS A was listed as no. 13 in the inventory (dated 1405-1407 by JULLIEN DE POMMEROL/MONFRIN, 1991, I, p. 136, Stu 13) of the books in his special library, the *Studium: Item epistola beati Calixti pape coopertus de viridi.* In the earliest inventory of Benedict XIII's Great Library at Peñiscola, dated 1412-15 by Jullien de Pommerol and Monfrin, it was no. 575: *Item sermones Calixti ex dictis diversorum sanctorum doctorum, et multa alia ad laudem beati Jacobi et ejus corporis et sepulcri in* [MS *et*] *Compostella.* (ed. FAUCON, 1886-87, II, pp. 43-150, Pa 375); and finally it was in the Great Library at Benedict XIII's family castle at Peñiscola near Valencia to which he retired in exile from Avignon, where it was no. 559 in the inventory made at his death in 1423: *Item Sermones Calixti pape et alique littere sue et alique Legende sanctorum et Descriptio visitationis sancti Jacobi in Castella, cum copertis de viridi, et incipiunt in secondo folio magnaque et finiunt in eodem similiter ad.* (JULLIEN DE POMMEROL/MONFRIN, 1991, I, p. 478, Pb 559). Daniel Williman has identified and kindly passed on to us a list of thirteen further hitherto unidentified manuscripts that were in Luna's library (Gerona Cathedral, Bible of Charles V [Lun. 1484]; Paris, BN, lat. 2072 [Lun. 1530], 2743 [Lun. 1531], 3360 [Lun. 1644], 3657 [Lun. 1582], 4046 [Lun. 1638], 4904 [Lun. 1616?], 5154 [Lun. 1640], 5514 [Lun. 1625] identified from the lists in JULLIEN DE POMMEROL/MONFRIN, 1991. Williman's own database has allowed him to add Paris, BN, lat. 2521 [Lun. 1593], 5099 [Lun. 1488], Reims, BM, 514 [Lun. 1592], and Vatican City, BAV, lat. 543 [Lun. 1596]. None of those in the BN, Paris, are in hands that resemble that of 'Laborans', nor do they include colophons of their own, nor any indications of Luna ownership.

The additional note in the 1423 inventory gives clues as to the subsequent fate of MS A: *Fuit traditus liber iste magistro Subirats pro provisione.-A.* (ibid.) This indicates that, like many books in this inventory, the manuscript was bartered by the bankrupt court for services rendered; a second item also went to Subirats, no. 580.

Who Master Subirats was is not altogether clear, and we have been unable to narrow the choice any further between the candidates proposed by Jullien de Pommerol and Monfrin: Jean 'Sobirani', priest of the diocese of Elne, bachelor of laws and treasurer of the University of Perpignan in 1394 (JULLIEN DE POMME-ROL/MONFRIN, 1991, I, p. 478, citing FOURNIER, 1890-94, II, p. 683), or Joan Sobirats, bachelor of laws at Lérida and rector of the University in 1393, at Zaragoza in 1393 and 1394 (JULLIEN DE POMMEROL/MONFRIN, 1991, I, p. 478, citing MATEU-IBARS, 1984, p. 198) or another person of the same name, sacristan of Belpuig in 1402 (JULLIEN DE POMMEROL/MONFRIN, 1991, I, p. 478, citing MOLLAT, 1905, p. 24).

There is at present nothing to connect any of the Sobirats or Subirats individuals with what has been surmised about A's subsequent history. DÍAZ Y DÍAZ, 1988a), p. 136, suggests that A may be the manuscript which belonged to the Galician antiquary and Benedictine monk Fra Martín Sarmiento (1695-1772), who was born at Villafranca near Santiago and entered the monastery of S. Martín, Alcalá (near Madrid), in 1710, at the age of 15 (PARDINAS VILLALOVOS, 1887, pp. 179-180). Sarmiento collected over 6,500 volumes (VESTEIRO TORRES, 1879, Appendix, pp. 53-59). PENSADO, 1987, p. 174, mentions among his manuscripts: 'Un códice manuscrito precioso y raro en 4.º y pergamino, con 184 hiojas, Latín y con caracteres del siglo XIV. Contiene todo lo que Calixto II escribió del apóstol Santiago. Un Itinerario de Francia a Santiago. La Historia de Carlos Magno de Turpín, variante de la impresa. 1, 4º'. Although the texts in A are not in this order, and the commentary on Job is not mentioned, A, of all the surviving manuscripts of CC, is the only one whose number of folios could have, at the time, numbered 184; the original component of the manuscript, comprising the CC, totals 183 folios, now so foliated; Sarmiento could have been following the first, inaccurate foliation, as described above, and discounting the Job commentary. As noted above, the present foliation, correcting an earlier foliation, was done in 1929. A was described as a manuscript 'in quarto' in the British Museum *Catalogue*, 1850.

The manuscript was acquired by the British Museum on 4 December 1841, from the London bookseller Thomas Rodd (1796-1849), and is listed as item 154 on p. 21 of his 1839 Catalogue; the entry, with the Museum's notice of purchase, is pasted to the front flyleaf. Rodd frequently acted for the ardent bibliophile Francis Douce, who left him and his brother, the art dealer Horatio, fifty pounds each in 1834.

That Rodd had a personal interest not only in Spain—his father Thomas (1763-1822) and grandfather Charles had both lived in Alicante—but in the component texts of the CC is indicated by his translation of Turpin's *Chronicle*, published in 1812 and reprinted by MORLEY in 1884. Rodd's *Turpin* is followed by a transcription of Spanish Ballads with his own English translations. The exact edition used by Rodd, cited by him as 'Spanheim on the Ecclesiastical Writers', has not been traced. The *De scriptoribus ecclesiasticis* of Johan Tritheim, Abbot of Spanheim (or Sponheim), published in 1492, gives a series of brief synopses that include Calixtus II, but does not include a full *Pseudo-Turpin*. Tritheim was not a believer in the 'authenticity' of *Pseudo-Turpin*. He omits (deliberately, according to SHORT, 1972, pp. 129-130), any mention of it in his *De origine gentis francorum compendium*, edited by M. Freher in 1514.

HYDE (editor of the Irish *Pseudo-Turpin* translation, 1917), noticed that Rodd's translation, and presumably therefore his Latin model, was in 32 Chapters, omitting the Liberal Arts and the building fund of St-Denis, ending with the death of Charlemagne and lacking C's Chapters 25 and 26, attributed to Calixtus. These are all in A, and suggest that Rodd worked from a copy that transmitted another recension (cf. the A6 version of MEREDITH-JONES). HYDE, who collated the Irish version of *Pseudo-Turpin* against the 1584 Frankfurt edition of Justus Rubeus, as the closest early printed edition he could find, also notes that 'If Rodd has translated literally, the text he worked from is different from the Frankfort text and that of Castets' (p. 125). CASTETS (1880) worked, in fact, from manuscripts in Montpellier

of the *Libellus*. RODD's introduction to his 1812 edition says (p. iv) that he knew from Fauchet of the existence of several editions of *Turpin*, of which he specifically mentions London, BL, Royal A. xviii, the printed edition in *Germanicarum rerum quatuor Chronographi*, Frankfurt, 1566, and a French translation, *La Chronique de Turpin*, printed in Lyon in 1583, as well as *Spanheim's Ecclesiastical Writers*. The likelihood is that, in 1812, Rodd had not yet acquired MS A.

The preface to the Ballads suggests that Rodd's knowledge of Spain was based in part on personal experience: 'Few gentlemen, I believe, have visited Spain without contracting a great predilection for the ancient literature of the country…' (RODD, 1812, p. 4). At the end of volume II is a list of Spanish Books sold by T. Boosey and T. Rodd. Although nothing indicates so directly, it would appear likely that Rodd acquired MS A in Spain sometime between 1812 and 1841 when the British Museum purchased it from him.

Secundo folio: *magnaque*

Contents:

f. 1 **Title**: *EX RE SIGNATUR IACOBUS LIBER ISTE VOCATUR. IPSUM SCRIBENTI SIT GLORIA SITQUE LEGENTI.* as in C (W 1)
Book I: Liturgy of St James
Opening heading, Prologue and Chapter list of 31 chapters as in C (W 1-6)
Texts for the Office and Mass of the feasts of St James on 25 July, 3 October and 30 December and the vigils and octaves; as in C, but without music (W 6-257)

f. 111 *Explicit* as in C, but with *FINIT* for *FINIS* (W 257)
Book II: 22 Miracles of St James
Opening heading, Prologue, Chapter list of 22 chapters, Text and Explicit as in C but without the Chi Rho monogram at the end of the explicit (W 259-287)

f. 126v **Book III: Translation of St James**
Opening heading, Chapter list of 4 chapters, Prologue, Text and Explicit as in C (W 287-299)

Leaf missing (between ff. 132v-133), presumably contained the opening full-page miniature, heading (painted out in C, preserved in VA), and Prologue in the form of the letter to Leoprand which begin Book IV in C (W 301)

f. 133 **Book IV: Pseudo-Turpin**
Chapter list of 26 chapters, text as in C (W 301-348)

f. 159v Explicit: *Finit codex quartus.* [not in C]. Text printed from VA, but with occasional readings from this manuscript, by THORON, 1934).
Book V: Pilgrim's Guide
Long Version as in C (W 349-389); see Table of Book V.

f. 180v *Explicit and colophon* as in C (W 389)

ff. 180v-182v **Songs**
Rubrics and texts as in C (W 391-398), but without musical notation, staff lines or space for them. The song *Ad honorem regis summi* preserves (with the exception of one skipped line) the last nine strophes now missing from C after f. 220 (*olim* 190). These are printed from A in W 398-399, with the missing line from LE CLERC, 1847. See also MSS VA, M, L.

ff. 182v-183 **Part of a Mass**
Inc. *Rex inmense pietatis deus suscipe hanc oblacionem…* expl. *una cum famulo tuo papa nostro illustrissimo.* [transcribed and commented in HOHLER, 1972,

p. 72. Not now preserved in C; the Postcommunion fragment in C f. 221 (W 399) is not copied in A.]

f. 183 **False bull of Pope Innocent II**
Text and signatories as in C (W 399-400)

f. 183v **Alberic of Vézelay's Miracle of 1139**
Rubric and text as in C (W 400-401)
Alleluia in Greek
Rubric and text as in C (W 401) but lacking the last two words in C:
Cantor. Alleluia. expl. *oy ustis. Chorus. Quod est filii.*
[Rest of C's texts omitted]
Colophon, in a different hand or written with a different pen, *Iam liber est scriptus qui scripsit sit benedictus*
Qui scripsit scribat et semper cum domino vivat laborans
Et a domino petro donum piissimum non admittat

ff. 184-190 **Commentary on Job** [not in C]
In Spanish, but with all biblical quotations in Latin. Not in the main text hand, nor part of the original quire structure, but part of the manuscript by the first foliation.
Heading, badly worn and difficult to decipher. *Dominus spiritus alleluia(?) nobis gratia domine*
Text inc. *Job estando en el munadal...*expl. *mal lugar non faga morada.*

f. 190v Pen trials, including *Rotulandus coreo; Rotulandus;* several R's

f. 191 Blank

Sigla: Meredith-Jones: B 2

Hämel: C2

Mandach: B 2

Díaz y Díaz: L

Bibliography: *Catalogue of the Additions to the Manuscripts in the British Museum in the Years MDCCCXLI—MDCCCXLV*, 1850, repr. 1964, p. 53; David, 1946, p. 31; Díaz y Díaz, 1983; id., 1988a, pp. 136-137, 192-194, 235, 253, 327, 335; *The Douce Legacy: An Exhibition to commemorate the 150th anniversary of the bequest of Francis Douce (1757-1834)*, 1984; Ehrle, 1890, p. 553; Faucon, 1886-87, II, pp. 43-150; Fournier, 1890-94, II, p. 683; Fredericksen, 1988, 1990 (forthcoming volumes include reference to Horatio Rodd); *Germanicarum rerum quatuor celebriores, vetustioresque chronographi, earum descriptionem ab orbe condito usque ad tempora Henrici IV Imperatoris...*, 1566; Hämel, 1943, p. 240; id., 1950, p. 72; id., 1953, IV, pp. 67-85; Herbers, 1984, p. 33; Hohler, 1972, pp. 31-80, esp. p. 72; Hyde, 1917; Jullien de Pommerol/Monfrin, 1991, I, pp. 136, 478; Le Clerc, 1847; Lejeune/Stiennon, 1966, I, p. 58; López Ferreiro, 1903, repr. 1983, IV, chs. 1 and 2; Mandach, 1961, p. 395; Mateu-Ibars, 1984, p. 198; Meredith-Jones, 1936, repr. 1972, pp. 9-10; Mollat, 1905, p. 24; Moralejo, 1985e, pp. 60-62; Morley, 1884 for Rodd's translation of Pseudo-Turpin; Pardinas Villalovos, Soto y Romero de Camano, La Coruña, 1887; Pensado, 1987, p. 174 (see also Sarmiento); [Rodd], 1812; id., 1839, p. 21; *Santiago Camino de Europa*, 1993, no. 104 (dated *c.* 1330); also nos. 103, 105 and 116; Sarmiento, 1745, ed. Pensado, 1975; Sicart, 1978; Smyser, 1937, repr. 1967, pp. 1, 2, 5f., 52, 54, 108f.; Stones, 1981, pp. 197-218, pls. 14.5, 14.9; ead., 1991, pp. 625, 627; ead., 1992, pp. 137-146; ead., 1996, figs. 10, 17; Stones/Krochalis, 1995, pp. 26-28, 35, fig. 9; Thoron, 1934; Tritheim, 1494; Vesteiro Torres, 1879, 6; Ward, 1888, repr. 1961, I, pp. 562-574, 951-953; Whitehill, 1944, pp. 398-399; Williman, private communications, 1994.

VA. Vatican City, Biblioteca Apostolica Vaticana, Archivio di San Pietro, C. 128

Jacobus
c. 1325, Spain, probably copied in Santiago

Parchment, iv + 181 + iv ff. First leaf (here numbered 0) says 'vitello', second, third and fourth are numbered I, II and III in modern pencil. Last two leaves glued together, numbered 182 and 183 in hand of original foliation and 183 in modern pencil. 375 × 260 mm. Written space 235 × 160 mm between inner vertical rulings. Text in one column (although this is the largest of the extant copies of CC, cf. MS S, written in 2 columns), 32 lines. (*Ills. 52–62*)

Quires:	15^{12} plus one flyleaf at end (blank). Catchwords throughout.
Script:	One hand throughout. The hand is not the same, but is of the same period, as those of MSS VA, S, and the Santiago cartulary Tumbo B (*SANTIAGO CAMINO DE EUROPA*, 1993, no. 103). Rounded, well-spaced *textura*, with forked ascenders; minims finish with a rounded curve to the right. Characteristic letters include round-backed uncial 'd', headed 'a', 'g' closed, or almost closed, at the bottom; hair-line finials on final 'e', 'h', 'x'; the uncrossed Tironian nota for 'et'. The 9-shaped mark of abbreviation is on the line for 'con' and above it for 'us'; common mark of abbreviation is small and slightly slanting; round 's' occurs only finally. There are double strokes through capital letters at the beginnings of sentences (cf. A, S, and Tumbo B). Document hand is used for the false bull of Innocent on f. 180-180v.
	There are occasional marginal notes in black ink in a post-medieval cursive hand.
Rubrics:	In red.
Musical Notation:	Two-line spaces left on ff. 84v-94v (W 193-212), 96-116v (W 215-257), 174-179v (W 391-399); accompanying text spaced for notation.
Decoration:	22 large pen-flourished initials in red and mauve, some with fish borders, on ff. 3v, 15v, 16, 17, 38v, 41, 46, 47v, 55, 56v, 60v, 62, 78, 82v, 90, 118, 129, 132, 135v, 144v, 157, 166. Pen-flourished initials closely similar to those in A and S.
Illustration:	Four foliage and dragon initials, copied from C, ff. 21, 17, 79v, 117.
	Three portrait initials, copied from C: f. 1, Calixtus; f. 3v, St James; f. 134v, Turpin.
	Two miniatures, copied from C: f. 133v, Dream of Charlemagne; f.134, miniature in two registers: Charlemagne and his army ride out from Aachen; knight and men outside Aachen. For the portrait and foliage initials and the miniatures, see also A and S, and the Santiago Cartulary Tumbo B (*SANTIAGO CAMINO DE EUROPA*, 1993, p. 108 and nos. 103, 104, 105, 116).
Binding:	Brown leather, fillets in lozenge within rectangle, stamped with arms of the Archivio di San Pietro, a papal tiara and crossed keys. Possibly 18th-century.
Provenance and History:	The manuscript has no direct indications of medieval provenance, but the fact that its illustrations are based on C, and close in style to those of the Santiago cartulary Tumbo B, indicate that it was probably made in Santiago under Archbishop Berenguer de Landoria (1317-30), OP. The manuscripts is listed, in the category of 'Historia Ecclesiastica' under the title *Calixti 2 de vita S. Jacobi Zebedei, de Carolo Magno et itinere ad Galician et aliis*, in the unpublished catalogues of 1598 and 1603 which list the manuscripts bequeathed to St. Peter's by Cardinal Giordano Orsini (d. 1438). He probably acquired it in Spain where he was sent as papal legate to negotiate with Antipope Benedict XIII, Pedro de Luna, himself the owner of A. On Orsini's career: Archbishop of Naples in 1400, cardinal in 1405, bishop of Albano 1412, bishop of Sabina 1431, see GAMS, 1957, pp. XXIII, 905; EUBEL, 1960, I, p. 26; AUBERY, 1632-49, II, pp. 7-9; CARDELLA, 1792-97, II, pp. 321-2. Jacomo Grimaldi

(d. 1623), archivist from 1581, made a copy of the Sermon of Leo (Book III, Ch. 1) for Borromeo, Archbishop of Milan, for the Ambrosiana (AASS, Julii VI). A slip glued to the left margin of f. 1 reads *Calixti Pape 2 uita et Miracula B. Jacobi n° 18*. The hand looks 19th-century. The manuscript is not among those listed in MERCATI, 1938.

Secundo folio: *in hoc codice*

Contents:

f. 0 v **Tabula**, in a cursive hand contemporary with the manuscript.
Nota quod iste liber di... (rest erased or never completed; repeated on f. iii v)

f. iii v **Tabula**, in a cursive hand contemporary with the manuscript: *Nota quod iste liber dividitur in quinque libros parciales et capitula primi libri Incipiunt folio 2°.*
Secundi libri folio 117°
Tercii libri folio 129°
Quarti libri folio 134°
Quinti libri folio 156°
an erased inscription beneath

f. 1 **Title:** *EX RE SIGNATUR, IACOBUS ISTE LIBER VOCATUR. IPSUM SCRIBENTI SIT GLORIA SITQUE LEGENTI.* (W 1)
as in C (W 1)
Book I: Liturgy of St James
Opening heading, Prologue and Chapter list of 31 chapters as in C (W 1-6)
Texts and spaces for music for the Office and Mass of the Feasts of St James on 25 July, 3 October and 30 December and the vigils and octaves as in C, but with the notation not inserted (W 6-257)

f. 117 *Explicit* as in C but with *FINIT* for *FINIS* (W 257)
Book II: 22 Miracles of St James
Opening heading, Prologue, Chapter list of 22 chapters, Text and Explicit as in C but without the Chi-Rho monogram (W 257-287)
Edited from the Marchiennes MS, Douai, BM 842, collated with this manuscript in AASS, Julii VI, pp. 47-58.

f. 129 **Book III: Translation of St James**
Opening heading, Chapter list of 4 chapters, Prologue, Text and Explicit as in C (W 287-299)

f. 134 **Book IV: Pseudo-Turpin**
Opening heading: *INCIPIT CODEX IIII SANCTI IACOBI DE EXPEDIMENTO ET CONVERSIONE YSPANIE ET GALECIE EDITUS A BEATO TURPINO ARCHIEPISCOPI* [painted out in C, missing in A; cf. SV, R, VB; for a longer version, P; for variant versions, M, T]

f. 134v Rubric: *EPISTOLA BEATI TURPINI EPISCOPI AD LEOPRANDUM. DOMINE GRATIA TURPINUS ARCHIEPISCOPUS* [painted out in C, missing in A]
Prologue, Chapter list of 26 chapters as in C (W 301-302)

f. 135 Rubric: *HIC INCIPIT LIBER QUARTUS* [*QUARTUS* omitted in C] (W 302)
Text as in C (W 302-348)

f. 156v Explicit: *Finit codex quartus.* [not in C].
Text printed from this manuscript with occasional readings from A by THORON, 1934.

f. 157 **Book V: Pilgrim's Guide**
Long Version as in C (W 349-389); see Table of Book V.

f. 174 expl. *diligenter procurandi.* (W 389). A two-line space follows, then the **Explicit** for Book V: *Ipsum scribenti sit gloria sitque legenti.* (W 389).
[No colophon; several lines of space are left blank]
Songs
Rubrics and Texts as in C (W 391-398) with space for music. The song *Ad honorem regis summi* preserves the last nine strophes now missing from C after f. 220 (*olim* 190). These are printed in W 398-399 from A; see also MSS M, L.
[Mass in C omitted (W 399); partially preserved in A, ff. 182v-183]

f. 180 **Alberic of Vézelay's Miracle of 1139**
Rubric and Text as in C (W 400-401)
Bull of Pope Innocent II (C f. 221, W 399-400)
written in document hand.
Text and signatories as in C (W 399-400)
[Rest of C's texts omitted]

f. 181 Blank

Sigla: Meredith-Jones: not included

Hämel: C3

Mandach: B 19

Díaz y Díaz: V

Bibliography: AASS, Julii VI, pp. 47-58, 80-103, 185; David, 1946, p. 31; Díaz y Díaz, 1983; id., 1988a, pp. 129, 137, 192, 229, 235, 253, 327, 335; Hämel, 1943, p. 240; id., 1950, p. 72; id., 1953, pp. 67-85; Herbers, 1984, p. 33; Hohler, 1972, pp. 31-80; Inventarium, 1598, f. 91, no. 18; Inventarium, 1603, f. 112, no. 18; Lejeune/Stiennon, 1966, I, p. 57, fig. 32; Mandach, 1961, p. 395; Mercati, 1938; Meredith-Jones, 1936/1972, pp. 9, 17 n.1, 42-46; Poncelet, 1909, pp. 39-40; Sicart, 1981, pp. 156-157; *Santiago, Camino de Europa*, 1993, p. 108 and no. 103 (dated second half of the 14th century by Díaz y Díaz); see also nos. 104, 105, 116; Smyser, 1937/1967, pp. 1, 2, 5 f., 52, 54, 108 f.; Stones, 1981, pp. 197-222, pl. 14.2, 14.4, 14.8, 14.13, 14.16, 14.22, 14.24, 14.26, 14.28, 14.30, 14.32, 14.34; ead., 1991, p. 625; ead., 1992, pp. 135, 145; ead., 1996, figs. 6, 8, 12, 16, 20; Stones/Krochalis, 1995, pp. 26-27; Thoron, 1934 text edited from this manuscript; unnumbered plates following text reproduce ff. 133v, 134, 134v.

S. Salamanca, Biblioteca Universitaria, 2631

Codex Calixtinus

c. 1325, Spain, probably copied in Santiago

Parchment, 2 (modern paper) +120 + 2 (modern paper; numbered 121-122) ff., 337 × 245 mm. Written space 255 × 180 mm. Two columns, 39 lines. Frame and line ruling in lead point. No rulings visible on ff. 73-75, 76 and 77 (ruling on ff. 76v and 77v).

Although not the largest of the extant CC manuscripts (see VA) this is the only one whose text is written in two-column format. See, however, Tortosa, Bib. Cap., 197, which is written in two columns; it measures 400 × 230 mm, and contains a selection from Books II and III of CC: Book II, Prologue and miracles 4, 6, 12, 20, 3, 5, 17, 22. The rubric announces 22 miracles, but only this selection is included. From Book III, Ch. 2 is included. See BAYERRI BERTOMEU, 1962, pp. 353-355, and DÍAZ Y DÍAZ, 1988a, p. 128, who considers its textual affiliations problematical. The possible implications of this for place and date of S's immediate exemplar are discussed under Tortosa in Lost Manuscripts in the Collation essay (pp. 197-240). There is a facsimile edited by GARCÍA PIÑERO and ORO TRIGO, 1994. (*Ills. 63–72*)

Quires:	1^8, 2^{10}, $3\text{-}5^{12}$, 6^{10}, 7^{12}, $8\text{-}9^{10}$, $10\text{-}11^{12}$. Catchwords and some quire signatures.
Script:	The scribe was careless in many ways, omitting words, phrases, passive endings on verbs, confusing the abbreviations for *ut* and *non*, and muddling the various words abbreviated as q-.
	The script is more professional than the Latin. Both words and lines are more closely spaced than in the contemporary CC copies, A and VA, and the Santiago cartulary Tumbo B, and the scribe writes with a thicker pen. He uses short, wedged, ascenders and descenders; minims finish with a slight curve to the right; he uses round-back uncial 'd'; 'a' is usually headed, but sometimes closed into a two-compartment form; he puts trailing finials on 'x' and 'h'; 'g' is usually closed top and bottom. Long 's' is used initially and medially, but round 's' finally; 'y' is dotted; 'c' and 't' are still distinguishable because the shaft of 't' protrudes slightly through the cross bar (cf. VA and A). Though other abbreviations are frequent, *et* is usually written out in full. The 9-shaped abbreviation for *-us* is always above the line. The common mark of abbreviation is curved. Capital letters at the beginning of sentences are often ornamented with a double vertical stroke (cf. A, VA, and Tumbo B).
Rubrics:	In red.
Musical Notation:	One-line spaces left between ff. 60 and 77 and filled with a single red line; text beneath is written smaller than the rest of the text, to accommodate notation which was never added.
Decoration:	Pen-flourished initials in red and mauve, and red and blue. On f. 1v: Chi Rho monogram in blue with red flourishing. Pen-flourished decoration closely similar to that of A and VA. Numerous errors in the selection of the small pen-flourished capitals, e.g. *Hoscat* for *Noscat* (f. 88), *Eltorum* for *Multorum* (Miracle 20, f. 85), *Erithmetica* for *Arithmetica* and *Ostronomia* for *Astronomia* (f. 103v), and others in the text of the *Guide,* recorded in our Latin notes.
Illustration:	Three historiated initials:
	f. 1: initial cut out [presumably a portrait of Calixtus].
	f. 2v: 'I' initial: St James as Pilgrim
	f. 90v: 'T' initial: Vision of Turpin. Accompanied by kneeling clerics, Turpin sees the souls of Roland and his companions borne in a napkin to Christ and the Blessed Virgin in Heaven as a devil flies off.

Two miniatures:

f. 90: full-page miniature in three registers: Dream of Charlemagne; Charlemagne and his army setting out from Aachen; knights and men holding weapons.

f. 120: miniature: St James Matamoro on horseback (*ill. 72*)

These are similar in style to the illuminations in A, VA and Tumbo B, but, unlike the arrangement in C, A, and VA, the three narrative miniatures are all on the same page. The scenes are also differently configured, and differ in details. St James points to scenes at the sides, showing Christians being killed by Saracens. These additional details illustrate the reason why St James asks Charlemagne to mount the Spanish crusade. They have no parallel in C, A, and VA. In the third scene, showing the warriors with civilians, Roland holds a rectangular banner *paly or and gules*; the arms of Aragon have been suggested (see PASTOREAU, 1980a; RIQUER, 1983, and POPOFF, 1989). But below a civilian holds a shield *fessy or and sable*. It may be no more than coincidence, but Queen Isabelle of Portugal (1271-1336) made a pilgrimage to Santiago in 1326, in memory of her husband. As the daughter of King Peter III of Aragon, her family arms would fit those in the miniature (*SANTIAGO CAMINO DE EUROPA*, 1993, pp. 99-119; but the other shield remains unidentified. And the manuscript appears to have remained in Santiago after Isabelle returned home.

The Vision of Turpin initial and the St James Matamoro miniature have no parallels in the other manuscripts of CC. There is, however, a miniature closely related to the Matamoro image in the Santiago cartulary Tumbo B (*SANTIAGO CAMINO DE EUROPA*, 1993, no. 116). The two legendary companions of St James, Theodore and Anastasius, who were allegedly buried with him in the Cathedral of Santiago, appear beside the enthroned James in the upper register of the miniature in Tumbo B. (For their legends, see AASS, Nov. I, pp. 1-16; for the identification of their relics, as well as those of James at the opening of the tomb in 1879, see our discussion of MS P.)

The Vision of Turpin is a subject that reappears in the French chronicles and other versions based on Book IV. Notably absent in this illustration is the soul of Marsile carried off by the devil. The devil is depicted, but he is empty-handed. See LEJEUNE/STIENNON, 1966, I, p. 56, fig. 34.

It is possible that the illustrations in S derive from a model other than C, possibly one associated with Baudouin de Hainaut's (now lost) copy. (see SMYSER, 1937/67, pp. 7 and 10). The arguments for such a copy, antedating C, were first made in STONES, 1981; the difficulty is that no other surviving copy of Book IV reflects these illustrations, nor can it be claimed that there is an independent picture cycle of St James images, or Charlemagne images, from which these scenes might have been excerpted. These issues are discussed in the Introduction, and under Lost Manuscripts in the Collation essay. See also STONES, 1996.

Binding: Brown leather, 18th century. On spine, in red: *S. Jacobi/ Codex/ 2631/ 3278/*

Provenance and History: Unlike the major cluster of Santiago products, C, A, and VA, S is not a *Jacobus* manuscript; it also omits all the texts following the *Guide* in C (not as in STONES, 1981 written before seeing the manuscript; DÍAZ Y DÍAZ, 1988a, p. 328). There is no medieval evidence of ownership, but its script, minor decoration and the style and iconography of its illumination suggest nontheless that it, like the *Jacobus* manuscripts, was made in Santiago. Like A and VA, it is closely similar to the Santiago Cartulary of c. 1326, Tumbo B, including the miniature of St James Matamoro. This puts its manufacture also in the period of intense copying activity in the time of the Dominican archbishop Berenguer de Landoria (1317-1330).

There are strong reasons, however, for supposing that it belongs to a different recension than C, A, and VA; the textual variants provide evidence that is analyzed in our Collation, pp. 197-240. One particular variant is crucial to reconstructing S's

history: DÍAZ Y DÍAZ, 1988a, p. 136, n. 95, suggests that S's unique variant in the wording of the colophon, *curia* for *Roma,* reflects the period soon after the removal of the papacy to Avignon (after 1305 with the accession of Clement V). *Curia* for *Roma* is not a variant that occurs in A or VA, whose text, throughout, is much closer to C's than is that of S; it may indicate that MS S itself depends directly on a now lost model made just after the papal captivity occurred, commissioned by a patron who was deeply concerned about the papacy. Archbishop Berenguer's predecessor, Archbishop Roderic (? 1304-1316) is a likely patron for S's model.

For Berenguer's career and interests, see DÍAZ y DÍAZ, 1983. He also suggests (1988a, p. 135) that it may have come to Salamanca, like other Compostelan manuscripts, with the collection of Alfonso IV de Fonseca, Archbishop of Toledo (1524-34). Alfonso began his episcopal career as Archbishop of Santiago (1508?-24). While still at Santiago, in 1521, he began to establish the College of the Archbishop in Salamanca (1521-27); he is buried in the church of Las Ursulas, Salamanca. On f. 121v, an erased ownership note: *Iste liber c(onstat)...*; rest illegible. Front flyleaf, verso: *S. Bart. no. 211,* i.e. Colegio de San Bartolomé (Salamanca), 211; no. 211 on f. 1, top margin. The college buildings can still be seen, but this was one of the many manuscripts moved to Madrid by King Charles IV (1788-1808): it contains the bookplate of Biblioteca del Rey N. Señor; Biblioteca del Palacio Nacional, Madrid, VII-H-1, 2-L-1, 3278. It was returned to Salamanca with the manuscripts of the Biblioteca del Palacio in 1954, in celebration of the 700th anniversary of the founding of the University of Salamanca by Alfonso X, the Wise (1252-84) in 1254, and is now housed at the University Library, Salamanca. REILLY, 1971, p. 138, notes the possibility that the HC now Salamanca BU MS 2658 also came to Salamanca with Archbishop Fonseca; it was probably owned by the colegio founded by Fonseca but was not, unlike S, part of the library of the Colegio de San Bartolomé.

Secundo folio: *Quodlibet non cantare*

Contents:

f. 1 [No title]
Book I: Liturgy of St James
[No Opening heading (cut off with initial C of Prologue text?)]
Prologue and Chapter list of 31 chapters as in C (W 1-6)
Texts and spaces for music for the Office and Mass of the Feasts of St James on 25 July, 3 October and 30 December and their vigils and octaves as in C, but with the notation not inserted (W 6-257)
Explicit as in C, but with *finit* for *FINIS* (W 257)

f. 77v **Book II: 22 Miracles of St James**
Opening heading as in C but omitting *eius* and adding *beati* before *Calixti.* (W 259)
Prologue, Chapter list of 22 chapters, preceded by heading as in C but omitting *eius; Text and Explicit* as in C but with *finit* for FINIS and without the Chi Rho monogram (W 287)

f. 86 **Book III: The Translation of St James**
Opening heading, Chapter list of 4 chapters, as in C (W 89)
Prologue rubric as in C but expl...*beati Iacobi maior editum* instead of ...*beati Jacobi maiorem* (W 289). Prologue as in C (W 289-290). **Chapter 1 rubric** as in C, but with *kalende* for *kalendas, a ierosolimis* for *ab iherosolimis* and *in galecie* for *in galleciam.* **Text of 4 chapters** as in C (W 290-299)

f. 89 Diagrams of phases of the moon drawn around holes in the parchment near the words *inter ramos palmarum et pascha* (W 297)

f. 89v Text expl. ...*aerie potestates.* (as in C, W 299)
[No explicit for Book III, but the rest of the folio is blank (W 299)]

f. 90 Full-page miniature in three registers
[No Opening heading to Book IV (preserved in VA)]

f. 90v **Book IV: Pseudo-Turpin**
Full page initial T

f. 91 *Text* inc. *[T]urpinus domini gratia archiepiscopus remensis* (this is treated as a rubric in C); text continues *Quoniam nuper mandastis...* expl. (as in C, W 301)
Chapter list of 26 chapters as in C (W 301-302)
[Rubric to Book IV omitted (W 302)]
Rubric to Ch. 1 *De hoc quod apostolus Karolo appariut.* [not in C: a repeat of the Ch. 1 heading above]
Text as in C (W 302-348), but chapters are rubricated and not numbered; text of Liberal Arts included, expl. (f. 107) *saltim legatur et exponatur* + dox. (W 348)
[*FINIT CODEX* omitted (W 348)]

f. 107 **Book V: Pilgrim's Guide**
Long Version as in C (W 349-389); see Table of Book V.

f. 120 *Explicit and colophon* as in C (W 389), but with *curia* for *ROMA* and, possibly though not certainly, *dimacum* for *CLUNIACUM* (W 389) (reading of last word of text partially obscured by banner of miniature).
Miniature: St James Matamoro
[None of C's other texts are included]

Sigla: Hämel: C4

Meredith-Jones: B. 11

Mandach: B 11

Díaz y Díaz: S

Bibliography: Bayerri Bertomeu, 1962, pp. 353-355; Díaz y Díaz, 1983; id., 1987, p. 47; id., 1988a, pp. 34, 135, 192, 217, 229, 243, 245, 246, 253, 327, 335; Domínguez Bordona, 1933, I, no. 1129; Fink-Errera, 1959, p. 118; García Piñero and Oro Trigo, 1994; *Guía del peregrino del Calixtino de Salamanca*, 1994; Hämel, 1936, pp. 147-148; id., 1950, p.72; Härtel, 1886, p. 515; Herbers, 1984, p. 33; Lejeune/Stiennon, 1966, I, p. 56, fig. 34, pl. II; Mandach, 1961, p. 393; Marcos Rodríguez, 1971, pp. 469-470; Meredith-Jones, 1936/1972, p. 12; Pastoureau, 1980a; Popoff, 1989; Reilly, 1971; Riquer, 1983; *Santiago Camino de Europa*, 1993, nos. 105, 116; *Santiago de Compostela*, 1985, no. 41; Sicart, 1981, pp. 152-156; id., 1982; Smyser, 1937/67, pp. 7, 10; Stones, 1981, and pl. 14.10, 14.14, 14.17; ead., 1991, p. 627; ead., 1992, pp. 143-144, fig. 23; ead., 1996, figs. 9, 13, 21, 29; Stones/Krochalis, 1995, pp. 26-27, figs. 8, 10.

VB. Vatican City, Biblioteca Apostolica Vaticana, Borghese 202

<div align="right">Short Version</div>

14th century, second half, Zaragoza

Parchment, in part palimpsest over 14th-century documents that refer to Zaragoza; rather grainy, with original firm overstitch mends on several folios, e.g. f. 61.
69 + iv ff., f. 1 is a medieval guard leaf, but included in the foliation; the back end leaves are paper. 217 × 144 mm; written space 150 × 90; text written in one column, 36 lines. *(Ill. 74)*

Quires:	1^1 (medieval flyleaf); 2^8, 3^{10}, 4-5^8, 6-7^6, 8-9^8, 10^6 (last leaf blank but ruled). Catchwords at the ends of quires 2, 4, 5, 6, 7, 8.
Script:	Rounded Italianate gothic, with a slight but definite backhand slant; clear and well-spaced, but with not much space between the lines. The scribe uses a small, curved mark of abbreviation, angled like an accent grave, and an uncrossed Tironian nota for *et,* with a rather long, flat top stroke. 'A' is the single-compartment form, sometimes rather difficult to distinguish from o. Sideways m is frequent at the end of words. The letter 'd' usually has a slanted ascender; other ascenders are upright; 'l' and minim strokes sometimes curve slightly at the bottom. Long 's' and 'f' sometimes extend slightly below the line. The scribe uses 'ç' for 'z'. He links letters at the top whenever possible. There are occasional marginal annotations in a late 16th or early 17th-century hand, possibly that of José Esteve (see below). The notes in the *Guide* section are transcribed in our Latin text; they comment on the Navarrese and on Bishop Theodomir and Archbishop Diego Gelmírez.
Rubrics:	Rubrics and capital letters come at the start of major sections in red. Most are two lines high; those on ff. 2 and 20 are 4 and 3 lines high respectively. Small guide initials for the rubricator are frequently visible in the margins. Smaller capitals, for sentences, often have a faint colour wash through them.
Musical Notation:	None, no spaces for it.
Decoration and Illumination:	None.
Binding:	Yellowed white parchment on boards. On spine, in an Italian (?) 15th-century hand, '*[Liber de] Miraculis, I[acobi] apostoli Zebedei*', partially covered by two labels, one saying '*Pleraque DE S. JACOBO ZEBEDEI, DO MEM (?) Saec. XV*'; the second reading '*Punte Borghes. 202*'.
Provenance and History:	The bifolium comprising ff. 36 and 41 is a palimpsest on which can be read, on f. 41v, the words '*Actum* (?) *Genon in app…sonon colombam in domo habuit…gol…domine J./ sancte Caterine de saragotu* (or *saragotia*?) *qui dixit et seruit se duos partes et contraherit*(?) *cognoscere et Joh/*'. The document can be approximately dated on palæographical grounds to the late 14th century. The Franciscan nunnery of Sta Catalina at Zaragoza was first founded *c.* 1239 by Domna Ermessenda de las Cellas, under the name of St Damian, according to Diego MORLANES, 1591, p. 135, who had seen the foundation charter and early documents. Presumably it was renamed when it was reconstructed by King James. Those buildings were still standing in 1591; see FALCÓN PÉREZ, 1981, p. 60 and map, and DHEE, IV, p. 2807.

The implications of a Zaragoza provenance for the parchment on which VB is copied can be best understood in relation to Z, for Z's CC selections begin with a note saying that the text was copied from an exemplar sent from Zaragoza in 1606, by Bartholomæus Morlanius, jurist, and son of Diego (the family is more fully discussed under Z). The scribe of Z does not say to whom the exemplar was sent, but the recipient can be identified from another source: it was none other than the

eminent Spanish historiographer Juan de Mariana (1535-1624). An undated manuscript version, not autograph, of his *Tractatus VII*, survives as part of London, BL, MS Egerton 1875. That version of the first tractate, on the debatable authenticity of the cult of St James at Santiago, has eleven chapters and a conclusion. The eleventh chapter laments the unavailability of Calixtine material, to settle the question of the early establishment of the cult once and for all. But before the work was published in 1609, Mariana acquired the material for Chapter XII. In that chapter, Mariana edited several selections from CC: Calixtus's Prologue and four sermons from Book I (Chapters 2, 5, 6, 19; reprinted in PL 163 from his edition); Calixtus's Prologue and Chapter 2, the Epistle of Leo, from Book III; and the false bull of Innocent II. His source was a book also sent from Zaragoza by Morlanius, as he relates on p. 21: *Hunc librum sane* [for *sine*?] *vestigiis omnibus inquisitum, ad nos tandem Cæsaraugusta misit Bartholomæus Morlanius præcpiua eruditione & humanitate vir, donum auro & gemmis maius, propter insatiabilem eum videndi cupiditatem.* He describes the contents of the book, from which it is clear that it had, as its Book I, the Miracles of St James; as its Book II, the Translation; as its Book III, the *Guide*, entitled *De itinere ad B. Jacobum*, with a chapter division that gave 15 chapters, and, as its last component, four sermons from CC, Book I. No mention is made of Book IV, *Pseudo-Turpin*, although it is likely that Mariana knew it, as he made disparaging remarks about the legends of Charlemagne and Roland in his History of Spain, published in Latin in 1603 and in Spanish in 1608 (cited in both languages by DÍAZ Y DÍAZ, 1988a, p. 323, n. 72). This sequence corresponds to the arrangement of CC texts in VB and Z; but Z is the only surviving copy to number the chapters of Book V as Mariana describes. R's selections are quired for the same sequence of Books, but the opening rubric to Book II also includes the explicit for Book I, copied in the original hand, showing that, in fact, R's present sequence was arrived at in the process of copying (see Catalogue entry for R).

It follows that Z is either Mariana's own copy of Morlanius's model, or a copy of that copy. We argue the choice in the Catalogue entry for Z, and, more fully, in the Collation essay. Mariana's transcript, published in *Tractatus VII*, includes the false bull of Innocent II (p. 23). His version contains the important variant *quem etiam Oliverius* for *qui etiam oliuerus*, which makes better sense than C's version, as it allows Aymeri Picaud and Olivier d'Asquins separate identities, and associates the Flemish companion Gerberga with Oliver, not with Aymeri. If Aymeri is the same person as the author of the *Ad honorem* song, he was a priest, and he would be unlikely to have mentioned a female companion so soon after the 1122 Lateran council's ruling on clerical celibacy.

Mariana's reading is quoted by DAVID, 1946, I, pp. 24, 31, citing ES, III, p. 120 (and incomplete references to Mariana). The full correct reference to *Tractatus VII*, 1609, pp. 22-23, for the false bull and Ch. 2 of Book III respectively, is given by WARD, 1883, I, pp. 550, 564. The variant spellings of *Escani* for *Iscani* and of the signatories *Ivo* and *Albericus* given by Mariana are also noted by WARD, pp. 550, 559 and HÄMEL, 1950, pp. 60-61.

HÄMEL (1950, p. 62) compared Mariana's readings of the Epistle of Leo (Book III, Ch. 2), Calixtus's Prologue to Book I, and the false bull with those of R and VB. He concluded that, for Calixtus's Prologue and the Epistle of Leo, Mariana's copy is closer to R, but for the bull it is closer to VB. This means that it is likely that what Morlanius sent to Mariana was an intermediary between R and VB, most likely a copy from the same Zaragoza exemplar as VB. What Hämel did not do was to add Z's version to the comparisons, although Z is listed on p. 72 in his list of MSS. VB, Z and Mariana all give the reading *quem etiam Oliverius* and the variant spellings of *Americus Picardus de Partiriaco* for *aymericus picaudus de partiniaco* and of one of the signatories, *Albertus* for *Albericus* (we differ from Hämel over VB's reading of *iuo* which we do not think is *Vio*). All three also omit *dicitur* after *uiziliaco* and *mea* after *penna*. There are more variants, which we list in the Catalogue entry for Z and

the Latin Appendix, in which Z and Mariana give the same reading, and which suggest that Mariana's copy was either Z itself or an intermediary between VB and Z. What is interesting in view of this, is that Mariana was not the first to introduce the *quem etiam* for *qui etiam* reading, as it first appears for us in VB. It is unclear who was responsible, whether VB's scribe or the scribe of VB's model. Is it possible that the Franciscan nuns of Sta Catalina in some way had a hand in its manufacture?

The later history of VB can be deduced to a large degree from inscriptions on its flyleaves. On the back endpaper, glued to the back cover, are the words: 'Aluaro dies tauaco (?) henero 1584' (date copied twice, and presumably 18 January 1584); on the back cover, 'el Stefani Vesta, rëcephroguy a dom fabio' (?); on the verso of the front cover is a paper flyleaf, glued down, with an inscription 'Armadro I 1'; on f. 1v: 'Ex bibliotheca Josephi Stephani Episcopi Uestani, 1586', written in a late 16th-century cursive hand. According to GAMS, 1873-86/1957, pp. 55, 941, Joseph Esteve or Estefan was Bishop of Viesti in Apulia from 17 March 1586, transferring to Orihuela on 3 March 1594 to his death on 2 November 1603. LÓPEZ in DHEE, I, p. 880, citing VIDAL TUR, 1961, pp. 147-164, gives his name as José Juan Esteve and notes that he was born in Valencia in 1550, studied at the University of Valencia, and taught at the University of Siena before his appointment as bishop of Viesti. After his return to Spain as bishop of Orihuela, he founded a house of canons at Alicante in 1600. The inscription mentioning Alfaro (between Logroño and Za-ragoza) and the date 1584 are probable indications of where and when he acquired VB; it was certainly in his collection by 1586, and the date of that inscription suggests that the book was catalogued at Viesti on his appointment there. It could have left his collection at any time after 1586, possibly upon his transfer back to Spain in 1594; or else it could have passed to other hands at his death in 1603, in which case the manuscript would presumably have been back in Spain. Soon after 1604, according to MANDACH (1961, p. 393, but citing no evidence), the manuscript was acquired by Pope Paul V Borghese. The future pope could, of course, have acquired the manuscript before Esteve left Italy. But Paul V was in Spain in the 1590s, and could also have acquired it there from José Esteve after 1594, or after the latter's death. It was not among the manuscripts he acquired in 1612 from the Duke Giovanni Angelo d'Altemps listed by MERCATI, 1938.

The Borghese library remained in the Villa Borghese outside Rome until 1891, when Pope Leo XIII acquired the collection for the Vatican.

Four further manuscripts from Esteve's library are in the library of Valencia Cathedral, all with his *ex libris* as Bishop of Viesti; see OLMOS CANALDA, 1928: no. 45, Remigius on the Epistles of St Paul, with an ownership note of 1592 (p. 38); no. 132, sermons of Pierre de Tarantaise, also with a note of ownership dated 1592 (p. 96); no. 182, Davantria [Divinorum Officiorum Rationale], with a note of ownership dated 1590 and the notation 'decani Valentini' as well as 'Episcopi Vestani' (p. 127); no. 252, various tracts of Cassiodorus, with no date for the ownership note but the mention 'decani Valentini' as well as 'Episcopi Vestani' (pp. 167-168).

Secundo folio: *te presbitero*

Contents:

f. 1v **Table of contents** in a hand of the late 14th or 15th century
In hoc uolumine continentur
Miracula plurima beati iacobi apostoli
Translatio corporis sancti iacobi apostoli in galicia
Tractatus Turpini archiepiscopi remensis de gestis caroli magni
Itinerarium ad sanctum iacobum in galicia
Sermo calisti pape in vigilia ante festo sancti iacobi apostoli
In a later hand:
Ex bibliotheca Josephi Stephani episcopi Vestani 1586

f. 2 **Book II: 22 Miracles of St James**
Rubric, Prologue, Chapter list of 22 miracles
(22 has no chapter number) *and Text* as in C (W 259-287) ending f. 13v

f. 14 **Miracles from Book I of C, numbered as Ch. 23**
Rubric: *Miraculum de illis qui non colebant festum sancti iacobi.* Text: *Hec sunt miracula que olim sancti iacobi festa non colentibus… expl. (f. 14) in oculis nostris.* (W 20-21)
Two miracles from texts following Book V in C, one of 1164, numbered Chs. 24 and 25
Rubric: *De puero suscitato. capitulum xxiv.* Text: *Anno incarnationis dominice mclxiiii…* (C f. 223; W 404)

f. 14v Rubric: *Aliud miraculum. capitulum xxv.* Text: *Miraculum sancti iacobi de facie torta filii vicecomitis…* (C f. 223; W 404)
Three miracles from Book V, Ch. 11 in C, numbered as Ch. 26
Rubric: *Qualiter peregrini sunt recipiendi. c. xxvi.* Text: *Peregrini siue pauperes…*
Expl. *et diligenter procurandi.* (C f. 213; W 388-389)

f. 15 **Alberic of Vézelay's Miracle of 1139 from texts following Book V in C, numbered as Ch. 27**
Rubric: *Miraculum sancti iacobi dompno alberico inziliacenti* [sic] *abate atque episcopo ostiensi et rome legato. c. xxvii.* Text: *Anno dominice incarnationis m.c.xxxviiii. ludovico rege francorum… expl. occulis nostris.* (C 221v; W 400)

f. 15v **Bull of Pope Innocent II, numbered as Ch. 28.**
Rubric: *Epistola innocentii pape capitulum xxviii.* Text: *Innocentius episcopus seruus seruorum dei…hunc codicem… expl. fore predico.* (C f. 221; W 399-400.)
Variants (VB's version first, C second): *americus* for *aymericus*; *picandus* for *picaudus*; *partiriaco* for *partiniaco*; *quem etiam oliuerius* for *qui etiam oliuerus*; *uiciliaco* for *uiziliaco*; *dicitur* after *uiziliaco* omitted, *galletianensi* for *gallecianensis*; *eretica* for *heretica*; *apocrypha* for *apocrofa*; *aymericus cancellarius* for *aimericus cancellarius*; *giraldus* for *girardus*; *mea* after *penna* omitted; *pisanus* for *pissanus*; *optimum* for *obtimum*; *lombardus* for *lumbardus* (mistranscribed in W); *ienua* for *ihenia*; *optimum* for *obtimum*; *albertus* for *albericus*, *carissimum* for *carisimum*.
Excerpts from Book III: Translation of St James [Chapter list omitted]
Rubric: *Incipit prologus beati calixti pape super translationem maiorem beati Iacobi apostoli capitulum xxix.* Text: *Hanc beati iacobi translationem a nostro codice excludere nolui… De tribus sollempnitatibus sancti iacobi, cap. xxxii…*
(same selection as R: includes the Prologue and Chs. 1, 2 and the first part of Ch. 3), expl. (f. 19v) *plebs galleciana gaudens suscepit.* (W 298, line 4)
[rest of Chapter 3 and Chapter 4 omitted]

f. 20 **Book IV: Pseudo-Turpin**
Same selection as R.
Rubric (shorter than R's): *Incipit liber de expedimento et conversione yspanie et gallicie editus a beato turpino archiepiscopo remensi ad leoprandum capitulum.* Text of Epistle to Leoprand: *Turpinus domini gracia archiepiscopus remensis ac sedulus karoli magni imperatoris in ispania consocius… Quoniam nuper… expl. vivas et valeas et domino placeas. amen.* Chapter list for 26 chapters, as in C, ff. 163v-164. Rubric: *Incipit liber capitulum primum.* Text: *Gloriosissimus namque…*
Chapter 21 and subsequent chapters are subdivided in the same places as R, and all rubricated; not all are given numbers.

f. 34v *Itaque peracto bello…* rubricated but not numbered, as in R (W 330)

f. 35 *Deinde proprio…* rubricated but not numbered; Ch. 22 in R (W 331)

f. 35v *Domine Ihesu Christe*… rubricated but not numbered; Ch. 23 in R (W 332) [*Non decet…sed tenet aula dei* omitted, as in R (W 334)]

f. 36v *Cap. xxiiii. Quid plura*… Ch. 24 in R (W 336)

f. 37 *Cap. xxv. Crastina namque*… Ch. 25 in R (W 336)

f. 38v *Postea vero ergo*… rubricated but not numbered; Ch. 21 [*sic*] in R (W 338) *Post hec Viennam*… rubricated but not numbered; Ch. 22 [*sic*] in R (W 338). Text from *in eo depinguntur* (W 339, line 28) to *Incipit mors anime* (W 341, line 29), describing the Liberal Arts, omitted, as in R. The text at *Post exiguum vero tempo* (W 341) is rubricated as in R, with variant: *Qualiter mors Karoli demonstrata fuit michi.*

f. 40 *Set valde*… rubricated but not numbered; Ch. 23 in R (W 343)

f. 40v *Beatus namque Turpinus*… rubricated but not numbered; Ch. 24 in R (W 344)

f. 41 *Quid patrie Gallecie*… rubricated but not numbered; Ch. 25 in R (W 345) VB, like R, ends Book IV at the end of Ch. 25 (the Chapter list on f. 56v notwithstanding), expl. (f. 41v) *munere remunerabuntur.* (W 347). Rubric: *Fuit* [*sic*] *codex quartus. argumentum beati calixti.*

f. 41v **Book V: Pilgrim's Guide**
Short Version, as in R and Z. For details of omissions in Short Version, see Table of Book V.
[For Chapter 11, see ff. 14v-15 above.]

f. 46 **Excerpts from Book I: Liturgy of St James** (selection similar to R, but shorter)
[Title omitted]
[For Opening heading and Prologue, see below]
[Chapter list of 31 chapters omitted (W 4-6)]
[Chapter 1 omitted (W 6-11)]
Chapter 2. Pericope and Sermon of Calixtus for the Vigil of the Feast of St James, 24 July.
Rubric (shorter than R, W 11): *Vigilia sancti iacobi zebedei apostoli. Lectio secundum marchum.* Pericope and Sermon text as in C, inc. *Uigilie noctis*… ending incomplete (f. 49v) *prima corona datur* (W 20, line 12).
[for the following Miracles (W 20-21), see f. 14; no cross-references in VB, unlike R]. The text resumes at *Cessemus ergo* (W 21, line 14) continuing complete to (f. 55v) *gaudere in celis.* (W 34)
[rest of Ch. 1, Venantius Fortunatus's hymn *Siderei proceres* and concluding paragraph, present in R, omitted]

f. 55v *Prologue to Book I* (W 1; in R, this correctly precedes Ch. 1)
Rubric: *Incipit epistola beati calixti pape.* Text: *Calixtus episcopus servus servorum*… *Quoniam in cunctis*… expl. (f. 55v) *data laterani. idus iani.* (W 4)
[Chapters 3-4 omitted (W 35-38)]

f. 56 *Chapter 5.* Sermon of Calixtus for the Feast of the Passion of St James, 25 July.
Rubric and text, inc. *Celebritatis sacratissime*… complete as in C (W 38-48), expl. f. 60v.

f. 60v *Chapter 6.* Sermon of Calixtus for the Feast of the Passion of St James, 25 July.
Rubric and text, inc. *Spiritali igitur*… complete as in C (W 48-61), expl. f. 66.
[Chapters 7-18 omitted, as in R (W 61-179)]

Chapter 19. Pericope and Sermon of Calixtus for the Feast of the Translation of St James, 30 December.
Rubric, pericope and sermon text as in C, inc. *Sollempnia sacra...* expl. f. 69 (W 179-186)
[Book I: remaining selections from R omitted in VB]

f. 69 **Colophon:** *finito libro isto sit laus gloria Christo.*

f. 69v Blank but ruled

Sigla: Meredith-Jones: not included

Hämel: R6

Mandach: R6

Díaz y Díaz: B

Bibliography: David, 1946, I, pp. 24-31; DHEE, IV, p. 2807; Díaz y Díaz, 1987, p. 48; id., 1988a, pp. 327, 335; ES, III, p. 120; Falcón Pérez, 1981, p. 60 and map; Gams, 1873-86/1957; Hämel, 1950, pp. 62-67; López in DHEE, I, p. 880, article on José Juan Esteve; Maier, 1948, reprinted in ead., 1967; ead., 1952, pp. 257-258; Mandach, 1961, p. 393; Mariana, 1603, 1608, 1609; Mercati, 1938, pp. 106-135; Morlanes, 1591; Olmos Canalda, 1928, pp. 38, 96, 127, 167-168; Pellegrin, 1975; Poncelet, 1909, pp. 39-40, 442-443; Stones, 1992, pp. 626-627; Stones/Krochalis, 1995, pp. 28-29, fig. 11; Vidal Tur, 1961, pp. 147-164; Ward, 1883, I, pp. 550, 564.

T. London, British Library, Cotton Titus A. XIX

Long Version

Miscellany of English historical texts, including Book IV and
part of Book V of the *Codex Calixtinus*
Late 15th century by watermarks, Kirkstall, O. Cist., England

Paper, iii (modern) + ii (16th century; foliated 1 and 2) + 156 + ii (modern). T may have
begun as several separate manuscripts, but it was a unit by the 1530s. A few leaves from
what is now Oxford, Bodl. Lib., MS Laud Misc. 722 were probably originally in T.
Leaves vary slightly in measurements; the *Guide* section: 200-216 × 140 mm, 51-62 lines
per page. Written space: variable. Ruling varies; frame but no line is the commonest
pattern, and sometimes there is no ruling at all. (*Ill. 75*)

Quires:
No folio is missing between ff. 4 and 5, though there are catchwords on every page
in this section, and the catchword is *divisit me*; text continues *vere mortuorum et in
inferno*. Since the volume has been rebound, and mounted on strips, the quiring is
frequently impossible to determine with certainty.

Cotton's librarian, Richard James, divided the manuscript into units before it was
bound. These seem to correspond to some extent with quiring; for the most part
they correspond with scribal units.

1. ff. 3-15v (probably two quires, of eight plus six or one of fourteen leaves; wants
last leaf). *York and Lincoln material.* Hand 1

2. ff. 16-31 (one quire of 16) *Glastonbury* quire (ff. 16-23) + *Pseudo-Turpin* Hand 2.

3. ff. 32-49 (one quire of 18? continuous text to fol. 47, and no catchwords) *Pseudo-Turpin* and the *Guide*, Hand 2, ff. 32-47; *3 Kings* Hands 3, 4; *Edmund*, Hand 1; *English
proverb* Hand 5, ff. 48-49.

4. ff. 50-58 (one quire with added leaf, 8 + 1?) *mathematical treatises*, Hand 6; *Thurstan*,
Hand 7; *Bernard dialogue*, Hand 8; *historical notes*, Hand 4; Hand K, *passim*.

5. ff. 59-62 (one quire of 4) Hand K's 16th-century quire

6. ff. 63-73 + 76-80, with 74-75 inserted, the whole lettered A-Q). ff. 63-80 (16, with
a bifolium inserted between leaves 11 and 12): *Merlin*, Hand 2; 74-75 *Merlin &
Lailoken*, Hand 1; 76-80, *Kentigern*, Hand 9.

7. ff. 81-100 (one quire of 20) Hand K (f. 80); *royal letters*, ff. 81-100, Hands 10, 11 and 1.

8. ff. 101-116 (one quire of 16) Hand 1 *Wales + Giants + 'Stafford'* (or possibly two
quires, one of 4 ff. 101-104, and one of 12, 105-116; there are no catchwords, but the
texts divide that way).

9. ff. 117-121, five leaves only; *W. de Carleton; beginning of Stubbs*; Hand 12.

10. ff. 121-131 (one quire of 10); *Stubbs*, Hand 12.

11. ff. 132-143 (one quire of 12); *Stubbs*, Hand 12 + *letter*, Hand 13.

12. ff. 144-152 plus 153-156, four damaged leaves. Original quire of 14? or 12 + 1?
Henry I; Battle of the Standard, Hand 14; *Latin poem on Roland*, Hand 2; notes, Hands
K, 1, 15, 16, and 17.

Watermarks:
ff. 8, 11, 53, 56, 65-67, 71, 76, 77: an entire cow; closest to BRIQUET no. 2810 (Poitiers,
1479, from the Archives capitulaires St-Hilaire). The same watermark is found in
Oxford, Bodl. Lib., Digby 196, f. 157, see below. These folios contain material about
York/Lincoln; Thurstan; *Fata Merlini*; Lailoken and Kentigern; copied by Hands 1
and 2.

ff. 18, 21, 24, 25-28, 30-32, 36-39, 40, 41, 146: a 'tête de boeuf' with bug eyes at the
edges of the face; not in BRIQUET. Text: Glastonbury quire plus the *Pseudo-Turpin*;
the *Guide*; Lacy notes.

ff. 49; 101; 152, 154: top of a differently-shaped 'tête de boeuf', with ears pointing

outwards and line with x extending up above the head. Digby 197, f. 157 (160): 'tête de boeuf' watermark more like BRIQUET no. 2814 (1454).

ff. 60, 61: knife. BRIQUET no. 5141 (Bar-le-Duc 1545). Text: Lacy notes.

ff. 83, 84, 86, 87, 89, 92, 94, 97, 98: crown. BRIQUET no. 4646 (Azeglio; Turin, Archivio di Stato, 1473). Text: Model letters.

f. 100: top of *tête de boeuf*, no vertical line. Text: Papal letters.

ff. 121, 122, 125, 126, 128, 130, 132, 135, 137, 138, 148, 151: Crossed keys. BRIQUET no. 3887 (Catene, 1468; Palermo, 1461-63; Sargens 1470). Text: Stubbs plus notes on bishops.

ff. 110, 112, 114: S with a vertical line through it. Text: Stafford.

ff. 105, 107: ? top of *tête de boeuf* with line but no x. Text: Stafford

Script:

The hands of the three scribes whose sections are closely related to the *Guide* are discussed here in detail. The other fifteen scribes are identified as they appear.

Script of the *Guide* section: (Hand 2) Anglicana, with occasional English long 'r', descending well below the line. Long 's' is regularly used at the beginning and in the middle of words; round '8'-shaped 's' appears only finally. Both backwards 'e' and the ordinary form occur. The two-compartment 'a' occurs only as a capital, or initially in prepositions like *Ab* or *Ad*; otherwise the single-compartment 'a' is used. There is some use of splay. Both WARD and Julian Brown (cited in LAPIDGE 1982) put the script early in the 15th century, but the watermarks indicate a date after *c.* 1460. Hand 2 seems to be earlier than (if not contemporary with) Hand 1 (*c.* 1452-89, see below), which writes in blank spaces on Hand 2 quires. The watermark evidence for the first 30 folios suggests that the two were contemporary, and using the same stock of paper with two different watermarks in it. Since Hand 1 never annotates Hand 2's work, one might put Hand 1 later than Hand 2, but not much later.

Hand 1: A very individual, irregular Anglicana, normally using a very black ink. A page tends to slant upwards to the right, and be very densely written. Letters within a word are widely spaced, but there is little space between words or between lines. Looped ascenders, backwards 'e', '8'-shaped 'g', long 'r'. The size varies, and historical entries suggest that the scribe worked over a period of more than twenty years. Events to the year 1489 are noted in one of the entries in the historical annals copied by Hand 1 in Laud Misc. 722 (on a leaf probably originally part of T; see Provenance below). The list of archbishops of York in T, f. 4 ends with *William Boothe*, who was Archbishop of York 1452-65. A later hand adds *George Nevyll* (1465). When listing archbishops again (f. 150) Hand 1 includes Thomas, but seems uncertain of the surname (Roderam or Scots; he used both) and leaves it blank; Hand K later fills it in. Thomas Roderam became archbishop in 1480.

1452 is a little earlier than the watermarks would suggest, but we can put Hand 1's activity in the period *c.* 1460-1489, extending possibly sightly later.

Hand K: Kirkstall Abbey information. TAYLOR, 1952 calls this the 'backwards' hand, because it consistently has a slight back slant, as if the writer were left-handed. The looped letter forms are Anglicana, but the hand includes a number of dated entries. The earliest is the dissolution of Kirkstall abbey in 1539; the latest are both from 1549; the appointment of Nicholas Hethe, on f. 150, and a note dated 1549 (*quando equamare regnat, tunc missa cessabit*) are added in other hands. Hethe's successor, Thomas Young, was appointed in 1560.

Rubrics:

Red capital letters in some sections, including *Pseudo-Turpin* and the *Guide*.

Musical Notation:

None.

Decoration:

None.

Illustrations:

Very simple line drawings, black ink, probably done by Hand K. None in the *Guide*

section. They indicate the type of material in the section: a crown for kings, a church for Kirkstall or York &c.

f. 3v: Knife

f. 6: upper margin: church

f. 16v: lower right margin: crown, beside text: *Hec est vera historia de morte arthuri.*

f. 35: grotesque head around rubric for verses on death of Roland, not in same hand as others.

f. 59: upper margin. church or castle crenellations (Note: This is in the 16th-century quire.)

f. 101: upper right margin, clover (?)

f. 103: upper right margin, sceptre with fleur-de-lis

f. 105: upper margin, heart surmounted by a cross.

f. 105v: upper margin, left, crown, with sceptre with fleur-de-lis through it

f. 117v: upper margin: sword

Binding: 17th-century leather over boards with Cotton's arms stamped on the centre of the front cover. Green leather inserts in spine, with gilt lettering. The volume was reinforced at the spine at a later date, and leaves mounted individually, so the quiring is difficult to determine; a few catchwords give indications of original quires, and a 17th-century numbering system indicates pre-binding units (not always quires, or even multiples of quires).

Provenance and History: This section deals primarily with the *Guide* and closely related sections of the manuscript. Problems of particular texts are discussed more fully under the individual entry in the list of Contents below.

T was probably assembled at the Cistercian abbey of Kirkstall, whose impressive ruin can still be seen in central Leeds, Yorkshire. Part of this evidence comes from Oxford, Bodl. Lib., MS Laud Misc. 722, which is a composite volume, parts of which certainly came from Kirkstall. A Kirkstall monk made notes on a flyleaf in 1505, and the manuscript contains the *Fundatio* of Kirkstall Abbey, in our Hand 9; notes on northern history by Hand 1; and marginal comments by Hands 2 and K. It also contains short texts on Bernard, Pope Sylvester, and *Amis and Amile*, in Hand 2; these leaves are added to quires in Laud, and may be the rest of an original quire containing *Merlin and Lailoken* (ff. 74-75) currently interpolated in section 6 of T.

T is the only English manuscript of the *Guide*, and, though a number of English libraries owned copies of *Pseudo-Turpin*, we have been unable to connect T with any now-lost copy of the *Guide* in any extant English medieval library catalogue. Textually, it is unlikely to have been copied directly from C; its immediate exemplar broke off in Chapter 7, and its *Pseudo-Turpin* text is not close to C's. But how many intermediary stages there were is impossible to determine. From the 12th to the 15th centuries, there were many royal and ecclesiastical links between the two countries, and ordinary pilgrims made the trip frequently, but no obvious direct link between Spain and Kirkstall/York has emerged. Pope Calixtus supported the controversial candidacy of Archbishop Thurstan of York (1114-40) and consecrated him himself, but Calixtus's death in 1124 makes the connection rather too early to have given direct impetus to the dissemination of *Pseudo-Turpin* and the *Guide* texts, unless Thurstan acquired them under the impression that they were the genuine work of Calixtus. One of the signatories of the false bull of Innocent II, Alberic of Ostia, was papal legate to England in 1138-39; could he have brought a copy of the CC with him?

In the interpolations in T's *Pseudo-Turpin*, the *Iter* of Charlemagne suggests a French connection, possibly ultimately with St-Denis—though it should be remembered that no French manuscripts of the *Guide* survive. But if St-Denis was a possible line of transmission, it may be worth noting that very few English churches are dedi-

cated to that saint. One which was founded as a dependency of the Paris St-Denis is the church at Northmoor, about six miles outside the city of Oxford, and, like Reading which will be discussed below, on the River Thames. But the version of the *Iter* in T derives, according to its rubric, from Helinandus, that is, the Chronicle of Helinand of Froidemont. That text had an English circulation, including an epitome of Helinandus in the library of the Austin friars at York (JAMES, 1909).

The *Ogier* legend is associated with the French monastery of Meaux, whose library was confiscated by Henry V. Intended for his new Carthusian foundation of Sheen, it was given by Henry VI to King's Hall (now Trinity College), Cambridge, but almost none of Henry's donated volumes is at Trinity now. But the version of Ogier in T comes directly from Alexander Neckam's *De Naturis Rerum*, an encyclopedic text which circulated widely in England (HUNT, 1984, p. 144) and was virtually unknown on the continent (HUNT, 1984, pp. 134-137). Thus the immediate source of T's Ogier episode must be English. It too could have come from York; the Austin friars had a copy, no. 334 (JAMES, 1909).

The monastic and Cistercian network remains a possible channel of transmission, especially when one remembers the Cistercian system of daughter houses, and the triennial reports to Cîteaux. Several other 12th-century pieces in T have Cistercian connections. The Kentigern and Merlin-Lailoken material is set in Scotland, but T is the only extant copy. The monk Joceline had a copy of the *Life of St Kentigern* by 1194 at the Lancashire Cistercian house of Furness; his disapproval of its flights of fancy led him to write his own version (WARD, 1983, p. 507 and FORBES, 1874). The first section on Walter l'Espec and the Battle of the Standard was written by Ailred of Rievaulx, a Cistercian house north of York; Walter was its founder. The life of Archbishop Thurstan was written by two monks from Fountains, the Cistercian house near Ripon, Yorkshire, where Thurstan retired. (Connections could work the other way too; the early chronicle of Fountains preserved in Cambridge, Trinity College, MS 1104 (KER, 1964) was composed by Hugo of Kirkstall).

Much of the other material in T clearly comes from libraries in and around York. Kirkstall monks, like those from other monasteries in the area, regularly attended the elaborate processions held at York Minster for Whitsun and other feasts (BORTHWICK INSTITUTE RECORDS). Thus the hymn to St William (f. 150) and the history of York on the minster tablets (ff. 5-11), would have been readily available. Non-liturgical works are more problematic. The minster itself had no formal communal library until the bequest of John Newton in 1414, and no complete pre-Reformation catalogue, so we can only guess at its contents (BARR, 1977, pp. 491-495). In addition, individual clergy frequently owned books. Stubbs' history of York (ff. 118-141) is a text with local interest and circulation. The letter collection on ff. 82-96v was originally compiled by a York notary, William de Carleton. The *Vera Historia* of Arthur (ff. 16-17v) may have been available in the extensive library of the Austin friars of York (see below, f. 16 ff.). One wishes that the York *Play of St James*, given to the Guild of St Christopher in 1446 by the will of William Revetour, had survived; it may have been part of an apostle/creed play, but may also suggest a local interest in his cult (DAVIDSON/O'CONNOR, 1978, p. 128).

John Harvey notes that the technique of staining glass yellow with silver salts was unknown in Western Europe in the 12th and 13th centuries, but was known to the Arabs of the Near East, and, presumably, those in Spain. It is described in the *Lapidario* of Alfonso X (*c.* 1276-79). One of Alfonso's clerks was an Englishman, Geoffrey of Eversley, who also worked for Alfonso's brother-in-law, Edward I of England. The first place such glass was made in Western Europe was at York Minster in 1308-10. HARVEY (1976, p. 65) observes, 'There surely in this case must have been transmission by diplomatic bag, and subsequent experimentation in England'. The same or another diplomatic—or craftsman's—bag could perhaps have brought a copy of the *Pseudo-Turpin* and the *Guide* to York.

But Yorkshire was not the only source of material in T. Reading Abbey should also

be mentioned as a possibility. Reading was a Cluniac foundation, headed by Hugh, former archbishop of Reims, and kinsman of Matthew of Albano, who figures in the history of the Pistoia manuscript of the *Guide*. Reading had the hand of St James, brought to England from the German imperial treasury by the widowed Empress Matilda, daughter of Henry I (LEYSER, 1975/1982; for its possible survival and preservation at Marlow today, see MORRIS, 1888 and GAFFNEY, *c*. 1975). The abbey became a pilgrimage site; a collection of 12th-century Reading miracles of St James survives in Gloucester Cathedral Library MS 1 (KER, 1977 and KEMP, 1965). For a discussion of material from the CC in this manuscript, see Lost Manuscripts, Gloucester Cathedral Library MS 1. The Reading medieval catalogue did list a *Vita Karoli et Alexandri et gesta normannorum ducum et alia* (BARFIELD, 1888, p. 120), but this is Einhard's life.

The Einhard part of the volume is now Cambridge, Gonville and Caius College, MS 177; the Norman ducal history is London, BL, MS Cotton Vitellius A. VIII (WATSON, 1987, p. 57). Neither KER, 1964, nor HURRY, 1901 have identified any other volume resembling all or part of a CC among surviving Reading manuscripts. No manuscript listed by MANDACH, 1961 or MEREDITH-JONES, 1936/1972 has the right grouping of texts. The surviving fragment of a late 12th-century Reading liturgy of St James (KER, 1964) in Oxford, Bodl. Lib., MS Rawlinson A 416, ff. 129v-132, shows no special Compostela readings or hymns; it is very close to the common form printed in *Analecta Hymnica* 26: 45. (The liturgy was cited by FRERE 1894, no. 38, and VAN DIJK 1957 as 15th century; as Frere is usually accurate, one suspects a misreading of xii as xv in handwritten notes.) Reading was an important pilgrimage site with strong royal connections in the 12th and early 13th centuries, and contained the tombs of Henry I, his queen Adeliza, and Richard of Cornwall's infant children. But by the later Middle Ages the cult of St James at Reading seems to have been on the wane; pilgrims went to Canterbury and Walsingham instead. Edward I—whose first wife was Eleanor of Castile—sent a pilgrim to Compostela, not Reading, in thanks when he recovered from a serious illness in 1306 (CHRONICLE OF LANERCOST, 1839, cited in MOORMAN, 1952). Edward III patronized Reading only once, early in his reign, in 1336 (ORMROD, 1989, p. 859, n. 59). The Eton fellow William Wey, who wrote an account of his trip to Compostela for Henry VI in 1456, asserts that the entire body of James was preserved at Compostela, and never mentions the relic twenty miles from home (WEY, 1857).

For about twenty years in the mid 12th century, the hand of James was not actually kept at Reading, but was in the custody of perhaps the most interesting ecclesiastic of his time, brother of King Stephen, Henry of Blois, Bishop of Winchester and Abbot of Glastonbury (LEYSER, 1975/1982). It is probably no coincidence that Glastonbury ended up with a bone of St James among its relics (*De Sancto Iacobo maiori os vnum*, JOHN OF GLASTONBURY, 1978, Ch. X, p. 29). Glastonbury is the key to another group of texts in T, in the same hand as the *Guide*.

Apart from the *Vera Historia* of Arthur, the material on ff. 16-23 would all have been available at Glastonbury. It includes part of the Glastonbury liturgy of St Benignus, and selections from the *Magnæ Tabulæ* on display in the abbey from the late 14th century. But Glastonbury probably did not supply *Pseudo-Turpin*. Cambridge, University Library, MS Dd. 1. 17 is attributed to Glastonbury in the catalogue, though on what evidence is not clear; it is not among the Glastonbury books listed in KER 1964. Cambridge University Library MS Dd. 3. 16 is acephalous at both ends, but in the same hand. If these are indeed Glastonbury books, then Glastonbury did not supply the exemplar for that section of T. Cambridge, University Library, Dd. 1. 17 follows *Turpin* with brief notes on the miracles, translation and Feast of St James, and the stature of Charlemagne (ff. 128v-129). MS Dd. 3. 16 has no extra material. MS Dd. 1. 17 is MANDACH, 1961 A 8a, close to A8, which is London, BL, Royal 13. D. 1; and to A9, London, BL, Harley 108, which also contains Stubbs, see below f. 117v. Neither they, nor any English copy we have examined, have the same

chapter headings, or divisions, and no manuscript listed by HÄMEL, 1950, MAN-DACH, 1961, or MEREDITH-JONES, 1936/1972 has the extra two chapters on Ogier as a monk and Charlemagne's *Iter*.

The Glastonbury material could have reached York in a variety of ways; pilgrimage to Glastonbury was a frequent pastime. The rest of the Glastonbury material in T, with the exception of the life and hymn of St Benignus, seems to be copied from the enormous (3 feet, 7½ inches x 20 inches, or 112 x 57 cm) *Magnae Tabulae Glastoniensis*, the wooden tablets displayed in the church, containing a brief account of the history and relics, from Joseph of Arimathea to Abbot John Chinnock (1375-1420), who repaired the chapel of St Michael in 1382. So the copy in T must come from a text copied at Glastonbury after 1382. Closeness of readings suggests that no more than a single intermediary is necessary; T Hand 2 could even have copied directly from the tablets.

The late 14th century is rich in Anglo-Spanish connections. John of Gaunt married Costanza of Castile in 1371 after the death of his first wife, the Duchess Blanche of Lancaster. This gave him a claim to the kingship of Castile, and various campaigns were waged in his support. In the campaign of 1386-87, he brought his wife, daughters and their households. This entourage moved around, but spent part of the time in Compostela. (ARMITAGE-SMITH, 1905, p. 310) In 1387, his daughter by Blanche, Philippa, married King João of Portugal, and two years later Katherine, his daughter by Costanza, married King John of Castile. All these battles, negotiations and weddings put numerous Englishmen in Compostela, and it is possible that one of them, instead of getting drunk on Spanish wine, as Froissart complained the soldiers did (quoted in ARMITAGE-SMITH, 1905, p. 326) put his time to holier use and copied the CC. But such speculations cannot be proved. John of Gaunt had no specially close connections with York, but his substantial estates in the region did mean a close connection with the bishops of Lincoln, from where the Grosse-teste material in T must have come.

The evidence of Hand K indicates that the manuscript was still at Kirkstall at the Dissolution. The *Valor Ecclesiasticus* of Henry VIII's commissioners is missing for this part of Yorkshire, and we have no record of the books its library contained. But for the Yorkshire Cistercian foundation of Meaux, we have lists from the 1550s of the books preserved by the prior and the sub-prior; it is possible that at Kirkstall the library was also divided up among the inhabitants.

Hand K seems likely to have been a Kirkstall monk, hanging on to some of the library's volumes, and making notes from the ones he did not keep, from 1539-49. His first dated note includes the dissolution of the monastery in 1539; his last, the inclusion of Nicholas Hethe in the list of archbishops of York. Hethe became archbishop in 1549. Many of the notes are gloomy and apocalyptic, but that he adapted successfully to the new religion is suggested by his reference to the happy times of Edward VI on f. 104.

For the later 16th-century history of T, we must return to Oxford, Bodl. Lib., MS Laud Misc. 722. By the 1590s, some, if not all, of the parts of Laud Misc. 722, including the *Chronicle* of Kirkstall Abbey, and the *Fundatio* account now in Oxford, Bodl. Lib., MS Dodsworth 140, were probably in the possession of antiquaries in Leeds. Roger Dodsworth took notes from Hand K's entries in Laud Misc. 722, when it was owned by Thomas Fowkingham of Leeds, and from the *Fundatio* when in possession of Mr Cooke of Leeds, in 1619. It would seem natural that T should also have remained in the Leeds area. Several of the Arthurian texts, including the *Vera historia*, were copied from T into a single paper quire in Oxford, Bodl. Lib., MS Digby 186, in the last third of the 16th century. The paper has a watermark very like BRIQUET no. 12783 (Rouen, 1564-69), and like a group of watermarks—some initialled, some not—from Normandy, 1536-92. All are pots, surmounted by a crown and flower.

Digby 186 is a composite manuscript, with a 13th-century flyleaf from St Mary's

York, and numerous items of York provenance. A note in a 15th-century hand on a front flyleaf records the death in 1304 of Robert Howorthe, onetime abbot of Stanlow. Stanlow was a not very prosperous Cistercian foundation in Cheshire; the abbot and most of the monks moved to Whalley in 1296. The record of his death may indicate a Cistercian connection.

The earlier sections of Digby 186 show drawings similar to those in the margins of T. There is a cross with a flight of three steps leading up to it on f. 5, and a crown on f. 16. These are also likely to be 16th century. Hand K does not appear in Digby, which may indicate that the drawings in T are not in his hand.

Digby 186 came to Sir Kenelm Digby (1603-65) from his former tutor Thomas Allen (1540-1632; see WATSON, 1978), who was based at Oxford from 1561 on; there is no indication of when or from whom Allen acquired the manuscript. On f. 2v there is a note, not in Allen's hand: *1572 John 26 et. Henry 23; Thomas etatis Mors henrici Savile de bradley patris die veneris xi septe(m)bris 1566 tempore parliamenti 8 Elizabeth.* Henry Savile of Bradley was the father of Henry Savile, who attended Merton College, Oxford, and became provost of Eton (1549-1622) and Sir John Savile, judge (1545-1607), and Thomas of the unknown birthdate, who died in 1593. He was thus a third cousin of Henry Savile of the Blaithroyd, father of Henry Savile of Bank, and brother of the Thomas Savile whose death is recorded in T. Both provost and judge Savile also collected manuscripts. The provost specialized in scientific texts, and his distinctive hand does not appear in Digby. Whoever wrote this note must have known or been interested in the Savile brothers, but was probably not one of them; surely they would have known Thomas's birthday. Allen knew the Saviles, and most of the more prominent antiquaries of his generation. Allen's manuscripts were catalogued in 1622, and their distinctive numbers in his collection can still be seen on the first text folio. He and Cotton did trade manuscripts, but there is no Allen number in T. The connection between T and Digby probably precedes Allen's ownership, and may indicate that T was still in the York/Leeds area in the 1560s.

If Hands 1 and 2 were contemporary monks of similar tastes, both at Kirkstall, their hands might well appear in more than one manuscript from that house. It is unfortunate that so few Kirkstall volumes survive; KER, 1964 lists only nine, including Dodsworth 140 and Laud Misc. 722; the remaining seven are pre-15th century. Both T and Laud are composite manuscripts. Neither is in its original binding, and Laud is so tightly bound that the quiring is not easy to determine. Allen apparently kept his manuscripts unbound (WATSON, 1978); both Laud and, more especially Cotton, bound miscellaneous texts together, more or less by size. Laud's manuscripts came to the Bodleian Library, Oxford in 1633, but we do not know how long before that it had been in his possession.

The leaves in Laud containing *Amis and Amile*, Pope Silvester, and Bernard look very much as if they were originally part of the same quire as the *Merlin and Lailoken* text now in T—the hand, measurements of both leaves and unframed written space are the same—but we have no idea of when that quire was broken up. It may even have been done at Kirkstall, to get all the Merlin material into the same volume.

By the early 17th century, T was in the collection of the politically controversial antiquarian Sir Robert Bruce Cotton. Cotton did not leave systematic records of how or when he acquired most of his manuscripts, but something can be inferred from internal evidence in surviving volumes. He had manuscripts from both Allen and Henry Savile of Banke, and lent manuscripts to Roger Dodsworth (WRIGHT, 1958, pp. 199, 203). He moved in circles where acquisition of T would have been easy, but exactly when and how he acquired it remains unclear. When Cotton died in 1631, his library had been confiscated by the government over a year before. It eventually became part of the British Museum, now the British Library.

Secundo folio: *audendo scilicet mee*

Contents:

ff. 3-4 Hand 1. **Simeon of Durham, *Epistola Symeonis De Archiepiscopis Eboraci.*** Inc. *Anno ab incarnatione domini 627 Rex Eadwynus predicante Paulino baptizatus est, quia Paulinus...* expl. *ossa illius ad corpus Sancti Cuthberti sunt translata.* A brief account of the Archibshops of York from Paulinus to Thurstan (1114-1140), sent by Simeon of Durham to Hugh, Deacon of York. Printed in SYMEON OF DURHAM, ed. Hinde, 1868, pp. xxxiv-xxxv and 132-137, and RAINE, 1886, II, pp. 252-258, from T, with variants from Corpus Christi College, Cambridge, F. V. 139, ff. 49-51, 12th-century, but with later interpolations, and Lincoln's Inn, Hale MS x iii 'a volume written in the 17th century, of no importance whatever' (RAINE, 1886, II, p. xvii). According to Hinde and Raine, T is the best manuscript of the three. It is translated from the earlier edition of Twysden, in *Decem Scriptores*, using only the Corpus manuscript, by STEPHENSON, 1858, § 18, pp. 769-774. The 1987 reprint of Stephenson includes only Simeon's *History of the Kings of England*, but includes the prefatory matter on his other works, citing T, 'which, though of comparatively modern execution, undoubtedly represents an earlier and better text' (p. 9).

f. 4 Hand 1. **Additional material on York ecclesiastical history.** Inc. *Nomina presulum ecclesie Eboracensis. Sanctus Sampson. Priamus. Tadiacus. Iste est ultimus de gente britonum...* expl. *Johannes Kempe presbiter cardinalis tituli Sancte Balbine qui post ea translatus est ad ecclesiam Cantuarensi succedente ei Willelmo de Bowthe, episcopo Cesternensis in Ecclesie Ebor'.* A later hand has added: *Georgius Nevill.* Booth became Archbishop in 1452; Nevyll in 1465. So 1452-65 is the earliest *terminus post quem* for Hand 1. He may have stopped with Booth simply because his exemplar did, but at any rate he cannot be writing earlier than 1452.

f. 4 Hand 1. **Notes on the etymology of Lincoln, adapted from Geoffrey of Monmouth, *De civitate lincolnensi.*** Inc. *Lincolnia que est caput provincie lyndeseye provocabatur Caerlud, deinde lindecolinum...* expl. *vide galfridum in libro de gestis britonum tempore regis arthuri &c.* 6 lines.
GEOFFREY OF MONMOUTH 1951. Book IX: Ch 1, recounts the adventures of Arthur, and gives all three names for Lincoln; our author is paraphrasing, not quoting directly.

ff. 4-5 Hand 1. **Notes on the bishops of Lincoln, chiefly on Grosseteste.** Rubric: *De Remigius qui fuit primus episcopus lincolnie et de suis successoribus, necnon de fundacionis ecclesie lincolii.* Inc. *Remigius Monachus ffyscanuieull Willelmo duci Normannie...* expl. *successit Willelmo Alnwycke ab ecclesia Norwycensi ad ecclesiam lyncoln' translatus.*
Folios 4v-5 contain a detailed account of Robert Grosseteste, including his usual morning prayer, *Jhesu mercy, Jhesu grant mercy*; his sister's pregnancy by his chamberlain, the chamberlain's confession, marriage, and restitution to office; his death at Woodstock in 1293; Pope Innocent IV's vision of the bishop. The catchword does not match, but the text continues as Robert and the Blessed Virgin both reproach the pope for his extravagance and pluralism. Part at least from Higden (*Item Ranulphus cestrensis*, f. 5, line 16), including the account of his trials with the curia, and its failure to approve his canonization. See HIGDEN, 1882, 8, Book VII, pp. 240-242. Higden does not include the account of Grosseteste's prayer, his sister, or the three lines of verse on his death in 1252, marked *versus* in the margin. The prayer and chamberlain are not in the

14th-century compilation of lives of Lincoln bishops by SCHALBY, 1952, nor mentioned by STRAWLEY, 1953. According to DIMOCK, 1877, pp. xlii-xliii, the account in Titus is indebted to Giraldus Cambrensis's prose lives of Remigius and St Hugh, but indicates no knowledge of Schalby. Several York-Lincoln links are possible. The Archbishop of York was among those approached to write letters for Grosseteste's canonization in 1286-87; could T in part reflect a copy of materials sent at the time? (KEMP, 1955, p. 244). Two successive archbishops of York, Thomas Rotherham or Scott, who is known by both these names (1480-1500), and Thomas Savage (1501-1508) were translated from Lincoln to York. Perhaps the first translation sparked an interest in Lincoln? There were tablets on display in Lincoln Cathedral (GRANSDEN, 1982); could this, like the York and Glastonbury material which follows, have come from such tablets? See KROCHALIS, 1997b.

The last mentioned bishop of Lincoln, William Alnwick, held the see 1436-49.

f. 5v Blank

f. 6 top margin: Drawing of a church.

ff. 6-11 Hand 1. **Poem on the history of the Church of York. Untitled.**
Rubric: *Prologus de origine et statu ecclesie Eboracensis.* Text inc. *Hic eboracensis templi metropolis urbis/ Ecclesieque statum presens pandit tabulatum...* expl. *Reges et cleri populi provincia regna/ Sunt unita ibi federe perpetuo. Amen.* As line 2 claims, the poem was preserved on wooden tablets in the minster at York, along with a short prose history, compiled from Geoffrey of Monmouth and later sources. Printed by RAINE, 1886, II, 246-463 (512 lines) from the late 14th-century *tabula* made under Archbishop Arundel (1388-97), and still in the possession of the Dean and Chapter at York, and from T and Cotton Cleopatra C. IV (imperfect; XV, northern hand); T was his MS B. Evidently he was unaware of a third manuscript, London, BL, MS Harley 1808, f. 48v. The prose general history on a second set of tablets, though not this tablet, was used by John de Foxton *c.* 1408, and collated with Foxton's text by FRIEDMAN, 1988, and discussed by FRIEDMAN, 1983. WALTHER, 1959, no. 7887.
The miracles of St William were also kept on tablets in York minster. RAINE, 1886, II, p. xxxi. See f. 151 below. For tablets at Ripon, see RAINE, II, xxix. For a list of other such tablets, see GRANSDEN, 1982, II, p. 495 and PURVIS, 1967. For the Glastonbury tablets which provided the source for some Arthurian texts, see Provenance above and ff. 16-23 below, and KROCHALIS, 1997a.
Marginal glosses in Hand K.

ff. 11v-15v Hand 1. **On the Antiquities of Rome,** including mountains, arches, baths, theatres, cemeteries, temples, and a long list of churches and indulgences. As Rome is not mentioned in the first sentence, the text may be acephalous. Inc. *Montes infra urbem sunt isti: Ianiculis qui dicitur Ianicarius ubi est ecclesia sancte sabine...* expl. *feria tercia. Ad sanctam Anastasiam. ii feria quarta, ad sanctam mariam maiorem fferia.* Catchword: *quinta;* no following text. Various texts on this theme survive; their relationships have not been much studied, so it seems worth mentioning that this is not the same text as the widespread *Mirabilia Urbis Romae* (trans. NICHOLS, 1988), nor the text in Oxford, Bodl. Lib., MS Digby 196, ff. 6-10v, which can be dated 1483-84, since in the genealogy of English kings on f. 29 (35), Richard III's son Edward is described as *Edward verus heres Anglie, Castelle et legionum.* He died in April, 1484. Our text must have been composed in or after the

late 13th century, since f. 13v refers to Pope Urban IV (1261-64) and f. 15v to Pope Nicholas Vrsinus (Nicholas III, 1277-80).
A few glosses by the same scribe.

ff. 16-23 Hand 2. **Lapidge's 'Glastonbury quire'.** On Glastonbury and the Grail; several sections, listed in detail by BARBER, 1985, whose numbers are included in the entries below. Most of the material in Barber's items 5-15, except the account of St Benignus (BARBER, 1985, no. 8), comes from the *Magnae Tabulae Glastoniensis,* the large wooden tablets measuring 112 cm (3 feet 7½ inches) in height, and 51 cm (20 inches) across (now Oxford, Bodl. Lib., MS lat. hist. a. 2) displayed in the church for visitors to read. The tablets are a hinged wooden box, containing two hinged, swinging, wooden leaves. The front pastedown is page 1; the swinging leaves are pages 2-3 and 4-5; the back pastedown is page 6. The wooden panels must date from after 1382 since they mention the repairs carried out in that year by Abbot John Chinnock (1375-1420) to the altar of St Michael. The closeness of the texts, including some eccentric spellings of personal names, suggests that T's Hand 2 himself may have copied directly from materials at Glastonbury. His Benignus text looks as if it comes from a lectionary for a reading at one of the hours on the feast, ending with a hymn; the feast was not in the general English calendar, and does not occur in late manuscript or early printed Sarum or York missals, even as a commemoration. Glastonbury is the only likely source for such a text. The letters preceding the titles of texts are probably in the scribe's hand, and are found in the margin. They do not reflect the order of texts in the *Magnae Tabulae.* Rearranged in alphabetical order, they put the entries in rough chronological order, and might reflect either the order of materials in his immediate source, if something intervened between the *Magnae Tabulae* and T, or, more likely, the order in which he—or somebody else, if they are not his—intended to include materials in a subsequent compilation. We have reproduced the scribe's capitalization, which varies.

f. 16-16v **An Arthurian Miracle.** I. Rubric: *Quedam narracio de nobili Rege Arthuro [in sacramentum altare non pleno] credente qualiter confirmatus fuit in fide et factus vere credens et quare mutavit arma sua.* Text inc. *Dominus deus universorum conditor cuius providencia in suo disposicione non fallitur…* expl. *Obiit duodeccimo die kalendas Iunii Anno ab incarnatione domini Dxlii et sepultus est in insulo avallonie in cimiterio monachorum inter duas magnas piramides.* A free version of John of Glastonbury, ch. 34 (BARBER, 1985, no. 1); also found in Oxford, Bodl. Lib., MSS Digby 186, ff. 23-24v; Bodley 622; and London, BL, Cotton Cleopatra D. VIII, of the early 15th century. See CARLEY, 1990-91, and f. 103 below.) A later hand has noted in Digby 186: *Haec fere omnia ad verbum recitantur Gulielmo Malmesberry in libro de antiquitatibus Glastonbury.* This is true, but the text is closer to John of Glastonbury who, of course, used William of Malmesbury's work on the Antiquities of Glastonbury. On Digby 186, see Provenance above. It also contains the *Vera historia,* and *De origine Gigantum* (see below, f. 103). BARBER, 1985 says that T must be the source for Digby's text of *Vera historia,* because the scribe incorporates the T corrections. The drawing of a crown which accompanies *Vera historia* in MS T is used in Digby 186, f. 16, for prophecies of kings. The Cotton Cleopatra manuscript is so far unlocalized, though CARLEY/CRICK, 1993 suggest Glastonbury; it contains the *De origine gigantum* but not the *Vera Historia.* Lapidge noted a volume in the library of the York Austin friars, no. 156c, an historical miscellany, which contained a text which may have been the *Vera Historia* on f. 16v; it also contained a text listed as *quedam narraciones.* The volume also contained Geoffrey of Monmouth and Gildas, as well as Petrus

Alphonsus, so cannot have been MS T, but may have provided an exemplar for some of its texts. In such a miscellany, *quedam narraciones* could refer to anything, but the similarity is worth remarking. See JAMES, 1909 for the Catalogue; LAPIDGE, 1982.
BARBER, 1985, no. 1; not on the *Magnae Tabulae*.

f. 16v drawing of crown in margin by beginning of text.

ff. 16v-17v **The *Vera Historia* of Arthur.** k. Rubric: *Hec est vera historia de morte Arthuri.* Text inc. *Igitur, finito prelio certamine…* expl. *Igitur Arthuro defuncto constantinus cadori ducis filius britannicum adeptus est regnum, et cetera.* Also in London, BL, MS Cotton Cleopatra D. III; London, Gray's Inn 7; Oxford, Bodl. Lib., Digby 186, ff. 24v-25v (see preceding entry); Paris, Bibliothèque de l'Arsenal, MS 982; Paris, BN, MS lat. 6041D (BARBER, 1986; BARBER, 1985, no.2; LAPIDGE, 1981, edition from the two other London manuscripts; LAPIDGE, 1982, readings from T).
Corrections in the Henricus hand: see below, f. 18.

f. 17v **Finding of the bodies of Arthur and Guinevere at Glastonbury.** *L.* Rubric: *De inventione corporis regis Arthure Giraldus Cambrensis archidiaconus landauensis narrat.* Text inc. *Tempore regis henrico secundo corpus regis Arthuri…*
Not from Giraldus, but from Ralph Higden, *Polychronicon*, Book vii, Ch. 23 (BARBER, 1985, p. 39). Later in the same article, BARBER, 1985, p. 59, the reference is to the volume and pages in the Rolls Series edition of Higden: Book viiii, 60-64. Both references are correct. Giraldus, *De principis instructione*, which was Higden's source, survives in only one copy: London, BL, MS Cotton Julius B. XIII (GIRALDUS, 1891); compare the version from his *Speculum Ecclesie* in GIRALDUS, 1873, p. 50.
BARBER, 1985, no. 3; not on the *Magnae Tabulae*, but cf. the *Magnae Tabulae* 4 on Arthur.

f. 18 **Untitled, from Chronicle of Margam Abbey.** *m.* Inc. *Anno quarto regni regis Ricardi…* expl. *Primum tumulum dicunt fuisse Wenenore uxoris enim secundum Modredi nepotis sui, Tercium eiusdam Arthuri.*
BARBER, 1985, no. 4; text printed pp. 52-53; the *Magnae Tabulae* has a burial list, mentioning Arthur and Guinevere on leaf 5.

f. 18 a medieval hand, not that of the scribe, and not occurring elsewhere in the manuscript, except in the corrections to these texts, has added a note: *Ego henricus non concedo proditores illius cum se sepultus, quia absurdum esse videtur.* Mordred is described as Arthur's *proditor* in *Vera historia*: *quod inter Arthurum regem britanum et modredum non dico nepotem, sed proditorem suum.*

f. 18 **Joseph of Arimathea at Glastonbury.** *a.* Rubric: *Incipit tractatus de Sancto Josepho ab aramathia extractus de libro quodam quem invenit Theodosius imperator in ierusalem in pretorio pilati.* (underlined in MS) Text inc. *Quoniam dubia sepe legentum fallunt certa, dubiis ablatis atque ex antiquis historiographicorum dictus probata… quorum viri actus in libro predicto leguntur.*
BARBER, 1985, no. 5; JOHN OF GLASTONBURY, 1985, ch. 18, with variant ending; see Carley's note, pp. 40-50. the *Magnae Tabulae 1*.

f. 18v Gloss, Hand K: *qui dicitur graal.*

ff. 19-23 **Texts on the foundation, antiquities and images of the monastery of Glastonbury.** BARBER 1985, nos. 6-16.

f. 19 **Note on Joseph of Arimathea.** *d.* Rubric: *Hec scriptura reperitur in gestis inciti Regis Arthuri.* Text inc. *Josephus Armathia nobilem decurionem cum filio*

suo Josephes dicto et aliis pluribus in maiorem britanniam… expl. *quidem die poterat portare.*

f. 19 **Prophecy of Melkin.** *e.* Rubric: *Iste scriptura invenitur in libro Melkini qui fuit ante Merlinum.* Text inc. *Insula Avellonus quidam funere paganorum…* Includes verses from the *Aurora* of Peter Riga on Joseph; expl. *filios scilicet Agrayvauns. Groerehes. Acheries.*
BARBER, 1985, no. 6; JOHN OF GLASTONBURY, 1978, end of ch. 20, beginning of 21, is the main source for this item. Includes information on King Arviragus from earlier in ch. 20; see note in JOHN OF GLASTONBURY, 1985.
B 6; the *Magnae Tabulae 1.*

ff. 19v-20 **Apostolic Foundation of Glastonbury.** *b.* Rubric: *Incipit quomodo xii discipuli sanctorum Philippi et Jacobi apostolorum primo ecclesiam Glostonie fundaverunt.* Text inc. *Post dominice resurrectionis gloriam…* expl. *donec placuit beato virgini suum orationem redire ad memoriam fidelium.*
BARBER, 1985, no. 7; WILLIAM OF MALMESBURY, 1981, pp. 42-47; Barber says a close copy. the *Magnae Tabulae 2,* top.

f. 20-20v **Summary of John of Glastonbury, Ch. 1, or the lost church lection on which that chapter is based.** *c. Anno post passionem domini xxxi° duodecim sancto ex quibus Joseph ab armiatheia primus erat huc venerunt qui ecciam huius regni primam in hoc loco construxerunt…* expl. *columpna a puncto medio inter predictos angulos xlviii pedum.* Ends with note on the dimensions of the old church. BARBER, 1985, no. 8; the *Magnae Tabulae 3.*

ff. 20v-21 **Liturgical Readings for St Benignus.** *g.* Rubric: *De Sancto Benigno.* Text inc. *Benignus ex nobilis parentibus hibernie oriundus sancto patricio evangelizanti puerulus benigne adhesit…* expl. *animam suam domino commendavit. vita vero eius in…conspectum domini gloriosam doctrinam et mores commendabiles plurima miracula testantur. Quorum plura habentur in libro translacionis eiusdem. Oratio ad Sanctum Benignum. Gaude sancte vir benignus. heremita dei dignus. dulcis flos hibernie…* Collect. *Ora pro nobis beate benigne…* The Feast of St Benignus was celebrated on 9 November; his translation was celebrated only at Glastonbury, on 27 June, according to the Sion Martyrology. The Life of St Benignus is in form comparable to John of Glastonbury, chs. 29-30, but has a totally different style. Mentions the yew tree which grew from his staff, and gives its location, which John does not. CARLEY, 1985, pp. xxxvii-xxxix, suggests William of Malmesbury's lost *Life of St Benignus* as a source. There is an account, again differing slightly, and without the prayer and collect, in John of Tynemouth (Oxford, Bodl. Lib., MS Bodley 240). BARBER, 1985, no. 9; longer than the version on the *Magnae Tabulae 3,* which also lacks the hymn. The *Magnae Tabulae 3* includes the same other saints in the same order.
AASS Nov. IV, p. 188, on the cult of St Benignus at Glastonbury. The prayer, collect and hymn used as an *Oratio* are not in AH, the early printed York or Sarum missals, the unprinted 15th-century York missal which is Oxford, University College, MS 78B, or the indices of CHEVALIER, 1892-1921 or WALTHER, 1959.

ff. 21-22v **Abbreviated early history of Glastonbury, loosely based on William of Malmesbury.** *f.* Inc. *Anno ab incarnatione domini lxiii° et assumpcione beate marie xv°, Sanctus Philippus episcopus…* Cf. *De antiquitate glostonie ecclesie,* Ch. 1; list of saints who visited Glastonbury, or whose relics were there, from an unidentified source, but post 1382, as it mentions that Abbot John Chinnock (1375-1420) renovated the chapel where Joseph of Arimathea's

relics were kept in that year. Ends with verse note on Arthur, repeated in the margins of Stafford's chronicle, f. 105:

Hic requiescat rex Arthurus flos britonum Guennora regina de quibus tales extant versus:
Hic iacet Arthurus flos regum gloria mundi
Quem morum probitas commendavit laude perenni
Arthurus iacet hic coniunx tumulata secunda
que meruit celos virtutum prole fecunda.

The word *et* is in diamond-shaped brackets because it is not completely legible in the manuscript. See also f. 14 below. This is followed by a list of royal visitors and burials at Glastonbury, expl. *...ibidem requiescunt.* BARBER 1985, no. 10. A shorter account of the chapel, mentioning Chinnock, is on the *Magnae Tabulae 6*; Arthur's epitaph the *Magnae Tabulae 3*, with two variant readings: line 1, *regni* (T: *mundi*); line 2: *mores* (T: *morum).*

Items B11-16 are all grouped together as item h in T. The same texts, in the same order, comprise the bottom third of the *Magnae Tabulae 3.*

f. 22v **The translation of St Dunstan.** h. *De translacione sancti Dunstani a Cantuaria ad Glastoniam.* Abbreviated from *De antiquitate*, Ch. 23. BARBER, 1985, no. 11; the *Magnae Tabulae 3.*

f. 22v **On a cross.** *De venerabili cruce que quondam locuta est.* From *De Antiquitate*, Chs. 27-28; In the English phrase *Nu to late, nu* is modernized to *now*. The *Magnae Tabulae* reads *nu*. BARBER 1985, no. 12; the *Magnae Tabulae 3.*

f. 22v **On another cross.** *De alia cruce de qua cecidit diadema.* From *De antiquitate*, Chs. 27-28. BARBER 1985, no. 13; the *Magnae Tabulae 3.*

ff. 22v-23 **On an image of the Virgin.** *De quadam ymagine beate Marie.* From *De antiquitate*, Ch. 29. BARBER 1985, no. 14; the *Magnae Tabulae 3.*

f. 23 **On an image in the old chapel.** <u>*De ymagine antiquioris capelle.*</u> (underlined in MS) *Exstat ymago ceteris antiquior in Anglia, de qua narrat magister Edmundus Stowrton' eiusdem loci monachus...* (f. 23) *Monasterio Glast' dictus Rex contulit devotissime. Insuper scripto regio terras possesiones et libertates eiusdem ecclesie confirmant.* A summary of the incident in JOHN OF GLASTONBURY 1985, Ch. 17, where Edmund Stowrton is described as *sacre pagine professor.* CARLEY 1985, notes to Ch. 17. BARBER 1985, no. 15; the *Magnae Tabulae 3.*

f. 23 **The relics of St David.** *De reliquis Sancti David.* From *De antiquitate*, Ch. 16, followed by excerpt from Ch. 40 on the churches founded in the Isle of Avalon. BARBER 1985, no. 16; the *Magnae Tabulae 3*, immediately above BARBER 1985, no. 11.

f. 23v Blank

ff. 24-39 Hand 2. **CC Book IV:** *Pseudo-Turpin*, **with interpolations**
Prologue. Rubric: *Incipit prologus Turpini Archiepiscopi Remencis, quomodo Karolis magnus Rex francorum adquisivit hispaniam. Hunc librum dicit papa Calixtus esse autenticum.* Text as in C (W 301) inc. *Turpinus dei gratia...* expl. (f. 24) *domino placeas. Amen.* Rubric: *Explicit prologus. Incipiunt capitula.* Chapter list of 25 chapters (lacks C's Ch. 26, although it is present, unnumbered and unrubricated, in the text). Rubric: *Expliciunt capitula. Incipit historia.* Chapters are rubricated as in the Chapter list, and numbered in the outer margins. Text as in C up to Ch. 21. Subdivisions of Ch. 21 are rubricated at *Domine Ihesu Christe* (W 332), *Non decet* (W 334), *Quid plura* (W 334), *Crastina namque* (W 336), *Tunc defunctorum* (W 336), *Et erant tunc* (W 337), *Beatum namque* (W 337), *Postea vero ego* (W 338). These

correspond to L's chapters, but L has two additional subdivisions at the beginning of the chapter which are not in T. Ch. 22 of C, *Post hec Viennam*, is rubricated but not numbered in T; the Liberal Arts are each rubricated, and *Post exiguum vero* (f. 38) is rubricated and numbered Ch. 22. Chs. 23 and 24 are as in C (W 343-345).

f. 39 The false bull of Innocent II, and versions of Charlemagne's *Iter* to the Holy Land and the *Conversio* of Ogier the Dane, not noted in the Chapter list, are interpolated between Chs. 24 and 25 of Book IV.

f. 39 Hand 2. **False bull of Pope Innocent II**
The text of the bull is slightly abbreviated throughout. Text and variants from all manuscripts are given in our Latin Appendix, in Vol. II (cf. WHITEHILL, 1944, pp. 399-400).
WARD, 1883, I, pp. 578-579, notes that the order of signatories is the same in London, BL, MS Add. 19513, but with Ivo included. Add. 19513 is a late 13th-century manuscript, and has the same order of texts, including the bull between Chs. 24 and 25 of Book IV, but cannot be the source for T, as it is defective at the end; the scribe left gaps, as though he had trouble reading his exemplar. See f. 163, where *vastata* is omitted in the phrase *que erat vastata detulent illud ait*. There are several longer gaps on f. 163v. Add. 19513 also lacks the ascription to Calixtus at the beginning, and the extra Charlemagne and Ogier material at the end.

f. 39v Hand 2. **A version of Charlemagne's *Iter* to the Holy Land.** This and the following section are not in the text of *Pseudo-Turpin* in C (as printed by Whitehill), or any other *Pseudo-Turpin* described by MEREDITH-JONES, 1936/1972, HÄMEL, 1950, 1953, MANDACH, 1961, nor in any manuscript we have examined. Inc. *Helinandus cum Karolus liberata terra sancta vellet adde reliquiis domini asportare de Neapoli. Daniel Neapolitensis episcopus...* expl. *In quo consilio fuit Leo Papa hoc statuens et turpinus archiepiscopus et multi alii.* Hand K has written in the margin: *Hic est valde mira.*
T's immediate source for the story has not been identified. Though he ascribes it to Helinandus (of Froidment), his version differs in some details from that in the printed version of the Chronicle of HELINANDUS, 1865, col. 845 ff., where the miracle occurs at Constantinople in 802. See WARD, 1883, I, pp. 578-579. Helinand was probably using a version of the early 12th century *Descriptio qualiter Karolus Magnus...*, whose editions and problems are discussed by BEDIER, 1929, pp. 122-141, and PICHERIT, 1984, pp. iv-vii. The miracle also occurs in Constantinople in the version in the *Iter* or *Expeditio Karoli Magni*, printed from MS I.F. 541 in the Universitätsbibliothek, Breslau (Bratislava), by KLAPPER, 1911, no. 3, pp. 8-11. John of Tynemouth, writing at Bury St Edmund's in the 14th century (Oxford, Bodl. Lib., MS Bodley 240, page 294 (Bk. 18.3) has a longer and more elaborate version of this story. Neapolis is the Syrian Neapolitanis, not Naples.
There is a possibility that T's immediate source was, as for the Arthurian material, the collection of volumes summarized under item 156c in the catalogue of the Austin friars of York. JAMES, 1909: item 156c also included a *flores elynandi*, which was presumably a florilegium drawn from the works of Helinand.

ff. 39v-40 Hand 2. **Ogier the Dane becomes a monk.** Inc. *Mortuo invictissimo triumphatore Karolo magno, placuit Ogero daco militi acerimo et strenuissimo gloriosi principis predicta pimipilo(na) transire...* expl. (f. 40) *sanctissime vivens consueretur obdormuit tandem in domino dux inclitus monachus sanctissimus. Amen.*

Same version as NECKAM, 1863, *De Naturis Rerum*, (*c.* 1200-1204), pp. 261-264, without the concluding moralization. In Neckam, it is told as a moral warning against the pride of horses, which humans should not imitate. According to BEDIER, 1913, pp. 288-310, Neckam's version is unique as a literary text, but reads as though it were taken from a lectionary or passional. TOGEBY, 1969, p. 35 considers that Neckam invented it, modelling his story on the *Moniage Guillaume*. The passage was not recognized as Neckam by WARD, 1883, I, pp. 579-580, who compares the *Conversio Othgerii Militis* printed in MABILLON, 1735, I, pp. 622-624. That converted knight, however, was not originally Ogier the Dane, and does not emerge from his monastery again. As Thomas Wright noted (NECKAM, 1863, p. lviii) Ogier does appear as a monk in the Meaux Life of St Faron, MABILLON, p. 665, but he does not fight Saracens there either. For similar stories about Walter of Aquitaine, Dietrich of Bern, and Heimer, see Ward. This version is closer to the vernacular French accounts of the *Moniage Ogier*, but not exactly like any of them.

Either T or his exemplar took the story from Neckam, whose text was widely available in England (HUNT, 1984, pp. 134-136). The fact that *De Naturis Rerum* was almost unknown on the continent (HUNT, 1984, p. 127) makes it likely that T's immediate exemplar was English, and that he was himself responsible for the insertion. The Austin friars at York had a copy (JAMES, 1909, no. 334, p. 51; cited in HUNT). It is tempting to think of T compiling a Charlemagne anthology to compare with his Arthurian anthology above.

Of the four manuscripts used by Wright, T's text is closest to his base text, London, BL, MS Royal 12. F. XIV, a 13th-century manuscript of unknown provenance.

f. 40 Hand 2. **CC Book IV, Ch. 25**
Text as in C (W 345), preceded by a rubric. There is a break at the end of the chapter; the writing is larger, and the pen nib broader, but the letter forms are like those of Hand 2.
Ch. 26 and Book V were copied after the break.

f. 41 Hand 2. **CC Book IV, Ch. 26**
No rubric or chapter number; text as in C (W 347-348), ending incomplete at *centum episcopis in concilio* (W 348, line 31). A small cursive hand has added *explicit* in the margin. C's injunction that this should be read between Easter and the Feast of St John the Baptist and doxology (W 348, lines 32-38) are omitted.
HÄMEL, 1950, p. 73, put T in his C group as C12. MEREDITH-JONES, 1936/1972, p. 16, puts it in his miscellaneous D group, as D 10, but notes that, although the text as a whole resembles D1—CASTETS, 1880 edn from Montpellier manuscripts—the early chapters and ch. 24 resemble the CC. In this he disagrees with WARD, 1883, pp. 578-579, who notes that T is textually like London, BL, MSS Harley 6358 and Cotton Nero A. XI, though with different chapter divisions. Harley contains no extra material. Nero contains the *Charta Charitatis* of Stephen Harding (f. 8 ff.) and so must be Cistercian. It also contains the standard collection of Miracles from the CC Book II on f. 38 ff., and the false bull on f. 64. The note on the Navarrese is on f. 23. Meredith-Jones classes Nero as A.7 (p. 7), and does not mention Harley 6358. Our brief spot collations indicate that T does not consistently line up with any of Meredith-Jones's three main groups (A, B, C).
Glosses in Hand K, ff. 39 ff.

ff. 41-43 Hand 2. **CC Book V: Pilgrim's Guide**

Long Version, see Table of Book V. Ends in Chapter VII (f. 43) *et de iumento iiij indigne*. Though treated as the end of the text by the scribe, this is not the complete sentence: *capiunt* is needed. Could this have been the end of a quire or leaf in his exemplar? It is not the end of a leaf in C, or any other extant manuscript. WARD, 1883, I, p. 580.

ff. 43-47v Hand K. **Notes, all in the same hand, but not written at the same time, or with the same pen.** Notes from Ambrose; Chrysostom; Isidore; Nicholas de Lyra on Daniel, Exodus and Isaiah; and an unidentified source who quotes Augustine and Gregory, ending on f. 46v.
The rest of f. 46v and all of f. 47r are blank.

f. 47v Hand K. **Notes about Kirkstall Abbey.** Inc. *Quidam abbas* (*de Kyrkestall* added above the line) *nomine hugo de grimston…* expl. *Successit hugoni de grimston Johannes bridesall annno domini m⁰ ccc⁰. iiii⁰.*
TAYLOR, 1952; see below, ff. 59-61 for detailed analysis. This material derives from Oxford, Bodl. Lib., MS Laud Misc. 722, including the debts. The same information appears in Oxford, Bodl. Lib., MS Dodsworth 116, f. 7v, following the copy of the *Fundatio Kirkstall*, described by Dodsworth as 'transcribed from the MS belonging to Mr Cooke, Vicar of Leeds, 6 September 1619'.

f. 47-47v Hand K. **Theological notes, one from Gregory's Dialogues.**

f. 48 Hands 3 and 4. **An unnamed King of Denmark's vision of the Three Kings of Cologne.** Rubric: *De tribus regibus.* Text inc. *Rex danorum ad tres regas qui stella duce ab oriente. iherosolimam venerunt singulariter dicere talia;…* (Text continues, but in a different hand.) *primus et senior dicit: Frater mi, feliciter senisti…* expl. *devotissime adimplevit. Expleto termino supradicto regna celestia meruit possidere.*
Not in the standard account of the three kings, by John of Hildesheim (*c.* 1364-75), whose account ends with the relics of the three kings coming to Cologne in 1164. HORSTMANN, 1886 includes a Latin text of John, for which he collated the only two English manuscripts he knew: Cambridge, Corpus Christi College, MS 275, and London, BL, MS Cotton Cleopatra D. VII. To that list should be added Oxford, Bodl. Lib., Rawlinson B. 149, and Lincoln, Dean and Chapter Muniments, Di/20/3. None have any added material. The Lincoln manuscript is cited in WILLIAMSON, 1956, p. 37, and described by KER, 1983, p. 142. On the legend in early printing, see WARD, 1883, entry on Cotton Cleopatra D. VII. The historical kings of Denmark who visited Germany were Valdemar I (1131-82), who was in Germany in 1162 and again in 1182, and Valdemar IV (*c.* 1320-75), who spent the years 1368-71 in Germany. Valdemar IV is likelier to have brought the three kings three golden crowns, as the story relates, though no contemporary Danish chronicler mentions the story. For Danish chroniclers, see GERTZ, 1917-18 and 1918-20, reprinted 1970.

f. 48-48v Hand 1. **Unidentified miracle of an unidentified King Edmund,** whose empty treasury is refilled after an angelic vision. Inc. *Legitur de Edmundo rege Anglie qui pater in regno successit, et die epyphanie in regem coronatus, fuisset votum velut queusque viveret si in dicto die oblacionem suam multiplicare…* expl. *quem collegit, et de hostibus triumphant cum honore igitur diviciis hic temporaliter et in celis eternaliter usus est.*
This miracle is not in any of the collections of miracles associated with King Edmund (ARNOLD, 1890-96) or (allowing for a possible misreading of the exemplar), with Edward the Confessor (LUARD, 1858). Edward the Confessor was at one point without funds and gave his ring to a beggar, who turned out to be St John the Evangelist, a subject popular in English 13th-century representations of his life. He was known for his generosity

and both he and Queen Edith lived as simply as possible, but even the building of Westminster Abbey did not exhaust his funds. Even the vast collection of Edmund miracles in Oxford, Bodl. Lib., MS Bodley 240 has so far not yielded up the story related here. No King Edmund or Edward whose coronation date is known was crowned on Epiphany.
Both Edmund Ironside and Edward the Elder were buried at Glastonbury. Could this too be a Glastonbury story?

f. 48v Hand K. **Theological notes, including one from Gregory.**

f. 49 Hand K. **An incident from the life of Edmund Rich.** *Legitur in Vita Sancti Edmundi Episcopi cantuariensis quod quociens carnis temptacio ipsum vel invasit tocies ymaginem Beate Virginis filium lactantis respexit, vel de tali ymaginem virginis intime cogitavit et statim eius temptacio cessavit, et hoc in aliis eciam impetravit, fluit scilla de mamilla gloriose virginis, fundens roram qui odorem extinguat libidinis.*
This statement, though plausible, is not found in any version of the life of Edmund Rich, or in his *Speculum*. A printed copy of the latter was at Kirkstall; the copy, with a note on the last leaf by T Hand 1, is now part of Oxford, Bodl. Lib., MS Laud Misc. 722. The first life of Edmund, by his pupil and friend, Richard of Chichester, and subsequent lives of Edmund do record that as an undergraduate, Edmund became disgusted with the women of the town, and 'wedded' the statue of the Virgin in St Mary's (unfortunately destroyed at the Reformation) with a very costly ring.

ff. 49-49v Hand K. **Theological notes, including Chrysostom and Jerome, and proverbs, two with English translations:**

f. 49v Proverbs:
Inc. *Male acquisisti et male perdidisti*
It is ryght that it be evyll loste; yt is evyll won… Expl.
Tolerabilius est audire basilicum sibilantem quam mulierem cantantem, ut dicit Origenes.
Hand 5. *Better is it to heare ye cocbakire hissinge, then to heare at any time a woman singinge.*

ff. 50-52 Hand 6. **Mathematical materials, problems with examples,** including the price of building a camp, and supplying an inn with food, some in French. Tables of weights and measures.

ff. 51v-52 Hand K. **Theological notes, one from Gregory**

f. 53 Hand K. Title: **Thurstinus Archiepiscopus Eboracnesis**

ff. 53-56v Hand 7. **Poems on the Church of York, under Archbishop Thurstan, with a prose introduction and inserts.** Inc. *Anno domini m° c° xv° Electus fuit venerabilis Thurstinus in Eboracensem Archiepiscopum. Anno xv° henrici regis primum post conquestum…venerabilis de Pontefracto. Hugo nominatus sic metrice canit versus: Urbem Eborum Eboris de nomine nomen…* expl. (f. 56v) *Cordis nil pena corporis immo preces. Explicit Vita Beati Thurstini Archiepiscopi Eboracensis.* None of the verse is in WALTHER, 1959 or RAINE, 1886, II, pp. xvii-xviii and II, nos. 259-269. T is the only manuscript of this text, which is our chief source for the life of Archbishop Thurstan. Most of the verses are by Hugh of Fountains, where Thurstan retired to die; some of the later verses are by Geoffrey of Nottingham. The compiler is anonymous. PAGE, 1913, ch. III; DIXON/RAINE, 1863, chapter on Thurstan.
Hand 7 has a similar duct to Hand 2, but a detailed comparison of letter forms (a, g, s, tironian nota &c.) indicates a different scribe.

f. 56v Hand 8. **Verse dialogue between Bernard and a monk.** Inc. *Dialogus inter*

*sanctum bernardum abbatum Claravallensem et quendam monachum eius
…Mira loquar, sed digna fide. Bernarde quid hic est? (M) Tu quis et unde? (B)
dei servus sum…* expl. *(B) Hoc quam fiet? Sis caro quando resurgas.* The
speakers' initials appear above the line. 20 lines; WALTHER (1959), no.
11071, listing 23 manuscripts; the only other English manuscript is
Manchester, Chetham's Library MS 181 (14th century). See also
CHEVALIER, 1892-1921 no. 26650.
The last three lines have been rearranged and marked *ACB* in the margin.
The text of line B might possibly be in Hand 1.

ff. 57-58 Hand 4 (see f. 48). **Notes on English history, and on Rome,** largely from
HIGDEN, 1865-86, including material on St Frideswide, the foundation of
Oxford University by Alfred, and Peter's Pence. Title and occasional
marginal glosses in Hand K.

f. 58v Hand K. **Notes on Plato, Alexander and Hippocrates, and from the
Gospel of John**

ff. 59-62 Hand K. 16th-century quire, by watermarks.

ff. 59-61 **Notes on property of Lacy family.** Heading: *Laci.* Text inc. *Post
conquestum autem in unum dominum omnia sunt redacta quod quidam
dominum de backburnschyre* (sic) *prefatus Willelmus rex conquestor dedit
cuidam hilberto de lacy militi qui secum…* expl. *quod hec est vera littera
quamvis aliquod historie dicunt.* Ends in the time of Matilda and Stephen.
On the ecclesiastical benefactions, and on the lands. Also in Oxford, Bodl.
Lib., MS Laud Misc. 722, ff. 97v-98v and 112, written in the same hand.
Also found, in a form with more material at the beginning and end, inc.
Memorandum quod tempore Ethelberti, in Oxford, Bodl. Lib., MS Dodsworth
157, f. 1v, line 8. This is a manuscript of the 15th century with an ownership
note, *'Ex dono Johannis Stanhop Armiger';* ff. 15-18 were also transcribed from
Stanhope's manuscript. Oxford, Bodl. Lib., MS Dodsworth 159, f. 15, item 2
lists *'Quodam antiquo libro manuscript. in Custod. Ricd. Lacy de recto inter evident'
patribus.* F. 15v, line 13–f. 18, line 11, continues the Lacy genealogy where
Dodsworth 157 (and Laud and T) leave off.
The same text occurs in a shorter form in London, BL, MS Cotton
Cleopatra C. III, a manuscript from the Abbey of Stanlow, on f. 330, Inc:
Memorandum quod rex Willelmus conquestor dedit cuidam Ildeberto de lacy;
this version omits the Pomfret chapel. See also T, f. 60, *venit quidem miles
cum Hugone…,* which also comes from this manuscript.
On T, Laud and Dodsworth's various manuscripts, see TAYLOR, 1952, pp.
32-35. He demonstrates that Laud and T were copied independently from
the Stanhope manuscript, and that Dodsworth copied from Hand K's
version in the Laud manuscript, not from T.

f. 60-60v **Lacy Genealogy** *Genealogia domini Henrici de Lacy…comes de Lancastrie
despensavit.*
cf. MS Laud Misc. 722, f. 126-126v; the original source was the *Historia
Laceiorum,* of the 15th century, now bound into Oxford, Bodl. Lib., MS
Dodsworth 157; DUGDALE used Dodsworth 157 (*Monasticon,* V, p. 533).
Dodsworth made the notes on the Lacy family which are now in Oxford,
Bodl. Lib., MS Dodsworth 118, f. 46v, *'in a pedegre of lacye in foure colomes in
Sr H. Saviles custody of Metyeley 1622'.;* the notes from Laud follow on f. 47
'in quidam antiquo MS in custodia Mr. Fawkingham de Leedis 19 Aug. 1620'.
He adds, in a different ink *'quidam Abbathiae de Kirkstall pertinentur'.* The
genealogy from the Cistercian foundation at Stanlow, Cheshire (London,
BL, MS Cotton Cleopatra C. III, f. 325) is very similar, but fails to list some
ecclesiastical foundations; also, William the younger dies in Normandy,
not *'in transmarinis partibus'.*

The genealogy of the Lacy family is not the same as that in London, BL, Harley 1808, f. 22, though the same general facts are presented as in T.

f. 60v Hand K. **The obit of Robert de Lacy.** *Inventum est in cronicis abbathie de Kyrkestal quod anno regis henrici quarto et anno domini m⁰· x. c. iii⁰.* cf. Oxford, Bodl. Lib., MS Laud Misc. 722, f. 138v.

f. 61-61v Hand K. **Notes on Kirkstall abbey, from foundation to suppression.** Inc. *Status domus de Kyrkestall in creacione domini hugonis de grymston abbatis die sancti lamberti episcopi et martiris anno domini m⁰cc⁰lxxx iiii⁰ inprimis boves… Supprecio \et eiusdem/ domus de kyrkestall die sabbati anno domini m⁰ccccc⁰xxxix⁰die Sancte Cecelie dicata x⁰ kalendas decembris littera dominicalis. E. ….* cf. Laud Misc. 722, f. 112v *(anno domini m.c. lx historie dicunt)* These notes come ultimately from the *Fundatio Kirkstall,* a 14th-century MS now part of Laud Misc. 722 (ff. 129-138) and the *Historia de Kirkstall,* in the same hand, now in Oxford, Bodl. Lib., MS Dodsworth 140. The *Historia* seems to be written in the Kentigern hand (Hand 9) below.

f. 61v **Crossed out:** *How William bastarde duke of Normandy cam into englande and slewe kynge herolde.* cf. Laud Misc. 722, f. 127v.

f. 62-62v Hand K. **Lacy family notes.** Inc. *Memorandum quod quidem hilbertus lacy intravit angliam tempore Willelmi bastardo… expl. de quo henrico processit henricus sextus qui nunc est etc.* TAYLOR, 1952, pp. 32-35. Cf. London, BL, MS Cotton Cleopatra C. III, f. 329, and especially f. 329v; Oxford, Bodl. Lib., MS Laud Misc. 722, f. 125v has more information than T, and must have a different source.

f. 62v Hand K. **On Holy Trinity, York, and a grange.** *Tempore lamberti abbatis tercii Apud akeryngton…* On the Akerington grange, see also the Kirkstall *Cowcher book* (LANCASTER/BAILDON, 1904).

ff. 63-73v Hand 8. **Geoffrey of Monmouth,** *Vita Merlini,* **abridged.** Rubric: *FFata Merlini Silvestri secundum historiam policronicon que contigebant anno gratie 525.* A later hand, probably 17th-century, has identified *Galfrid Monumetensi* in the margin. Inc. *Vatidici vetis rabiem musamque iocosam Merlini cantare pero tu corrige carmen…* expl. *ut valeam fungi vita sine fine prohenni. Amen.* In a previous binding, some of the leaves were out of order, and a 16th-century hand has made connecting notes with catchwords, which Cotton or the modern binders and foliators have followed; the leaves are now in the correct order. 33-36 lines per page. This is an abridged version of the poem. 698 lines. Leland says there was a copy of this work at Glastonbury; it cannot have been T, as he quotes vv. 908-15, which are not in T. (CARLEY, 1985, pp. xlii-xliii). Other copies include: London, BL, MSS Cotton Vespasian E. IV, f. 112v; Harley 655, late 14th century; Royal 13. E. I, *c.* 1380 (which also contains the *Epitome Cambrie,* T f. 101); Cotton Julius E. VIII, late 14th or early 15th century; York Minster Library XVI Q 14 (1387 of the total 1529 verses); extracts in London, BL, MSS Cotton Cleopatra C. IV, late 15th century, and Harley 6148, early 17th century. The Cotton Julius MS is closest textually to T. Also in Oxford, Bodl. Lib., MS Bodley 240, pp. 177-181b, with the marginal heading: *Merddyn Wyllt dicitur britannie* (late 15th or 16th century.) WARD, 1883, I, pp. 290-291; collated BLACK/GRENVILLE, 1833; ed.

MICHEL/WRIGHT, 1837 from this manuscript and London, BL, Cotton Vespasian E. IV; ed. PARRY, 1925; translated and edited, from Parry's text and variants, with a full discussion of all earlier editions, including several not using T, CLARKE, 1973.

WALTHER, 1959, no. 6286 (Inc. *Faticidi*).

Hand 8 is similar to Hand 2, but uses more secretary forms, such as single-compartment a, short r, and slant-backed d.

ff. 74-76 Hand 1. **Tales of Merlin and Lailoken.** Rubric: *Vita Merlini Silvestre* (in Hand K). Text inc. *Eo quidem in tempore quo beatus kentigernus heremi deserta frequentare solebat, contigit die quadam illo in solitudinis arbusto solicita orante...* expl. *In cuius campore lailoken tumulatus quiescit/ Sude perfossus lapidem perpessus et undam/ Merlinus triplicem fertur misse necem.*

Very small writing; 52 lines per page. Two leaves inserted in a quire of 16. Some of the other leaves in this original quire in T's Hand 2 may be inserted in Oxford, Bodl. Lib., MS Laud Misc. 722, ff. 111 (historical notes), 112 bis (Bruno), 127 (Amis and Amile), 141 (Pope Sylvester and historical notes).

T is the only extant version of this text (WARD, 1883, I, pp. 290-291, and, for the text: WARD, 1893 pp. 504-526; JARMAN, 1960, pp. 20-30; translated CLARKE, 1973). The story is paraphrased and retold in PETRIE, 1950, pp. 189-194. A version of the first tale was used by the 15th-century chroniclers Walter Bower and John de Fordun in *Scotichronicon*; see BOWER/FORDUN, 1759 and ed. Watt, 1987-91, Book III, Ch. 31. As Bower died in 1449, the story must have been in circulation earlier in the 15th century in Scotland (WARD, 1893, pp. 510-511).

f. 75v Hand K. **Theological notes.**

ff. 76-80 Hand 9. **Chapters 1-8 of a Life of St Kentigern.** *Vita kentigerni. Multas quidem* (*earumdem* crossed out) *perlustram regiones. earumdem mores et cleri plebiique devociones diligenter...patrono ecclesie ceteris datavit brittaniam.* A later hand, probably Cotton's librarian, has added: (*Cætera desunt*)

Hand 9 wrote the *Fundatio Abbathie de Kyrkestall* now in Laud Misc. 722, ff. 129-138v. The watermark on ff. 76-77 of T indicates a date *c.* 1479. The watermark in Laud is not visible. T is the only surviving manuscript of this text, but a copy—which, despite WARD's suggestion (1893, p. 505) is unlikely to be T—was available to Bishop Elphinstone of Aberdeen in 1483, when he devised readings from it for his breviary for the Feast of St Thaney (18 July). The breviary was printed for the bishop by Walter Chepman in 1510 (WARD, 1893, p. 506).

According to the preface, the life was compiled by an anonymous cleric (*qualemcumque clericus*) from material in SIMEON OF DURHAM's Life of Cuthbert (1882-85) and information supplied *viva voce* by Bishop Hubert of Glasgow (ob. 1164). Joceline of Brakelond's *Life of Kentigern* (before 1190) was an attempt to correct the style and romantic content of this version. WARD, 1883, I, p. 290 ff.; WARD, 1893, pp. 504-506.

f. 81-81v Hand K. **Notes on Eelimonsina triplex.**

ff. 82-100v Hands 10, 11 and 1. **Collection of royal and papal letters and documents.**

ff. 82-87 Hand 10. Pope Benedict to Edward III, from Avignon; Philip, King of France to Edward III. Hand 10 is similar to but not identical with, the hand of f. 116.

ff. 87-96v Hand 11. Letters.

f. 87 Robert of Scotland to Richard II, 1382.

f. 87v Testament of Henry III.

ff. 88-93 King Edward invites his ministers; reply of Archbishop John of Canterbury to Robert Bonser, Chancellor; various other letters between King Edward and Robert, Bishop of London, on ecclesiastical liberties, 12 February 1330.

f. 93v Duke Ludwig of Bavaria to King Edward; the King's reply.

f. 94v Edward to his bishops, prayers for the success of the wars against French and Scots.

f. 95 Edward to Pope Clement VI on the liberty of the English church, 1344.

ff. 95v-96v Hand 1. Clement's reply, beginning in a formal hand, but reverting to his usual scrawl by the bottom of f. 97.

ff. 96v-98v Letter of Richard II, without his name or title, to the pope. *Beatissime pater circumspecta sedis apostolicis prouidencia summe debet esse solicita vt omnipotenti deo…* mentioning *parliamento nostro london* on fol. 98; sealed with our seal and seals of uncles John Duke of Aquitaine and Lancaster; Edmund Duke of York; Thomas Duke of Gloucester; and faithful men, Edmund, Earl of Rutland; Roger Earl of the March, Thomas, Earl of Kent, John Earl of Huntingdon; Richard Earl of Salisbury, Thomas Earl of Nottingham, and numerous others, 26 May 1390. Described in COTTON MANUSCRIPTS, 1802 as from John of Gaunt etc.

f. 98v a second, undated letter to the Pope.

f. 99-99v Letter from the Duke of Gelrie to the King.

ff. 99v-100v Letter from Pope Innocent IV to the Archbishop of Canterbury. This is the one section of T listed in some detail in COTTON MANUSCRIPTS, 1802, pp. 513-514. The catalogue is in general accurate; a few differences have been noted above.

f. 98v Hand K. **Notes and collection of proverbs.**

f. 100v Hand K. **Notes and collection of proverbs.**

f. 101 upper right margin, drawing of clover (?).

f. 101 right margin Hand 1. Obituaries for John of Gaunt, 1398 and Humphrey, Duke of Gloucester, in 1407. Lower margin: note on the visit of Emperor Sigismund in 1431.
The duct is a little more upright, but the letter-forms are typical of Hand 1.

ff. 101-102v Hand 1. **A verse epitome, compiled from Giraldus Cambrensis, *Descriptio Cambriae* and *Itinerarium Cambriae*.** Rubric, Hand K: *De Wallia, id est cambria.*
Text: *Priusquam tangam Anglicam que vastam vult maturiem*
Iam propero ad Walliam ad priam prosapiam
Ad magni Iovis sanguinem ad dardani progeniem… (f. 102v) *vel ad urbem salopie ubi quiescit hodie.*
406 lines. Also in Oxford, Bodl. Lib., MS Digby 196, ff. 165-166 (161-162 new foliation, 418 verses, including 10 lines about cheese which may be an interpolation) quoted by HIGDEN, 1865, I, Book I, ch. 38; WRIGHT, 1840, pp. 131-136 from London, BL, MSS Royal 13. D. 1, f. 26v, and Royal 13. E. 1, f. 10v, from Bath Abbey. WALTHER, 1959, no. 14739. Glossed throughout for place and personal names in Hand K.
Digby 196 must have had a different exemplar. It begins: *De Cambria sive Wallia et de eius moribus. Sicut cursus nunc Cambriam. Prius tangit quam Angliam, sic propero ad Walliam.*

f. 103 upper right margin, drawing of sceptre with fleur-de-lis at top.

f. 103 Hand 1. **On Giants.** Rubric: *De origine Gigantum in Insula Albion. id est britannia maior, que modo Anglia dicitur habitancium et nomine insule.* Text: *Anglia modo dicta olim Albion dicebatur, et habebat inhabitatores gigantes…* (f. 103v) *Et sic veritas clare scit historie de primis habitatoribus huius turre. Explicit de ortu gigantum in Anglia.* Also in Oxford, Bodl. Lib., MS Digby 186, ff. 26-27v, immediately following the *Vera Historia* (see above, f. 16); Digby 196, ff. 74-75, untitled, where it is followed by notes in a different hand on six ages of the world and historical events to the year 1377, London, BL, MS Cotton Cleopatra D. VIII (see f. 16); Cotton Nero D. VIII; Cotton Vespasian E. X; Oxford, Bodl. Lib., MS Bodley 622; Bodley 257 (Vincent of Beauvais); Aberystwyth, National Library of Wales, MS Peniarth 43; and the Great Cartulary of Glastonbury, now Longleat, MS 39. Edited by CARLEY/CRICK, 1993; see also CARLEY, 1990-91; WARD, 1883, I, p. 290; BARBER, 1985, pp. 42-43; WATKINS, 1947-56.

f. 103v Hand 1. **Calculations on the time-span of English kings.**

f. 104 **Coronation table from William the Conqueror.** Concludes with *Henry Wyndesour* (Henry VI), 1429. Another hand has added: *5 Kal. Julii 1461 Edwardus comes Marchie quattuor die Marcii.*

f. 104 Hand K. **Notes from the Gospels of John and Matthew;** list of Kings from William the Conqueror to Edward VI. Inc. *Wil. con;…* expl. *Regnat Edwardus felici tempore sextus.* This passage must have been written after 1545, when Edward came to the throne.

f. 104v Hand K. **Theological notes.**

f. 105 Drawing of heart pierced by cross, upper margin.

f. 105 Hand 1. **Poems on England.** Rubric, Hand K: *De Anglia commoditates aliarum nacionum.* 10 lines of verse. Inc. *Ergo ut se mediam solio dedit advolat omnis/ Terra simul tuncque suos provincia fructus…* 28 lines Inc. *Anglia terra ferox, et fertilis angulis orbis.* Not in WALTHER, 1959.

f. 105 lower margin, Hand K. **Theological note.** Lower margin, Hand 1, 5 lines of verse. Inc. *Te quicumque reges bene si vis noscere reges…* expl. *Mille quater decabis sit Adam bruto prior annis.*

f. 105v upper left margin, crown with sceptre with fleur-de-lis through it.

f. 105v upper right margin, Hand K, Rubric: *de anglia de regibus anglorum;* below this, in the inner margin, a later and unidentified hand, the name *Iohannes Staffordi.* John Stafford is usually referred to as the author of the text, but some versions go beyond his lifetime, into the 15th century.

ff. 105v-114v Hand 1. **Johannes Stafford (?), *Verse History of England.*** Inc. *Anglorum regum cum gestis nomine scire/Qui cupit, hos versus legens poterit reperire…* expl. *Ense petens totum sibi quam brutus populavit.*
Also in London, BL, MSS Harley 1808, no. 24, f. 31, also with the *Pseudo-Turpin;* Harley 2386, no. 23; Cotton Claudius D. VII, f. 14; and Oxford, Bodl. Lib., Digby 186, ff. 42-63v, not in the 16th-century hand of the Arthurian material. The Digby text goes to *c.* 1399, and the watermark in BRIQUET, no. 15567 (? + 15568), Lübeck, 1399). WALTHER, 1959, no. 1052. HAMMER, 1938, edited the first part from London, BL, MSS Harley 2386, Claudius D. VII and T. The rest is unedited; A.G. Rigg, University of Toronto, is contemplating an edition. Hammer's H and C contain some marginal additions not in T; T contains some marginal additions from John of Glastonbury, following v. 24, *Diva Potens* (Hammer p. 133) and after v. 195, *Intravit avollonam,* 6 lines of John of Glastonbury; after v. 358, the epitaph of Arthur: *Hic jacet Arthurus, flos regum…prole fecunda* (see

above, f. 22v); the last gloss is the entire epitaph of Caedvalle from Bede, v. 7. These are not all in Hand 1; some might be in Hand 11. Marginal notes *passim* in Hand K.

f. 114v Hand 1. **Epitaph of William the Conqueror.** Rubric: *Epitaphum Willelmi conquestoris.* Text inc. *Qui rexit rigidos Normannos atque Britannos...* quoted from Ordericus Vitalis 8: 1, in CAMDEN, 1636, p. 368; WALTHER, 1959, no. 15639.
The writing is larger, and the pen nib broader, but the letter forms are like those of Hand 1.

ff. 114v-116v Hand K. **Notes on allegory, theology and history; remedy for Spasm, in Latin and English.**

f. 117 Hand 12. *Eschatocol* **of William de Carleton, clericus, of York.** Inc. *Venerabilis patris et ad requisicionum...*
Inscription, rubbed out: *Et ego Willelmus de Carleton, Ebor....*
On formulae for eschatocols for papal and apostolic notaries in England, see CHENEY, 1972, 1980 and PURVIS, 1957. This is a later copy; for Carleton's actual hand, see PURVIS, 1957, pl. 17, dated 1332. RAINE, 1886, III, p. 248 records William de Carleton as a notary attesting a letter of Archbishop Melton on Pickering's hospital 25 August 1330.
This hand uses later conventions than any other in the manuscript so far. It has a horned, open-tailed secretary g; 2-shaped r used initially.

ff. 117v-143 Hand 12. **Thomas Stubbs,** *History of the Church of York.* Inc. *Super Statu Eboracensis Ecclesie et illic famosa...* expl. *Anno domini millesim° ccc° lxxiii°. Et Regni Regis Edwardi tercii post conquestum xlvii.*
Also in Cambridge, Gonville and Caius College, MS 390 (449), ff. 104-126; Cambridge, Corpus Christi College, MS 298, ff. 128-143 (Thomas Cranmer's copy); Oxford, Bodl. Lib., MSS Barlow 27 and Rawlinson 447; London, BL, MS Harley 108 (from the York area, and also containing the *Pseudo-Turpin*); see MANDACH, 1961, A9, p. 361 (his A version is associated with St-Denis); The Lord Mayor and Corporation of York, unnumbered (Roger de Burton of York's copy); and London, BL, MS Harley 357.
Printed from this manuscript and others by RAINE, 1886, II, pp. 312-412; he calls T 'one of the best manuscripts of the second part of the chronicle' (II, xxvii); it is his MS E.
There are occasional running titles *passim* in Hand K.

ff. 134v-135 top margin of opening, Hand 13. **A letter of Archbishop Thurstan to Robert, King of Scotland.** There is no actual *signe de renvoie*, but the text discusses Thurstan's relationship with Scotland.

f. 143v Blank

f. 144 Hand 14. **Henry of Huntington** (in part), *Battle of Estrepym.* Inc. *Annis ab incarnacione domini Millesimus Cus nonus decimus tunc temporis effluebat quando lodovicus grossus Rex francorum homagium recepit a Willelmo longaspata de dicatu Normanie...* expl. *Gesta sunt hec prope villam que dicitur Estrepym.*
In the battle described, *William Crispinus, miles magnaminus,* Count of Evreux, strikes Henry I twice in the head with his sword. The king was so enraged that he struck his assailant and his horse right through. It is essentially the same account of the battle as in HENRY OF HUNTINGTON, 1879, Book VII, anno 1119, but with a fuller account of events leading up to the battle, and no concluding mention of its location. Ascribed in this manuscript in a later hand in the upper margin to *Nicholas de Walkinton de Kirkeham.* Kirkham was an Augustinian house on

the outskirts of York, founded by Walter l'Espec, who is the hero of the following selelction. BALE, 1557-59 listed this and the following text, which he did not realize was basically by Aelred, as works of Nicholas (fl. 1193); the *Dictionary of National Biography*, quoting Bale, ascribes these two texts to him, listing T as the only manuscript.

f. 144v bottom margin, Hand K. **Note from Nicholas of Lyra on Daniel.**

ff. 144v-149v Hand 14. **Account of the Battle of the Standard, from Aelred of Rievaulx, with additions.** Inc. *Anno domini m⁰c⁰xxx⁰ viii⁰ kl. Septembris Ac eciam anno Thurstani Archiepiscopi…* expl. (f. 149v) *et pro insperata victoria retulerunt.* (PL 195, col. 712 ends here; T adds: *Hoc bellum mense augusti factum est iii⁰ anno regni regis stephani, apud cucunemore duces standardi fuerunt Willelmus comes Albremerlie, walterus espec, Willelmus piperellus de Nothyngame, ilbertus lacy, cuius frater solus ex omnibus equitibus ibi occisus est.* Printed from York Minster Library, MS XVI, I. 8, from Rievaulx, *c.* 1200, with variants from Cambridge, Corpus Christi College, MS 139 (13th century) and T, in HOWLETT, 1886, pp. 181-199. He describes T as 'an absurdly corrupt and interpolated text' (p. lix), but gives its unique additions in his footnotes, which also identify the additions from Henry of Huntington's account. See also the text in AELRED OF RIEVAULX, 1885, cols. 701-712. On fol. 145 of T, two pointing hands indicate the physical description of Walter l'Espec.

f. 150 Hand 15. **Poem in honour of William Fitzherbert, nephew of King Stephen, and briefly (1153-54) Archbishop of York.** He was canonized in 1226. Feast day, 8 June; translation, only at York, 9 January. Inc. *Pasti greges de pastore distant dure…* expl. *Per solamen mundo tristi et quem tibi placuisti nobis placa iudicere. Am(en).* Last two letters cropped. DIXON/RAINE, 1863, pp. 231, 232. AH, 40, no. 225, version b, from printed York missals and the Sion Breviary. See also LAWLEY, 1871, I, pp. 675-702 and 939-944. A prose life of William, from London, BL, MS Harley 2, ff. 76-88, is printed by RAINE, 1886, II, pp. 270-291. See also AASS Junii I, pp. 134-146 (8 June). Tablets recounting his miracles were on display in York Minster; could the hymn text have come from these tablets? A window with 101 scenes from his life, made 1415-20, was in the north choir transept, and his entry into York was included in the window in the north choir aisle given by Canon Parker *c.* 1423 (TOY, 1985, pp. 10-13); for the late 13th-century window in the chapter house see TOY, 1985, p. 42; for 14th-century windows of St William, surviving in fragments, see pp. 30-31, pending the completion of the *Corpus Vitrearum* by FRENCH/O'CONNOR. Not in WALTHER, 1959.

f. 150 Hands 1, K. **A list of 15th and 16th-century archbishops of York,** begun by Hand 1 and finished by Hand K. Inc. *1343. Quadragesimus quintus magister Alexander Newyll…* expl. *Quinquagesimus tercius… Thomas.* Hand K has inserted *Magister* before *Thomas,* and added *Roderam or scots.* Thomas Roderam was archbishop 1480-1500. Hand K then continues the list, ending with *Quinquagesimus nonus magister Niccolaus hethe* (1549). Hand 1 has added a note in the lower margin, on installation day of Archbishop J(ohn) Kempton, 1 September 1453.

f. 150v Hand 2? **Bishops and archbishops of Canterbury.** The post-conquest list is in column 1: *Lanfrancus* to *Henricus Chichelsef* (*sic*; ob. 1453). The pre-Conquest list in col. 2 goes from *Augustinus Sanctus* to *Cuthbertus.* Hand 1 has added *Episcopi Eduardus* in the left margin.

f. 151 Hand 2? and others. **Archbishops of York, in two columns.** Inc. *Paulinus Sanctus…* expl. *Laurencius Bo* (oth) *Thomas.* Hand K *Roderam…Robertus*

Holgate and, with a different pen, *Nicholas heth*; (1555-59); Hand 17 *Thomas Young Edmondus Grendell* (1570-76).

f. 151v [numbered 150] Hand K. **Notes from Nicholas of Lyra on astrology, and from King James II of Scotland, and a note of 1549:** *Anno domini 1549. Quando equa mare regnat, tunc missa cessabit. Plus scitur per astrologiam de celo quam per theologiam de deo.*

f. 151v Hand 18. **Note on Thomas Saville.** *Thomas Savill of ye bledroyd dyed anno domini m° ccccc xxx.* See Provenance above. The Thomas Savill(e) referred to here is an uncle of the book collector Henry Savile of Banke; Thomas died young. Thomas Savil of Banke, great-grandfather of Henry Savile of Banke, died in 1539; Thomas Savil of Banke, the grandfather of Henry Savile of Banke, died in 1570. No death date is given for the uncle Thomas, but his brother, Henry Savile of Banke's father Henry, was born *c.* 1533. This note is not in either Henry Savile of Banke's hand. WATSON, 1969, p. 86 and plates.

f. 152 Blank

f. 152v Hand 17. *Anno 1576 dyed my lorde the vicomte heryford and Earell of Exsex in Jarland.*

ff. 153-155 Hand 2. **Poem on the Battle of Roncesvalles.** *Carmen de prodicione Guenonis.* Rubric: *Incipit prologus in bello de Runciavalle. Condita prodiconis fraus hic manifesta guenoni/ Per quam decepit gallos cum dona recepit./Incipiunt versus de Bello.* Text inc. *Rex Karolus clipeus regni tutela piorum/Contemptor sceleris sancto nostris erat/ Marte ferus...* expl. (f. 155) *Res ita finita testificatur ita. Explicit de tradicio guenonis.* (9 columns).
Edited by MICHEL, 1837, pp. 228-242, and PARIS, 1882, pp. 466-480. For later editions, not using the manuscript directly, and criticism, see HORRENT, 1951, p. 97. Translation by BOURLET, 1991. WALTHER, 1959, no. 3112, lists only this manuscript and BHL Suppl. 1602b; WARD, 1883, I, p. 630; MANDACH, 1961, no. T-37. PARIS, 1882 dated the poem to the 12th century; CURTIUS, 1942, suggested 12th or first half of the 13th century. Horrent suggested—perhaps not entirely seriously—that its treatment of women might suggest a date as late as the 14th century. The author is anonymous; the arguments about his country of origin are inconclusive, and summarized in HORRENT, 1951, pp. 98-99.

f. 155 bottom margin, Hand K. Repeat of 1549 note from f. 151v; *Benedicio credentes, non credentibus ero vobis iudex, id est eukaristia sacramenta altares.*

f. 155 note, very bottom margin, Hand 1: *laudo deum verum populum voco Congrego clerum/ defunctos plero predestem (?) fugo festa decoro.*

f. 156-156v Hand K. **Theological notes from the books of Judith and Daniel; Jerome, Matthew, Job, Daniel again, and John.** On f. 156v is a note written vertically in the margin, in a different, perhaps 17th-century hand: *Constat fol. 156.*

Sigla for the CC selections:

Hämel: C12

Meredith-Jones: D 10

Mandach: HA 80-Carmen (the *Pseudo-Turpin*) + T-37 (*Carmen de Prodicione Guenonis*)

Díaz y Díaz: not included

Bibliography: AASS Junii I, pp. 134-46; Aelred of Rievaux, ed. Migne, PL 195, 1885; AH, ed. Bannister, 1902; Armitage-Smith, 1905; Arnold, 1882-85; id., 1890-96; Bale, 1557-59; Barber, 1981, pp. 62-91; id., 1985, pp. 37-69; id., 1986, pp.163-4; Barfield, 1888, pp. 113-125; Barr, 1977, pp. 487-538; Bédier, 1908-13, 1929; Black/Grenville, 1833; Borth-

wick Institute Records, n.d.; Bourlet, 1991; Bower/John de Fordun, ed. Goodall, 1759; new edn, Watt, 1987-91; Camden, repr. ed. Dunn, 1984; Carley, see John of Glastonbury; Carley, 1990-91; Carley/Crick, 1993; Castets, 1880; *Chronicle of Lanercost*, 1839; Chevalier, 1892-1921; Cheyney, 1972; id., 1980, pp. 173-188; Clarke, 1973; Cotton Manuscripts, see *A Catalogue of the Manuscripts in the Cottonian Library deposited in the British Museum*, 1802, pp. 513-514; Curtius, 1942, p. 492 ff.; Davidson/O'Connor, 1978; Denholm-Young/Clarke, 1931, p. 100 ff.; Dimock, 1877; DNB; Dixon/Raine, 1863; Dugdale, 1817-1830; Eckhardt, 1982; Forbes, 1874; French/O'Connor, 1987 and forthcoming; Frere, 1894-1932; Friedman, 1983, pp. 391-418; id., 1988; Gaffney, *c.* 1975; Gertz, 1917-18 and 1918-20, reprinted 1970; Geoffrey of Monmouth, ed. Hammer, 1951; Giraldus Cambrensis, ed. Warner, 1891; id., ed. Brewer, 1873; id., see also Dimock, Goodman and Morgan, 1985; Gransden, 1982; *Great Chartulary of Glastonbury*, 1947-56; Hämel, 1950, p. 73; id., 1953, IV, p. 72; Hammer, 1938, pp. 131-151, part 1; Harvey, 1976; Helinandus, ed. Migne, PL 212, 1865, col. 845 ff.; Henry of Huntington, 1853 and 1879; Higden, ed. Babington (vols. 1-7), Lumby (vols. 8-9), 1865-82; Hope/Bilson, 1907; Horrent, 1951; Horstmann, 1886; Howlett, 1886; Hunt, 1984; Hurry, 1901, pp. 16-126; Innes, 1843, Introduction, Appendix II; James, 1909, pp. 2-96; Jarman, 1960, pp. 20-30; John of Glastonbury, ed. Carley, 1978/1985; Jusserand, 1889/1961; Kemp, 1965-66, pp. 1-20; Kemp, 1955, pp. 241-246; Ker, 1964, 1977, 1983, 1989; Klapper, 1911; Krochalis, 1997a; ead., 1997b; Lancaster/Baildon, 1904; Lapidge, 1964; id., 1977; id., 1981, pp. 79-93; id., 1982, pp. 163-168; id., 1983; id., 1989; Lawley, 1871; Leyser, 1975, pp. 481-506, reprinted 1982, pp. 216-240; Loomis, 1960; Luard, 1883; Mabillon, 1735, I, pp. 622-624 and 665; Mandach, 1961, pp. 383, 409; Meredith-Jones, 1936/1972, p. 16; Michel/Wright, 1837 (see Clarke, 1973, p. 46 for a discussion of this edition); Michel, 1837, Appendix II, pp. 228-242; id., 1862; Moorman 1952; Moran, 1979; Morris, 1882, pp. 272-279; Neckam, 1863; Nichols, 1988; Ormrod, 1989, pp. 849-877; Pächt/Alexander, 1973; Page, 1913; Pantin, 1937; Paris, 1882, pp. 465-518; Parry, 1925, 1960; Petrie, 1950; Picherit, 1984; Purvis, 1957; id., 1967, pp. 741-748; Raine, 1886; Schalby, 1952; Scott, 1981, pp. 42-47; Simeon of Durham, ed. Arnold, 1882-85 (see also Symeon of Durham and Stephenson); Stephenson, 1858/1987; Stones, 1991, p. 626; Stones/Krochalis, 1995, p. 30; Strawley, 1957; Stubbs, see Raine 1886, II, pp. 312-421; Symeon of Durham, ed. Hinde, 1868 (see also Simeon of Durham); Taylor, 1952, pp. 32-35; Togeby, 1969; Toy, 1985; Van Dijk, 1957; Walther, 1959; Ward, 1893, pp. 504-526; Ward, 1883/1961, pp. 201, 292-293, 578-580, 630-631; Watson, 1969; id., 1978, pp. 279-316; Wey, ed. Williams, 1857; William of Malmesbury, 1847 and ed. and trans. Scott, 1981, pp. 42-47; Williamson, 1956; Wright, 1958, pp. 176-212; Wright, 1840.

P. Pistoia, Archivio di Stato, Documenti vari 27 *Long Version*

Codex Calixtinus and Pistoian material about St James, followed by
the Translation and Miracles of Bishop Atto of Pistoia
After 1524-30 (by watermarks), Pistoia

Paper, iv + 232 + iv. The four beginning and ending flyleaves are of the date of the restoration of the binding. The 232 folios are numbered in two sequences: I-XIX and 1-213. 205 × 290 mm; written space: 105 × 240 mm. (measurements differ from those in GAI *et al.*, 1984, which gives overall dimensions of the bound MS). Text in one column, 27-30 long lines per page. Frame ruled only, dry point. (*Ills. 76–78*)

Quires:	a⁴ (ff. i-iv, flyleaves) + b²⁰ (wants 20 [ff. i-xix]) + 1-10²⁰; 11¹⁴ (wants 14) (ff. 1-213); + c⁴ (unnumbered flyleaves). No catchwords.
Watermarks:	1. Double-tailed, faceless mermaid wearing short-sleeved shirt in a circle 39-40 mm in diameter, surmounted by a 6-pointed star, 15mm diameter (BRIQUET, no. 13899 [Naples 1524-28, Rome 1526]; no. 13900 [Naples 1533, Imola 1536, Fabriano 1539]).
	2. Stylized flower, shaped like a tulip or pear with three inverted v's at the top and two asymmetrical lozenge-shaped leaves on stems coming off the stalk; the right leaf is above the left leaf; top to bottom, 40 mm (BRIQUET no. 6649 [Bologna 1472]; no. 7387 [Pisa 1518-20]).
Script:	Numerous Italian spellings and double consonants. Rapid, slanting cursive, early xvi; careless and often difficult to read; a, e, and o all appear as small, almost closed ovals.
	The 13th-century intermediary copy (Pistoia, Archivio di Stato, Documenti vari 1), of which thirty-four leaves survive (none containing any *Guide* text) has red rubrics in the same *gotica rotunda* as the text. See provenance below.
Rubrics:	In the brown ink of the text. Headings for books are in much larger, rather irregular Rustic capitals, perhaps in imitation of a now lost 12th-century original Pistoia manuscript of the *Codex Calixtinus*.
Musical Notation:	None. No spaces left blank for it. Possibly the chant ending on f. 199v (written as *Sevovae* rather than the usual *Evovae*) may suggest that the ultimate model was noted.
Decoration and Illustration:	None.
Binding:	Original white leather over cardboard, restored; three brown leather spine supports.
Provenance and History:	The correspondence preserved in the 13th-century manuscript Pistoia, Archivio di Stato, Doc. vari 1, (ff.1-16) and copied from it *c.* 1530 into P (ff. 8v-21v) reveals that Atto, Bishop of Pistoia, received a relic of a piece of the head of St James from the archbishop and canons of Compostela in or about the year 1138 (for the date, see FERRALI, 1979, p. 14; GAI, 1984, p. 34; the account is published in AASS, Julii VI, pp. 25-28). The project was apparently initiated by a deacon, called Rainerius, or simply R, or occasionally Robertus, in the manuscripts. He is described as a canon of Pistoia, who had studied in Paris, where he became a *magister* and founded a college for poor Italian students dedicated to the Blessed Virgin Mary in 1133. (Possible connections between Rainerius's foundation in Paris and the hospital of St-Jacques-du-Haut-Pas, of the Italian Order of Altopascio, between Pisa and Pistoia, are discussed in the Introduction, pp. 22-23). He also studied at Winchester in England (*quintonie in anglia*, AASS, Maii V, p. 197; Julii VI, p. 26) as P's account says, under Matthew, Deacon and Cardinal of St George.
	Then Rainerius went to Compostela, where he became the schoolmaster and a canon of the cathedral. The Pistoia manuscripts also refer to him as a cardinal, though they do not specify in the text whether he was a cardinal of Rome or of

Santiago; a marginal gloss says cardinal of Santiago. The backgrounds of all three of these people, Matthew, Atto, and Rainerius, are important in tracing how Pistoia came to acquire its Jacobean relic, and a version of all or part of CC.

Matthew is described by ORDERICUS VITALIS as a monk of Cluny, then cardinal bishop of Albano in 1125 (GAMS, p. XXII, gives his dates as 1125 to his death on 25 December 1134) and papal legate in Normandy and Germany in 1128. He began his career as a priest at Reims, then became a Cluniac at St-Martin-des-Champs, Paris in 1108. (On the possible role of St-Martin-des-Champs in relation to L, see the Catalogue of Manuscripts under L and Introduction p. 23.) He became prior there in 1117 and was called in by his close friend Peter the Venerable, Abbot of Cluny, in 1122, to reform the abbey after the troubles caused by the chequered last years of Abbot Pontius (CONSTABLE 1967, *passim*; BREDERO, 1974; COWDREY, 1978, pp. 182-186). He remained close to Cluny throughout his life, according to Peter the Venerable (*De Miraculis*, II, 8, col. 917D, 918A, and II, 14, col. 926C, cited by CANTARELLA, 1981, p. 279, from PL 189). Backed by King Henry I, Matthew was the chief organizer of the reforming Council of Rouen, held in September 1128. Among other issues, the council pronounced against new lay recipients of tithes (ORDERICUS VITALIS, Book XII, ch. 48, pp. 103-105); this was a problem prevalent in Pistoia (MILO, 1980).

It was about this time that he was expected in England, and had ordered his kinsman, Abbot Hugh of Reading, to prepare for his visit (BRETT, 1975, pp. 48, 243), although no English source actually notes his arrival. If P's account is to be trusted, it would suggest that he did go, and that he met Rainerius there. Matthew can also be traced in signatures to documents issued at Troyes, Reims and Rouen in 1128 (NICHOL, 1964, pp. 158, 259). He witnessed occasional documents for King Henry I when the court was in Normandy (*Regesta* II). He was back in Italy by 1130, in time to become influential in the disputed election of Pope Innocent II (WILLIAM OF MALMESBURY, *Historiæ Novellæ*, Lib. I, pp. 484-485). On his return, he wrote a rebuke to the abbots of the Province of Reims about their reforming chapters of 1131 and 1132, which elicited responses from William of Saint-Thierry (BREDERO, 1987) and Bernard of Clairvaux (CEGLAR, 1987, pp. 36-37). He died in 1134, and was later raised to the rank of Blessed, with a feast on 25 December. Peter the Venerable wrote a brief Life (PL 189, cols. 913-936), the foundation for the only monograph on him, by BERLIÈRE, 1901.

Depending on his own age, Rainerius might have known Matthew of Albano in Paris. Through Matthew, Rainerius may well have had connections at Cluny, the first place listed in the colophon to the *Codex Calixtinus*, as well as in England. Rainerius could have been in England, or in contact with the English royal court, when Henry I's daughter, the widowed Matilda, returned from Germany with the relic of the hand of James from the imperial German treasury (LEYSER, 1975/1982. For the hand, see also Catalogue of Manuscripts T, under Provenance, and Lost Manuscripts, under Gloucester Cathedral Library MS 1). It is extremely unlikely that the hand actually came from the body of James at Compostela, but in the 12th century one would not have known that. Henry I deposited it in his new Cluniac foundation of Reading (LEYSER, ibid.), where he and his second wife, Pope Calixtus's niece, Adeliza of Louvain, were later buried (STRICKLAND, n.d., pp. 121, 127). Did the connection with Calixtus make the relic especially valuable to them? After Henry's death, Adeliza married William d'Aubigny (see COMPLETE PEERAGE, 1910-59, IV) and had other children. Does her burial at Reading suggest that she retained a special affection for the monastery, or merely that she chose to be buried as a queen?

After Henry's death in 1135, the relics seems to have been in custody of that avid collector of artefacts and antiquities, Henry of Blois, Cluny-trained bishop of Winchester, abbot of Glastonbury, and brother of King Stephen, until it was restored to Reading in 1156 (LEYSER, 1975/82). Part of that time, Henry was in exile; he

returned to England from Rome via Compostela in 1151-52 (JOHN OF SALISBURY, 1965, pp. 80, 92-94). Depending on when Rainerius was at Winchester, he may also have seen the hand relic there. Circumstances such as these might have inspired Rainerius to seek a similar relic for Pistoia.

In 1133, Cardinal Matthew was influential in having the abbot general of the reformed Benedictine order of Vallombrosa, Atto, chosen as bishop of Pistoia (BEANI, 1855, p. 16 ff., citing SALVI, 1656-62, lib. 2, part 2, pp. 79-82; AASS, Maii V, pp. 194-195, 197). Pistoia, as noted above, was badly in need of reform, several previous bishops having alienated properties (MILO, 1980). A new cult would certainly have helped the economic and social status of the church in the city. Atto was a learned and holy man, who had written the life of the founder of the Vallombrosan order, John Gualbert (d. 1133), about whom it was recounted (AASS, Julii III, p. 313), as of St Bernard, that, in a vision, Christ leaned down from the cross to embrace him (AASS, Julii III, pp. 311-458; MARCHETTI, 1630; BRESCHI, 1855). According to the Vallombrosan historian MARCHETTI, 1630, Atto was a native of the Portuguese/Spanish border town of Badajoz, who had fled the Moors, which might explain why he might have had a personal interest in seeing a canon of Pistoia at Santiago in the 1130s, and in obtaining a relic of St James; Marchetti also says he made a visit to the Holy Land. The Spanish view is also that he was of Spanish origins (see DHEE, I, pp. 170-171, under Badajoz), although the more recent Italian opinion is that he was not born in Spain (DBI under 'Atto'). Atto died in 1153 and was himself raised to the rank of Blessed in the early 17th century (see below); MS P includes, at the end, an account of the Translation and Miracles of Atto (AASS, Mai V, pp. 180-200).

The correspondence about the translation of the relic of St James to Pistoia was assembled, according to P's account, by one *Cantarinus clericus*, who is independently documented as a chancellor in Pisa in 1140-47. He also copied Pistoia Cathedral Archives, MS C. 116, *Sermones* of Bruno di Segni, in 1144 (BANTI, 1971-72; BERG, 1964, p. 158). The 12th-century account of the relic transfer, allegedly assembled by Cantarinus, is now lost (see our discussion of Lost Manuscripts), but the correspondence and the account of the arrival of the relic are preserved both in the 16th-century copy P and also in the surviving section of a 13th-century copy, now Pistoia, Archivio de Stato, Documenti vari 1, ff. 10v-16. This manuscript also includes parts of the *Codex Calixtinus*, but not *Pseudo-Turpin* (GAI *et al.*, 1984, no. 2; GAI, 1985, no. 43). The presence of this correspondence at the start of a CC compilation may account for some later historians ascribing a 'Liber Compostellanus' to Atto (BOOK OF SAINTS, p. 77).

The correspondence of Rainerius of Pistoia, canon of Santiago, and cardinal, and its schoolmaster, with Archbishop Diego Gelmírez of Santiago (bishop 1100, archbishop 1120-40) and Bishop Atto of Pistoia (1133-53), is preserved in the surviving portion of Doc. vari 1, and also in P. Spot collations indicate that P is a faithful copy of Doc. vari 1. P's scribe classicizes spellings, and occasionally reverses words, or omits a word, but none of his changes to that text are substantive. It is attractive to suppose that Doc. vari 1 is itself a copy of a 12th-century exemplar sent to Pistoia when the chapel built to house the newly acquired relic of St James was dedicated on 25 July 1144, or perhaps as early as 1138, when the negotiations for the relic transfer began. P's additional material about the life and miracles of Bishop Atto of Pistoia derives, so it says, from an exemplar written between 1337 and 1357, now lost (GAI, 1985, no. 44).

The surviving sources for the acquisition of the Pistoia relic are mostly late, and the altar-shrine that houses the relics of St James at Pistoia dates only from the late 13th and early 14th centuries (GAI, 1984). MS Doc. vari 1 gives the dedication date of the chapel of St James at the Cathedral of Pistoia as 25 July 1145. FERRALI, 1979, p. 19, and GAI, 1984, p. 34, interpret this to mean 1144; see GAI's more detailed discussion, depending on when Pistoia calendars started the new year (1987, pp.

144-146). The chapel was destroyed in 1786 (GAI, 1984, p. 43). No Santiago sources appear to document the relic transfer, but the *Historia Compostelana* ends incomplete in 1134. The suggestion that Rainerius might have been one of the authors of HC comes from modern scholarly speculation about the correspondence preserved in the Pistoian manuscripts Doc. vari 1 and P. The letters claim he was schoolmaster of Santiago. HC is clearly by several different authors, of whom Geraldus, schoolmaster at Santiago, is perhaps the most important in the early phases of the production of HC. It seems logical to suppose that the new schoolmaster, Rainerius, could carry on the enterprise (HC, 1988, pp. xv-xvii; VONES, 1980, pp. 64-73). GAI adduces confirmation that the relic transfer itself is not a later forgery by noting the papal privileges granted in favour of the chapel by Eugenius III (22 November 1145 at Viterbo, JL 8794 [6175] and 8795 [6176]; KEHR, III, 1909, pp. 128-129). Gai also points to the independent existence in Pisan documents of the mid 12th century of *Cantarinus clericus cancellarius pisane civitatis,* claimed in P as the eye-witness of the dedication of the chapel (GAI, 1984, p. 35, citing BANTI, 1971-72, pp. 23-29); and the existence by 1163 at Pistoia of a *rector et custos ecclesie et Opere sancti Iacobi* (GAI, 1984, p. 41, citing RAUTY, 1974, p. 113). FERRALI, 1979, p. 11, citing RAUTY, ibid., p. 22, notes the use of the name Jacobino, clearly a derivative of Jacobus, in a Pistoian document of 1126. We further note that the Statutes of the City of Pistoia (ed. MURATORI, 1777, X, cols. 650-667, with the date of 1107 in the opening paragraph of the text), include the invocation of St James before that of St Zeno in the oath of the electors (...*ad honorem Dei et sancti Jacobi et sancti Zenonis et Populi Pistoriensis* [col. 662]); the same phrase is cited by GAI *et al.,* 1984, p. 49, from the edition by RAUTY/SAVINO (1977, p. 46) of a 12th-century fragment of the Statutes. There is one further piece of evidence to mention. Pistoia Doc. vari 1 preserves a number of '-æ' spellings, which are unexpected in a mid 13th-century text. Further research into Pistoian local documents is needed, because they may have been generally conservative. But the presence of such spellings does suggest copying from a 12th-century exemplar.

Pistoia Doc. vari 1 originally contained much more material about James and Bishop Atto. It is presumably one of the two *legenda* of St James listed in the cathedral inventories for 1260 (GAI *et al.,* 1984, p. 35) and for 1363 (BEANI, 1855, p. 31). At some subsequent point it turned up in the family archives of Flaminio Panciatici, who gave/returned it to the Opera of St James (BEANI, p. 31). The family took an active part in the stormy local politics of Pistoia from at least the 14th century (RICCARDI, 1968, pp. 62-114), and was active in the early 16th-century festivities of St James sponsored by the Compagna della Purità (VIGO, 1969, pp. 18-23; p. 37, no. 31; p. 38, no. 52; for the procession see pp. 87-90). One of them might well have borrowed or acquired our manuscript. It seems to have been in poor condition *c.* 1604, when Cardinal Cosimo Bracciolini and his notary, Mercurio Accursio, were assembling Pistoia materials, and collating them with materials in the Vatican Archive, for the canonization of Atto: *Haec est copia, sive exemplum quorumdam foliarum cartae Pergameni, antiquo quidem caractere scriptorum, quae in libro prius ligata esse apparebant, et modo dissoluta propter illlorum vetustatem et temporis injuriam, vix legi possunt.* (cited in BEANI, ch. 1; GAI 1984). P itself, fol. 204, records that material about Atto was contained in a book of St James kept in the sacristy. Bracciolini seems not to have been aware of the copy of all its materials in P, the early 16th-century Pistoia Documenti vari 27 (see ff. 13-15v below). Gai suggests that Bracciolini was probably responsible for the dismembering of Doc. vari 1, but some 'antichi manuscritti' about Atto were available to Marchetti later in the century (DONDORI, 1666, p. 10). It seems unlikely that a 17th-century author would describe P, Pistoia Doc. vari 27, the only other copy of Atto miracles now in Pistoia, as an 'ancient book'. Does this suggest that our manuscript was in private hands in the 17th century, rather than in the Cathedral library? Perhaps the Panciatici, who borrowed Doc. vari 1, could have transcribed it? A copy of Bracciolini's materials about Atto survives in Pistoia Doc. vari 4, (GAI *et al.,* 1984, no. 4)

and in a copy made for the Bollandists by Domenico Sardi, rector of the Jesuit seminary at Pistoia, in 1727 (BEANI, 1855, p. 32). The fact that the 19th-century Pistoian antiquary Sebastiano Ciampi, who edited 14th-century statutes of the Opera Sancti Jacobi, and some works of the humanist Cino da Pistoia, did not know of the existence of P when editing the *Pseudo-Turpin*, may be significant (CIAMPI, 1822). Ciampi used a Turin manuscript, and one which he had bought from a rag seller in Florence, who was using it to stopper a wine container; it was, regrettably, incomplete. But such enterprise suggests an uncommon determination to track down sources, which is borne out by the documentation in his edition.

The correspondence and bulls of Pope Eugenius, though not Cantarinus's subsequent account of the consecration of the chapel in 1145, have been edited most reliably by KEHR (1908/1961, pp. 128-129), as also by Ughelli in *Italia Sacra* (1647, II, 361-65; see also AASS, Julii VI, pp. 26-28); parts have also been quoted by more recent authors. Our quotations are taken directly from MS Pistoia Doc. vari 1. Rainerius writes to Bishop Atto (see f. 13 in P): *meoque non modico labore et sudore et angustissima difficultate non minimam reliquiarum de capite beatissimi apostoli iacobi fratris iohannis ævangeliste omnibus pro me apud dominum archiæpiscopum compostellane sedis, qui dedit intervenientibus personis, atque æiusdem æcclesie canonicis, et in locello in quo sunt propriis locavit manibus, optinui partem. Quam non promitto sed fideliter atque fialiter et devote per Medium Villanum prudentissimum virum, id est vestrum legatum, et per Tebaldum auunculum eius, vobis et sancte matri æcclesie pistoriensi adpresens mitto.* (By my own not immodest labour and sweat, and harshest difficulty, I have obtained for myself by the intervention of certain persons, in all ways from the lord archbishop of the see of Compostela, and from the canons of that church, not the least of relics, a part from the head of the blessed apostle James, brother of John the Evangelist; he placed it with his own hands in the small container. I do not send it myself, but faithfully and eagerly and devotedly through the means of a most prudent man, that is your legate, and through Theobald his uncle, I, present here, send it with vows to the holy mother Church of Pistoia.) He goes on to state that the relic should be welcomed with a procession: *et in honore supradicti apostoli in basilica nostre matris pistorie æcclesie altare larga benedictione consecrare sicut michi litteris significastis, quantotius studeatis.* (And in honour of the above-mentioned apostle, you should be very eager to consecrate an altar in the basilica of our mother church at Pistoia, with great blessing, as you have signified in your letters to me.) The letter from Archbishop Diego and the canons of Compostela follows (f. 14v in P), reporting that he has given to *magistrum Robertum domnum vestreque æcclesiæ filium…de reliquiis corporis beatissimi iacobi apostoli, quas accepit a nobis cum summa difficultate, benigna tamen caritate vobisque misit…et in rei veritate a nobis illud capud beatissimi iacobi apostoli…suscipiatis et honestissime tractetis. Valete* (to Magister Robert, son and lord of your church…from the relics of the body of the most blessed James the apostle, which he accepted from us with great difficulty; nevertheless, he sends them to you with benign charity…and you should receive as a true thing from us that head of the most blessed James the apostle, and treat it most worthily. Farewell).

A second, shorter, letter follows to Bishop Atto from Robertus (alias Rainerius, probably a misexpansion of R. in the original; Rainerius is in the heading, and Robertus has been erased and replaced by Rainerius twice in Diego's letter *Vestras quas*, so Rainerius is the correct form). The letter reiterates (f. 15 in P): *quo honore sint apud uos habita beati iacobi apostoli patricinia et quam honorifice locata quæ michi valde pro hoc fatigato benignæ tribuit, et vestræ sanctitati misi* (with what honour may be received among you the remains of blessed James the apostle in my fatherland, and how honourably placed, which I have gone to some trouble to send in tribute to your goodness and sanctity). There must have been a letter of thanks from Atto, for Diego writes again, thanking him (f. 15v in P): *Unde uobis gratias agimus et quia preciosissimi beatissimi iacobi apostoli capitis honorifice atque sanctissime tractastis patro-cinia.* (Whence we give you thanks, because in sending the most precious head of

the most blessed apostle James, you have treated your fatherland most honourably and most holily.)

The compilation ends (in Pistoia Doc. vari 1, but not in P) with a brief account of the building of the chapel for the relic of St James, and its dedication in 1145 (i.e. 1144, see above). The letter from Pope Eugenius which follows (f. 16 in P, JL 8794 [6175]) grants indulgences of seven days to those pilgrims travelling to the shrine of James at Pistoia, since aid has already been brought to *ceci, claudi, contracti, et aliis diversibus langoribus debiles* (the blind, the lame, the crippled, and others weakened by diverse ailments).

The Pistoia miracles were used by Jacobus de Voragine, Bishop of Genoa, in his *Legenda aurea* (*c.* 1265); see ff. 34 and 188.

Some of P's miracles (ff. 22-34) were later used in the liturgy for the octave of the Feast of St James, and through the octave. The prayers and lections for these liturgies are also preserved, without any music, in a manuscript compiled by canon Hieronymus Andrea of the cathedral of St Zeno at Pistoia in 1476. It is now Pistoia, Archivio di Stato, Documenti vari 2. DONDORI records that its lections, recounting local miracles, 'scritto in lingua latina' were still used at the vigil and feast of James in 1666 (p. 199). It is presumably the 'libro antichissimo, che tenevasi reposto nel tesoro di S. Iacopo ed ora si conserva nell'archivio del Commune; ...libro che, si soleva leggere ogni anno in Cattedrale per la festa di S. Iacopo, diviso in tanti lezioni per tota l'ottava' which BEANI mentions in 1855 (pp. 30-31). We have included cross-references to it where appropriate.

The Pistoia relic achieved a new importance in 1879, when the bodies of James and his two companions, reinterred in the apse in 1589 for safety during Drake's expedition against La Coruña (DUCHESNE, 1900, p. 179), were dug up at Compostela (AASS, Nov. I, p. 1, under the lives of James's companions, Athanasius and Theodore). It was necessary to decide which of the three skeletons was in fact St James, and which those of his two companions. The Pistoia reliquary was opened, and the bone identified as the mastoid process. Only one of the three bodies at Compostela was missing that particular bone (AASS, Nov. I, pp. 1-16, 18-22, esp. p. 7; BEANI, 1855; KENDRICK, 1927, p. 180).

The historical evidence outlined above makes it quite probable that Doc. vari 1 is a copy of a 12th-century exemplar sent to Pistoia when the chapel built to house the newly acquired relic of St James was dedicated on 25 July 1144 (GAI, 1984, p. 34). If it were sent earlier, with the relic in 1138, then P derives ultimately from a very early model.

For the *Guide*, the direct source could possibly have been C, as written by Hand 1: as we outline in the Catalogue for C, above, the earliest possible date for the CC, if Cardinal Robert Pullen is the author of the song in Book I (HOHLER, 1972, p. 47), is 1144; Pullen was appointed cardinal only in 1144/45 and was dead by 1145/46 (POOLE, 1925). But, if an earlier 'Cardinal Robert' (such as the Cardinal Robert appointed by Pope Calixtus II, and in office between 24 September 1120 and 28 December 1121, JL, p. 781) were to have written it instead, or if the term 'cardinal' were here used to refer to a cardinal of Santiago (see English note IX-131), possibly even the Rainerius discussed here, the schoolmaster of Santiago, also known as Robertus, might be the person meant. In the correspondence, Rainerius/Robertus is named as 'cardinal'; a note in P, f. 13, transcribed by the authors of AASS (Julii VI, p. 26), says he is so entitled because he was a canon of Santiago.

If the 'cardinal' is not Robert Pullen, then the earliest *terminus post quem* for the text of CC would be the death of Louis VI, mentioned in Book V, in 1137 (see English note IX-142 and the summary of internal dating evidence under C in the Catalogue above). Nothing about the physical appearance of the parts of C copied by Hand 1 precludes such an early date; see the Catalogue of Manuscripts. It is not impossible that C itself was produced in 1138, at the start of the negotiations with Pistoia, and

before the death of Diego Gelmírez, Archbishop of Santiago, whose correspondence authorizes the transfer. Gelmírez died on Easter Eve, 1140 (FLETCHER, 1972, p. 47).

Might it have been the Pistoia transfer that provided the impetus for the production of CC, and even C itself? If so, the texts now in P suggest that adaptations were made to suit Pistoia, for the liturgy in P has little or nothing to do with what is in C. Perhaps Bishop Atto was not ready to take over the liturgy of CC, or, more likely, the Pistoia liturgy was modified over the years to reflect the local cult and its miracles. Of the liturgical components in P, very few are also in C: the *Magna Passio* (Book I, Ch. 9 in C, P, f. 1); the pericope and sermon of Book I, Ch. 16 (P f. 38v) and the response *O adiutor omnium* (W 208; P f. 194v). Pistoia, at least by the 1540s, had its own liturgy of St James (ff. 37v-53v); nothing more from C's liturgical Book is included in P. The repetitions in the liturgy in P (transcribed below) suggest that P's model contained music: texts would have been repeated with different notation. It might be that Book I of C was not yet complete and available for copying into P's ultimate model, just as P's exclusion of the 1139 miracle, the false bull of Innocent, the songs and the later miracles following the *Guide* in C, suggests that its model may have predated those additions to C. But the other four Books of the CC were apparently considered appropriate accompaniments to a liturgy and a set of miracles that pertained to Pistoia's own interests in St James; even the *Guide* was copied, although it does not mention the Italian routes. Pistoia, in fact, is not on any of the main Italian pilgrimage routes to Spain, which are first mentioned in the itinerary of the Icelander, Nikolás Bergsson, first abbot of Munkathvera in 1155 (MAGOUN, 1940, 1944; MUZZI *et al.*, 1988, Map I). Most surprising of all is the fact that its extravagant claims about the immoveability of St James's relics (see English note IX-110) are in sharp contradiction to the historical events related in P itself and its model.

Our collation of the *Guide* does not offer unequivocal textual evidence that P does reflect an earlier copy than MS C, but support for such a case could be argued from it. In general, there is little to suggest other than that P is ultimately a close copy of C's Hand 1. The two key variants are P's readings of the Geats (Latin note VII-340-342) and the number of warriors killed at Roncesvalles (Latin note VII-262). In both instances, P appears to follow what is in C's Hand 2, copied *c.* 1173; but, in the case of the Geats, we argue that C's Hand 2 was simply recopying a reading already in C's Hand 1, so that P's model could equally have been copying that version directly; and in the case of the number of warriors, it is possible that P's model read *c(um)* as the figure *c*, which would explain how P, copying out the figure in full, came to write *cxl* as *centum quadraginta* (see Collation, pp. 197-240).

In the discussion which follows, we have referred to Pistoia Doc. vari 1 as P1, and Pistoia Doc. vari 2, the 15th-century manuscript containing the Pistoia local liturgy for the feast and octave of St James as P2.

Secundo folio: *discipulum.*

Contents:

O, P, R, S, T, V, are blank; D (IV), F (VI), H (VIII), and I (IX) have a few entries each, all covering material towards the beginning of the codex.

f. XIX Blank

f. 1 **Excerpt from CC Book I**
Book I, Chapter 9. Magna Passio of St James, 25 July
Opening heading [not in C]: *Incipit Prologus de Passione Sancti Jacobi apostoli.* Prologue [not in C] inc. *Jacobus qui interpretatur et supplevitetur filius zebedei frater Johannes hyspanie et. (?) Locis predicationis et sub herode gladio desuper (?) octubavit (?) sepultusque est in archaia mamorica. Natalis eius celebratur octava kalendas augustas.*
Rubric: *Incipit passio Sancti Iacobi apostoli.* Text inc. *Apostolus domini in yhesum cristum Iacobi…* (W 94 [first five words omitted]), text as in C with some variants, to *super caput eius* (W 100, last line), omitting the prayer of St James and ending (f. 6v) with a doxology not in C, *et Ita perfectus in fidei domini nostri Ihesu Christi cum apostolo uno hora simul martir affectus porrexit ad dominum cui est gloria in seculo seculorum Amen.*
[Same text in P1, ff. 1-5v, and P2, f. 15 ff.]

f. 7 **Excerpts from CC Book III, Translation of St James**
Chapter 2. Epistle of Leo.
Rubric: *Incipit epistola beati leonis papa de translatione Iacobi apostoli que iii kalendarum iunii celebratur.* Text inc. *Noscat fraternitatis…* expl. as in C (f. 8v) *suffragio patrocinaturus* + dox. (W 294-296)
[Same text in P1, f. 5v, with a note: *hec epistola etiam ponitur, id est ff. lxvi*; f. 66 is no longer extant.]

f. 8v *Chapter 1*
Rubric: *Incipit capitulum de translatione sancti Jacobi apostoli a sanctis patribus edita.* [not in C] Text as in C, inc. *Post salvatoris nostri passionem…* expl. incomplete (f. 13) *aditum populo.* (W 294, line 16). Followed immediately in main text column by *Hec sunt nomina discipulorum beati Jacobi appostoli Torquatus, Secundus, Endalecius, Sisefons, Eufrasius, Cecilius atque Isicius. Finit.* (passage omitted on f. 9 due to an eye skip, *quorum nomina* to *quorum collegio* [W 291, lines 5-7]). Rest of Chapter I, *Post aliquantum…patrocinaturus* + dox (W 294, lines 16-29) added by same hand in left margin (f. 13).

f. 13 **Letters from Rainerius** (with glosses on Rainerius) and Didacus (Diego Gelmírez) Archbishop of Santiago de Compostela, and Bishop Atto of Pistoia, concerning the relic of St James given by Compostela to Pistoia *c.* 1138, with the indulgence granted by Pope Eugenius to the chapel of St James in Pistoia, and accounts of the miracles by which the relic survived en route. [P1: ff. 10v-16, with some material from f. 12 repeated on f. 16.]
From Cardinal Rainerius to Bishop Atto of Pistoia.
Rubric: *Epistola missa pistoiensis episcopo a Raynerio cardinale.* Text inc. *Suo dilectissimo patri A. dei gratia…*
Note in left margin by the same hand about Rainerius being a cardinal of Santiago.
Note in bottom margin by a 17th-century (?) hand about Rainerius founding a college in Paris for poor Italian students in 1133: *Idem Raynerius clericus pistorinacensis erexit Collegium beate Nostre Domine caritate pauperum scolarium italicorum in civitate parisius cum domino Jo. Andree episcopo Atrebatensi canonico et civi florentino anno domini 1133 et ideo comunitas misit unum discipulum…* (rest illegible) [GAMS gives the Bishop of Arras in 1133 as Alvisus]

f. 14v From Archbishop Diego Gelmírez of Compostela to Bishop Atto of Pistoia

f. 15 From R. [*sic*] to Bishop Atto

f. 15v From Archbishop Diego to Bishop Atto
[ed. AASS, Julii VI, pp. 26-28; selections in BEANI, 1855]

f. 16 **Bull of Pope Eugenius**
Rubric: *Epistola Domini papa.* Text inc. *Eugenius + sal. Oratorium beati Jacobi apostoli quod in pistoriensi ecclesia situm est...* [AASS, Julii VI, p. 27; JL 8795 (6176) and KEHR, III, 1988, pp. 128-129]

f. 16v **Four Miracles of the Pistoia relic of St James in transit from Santiago**
Prologue and first two miracles.
Opening heading: *Incipiunt miracula beatissimi Jacobi noviter facta.*

f. 18 [ff. 18-21v in P are the first three readings in P2 for the Feast of the Vigil of St James, ff. 6v-8v.]

f. 18v Rubric: *Quanto et qualia sunt magnalia...* Text inc. *Quomodo reliquiae Beati Jacobi apostoli portatae sunt pistoriensem in provinciam...* [P1, f. 14v; AASS, Julii VI, p. 59]

f. 19v Rubric: *Aliud miraculum in transitu fluvii*
[P1, marginal title: *Miraculum in transitu fluminis*; P2, f. 7; AASS, p. 60]

f. 20v Text inc. *Letetur...*
Rubric: *Miraculum de lumine.* Text inc. *Cum vero...*
[P2, f. 7; AASS, pp. 60-61]
[ed. in *Italia Sacra* III, pp. 361-365; these are the first two of those edited in AASS, Julii VI, listed on p. 59, and printed pp. 60-68. Here, each one is preceded by a rubric; in the AASS edition, the rubrics are grouped together at the beginning. See also below, ff. 22-34v and 183-190v. Summarized, in Italian, in BEANI, 1855.]

f. 21 **Account of the arrival of the relics and the building of the Chapel of St James in the Cathedral of St Zeno, Pistoia**
Text inc. *Remeanentibus autem...* expl. (f. 21v) *et capella Sancti Iacobi co(n)struto. Ego Cantarinus clericus licet indignus qui hec scripsi cancellarius pisane civitatis oculis meis vidi perlegi et memoriter tenui scripsi utique veritate atque fidelis...* (rest illegible). Date: *Anno millesimo Centesimo quadragesimo quinto*, follows, then a note about the consecration of the altar of St James.
[P2, f. 8]

Eighteen Miracles of the Pistoia relic of St James

f. 21 (1) Rubric (in left margin): *Miraculum de uno chrommoto leto secco et rigido liberato eiusdem...* [AASS, p. 61, secs. 260-262]

f. 23v (2) Rubric: *Miraculum de muliere paralitica liberata* [AASS, p. 61, secs. 263-264]

f. 24v (3) Rubric: *Miraculum de Muliere contracta sanata* [AASS, p. 62]

f. 25 (4) Rubric: *Miraculum de uno medico dubitando de miraculis Beati Iacobi.*
[AASS, p. 62]
[copied in P2, f. 10v, as part of the liturgy for the octave before the Feast of St James]

f. 26 (5) Rubric: *Miraculum de muliere contracta...* [AASS, p. 62]

f. 26v (6) Rubric: *Miraculum de muliere pauperrima...* [AASS, p. 63]

f. 27v (7) Rubric: *Miraculum de quodam de Sancto Baronto curibus infirmis* [AASS, p. 63]

[copied in P2, f. 3 as part of the liturgy for the fourth day before the Feast of St James]

f. 28 (8) Rubric: *Miraculum de filio cuiusdam dominum florentinae contracto...* [AASS, p. 63]

f. 29 (9) Rubric: *Miraculum de columba* [AASS, p. 64]
[copied in P2, f. 8v, as Lectio I for the Feast of St James, followed by the bulls of Pope Eugenius]

f. 31v (10) Rubric: *Miraculum de columba que ostendit pauper...* [AASS, p. 64]

f. 32 (11) Rubric: *Miraculum de sancti moniali* [not in list on p. 59, but in text in AASS, p. 64]

f. 33 (12) Rubric: *Miraculum de puero bononiensi contracto* [AASS, p. 65]
(13) Rubric: *Miraculum de quodam Florentino de Montebono* [AASS, p. 65]

f. 34 (14) Rubric: *Miraculum de alio contracto* [AASS, p. 65]
(15) Rubric: *Miraculum de sanata in manu* [AASS, p. 65]
(16) Rubric: *De multis aliis miraculis* [AASS, p. 65]
(17) Rubric: *Miraculum de Demoniaco liberato* (cf. no. 5 in JACOBUS DE VORAGINE, attributed to Hugh of St Victor) [AASS, p. 65]

f. 34v (18) Rubric: *Miraculum de quodam super mula* [P2, f. 6]
[see also below, f. 183; AASS, pp. 65-66]

f. 35 **Another account of the Translation of St James to Spain**
[not in C; it is a variant on Book III, Ch. 1, close to, but not identical with, BHL 4068 (Brussels, Bibliothèque Royale, MS 5333-5), which GAIFFIER, 1971, cites in part on pp. 57-58; its text was copied in the 12th century into an 11th-century copy of Lucan, later owned by Gembloux; but it is probably nothing to do with Guibert. Albert Derolez kindly informs us that the Gembloux connections in Brussels, BR, 5333-5 are late, as there is an earlier, erased ownership mark, no longer decipherable. For further Gembloux links in CC manuscripts, see Catalogue of Manuscripts under L, whose St Martin texts suggest some sort of ultimate asociation with Tours; Guibert de Gembloux (d. 1213) obtained his texts about St Martin and St James from Marmoutiers, according to Brussels, BR 5527-34 (DAVID, 1947, p. 159 and HERBERS, 1992, p. 22, n. 70).
Rubric: *Qualiter Corpus beati Iacobi ad hyspaniam venit.* Text inc. *Nemo putat que este sit Jacobi qui cognominatus est Alphei iustus qui apharisus est de pinnaculo templi...sed ipse est Jacobi filius Zebedei...* expl. (f. 37) *in synodo sancto re* (rest illegible).
[copied in P1, f. 9 (?); P2, f. 2v, reading for the octave before the Feast of St James.]

f. 37 **Bull of Pope Eugenius III**
Rubric: *Epistola Domini Pape De his qui ostendunt universa &c. Ad sanctum Jacobum.* Text inc. *Eugenius* + salutation. *Vestram notitiam...* [AASS, Julii VI, p. 27; JL 8794 (6175)] expl. (f. 37v) with date of 1145; KEHR, III, 1908, pp. 128-129]

f. 37v **Pistoia Liturgy: pericopes, sermons, miracles**
Sermon of Peter of Ostia
Rubric: *Sermo dicitur Petrum hostiensis episcopi* (glossed: *Pietro vescovo Ostiense*) Rubric: *De Visita Sancti Iacobi.* Text inc. *Pluribusque vigilias Beati Jacobi...*
[not in C; this is presumably Petrus du Colombier, bishop, according to GAMS, from 1353 to his death on 13 July 1361, rather than the two alternative candidates, Peter of Tarantaise who became pope in 1276 as

Innocent V, or Peter d'Esteing (de Stagno), bishop from 1373 to his death on 18 November 1387; and it is not Peter Damian]

f. 38v **Book I of CC, Ch. 16.** Pericope and Sermon of Jerome for feria 7 in octave of St James, 31 July.
Pericope, rubric and text as in C (W 137). Rubric: *In die festivitatis S. Iacobi appostoli secundum Mattheum*. Pericope: *In illo tempore accesit ad Jhesum mater filiorum Zebedei…* (Matthew 20: 20) Rubric: *Omelia Sancti Ieronimi*
Text inc. *Unde opinionem habetur regni…* (as in C, starting at W 138, line 1) expl. (f. 40) *credere volverit.* (W 141, dox. omitted)
[Pericope the same as P2, f. 18; sermon different; P2 begins *Quod autem dicit sedere.*]

f. 40 **Pericope and Sermon of St Remigius**
Rubric: *Item aliud…* Pericope as in C (W 87): *In illo tempore a accessit ad dominum Jhesum mater filiorum Jacobi cum filiis suis Jacobo et Johanne…* Rubric [not in C] *Omelia Sancti Remigii episcopi.* Text inc. *Tunc quod de ad supram (?)* [not in C]

f. 44 **Pericope and Sermon of St Gregory**
Rubric: *In numerorum (?) apostolorum. Aliud evangelium secundum Mattheum* (crossed out) *Marchum.* Pericope: *In illo tempore misit Jhesus duodecim discipulos suos dicens in viam…* (Matthew 10: 5). Rubric: *Omelia S. Gregorii pape.* Text inc. *Cum corpus beati fratres karissimi quia…* [not in C]

f. 47 **Sermon on the Seven Deadly Sins**
Rubric: *Sermo de septem principalibus vitiis.* Text inc. *Septem plane sunt principalia vitia, et quibus…* [not in C]

f. 48 **Hymn to St James**
Rubric: *In Sancti Iacobi appostoli Rithmus de quibusdam miraculis prefati apostoli.* Text inc. *O patrone, frater dei…*
[P2, f. 8; not in C]
[P2 follows *O patrone* with: *Miles quidam bello victus Et a suis derelictus;* see below, f. 53]

f. 48v **Five Miracles of St James**
Miracle 17 of CC Book II
Rubric: *Miraculum grande Sancti Jacobi…de quodam peregrino lugdunensi qui diabolo instigato in nomine…a sancto Anselmo Cantuariensi archiepiscopi editum* [longer than C, W 278] Text inc. *Prope civitatem lugduniensem est vicus…* expl. (f. 53) *obsequiis* + dox. (W 278-282)

f. 53 **Miracle about a knight** (in verse)
Rubric: *Rithmus de quodam miraculo Sancti Jacobi de milite chapto quem…gladio…* (rest illegible) Text inc. *Miles quidam bello victus…* [not in C; cf. P2 above, and P f. 48]

f. 53v **Miracle 20 of CC Book II**
Rubric: *Miraculum Sancti Jacobi supra dechantatum a domino Calixto pape conscriptum.* Text inc. *Multorum itaque labente curriculo…* (W 285)

f. 54v **Miracle about a hanged man** (in verse)
Rubric: *Rithmus de quodam miraculo sancti Jacobi de peregrino suspenso quem ipse beatus Jacobus liberavit.* Text inc. *Rem miserere…* [Not in C, but see C fol. 223 for a different verse miracle of a hanged man.]

f. 60v **Miracle 5 of CC Book II**
Rubric: *Miraculum Sancti Jacobi supra deconstatum de quodam peregrino suspenso a domino pape Calixto conscriptum.* Text inc. *Memorie tradendum est…* (W 267)

f. 61v **22 Miracles of St James: CC Book II**
Opening heading: *Incipit liber secundus sancti Iacobi Zebedei patrone Galetie de viginti duobus miraculis eius.* Prologue as in C. Rubric: *Argumentum beati Calixti pape* Text inc. *Summopere pretiosus est...* expl. *diligenter legatur.* (W 278)
[no Chapter list]
22 miracles, each numbered, as in C (W 261-287); cross-references for the three miracles already transcribed, nos. 5, 17, 20. Expl. (f. 81v) *Finit codex secundus Feliciter. Amen.* [*Feliciter* not in C]

f. 82 **Translation of St James: CC Book III**
Opening heading: *Incipit Liber Transitus Sancti Iacobi apostoli domini.* ***Chapter list of 4 chapters and Prologue*** as in C (W 289-290). Rubric: *Incipit Prologus beati Calixti papa super translationem beati Iacobi Maioris.* Text: *Hanc beati Jacobi...* expl. (f. 83v) *remuneravit muneribus.* (W 289-290). Incipits and cross-references to f. 13 (Chapter 1) and f. 8 (Chapter 2), and a note next to Chapter 4, saying *istud non habetur.*

f. 83v *Chapter 3*
Rubric: *Calixtus papa de tribus sollemnitatibus Sancti Jacobi.* Text inc. *Beatus Lucas evangelista...* as in C, ending incomplete (f. 85v) at *regalibus indutus* (W 298, line 15), with a note: *hic deficit reliqua.* [Chapter 4 omitted]

f. 86 **Pseudo-Turpin: CC Book IV**
Opening heading: *INCIPIT CODEX QUARTUS SANCTI JACOBI DE EXPEDIMENTO ET CONVERSIONE HYSPANIE ET GALLETIE EDITUS A BEATO TURPINO ARCHIEPISCOPO REMENSI PARI FRANCIE CANCELLARIO CAROLI MAGNI IMPERATORIS.* [painted out in C; cf. VA, SV, R, VB, but P's version is longer]. Rubric: *Epistola Beati Turpini ad Leoprandum.* Prologue text: *Turpinus Dei gratia...* [part of the rubric in C] *...Quoniam nuper mandastis...* (W 301)

f. 86v *Chapter list of 26 chapters,* as in C (W 302) followed by an explicit: *Explicit capituli libri quarti.*
Rubric: *De hoc quod appostolus Carolo apparuit.* [not in C] Text inc. *Gloriosissimus namque...* as in C (W 302)
Text of 26 chapters, as in C, but each preceded by a titulus as in the Chapter list; the Liberal Arts are included in Chapter 22, with no chapter division at *Post hec Viennam* (W 338); *Post exiguum* (W 341) is Chapter 23; the remaining three chapters as in C, expl. (f. 138) *saltim legatur et exponatur* + dox. (W 348), followed by an explicit [not in C] *Finit codex quartus sancti Jacobi apostoli dei.*

ff. 138v-182v **Pilgrim's Guide: CC Book V**
Long Version; see Table of Book V.
[colophon omitted]

f. 183 **Five Further Miracles of St James**
[not in C; AASS, Julii VI, pp. 66-68; see also above]
Rubric: *Miraculum Sancti Jacobi de quodam adolescentia pistoriensi* [AASS, p. 66, sec. 286] [cf. P1 ff. 42 and 90v according to GAI, 1987, pp. 205-206]

f. 184 Rubric: *De iuvene civitatis pistorii* [AASS, p. 66, sec. 287]

f. 186v Rubric: *De Rustico de Braudeglio Pistorii comitatis...* [AASS, p. 67, secs. 290-291]

f. 187v No rubric, text inc. *Si verba...* [not on AASS list, or in text, but part two of the immediately preceding miracle begins *Is vero*]

f. 188 Rubric: *Miraculum de Milone de Savignano* [cf. P2, f. 6; this is the last of JACOBUS DE VORAGINE's Miracles of St James, no. 11, dated 1238; AASS, pp. 67-68, secs. 292-296]

f. 191 **Prayers to God, the Virgin and the Apostles**
Vt omnibus laudantibus et benedictionibus domini nomen et apostoli iuverandi…XPS laudemus…Finit. Laus Deo et virgini et apostolo Jacobo profissimo… expl. (f. 191v) *quid magnus sit dominus.*

f. 192 Hymn: *Christus laudetur* (in verse, copied in two columns)

f. 193 **Proper Services for the Feast of St James**

In listing contents of the liturgy, we follow the usual pattern of abbreviation: A=Antiphona; Alla.=Alleluia; Com.=Commemoratio; Ew.=Ewangelium; Gr.=Gradual; Inv.=Invitatorium; Mag.=Magnificat; Off.=Offertorium; Ps.=Psalmus; R=Responsorium; Trop.=Tropus; V=Versiculum.

Brackets indicate the word is not in the manuscript.

In solemnitatem Sancti Jacobi apostoli
Tropi cum officio
Hodie celorum curia…
Off. Gaudete omnes gentes…Ps. Nimis honorati

f. 193v ***In festivitatem Sancti Jacobi Ad missam***
AD MISSAM
Gaudete omnes gentes…Ps. Nimis honorati
Gr. Ductus est beatus Jacobus…
Stigmata crucis…
Alla. Apostolo Jacobo predicante…
Alla. Ipse quidem Jacobus…
Alla. Hoc est preceptum meum…
Off. Cum duceretur ad palmam…
Com. Laudate populi gaudentes…
SEQUENTIA
Sancti Jacobi famosa. orbe toto gloriosa.
AD MATUTINAS

f. 194 *Regem apostolorum.*
Ps. Venite exultemus…in requiem meum. (XCIV)
Gloria patri…Amen.

f. 194v ***In honore beatissimi Jacobi cantandum est hoc responsorium***
R O adiutor omnium seculorum (also in C, W 208, with a different dox)
…Et duc nos ad salutis portum
Qui subvenis
Et duc nos ad salutis portum
Et duc nos

In solemnitate sancti Iacobi
Ad I. Vesp. Antiphone super Psalmos usque ad Octavam.
A Ingrediens Ps. Dixit dominus (CIX)
A Contigit autem Ps. Laudate pueri (CXII)

f. 195 *A Jussit itaque Ps. Credidi* (CXV)
A Apostole Christi Ps. In convertendo (CXXIII)
A In nomine Jhesu Christi Ps. Domine probasti (CXXXVIII)
Ad Mag. Iste est Jacobus apostolus Ps. Magnificat
Ad Mag. Alia A Honorabilem eximii

f. 195v *Ad Matutinas*

Super V Regem seculorum… Ps. Venite
Aliud super V Adoremus Christum… Ps. Venite
In primo nocturno
A Apostolus Christi Jacobus Ps. Celi enarrant (XVIII)
A Docente Ps. Benedicam (XXXIII)
A Cum autem venisset Ps. Eructavit (XLIV)
V In omnem…R Et in fines
R Apostolus Christi…V Monita sequens
R Sanctissime Iacobe…V Gentibus
R Cum venisset…V Prius ergo
In secundo nocturno

f. 196 *A Eo namque Ps. Omnes gentes* (XLVI)
A Ait namque Phyletus Ps. Exaudi domine deprecationem (LX)
A Audiens ergo Ps. Exaudi deus orationem (LXIII)
V Constitui eos
R Facta autem in turba…V In fontem
R Gloriosus domini…V Lavacro sancte
In tertio nocturno

f. 197 *A Accipe tibi baculum Ps. Confitebimur* (LXXIV)
A Tunc ille accipiens Ps. Dominus regnavit, exultet (XCV)
A His itaque gestis Ps. Dominus regnavit, irascantur (XCVIII)
V Nimis honorati R Instante V Cum ergo R Alme perpetui V Sedulus iste
R O speciale decus V O Jacobe tui

f. 197v *In laudibus*
A Predicante apostolo
A Apostolus Christi
A Videns ergo
A In nomine
A Quidam autem deorum cultor
In Ew. A Apostolus domini Jacobus Ps. Benedictus
Ps. Benedictus
Ad secundas Vesperas
Ad Mag. A O beate Jacobus Ps. Magnificat
Sepultus Ps. Magnificat
A O splendidum Alia A Apostolus Christi Jacobus lux Gallecianorum
Benedicamus domino.

In festo sancti Jacobi

f. 198 *Hymnus in Vesperis*
Lux de celis dux fidelis est Jacobus… [Chevalier 29245, AH XVI, p. 155, from 15th-century breviaries of Jaen, Burgos and Santiago]
Hymnus ad [illegible]
O eterne rex superne… [cf. *Rex eterne, rex superne*, AH XVI, p. 155]

f. 199 *Hymnus in Laudibus*
Laudes Christi psallat isti… [AH XVI, p. 156, from a 15th-century breviary of Santiago and a manuscript there without shelf number]

f. 199v Collects
Omnipotens sempiterne deus qui apostolum Jacobum in celo triumpho…serviamus.
Deus qui ecclesiam tuam beatissimi apostoli…laude letamur
Beati apostoli tui Jacobi quesumus domine…gloriatur.
[illegible word] Per te Beate Jacobe…Sevovae [sic].
In honorem sancti Jacobi apostoli. In Albis
Regem apostolurum

Incipit officium ab Octava Resurrectionis usque Pentecosten
Super Venite Regem apostolorum

f. 200 <u>*In primo nocturno*</u>
 A Stabant iusti. Ps. Celi enarrant (XVIII) V Sancti et iusti…R Vos eligit
 Primum R Tristia vestra.
 Secundum R Pretiosa in conspectu.
 Tertium R Lux perpetua.
 Ri Virtute magna…V Apostli…
 V Repleti…
 Rii Isti sunt agni novelli…V Repleti…
 Riii Ego sum vitis vera…V Sicut dilexit…

f. 200v <u>*Ad secundum nocturnum*</u>
 A Ecce quomodo…
 V Lux perpetua…V Et eternitas…
 Riiij Filie Jerusalem venite.
 Rv Virtute magna.
 Rvi Isti sunt agni novelli.
 <u>*In tertio nocturno*</u>
 A Omnes gentes. Ps. Confitebimus (LXXIV)
 Lux perpetua

f. 201 *V Letitia sempiterna…R Gaudium…*
 Rvii Ego sum vitis vera…
 Rviii Candidi facti sunt…V Ego di(xi)
 R Uidi portam…V Uidi sanctam civ(itatem)
 Rviiij Candidi facti sunt Nazarei.
 R Preciosa in conspectu
 Splendorem…V Candidiores
 R primum Tristitia vesta…V Mundus
 R Lux perpetua…V Custodit
 V Letitia sempiterna

f. 201v *R Filie Jerusalem…V Proniam confortavit…*
 V Regem apostolorum… Ps. Venite
 Super V Gaudete et exultate… Ps. Venite
 <u>*Ad primum nocturnum*</u>
 In omnem terram… Ps. Celi enarrant (XVIII)
 A Clamaverunt Ps. Benedicam (XXXIII)
 V Constitues…
 Ri Ecce ego…V Dum lucem…

f. 202 *Rij Tollite iugum…V Et invenietis…*
 Riii Dum steteritis…V Non enim vos…
 <u>*Ad ij nocturnum*</u>
 A Principes populorum… Ps. Omnes gentes (XLVI)
 Edisti hereditatem Ps. Exaudi deus (LXIII)
 V Annuntiaverunt
 Riiij Uidi coniunctos uiros.
 Rv Beati estis cum mala Ps. Exaudi deus orationem (LXIIII)
 V Constitues eos.
 Rvj Isti sunt triumphatores V Isti sunt qui

f. 202v *Rviiij Fuerunt sine querela… V Tradiderunt*
 R Vidi coniunctos uiros…V Uidi angelum
 <u>*Ad iij nocturnum*</u>
 A Exaltabuntur cornua iusti… Ps. Confitebo
 V Lux orta est Ps. Dominus regnauit

> *V Nimis bonus*
> *Rvij Isti sunt qui V In omnem terram*
> *Rviij Isti sunt visi…V Sancti perfidem*

f. 203 *R Beati estis V Cum vos oderint*
R Nimis honorati V In omnem terram
Hoc est preceptum V Vos autem dixi
Hoc est preceptum
Maiorem caritatem

f. 203v *Uos amici mei*
Beati pacifici
In patiemtia
Ora pro nobis Beate Jacobe.

f. 204 **Translation in 1337 of Bishop Atto of Pistoia and his Seven Miracles, compiled in 1357**
Rubric: *In quodam libro chartarum hedinarum cooperto pavonatio corio obscuro. In honorem beatissimi Jacobi apostoli in suis vigiliis existente in sacristia dictae operae quasi in fine dicti libri reperiuntur infrascripta de beato Atto episcopo et de eius sancto corpore.* [AASS, Maii V, p. 180F] Text inc. *In nomine et ad reverentiam omnipotenti dei…*

f. 205 Rubric: *Hec sunt quedam miracula inter alia facta per dominum nostrum et intercessionibus Sancti Atti tempore translationis sui sanctissimi corporis visa et publica manifestata multitudini populi civitatis pistorii Amen.* [AASS, Maii V, p. 199F]
Text inc. *Matteus bernardi sartor civis florentinus…* [AASS, ibid.; *BHL* NS 745h]

f. 205v Rubric: *Aliud miraculum.* Text inc. *Domina Viola uxor…* [AASS, Maii V, p. 200A]

f. 206 Rubric: *Aliud miraculum.* Text inc. *Quidam Ricovenis habebat…* [AASS, Maii V, p. 200B]
Rubric: *Aliud miraculum.* Text inc. *Gentilis Jacomucci de Fognano…* [ibid.]

f. 206v Rubric: *Aliud miraculum.* Text inc. *Domina Bandina Guidi Ormagni…* [ibid.]
Rubric: *Aliud.* [dated 1357] Text inc. *Bonocursus Neri de Florentia…* [ibid.]

f. 207 Rubric: *Miraculum.* Text inc. *Dum ipse Bonocursus* (rest of folio blank.)
[AASS, Maii V, p. 200 says *Hic nos deficit antiquum codex.*]

ff. 207v-213 Blank, followed by four end leaves, date of binding.

Sigla: Meredith-Jones: not included
Hämel: not included
Mandach: not included
Díaz y Díaz: P

Bibliography AASS, Maii V, pp. 194-203; Julii III: p. 365 ff.; Julii VI, pp. 59-68; Nov. I, pp. 1-22; Banti, 1971-72; Beani, 1855; Berg, 1964, p. 158; Berlière, 1901; *Book of Saints*, 1947; Bredero, 1974, 1987; Breschi, 1855; Brett, 1975; Briquet, 1935; Caggese, 1907, p. 107 ff.; Cantarella, 1981, p. 279; Capponi, 1874; Ceglar, 1971, 1976, 1987; Ciampi, 1822; Constable, 1967; Coturri, 1987; Cowdrey, 1978; Díaz y Díaz, 1988a, pp. 137, 229, 235, 327, 335; Dondori, 1666; Ferrali, 1979; Gai, 1984, pp. 34, 189-192; and notes 21, 32, 41; ead., 1985, see *Santiago de Compostela*, 1985, no. 43; ead., 1987; Gai *et al.*, 1984, pp. 41-45, with plate of f. 1, and plates of f. 1 of Doc. vari 1 and f. 1 of Doc. vari 2; Gams, 1873-86/1957; Hohler, letters to Alison Stones, 21 October 1990 and 25 June 1993, on the Liturgy of St James in P; *Italia Sacra*, 1647/1970; Jacobus de Voragine, 1969; John of Salisbury, 1952/1965; Kehr, 1908, III, p. 128; Kendrick, 1927; Leyser,

1975/1982; Magoun, 1940 and 1944; Marchetti, 1630; id., Manuscript materials, cited in Capponi, and used by subsequent scholars; Milo, 1980; Muzzi *et al.*, 1988; Nichol, 1964; Ordericus Vitalis, 1848; Poole, 1925; *Regesta Regum Anglo-Normannorum II*, eds. Johnson and Cronne, 1956; Rauty, 1974 and 1988; Rauty/Savino, 1977, p. 46; Riccardi, 1968; Salvi, 1656-62; *Santiago de Compostela*, (Exh. Cat.) 1985, nos. 43 and 44; Savino, 1984, pp. 97-98, 106; Stones, 1991, p. 627; Stones/Krochalis, 1995, pp. 18-20, fig. 6; Strickland, n.d., pp. 113-135; Ughelli, see *Italia Sacra*; Vigo, 1969; Vones, 1980, pp. 64-73; William of Malmesbury, 1847; Zaccaria, 1765, p. 449.

M. Madrid, Biblioteca Nacional, 4305 *Long Version*

Codex Calixtinus and additional material in Latin and Spanish about Pope Calixtus, St James, and Santiago and vicinity
1538, Spain (Santiago), copied by Fra Juan de Azcona

Paper, 212 ff., 210 × 155mm, written space 170 × 125 mm. Text in one column, 29 lines. Rulings not visible. (*Ills. 79–83*)

Quires:	Lettered, in original hand, and numbered on the first four leaves: A6, B-O8, P4, Q-T8, V-Z8, A7, B-D8. Catchwords on most pages.
Watermarks:	Somewhat like BRIQUET, no. 864 [Soleure, after 1469].
Script:	Folios 1-114v and 132v-212 by the hand of Fra Juan de Azcona. Signed 'Johannis de Azcona', on ff. 209, 211 and 211v, and dated 1538 on f. 207v in the introduction to the list of bishops and archbishops of Iria and Compostela that follows directly after the *Guide*. It is generally assumed that this copy is the one made by Fra Juan de Azcona, although DÍAZ Y DÍAZ, 1988a, p.137 advises caution on this point; it is also possible that M is Juan de Azcona's fair copy, made from his own rougher version. The Miracles of St James, entitled Book II as in C, on ff. 115-132, are by another (perhaps slightly earlier) scribe, whose work is not signed. Juan de Azcona copied additional miracles of St James in Spanish on the verso of the last of the 22 Latin miracles of Book II, and continued Book III with a fresh quire. In the *Guide*, Juan de Azcona makes many additions to the place names, adding contemporary Spanish names, most likely from personal local knowledge. The additions, listed in our collation of the Latin text, are also of local interest.
	Juan de Azcona writes a small but clearly spaced cursive, with an irregular duct, basically upright, with very tall ascenders and descenders; the lower bow on 'g' is particularly large. Rather sprawling capitals. Some use of paragraph marks, indicated §.
Rubrics:	In the brown ink of the text.
Musical Notation:	None; no spaces provided for it. Musical texts omitted with the exception of the song *Ad honorem* on f. 180, of which the text alone is copied.
Decoration and Illustration:	None in the *Guide* section; drawings of altarstones, f. 211-211v.
Binding:	19th- or early 20th-century Holland cloth and paper binding.
Provenance and History:	This is presumably the copy made by Fra Juan de Azcona in 1538 in Santiago. It seems to have been taken directly from C, because Book I (M ff. 1v-114v) copies a quire that is misbound in C, containing Chapters 6 and 7 (C ff. 27-32). Juan omitted the music and the illumination but copied the other four books complete, except for omitting the Chapter list and Chapter 4 from Book III, and renumbering the subdivisions from Chapters 22 to 26 of Book IV, the *Pseudo-Turpin*, making a total of thirty chapters. This is similar to the chapter numbering in L, and suggests that Juan de Azcona may have had access to another version of the *Pseudo-Turpin*, and perhaps of other *Codex Calixtinus* texts. This supposition is also supported by a few of the variant readings in the text of the *Guide* which suggest he also had access to another copy besides C (see Collation, pp. 197-240). In addition to the place names and chapel dedications mentioned above, Juan also added related material in Latin and Spanish that does not appear elsewhere in the manuscript tradition of the *Codex Calixtinus*. This includes Blondo's Latin *Life of Calixtus*, further miracles of St James in Latin and Spanish, a Spanish version of the Translation, and a list of the bishops and archbishops of Iria and Santiago. He also had access to a copy of HC, from which he excerpted the account of the discovery of the tomb of St James by Bishop

Theodomir in 866, and inserted it between Chapters 2 and 3 of Book III; these are all texts that are likely to have been available in Santiago.

Regrettably, we know nothing of Fra Juan de Azcona beyond his name. The title 'Fra' was used by all monastic orders, though not by the newly-founded Jesuits; perhaps the fact that he does not identify himself as a Franciscan or Dominican indicates that he was a Benedictine. The present-day village of Azconita is in the Basque country, not far from Ignatius's village of Loyola, but Fra Juan must have written his manuscript in Santiago. The word 'azcona' in Basque is common, we learn from Léon Pressouyre, and means 'badger'. Perhaps this explains his alteration of *auconas* to *azconas* (Latin note VII-392).

Formerly P120 in the Biblioteca Nacional.

Secundo folio: *esse quod ipse*

Contents: Folios 1-114v copied by Fra Juan de Azcona

f. 1 **Life of Calixtus by Flavius Blondus (1388-1463) [not in C]**
Preliminary note: *Vita calixti non invenitur in libro calixti addita sunt abgreibe*
Rubric: *Ex blondo forhuiensi historiographo breviarium de vita et obitu calixti pape huis nominis secundus.*
Text inc. *Cum ob metum imperatoris enrei qui ab gelasio…* expl. *Archiepiscopo remensi fundavit mor…* (last line and a half illegible). [BLONDUS, 1559]

f. 1v **Book I: Liturgy of St James** [lacks Opening heading, Prologue (for last paragraph of Prologue see f. 209 below), and Chapter list of 31 chapters in C (W 1-6)]
Chapter 1. Pericope and Sermon of Bede for the Vigil of the Feast of St James, 24 July.
Rubric: *Nono kalendas augusti vigilia sancti Jacobi lectio epistole Beate Jacobi apostoli.* Pericope: *Jacobus dei et domini nostri iesu christi seruus duodecim tribuba que sunt in dispersione salutem etc.*
Rubric: *Homelia venerabilis Bede presbiteri.* Text inc. *Quoniam beati Jacobi vigiliam…* complete to *perturbare studiebant* (f. 1v) (W 7, line 8);
leaf missing between ff. 1v and 2. F. 2 resumes at *esse quod ipse…* (W 10, line 14) expl. complete (f. 3) *…in malum* + dox. (W 11)

f. 3v *Chapter 2.* Pericope and Sermon of Calixtus for the Vigil of St James, 24 July, Office.
Rubric: *Nono kalendas augusti vigilia sancti Jacobi lectio epistole Beate Jacobi apostoli Gallecie, que studio ieiunii propriique divini officii digne celebretur. Lectio sancti evangelii secundum Marcum.* Pericope: *In illo tempore, ascendens dominus Jhesus in montem…* expl. *eos predicate et reliqua.* Rubric: *Sermo beati Calixti pape eiusdem lectionis.* Text inc. *Vigilie noctis sacratissime…* complete to *colunt in celo* (f. 4v, W 13, line 36); ff. 5 and 6 misplaced, text continues on f. 7, expl. complete (f. 21v) *…sedibus coronandi* + dox. (W 35)

f. 21v *Chapter 3.* Benedictions of Pope Calixtus to the lessons.
Rubric: *Benedictiones Calixti Pape ad lectiones sancti Jacobi.* Text inc. *Adsit nobis…* expl. complete *…prebuit palmam.* (W 35)
Chapter 4. Calixtus's Prologue and Modica Passio of St James, 25 July.
Rubric: *Incipit prologus beati Calixti Pape super modicam passionem sancti Jacobi Zebedei apostoli Gallecie que octo Kalendas Augusti celebrat.* Text inc. *Hanc beati Jacobi…* expl. complete *…quam aliam legere.* Rubric: *Explicit Prologus. Incipit Passio.* Text inc. *Gaio quatuor annis…* expl. complete (f. 23v) *…Cesare imperatore actis* + dox. (W 38)

f. 23v *Chapter 5.* Sermon of Calixtus for the Feast of the Passion of St James, 25 July.

Rubric: *Sermo beati Calixti Pape in Passione sancti Jacobi apostoli que VIII Kalendas Augusti celebratur. Capitulum V.* [previous chapters lack heading Capitulum and number] Text inc. *Celebritatis sacratissime...* expl. complete (f. 30v) *...celebramus sollempnia* + dox. (C f. 25, W 48)

f. 30v [*Chapters 6 and 7* have gaps and copy C's disarranged foliation, C ff. 27-32v (W 52-64)]
Rubric: *Prologus in magnam passionem Beati Calixti pape sancti Jacobi octavo kalendas augusti.* Marginal Note: *Va hasta el alphab.* [not in C]

f. 31 Ch. 7 begins (C f. 31, W 61)
Rubric: *Octauo kalendas augusti* [sic]. *Lectio actuum apostolorum.* Pericope: *In diebus illis superuenerunt ab Jerosolimis prophete antiochiam. Etc.* Rubric: *Sermo beati calixti pape eiusdem lectionis.* Text inc. *Adest nobis dilectissimi fratres...* complete to f. 31v *...solempni officio* (C end of f. 29v, W 622, line 19) in C; resumes with Ch. 6 *prelationis inter alios* (C top of f. 32, W 58). Continues, with several sentence-long omissions, to end of Ch. 6 (f. 33) *...Christi baptismantes* + dox. (C f. 31, W 61).

f. 33v Ch. 6 begins (C f. 24v, W 48) Rubric: *Sermo beati Calixti pape in passione sancti Jacobi apostoli.* Text inc. *Spirituali Jocunditate igitur diletissimi fratres...* continues with several sentence-long omissions, to f. 38 *...penetrauit, quia* (C end of f. 28, W 54, line 19), followed by Ch. 7 *ostendimus quod ipse viuat veraciter cum deo...* (C f. 30, W 62). Continues with Ch. 7 to f. 47v *...aut quia non sunt legenda aut sunt legendum laboriosa* (C top of f. 39, W 75). [rest of Ch. 7 omitted]. Colophon: *Valete.* [not in C]

f. 47v *Chapter 8.* Pericope and Sermon of Bede for the Passio of St James, 25 July. Rubric: *Octo Kalendas Augusti. Passio sancti Jacobi Zebedei apostoli Gallecie. Lectio Sancti Evangelii secundum Matheum.* Pericope: *In illo tempore accessit ad dominum... Nescitis quid petatis et reliqua.* Rubric: *Homelia venerabilis Bede presbyteri.* Text inc. *Dominus conditor...* expl. complete (f. 52v) *...merebimur* + dox. (W 93) *Explicit Homelia Bede Venerabilis.*

f. 53 *Chapter 9.* Prologue of Calixtus and Magna Passio of St James, 25 July. Rubric: *Prologus in magnam passionem Jacobi apostoli a beato Calixto papa editus...* Text inc. *Constat illos...* expl. (f.53v) *...secure legatur.* Rubric: *Explicit prologus. Incipit pasio* [sic] *magna.* Text inc. *Post ascensionem...* expl. complete (f.60) *...Stephani prothomartyris et Jacobi maioris et Jacobi minoris regnante per omnia* + dox. (W 103) *Explicit magna passio beati Jacobi.*

f. 60 *Chapter 10.* Pericope and Sermon of Jerome for the second day in the octave of St James, 26 July.
Rubric: *Septimo Kalendas Augusti. II die infra octavas sancti Jacobi colitur...* Pericope: *In illo tempore convocatis domuinus Jhesus...* expl. *et tradidit eum et reliqua.* Rubric: *Sermo sancti Jeronimi eiusdem lectionis.* Text inc. *Apostolica solempnia...* expl. complete (f. 62v) *...supplicia sunt* + dox. (W 107) *Explicit sermo B. Jheronimi.*

f. 63 *Chapter 11.* Pericope and Sermon of Jerome for the third day in the octave of St James, 27 July.
Rubric: *Sexto Kalendas Augusti. III die infra octavas sancti Jacobi. Lectio...* Pericope: *In illo tempore post dies sex assumpsit Jhesus...* expl. *Transfiguratus est ante eos et reliqua.* Rubric: *Sermo beati Jheronimi eiusdem lectionis.* Text inc. *Quare Petrus...* expl. complete (f. 64v) *...Scandalem faceret...Ille ergo* + dox. (W 110) *Explicit sermo B. Jeronimi.*

f. 65 *Chapter 12.* Pericope and Sermon of Calixtus for the fourth day in the octave of St James, 28 July.

[Heading omitted] Rubric: *Lectio sanctio evangelii secundum Lucam.*
Pericope: *In illo tempore Jhesus domunus faciem…* expl. *ante conspectum suum et reliqua.*
Rubric: *Sermo beati Calixti pape eiusdem lectionis.* Text inc. *Plecara* [sic]
solemnitas… expl. complete (f. 73) *…salubriter mereamur* + dox. (W 122)
Explicit sermo beati Calixti pape.

f. 73v **Chapter 13.** Pericope and Sermon of Jerome for the fifth day in the octave of St James, 29 July.
Rubric: Quarto kalendas Augusti infra octavas sancti Jacobi. Lectio…
Pericope: *In illo tempore assumpto Petro…* expl. *mestus esse et reliqua.* Rubric:
Sermo beati Jheronimi doctoris eiusdem lectionis. Text inc. *In presenti capitulo…*
expl. (f. 75) *…usque ad mortem* + dox. (W 125)

f. 75 *Chapter 14.* Pericope and Sermon of Pope Gregory for the sixth day in the octave of St James, 30 July.
Rubric: *Tercio Kalendas Augusti infra octavas sancti Jacobi VI die. Lectio …*
Pericope: *In illo tempore accesserunt ad dominum Jhesum filii
Zebedei…sedeamus in gloria tua et reliqua.* Rubric: *Homelia beati Gregorii pape
eiusdem lectionis.* Text inc. *Quia naturalem beati Jacobi…* expl. complete (f.
77) *…largiri quod iubet.* + dox. (W 128)

f. 77 *Chapter 15.* (Fictitious) Sermon of Leo [without pericope] for the seventh day in the octave of St James, 31 July.
Rubric: *Secundo Kalendas Augusti infra octavas sancti Jacobi VII die. Sermo
beati Leonis pape de sancto Iacobo.* Text inc. *Exultemus in domino…* expl. (f.
84v) *…faciet efficaces* + dox. (W 137)

f. 85 *Chapter 16.* Pericope and (Fictitious) Sermon of Jerome for the seventh day in the octave of St James, 31 July.
Rubric: *Secundo Kalendas Augusti infra octavas sancti Jacobi apostoli VII die.
Lectio…* Pericope: *In illo tempore accessit ad dominum Jhesum mater
filiorum…* expl. *…et alius ad sinistram tuam in regno tuo et reliqua.* Rubric:
*Sermo beati Jeronimi doctoris atque Johannis episcopi eiusdem lectionis in natale
sancti Jacobi apostoli fratris Johannis evangeliste qui requiescit in territorio
Gallecie.* Text inc. *Sollempnitatem hodiernam…* expl. (f. 87v) *…gaudere faciat*
+ *dox.* (W 141) *Explicit sermo beati Jeronimi vel Johannis episcopi.*

f. 88 *Chapter 17.* Sermon of Calixtus [without pericope] for the Feast of the Election and Translation of St James, 30 December.
Rubric: *Sermo beati Calixti pape in sollempnitate electionis ac translationis
sancti Jacobi apostoli que III kalendarum Januarii celebratur.* Text inc. *Veneranda
dies…* expl. (f. 114v) *…possidere celorum* + dox. (W 176)
*Explicit sermo Beati calixti in festo translationis et electionis Beati Jacobi apostoli
patroni gallecorum et hispanorum*
[Book 1, Chapters 18-31 omitted (W 177-257)]
Folios 115-132 copied by Scribe 2

f. 115 **Book II: 22 Miracles of St James**
Prologue, rubric and text as in C (W 259)
[List of Miracles omitted]
Miracle texts as in C, with Miracle 5 dated 1900 [*sic*] not 1090 as in C,
Miracle 11 dated 1205, not 1105 as in C, Miracle 14 as 1207 not 1107 as in
C, Miracle 15 as 1210 not 1110 as in C, Miracle 22 as 1206 not 1100 as in C.
Expl. (f. 128) as in C, but with *Finit* for *FINIS;* Chi Rho monogram, as in C.
(W 287)

f. 128v **Poem about pilgrims** [not in C] Text inc. *Qui viginti viros olim solvitur ab
ergastulis…* expl. *soluit virum terderes dubiter.* [not in WALTHER, 1959 nor
in the incipit file at HMML]

f. 129 **Additional Miracle, the Voto Privilege** [not in C; cf. LÓPEZ FERREIRO II 1899, repr. 1983, pp. 132-137, identified by Klaus Herbers (personal communication)]

Note: *Hoc miraculum non scripsit calixtus in libro suo.* Rubric: *Miraculum sancti Jacobi de votis quomodo instituta arenemiro. In nomine patris et filii & spiritus sancti. Amen.* Text inc. *Antecessore facta perque sucessores ad bonum poterunt...* expl. (f. 132) *dei misericordiam obtimum. Quod superius scriptum est sancimus et perpetuo confirmamus permansarum. Tu autem domine miserere mei.*

Folios 132v-212 copied by Fra Juan de Azcona

f. 132v **Miracles of St James in Spanish** [not in C]

Rubric: *Milagro de las conthas et veneras de s. tiago.* Text inc. *Quanto est glorioso dios entre los hombres...* expl. (f. 134v) *...consomaro matrimoni* + dox. *Et gloria per todos los siglos delos siglos. Amen.* [signed?] *Telos. Vale.*

Note at bottom of f. 134v reads *El miraglo de los votos y este de las conchas fueron ariechio los que no son de los que escrivio del papa Calixto sy no de otra historia.* [not in LÓPEZ AYDILLO, 1918) or PENSADO, 1958)]

ff. 135-137 Blank

f. 138 Rubric: *Liber Secundus.* Rest of leaf blank

f. 139 **Book III: Translation of St James**

Opening heading: *Incipit liber tercius Beati Jacobi De translatione eiusdem Beati Jacobi maior. Prologus.* [different from C, W 290]

Prologue of Calixtus

[Chapter list omitted] Text inc. *Hanc translationem Beati Jacobi a nostro codice...* expl. as in C (f. 139v) *...remuneravit muneribus.* [*Explicit prologus* omitted] (W 290)

f. 139v *Chapter 1.*

Rubric: *Incipit opusculum translationem B. Jacobi apostoli.* Text inc. *Post salvatoris...* expl. (f. 142) *...fragia procuraturus* [sic]. (as in C, W 294)

f. 142 *Chapter 2.* Epistle of Leo.

Rubric: *Epistola beati Leonis pape de translationis beati Jacobi apostoli que III Kalendas Januarii celebratur.* Text inc. *Noscat fraternitas...* expl. (f. 142v) *...suffragio patro cinaturus* + dox. (as in C, W 296)

f. 143 **Account of the discovery of the tomb of St James by Bishop Theodomir in 866, from HC, Liber I, Cap. 1** [not in C]

Rubric: *Calixti pape in epistolam Leonis Ampliatio.* Text inc. *Floruerat autem antiquitus in illo loco...* expl. (f. 143v) *...regali privilegio commitavit* + dox. [HC, 1988, I, i lines 40-48, and (gap due to eyeskip at Theodomir?) I, ii, lines 1-25, with the addition of the date 866 (*hera 904*) between lines 17 and 18 and the variant *hispaliensis* for *Hiriensis*.]

f. 143v *Chapter 3.* Calixtus on the Three Feasts.

Rubric: *Calixtus papa de tribus sollempnitatibus sancti Jacobi.* Text inc. *Beatus Luchas...* expl. (f. 145v) *...decorabantur.* (as in C, W 299)

f. 146 *Epistle of Pope Leo,* in Spanish [not in C]

Rubric: *La epistola de sant Leon papa de la trasadacio del cuerpo de sant iacobo apostol nostro de sant juan evangelisto filos del Zebedeo con la adition del papa calixto.* Text inc. *Sabed por certo fratres mios mucho amados...* expl. (f. 148v) *...inauctoridad la passo en la gloria de Compostella* + dox. [not in PENSADO, 1958)]

[Chapter 4 omitted (W 299)]

f. 148 Blank

f. 148v Rubric: *Libro tercero dela legenda de Sant Jacobo apostoli* [rest blank]

f. 149 **Book IV: Pseudo-Turpin**
Prologue
Rubric: *Prologium* [sic]. *Turpinus domini gratia archiepiscopus remesis ac sedulus charoli magni imperatoris in hispania consotius leprando decano aquisgrenensi salutem in xpo.* Text inc. *Quoniam nuper mandastis mihi apud vienam…* expl. *…domino placeas Amen.* (W 301) [Chapter list omitted; individual chapters are numbered I-XXX]
Chapters 1-21
Rubric: *Capitulum I.* Text inc. *Gloriosissimus…* continues as in C to Chapter 21 (C f. 180v, W 330), after which M has a different sequence of chapter divisions, although the text is substantially the same as in C (cf. the subdivisions in L, which occasionally coincide with M, and with A6 in MEREDITH-JONES, and in R and VB).

f. 168v *Capitulum XXII. Itaque peracto bello…* (C f. 180v, in Ch. 21, W 330; Ch. 22 in L and MJ 184)

f. 172 *Capitulum XXIII. Crastina namque die…* (C f. 184, in Ch. 21, W 336; L Ch. 27; MJ 206, Ch. 26)

f. 173 *Capitulum XXIV. Et erant tunc temporis…* (C f. 184v, in Ch. 21, W 337; L Ch. 29; MJ 212, Ch. 28)

f. 173v *Capitulum XXV. Postea ego…* (C f. 185v *Postea vero ego…*, in Ch. 21, W 338; L Ch. 30; MJ 216, in Ch. 29) expl. (f. 174v) *…gentium libera.* (C f. 186, W 339, line 18)

f. 174v *Capitulum XXVI. Tunc Carolus…* (C f. 186, in Ch. 22, W 339, line 20; includes Liberal Arts; L in Ch. 30; MJ 220 in Ch. 30)

f. 176v *Capitulum XXVII. Sed valde…* (C f. 188v, Ch. 23, W 343; L in Ch. 30; MJ 234, Ch. 33)

f. 177 *Capitulum XXVIII.* Rubric: *Calixtus papa de inventione corporis beati Turpini episcopi et martiris.* Text inc. *Beatus namque…* (C f. 189, Ch. 24, W 344; L Chs. 23/24 [sic]; MJ 240, in Ch. 33, no chapter number)

f. 177v *Capitulum XXIX.* Rubric: *Calixtus papa.* Text inc. *Quid patrie Gallecie…* (C f. 190, Ch. 25, W 345; L in Ch. 23/4, no chapter number; MJ 244, in Ch. 33, no chapter number)

f. 178v *Capitulum XXX.* Rubric: *Incipit epistola beati Calixti pape de itinere Hispanie omnibus ubique propalanda.* Text inc. *Calixtus episcopus… Crebro dilectissimi…* (C ff. 190v-191, Ch. 26, W 347; not in L or MJ) expl. (f. 179v) *…salus et gloria* + dox (f. 180). (C f. 191v, W 348).
[*Finit codex* omitted]

f. 180 **Song: *Ad honorem* [among the songs that follow Book V in C]**
Rubric: *Prosa beati Jacobi.* [author's name, Aimericus Picaudus, omitted]
Text: *Ad honorem regis sumi qui condidit omnia…* (C f. 219v, W 398) continues with text now missing in C, but preserved in A, VA and L: *Ermogeni et fileto christi fidem tribuit.* expl. (f. 189v) *esus eya decantemus iugiter. Amen.* [transcribed W 398-399; variants in M are *Hermogeni* for *Ermogeni* (A, VA, L); *illi* for *egro* (A, VA, L); *mundum fulget* for *fulget mundum* (A, VA, L), *aparuit* for *apparuit* (A, VA, L); *tradidit* for *reddidit* (A, VA, L); *Peregrino Pictavensi asinumque traddidit* omitted; *contritum* for *contractum* (A, VA, L); and *eya* for *eia* (A, L), *ea* (VA).]

f. 181 **Book V: Pilgrim's Guide**
Long Version, with some variants. For M's selections see Table of Book V.

f. 207v Explicit and colophon (W 389)

Additional colophon: *Telox id est finis.* [not in C]

[None of the other texts following the *Guide* in C are included]

List of bishops and archbishops of Iria and Compostela [not in C]

We have collated M's list with that from the Salamanca manuscript of HC, the list in ES, XX, pp. 611-613, GAMS, and FLETCHER, 1972.

Rubric: *Sequitur numerus episcoporum & archiepiscoporum qui fuerunt in eclesiis iriensis et compostellanensis A fundatione ipsarum usque nunc tempus in quo Hec scripsimus Anno Domini M D xxxviii.* Text inc. *In eclesia Iriensi fuerunt viginti et octo episcopi qui in eadem sunt sepulti et vocantur per unum privilegium corpora sanctorum exceptis hiis sequentibus domino crisostomo, domnino sesnando, sancto samuel, domino dominico, domino theodomiro qui invenit corpus beati Jacobi et fuit ibi, dominus didacus ultimus episcopus iriensis et primus archiepiscopus compostellanus et legatus hispaniarum qui in vita sua multas edificavit eclesias et fecit multa bona obiit Era Millesima.c.lxxi. Scilicet Era Millesima c lxxi. Annos l.* [i.e. AD 1133, which does not accord with FLETCHER 1972, p.47), who gives 1140 and GAMS who gives a date after 17 April 1139].

Era domini Diii° lxxvi [Era 876, AD 838].

Aldephonsus rex catholicus [Alfonso II, 789-842] *Invencto* [sic] *corpore beati Jacobi dedit eclesie compostellanensi pro fundatione tria milliaria in giro. Era Dccc° lxxxvi* [Era 886, AD 848], *ordonius* [Ordoño I, 850-866; perhaps the scribe missed an x in copying] *filius Raimiri* [Ramiro I, 842-85] *dedit alia tria millia eiusdem eclesie.*

Era Dcccc° iii [Era 903, AD 865] *Aldephonsus filius ordonii* [Alfonso III, 866-909] *confirmavit facta eorum et dedit eclesie b. Iacobi eclesiam Iriensem cum sua sede et totum plebem et diocesim.*

1. *Primus Archiepiscopus compostellanus fuit didacus obiit ut supra.*

2. *Secundus berengarius.* [in office 1141 or 1142? FLETCHER, p. 49; not in GAMS; he is also omitted from the list in HC, printed in ES, p. 611]

3. *Tercius petrus Helie.* [elected 30 January 1143, ob. 8 November 1149 FLETCHER, ibid.; not in GAMS; also omitted in ES list]

[Note: M does not include Berengar of Salamanca, 1150-51, FLETCHER, p. 50; GAMS]

4. *Quartus bernardus.* [1151-26 April 1152, FLETCHER, ibid.; GAMS gives his death as March 1153)

5. *Quintus pelagius Jamundius.* [1153-12 December 1155; FLETCHER, ibid.; GAMS give his death as 1156; ES, p. 611, *Camunds*]

6. *Sextus Martinus* [1156-29 November 1167, FLETCHER, p. 53; GAMS]

7. *Septimus pelagius gundestius, idest degodoy* [1167-1172 or 1173, FLETCHER, p. 54; GAMS; ES, p. 611, *Petrus gudestey*]

—*Octavus Ferdinandus Cortes* [not in FLETCHER or GAMS; the HC list in ES, p. 611, names him after Petrus Gundestiz but denies him a number on the grounds that he was never confirmed in office.]

8. *Nonus petrus sugerius; Suerus; aporcibus* [1172/3-1206 FLETCHER, p. 54; GAMS gives *c.* 1177-99; *Muniz* ES, p. 611]

9. *decimus petrus ul muim* [M reads *nuim*, but given the vernacular form, *muim* must be what he intended to write.] 11. *idest muniz alius* [1207-24, GAMS]

10. *Vndecimus bernardus* [1231-34, GAMS; *Undecimus Johannes primus* ES, p. 611]

11. *duodecimus Johannes Arias. Arius.* [1234-55, GAMS; *Duodecimus Egeas primus*, ES, p. 612]

12. *tredecimus egeas episcopus colibriensis et antequam eclesiam aciperet vel ad eam accederet obiit in Monte pesssullano qui vulgo dicitur Monpeller* [1267-19 March 1268, GAMS; the information about his death in Montpellier is also in HC, ES, p. 612]

[Note: M's list, and ES, omit Johannes Fernandez de Temez, ob. 1275 or 1282, GAMS; he is also omitted in HC, ES, p. 612]

13. *Quatuordecimus gundisaluus gometii* [ob. before 29 May 1285, GAMS; *tredecimus* ES, p. 612]

14. *Quintus decimus Rodericus de ordine predicatorum* [left office 1304, GAMS; *quartus decimus* ES, p. 612]

15. *§ decimus sextus Rodericus patroni, idest del padron. Sepultus est retro chori in Sancti Jacobo* [ob. 3 November 1316, GAMS; *quintus decimus* ES, p. 612]

16. *§ decimus septimus beringarius de ordine predicatorum qui interfecit milites et obit hispali, Idest in sibilia.* [1317-25, GAMS; *sextus decimus* ES, p. 612]

17. *decimus octauus Johannes Ferdinandus* [1331-38, GAMS] [From here on, the sequence in ES differs from that in M, and is not numbered.]

Decimus nonus martinus ferdinandi degrem qui obiit tempore ferdinandi in algezira alphonsi [Martinus Ferd. Gres II, ob. 1350, follows Petrus in GAMS]

[M's list omits *Johannes, qui fecit Castellum Ripae fortis,* and the two Rodericuses and Johannes listed next in HC, ES, p. 613]

vigessimus petrus [took office 1342? precedes Manrique in GAMS, not in HC]

vigessimus primus dominus sugerius quem cum decano interfecerunt in platea fernandus petri turach'on et alphonsus gometii gallinato. [ob. 29 June 1366, follows Manrique in GAMS and HC, ES, p. 613]

vigessimus secundus gometius Manrriquem postea fuit Toletanus archiepiscopus [ob. 19 December 1362, precedes Sugerius in GAMS and HC, ES, p. 613]

vigessimus tercius Aldefonsus qui obiit in tranipalis de noya domus sic nominata morte supitanea [ob. 1378? GAMS and HC, ES, p. 613]

vigessimus quartus Rodericus de Moscoso qui obiit xxvi die aprilis era $M^{ma.}$ $cccc^o$ $xx.$ [i.e. 1382; ob. November 1382 GAMS; his death date is also given in HC, ES, p. 613]

vigessimus quintus Johannis guarcia Manrrique qui fuit exul in Regno portugalie Anno domini M ccc. $Lxxx^o$ $viii^o$ [1386-97 GAMS and HC, ES, p. 613]

vigessimus sextus lupus de Mendoca [1399-ob. 3 February 1445 GAMS and HC, ES, p. 613]

vigesimus septimus dominus Alvarus de Ysorna [1445-49 GAMS and HC, ES, p. 613]

vigesimus octabus dominus Rodericus de limja [did the scribe copy *limja* for *lunya*? de Luna in GAMS, no dates; HC, ES, p. 613 also gives 'Luna']

vigesimus nonus dominus Alphonsus de fonseca archiepiscopus hispaliensis et simul compostellanus. [1460-ob. 1486 GAMS; this is the last entry in HC, ES, p. 613, ending with Alphonso's capture by Bernardus Johannis in 1465]

Trigessimus (M: *vicessimus*) *alphonsus de fonseca archiepiscopus Compostellanus et postea primarchia Alexandrinus* [ob. 1508 GAMS]

Trigessimus primus Aldephonsus filius istius patriarche qui postea fuit Archiepiscopus Toletanus. [tr. to Toledo 1524 GAMS]

Trigessimus (M reads *vicessimus*) *secundus Johannes de Tabera archiespiscopus Compostellanus presidens Regni et Cardinalis Sancte Romane eclesie titulo Sancti Johannis Ante portum latinum, primus Cardinalis in eclesia Sancti Jacobi qui postea fuit Archiepiscopus Toletanius. me hoc suabenter xxiii. dominus* [1525-13 May 1534 GAMS] added, with a thinner pen, but by the same scribe:
§ *vigessimus quartus Johannes sarnientus* [named *Petrus*, August 1534-13 October 1541; became cardinal 1538, GAMS]

f. 209 **Book I: Prologue, last paragraph, on the Pilgrim's Mass at Santiago** [for other excerpts from Book I see above]
Rubric: *Notabilia fratris Johanis de Azcona.* Text inc. *Calixtus papa in epistola super totum librum in fine totius epistole dicit hoc faciendum clero Sancti Jacobi in eius basilica. Precipimus cunctis diebus excepto die natalis domini et scenæ et parasceve et subsequentis sabati et pasche et pentecostes similiter.* (W 4 *pentecostes. Similiter*) § *prima missa prop(r)ia omnibus diebus de Sancto Jacobo peregrinis decantetur exceptis diebus prefactis; et post primam preccem misse sedule prosequatur pro peregrinis hec oratio: Pateant Aures misericordie tue quesumus, Domine precibus supplicantium tibi* (C reads *beati Iacobi* for *tibi*) *peregrinorum etc.* (W 4) [rest omitted]

f. 209v **List of institutions in and around Santiago, in Spanish** [not in C]
Headings: *Los monestirios...extra muros. Sancto domingo delos predicadores... Dentro de la ciudad... Las iglesias de la ciudad.*

f. 211 Rubric: *Frater Johanes de Azcona legentibus.* Text inc. *Veni ad locum qui dicitur bivarium...* expl. *ficatur nicalaus laicus.*
Description and drawing of the altar-stone at San Payo de Antealtares, Santiago [not in C]
En sant payo Monesterio de Monjas alas espaldas de Santiago esta enl' altar mayor una piedra de alabastro puesta per Ara que dizen que la consagraron doze obispos tiene tanto en Archo como en largo en medio esta una scriptura enseys. T(?)englones que no al puidem accetar alcer

f. 211v Drawing of square stone, with inscription in Rustic Capitals and comments added below in cursive by Juan de Azcona, and a local explanation (transcribed in *SANTIAGO CAMINO DE EUROPA*, no. 5, p. 252 with reference to PEREIRA MENAUT (1991), I, no. 48, pp. 131-134, whose transcription we give in comparison)

Juan de Azcona	Pereira Menaut
D.M.S	
ATIAMOET.AT.	*ATIA MO(DESTA ET AR(TIUS?)*
T.ET.LVM.P.C.	*TET(U)LUM P(OSUERUNT) SE*
VI.R.I.AMO.N.	*VIRIAE MO(DESTAE)*
NEPTIS.ET.S.F.C.	*NEPTI S(UAE) PI(IENTISSIMAE)*
que hec su possu	*AN(N)O(RUM) XVI ET S(IBI)*
interpretari	*F(ACIENDUM) C(URAVERUNT)*
neptis pia	
anno decimo sexto	
etatis faciendum curavit	
Atia modestina	
pro salutatem suorum	

Los interpetres de Santiago dizen por las primeras letras D.S.M. 'discipuli mei susticiferunt' po lo de mas Arida y Buscaldo.

What is interesting here is that Juan de Azcona makes no comment about the function of this Roman stele as part of an altar; Ambrosio de Morales, who visited a generation or so later, in 1572, thought it was entirely inappropriate (see *SANTIAGO CAMINO DE EUROPA*, 1993, p. 252).

Notes about Padron [not in C]
Rubric: *Ay en el lugar del padron dos iglesias…a la reyna Luparia.* Written at
the bottom of the leaf, with a different pen: *En vn previlegio que halle en el
lugar del padron halle/Jo fray Juan de Azcona esto qui designe.*

f. 212 *Eynde mays se colifico la dichavilla que es llamada padron por honrra ez loor del
sancto padron bendicho del apostol que ay quedo en lo quoal fue puesto suo corpo.
En el mismo privilegio ondo quedo esta el su padron en que fue puesto el suo
corpo.*

Sigla: Hämel: C5

Meredith-Jones: B.13

Mandach: B.13

Díaz y Díaz: Ma

Bibliography: Blondus, 1559; Briquet, 1935; David, 1946, p. 31; Díaz y Díaz, 1988a, pp. 137, 327;
Fletcher, 1972; Gams, 1873-1886, repr. 1957; Hämel, 1950, p.72; id., 1953, p. 69; HC,
1765/1965, 1988; Herguet, 1904, p. 429; *Inventario general de Manoscritos de la
Biblioteca Nacional,* 1984, pp. 329-330; López Aydillo, 1918; López Ferreiro, II, 1899,
repr. 1983, pp. 132-137; Mandach, 1961, p. 395; Meredith-Jones, 1936, repr. 1972, p.
12; Pensado, 1958, p. xii; Pereira Menaut, 1993, I, no. 48, pp. 131-134; *Santiago Camino
de Europa* 1993, no. 5, p. 252; Stones, 1991, p. 626; Stones/Krochalis, 1995, pp. 31-32,
fig. 12; Walther, 1959.

Jacobus

Copied between 23 June and 22 July 1657, Estepa (near Seville), Spain

Paper, 1 + 91 + 1 ff., 314 × 217 mm. Written space 266 × 136 mm. Text in one column, 25 lines. Rulings not visible. (*Ills. 84–86*)

Quires:	Difficult to determine with certainty; generally quired in ternions. No catchwords.
Watermarks:	On almost every page: close to BRIQUET No. 3246 [Perpignan, after 1639].
Script:	By a single hand throughout, except the note on f. 91 and a note in cursive (late 18th century?) on the front flyleaf. Copied in Estepa (near Seville) in 1657, between 23 June and 22 July, from the copy written by the Excalced monk Peter of San Caecilio in 1632, by another scribe who is unnamed except for his monogram VS (?). See also below under provenance.
	Written in small italic cursive with very tall ascenders and descenders; descenders, including 'q', curve to the left. The spellings, on the whole, are classical and hooked 'e' is regularly used. The scribe of SV would appear to copy Peter's strenuous efforts to imitate the early 14th century (? cf. the display script in A, VA and S) decorative capitals of his exemplar, also copying Peter's note (f. 1) that they were done in colour in the exemplar. SV records (f. 24) that the scribe had great difficulty deciphering his model, which had many gaps; the text in SV has many gaps throughout, which our scribe (and Peter before him?) marked with dots.
Rubrics:	In the brown ink of the text.
Musical Notation:	None. No spaces left for it, but f. 25 has a note explaining that the exemplar had musical notation on a staff and that its presence is indicated in this copy by a line in the margin.
Decoration and Illustration:	None.
Binding:	Beige parchment with two leather thong straps. No tooling.
Provenance and History:	The colophon indicates that the Excalced monk Peter of San Caecilio made a copy in 1632 in his cell in Granada, based in part on what he refers to as *Exemplar Hispaliensis*, which we have abbreviated EH. On f. 1 of SV, this exemplar is described as being in the Cathedral of Seville, written in very ancient letters, and in many places rotted with damp. Peter also had (f. 90v) another copy made from the same exemplar. The marginal inscriptions at the beginning and end of SV, on ff. 1 and 90v, would suggest that SV is a copy of Peter's copy, made in 1657 at Estepa, by a scribe named only by his monogram VS (?). We believe that this scribe added the marginal notes recording the beginning and ending dates of his work. There are references in the margins and in square brackets in the text to Mariana's *Tractatus VII*, published in 1609, and to the *Magna Biblioteca veterum Patrum*, published in Cologne in 1622 (ff. 4, 5v), which reprinted Mariana's text of Calixtus's sermons. Similar references to a seven-volume set of Bede, including the summer sermons, and to a German edition of the *Pseudo-Turpin* are more problematical. Whoever added them also had editions of Eusebius, and Vincent of Beauvais. Insofar as these editions can be identified, they would fit either date. These printed editions enabled VS or Peter to cut most of the text of the sermons of Calixtus in the *Magna Biblioteca veterum Patrum*, the authentic sermon of Bede, and the *Pseudo-Turpin*.
	The existence of a widely disseminated (*vulgo circumferatur*) printed text of *Pseudo-Turpin* enabled the scribe (whether Peter or VS) to skip much of Book IV, though he carefully recorded differences, and copied, for instance, the long list of Spanish cities in Chapter 3 which his printed edition omitted. The edition was *cum typis edita inter scriptores veteres rerum Germanicarum*, which sounds like the composite volume

by Simon Schard published at Frankfurt in 1566 (listed in CIAMPI, 1822, pp. vi-viii), entitled *Germanicarum rerum quatuor celebriores, vetustioresque chronographi, earum descriptionem ab orbe condito usque ad tempora Henrici IV Imperatoris*. It included the *Pseudo-Turpin*, Reginald of Prüm, Sigbert of Gembloux, and Lambert of Hirschfeld, and was reprinted at Frankfurt by Justus Rubeus in 1584, with the title: *Veterum Scriptorum qui Caesarum et imperatorum Germanicorum res per aliquot secula gestas literis mandaverunt*. Or the scribe of SV might have used Simon Schard's 1566 edition, also published at Frankfurt, *Germanicarum rerum quatuor celebriores vetustioresque chronographi*. Having decided that the Sermon of Bede with which the liturgy begins was not authentic, *Hæc ab Authore (quisquis is est) conficta et falsa Bede adscripsa sunt*, f. 3v, he skips large parts of it. Presumably he checked in the same seven-volume Bede where he found an authentic sermon among the summer homilies, col. 117 (f. 18v). See C, ff. 4, 44.

We cannot be sure whether it was Peter or the scribe VS who was collating a manuscript model with printed sources. But the source of the comment that EH had music must be Peter, who had seen EH (f. 24). Corrections and comments about the legibility of the model occur with some frequency (ff. 1, 1v, 3v etc.). One is inclined to attribute all the comments to the same person, as indicating the same kind of scholarly mind, in which case VS simply copied the comments, adding only the beginning and ending dates of his work and his signature.

SV's scribe imitates the original's decorative letters at the beginnings of books, and these give us some clue as to the possible date of EH. They are close in style to those in A, VA, and S, which would put EH in the group of *Codex Calixtinus* manuscripts written early in the 14th century and entitled *Jacobus*.

While A has no music nor spaces for it, and VA and S both left spaces for notation that was never filled in, the indications left by the scribe of SV are that his model did have notation. He says that he has indicated its presence by drawing vertical lines in the margins next to the sections of text which were accompanied by music in his model. This would make his exemplar the only copy of C, other than R, to transmit music.

One other comment worth making about SV is that he had read Mariana, and had a certain scepticism about his material; he refers to *Pseudo Calixtus* at f. 3v.

Identified by ANDRÉS, 1979, p. 619, as no. 101 in the inventory of Don Antonio López de Zúñiga, 13th Count of Miranda, made in 1755, at the death of his wife, for the sale of his books. Possibly this was among the books inherited from his father Don Joaquín López de Zúñiga Chaves (d. 1725), whose will lists books, among which items 74-164 are 91 'libros de diferentes crónicos, historias y papeles curiosos'. Acquired by the BN, Madrid, with the Miranda collection in 1757. Formerly T. 198 in the BN.

Secundo folio: *nostri sermones*

Contents: In top left margin of folio 1: *CALISTI I* (texts attributed to Calixtus are so indicated, and numbered in order, in the top margin)

In top right margin: *en 23. de Junio. 1657. comenze asaur (?) escrivir lado en Estepa*

f. 1 **Introductory Explanation:**
COPIA
De un libro MS. dela Santa Iglesia de Sevilla escrito en pergamino de letra mui antigua, i esta por algunas partes podrido con la umedad. Su principio es como sesigue i con esta mesma forma de letras el titulo que en el es de letra colorada.
Title
EX RE +GNAtur
IACOBUS LIBER ISTE Chi Rho (on its side)
IPSUM SCRI+BENTI

SIT GLORIA SIT QUE LEGENTI
(cf. C, A, VA [W 1])
Excerpts from Book I: Liturgy of St James
Prologue and Chapter list of 31 chapters as in C (W 1-6)
In right margin: *Habeo hanc epistolam editam apud Marianum, in disputat. de adventu D. Iacobi in Hispaniam cap. 12, pag. 21.*

f. 3v *Selections from Chapter 1.* Pericope and Sermon of Bede for the Vigil of the Feast of St James, 24 July.
Rubric: *VIIII Kal. Aug. Vigilia S. Iacobi. Lectio Epistole Beate Iacobi Apostoli.*
Pericope: *Iacobus Dei et Domini nostri Iesu Christi seruus duodecim tribuba que sunt in dispersione salutem etc.*
Left margin: *Cap. 1.* Rubric: *Sermo Venerabilis Bede presbiteri.* Text inc.
Quoniam beati Jacobi vigiliam…salvus erit (W 6)
Note (not in C): *[Hæc ab Authore (quisquis is est) conficta et falsa Bede adscripsa sunt* (rest of line cancelled). See our note in C; SV was partially right. It is Bede's sermon on James the Less. *Quæ tamen deinceps sequuntur, videlicet]* (square brackets in MS)
Text continues: *Dixit de hoc Iacobo Apostolus Paulus, Cephas, et Ioannes [et cetera usque ad illa]* (W 6)
[skips to W 11]
Abstractus a recto itinere et inlectus (W: *intelectus*) *in malum. etc.*
Note (not in C): *[Ab expositione Bede in cap. i. Epistole B. Iacobi tom.S. desumpta sunt, quapropter a nobis omittuntur. quibus tamen Pseudo Calixtus ut finem sermonis simulet, ait]*
A qua tentatione… + dox as in C (W 11)

f. 4 *Selections from Chapter 2.* Pericope and Sermon of Calixtus for the Vigil of the Feast of St James, 24 July, Office.
Rubric: *VIIII Vigilia Sancti Iacobi Zebedei. quæ studio Ieiunii, propiique divini officii digne celebretur. Lectio S.Evangelii secundum Marcum. cap. 3* Pericope: *In illo tempore, Ascendens Iesus in montem…* expl. *eos predicate et reliqua.*
Rubric: *Sermo B. Calixti pape ejusdem lectionis.* In right margin: *Cap. 2.* Text inc. *Vigilie noctis sacratissima solemnitatis B. Iacobi Zebedei Apostoli Gallecie et cetera.* (W 11)
Note (not in C) preceding a gap from W 11 to W 34: *[Reliqua omittimus, quia typis mandata cum aliis (de quibus infra) tom. 15. Biblioth. Patrum in editione Coloniensi ann. 1622. pag. 324. In exemplo autem de quo hee transcripsimus post illa hujus primi sermonis ultima verba:*
Mereamur cum illis gaudere in celis (W 34)
Adduntur sequentia
Text continues (W 34) *De hiis Apostoli…* complete to end of chapter as in C (W 35).

f. 4v *Chapter 3.* Benedictions of Pope Calixtus to the lessons.
In left margin: *Cap. 3.* Rubric: *Benedictiones Calixti PP ad Lectiones S. Iacobi.*
Text (adding an additional initial letter at the beginning of each line) inc.
A. Adsit nobis… expl. complete *…prebuit palmam.* (W 35)

f. 5 *Selections from Chapter 4.* Calixtus's Prologue and Passion of St James, 25 July.
Rubric: *Incipit prologus B. Calixti PP super modicam passionem S. Iacobi Zebedei Apostoli Gallecie que VIII Kal. Aug. celebratur* Text inc. *Hanc B. Iacobi…* expl. complete *…quam aliam legere.* In right margin: *Cap. 4.* Rubric: *Explicit prologus. Incipit passio.* Text inc. *Caio quatuor annis nec integris Romæ principatu ministrato…* (W 36) first line of text followed by note (not in C): *[Prout Eusebius l.2.c.7.et.9]*
[rest of chapter omitted]

Selections from Chapter 5. Sermon of Calixtus for the Feast of the Passion of St James, 25 July.
[chapter number omitted]
Rubric: *Sermo B. Calixti PP in passione S. Iacobi Apostoli VIII Kal. Aug. celebratur.* Text inc. *Celebritatis sacratissimæ, fratres, B. Iacobi Apostoli hodie nobis dies veneranda refulsit...* (W 38) first line followed by note (not in C): *[Prout excursum habemus dicto tomo Biblioth. a pag. 330. ad 333]*
[rest of chapter omitted]

f. 5v *Selections from Chapter 6.* Sermon of Calixtus for the Feast of the Passion of St James, 25 July.
Rubric: *Sermo B. Calixti PP. in passione S. Iacobi Apostoli quæ VIII. Kal. Augusti celebratur.* Text inc. *Spiritali igitur jocunditate, dilectissimi fratres, letemur in domino...* (W 48) first line followed by note (not in C): *[Excursum etiam habeo totum hunc sermonem in Biblioth. tom. 25 pag. 333. et sequent.]*
[rest of chapter omitted]

Chapter 7. Pericope and Sermon of Calixtus for the Feast of the Passion of St James, 25 July.
Rubric: *VIII. Kal. Augusti Passio S. Iacobi Galleciæ.* In left margin: *Cap. 7.*
Rubric: *Lectio Actuum Apostolorum* Text inc. *In diebus illus supervenerunt a Ierosolymis...* expl. *sub Claudio etc.*
Rubric: *Sermo B. Calixti PP. ejusdem lectionis.* Text inc. *Adest nobis dilectissimi fratres...* continues as complete as he can read his model, and in the correct order, expl. (f. 18v) *suorum miserebitur* + dox (W 87).

f. 18v *Selections from Chapter 8.* Pericope and Sermon of Bede for the Passio of St James, 25 July.
Rubric: *VIII. Kal. Augusti. Passio S. Iacobi Zebedei apostoli Galleciæ. Secundum Matheum.* Pericope: *In illo tempore accessit ad dominum... Nescitis quid petatis et reliqua.* In left margin: *Cap. VIII.* Rubric: *Omelia Venerabilis Sancti Bedæ Presbyteri.* Text inc. *Dominus conditor ac redemptor noster vulnera superbie nostre sanare desiderans etc.* (W 87) first line followed by note (not in C): *[Prout extat tom.7.Operum Bede inter homilias æstivales de Sanctis in Natali S. Iacobi. col. 117]*
[rest of chapter omitted]

f. 19 *Chapter 9.* Prologue of Calixtus and Passio of St James, 25 July.
[Chapter number omitted]
Rubric: *Incipit Prologus B. Calixti PP. ante S. Iacobi magnam passionem quæ etiam de S. Iosia martyre VII. Kal. Augusti potest legi.* Text inc. *Constat omnes illos errare...* expl. (f. 53v) *...secure legatur.* Rubric: *Explicit prologus. Incipit Passio.* In left margin: *Cap. IX.* Text inc. *Post ascensionem...* complete text expl. (f. 24) *...Stephani Prothomartyris et Iacobi maioris et Iacobi minoris* (James the Less not in C) *Regnante per omnia* + dox. (W 103) [Explicit omitted]

f. 24 [Chapters 10-20 omitted with an explanatory note]
[In sequentibus multa desiderantur scilicet a cap. x. ad. xx.]

Chapters 21-27
copied complete. After Fulbert's hymn (W 193-194) is a note: *[Quæ deinceps sequuntur lineis in margine signata musicis notis et regulis ad cantum disposita erant in exemplari MS.]*
Thereafter, notation in the exemplar is indicated by a line in the margin, corresponding to the presence of notation on staff lines in C.

f. 36 *Chapter 28*
complete to *possimus pervenire* (f. 39, W 239).

[Calixtus's Prologue and Mass for the Feast of the Miracles, 3 October, omitted (W 239-240)]

f. 39 *Chapters 29-31*
complete, expl. (f. 43v) *quia sedes ethereas ascendit. Deo gratias.* (W 257)

f. 43v Explicit: *FINIT CODEX PRIMUS IPSUM SCRIBENTI SIT GLORIA SITQUE LEGENTI. AMEN.* (W 257) Chi rho on its side (not in C).

f. 44 **Book II: 22 Miracles of St James.**
Opening heading, Prologue, Chapter list of 22 chapters, Text and Explicit
as in C, but with chapters numbered in the margins. On ff. 56v and 57, Miracles 18 and 19, are marginal cross-references to Vincent of Beauvais, *Speculum Historiale*, tom. 4: *Vincent L. 26, c. 40.* Expl. (f. 59) as in C but with *Finit* for *FINIS.* Includes a Chi Rho on its side. (W 287)

f. 59v **Book III: Translation of St James**
Opening heading, Chapter list of 4 chapters, Prologue, Text and Explicit
as in C (W 289-299). On f. 59v a reference to Mariana's *Tractatus VII: Mariana in disput. de Adventu B. Iacobi in Hisp. cap. 12. p. 24.* The Prologue text is noted with a series of six + marks, indicated in the margins as the text for six lessons.

f. 65v **Excerpts from Book IV: Pseudo-Turpin**
Opening heading: *INCIPIT CODEX .IIII. S. IACOBI Ex scriptoris Premonitio.* Note: [*Codicis hujus quarti major pars ex Turpini Historia de Vita Caroli Magni desumpta est, que cum typis edita inter scriptores veteres rerum Germanicarum vulgo circumferatur; ideo nos super vacuo parcenne labori, ea tantum ad scribere correcti erimus, que apud Turpinum non reperiuntur*].
Rubric: *De Expedimento et conversione Hispaniæ et Gallæciæ editis a B. Turpino Archiepiscopo. Epistola B. Turpini Archiepiscopi ad Leoprandum.* (cf. VA)
Probably a version of the edition first printed at Frankfurt in 1566, by Justus Rubeus, *Germanicarum rerum quatuor celebriores, vetustioresque chronographi, earum descriptionem ab orbe condito usque ad tempora Henrici IV imperatoris*, printed by Justus Rubeus, Frankfurt, 1566, and reprinted later with various titles, including *Veterum Scriptorum qui Caesarum et imperaturum Germanicorum res per aliquot secula gestas literis mandaverunt*, printed by Justus Rubeus, Frankfurt, 1589.
Selection from Prologue: Turpinus gratia Domini Archiepiscopus Rhemensis...[usque ad] vivas et valeas et domino placeas. Amen. [In Turpino cap. I] .
Note: [*Sequitur in Calixti Codice series capitum que deficit in Turpino*]
Chapter list of 26 chapters as in C (W 301-302)
Rubric: *Incipit Liber.*

f. 66 *Chapter 1.* Chapter number, incipit and explicit only: *Capitulum.I. Gloriosissimus itaque Christi Apostolus Iacobus...[usque ad]...Hispaniam ingressus est. [Turpinus cap. 2]* (W 302)
Chapter 2. Chapter number and incipit only: *Caput. II. Prima urbs... [Totum in Turpino cap. 3]* (W 303)
Chapter 3. Chapter number and text as in C (W 302-303)
Note in margin (f. 66): *Hec sane propria urbium. scilicet locorum nomina sic prorsus inveniuntur scripta in veteri exemplari quo usi sumus in Eclesie Hispalensis, unde religiose transcripsimus, ne una quidem literula mutata, addita, vel dempta.*

f. 67 *Chapters 4-22 omitted* (W 305-338), with an explanatory note: [*Cap. IV. et reliqua usque ad caput xxii. desumpta sunt ex Turpino, a cap. etiam illis iv. usque ad xxxi. sed capiti xxii (quod in editis Turpini xxxi. numeratur) adduntur*

in codice hoc MS. Calixti nomine, septem artium liberalium imagines et earum utilitates, post illa verba que in utroque extant: videlicet: <u>Et septem liberales artes inter cetera miro modo in eo depinguntur.</u> quibus sequentia in nostro exemplari nectuntur.]

Chapter 22. Selection on the Liberal Arts only (W 339-341), omitting the beginning and end of the chapter, inc. *Et septem liberales artes inter cetera miro modo in eo depinguntur. Grammatica scilicet…* as complete as the model allows, expl. (f. 68v) *Post exiguum vero tempus, Caroli Regis mors mihi ita demonstratur…* followed by a note: *[Cum reliquis que in Turpino de morte Caroli cap. 32. reperiuntur, quod postremum est in Turpino et in nostro Calixti codice xxii. Diversa est enim divisio capitum in hoc quam in illo. Nempe a capite iv. usque ad xxi. e qua divisione et sub eisdem numerii distinguuntur. Ast in cap. xxi. Calixti Codex ea omnia conclusit que Turpini Libro per plura capita deinceps persequitur. Quam obrem quod in Turpino est xxxii. et ultimum caput in Calixti codice est xxii. uti premisimus Reliqua vero que sequuntur capita Calixti Codice adjecta erat.]* cf. L's division of 32 chapters followed by a final chapter numbered 23.

f. 68v **Chapter 23.** Chapter number and text as in C, as complete as the model allows (W 343-344)

f. 69v **Chapter 24.** Chapter number, rubric and text as in C, as complete as the model allows (W 344-345)

f. 70 **Chapter 25.** Chapter number, rubric and text as in C, as complete as the model allows (W 345-347)

f. 71 **Chapter 26.** Chapter number, rubric and text as in C (W 347-348)

f. 72 Explicit: *Finit Codex quartus.* (not in C)

Book V: Pilgrim's Guide
Long Version, with gaps due to the illegibility of the model. For SV's selections see Table of Book V.

f. 90v Explicit and colophon as in C (W 398)
[None of the texts following the *Guide* in C are included]

Note: [not in C]
Et quia Ego Frater Petrus a Sancto Cæcilio Monachus ex familia Excalciasorum Sacri Ordinis Redemptorum Beate Marie de Marcede hoc transumptum bene et fideliter transcripsi (ex partim cancelled) *partim ex Autographo, partim ex alio transumpto exipsomet Exemplari Ms. sumpto. Ideo me subscripsi. Granate in camera mee solite residentie apud sacrum cenobium B. Marie Virginis de Bethleem, pridie Nonas Decembris anno domini M Dc xxxii.* [signed] *Fr. Petrus a Sancto Cæcilio.*
Monogram: *PC* (?).
In margin, in the same hand: *Acebelo de copiar en Estepa. 22. de Julio. 1657.*
followed by another monogram: *VS* (?).

f. 91 **Note** (in a later hand, 18th century?) [not in C]
Ambrosio de Morales en las Relaciones del Viage quæ hizo a Galizia y Asturias a reconocer Los Archiuos de las iglesias y Monasterios, Dize que en el Monasterio de Sandoval hallo que en un libro viexo de Vidas de Santos esta tanbien loque escrivio el Papa Calixto del Apostol Santiago: y an sido(?) ede comunmente a tribuy en a quel libro al Papa Calixto ermano de los dos Zernos del Rey Don Alonso el Sesto; mas yo tengo per cierto que no lo escrivio el.
MORALES, 1765, p. 40, refers to a manuscript, attributed to Pope Calixtus, about St James, at the monastery of Sandoval, O. Cist., dioc. León. See Lost Manuscripts in the Collation essay, pp. 227ff.

Sigla: Hämel: C6, with old shelf-mark correct and current shelf-mark confused with year of writing: 1657

Meredith-Jones: not included

Mandach: B 18, repeating Hämel's erroneous shelf-mark

Díaz y Díaz: not included

Bibliography: Andrés, 1979, no. 101, p. 625; Briquet, 1935; Ciampi, 1822, pp. vi-viii; *Germanicum rerum*, 1566; Hämel, 1950, p. 72; id., 1953, IV, p. 69; *Inventario general de Manuscritos de la Biblioteca Nacional*, XII (7001-8499), 1988, p. 82; Mandach, 1961, p. 395; Mariana, 1609; id., 1622, XV, repr. PL 163, cols. 1375-1410; Morales, 1765, repr. 1985; Stones, 1991, p. 625; ead., 1992, p. 135; Stones/Krochalis, 1995, pp. 34-35, figs. 13, 14; *Veterum scriptorum qui Caesarum et imperatorum Germanicorum res per aliquot secula gestas literis mandaverunt*, 1589.

Z. Madrid, Biblioteca Nacional, 13118 *Short Version*

An antiquarians' collection of documents and texts of interest to the history of Spain, copied from earlier codices in a variety of 18th-century hands, including selections from a Short Version of the *Codex Calixtinus*, based on a model from Zaragoza
c. 1750 assembled in Toledo, Spain

Paper, 211 ff., 317 × 217 mm, written space 234 × 140 mm, single column of 25 lines, ruled in drypoint. *(Ill. 87)*

Quires:	The selection of CC texts is quired as 14 quinions followed by a quaternion: 1-14 10, 15 8 each numbered in the top left corner of the beginning folio.
Watermarks:	Various watermarks occur in the manuscript, including (f. 150) a cross within a pointed oval shield (cf. VALLS I SUBIRÁ, 1982, III, p. 61, no. 17.1627; French paper, in a work published in Madrid in 1627); (f. 100) a maltese cross surmounted by symmetrical branches with quatrefoil flowers and a double fleur-de-lis; (f. 153) a double fleur-de-lis with an oval pendant surmouted by a crown (cf. VALLS I SUBIRÁ, 1982, III, p. 45, no. 7.1730, Italian paper in a work of 1730 published in Madrid). The watermark in the CC section of the manuscript shows a heart-shaped heraldic shield with crown, lions, castles, fleur-de-lis, borded by a chain with a hanging pendant of a lamb (?) and surmounted by a crown. Not in BRIQUET or VALLS I SUBIRÁ, but thought to be royal and to date to the 18th century by Manuel Sánchez Mariana, Jefe, Sección de Manuscritos, Biblioteca Nacional, Madrid, to whom we are grateful for his advice. We also thank Ann Boylan, Thomas Lymant, Carmen Manso and John Williams for checking the watermarks and their distribution.
Script:	Written in a variety of 18th-century cursive hands, none identified except perhaps that of Joseph Vazquez Venegas, (ff. 86-100) dated 1751 on f. 100. The division of scribal hands is as follows (omitting blank folios). Hand A: Table of contents; Hand 1: ff. 1-56; Hand 2: ff. 57-62; Hand 3: ff. 63-64 and 73-85; Hand 4: ff. 65-67; Hand 6: ff. 69-70; Hand 7: f. 85; Hand 8: [Venegas] ff. 86-100; Hand 9 [CC hand] ff. 101-144v; Hand 10: f. 149; Hand 11: f. 152; Hand 12: ff. 153-207v; Hand 13: ff. 208-211. Other folios give dates of 1750 (ff.i, 152, 153) and 1751 (f. 85). The date 1606 is that of the source of the material; the script of the CC hand is 18th-century. The hand of the CC section, ff. 101-144v, is clear and small, with little elaboration. It has very long capital 's' throughout, with a definite curve upwards to the left at the bottom of the shaft; looped capitals, ascenders and descenders; no red rubrics; some use of display script, larger in scale than the main text. It is clearly distinct from the other hands and is identified here as Hand 9, and seems to date from approximately the same period as the rest of the codex. There are a few points of comparison to be made between this hand and that of Mariana's secretary, as reproduced by CIROT, 1905, pl. II, from London, BL, MS Egerton 1869. It is certainly not Mariana's own, reproduced on pl. I from Egerton 1875, and in the marginal annotations on pl. II. On the other hand, the letter forms do not suggest a difference in date of close to 150 years between Hand 9 and Hand 8, dated 1751, the immediately preceding hand (perhaps that of Joseph Vazquez Venegas, see above). While Hand 9 may not be quite as late as the other texts in Z, we think it is likely to be substantially later than 1606 (see below under Provenance for further discussion).
Rubrics:	In the brown ink of the text.
Musical Notation:	None, no spaces left for it.
Decoration and Illustration:	None.
Binding:	19th- or early 20th-century Holland cloth.

Provenance and History:

Z's exemplar for the selections from the Short Version of the CC was owned by Bartholomæus Morlanius at Zaragoza, and sent in 1606 (f. 101 says *Descriptus ex Codice, quem Bartholomeus Morlanius iure consultus Cæsaravgusta misit. Anno M. DC. VI.*) Bartholomæus Morlanius (de Morlanes) was the son of the eminent Zaragoza jurist Micer Diego de Morlanes, author of the massive compendium of Aragonese law, *Alegaciones de Micer Diego de Morlanes Doctor en Ambos Derechos, y cividadano de la Cuidad de Zaragoza en fauor del Reyno de Aragon, en la causa de Virrey estrangero, que la Magestad del Rey nuestro señor trata, en la Corte del Illustrisimo sennir Don Iuan de Lanuça Y Perellos, Iusticia de Aragon y Vizconde de Roda*, published at Zaragoza in 1591. Diego mentions a *Jacobo Morlanio a primariis ipsius vrbis Iuratis*, who accompanied him on one examination of early documents, including Zaragoza's charter from Alfonso (era 1133) in 1588; presumably this was another relative (p. 135). The royal approval of Diego's enterprise is recorded by BLANCE, 1589. Bartholomæus's brother Augustín was the father of the poet Diego de Morlanes, who died in 1633; other members of the family were painters and architects in Zaragoza. Bartholomaeus himself was an oblate (REY [1948]).

As we have recounted above in our Catalogue entry for VB, part of which is a palimpsest copied over documents relating to the Franciscan convent of Sta Catalina, Zaragoza, the recipient of Morlanius's copy, sent in 1606, was the eminent Spanish Jesuit and historiographer Juan de Mariana (1535-1624). He prized it *auro & gemmis maius* and edited from it the Prologue of Calixtus to Book I, four sermons from Book I (Chs. 2, 5, 6, 19), the Prologue of Calixtus and the Epistle of Leo (Ch. 2 of Book III), and the false bull of Innocent II, in his *Tractatus VII*, published in 1609. (We thank Carolyn Lee, Rare Books Librarian at The Catholic University of America, one of only two libraries in the USA to own *Tractatus VII*, for kindly supplying a xerox of Book I, *De Adventu B. Jacobi Apostoli in Hispaniam*, in which Mariana transcribed parts of his copy of the CC as Ch. 12, pp. 21-25. The copy in the Bodleian Library, Oxford, was also consulted.) The other tracts were theological, and the volume was later put on the *Index Librorum Prohibitorum*, which may account for the scarcity of copies. Mariana himself was condemned and imprisoned by the Inquisition, see CIROT, 1905, pp. 96-102.

It is just possible historically, as we have said, that what Morlanius sent was VB, which is in part a palimpsest written on parchment that had been previously used to write documents pertaining to Zaragoza. But the analysis by HÄMEL, 1950 of the texts common to R, VB and Mariana's publication—Calixtus's Prologue to Book I, the Epistle of Leo and the false bull of Innocent—shows that VB stands closer for Calixtus's Prologue and the Epistle of Leo to R than to Mariana, and for the bull it is closer to Mariana's version; this suggested to Hämel that Mariana's version was not based on VB directly. We note under VB what the variants are that VB, Z, and Mariana share in the bull text; for the full collation, see the Latin Appendix. Mariana's transcript of the bull is, however, much closer to Z than to VB: both spell *Iscani* as *Escani*, and give *Vio* for *Ivo* among the other signatories, variants that do not occur in VB (*pace* HÄMEL, p. 62, on *Vio* in VB). They are spellings whose accuracy Mariana questioned, as for some of the other spellings of names shared by VB, Z, and his model (1609, p. 23). Both Mariana and Z also have *oratione* for *accione* . The most likely conclusion is that Z, which is itself too late to be Mariana's own copy, is a very close copy of Mariana's text. One reading to take into account is that, since VB and Z both read *Armericus cancellarius* for *aimericus cancellarius*, a variant not given by Mariana, it is possible that Z depends on VB directly. This relationship will be further explored below.

Our collation of the *Guide* shows that the textual relationship between VB and Z is a close one: Z's text includes numerous headings that are not in R but are in VB; Z also shares many readings with VB, but there are also variants between them that suggest that Z does not derive directly from VB but that an intermediary stood between the two.

There is also one feature, unnoticed hitherto, that links Z's text of the *Guide* closely to Mariana's copy: Z has its own system of numbering the chapters, in such a way that, despite the omissions, there is a total of 15, and C's Ch. IX is Z's Ch. XIV. Mariana's description of the manuscript from which he published in 1609 says of the *Guide*: '*Venio ad tertium librum De itinere ad B. Iacobum, qui Calixti non est haud dubium, nam neque nomen eius in fronte prefert, secus quam alij duo libri: & totus ex fabulis & mendacio est compactus, eius, qui sine iudicio ex alijs fabulosis libris corrasit. Quæ vt sigillatim prodantur singula, opere non erat; ipsa se produnt. Quid quod capit. XIV. auctor Calixti meminit tanquam mortui, quippè bona memoria dignum dicit…*' (I come to the third book on the Route of St James, which can scarcely be doubted not to be by Calixtus, for his name does not come at the front of it, as in the other two books; and it is all compacted of fables and lies of him who compiled it from other fabulous books without judgement. These singular tales are produced as if by signs, not by work; they produced themselves. For instance, in Ch. 14, the author recalls Calixtus as if he were dead, saying he is worthy to be well remembered…). Z is the only extant manuscript to number the *Guide* as Book III and its Chapter IX as Chapter XIV. Moreover, Z does not mention Calixtus in its heading (f. 136v).

The only scholar to have recognized the link between the manuscript from which Mariana published *Tractatus VII* and Z is CIROT, 1905. He thought the CC in Z (ff. 101-144v, not ff. 117-144v as in Cirot, p. 397) was itself the manuscript owned by Mariana.

He records that Mariana's copy of the CC was among nine of his books which came to the Jesuit College in Toledo. In 1762 they were in the possession of the antiquarian and bibliophile P. Marcos Andrés Burriel, SJ (1719-62) of Toledo, where Juan de Santander, head librarian of the Jesuit College of Toledo, saw them as he catalogued Burriel's manuscripts. Santander's note about this is preserved in MS X 230 at the BN, Madrid (Cirot, p. 396). Santander, according to Cirot, says he gave the nine volumes to the rector of the Jesuit College, P. Diego de Rivera. They do not, however, figure among the list of MSS donated by the latter to the Biblioteca Real (now at the BN, Madrid), nor among the list of Rivera's own manuscripts published in *Colección de Documentos para la Historia de España*, XIII, pp. 325-365 (Cirot, ibid.). Of the nine MSS, seven correspond to MSS that are now London, BL, Egerton 1869-75; other Mariana MSS in the BL, London are Egerton 291, 445, 451, and part of Add. 10248 (Cirot, ibid.).

Cirot quotes Santander's index of Mariana's 9 books, describing no. 9 as '*Tomo nono. Liber Calixti secundi de miraculis S. Jacobi, tiene una nota en la primera hoja, de puño del P. Mariana, que dice es copia fiel de el que tenia un abogado de Zaragoza*'. On the basis of this, Cirot concluded that Z was Mariana's manuscript itself. But he also notes that Burriel had taken a copy of Mariana's ninth volume, that this copy was given by P. de Rivera to Santander for the Biblioteca Real, and that it figured on the list of such books as '*un tomo en papel sin encuadernar, que contiene cinco cuadernos. Calixti 2 Papae, de miraculis Beati Jacobi liber primus. Ejusdem, de translatione corporis S. Jacobi Apostoli ab Hierosolimis in Gallaciam* [sic] *liber primus. De itinere ad S. Jacobum liber primus. Homiliae sive sermones quator in vigilia, et festo ac translatione ejusdem S. Jacobi, quae celebratur tertio Kalendas Januarii, cum epistola Calixti Papae. Copiado de orden del Padre Andrés Burriel de un tomo de mss. del Padre Mariana, pertenecientes al archivo de su colegio de la compañia de Toledo*'.

Z has all the texts mentioned here, in the same order, except the homiliary; but the homiliary is mentioned in the list of contents on f. 101. Cirot (ibid.), thinking Z to be Mariana's own copy, explained the absence of the homiliary by supposing Mariana had sent those folios to the editor of the *Magna Bibliotheca veterum Patrum*, in which a selection of Book I of the Codex Calixtinus was published in Cologne in 1622. The same argument, Cirot noted, would also explain the absence of the homiliary in Burriel's copy, while allowing for its mention in its table of contents. Cirot concluded that Z is the copy Santander saw, which was Mariana's own, and

that Burriel's copy was lost. For the palaeographical and textual reasons given above, we take the opposite view: that Z is Burriel's copy, made from Mariana's, and that the copy now lost is Mariana's, not Burriel's. According to VELÁSQUEZ DE VELASCO, 1765, p. 11, the bulk of Burriel's collection went directly to the Biblioteca Real; probably this was among them.

This is further borne out by the other texts in the manuscript. For Burriel was the centre of a group of ecclesiastical scholars who were gathering ancient documents for the ecclesiastical history of Spain, especially ligturgical councils. The others sent their material to him to assemble. He died before the project was completed, and his papers were deposited at the Biblioteca Real. Among the manuscripts made for Burriel is a copy of HC done in 1753, now Biblioteca Nacional MS 13001 (REILLY, 1971, p. 136). The enterprise is described by the man who continued it (VELÁS-QUEZ DE VELASCO, 1765, pp. 10-11). Among the information gatherers was D. Josef Vasquez, Canon of the Colegiata de S. Hypolito de Córdoba. (VELÁSQUEZ DE VELASCO, 1765, p. 10 and note). This must be the Josef Vasquez de Venegau who transcribed the Córdoba material on ff. 86-100. Velásquez de Velasco gives a list of some other members of the team. If this is indeed one volume of Burriel's compendium of materials sent him, then the Barcelona documents came from D. Andrés de Simon Pontero, Oídor de la Audiencia de Barcelona. The Toledo material was probably sent by D. Francisco Perez Bayér, who began work on the archives there in 1750 (VELÁSQUEZ DE VELASCO, 1765, pp. 8-10). Other 18th-century antiquarian materials copied by a canon Josef Valcanze ended up at the Archivo Histórico Nacional, Consejos. leg. 4. 179, pieza 2a, ff. 105-108. See BARREIRO SOMOZA (1987), p. 47, citing GARCIA ALVAREZ (1962), pp. 534-535.

The sources for Z's other texts were obtained in Alcalá, León, Córdoba, Barcelona and Toledo, according to notes in those texts: f. i, *Biblioteca de Colegio Mayor de S. Yldefonso de Alcalá* (Alcalá de Henares, near Madrid); f. i verso, in a hand contemporary with the hand of the index, mentions *Compendium Ordinis ecclesie S. Auditus*, with a reference to f. 56; on that folio *Ecclesie Sancti Auditus* is again mentioned. Below, in a more cursive and informal hand: *Tray que hacer esta cedula per S. Audito*. The monastery and church of St Auditus was an ancient foundation of canons regular, solitary retreat, near Toledo in the mountains near Buitrago. It was not named after either Ovidio or Alvito, third bishop of Leon, who died in Seville, having revealed the location of the relics of St Isidore, but was buried at the Cathedral of León in 1064 (see BS, and ES 35, pp. 92-95), or Audito or Ouvido, 5th-century priest of Braga, (see BS under Audito, and ES 15, pp.102, 306-9), but an obscure early saint, Ui, or Oid. In 1162, the Archbishop of Toledo gave it to the the house of canons of St Leocadie of Toledo, who restored it. It was restored again by Cardinal Ximenez in 1515, and given by him to the College of San Ildefonso d'Alcalá, which became the college at Alcalá de Henares. Thus the college would be in a position to supply material from St Auditus (DHGE, V, 1931, s.v. Auditus, p. 315).

On f. 65 the *Bibliothece Folenane Ecclesie* is cited; presumably this refers to St Froylan, whose relics were translated to the Cathedral of León between 1181 and 1191 (ES 35, p.273); and on f. 85 the place and date, Córdoba, Sept. 9, 1751 are at the top of the page; on f. 100 the *Archivo de papeles del Cabildo de la Santa Eglesia de Córdoba* is named as the source. Items on ff. 1-56 and 149-211 concern Toledo; those on ff. 57 and 59 concern Barcelona.

The year 1750 occurs on f. i, in reference to an item on tomb inscriptions made in Toledo in that year: *Inscripciones Sepulcrales que existian en las Capillas y otros lugares de la Yglesia de Toledo año de 1750*, with reference to f. 153, written in the hand of the index (Hand A); on f. 152 the same heading is repeated, written by Hand 11. On f. 85 the place and date, Córdoba, Sept. 9, 1751, are given at the top of the page in the same hand as the text on that page; Córdoba, 1751 are also the date and place mentioned on f. 100.

The manuscript presumably came to the Biblioteca Real in Madrid with Burriel's other materials, which were there by 1765 (VELÁSQUEZ DE VELASCO, p. 11).

Formerly Madrid, BN, Dd. 140.

Secundo folio: (of the CC selections) *Argumentum*

Contents:

f. i **Table of contents** (Hand A)
with folio numbers for each item. Text:
Indice de los papeles contenido en esta volumen.
Noticia exacta e individual de un codice MS. que se conserva en la Biblioteca de Colegio Mayor de S. Yldefonso de Alcala, con el titulo de Coleccion de Concilio 1
Otra igual noticia de un Volumen grande en pergamino, con el titulo de Historia Catolica del Arzobispo de Toledo D. Rodrigo 34v Constitutiones Synodales del Obispado de Barcelona, letras por su obispo Fr. Ferrer, á 4 de Mayo de 1341 57
Otras por su obispo D. Bonifacio á 19 de Agosto de 1345 59
Noticia de la contenido en dos Codices de la Yglesia de Toledo 63
Noticia de varios Privilegios, Cartas…y Bulas de Pontifices, sobre rentas ecclesiasticas y donaciones de Yglesias 67
Noticia de los derechos que tiene el Arcediano de Toledo en su Arzedianargo. Se encuentra en un Codice que fue de D. Jofré de Loaysa 73
Ordenamiento de juego de los dados, que compuso Maestre Roldan con el nombre de Libro de las Tafuerias, año de 1276, por mandado de D. Alonso X. Auadense las formulas de los juramentos de los Cristianos, Moros y Judios 85
Calixti Papæ II. de miraculis Beati Jacobi Apostoli 101
Ejusdem de translatione Corporis Sti Jacobi. 129
De itinere ad Sanctum Jacobum 137
Copia de una Carta escrita al parecer á algun otro obispo de Toledo, dandole razon de los Privilegios que los Reyes de Castilla han concedido á los Arzobispos de Toledo y á su dignidad del oficio de Canciller Mayor de Castilla 149
Inscripciones Sepulcrales que existan en las Capillas y otros lugares de la Yglesia de Toldeo año de 1750 153
Cedula de Phelipe III. de 28 de Junio de 1619 parague en todas

f. i v *las Ciudades y Villas de estos Reynos no haya mas Alguaciles de las que pueden tener por Executoria 206*
Otro del mismo Rey, por la qual da lisencia á qualquier persona que labrare en cada un año veinte y cinco hanegas de tierra y las sembrare, pueva andar en coche de dos mulas, excepto en la Corte. Esta incompleta. 207v Bula de Celestino III. de 4 de Junio de 1192. al Dean y Cabildo de Toledo, confirmando la eleccion del Arzobispo D. Martin. 208
Otra del mismo Papæ de 31 de octubre de 1196 al Arzobispo de Toledo D. Martin y Sufraganeos, paraque declarasen descomulgado al Rey de Leon Alonso IX. por su alianza con los Moros, y en caso de admitirlos en sus Reynos, absolviesen á los Pueblos del juramento de fidelidad, concediendo las egacias de Cruzada á los que guerreas encontra el. 209

f. ii Blank

f. 1 **Incipits of Concilia, synod chapters, etc.** (Hands 1 and 2)
Inc. *Incipiit Toletana synodus secunda viii…* Expl. (f. 34v) *et hæc est individualis, exactiorque notitia voluminis miñor cui titulus collectio conciliorum, quiquidem in bibliotheca maximi dicitur Yldephonsi complutensis collegii asservatur.*

f. 34v **Incipits and explicits of chapters from Roderici Toletani** *Historia Catholica*
Inc. *Incipit Prologus: Novae legis salutare preconium…Incipit breciarium historiæ catholicæ completatum a Roderico ecclesiæ toletanæ sacerdote. Caput. I. De opere primæ diei. Incipit. Rerum principium creavit Deus…* expl. (f. 56) *terminavit ascendit.*

Compendium ordinis Ecclesie Sancti Auditus incipit cum incipit pulsari signum.
Quod cum non habebat divisionem capitum librorum, ullam ve alteram seo
terminat omnia explicantur. Et complet LIII folia membranicea ejusdem
caracteris, ac regula Sancti Augustini estque volumen in 4º.

f. 56v Blank

f. 57 **Constitutions of Barcelona** (Hands 2, 3)
Rubric: *Constitutiones facte in Capitulo generali per fratrem Ferrarium*
Episcopum Barchinonensem. The first document dates from 1341, but the
concluding inscription reads: *Supra scriptos constitutiones ceditet condidio*
Reverendus in Christo Pater Dominus frater Bonifacious (corrected from
Dominus, with a note about what must have been the original
abbbreviation b-s, with a long s) *divina providentia Barchinonensis Episcopus*
in prima Sinodo, quam celebravit in Eclesia Barchinonensis die veneris XIIII
Kalendas Septembris Anno Domini M.CCC.XLV.

ff. 61v-62v Blank

f. 63 **Tabula for a work in two volumes at Toledo** (Hand 3)
Rubric: *Estos escriptos que aqui yuso son escriptos yacen en este libro daqui*
adelante. El primero es el ordenamentio de las horas de Sancta Maria. Followed
by a list of Papal Letters, with the foliation from the exemplar I- XCI. expl.
(f. 63v) *El ordenamento que fuè fecho por el Arçobispo de Toledo en los sus*
Sufraganeos en pena fiel. XCI.

f. 64-64v Blank

f. 65 **Notes about manuscripts in the Library of the Church of St Froylan (not**
listed in the Table of contents on f. i) (Hand 4)
Rubric: *Codex 29=8 Bibliotheca Foleneus Ecclesie in 8º membranae, qui fuit*
Gaufridi de Loaysa (cf. f. 73). Text: *Canon Misse prout nunc in Missali excepto*
quod ad verba… notes also about *Missale S. Facundi, Cod. 30-13 in eodem*
Bibliotheca…iudicarit = Bodegas Schottorum Grecarum Litterarum doctor apud
toletanos.

ff. 65v-66v Blank

ff. 67-71 **Privileges, charters, bulls and copies of documents, from 1161-1384, in**
chronological order except for the last three. All relate to Toledo (Hands
5, 6)
Change of hand on f. 69v, in the middle of the folio.

ff. 71-72v Blank

f. 73 **Toledo documents** (Hand 3)
Title: *Estos sòn los derechos que há el Arcidiano de Toledo en el su Arcidianadgo.*
Expl. (f. 84v) *Hallase en la Libreria de la Sta Iglesia de Toledo en un Libro en 4*
al.fo.LXXIJ. escrito en perg. Cax.29-num.8 que fue del Arzediano Don Jofre de
Loaysa. (cf. f. 65)

f. 84-84v Blank

f. 85 **Date and place at the top of the page:** *Cordoba y Sept. 9. de 1751* (Hand 3)
Two *Ordenamientos* of Alfonso the Wise, dated 1276, crossed out.
Another ordinance of 1276, copied in a different hand (Hand 7)

f. 85v Blank

ff. 86-100 Documents from Córdoba (Hand 8)
Era de mil, e trecientos, et catorce annos. Este es el Libro que yo Maestre Roldan
ordene e compure en razon de la Tafurerias por mandado del muy noble, e muy
alto Senor Don Alfonso por la gracia de Dios Rey de Castilla de Leon, De Toledo

de Gallicia de Sevilla de Córdoba de Murcia, de Iaen, del Algarve...al Rey Fârus Iusticiar. Then follows a note (f. 99v) on when (1751) and where the copy was made, and with whose permission: *(C)esta estendido en circo hajar utlies de papel antiguo de marca, y escrito á columnas conteniendo cada boja quatro dollas, y de letra muy antigua Concuerda con igual copia que se halla en un Libro grande resguardado de baquetais y compuesto de varios ordienamientos xv trassumptados cuy Libro que se conpone de 348 fojas utiles in guarda, et el Archivo de papeles del Cabildo de la Santa Eglesia desta Ciudad de Córdoba, de donde se saco para este fecto y en virtud de xl orden a presencia de los Diputados Capitulanes que nos asisten de que certificamos en ella, a siete de septiembre de mil setecientos, y cinquenta, y un annos, Don. Dm. Marcos Dominguez de Alcantara= Licendo D. Joseph Vazquez Venegas.*

f. 100v Blank

f. 101 **Excerpts from CC Books II and I, texts following Book V in C, Books III and V** (Hand 9)
Table of contents (not in C)
Rubric: *Calixti .II. Papæ de miraculis Beati Jacobi Apostoli Liber I. Eidem de translatione corporis Sancti Iacobi Apostoli ab Hierosolymis in Galetiam liber I. De Itinere ad Sanctum Jacobum Liber .I.*
Homilium eius Sermones Quatuor in vigilia et festo ac translatione eiusdem Sancti Jacobi que celebratur tertio Kalend. Januarii cum Epistola Calixti Pape.
Followed by a note (not in C):
Descriptus ex Codice, quem Bartholomeus Morlanius iure consultus Cæsaravgusta misit. Anno M. DC. VI.

f. 101v Blank

f. 102 **Book II: 22 Miracles of St James** (Hand 9)
(Opening heading omitted, W 259)
Rubric to the Prologue, Prologue text, Chapter list of 22 chapters, Miracle texts as in C, but each numbered. (W 259-287)

f. 125 **Miracles from Book I in C** (Hand 9)
numbered as 23 (not included in Chapter list above; see also VB).
Rubric: *Miraculum de illis, qui non colunt festum S. Jacobi. Cap. XXIII.* Text inc. *Hec sunt Miracula memoranda, que olim S. Jacobi festa non colentibus...* Expl. (f. 125v) *magis singuine rejicit* + dox. (as in C, f. 11; W 20-21)

f. 125v **Two Miracles from texts following Book V in C** (Hand 9)
numbered as 24 and 25 (not included in Chapter list above).
Rubric: *De Puero suscitato. Cap. XXIV.* Text: *Anno Incarnationis Dominice 1164.* (as in C, f. 223; W 404)

f. 126 Rubric: *Aliud Miraculum. Cap. XXV.* Text: *Miraculum S. Jacobi de facie torta filii Vicecomitis...* (C, f. 223; W 405)

f. 126v **Three Miracles from Book V, Chapter 11 in C** (Hand 9)
numbered as 26 (not included in Chapter list above).
Rubric: *Qualiter Peregrini Sancti Jacobi sint recipiendi. Cap. XXVI.* Text: *Peregrini, seu Paperes...* Expl. (f. 127) *et diligenter procurandi.* (C, f. 213; W 388-389)

f. 127 **Alberic of Vézelay's Miracle of 1139 from texts following Book V in C** (Hand 9)
numbered as 27 (not included in Chapter list above).
Rubric: *Miraculum S. Jacobi à Domino Alberico Inciliacenti* [sic] *Abbate, atque Episcopo Ostiensi, et Rome Legato. Cap. XXVII.* Text: *Anno Dominice Incarnacionis 1139. Ludovice Rege Francorum...* (C, f. 221v; W 400)

f. 127v **False bull of Pope Innocent II among texts following Book V in C**
(Hand 9)
treated as a miracle and numbered as 28 (not included in Chapter list
above).
Rubric: *Epistola Innocentii Pape. Cap. XXVIII.* Text: *Innocentius Episcopus
servus servorum Dei…hunc codicem…* expl. (f. 128) *fore predicto.* Variants (Z
first, C second): *quem Pictavensis Americus Picardus de Partiriaco veteri, quem
etiam Oliverius de Escani; Viciliaco* for *uiziliaco, dicitur* after *uiziliaco* omitted,
socia for *sotia, oratione* for *accione, apochrypha* for *apocrifa; authenticum* for
autenticum, Authoritas for *auctoritas.* First among the signatories is
Armericus Cancellarius [sic]; other variant spellings are *Giraldus* for
girardus, mea after *penna* omitted *Pisanus* for *pissanus, Vio* (for *ivo,* optimo
for *obtimo, Lombardus* for *lumbardus, Genua* for *ihenia, Albertus* (for *albericus,*
with a marginal note saying *lege Albericus ex Cap.27°* (i.e. Albericus of
Vézelay, author of the 1139 miracle and also signatory here), and
charissimum for *carrisimum* (C, f. 221; W 399-400). Relations with VB and
Mariana's text are discussed above.

f. 128v Blank

f. 129 **Selections from Book III: Translation of St James** (Hand 9)
Rubric: *Liber secundus. Incipit Prologus Beati Calixti Pape super Translationem
maiorem B. Jacobi Apostoli. Cap. I.* Text: *Hanc B. Jacobi translationem à nostro
Codice excluere nolui…* (f. 129v) *sepeliuntur.* [Same selection as R and VB:
ends on C, f. 156v (W 290), copying selections of the Prologue, continues
on f. 130 with Ch. 1 of C as Cap. II, followed on f. 133v by Ch. 2 of C as
Cap. III and on f. 135 by Ch. 2 of C as Cap. IV, ending f. 136v, C f. 161 (W
298), omitting the end of Ch. 3 of C and Ch. 4 of C (W 298-299)]. Expl. (f.
136v) *Plebs Galeciana gaudens suscepit.*

f. 136v **Book V: Pilgrim's Guide**
Short Version, as in R and VB, but entitled *Liber Tertius de itinere Beati
Iacobi* and with an original sequence of Chapter numbers. For details of
omissions in Short Version, see Table of Book V. The hand is unidentified,
but there are four brief correcting glosses in the hand of Joseph Vasquez
de Venegau, which are recorded in the Latin text, but not identified as to
scribe: f. 140, VII-350; f. 143, near n. IX-465; f. 144v, between notes X-5 and
6; f. 142, at note VIII-1151.
[Explicit and colophon omitted (W 389)]
[None of the other texts following Book V in C are included: see above for
the bull of Innocent and the miracles of 1139 and 1164]

ff. 145-148v Blank

f. 149 **Privileges of 1244-1369** (Hand 10)
Rubric: *Illmo.senor* Text: *Estos papeles que embio a V. S. Illma. son los
privilegios que Los Reyes de Castilla andado a los Arcobispos de Toledo…* (f.
149v) *que se ladieron.*

ff. 150-151v Blank

f. 152 **Note of Inscriptions from Tombs in Toledo** (Hand 11)
*Inscripciones sepulchrales que existen en las Capillas, y oltro Eng. rei de la
sancta Iglesia de toledo en Año de 1750, en T. Inadernos de qui falta el 6to.*
Below, in blank space, a pen trial *Si.*

f. 152v Blank

f. 153 **Note repeated from f. 152, with Inscriptions** (Hand 12) *Inscripciones
sepulcrales que existen en las Capillas, y otros lugines de la Santa Iglesia de
Toledo este año de 1750…* followed by Transcriptions of inscriptions on

some 57 tombs in the Cathedral of Toledo. The transcriptions are written on rectos, with the versos left blank (for drawings?), and are located by the chapel in which they are situated, beginning with the tomb of Don Pedro Gonzalez (1495) in the choir and ending (f. 204) with an inscription commemorating the diocesan synod of 1566.

ff. 204v-205v Blank

f. 206 **Transcriptions of documents, one of 1619** (Hand 12)
Rubric: *Cedula de su Magestad. a instancia del Reyno, por la qual manda, que in todas las Ciudades u Villas destos Reynos, no aya mas Alguaziles, de los que puede aver por execcutionea or recaudo,. que qualquiera de la dichas Ciudades y Villas tengan. El Rey.* Text: *Por quanto entre las condiciones…con que el Reyno, que esta junto en Cortes, en la que al presente se estan celebrando…* (f. 207) *en ella contenido. Fecha en Belen a 28. de Junio de 1619, anno. Lo del Rey. El Arçobispo de Burgos. El Licenciado Luys de Salcedo. Por mandado del Rey nuestro Señor. Thomas de Angulo.*

f. 207v Rubric: *Cedula de S. M. por la qual da licencia a qualquier persona que labrare en cada un año veinte, y cinco hanegas de tierra, y las sembrare, puedo andar en coche de dos mulas excepto en la Corte. A. Rey.* Text: *Por quanto entre otras condiciones con que el Reyno, que esta junto en Cortes, en las que al presente se celebran en la Villa de Madrid, y se començaron en nueue…* (f. 207v) *a qualquien perssona de qualit/* (ending incomplete)

f. 208 **Bulls of Celestine III of 1192 and 1196** (Hand 13)

f. 211 Note at end of bulls. *original enel Archibo dela Iglesia de Toledo, conel sello deplomo.*

Sigla: Hämel: R7

Meredith-Jones: not included

Mandach: R7

Díaz y Díaz: M

Bibliography: Barreiro Somoza 1987, p. 47; Blance, 1589; Briquet, 1935; BS, 1961-69; Cirot, 1905, pp. 396-397; David, 1946, 1947, 1948, 1949; DHGE, V, 1931, s.v. Auditus; Díaz y Díaz, 1988a, pp. 329-330; ES, XX, 1765; García Álvarez, 1962, pp. 534-535; Hämel, 1950, pp. 33, 60-61; Mariana, 1609/1618, pp. 22-23; id., 1622, XV, reprinted PL 163, cols. 1375-1410; id., 1622, XX, reprinted 1677, pp. 1278-1293; Mandach, 1961, p. 393; Morlanes, 1591; Reilly, 1971, p. 136; Rey, 1948, pp. 85-91; Stones, 1991, pp. 626-627; Stones/Krochalis, 1995, pp. 34-36, fig. 15; Velásquez de Velasco, 1765; Valls i Subirá, 1982; Ward, 1883/1961, p. 550.

CHART OF MANUSCRIPTS CONTAINING 'THE PILGRIM'S GUIDE'

The Key to the Sigla is on the endpaper. Dotted lines indicate hypothetical lines of transmission.

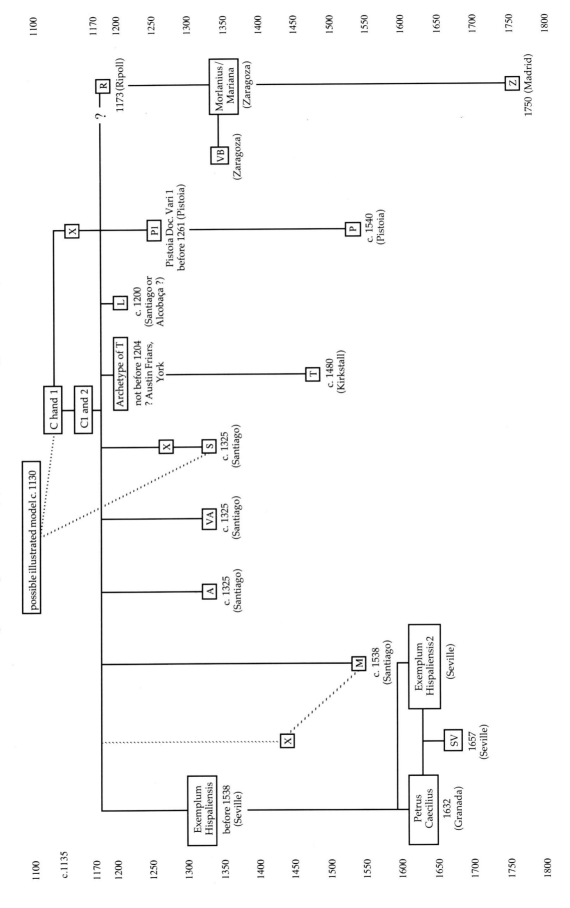

COLLATION OF THE 'PILGRIM'S GUIDE'

The *Pilgrim's Guide* survives in twelve manuscripts. Eight manuscripts contain the Long Version (C, A, VA, S, T, P, M, SV); three contain the Short Version (R, VB, Z); and one manuscript, L, contains a series of eclectic selections from the Long Version. See the Chart of Manuscripts on the endpapers, and Catalogue of Manuscripts. The Table of Chapters on page 52 outlines which sections of text are present in the twelve manuscripts that preserve all or parts of the *Guide*.

Overall, the number of variants is extremely large, but most of them are spelling variants. The notes accompanying our edition of the Latin text record all the spelling variants as well as the other variants. The spelling variants tend, however, to fall into chronologically and geographically determined patterns, and so we have not analyzed them in the same detail as the other variants. In the Long Version, significant omissions and alterations are not numerous, but no two manuscripts make the same scattering of minor omissions and alterations. Some copies form a close-knit sub-group, centred on C, and the relationships are straightforward; in other cases the variants are much more difficult to interpret, and we have no clear linear stemma. The argument for lost intermediaries is sometimes a certainty, on historical or textual grounds, or both; in other instances it is a question of how significant the variants are, and the outcome is debatable.

The case for an exemplar other than C, which some scholars have suggested for other textual components of the *Codex Calixtinus*,[1] is not altogether clear-cut for the *Guide*. It depends how the evidence presented below is weighted. Crucial to the arguments is the distinction between the two major scribes of C, as Hämel was the first to note, and the relationship between C and its earliest copy, R; we consider both questions below.[2]

The three manuscripts of the Short Version present a more straightforward situation; the line of transmission from R to VB and Z is clear. There is both historical and textual evidence for at least one lost intermediary between R and the two later manuscripts VB and Z, but the three remain closely linked.

Most of the work on manuscript relations among *Codex Calixtinus* manuscripts has concerned Book IV, the *Pseudo-Turpin*, which purports to be the account of Charlemagne's Spanish campaign by his archbishop, Turpin of Reims. This text has a wide circulation independent of the *Codex Calixtinus*. MEREDITH-JONES, 1936 thought a short version of Book IV of the *Codex Calixtinus* (his A group) preceded the longer version (his B group, which includes our C as his B1); DAVID, 1947-49, saw C's text containing numerous *remaniements* in Books IV and V which antedate its copying by Scribe 1 of C; HÄMEL, 1950, thought the long versions of Book IV antedate the short versions, and he derived R's version of Books II and III from a text written originally by C's Scribe 1, substantial parts of which were replaced by later scribes. For Hämel, the A and B groups of Book IV also derive from C before the intervention in it of Scribe 2 (pp. 14, 18-19). MANDACH, 1961 sees earlier models than C for Book IV of the *Codex Calixtinus*, and derives Meredith-Jones' A group from them rather than from C Scribe 1.

Scholars working on the *Pseudo-Turpin* have over a hundred Latin manuscripts to consult, as well as vernacular versions. For the *Pilgrim's Guide*, the situation is very different. In addition to the twelve surviving manuscripts, historical and textual evidence indicates that seven or eight other copies which must once have existed have been lost. Our discussion is therefore divided into three sections: Long, Short and Lost Manuscripts.

I. Manuscripts of the Long Version of the 'Pilgrim's Guide'

Eight manuscripts transmit the Long Version in a greater or lesser state of completeness: listed in approximate chronological order, they are C, A, VA, S, T, P, M, SV.[3] One manuscript, L, presents a special selection of excerpts from the Long Version. There is a core sub-group of Long Version manuscripts consisting of C, A, VA and SV, which call themselves *Jacobus* on their opening folio.[4] In

all eight Long Version manuscripts, the *Pilgrim's Guide* is copied as part of a compendium of texts that includes other sections of the five-book *Codex Calixtinus*; most of the eight manuscripts also copy the false bull of Innocent II and some of the songs and miracles that follow the *Guide* in C. P, M, T, and L include other texts, which differ in each manuscript.[5]

Our collation indicates that, of the extant Long Version manuscripts, none except C gives rise to any copies.

C: Santiago de Compostela, Archivo de la Catedral, no shelf number

C is the oldest extant manuscript and contains the five books of the *Codex Calixtinus* compilation, followed by songs, part of a postcommunion, the false bull of Innocent II, the miracle of 1139, an Alleluia in Greek, then further miracles, including two of 1164 and 1190, and other Jacobite texts.[6] Of all the copies of the *Pilgrim's Guide*, its text is the most reliable. Our earlier discussions of C have established that the manuscript could have been assembled before the death of Archbishop Diego Gelmírez in 1140, and possibly be as early as 1137, after the death of Louis VI of France, which is mentioned in the text. The 'Cardinal Robert' who composed one of the songs in Book I, need not be Robert Pullen, who was made a cardinal in 1144 and died in 1145. Other possibilities are discussed in the Catalogue of Manuscripts under C, and summarized in the Introduction. C may well have been copied shortly after the composition of the texts it contains. The group of songs following the *Guide* we see as contemporary with the first phase of execution, while the fragmentary Mass, false bull of Pope Innocent II, Miracle of 1139, and Alleluia in Greek, all copied in another hand and on a new bifolium, were added after 1139; the texts that follow were added still later. A second hand, difficult to date more precisely than the second half of the twelfth century on palæographical grounds, altered parts of the main body of the manuscript; on artistic grounds, we propose that this hand wrote about 1173.

The Scribes, or Hands, of C and their Roles

Two scribes copied the *Guide* in C.[7] Their script is easily distinguished and the distinctions have been recognized since Hämel.[8] Less attention has been paid to the decorative initials that accompany the work of each scribe. They consist, in each case, of two levels of decoration: coloured initials, mostly in two colours (*ills. 11-13, 16, 29-31; ills. 22, 26*), and, for major text divisions, foliage-dragon initials (ills. 2-10; ill. 23). The styles of both kinds of initial correspond to the division of script styles.[9] The historiated initials and miniatures in C all occur in sections of the text copied by Scribe 1.[10] While the division of labour is clearly recognizable, the reasons for it are puzzling and a convincing explanation not readily apparent.

The distribution of the work of the two scribes in C is irregular. The second scribe appears only towards the end of Book II, and sporadically thereafter.[11] He and the first scribe never share the same bifolium; ff. 162-163 by Scribe 1 and 168-169 by Scribe 2 (quire 21) are in fact two pairs of joined singletons, not two bifolia. The work is divided in such a way that, on the basis of the script alone, it is hard to be sure whether the two major scribes are collaborators—one old, reflecting styles of writing already in vogue a generation earlier, in the second quarter of the twelfth century, or even earlier; the other young, with a style of writing that continued on into the thirteenth century—or whether the second recopied or rewrote, at a later date, text that had been in place by the mid twelfth century.[12]

Neither the argument for collaboration nor that for rewriting is completely satisfactory. The collaboration shows little sign of the patch job that one might expect from a second scribe doing replacements or repairs to a pre-existing text. No two scribes write with exactly the same dimensions, and Díaz y Díaz has indeed shown that the proportions used by each scribe are different.[13] If Scribe 2's work were later, one would expect the leaves he copied to be awkwardly spaced and to show signs of a later scribe adapting himself to the situation—cramming material in towards the end of a leaf or writing larger, to spread material out.[14] As it is, the joins between the hands always occur in mid-sentence, occasionally even in mid-word (by Latin notes IX-459 [W 383], IX-606 [W 385]) and the quire structure, consisting of quaternions, is maintained. Scribe 2's work never occupies a quire on its own, nor does it ever occupy leaves that lie outside the regular quaternions that are the rule throughout the book.[15]

But if the scribes were contemporary collaborators, it is hard to see why their work is not more evenly divided in the manuscript, why each scribe did not write in entire quires, nor why it was necessary to split two bifolia. If the second scribe is a younger man appearing on the scene as the work was far advanced, he did not completely displace his older collaborator from the project. Why did the older man not simply finish the job he had begun, and to whose last stages he contributed?

Hämel's interpretation was that the second scribe replaced leaves originally copied by the first scribe, from which decoration had been excised, making recopying a necessity. His argument rests on the valid observation that the first scribe uses more abbreviations than the second. By omitting the decorative initials, the second scribe was able, according to Hämel, to space his writing more evenly while occupying the same number of folios. The presence of the joined folios mentioned above is a strong indication that Hämel's interpretation of the chronological sequence is substantially right. But only much later than the Middle Ages, in the eighteenth and nineteenth centuries, did biblio-philes cut initials out of manuscripts.

Hämel also brings textual arguments to bear in support of his position that different readings between R and C's Scribe 2 show that what R copied was an earlier version of C, copied before Scribe 2 arrived on the scene.[16] But, if decoration had been excised from the sections of text that Scribe 2 recopied, Scribe 2 would have needed another exemplar to provide the text missing from the other side of Scribe 1's excised initials; or else another explanation is needed to justify the recopying. Was it simply the need to make Scribe 1's text more legible, or was it the desire to emend what that text said? If the latter, then one would expect greater differences than we find between the Long Versions and the Short Versions, which depend on R, copied, according to its colophon, in 1173.

The divergence between the decorative initial styles that accompany the work of the two scribes is also considerable, and difficult to reconcile with a chronological overlap between the two. The first group of minor coloured initials and major foliage and dragon initials, found in the work of Scribe 1, is strongly Romanesque, depending on models current in Normandy and the Loire from the turn of the twelfth century; the other, in the work of Scribe 2, is distinctly Proto-gothic, with a style of pen-flourished initials in red and blue that can be closely paralleled, if on a more modest scale, in some of the initials in R, copied in 1173; and this type of initial continues on into the thirteenth century.[17]

Overall, then, it is preferable to consider the two scribes and their decorators as separated, for reasons that are not entirely clear, by a generational gap, the exact limits of which will be argued later. We consider now what contribution the collation of the *Guide* makes to an understanding of the relationship between the two scribes, their sources and their posterity.

Errors in C

On the whole, the text of the *Guide* as presented in C is relatively error-free and makes sense as it stands; we have rarely needed to emend C's text in our edition. Both scribes make a number of small errors which we consider insignificant; in these cases we have made emendations and so indicated. There are a few readings that are critical for the question of filiation; in the few cases of obvious error, we have emended C's text; elsewhere we have kept C's reading.

Errors not due to Scribes 1 and 2

We have made three emendations which do not arise from problems due to a misunderstanding by either scribe. At I-1 and XI-78, the seventeenth-century replacement of Scribe 1's original *quintus* by *quartus* is a result of the removal of the *Pseudo-Turpin* in 1619.[18] We have restored the original reading. At III-2 *acobi* for *Iacobi* is an omission of the decorator, who may or may not have been C Scribe 1. We have supplied the missing capital.

Minor Errors by Scribes 1 and 2

Twenty readings in C arise from minor errors. In these instances we have emended the text.

First, the omission of abbreviation signs, single letters, or small words: I-14 *qlitatibus* for *qualitatibus* (Scribe 1); VI-2 *qui itinere* for *qui in itinere* (the reading of Scribe 1 is possible, but inclusion of the preposition is more usual in this text); VIII-469 *ungento* for *unguento* (Scribe 1; a reading also found

in M); VIII-480 *sepultura* for *sepulturam* (Scribe 1); VIII-914 *admiradus* for *admirandus* (Scribe 2, possibly reflecting a Spanish spelling); IX-5 *fluios* for *fluuios* (Scribe 1). At IV-19, Scribe 1 writes *egentum*. We have emended to *egentium*, the reading in S, P and M; but this was a word in which medieval practice varied, and perhaps should not be counted as an error.

The second category of errors is adding an unnecessary word, such as doubling the *eo* at VIII-849 (Scribe 2), or the abbreviation mark, as at VIII-1259, *Compostellam* for *Compostella* (Scribe 1).

The third category is adding an extra letter: VIII-339 *deferrre* for *deferre* (Scribe 1); IX-95 *sstatum* for *statum* (Scribe 1); IX-492, *psalmis* for *palmis*, (Scribe 2); IX-533 *temperre* for *tempore* (Scribe 2); VIII-1198 *regris* for *regis* (Scribe 1).

The fourth category is misreading a letter: VII-191 *Bafclorum* for *Basclorum* (Scribe 1; correctly spelled at VII-118 by the same scribe); *Iusta* for *iuxta* (VIII-1049, Scribe 1) is probably, strictly speaking, merely a spelling variant, but, as *iusta* is also a common word, we have emended it.

Three emendations arise from spacing problems. As Scribe 1's spacing is erratic at best, two of the errors might well not have caused problems to a medieval reader, and are therefore not genuine errors, but matters of interpreting the text: VIII-1257, *summo pereatque* for *summopere atque* (Scribe 1); IX-344 *sedet* for *sed et* (Scribe 1).

While all categories of error occur in both hands, Scribe 1's errors are more numerous. From the foregoing list, we have emended his text fourteen times, and the work of Scribe 2 only six times. In the readings discussed immediately below, we have emended Scribe 2 only once, and Scribe 1 three times. These instances may support the idea that the reason for Scribe 2's replacement of certain leaves was that on them Scribe 1's errors were unusually numerous, or that the appearance of certain pages was considered too untidy for a display copy of the text. Both could conceivably have resulted from observations made by Arnault de Munt at the time his copy was made, although the only positive evidence is the similarity between the minor initials of C's Scribe 2 and those in Arnault's manuscript.[19]

Significant Readings in C

In a few cases there are readings which require more extensive discussion. In six instances, three in each hand, we have emended the text. In four other instances, C's reading is correct, but variations in the later manuscripts are significant in determining relationships.

HAND 1: V-7: The reading *citra* rather than *circa*, with a year, occurs in C (Scribe 1), S, P, T, and SV, but not in A or VA. (M, L, and the Short Version manuscripts omit Ch. V.) *Circa*, the commoner word, is a *lectio facilior*; anyone could have made the substitution almost unconsciously. To preserve *citra* suggests that one is copying C or something very close to C.

VIII-171: The solar signs. *xxᵗⁱ* C (Scribe 1), A, VA; *.xii.* S; *duodecim* P; *duo decim* M; *xx* with a *signe de renvoie* and *sic* in the margin SV (section omitted in T, L, and the Short Version manuscripts). There are, of course, only twelve solar signs. This reading in C, copied by A, VA, and SV's exemplar, was corrected by S, P, and M. This is one of the readings which suggests that C may not be the archetype, or a holograph; it is a copyist's kind of error.[20] SV, for instance, reads *xxii.* for C's *.xii.* at IX-477, and S reads *xxx.ᶜⁱᵐ* for C Scribe 2's *xxi* at IX-493.

VIII-232: *dextera* C (Scribe 1), and all other manuscripts containing the passage (A, VA, S, P, SV; section omitted in T, L and the Short Version manuscripts), except M, read *dextera*. The word occurs in a description of Christ, and its use means he is both blessing and also holding a book with his right hand. He usually holds a book in his left. We have emended to *leva*, C's usual word for left. M changed the reading to *sinistra*, and SV put *sic; legitur sinistra* in the margin. Again, this is the kind of error that could have resulted from careless copying.[21]

VIII-993: *cetibus* C (Scribe 1) and all copies containing the passage (Long Version only: C, A, VA, S, M, L; P omits the word, SV is in a gap, T's text has ended) read *cetibus*, the dative/ablative plural for 'whales'; *ceteris*, 'others', is correct.

IX-93: *dimii* (Long Version only): C (Scribe 1), A, and VA read *dimii*; P, S, M and SV read *dimidii* (T's text has ended). Either is possible, and both words mean 'half'; *dimidii* is by far the commoner word, and the form likely to occur to the more Classically oriented, later scribes like P, M, and SV, without necessarily implying the use of a different archetype.

IX-658: *Wicarto* (Long Version manuscripts only) *WICARTO* C (Scribe 1); *Vicario* A; *Vicarto* VA; *vicario* S; *Guicarto* P; *vuicarto* M; *Vvicarto* SV (T's text has ended). In C, the word is set off by full stops, as is *Segredo*. The capitalization and punctuation emphasize that the scribe considers *Wicarto* as a proper name. So, clearly, does P. The capital letters in A and VA could indicate either a name or an office; A's *Vicario*, like S's *vicario*, probably shows the scribe thought the office of vicar was being referred to. M's and SV's exemplars must have had an initial 'w'; and the words look more like proper names. This is probably more significant in showing whether various scribes interpreted the word as a personal name or an office than for the relationship of the manuscripts.[22]

HAND 2: VII-262: The number of warriors killed at Roncesvalles is given as *C.XL.* in manuscripts C (Hand 2), A, VA; *.cum.xl.* S; *CXL* SV; *centum quadraginta* P, M; *.c'.xl.* R, which would normally be expanded *cum. xl*, though a full stop before a preposition is unusual; *.CXL.* VB; *cum Centum, et quadraginta* Z. S's reading is preferable syntactically, and it also occurs in R; the word that follows, *milibus*, is in the ablative case, in a construction which customarily employs the preposition *cum*. If two *c*s came together, it would be perfectly possible to miss one out by mistake, and the error would be C Scribe 2's.[23] Interesting here is that the core sub-group of *Jacobus* manuscripts (A, VA, SV) all give C Scribe 2's reading, as do P and M, although, following their usual practice, they write the figure out in full. VB's reading can be explained as an omission of the abbreviation sign. Z's reading suggests that the intermediate exemplar derived from R retained it; Z himself must have given both the figure and the grammar some thought. We emend the text to S's reading.

VII-340, 341, 342: *Getis et Sarracenis*:[24] *getis* C (Scribe 2), A, VA, P, SV; *gentis et sarracenis* S; *gentis sarracenorum* R, with the final 's' of *gentis* erased, and *sarraceni* corrected to *sarracenorum*; *genti Saracenorum* VB; *genti Sarracenorum* Z; *gentibus et sarracenis* M; not in T or L. C's version makes the best sense. It would be easy for a scribe to misread *getis*: a common mark of abbreviation over the 'e' would turn it into *gentis*. The grammar would be barely possible, but strained, with *Sarracenis* in the dative and *gentis* in the genitive, meaning 'and similar to the Saracens of the race', but the word order and position of *et* would be unusual. C Scribe 2's version is therefore the better reading.

R's correction of *gentis* to *genti* could be explained, as Herbers suggests, if the original leaf, in C Hand 1, read *gentis*, which R copied but then rejected, realizing that the syntax demanded a dative, *genti*. He would then need to alter his original reading *sarraceni* to *sarracenorum*, to make the syntax work.[25] To derive R from C Hand 1 would be consistent with the pattern of variants between R and C in Books II and III noted by Hämel, where R's variants also occur in passages copied in C by Hand 2, suggesting that what R had before him was another version: one copied entirely by Hand 1 of C, or something else.[26] But it is unlikely that C's Hand 1 had *gentis*. To assume so would mean that the change from an incorrect word to a correct word would then have been initiated by C's Hand 2; it is more likely that the word was correct to begin with, and accurately copied by C Hand 2. The error would then have been made by R—eminently possible, if he had never heard of the Geats—or copied by R from another version that included it.

The same error about the Geats also occurs in S, and there it cannot have been copied from C Hand 1 because, by the time S was copied c. 1325,[27] C's Hand 2 had long since completed his part of the text. Nor can S be copied from R, as S is a Long Version Manuscript and R contains only the Short Version. M's version looks like a correction from *gentis* to *gentibus* in the dative and would be a change consistent with M's grammatical accuracy. It would suggest that M's source manuscript also had *gentis* rather than *Getis*, a word which one would expect M's scribe, who is normally, as we argue below, both thoughtful and educated, to recognize. So, unless all three made the same error through ignorance about the Geats—which is not impossible—this variant reading might support an argument for the existence of another model, between C Hand 1, R's original reading, and S and M, though one reading is not much to go on. VB and Z, or more probably their common exemplar, has rationalized the grammar by omitting *et* and changing *sarracenis* to *sarracenorum*.

VIII-853: *impueritia* C Hand 2 (Long Version only). *impueritia* (VIII-853) reappears in A, VA, S and L; only M and P make the correction; SV is in a gap. Hand 2's reading is a genuine error. He writes *impueritia*, lack of skill; we have emended to *in pueritia*, in youth. Other scribes could have independently written the correct number of minims and given the preferable reading.

IX-468: *fraglantibus* C Hand 2's reading is shared by A, VA, S, P and R. It is a possible, if uncommon reading. M omits the word. SV, VB and Z opt for the *lectio facilior, flagrantibus*. See note to Latin text. Agreement between VB and Z on this point suggests that their common antecedent, an intermediary

between R and VB, read *flagrantibus*. The presence of C's reading in the Short Version manuscript R, as well as in the other Long Version manuscripts, suggests that *fraglantibus* was also the reading in R's model, whether that was C's Hand 1 or another copy.

IX-544: *ALTARIO* C Hand 2 only. The word is in a heading, where the syntax demands the genitive *ALTARIS*, as other scribes realized.

Conclusion

Hand 1's *dextera*, *cetibus* and the wrong number of Zodiac signs are the errors that might suggest that C's Hand 1 is not a holograph. But each one can also be argued into insignificance: while *dextera* and *cetibus* could be the result of a slip of the pen, it is not impossible that *xii* and *xx* might have been the result of misreading the upper part of the *x* as two minims; but then there is the superscript ti to show that Hand 1 really meant 20.

The variants on *cetibus* show the continuation of the error in all the other manuscripts except P, which omits it—perhaps because his model was in doubt and left the word out. This is evidence for the line of transmission being very close-knit. M is the only manuscript showing the substitution of *sinistra* for *dextera*; either his scribe used a different model, or, more likely in the light of his numerous emendations of the text, discussed below under M, he realized that error and corrected it. SV also realized the error, and added his correction in the margin. C's error of 20 for 12 is copied only in A, VA and SV's exemplar. Were the other scribes copying the figure 12 from another model, or had they considered the meaning and emended accordingly?

These variants do not necessarily require another intermediary between C Hand 1 and the later manuscripts, nor do they conclusively prove that any extant manuscript is copied from an earlier version than C Hand 1. They could simply show that some of the later scribes had thought about the questions and others had not.[28] The other three significant readings in Hand 1, *citra*, *dimii*, *Wicarto*, are all possible, but not necessarily easy, readings. Variants could have been 'corrected' from C as easily as copied from another archetype.

It is also interesting, and important, that none of the variants between C's Hand 1 and the later Long Version manuscripts are reflected in the filiation of the Short Version copies: all of them occur in passages that were not copied in R, VB and Z. Otherwise put, there are no significant variants between C Hand 1's text and the text copied in R, VB and Z. The Hand 1 variants present no reasons why the Short Version manuscripts should not derive from C's Hand 1. The textual evidence for dependence of the Short Version on a C Hand 2 version—the text now present in the *Codex Calixtinus*—is also inconclusive, and will be discussed below.

The case for a possible earlier archetype is largely based on P. P's *getis*, coupled with its *centum quadraginta* for the warriors of Roncesvalles, would suggest it is close to C in its present state, copied by Hands 1 and 2. But both variants could be argued otherwise. For the Geats, the link could be with either hand, according to the argument that both versions had *getis*; while P's variant on the number of warriors, which he writes out in full, could be argued to derive from an intermediary that had *c(um)* without a mark of abbreviation, or with a mark which P's scribe missed. There are historical reasons why it would be attractive to see P as an early derivation from C's Hand 1: the transfer of the Pistoia relic, the circumstances of which are narrated in the Catalogue of Manuscripts entry for P, was negotiated in 1138, and had taken place by 1144; it would be logical—though the correspondence nowhere mentions it—for the relic to have been accompanied by a copy of the *Codex Calixtinus*. It is just possible to argue the variants of the text of the *Guide* between P and C to support such a view, but such arguments are far from conclusive. This is especially true when we remember that P is at least a third-generation copy of whatever was sent from Compostela.

Different patterns of relationship emerge from the readings of C's Hand 2, and they suggest that there was another version prior to C's Hand 2.

Hand 2's *impueritia*, *ALTARIS* and the warriors of Roncesvalles are the readings that suggest that Hand 2 misread an earlier version copied by Hand 1 or another exemplar, confirming the observations noted by Hämel in relation to Books II and III of C.[29] The most important is the variant, and more grammatically correct, reading in R and S for the number of warriors killed at Roncesvalles, to which we have emended the text. But one could also argue that R's version of it requires no more than that C's Hand 1 had *cum xl*, or *c'xl* instead of *cxl*; nothing requires another version altogether.

All that is required to account for S's *cum xl* is an immediate exemplar with *cxl* and a tailed letter in the line above which could be misread as an abbreviation mark. The same argument could apply to P.

The *gentis* mistake could easily be made by R, S, and M acting independently, due to ignorance about the Geats. Only M's scribe, Juan de Azcona, is the kind of erudite scribe one instinctively feels is unlikely to make such an error. But as C's Hand 1 is likely also to have had the reading *getis*, and M's Book I must have been copied directly from C, because it reproduces C's misbound quire, the most logical conclusion is that Juan de Azcona did misread or emend what was before him.

The filiation between C, R and S is further complicated by the agreement between C's Hand 2, R and S at *fraglantibus* (IX-468). Ian Short has found parallels for agreement between C's Hand 2 and R in Book IV as against other versions of the *Pseudo-Turpin*.[30] But Short does not make a point about the relationship between the variant readings and the work of C's different scribes. We suggest the shared readings in Book IV and the variant *fraglantibus* are further instances, like the Geats, of C's Hand 2 accurately copying what was already in C's Hand 1.

The evidence, as provided by the collation against C, suggests that there was another Long Version copy, also deriving from C's Hand 1, that provided a model for S, and possibly, though there the evidence is weaker, in part for M. Did the same model serve S and M?

The evidence that R copied from a model other than C is too slight to be significant. The copy would have had to have been so close to C's Hand 1 that it presented no variants from it, at least in the sections of text that R selected. It would have had to have had *dextera* and *cetibus*, both copied in S. The 12 solar signs do not occur in R.

The Core Long Version Sub-group: C, A, VA, SV (The Jacobus Manuscripts)

Whether C dates from shortly before the mid twelfth century or the third quarter, or both, it is still the oldest of the core sub-group manuscripts. SV is the latest, dated 1657. SV, like C, A, and VA, has the name *Jacobus*. Its special historical position sets it slightly apart from A and VA, and we postpone discussion of it until later. A and VA both date from about 1325. Both are in Spanish hands, and their illustrations, especially those in A, offer very close stylistic similarities to the illustrations in the 1326 section of the Compostela Cartulary Tumbo B. It is most likely, though not certain, that they were produced at Santiago at the end of Archbishop Berenguer de Landoria's rule (1317-30). A has the emblem of León and Castile in the lower margin on f. 1 (*ill. 47*), a possible indication it might have been a gift to a member of the royal house. (See Introduction above, p. 33.)

A: London, British Library, Additional 12213

VA: Vatican City, Biblioteca Apostolica Vaticana, Archivio di San Pietro C. 128

As is to be expected from the close similarity in the selection of other textual components and of decoration and illumination outlined above, the collation of the *Guide* in C, A, and VA shows that they form a closely related group.

Relationship of A and VA to C

None of the few variants makes it necessary to posit an intermediary manuscript between C and either A or VA. The three manuscripts share almost all readings, including C's doubled *eo eo* at VIII-849, and *getis*, in the discussion of Geats and Saracens, at VII-340-342. They (along with P and R) also retain C's possible but uncommon *fraglantibus* at IX-468. For *dimii* at IX-93, only A and VA agree with C.

Relationship of A and VA to each other

The evidence that neither is copied from the other derives from a small but significant number of readings. A cannot be copied from VA; VA omits the explicit to Book V and most of the colophon. It

also omits the word *matri* at VIII-739, and has a longer eyeskip at IX-390, omitting *fontis et due super portallem meridianum et due super portallem*. None of these passages is omitted from A, or any other extant Long Version manuscript. Nor does any other manuscript read *urbs* for *urbis* at III-30; *plumbeatii* for *plumbeatis* at VIII-1105; *xii*, rather than *vii*, for the width of the altar of St James at IX-478; *altare* for *altaris* at IX-544; or *ceci* for *cecis* at IX-690. S also reads *luminaribus* for *liminaribus* at IX-282, but this is the only one of S's numerous errors which also occurs in VA, and it is an easy mistake to make. VA is thus the end of a line of transmission; no other extant manuscript is copied from it.

VA cannot be copied from A. A reads *aquam*, C and VA *aqua*, in the Basque word list where the Latin nouns are all in the nominative (VII-321); VA retains C's *volunt* at VIII-821, in an *omnes qui* construction; A alone reads *voluit*. And at VIII-852, A reads *conversascionem*; VA and other manuscripts retain the correct reading, *conversionem*. At VIII-497, A reads *impercuciuntur* for C's *imperciuntur*; no other manuscript adds the extra syllable.

No other extant manuscript can be copied from A. Very occasionally, A changes a word, such as *portas* for *portus* I-34, making the harbour into gates, or *nunquam* for *nusquam* VI-71, *conuertus* for *conuerti* VIII-1054 or *habe* for *habebit* (XI-16). At VIII-1073, A and S both read *occidunt* rather than *occident*, but this is the only real error they share; at IX-658, A reads *Vicario* and S *vicario*, but the difference in the capitalization suggests the readings do not derive one from the other. A treats the word as a proper name, and S as an office. A also has one unique omission, *Iacobi* (IX-168) and two variations in the word order, as at IX-431: *est altare* (other MSS have *altare est*) and at IX-609, *altare beati Iacobi*, rather than *Beati Iacobi altare*.

Conclusion

Individually, these omissions and additions might not provide conclusive evidence to preclude copies depending on VA or A; collectively, the fact that no other manuscript picks up on any one of them is a convincing argument that none is copied from either. A and VA each appear to have been copied directly and independently from C in the early years of the fourteenth century, while the final stanzas of *Ad honorem* and the Mass for the Living and the Dead were still in the manuscript, and before the rebinding which rearranged quires in Book I (see M in the Catalogue of Manuscripts). Each represents the end of a line of transmission.

S: Salamanca, Biblioteca Universitaria, 2631, copied c. 1325, probably at Compostela

S is the other Spanish manuscript contemporary with A and VA, as noted above. Its illumination has some interesting points of similarity with C, A, and VA. The miniature of St James Matamoro (*ill. 72*) at the end of the *Guide* is close to the miniature of 1326 in the Santiago Cartulary Tumbo B (*ill. 73*) made at Santiago under Archbishop Berenguer de Landoria (1317-30); but S would seem to depend, for its Charlemagne illustrations (*ills. 70-71*), on a different, more fully illustrated model, than A and VA, which each depend directly on C itself.[31] The dream of Charlemagne and the two warrior scenes are grouped together as a single three-level miniature (*ill. 70*); the opening initial for Book IV, which shows Turpin's vision of the souls of Roland and his companions borne to heaven (*ill. 71*), has no parallel in the illustrations to C (*ills. 19-21*). The style of the script and the pen-flourishing in S are also comparable to those in A, VA and Tumbo B.[32] The wording of the colophon, discussed in the Catalogue of Manuscripts and below, might suggest that its immediate model was made under Archbishop Roderic (?1304-1316).

The significance of S's two-column layout will be discussed below, after we have examined its textual variants.[33]

General Remarks about S

The main characteristic of the scribe of S is his carelessness. In this he is unlike his extremely careful contemporaries, A and VA, who are both remarkably accurate. If he did his own decorative initials, he failed to read the text while he did it, writing a capital I for the first letter of *(P)rimitis* VIII-7 and *El* for *(Ci)borius* IX-545. He writes *Hec* for *Nec* at IX-703. The capital I on *(I)tem* is missing at VIII-1188, as is the I of *Inter* at IX-4, and of *in* at IX-285. At X-4, the initial H of *Huic* appears both in the rubric and in the text. Similar errors in decorative capitals abound in the other four Books of S.

S's scribe also occasionally repeats words, such as *hominibus et hominibus* VI-59 or phrases, such as *et quicumque et quicumque* VII-179. He readily confuses q-words, as when he writes *qui* for *quod* VI-10; *quidem* for *qui* VI-17; *quam* for *quod* VII-114; *quod* for *quia* VII-121; *qua* for *quod* VII-194 and 214; *que* for *quem* VII-94 and 249, VIII-718; *qui* for *que* I-23, VIII-3, IX-398, and IX-620. The reading at VIII-3 is shared with L. He also reads *quam* for *quod* VIII-448, 528; *quem* for *quod* VIII-553; *quod* for *quidem* VIII-1087, shared with M; *quis* for *qui* VIII-1079. Was this in part because his exemplar was heavily abbreviated? Several times VII-100, 160, 242 he uses the normal *per-* abbreviation for other p syllables: *pro* or *por* or *post*; at VIII-218 he has *profecto* for *perfecto*, and at IX-384 *per* for the preposition *pre*. Could this indicate that his exemplar retained the old Visigothic Spanish abbreviation for *per*? He often adds a letter *h* as in *Luchas* VIII-248, 304; *Lucham* VIII-254 and *Marchus* VIII-252, 311.

In the list of variants which follows, we have not included -c- for -t- in words like *temptatio/temptacio*; these spellings are recorded in the footnotes to the Latin text, but we are here concerned with variants which are significant for S's ability to read his exemplar.

S reverses the word order of C's text only three times, the first in a heading: *DE ALTARE ET CORPORE* for *DE CORPORE ET ALTARE* IX-442. The others are *recipiendi sunt* for *sint recipiendi* XI-5 and *romana ecclesia* for *ECCLESIA ROMANA* XI-85, in the colophon.

Additions in S

Occasionally, especially in chapter headings, S includes a word which C does not. At V-2, S supplies *Viatorum*, which is in the text but not in the chapter heading in C Hand 1. At VI-2, S and SV read *in itinere*; C Hand 1, A, VA, M, R, VB and Z have *itinere*. At VII-262, he has *.cum. xl. milibus.*, where C's Hand 2 reads *C.XL. milibus*. The preposition *cum* gives a more grammatical reading; he cannot have copied it from C; is he likely to have thought it out for himself? At VII-479, the word *et* is added in the margin. He adds *in*, reading *viderat in cunctis* VIII-951; *et*, reading *audiuit et* VIII-962; *autem* after *transacto* VIII-975; and *uel* after *Frisie* at VIII-1194. He adds *palmis* after *sex* at IX-104; *est* after *tradendum* IX-322. The *et* at IX-598 may be a later addition. Did he think these additions made the passages read better? Or do they indicate an exemplar other than C?

A rare example of S considering a reading occurs at VIII-975, where C's Hand 1 quite clearly wrote *adeuntibus*. S first read *ad cunctibus*, which gives words but not correct grammar, and then emended to *venientibus*.

Omissions in S

S has a number of small omissions which no other manuscript shares. He omits *ad* II-18; *Quinto—equitibus*, the fifth road sentence, II-28; *Dei* IV-26; *Regine* VI-15; *illam dedimus* VI-30; *cantat* VII-403; *clarissimis* VII-492; *coram Deo* VIII-76; *cunctisque inuicandus* VIII-90; *illos* VIII-565; *transmare* VIII-587; at VIII-888 *quinque—vidente* omitted and *gentem* added, where S omits 5 loaves and 2 fishes in Eutropius's account of Christ's miracle; *fas* VIII-923; *paganorum* VIII-1206; *usque* VIII-1212; *et* VIII-1233; *et cauata* IX-184; *in* IX-277; *ibi* IX-374; *scilicet* IX-395; *panditur* IX-693. The omission of *confessoris* VIII-1226 also occurs in M.

Variants unique to S

Most of S's variants are unique. Apart from c for t spellings and other spelling variants, these include:

CHAPTERS I-VI: *vi.* for *vii.* I-13; *requiendis* for *requirendis* I-18; *ad* for *et* I-31; *alii* for *alia* I-35; *Villa* for *Villam* II-38; *Francam* for *Franca* II-41; *Terimas* for *Termas* III-12; *Pampinolla* for *Pampilonia* III-31; *Alterda illa* for *Alterdallia* III-42; *Furmesta* for *Frumesta* III-46; *a* for *ad* III-55; *inferantur* for *referuntur* III-58; *urbe* for *urbs* III-60; *Obrega* for *Orbega* III-63; *Obsturga* for *Osturga* III-64; *inde etiam* for *in* III-81; *Nostri* for *unde* III-96; *icti* for *Iocci* IV-9; *edificaverat* for *edificauerit* IV-24; *Ruina* for *Runa* VI-13; *similis et Ruina* for *simul et Runa* VI-16; *Navarridos* for *Nauarros* VI-23; *recurrit* for *decurrit* VI-44; *letiferis* for *letiferi* VI-58; *dipiam* for *clipiam* VI-67; *Yspaniam et Galleciam* for *Yspania et Gallecia* VI-70; *Segionem* for *Legionem* VI-98; *Asturgam* for *Austurgam* VI-104; *Potem* for *Pontem* VI-106; *que*, corrected to *usque* for *que* VI-109; *Galliea* for *Gallica* VI-121;

CHAPTER VII: *primiis* for *premiis* VII-26; *plena* for *plana* VII-50; *grugius* for *gruguis* VII-55; *fuis* for *fueris* VII-69; *fontis* for *fontibus* VII-75; *fuit* for *sint* VII-93; *etiam* for *enim* VII-98; *Opertebit* for *Oportebit* VII-100; *thare* for *trahere* VII-101; *tanta* for *tantam* VII-110; *debent* for *debeant* VII-141; *Ravirandus* for

Raimundus VII-154; *pergeniis* for *progeniis* VII-160; *navigo* for *nauigio* VII-184; *milliarii* for *miliariis* VII-202; *recto* for *octo* VII-204; *curisantes* for *curuantes* VII-225; *infigere* for *infigunt* VII-227; *inueniunt* for *inuenitur* VII-247 and 254 and 267 and 487; *palliosis* for *palliolis* VII-284; *familie* for *familia* VII-292; *solus* for *solet* VII-297; *uicia* for *urcia* VII-309; *ogui* for *orgui* VII-311; *argui* for *aragui* VII-313; *bellatram* for *bellaterra* VII-318; *eregma* for *ereguia* VII-323; *Ioana* for *Iacue* VII-326; *uisum* for *uisu* VII-330; *contentosa* for *contentiosa* VII-334; *edoctis* for *edocta* VII-339; *inimici* for *inimica* VII-346; *ubi* for *uir* VII-355; *veneranda* for *uerenda* VII-356; *multis* for *mulieris* VII-367; *pani* for *uini* VII-382; *uocas* for *uocat* VII-393; *instam* for *instar* VII-404; *gens Nubilianos* for *gentes Nubianos* VII-407; *Scoitos* for *Scotos* VII-409; *fuissent* for *essent* VII-418; *fine* for *fines* VII-424; *ut* for *ui* VII-442; *Narrus* for *Nauarrus* VII-447; *ortus* for *aut* VII-451; *nostri* for *nomen* VII-457; *Legionibus* for *Legionis* VII-485; *segretibus* for *segetibus* VII-493; *silignensi* for *siliginensi* VII-495; *recordantur* for *concordantur* VII-508;

CHAPTER VIII: *Inimitus* for *Primitus* VIII-7; *ductum* for *ductu* VIII-50; *vider<u>nt</u>* for *uidebis* VIII-69; *in et omnibus que est petendus* for *omnibusque est petendus* VIII-92; *Perroti sudoris* for *Peiroti sutoris* VIII-104; *erreptus* for *arreptus* VIII-115; *Theolecte* for *Theocrite* VIII-116; *perveniuntur* for *perveniunt* VIII-133; *iiii* corrected to *universa* VIII-149; *Uemasansem*, where all other manuscripts begin the word with *Nemau*, VIII-160; *ecclesia* for *cantica* VIII-189; *virtum* for *virtutes* VIII-197; *dextradi* for *dextrali* VIII-190, 204; *resides* for *residet* VIII-261; *celsum* for *celum* VIII-277; *columbam* for *columba* VIII-299; *pro gratia* for *patriam* VIII-336; *ut* for *ire* VIII-340; *pacis* or *paris* for *regis* VIII-368; *ut* for *non* VIII-369; *He* for *Hic* VIII-373; *urbe* for *urbem* VIII-374; *os* for *omnes* VIII-415; *fabricartur* for *fabricatur* VIII-452; *Nuallia cuius* for *Nualliacus* VIII-509; *orlibem* for *celibem* VIII-511; *tunc* for *tamen* VIII-557; *Cordiniacenses* for *Corbiniacensis* VIII-563; *durat* for *ditat* VIII-566; *tentatorum* for *tantorum* VIII-579; *cunctis* for *vinctis* VIII-586; *deum* for *ad eum* VIII-592; [*portas e. et u.f.* for *portas ereas et vectes ferreos* VIII-595 is not really an error, just an abbreviation]; *manibus* for *manus* VIII-600; *eum* for *tamen* VIII-647; *refero* for *refert* VIII-764; *Pharisiorum* for *Parisiorum* VIII-783; *grecit* for *grecis* VIII-785; *incipiebant* for *incipiebat* VIII-796; *uere* for *nunc* VIII-832, in verse; *summes* for *summos* VIII-857; *est* for *cum* VIII-869; *ennarre* for *enarrare* VIII-885; *frames* for *fames* VIII-894; *hoc* for *hec* VIII-903; *ase* for *ad se* VIII-943; *uideri* for *Iudei* VIII-944; *esset occisus* for *essent occisuri* VIII-945; *crude* for *cruce* VIII-960; *didicunt* for *didicerit* VIII-964; *uidens* for *Iudeos* VIII-968; *per fidem* for *Persidem* VIII-980; *erectis* for *eiectis* VIII-982; *gentibus* for *generibus* VIII-986; *errorem* for *errore* VIII-989; *currum* for *ciuium* VIII-994; *audierunt* for *audierint* VIII-1056; *Antifrodorum* for *Autisiodorum* VIII-1061; *descendentes* for *discendentes* VIII-1064; *custellam* for *Eustella* VIII-1085; *aliis* for *asciis* VIII-1107; *frammta* for *framea* VIII-1151; *uerbibus* for *uerberibus* VIII-1168; *Galdebodi* for *Gandelbodi* VIII-1193; *villa* for *uillam* VIII-1236; *baste* for *haste* VIII-1238;

CHAPTERS IX-XI: *Piniaris* for *Pinario* IX-32; *ciboriosi* for *ciborios* IX-101; *sibi* for *sunt* IX-119; *Portallulus* for *Portallulis* IX-143; *que* for *Et* IX-152; *temperanti* for *temperata* IX-210; *invenerunt* for *inuenitur* IX-234; *angrini* for *anni* IX-266; *luminaribus* for *liminaribus* IX-270; *cetri* for *tetri* IX-302; *etiam* for *et* IX-315; *interpretationem* for *temptacionem* IX-323; *in* for *suas* IX-339; *super* for *frater* IX-343; *cibiores* for *ciborios* IX-355; *et* for *apparuerunt* IX-378; *sinistrale* for *sinistrali* IX-437; *magnum* for *magno* IX-482; *uiri* for *quattuor* IX-517; *oe'* (that is, *omne*) for *etiam* IX-525, compare 529, where he has corrected his initial *omne* to *eciam*); *cibori* for *cimborii* IX-561; *coopertum* for *coopertura* IX-582; *et deitas* for *deica* IX-598; *magna* for *magni* IX-612; *balsani* for *balani* IX-618; *Segererio* or *Segereno* for *Segeredo* IX-661; *auditur* for *auditus* IX-692; *urbis* for *urbi* IX-709; *inte* or *uite* for *rite* X-36; *luminibus* for *liminibus* XI-8; *ipsum* for *ipso* XI-17; *Gehennam* for *Gebennam* XI-26; *regus* for *rogus* XI-63; *legem* for *legenti* XI-81; *curia* for *ROMA* XI-88; and, most likely, *dimacum* for *CLUNIACUM* XI-95 (compare *dipiam* for *clipiam* VI-67). The last three variants occur in the colophon.

Variants shared with Others

A few of S's alterations are shared with others. Those that are significant for C have been discussed above, in relation to C. S agrees with C Hand 1 in reading *citra* for *circa* (C, S, P, T, SV) V-7; *dextra* for *sinistra* (C, A, VA, S, P, SV) VIII-232; *cetibus* for *ceteris* (C, A, VA, S, M, L) VIII-993. S agrees with C Hand 2 in reading *impueritia* at VIII-853 (C, A, VA, S) and *fraglantibus* at IX-468 (C, A, VA, S, P, and R). S differs from C Hand 1 in reading 12 for 20 solar signs at VIII-171 (S, P, M, cf. SV, which agrees with C in the text, but corrects the error in the margin); *dimidii* for *dimii* at IX-93 (S, P, M, SV), *vicario* for *WICARTO* IX-658, shared with A. In relation to C's Hand 2: 40,000 warriors killed at Roncesvalles VII-262 (shared with R, VB and Z); *gentis* for *getis* at VII-340 (shared with R's initial reading).

Further variants shared by S and others which do not bear on C, are: *egentium* for *egentum* IV-19 (S, P, M, R, VB, Z); *qui* for *que* VIII-3, a reading shared with L. S and M read *monachorum* for C Hand 1's *monacharum* VIII-22, in discussing the rule of Caesarius of Arles, which was for nuns, which might suggest they had not heard of it and corrected, independently, to the *lectio facilior*, what they perceived as an error in C. At VII-245, S, P, M, R, VB, and Z all read *in decensione* for *decensione*. At VIII-815, S and L read *Cristi amore* for *Cristi nomine* in C Hand 2. The reading *nequit* for *nequivit* VIII-895, in C Hand 2, is shared with with M and L; *occidunt* for *occident* VIII-1073, C Hand 1 is shared with A. The word *confessoris* is omitted at VIII-1226, as also in M, and at VIII-1234, *basilica* for *basilicam* is shared with M. The readings *celebratur* for *celebretur* VIII-82; *prospicere* for *perspicere* VIII-862; *quod* for *quidem* VIII-1087 and *quorum* for *quarum* IX-82 are also shared with M; *sunt* for *sint* XI-4 is shared with M, R, VB, Z. S writes *luminaribus* for *liminaribus* IX-270 and 282, both C Hand 1; the latter also occurs in VA; *oportuno* for *obtimo* IX-453, C Hand 1, a reading shared with M. This might possibly be a mistaken expansion, but not from C, if so, as the word is very clearly written out in full by C's Hand 1; *vicario* for *Wicarto* IX-658 recalls A's *Vicario*, but the difference in capitalization suggests that S is thinking of an office and A of a proper name. S, VB and Z all read *Nantuarum* for *Nantuavim* at XI-25.

Significant Variants in S

Three variants that are significant for C's relationship with other manuscripts have been discussed already: at VII-262, S's version of the number of soldiers killed at Roncesvalles makes better grammatical sense than C Hand 2's version. It must depend on an exemplar with *cum* or *c'*, or a tailed letter in the line above which could be read as *c'*.[34] This would be difficult to do from C's clear script. S's preferable reading of 12 for 20 solar signs, written in C by Hand 1, might suggest that that reading was also in S's model, unless S was displaying an unusual amount of thought as he copied. We have cited one instance in S's variants that shows that he was, on occasion, capable of reflection: at VIII-975 among his additions.

The other key variants are less decisive in their implications. At IX-93 (C Hand 1), A, and VA read *dimii*; P, S, M and SV read *dimidii*. Either is possible, depending on whether the scribe prefers a commoner word and a classicizing spelling or not. At IX-658, *WICARTO*, written by Hand 1 in C is discussed above. Just possibly, the reading could indicate a model for S other than C Hand 1, a hypothesis we rejected for A, but which, with other evidence, might be valid for S. Again, the evidence is tenuous.

There are a few further variants that appear to support the idea of an exemplar other than C for S. At VIII-869, S reads *est*, where C's Hand 2 has *cum* written out in full. This is the kind of error which is easy to make if *est* is abbreviated 'e' and 'e' is mistaken for 'c', a kind of error that is otherwise rampant in S's scribe's work. S frequently writes numbers as figures, usually accurately, but with some key mistakes which indicate that his exemplar had figures rather than words. Numbers are notoriously tricky, and we have argued for C's Hand 2 that the discrepancy in the number of solar signs could be a case of misread strokes, perhaps in a rough copy, rather than a dependence on an earlier complete archetype. Would it be equally easy to misread C Hand 2's *xxi* IX-493 for the length of the altar-cloth in palms as *xiii.ᶜⁱᵐ*, as does S? We argue that C's measurements give a more satisfactory altar-cloth, and so S's reading is probably a misreading rather than a preservation of a more valid version.[35] Finally, at IX-517, S reads *viri*, presumably instead of *iiii* for *quattuor*, which is written out in full in C Hand 2, P, (with one 't'), and SV, and abbreviated only with the <u>ua</u> superscript, *quattuor*, in A, VA, M. This is not a mistake even S seems likely to have made from C, which is extremely clearly written—by Hand 2. He is more likely to have copied it from another model, close to C's Hand 1 but not necessarily earlier than it. The use of *curia* for *Roma* in the colophon is probably not an error, but a reflection of the current presence of the papacy not at Rome but at Avignon. But the reading *dimacum* for *CLUNIACUM*, also in the colophon, is not a mistake one could easily make from C's clear capitals. The latter could be explained as an expansion of a difficult to read contraction and would be consistent with the kind of error S's scribe makes throughout. The substitution of 'curia' for 'Roma' has been interpreted by DÍAZ Y DÍAZ (1988a, p. 136, n. 95) to refer to the move of the papacy to Avignon and an indication that S's immediate model was made under Archbishop Roderic (?1304-1316). Thus the textual evidence reinforces the suggestions made in relation to the two-column layout and the different iconography discussed in the Catalogue of Manuscripts under S. An exemplar other than C seems likely.

Conclusion

Many of S's errors make the syntax difficult if not impossible, and a few, such as *dextradi* (VIII-190, 204) are not even words. He misreads minims, 'o' for 'c', 'a' for 'o', 'e' for 's', 's' for 'o', and confuses letters with ascenders for letters without: 'c' for 't', 'r' for 'd'. His numerous misreadings of q-words are listed above. It would be difficult for him to make these kinds of errors from C, which is on the whole clearly written; even words like *qui* are frequently spelled out in full. Even allowing for his use of a heavily abbreviated, laterally compressed exemplar, with little space between the lines and low ascenders, the level of his competence is minimal. The number of mistakes, and the kind of errors they are, indicate an exemplar more difficult to read than either part of C, especially in its abbreviations. On the evidence of *viri, cum,* the numbers, and the small verbal variations, one might convincingly posit a manuscript very close to C, heavily abbreviated, but including 40,000 warriors dead at Roncesvalles, available to S *c.* 1325. It cannot have been C's Hand 1 complete, as by *c.* 1325 Hand 2 had long since completed his part of the codex; it could have derived either from C's Hand 1 or from another manuscript very close to C's Hand 1, or from an intermediate copy.

However, no textual reasons absolutely require that S's model was earlier than C Hand 1. The variants that point in that direction are all ones that can be argued either way. An argument for S's dependence on a model earlier than C's Hand 1 (though a weak one, taken on its own), is the unsatisfactory nature of the iconography of the *Pseudo-Turpin* illustrations in C, accompanying the text copied by Hand 1, as against the marginally more appropriate illustrations in S.[36] But there is no compelling reason to assume that twelfth-century artists were better at fitting illustrations to a text than thirteenth-century artists. Was S's exemplar, then, a pre-C Hand 1 version, possibly written in two columns and illuminated? The difficulty here is that such a book, if made in the first half of the twelfth century, would have been likely to be a neatly copied, lightly abbreviated version. S's textual variants seem to require a heavily abbreviated exemplar, not always easy to decipher. Even informal twelfth-century hands, in documents and in books, are sparingly abbreviated, and written with space between words and lines. Partly because ascenders and descenders were long in all hands until near the end of the twelfth century, even glossing hands are less compressed than they later became.

It might therefore be worth considering the possibility that S's direct exemplar was a thirteenth-century copy (or perhaps a copy made very early in the fourteenth century, taking account of the 'curia' for 'Roma' substitution discussed above), made in a period when, under the influence of schools and the universities, the use of abbreviations in this kind of text was a more general phenomenon than had been the case in the twelfth century. That version would either have included illustrations copied from an earlier illustrated version that differed from C's in the ways that S's do, or it could have itself initiated illustrations similar to those in C but with the differences that S presents. The latter solution is less satisfactory in that the earlier illustrations, in C, make less sense than those in S. Degeneration is easier to argue than improvement in an artistic tradition, though literate artists or patrons who read the texts carefully did exist at all periods. But S's model for the illustrations might well have been a manuscript that contained only *Pseudo-Turpin,* and lacked the *Guide,* like Baudouin de Hainaut's manuscript.[37] And, as we have argued, S's text is less reliable than C's. If a model earlier than C is proposed for S, then considerable corruption through poor copying must also be adduced, in the form of at least one intermediary.

The pattern of relationships between S and the other Long Version manuscripts is variable. It is not close to L, A or VA. S's variants indicate only two readings, of questionable significance, shared with L: *qui* for *que* (VIII-3) and *nequit* for *nequivit* (VIII-895), the latter shared also with M. None of S's small omissions are shared with VA; S includes those few phrases VA omits, and shares only one of VA's variants, *luminaribus* for *liminaribus* at IX-282. This is a mistake S also makes, alone, at IX-270; both are written by Hand 1 in C. Two of A's variant readings, *occidunt* for *occident* (VIII-1073, C Hand 1) and *Vicario* (IX-658, C Hand 1, mentioned above), are also in S, and can be argued either as significant or as insignificant. It might be possible to argue differently in the cases of P and M.

One of S's omissions, one minor addition, and twelve of its readings are shared with M. No other manuscript shows a unique pairing with S more than once, or shares any of its omissions. While M itself is later than S, its immediate exemplar could be earlier. The evidence for any link is severely blurred by the fact that S also contains numerous other variants that are not shared, as does M. Many of the shared readings are the kind that result from reading a heavily abbreviated exemplar: *prospicere* for *perspicere* VIII-862; *quod* for *quidem* VIII-1087; *oportuno* for *optimo* IX-453; or *nequit* for *nequivit*

VIII-895, all shared with M. Some, such as *quorum* for *quarum* IX-82, or *celebratur* for *celebretur* VIII-82, suggest a difficulty reading letter-forms.

The small scattering of alignments with SV and P are not in significant readings, and are far outweighed by the numerous unique variants in all three. There is no alignment with A or VA. Furthermore, these manuscripts contain the text for all of S's small omissions. None of S's variants against C align with T. No later manuscript can be proven to depend on S directly.

P: Pistoia, Archivio di Stato, Documenti vari 27

Copied in the second quarter of the sixteenth century, in Pistoia (*ills. 77-79*); a unique compilation, comprising selections from the *Codex Calixtinus* with Pistoian texts relating to the acquisition of the relic of St James in 1138, and the building and consecration of his chapel in 1144, his miracles *en route*, his Pistoian miracles and his local Pistoian liturgy.[38]

Spellings in P

P has a large number of variants, but most of them are spellings. Many are shared with M, and some with SV; their scribes wrote in 1538 and 1657 respectively, while P is dated by water-marks to the second quarter of the sixteenth century. Similarity of spelling is more likely to be a feature of later periods than to indicate a more fundamental textual relationship.

Some are classicizing, like *fælicitatibus* for *felicitatibus* (cf. *fælicitatibus* M) III-52; *tertius* for *tercius* IX-11; or *pretiosus* for *preciosus* IX-15. A few of these, like *fæmoralia* VII-135, *erepta* for *erecta* VIII-39, *Bachus* for *Baccus* IX-16, or *abbatia* for *abbacia* IX-26, are also in M, and both write numbers out in full as words.

P has a few Italian spellings, like *schripte* for *scripte* IX-215 and variant spellings of place names, like *massilie* for *Marsilie* VIII-479 or *Sarella* IX-6, 8 (*Sarela* in all other manuscripts).

Our discussion of variants below ignores spelling variants, unless they produce genuine alternative readings.

Variants in Word Order in P

Chapter names precede chapter numbers I-10; *eius itinere* for *itinere eius* I-19; *legionem urbem* for *urbem Legionem* II-37; *laudem domini* for *Domini laudem* III-56; *urbibus hyspanie* for *Yspanie urbibus* III-98; *regnum dei proculdubio possidebit* for *proculdubio regnum Dei possidebit* IV-25; *archum et hospitale scilicet idem* for *Arcum scilicet et hospitale idem* VI-43; *rustici lingua* for *lingua rustici* VII-39; *spoliis mortuorum* for *mortuorum spoliis* VII-116; *illum montem* for *montem illum* VII-236; *tantum nummo* for *nummo tantum* VII-347; *suis finibus* for *finibus suis* VII-428; *evangelii sui predicatione* for *euangelista, sua predicacione* VII-466-467; *eius amplius* for *amplius eius* VIII-108; *eius osculabitur* for *osculabitur eius* VIII-111; *omnia eius acta* for *eius omnia acta* VIII-135; *secum sede* for *sede secum* VIII-156; *continent sancti* for *Sancti continent* VIII-212; *beati Iacobi scilicet* for *scilicet beati Iacobi* VIII-348; *sui socii* for *socii sui* VIII-625; *tui socii* for *socii tui* VIII-629; *Codice quodam* for *quodam codice* VIII-791; *credere cepit occulte* for *credere occulte cepit* VIII-940; *discipulis dominicis* for *dominicis discipulis* VIII-965; *dicitur Sconnas* for *Sanctonas dicitur* VIII-1021; *urbem et insignem* for *ac insignem urbem* VIII-1035; *apud Deum nobis* for *nobis aput Deum* VIII-1126; *scilicet ictu* for *ictu scilicet* VIII-1153 (shared with VB, Z); *fide christi* for *Cristi fide* VIII-1208; *basilicam sancti Iacobe* for *Beati Iacobi basilicam* IX-43; *habet parva capita* for *parua capita habet* IX-72; *in ecclesia inferius* for *inferius in æcclesia* IX-117; *portam tamen super quam* for *tamen super portam quæ* IX-263; *bestiis, sanctis* for *sanctis, bestiis* IX-350; *introitus duos* for *duos introitus* IX-359.

In addition to these small changes in word order, two entire sections have been reversed: *De Dignitate* (IX-625) and *De Lapicidibus* (IX-644).

Additions unique to P

et VII-47; *esse* VII-175; *post* VII-177; *que* VII-196; *et* VIII-109; *a vobis in celum* VIII-284; *Corpus Beate Marie Magdalene* VIII-458; *De Corpore Sancti Leonardi* heading VIII-500; *ligatos* VIII-591; *De Corpore Frontonis episcopi confexoris* heading VIII-609; *De ligno Domini et Calice beati Euurcii episcopi confexoris* heading VIII-658; *De Corpore Beati Martini episcopi et confexoris* heading VIII-704; *De Capite Beati Iohannes baptiste*

heading VIII-747; *pericula* VIII-760; *De Corpore Beati Eutropii episcopi et martiris* heading VIII-777; *De Passione Sancti Eutropii—cᵒ viiii* heading and new chapter number VIII-834; *De Beato Romano* VIII-1136; *De Corpore Beati seuerini episcopum et martirum* heading VIII-1182; *De Corpore sancti Dominici confexoris* heading VIII-1224; *De Qualitate Urbis et Basilice Sancti Iacobi appostoli gallecie Calixtus papa et Almericus Cancellarius—cᵒ x* IX-1; *in* IX-572; *apostoli* IX-714; *De numero Canonicorum sancti Iacobi vel De discretione oblationum altaris sancti Iacobi—cᵒ xi* X-1; *De peregrinis sancti Iacobi digne recipiendis—cᵒ xii* XI-1; *peregrinos* XI-24; *est* XI-71.

Of particular interest are P's added headings in Chapter VIII. By giving the Passion of St Eutropius a numbered heading, as Chapter IX, he ends up with 12 chapters for the *Guide* instead of 11. No other extant manuscript does this.[39]

Omissions in P

Beati I-2; *eius* I-17; *et* I-19; *ad…Yspanie* I-25; *et* I-50; *portuum* II-15; *scilicet* II-17; *est* II-20; *inde Palcium Regis* III-88; *uulgo* VI-62; *diu* VI-79; *et nisi…habundant* VII-65; *et* VII-134; *per* VII-198; *Sique…memorares* VII-302; *et reproba* VII-333; *dum* VII-379; *et* VII-465; *ad dominum* VII-468; *pro defunctis* VIII-72; *eius…iactant se habere* VIII-327; *Beati* VIII-424; *frigoribus* for *frigoribusque* VIII-514; *in* VIII-596; *nomine* VIII-616; *multa* VIII-637; *in* VIII-732; *se* VIII-816; *cetibus* VIII-993; *cepit* VIII-1032; *illum* VIII-1044; *crebro* VIII-1120; *et* VIII-1185; *Magni* VIII-1203; *quæ…Iacobi* IX-46; *quadraginta*, with blank space IX-61; *desubter…pilares qui* IX-114; *superius in nauibus, et quot cingule inferius tot sunt* IX-120; *semper…uocantur* IX-125; *i.c.l.x.iij. Idus aprilis*, omitting the e. for *era* which is present in C at IX-221; *eius* IX-253; *et*, reading only *sed* for all other manuscripts *sedet* IX-344; *eos* IX-506; *in* IX-604; *ab* IX-642; *dominis* IX-657; *nequam* XI-37; colophon XI-76.

Variants unique to P

Note: P is the only manuscript to use the same chapter headings in the chapter list and in the text. We have therefore not included these readings here among the textually significant variants, though they are all recorded in the collation of the text. See also Catalogue of Manuscripts under P.

Insiliaci or *Iusiliaci* for *Viziliaci* I-42; *Impede* for *in pede* III-5; *villa ux* for *Uillaus* III-75; *campus leurarius* for *Campus Leuurarius* III-90; *illi* for *illum* VI-64; *appellantur* for *nuncupantur* VI-84; *Cor* for *Sil* VI-105; *villi* for *viri* VII-22; *tres* for *ui* VII-96; *Caudent* for *gaudent* VII-115; *illis* for *illorum* VII-152; *Arnaldus* for *Arnaldo* VII-163; *predistarum* for *predictarum* VII-167; *palpare* for *palpitari* VII-207; *hoc* for *hora* VII-210; *Deinde* for *Deum* VII-308; *andrea mariam* for *Andrea Maria* VII-310; *fert* for *tulit* VII-395 *ferens*, cf. R, VB, Z; *progenis* for *progenie* VII-450; *siligineo* for *siliginensi* VII-495; *scilicet apostoli* for *apostoli* VIII-11; *que* for *qui* VIII-35; *es* for *est* VIII-58; *uisus* for *usus* VIII-95; *quod* for *que* VIII-101; *peruenerunt* for *perueniunt* VIII-133; *longissimus* for *longinquis* VIII-338; *transferre* for *deferre* VIII-354; *vixit* for *duxit* VIII-516; *eligunt* for *diligunt* VIII-554; *ditant* for *ditat* VIII-566; *iampropter* for *iam per* VIII-571; *iniucta* for *coniucta* VIII-577; *impiorum* for *eorum* VIII-594; *invicti* for *uincti* VIII-599; *sunt* for *sed hic* VIII-602; *Angelios* for *Angelicus* VIII-752; *sconensium* for *Sanctonensium* VIII-778, suggesting a form with the standard *sc'*-abbreviation for *sanct-*, cf. VIII-802, 834, 839 and 1066; *Greciam* for *Grecia* VIII-787; *sconnas* for *Sanctonas* VIII-802; *Sconnensis* for *Sanctonensis* VIII-834; *sconnensis* for *Sanctonensis* VIII-839; *audens* for *audebat* VIII-879; *quindecim* for *quinque* VIII-956; *excogitabat* for *excogitare* VIII-1033; *Sconas* for *Sanctonas* VIII-1066; *corpore* for *corpora* VIII-1211; *detulerit* for *detulerunt* VIII-1216; *portallis* for *portales* IX-143; *fasta* for *facta* IX-373—could this just be a spelling?; *habita* for *habiture* IX-388, suggesting an ultimate source with the *-ur* abbreviation, omitted by P or his exemplar; *viginti et tribus* for *.xiii.* IX-499; *Arfonsus* for *Anfonsus* IX-540; *sui* for *EIVS* IX-647; *Guicarto* for *WICARTO* IX-658; *quinquaginta novem* written out in full IX-675.

Variants shared with Others

angliacensem for *Angeliacensem* I-53 VB; *parve* for *pauce* II-4 M, T; *vero* omitted II-49 T; *hospitale* for *hospitalis* III-7 M; *egentium* for *egentum* IV-19 S, M, R, VB, Z; *ea* for *eo* VI-120 T; *in* added VII-245 S, M, R, VB, Z; *centum quadraginta* for *cum XL* VII-262 M, cf. other variants; *aquam* for *aqua* VII-321 A, M, Z; *nullis…culta* for *ullis…inculta* VII-335-336 R, VB, Z; *et* added VII-408 M; *aut non legitima* for *aut legitima* VII-451 M. This reading, about the Navarrese doubles the negative in the sentence; *confessoris piissimi* for *piissimi confessoris* VIII-85 M; *sumo opere* for *summopere* VIII-87, cf. *summo opere* M; *duodecim*

written out in full for the signs of the zodiac VIII-171 M, cf. *xii* S; *.xxiiij.* in figures for *uiginti quatuor* written out in full in C Hand 1 VIII-208, cf. *.xxiiii.º* M; *deferre*, correcting C Hand 1's *deferrre* VIII-339 A, VA, S, M, SV; *quinto* written out in full VIII-390 M, Z; *quarto* written out in full VIII-404 M; *tercio* written out in full VIII-427 M; *est enim* for *Hec enim* VIII-462 M; *octavo* written out in full VIII-607 M; *vi* written as a figure VIII-769 S, SV; *cum* for *eum* VIII-955 P, M; *duodecim* written out in full VIII-1144 M, SV, Z; *summopere atque* VIII-1257 A, VA, cf. other variants; *xiiii* written as figures IX-63 S; *dimidii* IX-93 S, M, SV; *exilientum* for *exiliencium* IX-283 S, M; *fraglantibus* IX-468 C, A, VA, S, R; *quinque* written out in full IX-476 M, SV, Z; *septem* written out in full IX-478 M, Z; *novem* written out in full IX-491 S, M, SV; *viginti vno* written out in full IX-493 cf. M; *viginti* written out in full IX-501 M; *quattuor* written out in full IX-517 cf. C, A, VA, M, SV; *altaris* IX-544 A, S, M, SV; *quattuor* written out in full IX-587 cf. M, SV; *beati* for *SANCTI* IX-627 M; *quinquaginta* written out in full IX-654 M; *sexaginta tres* IX-680 cf. M; *quadraginta quattuor* written out in full IX-684 cf. M.

Relationship of P to other Long Version Manuscripts

Most of P's numerous variants are spellings, word reversals, or omissions unique to it. As shown in the discussions of the manuscripts so far considered, P does not share any of the occasional omissions of A, VA, or S. P's relationship to A and VA is variable: at V-7, P's *citra* reading, where A and VA have *circa*, indicates a derivation from C Hand 1 itself; *getis* at VII-340, is found only in C Hand 2, A, VA, S and P, and *fraglantibus* IX-468 is only in C Hand 2, A, VA, S, P and R, although we argue above that both readings were also in C Hand 1.

Dimidii, rather than C Hand 1, A, VA's *dimii* at IX-93, and the correct number of solar signs at VIII-171, where C writes *xxᵗⁱ*, could reflect an earlier version than C's Hand 1, but these readings are too widespread to provide convincing evidence. *Dimidii* is shared with M and SV, which suggests a similar classicizing approach to language, such as is shown by other variants shared by P and M and P and SV. P and M are close in date, but their geography makes any direct relationship between them unlikely. Although P and M share a number of readings, there are omissions in M, (including *fraglantibus*, discussed below under M), which are present in P. Only a few readings link P and M: three small additions (*in* at VII-245 S, P, M, R, VB, Z; *et* at VII-408 P, M; *aut non legitima* at VII-451 P, M for C Hand 1's *aut legitima*) and five variant readings (*parve* for *pauce* II-4 P, M, T; *aquam* for *aqua* at VII-321, a reading shared, curiously, by A, Z and M; *est enim* for *hec enim* at VIII-462 P, M; *beati* for *SANCTI* at IX-627 P, M.

P's variants do not require that its ultimate model was either earlier or later than C in its present state, although it can be argued, to fit what are claimed to be the historical circumstances, that C's Hand 1 was what its model was based on. As we debate above, *getis* and *fraglantibus* could come either from C's Hand 1 or from C Hand 2's recopying. No cluster of readings in P suggests a particularly cramped or difficult exemplar, though the reading of *Sconnensis* for *Sanctonensis*, Saintes, in all five instances in Chapter VIII suggests that the word was abbreviated in his exemplar. *Angliacensis* for *Angelicaensis* may also indicate a scribe unfamiliar with French place names.

The surviving portion of its most likely immediate exemplar, Pistoia Doc. vari 1, is clear and easy to read. The reading *citra*, as in C's Hand 1, indicates that P's ultimate model was C's Hand 1 itself, while the reading *centum quadraginta*, in Hand 2 in C, may mean that P's model was copied from C after Hand 2 had completed its part; or it can be argued as a misreading, by P's model, of a C Hand 1 exemplar, which P (or his model) then copied out in full, as he usually did with numbers.[40]

The particularly interesting historical relationship that can be suggested (assuming that what is said in P about the relic transfer can be trusted) between P's ultimate model and C,[41] may lead to the question as to whether it might not be C that depends on P's model, rather than the other way round. Three very minor variants shared by P and T are interesting in relation to this: *parve* for *pauce* at II-4, also in M; *ea* for *eo* at VI-120; and *vero* omitted at II-49. It is possible that T may also ultimately depend on an early version, for the historical reasons discussed in the Catalogue of Manuscripts under Lost Manuscripts.[42] But the positive evidence is extremely slender, and the number of actual spelling errors and omissions in P argues against such an option. Moreover, the state of T's text does not suggest transmission by careful scribes.

M: Madrid, Biblioteca Nacional, 4305, copied in 1538, presumably in Santiago, by Fra Juan de Azcona

M includes a great deal of extra information on vernacular names for places, rivers, doors, gates, altars etc., which were current in the sixteenth century and seem most likely to be based on personal local knowledge gained *in situ*. These additions concern the route through Spain, and particularly Compostela itself; the routes through France are left without comment, suggesting that Juan de Azcona did not know them personally. Variants like *aquis* for *Conquis* I-39 and *egeni* for *Agenni* VIII-437 (but *Ageni* VIII-433) would support such a view, although variant spellings for place-names in Spain are also abundant in M's text. There are many other variant spellings, some of them classicizing, as well as frequent changes of word order and sometimes of construction. Juan de Azcona improves the grammar of the text, reading *transitu portu ciseree* for C's *transito portu Cisere* at I-65; at I-67, he reads *Viaque*, where C has *vie que*. Juan de Azcona is clearly reading what he copies. At VIII-232 all other manuscripts follow C in having Christ *manu dextera benedictionem innuens, et in dextera librum tenens*, both blessing and holding the book in his right hand. M has him holding the book in his left hand, *in sinistra*, which clears up the confusion and indicates that M knew which hand Christ blessed with.[43]

Such features are a clear indication that an exemplar for M, other than C, cannot be the source for any of the later manuscripts. The question of its derivation is not so simply answered. For Book I, M is copied from C or from a copy made from C after it had become misbound between *c.* 1325 and 1538.[44] In Book V, it is sometimes difficult to determine which readings are copied from the exemplar and which reflect Juan de Azcona's efforts to correct, improve and add comments to the text he had before him. Several of the more significant variants can be explained in a number of ways, so that the conclusions to be drawn from what is in M are ambiguous.

Geographical, Topographical and Architectural Additions in M

similiter ad Pontum Regine coadunatur & una simul exinde via efficitur for *et una via ex inde* I-69; *inde locronium vel grugnnus* III-35; *februarii als Zebruarii* for *Februarii* at III-77, cf. II-44; *id est ibera flumen que aqua est sana* for *que est sana* VI-54; *Grugnum id est logroniam* for *Grugnam* VI-57; *scilicet Bernesca aqua que iuxta Legionem adversus Asturieam urbem defluit* VI-103; *dicitur Sancti Iacobi posita a carolo magno vel Crux Karoli* for *dicitur Crux Karoli* VII-215; *in gallecia et Beati Martini episcopi Turonensis* for *et Beati Martini Turonensis* VIII-349; *civitate Samarie* added after *in Sebastie*, VIII-776; *qui vulgiter dicutur rio del archpuro* (?) IX-9; *que nunc porta de azavachoria dicitur* IX-234; *qui vocatur delaplateria* IX-284; *del obradeiro deoreo* IX-358; *inter istius duas scilicet portas sunt etiam alie due vnaque dicitur Sancte Marie de quinta Angustia et alia vocatur porta Sancti Spiritus* IX-385; *quod nuc est altare Sancti Bartholomei* IX-412; *nunc ibi est sacramentum et vocatur capella regis francorum* IX-413; *nunc est sancti frutuosi* IX-419; *Idest Alla se ab enga.* X-59.

Word-order Changes in M

quatuor sunt vie for *QVATUOR vie sunt* I-23; *uille habentur in via Iacobitana* for *uille in Via Iacobitana habentur* III-4; *calidi jugiter* for *iugiter calidi* III-13; *in estate si* for *si in estate* VII-57; *pedem diligenter* for *diligenter pedem* VII-66; *ferocitas lingue vultuumque similitudinem barbaram* for *ferocitas uultuum similitudinisque lingue barbare* VII-139; *Iuxta montem vero* for *Iuxta vero montem* VII-235; *corrupta et* for *et corrupta* VII-332; *Verum vno quoque enim die* for *per unum quemque enim diem* VII-378; *dicitur Nadauer* for *Naddauer dicitur* VII-455; clause omitted at VII-456, inserted at 469; *in gradu sexto apostolicis* for *primo gradu sex apostolorum* VIII-165; *Benignitas et fortitudo et mansuetudo* for *Benignitas et Mansuetudo* VIII-201; *clauis aureis* for *aureis clauis* VIII-269; *valuerunt cum eo* for *cum eo ualuerunt* VIII-341; *corpora sanctorum* for *sanctorum corpora* VIII-343; *scilicet corpus beati Iabobi* for *beati scilicet Iacobi* VIII-347; *nullo modo potuit de* for *nullo modo de...potuit* VIII-355; *custoditur summopere* for *summopere custoditur* VIII-453; *Maria illa* for *illa Maria* VIII-463; *super eum corpus socii tui* for *super socii tui corpus* VIII-628; *fuisse illum* for *illum fuisse* VIII-642; *sepulchris sanctorum* for *sanctorum sepulchris* VIII-645; *pro nobis crucifixus* for *crucifixus pro nobis* VIII-685; *confessoris in Pitava urbe corpus santissimum visitandum* for *confessoris corpus sanctissimum in Pictaua urbe uisitandum* VIII-729; *urbe pitaua* for *Pictaua urbe* VIII-740; *caput venerandum* for *uenerandum caput* VIII-748; *cuius santissimam* for *Santissimam cuius* VIII-779; *Eutropius Cristi martir Santonensis* for *Cristi martir Eutropius Sanctonensis* VIII-838; *genere gentilis* for *gentili genere* VIII-840; *potuit esse* for *esse potuit* VIII-850; *iam celi tereque creator illum* for *iam illum celi*

terreque creator VIII-896-897-898; *denuo videre* for *uidere denuo* VIII-909; *Iohanes testificat* for *testificat Iohannes* VIII-928; *literis Grecis* for *Grecis litteris* VIII-1006; *esset diligenter* for *diligenter esset* VIII-1015; *mihi faciat* for *faciat mihi* VIII-1072; *amore nate sue compunctus* for *nate sue amore conpunctus* VIII-1092; *per medium divisit tubam vero eburneam sonando oris sui* with *vento similiter* omitted, for *tubam sonando oris sui uento similiter per medium diuisit. Tuba uero eburnea* VIII-1152; *habetur dicimus status de orbe palmis* for *habet in longitudine quinquaginta tres hominibus status* IX-56; *altare in longitudine habet. In* for *altare. In latutudine vero habet* IX-59-60; *minus unum* for *unum minus* IX-62; *habentur singula* for *singula habentur* IX-73; *gubernant omnem eclesiam* for *omnem gubernant æcclesiam* IX-79; *naves magne* for *magne naves* IX-81; *fenestre habentur* for *habentur fenestre* IX-142; *nequit videri* for *videri nequit* IX-205; *dextrali in* for *in dextrali* IX-278; *pilatus sedet* for *sedet Pilatus* IX-289; *tetre larve quasi statuentes* for *tetri angeli quasi larue statuentes* IX-302; *floribus imaginibus* for *immaginibus floribus* IX-318; *Iohannes frater eius juxta* for *Iohannes iuxta eum frater eius* IX-342; *sunt tanta* for *tanta sunt* IX-367; *scilicet in corona* for *in corona scilicet* IX-407; *et est aliud altare* for *et aliut altare est* IX-435; *transmontani emuli* for *emuli transmontani* IX-463; *amplitudine et altitudine* for *altitudine et amplitudine* IX-551; *disciplorum lxxii duorum iesu cristi septuaginta duo canonici* for *septuaginta duorum discipulorum Cristi canonici septuaginta duo* X-7; *teneatur dei* for *Dei teneatur* X-39; *procurandi sunt* for *sunt procurandi* X-48; *recipiendi sunt* for *sunt recipiendi* XI-12; *panem se* for *se panem* XI-32; *lapidem in loco panis rotundum* for *lapidem rotundum in loco panis* XI-38.

Other Additions unique to M

a papa Calixto contratis for *CALIXTUS PAPA* II-3; *urbem* II-31; *floruerunt vel fronduisse* for *fronduisse* III-57; *est* III-86; *tuum* VI-21; *que decurrit* for *de* VI-93; *Aixsela que decurrit* for *Aisela* VI-94; *que decurrit ad* for *ad* VI-96; *illorum* VII-131; *ex* VII-144; *puta* VII-161; *vel* VII-174; *terram* VII-200; *sunt* VII-273; *collo ut venator collo cornum suspendit* for *cornu ut uenator collo suspendit* VII-389; *tellus* VII-488; *et* VII-489; *plena et* VII-504; *ait et* VIII-13; *que scilicet domus* VIII-106; *insculta* VIII-164; *et fortitudo* VIII-201; *eumtem in celum* VIII-285; *sic* VIII-323; *possunt neque* VIII-346; *corpus* VIII-347; *etiam* VIII-351; *Itaque sunt in mobilia* VIII-357; *in* VIII-371; *eiusdem* VIII-437; *famossi* VIII-540, cf. VIII-539; *comedentes fœnum* VIII-548; *eum* VIII-628; *qua* VIII-681; *multa et* VIII-761; *beati* VIII-765; *fide et nomine acepisse et …ut* VIII-815; *est* VIII-841; *cum* VIII-864; *et …que supererat* VIII-890; *considerabat et* VIII-906; *eum* VIII-971; *et* VIII-1023; *barbari* VIII-1041; *et* VIII-1051; *et* VIII-1071; *in loco qui dicitur* VIII-1227; *Cristi confessor* VIII-1229; *compostelle…sive eclesie sive eclesie…* IX-2; *ad ceniam* IX-10; *quatuordecim…ad* IX-98; *longitudine* IX-110; *porticibus vel portalibus* for *portallulis* IX-143; *scilicet* IX-167; *redeunt et* IX-204; *De qualitate eiusdem aque* IX-206; *id est* IX-217; *eclesie et* IX-222; *septemtrionali eclesie* for *septemtrionalis* IX-231; *est* IX-233; *sunt* IX-260; *vero* IX-272; *suis* IX-273; *marito* IX-329; *ad* IX-345; *speciebus et* IX-366; *scilicet* IX-401; *est* IX-408; *et altaribus* IX-445; *multi* IX-463; *et* IX-569; *est* IX-589; cross sign IX-607; *computantur et .L.º* IX-680; *Sancti Iacobi* X-42; *eclesie vel* X-55; *carithative* XI-5; *vero* XI-18; *id est sub ceneritios* XI-29; *egens a* XI-34; *recedens acessit* XI-35; *et panem invenit lapideum id est …invenit et* XI-38; *asumpto ad Santum Iacobum res proposuerit et dum redirent* XI-45; *Teloᵉx. id est finis.* XI-95.

Omissions unique to M

enim I-7; *Monte* II-10; *est a* II-34; *ad* II-46; *et* II-51; *constat* III-15; *scilicet* III-23; *repperitur* III-27; *inde* III-68, 70, 72; *scilicet* III-81; *inde* III-89; M omits the whole of Chapter V, like the Short Version manuscripts, but the omission is unique among the Long Version Manuscripts; *quia* VI-77; *scilicet* VI-86; *fluuius* VI-131; last paragraph of chapter omitted VI-134; *eorum* VII-130; *etiam* VII-190; *namque* VII-205; *locus scilicet* omitted, replaced by dash VII-256; *scilicet* VII-274; *hec* VII-327; *scilicet et* omitted, replaced by *vel* VII-354; *etiam* VII-453; *in* VII-461; *Beatus* VII-463; *est* VII-480; *uidebis* VIII-69; *qua* VIII-98; *domestica* VIII-121; *veneranda* VIII-136; *dominica* VIII-150; *Cristi* VIII-196; *et* VIII-202; *uero* VIII-234; *similiter* VIII-255; *scilicet* VIII-298; *una* VIII-341; *ut fertur* VIII-376; *et* VIII-408; *-que* VIII-417; *scilicet* VIII-432; *a Cristianis* VIII-450; *summi* VIII-504; *numcupatur* VIII-510; *et miraculis* VIII-525; *ac famosi* VIII-539; *etiam* VIII-567; *Lemouicensis* VIII-570; *Cristi* VIII-640; *sancte* VIII-668; *maliciam* VIII-689; *ex more* VIII-690; *Beati* VIII-727; *enim* VIII-762; *dum* VIII-863; *ceterorum* VIII-877; *illum* VIII-896; *his* VIII-904; *regis* VIII-912; *scilicet* VIII-1099; *ab* VIII-1111; *a Cristianis* VIII-1118; *trino…et* VIII-1152; *pro* VIII-1169; *aput Blauium* VIII-1177; *ibi* VIII-1217; *fecit* VIII-1228; *scilicet* VIII-1232; *urbem* VIII-1244; *episcopi et* VIII-1247; *apostoli* VIII-1256; *quesumus* VIII-1264; *est* IX-7; *de cisterna quarta* IX-29; *namque* IX-54; *Sancti* IX-58 and IX-68; *vero* IX-136 and 150; *habentur* IX-170; *invenitur* IX-234; *scilicet* IX-239; *sua* IX-262; *scilicet* IX-264;

habentur IX-268; *singulos* IX-274; *angeli* IX-302; *pulchre* IX-335; *enim* IX-337; *ceteri* for *ceterique* IX-346; *tamen* IX-370; *qui* IX-376; *lapidibus* IX-394; *Sancti* IX-411; *scilicet* IX-414; *episcopi* IX-419; *scilicet* IX-433; *condecenti* IX-456; *corpus* IX-457; *fraglantibus* IX-468; *fulgentibus* IX-470; *lateribus* IX-481; *et* IX-497; *euis* IX-498; *vero* IX-519; *scilicet* IX-522; *etiam* IX-529; *scilicet* IX-569; *per circuitum* IX-575; *vero* IX-593; *et* IX-602 and IX-610; *in* IX-619 and IX-669; *Anglorum* IX-677; *enim* IX-689; *fidelium* IX-696; *omnes* for *omnesque* IX-698; *Papa* IX-707; *vero* X-27; *Galli* XI-43; *et Sancti Iacobi* XI-52; *apud* XI-56; *prius* XI-83.

Variant Readings unique to M

CHAPTERS I-VI: *quintus Calixti papæ de Itineribus et ecclesia Beati Jacobi apostoli Argumentum* for *INCIPIT LIBER QUINTUS SANCTI JACOBI Apostoli Argumentum Beati Calixti Pape* I-1; *Aliam* for *alia* I-35; *aquis* for *Conquis* I-39; *transitu* for *transito* I-65; *sociantur. Viaque* for *sociantur vie que* I-67; *ab* for *a* II-25; *scilicet* omitted, replaced by *ipsa est* II-27; *Zebruarii* for *Februarii* II-44; *trimas unde* for *Termas* III-12; *fiterius* for *Fiterie* III-45; *pons urbigi* for *Orbega* III-63; *Porta* for *portus* (cf. T's reading *porrua*) III-67; *bulla* for *Bucca* III-74; *inde* for *in* III-81; *Campus de lemurarius* for *Campus leuurarius* III-90, cf. T's reading *Campus Leporarius*; *urbis* for *urbs* III-95; *prescripsione* for *perscripcione* III-101; *hoc* for *hec* III-107; *que* for *quod* IV-11; *qui* for *quod* VI-19; *erant* for *erat* VI-29; *illia* for *ilico* VI-33; *ab* for *a* VI-56; *usquam* for *nusquam* VI-71, but cf. *nunquam* A; *De hiteros* for *Fiterios* VI-88; *decurrit* for *currit* VI-93; *castro* for *castrum* VI-100; *solent* for *solet* VI-127;

CHAPTER VII: *orche* for *Arge* VII-11; *terrea* for *tellus* VII-29; *habentur* for *habetur* VII-37; *vocantur* for *dicuntur* VII-63; *transitu* for *transito* VII-70; *Iohanes* for *Iohannis* VII-90; *dagnantur* for *dampnantur* VII-92; *quique* for *quem* VII-94; *dagnantur* for *damnantur* VII-128; *ibi* for *hi* VII-148; *lagunia* for *Guinia* VII-164; *ac harum* for *aquarum* VII-166; *consentuit* for *consenciunt* VII-175; *voluerit* for *voluerint* VII-181; *percutiatur* for *percuciantur* VII-182; *magne* for *magnas* VII-188; *et onium* for *etiam* VII-211; *invenire* for *inueniri* VII-228; *vnus* for *primus* VII-229; *terra* for *tellus* VII-268; *videris* for *uideres* VII-301; *sicquis* for *sique* VII-302; *canem* for *canum* VII-303; *ardo* for *ardum* VII-312; *usi* for *uric* VII-322; *gentibus* for *Getis* VII-340; *gallorum* for *gallice* VII-345; *terris* for *horis* VII-352; *peram* for *Seram* VII-360; *siliendum* for *assiliendum* VII-371; *aut* for *et* VII-391; *tolit* for *tulit* VII-395; *egreditur* for *ingreditur* VII-396; *more* for *ore* VII-397; *tamen* for *tantum* VII-416; *que* for *qui* VII-432; *adversus* for *versus* VII-436; *horam. Intra* for *terra* VII-438; *Alabe* for *Alaue* VII-440; *in* for *a* VII-444; clause omitted at VII-456, inserted at 469; *a* for *e* VII-469; *partibus* for *portibus* VII-486;

CHAPTER VIII: *qua* for *que* VIII-41; *isius* for *ipsius* VIII-46; *inintelligibilia* for *inintelligibili* VIII-64; *cuntis* for *antiqua* VIII-65; *cunctis* for *cunctisque* VIII-90; *quisquis* for *quis* VIII-99; *ego* for *aio* VIII-102; *tunica* for *tunicam* VIII-113; *eius* for *Ipsius* VIII-114; *redit* for *redditur* III-126; *memorie* for *me mori* VIII-134; *aduxit* for *eluxit* VIII-139; *in gradu sexto apostolicis* for *primo gradu sex apostolorum* VIII-165; *digne* for *congrue* VIII-169; *insculpitur* for *sculpitur* VIII-170; *duo decim* for the signs of the Zodiac, VIII-171; *solis* for *solaris* VIII-172; *scilicet Benignitas et fortitudo et mansuetudo* for *Benignitas et Mansuetudo* VIII-201; *sanctas* for *Sancti* VIII-212; *malogranatorum* for *millegranorum* VIII-222; *quidem* for *quippe* VIII-225; *Ana* for *antea* VIII-229; *circuitu* for *circulo* VIII-230; *sinistra* for *dextera* VIII-232, where M is the only scribe to make the logical correction in the text, but cf. SV's marginal note; *scabello* for *scabellum* VIII-233; *sum* for *super* VIII-256; *amorem* for *honorem* VIII-270; *ereptis* for *erectis* VIII-276; *ereptus* for *erectus* VIII-291; *volans* for *uolitans* VIII-300; *scilicet corpus beati Iabobi* for *beati scilicet Iacobi* VIII-347; *defferri* for *deferre*, and cf. *transferre* P, *referre* SV, VIII-354; *nullo modo potuit de* for *nullo modo de…potuit* VIII-355; *dotissimus* for *doctissimus* VIII-372; *impleuerunt* for *compleuerunt* VIII-397; *sanctisimus* for *sanctissimum* VIII-431; *intulerunt* for *detulerunt* VIII-435; *egeni* for *Agenni* VIII-437; *conchans* for *Conquas* VIII-445; *et* replaced by *duodecim* VIII-454; *Madaglene* for *Magdalene* VIII-460; *omnium* for *universorum* VIII-472; *domicis* for *dominicis* VIII-478; *constituit* for *constituitur* VIII-490; *vrsus* for *uisus* VIII-493; *impartuntur* for *imperciuntur* VIII-497, a mis-expanded contraction; *dicitur vualliacus* for *Nualliacus numcupatur* VIII-508, 510; *crebis* for *crebris* VIII-512; *multisque frigoribus* for *multis fregoribusque* VIII-513; *loco* for *libero* VIII-517; *paruum* for *paucis* VIII-520; *et alii* for *alique* VIII-523; *venirent* for *advenirent* VIII-541; *procopiam* for *propriam* VIII-543; *et* for *etiam* VIII-545; *Qui cum apud* for *Quicumque aput* VIII-556; *testimonio* for *testimonium* VIII-580; *miraraberis* for *mirareris* VIII-581; *vetis* for *uectes* VIII-584; *visus* for *usus* VIII-588; *colunt* for *coluntur* VIII-606; *pererrexisent* for *perrexissent* with *per-* written out as well as abbreviated VIII-622; *Evultii* for *Euurcii* VIII-665; *eclesiastæ* for *æcclesia* VIII-667; *egroti* for *egri* VIII-722; *frigiam* for *Frisiam* VIII-737; *Beatissimi* for *beati* VIII-748; *qui socius* for *consocius* VIII-782; *gloriossimi* for *gloriosi* VIII-795; *misisti* for *misistis* VIII-799; *Xantanos* for *Sanctonas* VIII-802; *his similibus* for *dissi-*

milibus VIII-823; *gunca* for *Guiua* VIII-847; *enim eo* for C, A, VA, *eo eo* VIII-849; *neque* for *nec* VIII-851; *aliquod* for *aliquid* VIII-861; *eodem* for *abeuntem* VIII-866; *qui* for *que* VIII-871; *aflacue* for *adstante* VIII-875; *non* for *nec* VIII-878; *mundationem* for *emundationem* VIII-887; *quinquinque* for *quinque* VIII-888; *saturavit* for *saciauit* VIII-890; *exiberem* for *exiberet* VIII-901; *bis* for *vix* VIII-907; *quod* for *quos* VIII-913; *fili* for *filio* VIII-922; *quatridianum* for *quatriduanum* VIII-925; *confluentium* for *circumfluentium* VIII-926; *de his* for *ipse* VIII-927; *aut* for *autem* VIII-929; *advenerant* for *uenerant* VIII-930; *paulum* for *paululum* VIII-953; *translato* for *transacto* VIII-974; *constituerunt* for *instituerunt* VIII-998; *aduxerat* for *adduxerant* VIII-1000; *populum* for *plebem* VIII-1002; *remoratus* for *commoratus* VIII-1017; *panariis* for *pomariis* VIII-1030; *sitan* for *si tam* VIII-1034; *constanter* for *instanter* VIII-1039; *et* for *est* VIII-1071; *ocidiit* for *occident* VIII-1073; *signum* for *regnum* VIII-1078; *autem* for *etiam* VIII-1081; *male* for *malle* VIII-1094; *aut* for *autem* VIII-1100; *lapidaverunt* for *lapidarunt* VIII-1104; *auditum* for *auditus* VIII-1121; *iuvamenta salutatoria* for *iuuamina salutaria* VIII-1123; *omnia* for *infinita* VIII-1134; *Petronium* for *Petronum* VIII-1148; *quodam* for *quendam* VIII-1149; *fragmea* for *framea* VIII-1151; *per medium* for *scilicet* VIII-1152; *scaloribus fatigatus alapis* for *caloribusque nimis fatigatus alapis* VIII-1166; *sic fortiter ferendo* for *siti fertur* VIII-1173; *obiit* for *obisse* VIII-1176; *aradflagni* for *Arastagni* VIII-1197; *sub* for *in* VIII-1220; *fragat* for *flagrat* VIII-1221; *calciata* for *calciatam* VIII-1227; *novembris* for *Decembris* VIII-1240; *atque* for *sive* VIII-1248; *Itaque hic prefactus sanctus* for *Hii prefati sancti* VIII-1261;

CHAPTERS IX-XI: *Marquelliis* for *Macerellis* IX-14; *in* for *ad* IX-17; *alia* for *aliam* IX-80; *tamen* for *tantum* IX-91; *longitudine* for *latitudine* IX-94; *quodam* for *quidem* IX-113; *alter* for *alium* IX-148; *et alter* for *alterum* IX-149; *in hoc* for *inde* IX-169; *gradus* for *graduum* IX-173; *hoc* for *tot* IX-177; *parosidis* for *parapsidis* IX-181; *bacine* for *bacinni* IX-182; *hic* for *hinc* IX-200; *aut* for *autem* IX-207; *et* for *est* IX-226; *pariete* for *parietibus* IX-268; *levam* for *dexteram* IX-280; *sinistram* for *levam* IX-281; *insuper* for *in* IX-299; *super* for *supra* IX-303; *letatoris* for *lecatoris* IX-324; *osculas* for *osculans* IX-326; *coapta* for *coacta* IX-328; *Sed et* for *Sed* IX-353; *que* for *quia* IX-368; *ipso* for *illo* IX-377; *magistri* for *magister* IX-427; *altari* for *altare* IX-442; *Et* for *Set* IX-444; *quidem* for *siquidem* IX-450; *moveri* for *movere* IX-462; *eius* for *eiusdem* IX-473; *suas* for *sua* IX-505; *quinquenii* for *quinquenni* IX-534; *foris* for *deforis* IX-548; *mulieris* for *mulierum* IX-555; *hi* for *in* IX-579; *simul* for *similiter* IX-580; *aut* for *vero* IX-588; *dei* for *deica* IX-598; *auferri* for *auferre* IX-643; *lapidici* for *lapidice* IX-648; *aut* for *autem* IX-668; *qui* for *quo* IX-672; *famossissimi* for *famosi* IX-674; *positus fuit in* for *ponitur* IX-681; *auditum* for *auditus* IX-692; *currunt* for *occurrunt* IX-700; *eius* for *eiusdem* IX-710; *ante* for *antea* IX-713; *Capitutolum* for *CAPITULUM* X-2; *beati* for *SANCTI* X-3; *In primis* for *decima* X-40; *Nantium* for *Nantuaivm* XI-25; *montem gebenam* for *Gebennam* XI-26; *per* for *petenti* XI-27; *panes* for *panem* XI-29; *et non* for *nec* XI-54; *ipsi* for *ipsum* XI-79; *atque* for *sitque* XI-80; *libenter* for *diligenter* XI-86.

Variant Readings shared with Other Manuscripts

List of chapters, omitted, I-10 as in T, R, VB, Z; *parve* for *pauce* II-4 P, M, T; *usque ad* for *usque* II-21 M, T, SV; *hospitale* for *hospitalis* III-7 P, M; *egentium* for *egentum* IV-19 S, P, M, VB, Z; the *i* is added superscript in R; *in* omitted VI-2 C, A, VA, M, R, VB, Z (passage omitted in P and T), *in* present in S, SV; *quod* for *qui* VI-25 M, Z; *ipsi* omitted VI-34 M, VB, Z; *decurrit* for *defluit* VI-115 M, T; *fœmoralia* VII-135 P, M, cf. S *femorialias*, C *femoralias*, SV *sic* in margin; *et* added VII-156 P, M; *qui* for *quod* VII-194 M, R, Z, cf. VB *que*; *palpitare* VII-207 M, R, VB, Z, cf. *palpare* P, *palpitari* C; *qui* for *quod* VII-214 P, M, R, Z, cf. *quod* VB; *in* added VII-245 S, P, M, R, VB, Z; *olim* omitted VII-257 M, R, VB, Z; *abarcas* for *lauarcas* VII-279 M, Z; cf. R, VB *avarcas*; *quas* for *quos* VII-288 M, Z; *cum* omitted, VII-295 M, Z; *solent* for *solet* VII-297 M, SV, R, VB, Z; *aquam* for *aqua* VII-321 A, P, M, Z; *vulve* omitted, replaced by *Sed ipse*, VII-365-366 M, cf. Z's longer omission here; *vocant* for *vocat* VII-393 M, VB, Z; *et* added VII-408 P, M; *aut* for *autem* VII-429 M, VB; *aut non legitima* for *aut legitima* VII-451 P, M; *in cuntis* for *incultis* VII-507 P, M; *monachorum* for *monacharum* VIII-22 S, M, cf. P; *erepta* for *erecta* VIII-39 P, M; *celebratur* for *celebretur* VIII-82 S, M; *confessoris piissimi* for *piissimi confessoris* VIII-85 P, M; *summo opere* VIII-87 M (cf. P *sumo opere*) for *summopere*; *duodecim*, correcting *xx*^ti C, A, VA VIII-171 P, M, cf. *.xii.* S; *celos* for *celum* VIII-277 M, SV; *a uobis in celum* for *in celum a vobis* VIII-284-285 P, M; *Dominum* omitted VIII-295 P, M; *est enim* for *enim est* VIII-462 P, M; *ungento* for *unguento* VIII-469 C, M, see above under C; *Ierosolimitan* for *Iherosolimitanis* VIII-475 P, M, SV; *prospicere* for *perspicere* VIII-862 S, M; *nequit* for *nequiuit* VIII-895 S, M, L; *cum* for *eum* VIII-955 P, M; *quod* for *quidam* VIII-1087 S, M; *sepelitur* for *sepelierunt* VIII-1181, M cf. *sepellitur* P; *retulere* for *detulerunt* VIII-1216 M, cf. *detulerit* P; *confessoris* omitted VIII-1226 S, M; *summo opere atque* M for *summo pereatque* C, emended to *summopere atque* A,

VA, P, *sumopere atque* S, VIII-1257; *porta* for *portali* IX-76 M, SV; *quorum* for *quarum* IX-82 S, M; *dimidii* for *dimii* IX-93 S, P, M, SV; *oportuno* for *obtimo* IX-453 S, M; *eius* omitted, IX-628 M, VB, Z; *et* omitted IX-633 M, VB; *vuicarto* for *WICARTO* IX-658 M, cf. *Vicario* A, *Vicarto* VA, *vicario* S, *Guicarto* P, *Vvicarto* SV; *canonico* for *canonice* IX-660 M, SV; *Palmas* for *Palmos* X-33 M, R, VB, Z; *sunt* for *sint* XI-4 S, M, R, VB, Z.

Conclusion

M's scribe, Juan de Azcona, was an independent thinker. His enormous number of unique additions, omissions, changes in word order and classicizing or Spanish spellings, indicate that he was not a servile copier. He seems to have disliked filler words such as *scilicet* and *vero*, both of which he frequently omits. A number of alterations indicate his fondness for passive infinitives. At the same time, many of the variants suggest that he had difficulty expanding abbreviations, in particular for 'q-' words—perhaps simply because he was working rapidly. Though only one of his misinterpretations of a q-word (VIII-1087) is shared with S, he has similar difficulties at IV-11, VI-19, VII-94, VIII-41, VIII-99 and IX-113. On the whole, C is unambiguous in this respect, and therefore presents a problematic exemplar for M. M also mistakes—or changes—endings on words, which again suggests that they were abbreviated in his exemplar. But, as noted above, M's version of Book I does reflect C's misbinding, dating somewhere in the period *c.* 1325-1538, and not reflected in any of the other Long Version manuscripts.[45]

Several further points suggest that for the *Guide*, M is unlikely to be copying directly from C. At VII-416, C Hand 1 writes *tantum*; with an abbreviation mark for the 'm'; M copies *tamen*, a reading which would be possible from a confusion between the abbreviated forms of *tm* and *tn*, but which could not be arrived at from the abbreviation that is in C. At VIII-782, M has *qui socius* where C's Hand 2 has *consocius* written out in full; an exemplar with a 9-shaped abbreviation for the syllable *con-*, easy to confuse with the letter q, would seem a likelier source. Similarly, M reads *nec* for *non* at VIII-878, possibly a mistaken expansion of a contraction, but not from C, where *non* is written in full by Hand 2. M reads *gentibus* for C Hand 2's *getis* at VII-340, which looks as if he is rationalizing the grammar of a model which read *gentis*. At V-7 M has *circa* and so does not align with C, S, and T, but this could be a *lectio facilior*.

On the other hand, M reads *enim eo* at VIII-849, where C's Hand 2, A, and VA all read *eo eo*. The other manuscripts S, P, SV, L all have only one *eo*. This looks like M trying to make sense of what is in C. M is also in agreement with C Hand 2 over the number of warriors killed at Roncesvalles (VII-262), giving *centum quadraginta*, written out in full as in P. And at VIII-497 M reads *impartuntur* for *imperciuntur*; C's Hand 1 writes the *per* abbreviation.

It is possible, then, that M had access both to C and to another copy, textually very close to C. As with S's presumed model, the other version would most likely have been written with many more abbreviations than C. As we have said above, one of S's omissions *confessoris* VIII-1226, one addition in VII-245, and twelve readings are shared with M.

M shares one omission with P (*Dominum* VIII-295); 3 minor additions, at VII-156, VII-245, VII-408, together with the possibly more significant *aut non legitima* for *aut legitima* at VII-451; 3 word-order changes, 12 readings, 5 closely similar readings, and several cases of numbers written out in full, listed above under P. Eight readings are shared with SV, and a few with T and with the Short Version manuscripts R, VB and Z. None of the links with the Short Version are significant; see discussion of that tradition below. The only reading shared by the four Long Version manuscripts P, S, T, and SV seems to be a shared case of misexpanded contractions, suggesting that all four Long Version manuscripts were working from models more heavily abbreviated than C: *oportuno* for *obtimo* (IX-453, S, M but not P or SV). There is no clear case for a common model, and historical circumstances argue against it. For none of the manuscripts do we need to postulate a model antedating C; it is more probable, for M as for S, that their exemplars were copied from it after *c.* 1325, after the quire in C's Book I became disarranged, but perhaps in the wake of the copying of A, VA and S around 1325. One might argue that M's links with S, P, T and R, each of which may derive from an earlier model, might suggest that M, too, derives at least in part from the same early model or from a copy derived from it. But none of the variants offers indisputable evidence.

Perhaps a more plausible conclusion is that we have M's fair copy, from Juan de Azcona's own earlier rough draft, which might well have been more heavily abbreviated. The manuscript is an assemblage

of related texts, in a hand which, given the conventions of its period, is relatively easy to read. (Those who remain unconvinced are invited to spend half an hour with a random collection of sixteenth-century Spanish documents.) One hesitates to posit complete rough drafts in the twelfth century, because of the scarcity and price of parchment. But by the sixteenth century, paper was cheap, and a scribe might well make a fair copy from his own rough draft.

M's omissions and rearrangements of text indicate that no surviving manuscript was copied from it.

SV: Madrid, Biblioteca National, 7381

SV was copied in June and July 1657, from a copy made in 1632, which itself derived from an ancient, damp-stained exemplar belonging to the church of St Isidore in Seville, as recounted in the colophon at the end of the volume.[46] It contains parts of the *Codex Calixtinus*, Books I-V, without the supplementary material which follows Book V in C and without the notation, or space for it, in Book I. But the exemplar had notation, for SV comments on it, and uses wavy lines to indicate where it occurred. Like C, A, and VA, it calls the compilation *IACOBUS* on f. 1. SV differs from C, A and VA in omitting to copy in full any text of which he had a printed edition available. This included the sermons of Calixtus, the authentic sermon of Bede, and much of *Pseudo-Turpin*. He omitted Chapters X-XX in Book I, and has one substantial omission, most of the Passion of St Eutropius, in Book V. SV reproduces its model's decorative script, which looks remarkably close to the display script in A, VA and S, all of which date *c.* 1325.

Word-order Changes in SV

a demone arreptus for *arreptus a demonio* VIII-115; *proprium nomen* for *nomen proprium* VIII-534; *sunt petenda* for *petenda sunt* VIII-1140; *fulgentibus celestibus* for *celestibus fulgentibus* IX-469.

Additions in SV

suas III-104; *dixerunt mihi quod sana erat aqua* for *dixerunt quia sana erat ad potandum.* VI-29; *in* VII-51; *sydus* VIII-152; *intus domus, sed extra* for *intus quanta sit extra* IX-64. None of these additions appear in any other manuscript.

Omissions in SV

Where the exemplar was defective in a single word, SV's scribe indicates the problem by substituting dots (*ills. 84, 85*), as for example following *deorsum* VIII-250; there are many longer gaps of a similar nature, also indicated by dots, which are too numerous to list here, but which are indicated in the notes to the Latin collation. The following list is of omissions in SV not marked by dots, which are therefore likely to have already been omitted in SV's exemplar, or to be errors on his part:

et perimere VII-234; *temporibus* VII-462; *sua* VIII-143; *inicia* VIII-245; *liberabit...Reuelamini*, the last paragraph about St Leonard VIII-598; *energuminosque* VIII-711; *primum* VIII-775; *quem...ipso ergo* VIII-843-1125, the bulk of the Passion of Eutropius. Preface and part of first sentence and entire last sentence included; *qui...paganorum* VIII-1204; *de fontis* for *de fonte Sancti Iacobi* IX-162; *Septemtrionalis* IX-231; *in pariete* IX-246; *mater* IX-293; *ei* IX-306; *est altare Sancti Nicholai inde* IX-403; *actenus* IX-446; *IN ROMA* XI-87.

Variant Readings unique to SV

decurrit for *defluit* VI-50; *fortem* for *forte* VII-58; *paucis in gradu oportet* for *paucis ingredere nauim* VII-105; *omnibus* for *dominis* VII-165; *numerum* in text, with note in margin *Sic cum legi debeat nummum*, where C does in fact read *nummum* VII-185; *Beato* for *Sancto* VII-222; *Et* for *Quapropter* VII-224; *Domino* for *Deo* VII-386; *quas* for *quam* VII-460; *Sanctissimus* for *Beatus* VII-463; *ad Christi fidem* for *ad Dominum* VII-468; *Episcopus* for *antistes* VIII-12; *festiuius* for *festiuitas* VIII-23; *conspexeris* for *perspexeris* VIII-67; *et* for *atque* VIII-86; *emittens* for *amittens* VIII-144; *que* for *et* VIII-215; *Consataniani* for *Constanciani* VIII-330; *referre* for *deferre* VIII-354; *Guillermi* for *Guillelmi* VIII-363; *derilit* for *detulit* VIII-383; *atque* for *ac* VIII-412; *qui...spelunca* in parentheses VIII-439; this is a mark of punctuation not used in other manuscripts. SV uses them again at VIII-547. *Marria* for *Maria* VIII-463; *sepulturum* for *sepulturam* VIII-480; *peccatorum* for *peccatoribus* VIII-491; *generis* for *genere* VIII-502; *nobilissimi* for *nobilissimus*

VIII-503, to agree with the previous reading; *Nobiliacus* for *Nualliacus* VII-509; *corrigit* for *corripit* VIII-549; *rei excitunt qui* for *religantur* VII-564; *dicitur* for *hic* VIII-597; *Aurelianensi* for *Aurelianensium* VIII-662; *eius* for *cuius* VIII-780; *Constantinopoli* for *Constantinopolum* VIII-788; *exoramus* for *exoro* VIII-804; *quia propter per has tribulationes* for *quia per multas tribulationes* VII-827; *sananda*, note in margin *pro sonando*; C reads *sonando* VIII-1155; *in* for *de* IX-115; *lapidicimis* for *lapidicibus* IX-116; *crugillæ* for *cingule* IX-121; *canonicis* for *Canonica* IX-156; *Grammaticis* for *Gramaticorum* IX-160; *fontibus* for *de fonte* IX-162; *alia* for *apta* IX-190; *per quos iiii*[or] for *per quorum ora quatuor* IX-193; *atque* for *et* IX-199; *subter* for *subtus* IX-203; *pontem* for *fontem* IX-223; *parte* for *persona* IX-257, probably misreading an abbreviation; *parte* for *ordine* IX-292; *levam* for *sinistram* IX-338; *Apostolus* for *Sanctus* IX-341; *rebus* for *operibus* IX-351; *tenentem* for *tenentes* IX-356, with a note in margin–*sic*; *domus* for *dicimus*, with a note in the margin, *Sic pro tegulis* IX-399. S's exemplar, like C, probably read *ds'*; *Sed hactinus* for *Set enim* IX-444; *scilicet* for *siquidem* IX-450; *xxii.* for *.xii.* IX-477; *et sursum* for *clausum* IX-483; *xxii.* for *.xxi.* IX-493; *hronus* for *tronus* IX-500; *et totidem* for *totidemque* IX-508; *convenienti* for *congruenti* IX-552; *deinde* for *deintus* IX-553; *erecti* for *recti* IX-558; *prenuntiant* for *pronuntiant* IX-566; *effigiem* for *effigie* IX-611; *Vvicarto* for *Wicarto*, in a reading close to C, IX-658; *CLUNIACENSES* for *CLUNIACUM*, suggesting an abbreviated form in the exemplar XI-95.

Variant Readings shared with Other Manuscripts

solent for *solet* with *omnis familia* as subject VII-297 M, SV, R, VB, Z; *celos* for *celum* VIII-277 M, SV; *opinionem* for *opinione* VIII-538 S, SV; *porta* for *portali* IX-76 M, SV; *ut puto* omitted IX-185 S, SV; *flagrantibus* IX-468 S, SV, VB, Z for *fraglantibus* C, A, VA, P, R; word omitted M—Is this a *lectio facilior*? These shared readings would not seem sufficient to posit any close relationships; SV's pattern of omissions and additions also shows that is does not align with any other extant manuscript.

Relationship of SV and its Exemplar to C

SV's ultimate exemplar was the damp-stained, and partly illegible Seville manuscript he refers to as *Exemplar Hispaliensis*. The 1632 colophon he copies, which we transcribe in the Catalogue of Manuscripts, indicates that the monk Peter had two different copies from the *Exemplar Hispaliensis*, one made at an unknown place (? Seville), the other made by himself in his cell in Granada in 1632. SV is a copy of that second copy, made at Estepa, near Seville, in 1657. Our full discussion of the one or two lost manuscripts are in the section on Lost Manuscripts below. We here assess the textual evidence for how close SV's exemplar or exemplars was to the rest of the *Pilgrim's Guide* tradition.

SV would seem to have been a careful scribe, who retained readings in his exemplar even when he disagreed with them. A number of readings suggest that the *Exemplar Hispaliensis* must have been very close to C as written by Hand 1. At V-7 SV reads *citra*, along with C Hand 1, S, P, and T, but not A or VA; M omits the chapter. At VII-340, he reads *Getis*, not *gentis*, for the Geats and Saracens, with C Hand 2 (and, as we argue above, C Hand 1's original version); *VVicarto* at IX-658 is very like C Hand 1's *WICARTO*. At VIII-171, SV retains C Hand 1's reading of twenty signs of the zodiac; the scribe writes *xx*, with a *signe de renvoie*, and *sic* in the margin. At VIII-232, he retains C Hand 1's *dextra* for what should be *leva* or *sinistra*, and notes in the margin: *sic legitur sinistra*. He differs from C in reading *dimidii* rather than *dimii* at IX-93, a reading shared with S, P and M.

A number of features about SV suggest, however, as with S, P, and M, that its exemplar was probably not a twelfth-century manuscript. Many of SV's unique variants seem likely to arise from reading a more heavily abbreviated and closely written copy than C, or any twelfth-century scribe, would produce. SV frequently gives a word the wrong ending: *-is* for *-bus*, *-em* for *-e*. Readings like *decurrit* for *defluit* VI-50, *omnibus* for *dominis* VII-165, *referre* for *deferre* VIII-354, *Guillermi* for *Guillelmi* VIII-363, and *derilit* for *detulit* VIII-383, all suggest a closely written script, in which ascenders are not very tall. Writing *-em* for *-e* is a mistake one is likely to make if there is not much space between the lines, so that the bottom of a letter in the line above can be read as an abbreviation mark. One variant may indicate a heavily abbreviated model: *parte* for *persona* at IX-257 which might be a mis-expansion from a model with the *per* abbreviation and also an abbreviation for the 'e'; C's Hand 1 has only the first abbreviation, writing out *-te*.

SV tries to reproduce the decorative script of his exemplar precisely; he says so on f. 1: *Su principio es como se sigue i con esta misma forma de letras el titulo que en el es de letra colorada*. His forms of the

letters E, T and G in particular, with very curled finials, and a line closing up the right side of E, look thirteenth-century or later—they are not unlike the display script of *c.* 1325 in A and VA—rather than twelfth-century; so SV's exemplar is more likely to have been copied after C rather than before. There is certainly no textual reason for positing an exemplar for SV that is earlier than C.

There is another clue as to what SV's direct exemplar was like. At the end of Ch. IX is a gap in SV, at IX-708, to which is appended an explanatory note: *Reliqua per tres pagines desiderantur in Exemplari Hispalensi penitus obliterato et putredine ac situ obscuro* (the last word, *obscuro,* is difficult to read). *Post quas paruula hæc ut cumque legi potuerunt.* (For three pages, the rest is lacking in the Seville Exemplar, nearly obliterated and rotted and obscure on the page. After those [pages], these few things here could be read.) If this indeed means that 21 lines of C's f. 212v, and 30½ lines of C's f. 213, or a total of 51½ lines of C equal three pages of SV's *Exemplaris Hispalensis,* then the latter would have only 17 lines to a page. This measurement eliminates any of the extant manuscripts from consideration as SV's *Exemplar Hispaliensis.*[47] It had only half to two-thirds as much writing to a page as any of these extant copies. In any period, a volume with only 17 lines per page would be an unusually small text volume—or perhaps one written in a very large script.

T: London, British Library, Cotton Titus A. XIX

This is the one English manuscript of the *Pilgrim's Guide,* dating, by watermarks, from about 1460-89. It includes a version of the *Pseudo-Turpin* belonging to Hämel's Picard/English group,[48] but with additional material. The text of the *Guide* comes to an abrupt halt in mid-sentence early in Chapter VII. The rest of the leaf, and blank spaces in subsequent leaves, contain theological notes, some from Nicholas of Lyra, in another more rounded hand, which can be dated 1539-45.[49]

Only on the Glastonbury tablets can T's scribe be checked against a known exemplar, and there he is reasonably careful. The state of his *Guide* text suggests that he was not working from a very good exemplar. Most of T's variants are simply spellings (too numerous to list here but all recorded in the Latin notes), or omissions.

Variants in Names

quonquis for *Conquis* I-39; *Tubonensem* for *Turonensem* I-46; *Angliacensem* for *Angeliacensem* I-53; *Lacca* for *Iacca* III-10; *Osturra* for *Osturit* III-11; *Belliforesta* for *Belfuratus* III-38; *Oqueo* for *Oque* III-39; *Taporca* T for *Altaporca* III-40, cf. all others except S, which reads *Altaporta*; *Alterdalcia* for *Alterdallia* III-42; *porrua montis Irati* for *Porta montis Iraci* III-67; *Vrinie* for *Minee* III-87; *Leporarius* for *Leuurarius* III-90; *Castamella* for *Castaniolla* III-92; *Ferretus* for *Ferreras* III-93; *rogus* for *Rotgerius* V-12; *Rumpna* for *Runa* VI-13, 16; *Hiberna* for *Ebra* VI-53; *FFisorga* for *Pisorga* VI-85; *Sicerie* for *Fiteris* VI-88; *Escola* for *Aisela* VI-94; *Burma* for *Burdua* VI-111; *fluuio Garrona* for *flumine Garona* VII-5; *Galconica* for *Gasconica* VII-7; *per ortum Cisere* for *portum Cysere* VII-14; *Burdegalentium* for *Burdegalenses* VII-33; *longe* for *Lande* VII-45. Occasionally he adds a name. At II-40, for example, T inserts *Februariis* to read: *portibus Februariis Montis,* but the word occurs in the line below. Occasionally, when he could not read a name, he left a blank space, as at III-75, for *Uillaus.* The same problem occurs with proper names. T gives *rogus* for *rotgerius* V-12; *aluicus* for *Aluitus* V-13; *forus* for *Fortus* V-14.

Word-order Changes in T

Esse testentur vera for *uera esse testantur* I-9; *montis eiusdem* for *eiusdem montis* III-21; *que scilicet* for *scilicet que* VI-86; *parte alia* for *alia parte* VI-132; *utuntur bibere* for *bibere utuntur* VII-84.

Additions in T

quia IV-23; *qui* VI-78; *aque* VI-138.

Omissions in T

T omits all headings, including the preface, and also the chapter list; *que* I-24; *Montis* II-43; *Borcia* III-6; *urbs* III-64; *Uillaus,* space left blank III-75; *inde Linar de Rege* III-80; *Isui* VI-125; *sic* VI-136; *eligere* VI-137; *terra* VII-8; *et* VII-12; *melle* VII-51; *pauperum* VII-80; *Sancti* VII-89; *ui etiam* VII-96.

Unique Variants in T

suum for *unum* I-24; *coadunatur* for *coadunantur* I-28; *transeunt* for *transit* I-69; *a* for *ad* II-18; *parva* for *pauca* II-23; *portubus* for *portibus* III-16, IV-12, VI-5, VI-12; *iuxta* for *inde* III-43; *omnis fertilitatis* for *omni fertilitate* III-49; *froridnose* for *fronduisse* III-57; *inde* for *de* III-73; *retraxi* for *restrinxi* III-102; *sustinendum* for *sustinendos* IV-4; *hospitale .s. Montis Iocci* for *hospitale Montis Iocci* IV-9; *Domini* for *Dei* IV-17; *quedam* for *quorumdam* V-3; *fecerunt* for *refecerunt* V-11; *admentorum* for *adiutorumque* V-16; *partibus* for *portibus* VI-7; *flunem* for *flumen* VI-8; *quod* for *quia* VI-22; *qui* for *que* VI-24; *proximo* for *proxime* VI-73; *egrotaverit* for *egrotaveris* VI-74; *qua* for *que* VI-113; *ducat* for *distat* VI-117; *super* for *inter* VI-128; *in* for *et* VI-129; *Occidentem decurrit sanum* for *Ocasum defluit sanus* VI-133; *in* for *et* VI-139; *homines* for *heroes* VII-21; *hospitalitate* for *hospitibus* VII-27; *qui* for *que* VII-34; *circum* for *trium* VII-46; *gragnis* for *gruguis* VII-55; *amarissimis* for *immanissimis* VII-60; *cauones* for *tauones* VII-62; *fluminibus quia* for *fluminibusque* VII-74; *tempore* for *turpe* VII-87.

Sometimes T's scribe puts plural verbs for singular, as in *transeunt* I-69 for *transit*, or vice versa: *sustinendum* for *sustinendos* IV-4; or changes the person: *egrotaverit* for *egrotaveris* VI-74. Sometimes he changes cases: for C's *omni fertilitate*, T gives *omnis fertilitatis* III-49.

Variant Readings shared with Other Manuscripts

Chapter list omitted M, T, R, VB, Z, I-10; *Angliacensem* for *Angeliacensem* I-53 T, Z; *parve* for *pauce* II-4 P, M, T; *ad* added II-21 M, T, SV; *vero* omitted II-49 P, T; *egentum* IV-19 C, A, VA, T, cf. *egentium* S, P, M, R, VB, Z; *decurrit* for *defluit* VI-115 M, T; *ea* for *eo* VI-120 P, T.

T shares a few readings with M, to which it is reasonably close in date. They both read *parve* at II-4 for *pauce*. But T also reads *parva* for *pauca* at II-23, where M retains *pauca*. The previous sentence reads *ipsa est parva*, and T may be repeating the word from there.

One reading suggests a dependence of T on something close to C. At V-7 *citra* for *circa* is a reading shared only by C Hand 1, S, P, T and SV. A and VA have the *lectio facilior*, *circa*. If we eliminate S as T's source, then T must be copied directly from C Hand 1 or from an intermediary very close to C. It cannot be P, which is later than T, but it could be P's ultimate model, which may have been copied as early as 1138;[50] and P and T share one omission and two minor variants in addition to the *citra* reading. But Pistoia is an unlikely place to find an English scribe.

Two readings may indicate that T was not copied directly from C: at V-12, T reads *rogus*; A, VA, S and C Hand 1 all write out *Rotgeri*[9], with a figure 9-shaped '-us' abbreviation. This particular mistake would make sense if T's exemplar had the abbreviated form, *rog'ius*. Unlike the place names, *Rogerius* could scarcely be a name unfamiliar to a fifteenth-century Englishman. The second instance is at VII-87, where T gives *tempore* for C Hand 1's *turpe* written out in full. T's reading could be a mis-expansion from a contraction such as *t'pe*. But, of the extant manuscripts earlier than T, only A (which cannot be T's direct exemplar, as it reads *circa* at V-7) has *t'pe*. In addition, at VI-22, C reads *q'a*, and T reads *quod*. As the words are synonymous, this could be just one more of T's small changes.

T's exemplar could not be S. T includes the fifth road at II-28, which S omits. Together, these variants show that T's immediate exemplar cannot be any of the extant copies, but again was likely to have been an abbreviated version close to C Hand 1. T's text has ended by VII-97, before C's Hand 2 first appears, so it is not possible to determine whether T would have to depend ultimately on a pre-or a post-Hand 2 version of C. Since T's text also lacks the passages including the solar signs and *dextera*, there is nothing to suggest that its model was earlier than C. Historical reasons may suggest that T's ultimate model, like P's ultimate model, was a twelfth-century copy, and we present them below under Lost Manuscripts.

There is no historical evidence to suggest that the scribe of the *Codex Calixtinus* parts of T himself travelled outside England; almost all the texts concern English history, and the *Ogier the Dane* insertion in *Turpin* was available only in England. His immediate exemplar for *Pseudo-Turpin* and the *Pilgrim's Guide* is overwhelmingly likely to have been English.

L: Lisbon, Biblioteca Nacional, Alcobaça CCCII/(334)

L's few selections from Chapters VII and VIII are assembled in an eclectic order, often with small headings of their own, such as ITEM (VIII-19, 26, 357) or ALIUM [*sic*] (VIII-54 and 428) or AIUD

(VIII-657, 1188), or AL', which could be ALIUM or ALIUD (VIII-405, 610, 726, 747) or CAPITULUM (VIII-1242, 1255, 1260). The primary focus of the volume is St Martin of Tours, and it was presumably made, or depends on a model made, for a centre where St Martin was of primary importance.[51]

Some of L's variants, including all those from his brief excerpts from Chapter VII, are spellings. In Chapter VIII, there are occasional word reversals, and some variants. At VIII-3, both L and S read *qui* for *que*. But most of L's readings are unique to it, such as *rome* for *Romam* VIII-1010; *flatu* for *vento* VIII-1156; *fabricata est* for *fabricatur* VIII-1164. Most of L's variations are omissions which no other manuscript shares. They are *et obtima* VIII-29; *optima* VIII-38; *excepto in illo* VIII-61; *igitur* VIII-358; *martirum* VIII-393; *fluvium* VIII-398.

There are two instances where L's omissions align with the manuscripts of the Short Version: in Chapter VIII, where L omits VIII-1182 (St Severinus) and VIII-1224 (St Dominic), so do R, VB, and Z. Both passages are brief, and, given L's extremely selective text, the sharing of these omissions is likely to be coincidental. At VIII-1162, for instance, L omits *quedam*; but the word is in the Short Version manuscripts. Elsewhere, the Short Version has gaps where L has texts: for instance, L contains the Passion of St Eutropius at VIII-776 ff., and *Primitus namque his* at VIII-7. Therefore its exemplar must have either have contained the Long Version or must depend on the alternative tradition for its Book V, Chapter VII and Chapter VIII selections, the *Libellus* or 'Revised Version'.[52]

The only readings which might indicate that L's immediate exemplar was a manuscript other than C occur at VIII-3 and VIII-895. In the first instance, L and S both read *qui* for *que*; in the second, L, together with S and M, has *nequit*; C *et al.* have *nequiuit*. But there are no other links between L and either S or M, and these two readings alone, each of which could easily arise independently, hardly constitute a case for a common model.

Although L does not include text from the passages with most of the readings in C that are significant for determining affiliation, in the two cases where L has text, at VIII-993 he copies C Hand 1's reading of *cetibus*, and at VIII-853 he copies C Hand 2's *impueritia*. From the collation of the *Pilgrim's Guide* text selections, then, there is no reason why L's exemplar could not have been C in its present state, as copied by Hands 1 and 2. Unless one were to assume that his copying of *impueritia* were a chance alignment with C's Hand 2, there is nothing to suggest that L presents a text that antedates C or depends on a different textual tradition. All that is necessary is an exemplar with *i'pueritia*, or a hasty reading. As we would expect from his eccentric selection, L is also the end of a line of transmission; no other manuscript of the *Pilgrim's Guide* depends on it.

Manuscripts of the Long Version: General Conclusions

C is the earliest surviving manuscript. It is in good condition, but contains a considerable amount of later annotation, as Díaz y Díaz has shown.[53] In terms of decoration, it is fairly elaborate. It probably functioned as a display copy, but was also available for copying.[54]

The collation of the *Guide* suggests that there was another such exemplar available for copying. VA and A depend directly on C in its present state, with the *Guide* as copied by Hands 1 and 2. *Citra* (V-7, C Hand 1) and *dimii* (IX-93, C Hand 1) are the only two readings they do not share with C, and the correction of each could be a *lectio facilior*. Nothing else suggests that their *Pilgrim's Guide* text was copied from another exemplar, and the close dependence of their illustrations, particular in the case of VA, suggests that they had C itself in front of them. L would also seem, from its very few variants, to depend directly on C in its present form. While P is most likely to depend directly on a thirteenth-century exemplar, that copy seems to be a direct descendant of C, perhaps as written by Hands 1 and 2, but more likely made at an earlier stage, from C's Hand 1 alone. It is also likely that T's ultimate model depended on C, but T's situation in the *Guide* stemma is difficult to assess as most of the readings that are significant to the stemma occur after T's text has finished. Its relationship to the *Codex Calixtinus* as a whole is complicated by the fact that its *Pseudo-Turpin* belongs to a different recension than that of the other manuscripts containing the *Guide*. SV tells us that his problematic exemplar at Seville was hard to read, and had music: nothing corresponding to his description, according to which the manuscript was probably rather small, now survives. The collation of SV shows that it was probably also heavily abbreviated, yet retained display script with early four-

teenth-century characteristics and, as far as the text was concerned, depended closely on C as copied by Hands 1 and 2.

That leaves S and M, the two most complicated manuscripts of the Long Version. S seems to derive ultimately from a version in which the *Pseudo-Turpin* was illustrated (perhaps written in two columns), and heavily abbreviated. Either this was a version earlier than C's Hand 1 and there was at least one further intermediary between it and S, to allow for the introduction of heavy abbreviation, or it derived from C's Hand 1, and there was again an intermediary with the illustrations altered and the text heavily abbreviated. But the illustrations could have derived from an illustrated manuscript that contained only the *Pseudo-Turpin*. Textually, there is nothing that requires, unequivocally, an earlier model for the *Guide* in S than C Hand 1, assuming that Hand 1's version of the battle of Roncesvalles had 40,000 warriors dead. S's scribe copies C Hand 1's *dextera* and *cetibus*, and could himself have changed the solar signs from 20 to 12. S's exemplar is not likely to have been the same heavily abbreviated model as SV used, because S does not include the *titulus* with the name *IACOBUS* at the beginning of Book I, because there are few unique S/SV alignments filiation: *opionem* for *opinione* VIII-538; the omission of *ut puto* IX-185. SV includes some key readings of C Hand 2, which S does not, and because SV's model was small and presumably written in one column, while S's was large and written in two columns.

M is the most difficult of all the Long Version manuscripts. A full understanding of its position would need to be based on a complete collation of its other texts as well as the *Guide*. The relation of M to C's Book I shows a direct dependency on it, or on something closely based on it, copied after *c.* 1325, because around that date A and VA copied C directly, with Book I in correct original sequence. The evidence, as the *Guide*'s text presents it, is conflicting. Some readings seem to depend on C's Hand 1, but others do not. There are also some readings that seem to derive from C's Hand 2 and others that diverge from it. Juan de Azcona, M's scribe (like the scribes of S, T and SV), seems also to have had a heavily abbreviated exemplar before him. In Juan de Azcona's case it is likely to have been a fourteenth-century copy, if we assume that it included a close copy of C's Book I. It is unlikely, then, that his heavily abbreviated exemplar was the same as those of S, T and SV; but it is also possible that Juan de Azcona had access to, or made himself, more than one copy.

II. *Manuscripts of the Short Version of the 'Pilgrim's Guide'*

Three manuscripts transmit a shortened version of the *Codex Calixtinus*, including the Short Version of the *Guide*: R, VB and Z.[55]

R: Barcelona, Arxiu de la Corona de Aragó, Ripoll 99

Of the Short Version manuscripts, the earliest is R. R's colophon, on f. 85 (*ill. 41*), following the end of the *Guide*, states that it was copied in 1173 in Santiago by Arnault de Munt, monk of the Benedictine abbey of Ripoll. There is nothing in R itself to contradict the idea that the colophon is to be believed.[56] In the *Guide* section, there are no variants between C Hand 1 and R; this indicates that the scribe's model was either a copy written entirely by C Hand 1 or another closely related copy. In discussing C, we note the particularly close relationship between the pen-flourished initials in most of R and those that accompany the script of C's Hand 2.[57]

The original quire numbers (vii-viii; 1-v, [ix unnumbered]) are still visible on the centre of the bottom of the last leaf of each quire except the last. As the original quiring indicates, Arnault began with the 22 miracles which comprise Book II in C, adding at the end the two miracles of Book I in C (W 20-21), then two miracles copied after the *Guide* in the additions at the end in C (the Miracle of 1164 and the miracle that follows it in C) and the three miracles from *Guide* Chapter XI; then the miracle of 1139 and the false bull attributed to Innocent II, found among the texts added at the end of *Guide* in C. That is followed by selections from what is in C Book III, the Translation, Book IV (*Pseudo-Turpin*), and selections from Book V. Arnault omitted most of Book I, the Liturgy, retaining parts of the mass and including chants with notation; but he changed the order of books in the course of copying, as is clear from the fact that the explicit to Book I and the opening heading to Book II, in the original hand, both occur on f. 35.

The omissions in the Short Version manuscripts are discussed above,[58] and summarized in the Table of Book V.[59]

In general, Arnault was a careful scribe whose copy is clear and legible. His *Guide* text reflects very few variants from C. None of C Hand 1's readings crucial for the filiation of the Long Version manuscripts occur in passages included in the Short Version manuscripts: V-7, VIII-171, VIII-232, VIII-993, IX-93 and IX-658, all discussed above. This is clear evidence that the text that R selects is extremely close to C Hand 1, as has been surmised in previous scholarship for Books I, II and III of the *Codex Calixtinus*.[60]

It is highly significant that the readings in which R, and the other Short Version copies, VB and Z, differ most clearly from C are in the key readings by C's Hand 2 already discussed in relation to the Long Version manuscripts. For three of them, the Short Version manuscripts include the reading in their text. The most important is the warriors of Roncesvalles, at VII-262, discussed above under C.[61] R, VB and Z present a reading that is grammatically preferable to C Hand 2's version, as does S. The variant *.cum.xl.* appears only in S; R gives *.c'.xl.*, which would normally also be expanded *cum.xl.* C, VB and SV give the Roman numeral c (capitalized in SV) for *cum*, followed by the Roman numerals *xl*. P and M have *centum quadraginta*. In fact, one would expect the preposition *cum* syntactically in this construction: (*cum xl milibus,* with 40,000 soldiers).

It is possible that this is a correction any careful scribe might have made, as Z appears to have done, having understood both the syntax and the need for large numbers, and transcribed *cum centum et quadraginta*. It is more likely, however, that R's exemplar (like S's) had either *c'* or *cum*. Arnault could have copied such a version from a manuscript copied entirely by C's Hand 1, or from another version very close to C's Hand 1.[62]

At VII-340, C Hand 2 reads *getis*. Arnault read *gentis*, then erased the final *s*. It has been argued above that, since *getis* is right in C's Hand 2, it is likely that scribe 2 copied *getis* correctly from Hand 1's version. The erroneous reading *gentis/genti* could be Arnault's, but it might also indicate an exemplar other than, though very close to, C; see discussion under C, above. Arnault also read *sarraceni* and changed his reading to *sarracenorum*, the variant copied in VB and Z at VII-342.

The third key word in C Hand 2 is *fraglantibus* at IX-468, where Hand 2's reading is shared by A, VA, S, P and R. Again we suggest that the affiliation is to be explained by the pre-existence of the same spelling in C Hand 1's version. The alternative reading *fragrantibus* would then simply be the choice of a *lectio facilior*.

These variants present nothing to suggest an intermediary between C Hand 1 and R, and no very strong evidence for a direct link between C Hand 2 and R. We cannot, in fact, determine satisfactorily which stage in the compilation of C Arnult de Munt saw and copied.

Variants unique to R among the Short Version Manuscripts

olin for *olim* XI-21; *Pinario* IX-32 (also shared with M).

Variants shared by R and VB but not Z

R and VB both omit the chapter numbers; Z, however, adds chapter numbers of his own. The only other variant is the addition of *in* at VII-359.

Variants in R, VB, Z

Additions: *in* I-4; *flumina letiffera que habentur in itinere Sancti Iacobi* VI-3; *ubi* VII-192; *vero in* for *vero*, a reading shared with S, P and M VII-245; *In vallem gelloni corpus beati Guillelmi* added heading in R, copied also in VB and Z with minor spelling variants and *valle* for *vallem* VIII-357; *Miraculum sancti frontonis*, added heading in R, VB, Z, with *Cap. VI* added in Z and *beati* for *sancti* in R VIII-608; *Miraculum Beauti Auricii* R, *Miraculum Beati Euurcii* VB, *Miraculum Beati Euuricii. Capitulum VII.* Z VIII-657; *Aput blavium requiescit corpus rotolanndi* R, *Apud Blavium requiescit beati rotolandi corpus* VB, *Apud Blauium requiescit Beati Rotulandi Corpus. Cap. VIII.* Z VIII-1135; *De sancto facundo* R, VB, *De Sancto Facundo. Cap. X.* Z VIII-1229; *nobilis monachorum abbacia* R, with spelling variants in VB and Z IX-44; *sunt* IX-425.

Omissions: *iumentis et hominibus* VI-45; *Ad...habundat* VI-51; *Pictauti...prodigi* VII-20; *olim* M, R, VB, Z VII-257; *Deinde...requiescit,* also omitted in L, VIII-1224; *de* IX-30; *solent esse* IX-426; *altare* IX-428; *etiam* IX-440; *argentea* IX-486; *CAPITULUM .X.* X-2; *enim* expuncted R, omitted VB, Z XI-58.

Other Variants: *egentium* for *egentum* a variant shared with S, P, M IV-19; *Lorcha* R, VB *Loncha* Z for *Lorca* VI-18; *tantum* for *tamen* VII-52; *qui* M, R, Z, *que* VB for *quod* VII-194; *palpitare* for *palpitari,* a variant shared with M VII-207; *qui* for *quod* P, M, R, Z, *quod* VB VII-214; *avarcas* R, VB *abarcas* M, Z for *lavarcas* VII-279; *nullis bonis culta* for *ullis bonis inculta,* a variant shared with P VII-335-336; *gentis et Sarracenis* S, *genti sarracenorum* R, with the final 's' of *gentis* erased, and *sarraceni* changed to *sarracenorum, genti Sarracenorum* VB, Z, for *Getis et Sarracenis* (see discussion under C above) VII-340-342; *Sicumque* R, *Sicque* VB, Z for *Vbicumque* VII-387; *ferens* for *tulit* R, VB, Z, compare *fert* P VII-395; *quod quamdocummque* added above the line R, *quod* or *quandocumque,* VB, *quod quamcunque* Z for *quisquis* VIII-681; *maius* for *magister* IX-427; *Hec quidem de* for *Set enim de* IX-444; *cantat* for *solet celebrare* IX-630; *sunt* for *solent* IX-632; *euenerit* for *euenit* X-26; *Palmas* for *Palmos,* a variant shared with M X-33; *Pascha* for *Pascham* X-34; *qualiter* for *quot* XI-3; *sunt* for *sint,* a reading shared with S and M XI-4.

The collation shows that, except for the obviously erroneous *olin,* and the variant spellings *Pinario* (R, M) IX-32, *Auricii* (R), *Euuricii* (VB, Z) at VIII-657, and VB's correct *quod* at VII-214, there are no variants in R that are not also shared by both VB and Z. Variations in q-words are common, and usually arise from hasty reading of an abbreviation. In addition to their major shortenings of the *Codex Calixtinus* texts, the three manuscripts also share thirteen small additions and twelve brief omissions. This means that the filiation between them is a close one. The major difference is the omission of chapter numbers in R and VB, and the addition of a new numbering system in Z. The exact nature of their relationships will be more precisely defined by looking at the relationship of VB and Z.

VB: Vatican City, Biblioteca Apostolica Vaticana, Borghese 202

The selections from the *Codex Calixtinus* and the *Guide* in VB are the same as in R, except that the liturgy lacks notation and the selections from Book I are shorter than R's. They follow the original order planned for R, which, since R's present sequence was arrived at in the course of production, perhaps means that Arnault made two copies, not one, and VB derives from the other. VB's text was copied in the second half of the fourteenth century, by a scribe whose hand shows some Humanist traits, though the reuse of palimpsest parchment from Zaragoza means he is likely to have been Spanish rather than Italian.

Additions shared by VB and Z

vadit added I-56; *est* added VIII-685; *inde* added and puctuation changed IX-422.

Omissions common to VB and Z

tendit I-63; *inter...hospitale* VI-42; *Sancti Iacobi* VII-2; *trium* VII-46; *nostre...inimica,* possibly a deliberate change, implying derivation from a model not written by a French scribe VII-344; *et* VII-391; *ui* VII-442; *in itinere et* VB, *in itinere* Z VIII-623; *super altare* VIII-675; *presidia* VIII-1139; *Sancti Iacobi* IX-627; *eius,* an omission shared with M IX-628; *SANCTI IACOBI* X-3; *in* X-22; *iterum* X-28; *et venerandi* XI-13; *panem* XI-32.

Other Variants common to VB and Z

columpnas ad sustenandos pauperes suos valde necessarias VB; *columnas ad sustentandos pauperes suos valde necessarias* Z for *columnas ualde necessarias ad sustinendos pauperes suos* IV-2; *Conas* for *Couas* VI-49; *Garonne* for *Garona* VII-32; *panico* for *panicio* VII-54; *in manissimis* for *immanissimis,* variant shared with M VII-60; *arrenum marrinam* VB, *arenam marinam* Z, for *arena marina* VII-67; *manubiis* for *manubriis* VII-218; *et* for *etiam* VII-243; *uircia* for *urcia* VII-309; *ogin* VB, *ogia* Z, for *orgui* VII-311; *inaona* VB, *iuaona* Z, for *iaona* VII-315; *urie* for *uric* VII-322; *Saracenorum* VB, *Sarracenorum* Z for *Sarracenis* VII-342; *obsidendum* for *assiliendum* VII-371; *sicque* for *ubicumque* VII-387; *unde* or *ut* VB, *unde* Z for *ut* VII-390; *asconas* for *auconas* VII-392; *uocant* for *uocat* shared with M VII-393; *et moribus* for *ex more* VII-394;

terram for *terra* VII-438; *primus* VB, *primitus* Z VII-456; *Compostella* for *Campos* VII-475; *Geumagensem* for *Neumausensem* VIII-375; *alias* for *aliasque* VIII-378; *lignumque dominice* VB, *lignum dominice* Z for *lignumque dominicum* VIII-381; *fine quiescit cristi* VB, *fine quiescit christi* Z, for *fine Cristi…requiescit* VIII-386; *Beato Fronto* VB, *Beatus Frontonius* Z, for *Beatus Fronto* VIII-624; *Sursum* for *Rursum* VIII-658; *vel* for *et* VIII-678; *corporis* for *corpus* VIII-684; *In eadem etiam urbem* for *Item in eadem urbe* VIII-694; *In eandem item etiam urbe* VB, *In eandem item urbe* Z, for *Item in eadem urbe* VIII-697; *scilicet ictu* for *ictu scilicet* a word order change shared with P, VIII-1153; *bestinus* VB, *Bestinus* Z for *Belinus* VIII-1190; *eorum* for *illorum*, variant shared with L VIII-1215; *in villa sancti facundi* added VIII-1230 *octobris* VB, *Octobris* Z, for *Decembris* (cf. M's *Novembris*, VIII-1240; *est inde* VB, *etiam inde* Z for *inde est* IX-405; *Deinde* for *inde* IX-406, see also previous variant; *Andree apostoli, inde est altare Sancti Petri* for *Petri apostoli, inde est altare Sancti Andree* IX-416; *archiepiscopali* VB, *Archiepiscopalis* Z, for *archiepiscopi* IX-441; *BEATI* VB, *BEATI. Cap. XIII.* Z IX-443; *venerabiliter* or *venerabilis* VB, *venerabiliter* Z for *uenerabili* IX-448; *igitur transmontani emuli* VB, *ergo transmontani Aemuli* Z, for *igitur emuli transmontani* IX-463; *flagrantibus* for *fraglantibus,* a reading shared by SV and a *lectio facilior;* R follows C here, see above IX-468; *sicut* for *sic* IX-479; *post* VB, *possit* Z, for *potest* IX-485; *Archiepiscopus* for *archiepiscopatus* IX-704; *translatum* VB, *translatam* Z, for *translatauit* IX-711; *seu* for *sive* XI-6-7; *incurrerunt iram Dei* for *iram Dei incurrerunt* XI-22; *Nantuarum* for *Nantuaivm* a variant shared with S, XI-25; *redeuntes* for *redientes* XI-48.

There are no additions unique to VB.

Omissions unique to VB

et omitted VII-362; *Primo dantur oblaciones* omitted VB, *dantur oblaciones* omitted, but *Primo* included Z X-15.

Variants unique to VB among the Short Versions

amputo for *amputato* I-5; *videntes* for *uiuentes* I-8; *Incipit liber quintus de itinere Beati Jacobi* I-10; *Riuius* for *Riuus* VI-20; *que* VB, *qui* R, Z, M for *quod* VII-194; *tritici* for *triticum* VII-320; *ab ecclesia* for *ad ecclesiam* VII-380-81; *Beato Fronto* for *Beatus Fronto* VIII-624; *ventu* for *vento* VIII-1156; *munimus* for *numinis* VIII-1170; *latibus* for *lateribus* IX-481; *magne* for *magno* IX-482; *adveniens* for *advenientes* XI-10; *porcanum* for *Porcarium* XI-50; *operte* for *operante* XI-59; *in eum* for *vicum* XI-61; *rogiis* for *rogus* XI-63.

Several points about the collation of the *Guide* support the hint suggested by the organization of the text, that VB may not be a direct copy of R. In both VB and Z, the substitution of *obsidendum* for *assiliendum* at VII-371 and *octobris* for *Decembris* at VIII-1240 are the only misreadings that are more than mistaken minims or other minor spelling or word order changes. *Que* for *quod* at VII-194, *adveniens* for *advenientes* XI-10 and *operte* for *operante* XI-59 suggest an exemplar with these words abbreviated. Occasional misreadings of vowels, such as *magne* for *magno*, IX-482 or *ventu* for *vento* VIII-1156, suggest an exemplar with a compressed script, in which these forms are confusable. But these errors should not have been made from R, which is perfectly legible, with distinct letter forms throughout. Further points suggesting an intermediary between R and VB-Z will arise in our discussion of Z.

Z: Madrid, Biblioteca Nacional, 13118

This manuscript, copied *c.* 1750 from a manuscript sent from Zaragoza in 1606, further condenses the selections from C.

Additions unique to Z

Incipit Liber Tertius de itinere Beati Jacobi I-10; *Capitulo I.* I-22; *Cap. II.* IV-1; *subsidium et* for *subsidium* IV-21; *Cap. III.* VI-1; *Cap. IV.* VII-2; *et Orientiale* VII-209; *et est terminus* VII-210, see also under omissions; *cum Centum, et quadraginta* (see discussion above under C, VII-262; *Cap. V.* VIII-357; *Cap. VI.* VIII-608; *in urbem* VIII-617, see also under omissions; *Cap. VII.* VIII-657; *Cap. VIII.* VIII-1135; *Cap. IX.* VIII-1187; *Cap. X.* VIII-1229; *Cap. XI.* IX-18; *Capitulum XII.* IX-402; *Cap. XIII.* IX-443; *Capitulum XIV.* IX-628; *Capitulum XV.* X-3.

Omissions in Z

maxime IV-5; *tuam* VII-59; *ora etiam trium* VII-210 (see also under additions); *et* VII-274; *cum*, an omission shared by M VII-295; *In…libidinosa*, the passage about the sexual practices of the Navarrese (cf. *vulve* omitted, replaced by *Sed ipse* in M, VII-354) VII-351; *ad predicandam* VIII-617, see also under additions; *baculum* VIII-627; *unde… requiescit* VIII-1222; *Cristi* X-8; *et Beati Iacobi* XI-31; *se* XI-32.

Other Variants in Z

Angliacensem for *angeliacensem* T, Z, I-53; *Sconnensem* for *Sanctonensem* I-55; *ergo* for *igitur*; the exemplar of Z must have had the abbreviation *g*i. R and VB have that abbreviation IV-22; *quod* for *qui* a variant shared with M VI-25; C reads *quia*, R has *q2*, a standard *quia* abbreviation, VB reads *que*, Z reads *quod*, which he could not have copied from VB VI-28; *itidem* for *idem* VI-42; *habitata* VII-17; *inter* for *inde* VII-28; *in* for *inde* VII-31; *quaproter* for *quapropter* VII-224; *curbantes* for *curuantes* VII-225; *premere* for *et perimere* VII-234; *aquam* for *aqua*, shared with A, P, M VII-321; *predictis* for *peritis* VII-368; *prohibentur* for *probi habentur* VII-370; *probi* for *improbi* VII-372; *Hinullus?* for *miluus* VII-399; *omne* for *omnem* VII-414; *Maritimos* for *Marinos* VII-431; *pergunt* for *tendunt* VIII-361; *insimul* for *simul* VIII-621; *Frontonius* for *Fronto* VIII-624; *annunciavit* for *nunciavit* VIII-626; *dicens* for *dices*, a variant shared with L VIII-630; *bona* for *beneficia* VIII-638; *vel* for *et* VIII-678; *visitandus* for *visitandum* VIII-703; *tuba* for *tubam* VIII-1154; *predicta* for *prata* VIII-1237; *refulget sita* for *sita refulget* IX-24; *Pinrrio* for *Piniario* IX-32; *arevato* for *arcuato* IX-454; *sepulturo* for *sepulcrum* IX-471; *illum* for *illud* IX-474; *parum* for *parvum* a variant shared with SV IX-480; *etiam* for *et enim* IX-634; *confirmatur* for *confirmati* IX-640; *Hinc* for *Hvic* X-4; *redeuntes* for *redientes* XI-9; *fuerunt* for *fuere* XI-20.

The fact that R was at Ripoll throughout the Middle Ages and came to Barcelona with Ripoll manuscripts, while VB was made in Zaragoza, may lend historical support for the idea that there was an intermediary between R and VB. The collation of the *Guide* indicates that VB and Z are extremely close to each other, and not to any other manuscript except R. VB and Z share one addition with P and M, and one spelling variant with M, which is not enough to build a convincing supporting case for an alternative derivation from the exemplar of either.

While VB and Z share the nineteen omissions and fifty-two variants listed above, the fifteen unique variants in VB make it unlikely that Z was copied directly from VB. Some are mistakes a careful scribe might have corrected, but others are not. A scribe sensitive to syntax might have corrected *Beato Fronto* to *Beatus Fronto* VIII-624, and inserted *Primo* at X-15, but it seems unlikely that he could have reconstructed *vicum*, or produced his actual reading, *vicus* from *in eum* at XI-61. Z also includes the text of VB's two omissions. Therefore, we have textual grounds for positing an intermediary between R and the two later copies, VB and Z.

The scribe of Z also originates additions and errors of his own. He is careless, and his sense of the Latin language is a dismal comment on the state of learning in the eighteenth century. He seems to miss or misinterpret abbreviations, such as the superscript 'a' for 'ra' in *Pinrrio* for *Pinarrio* IX-32. Z shares only one variant with a Long Version manuscript, the spelling *Angliacensem* for *angeliacensem* (I-53), shared with T. His text reflects a rationalized structure of the *Codex Calixtinus* texts into Books and Chapters, arriving thereby at a numbering sequence not found elsewhere; for the historical reasons outlined above in our Catalogue of Manuscripts, it is likely that he copied these numbers from his model. The numbering system is important in establishing the links between Z and that manuscript.

As far as the textual evidence goes, we must conclude that Z was not copied directly from VB. The historical evidence indeed makes at least one intermediary stage necessary. Z records that it was transcribed from a copy sent from Zaragoza by Bartholomaeus Morlanius in 1606. We have established in our Catalogue of Manuscripts that it was sent to the historian and theologian Juan de Mariana, who included its information in Chapter 12 of the first tract of his *Tractatus VII* in 1609, in which he disparaged the historical accuracy of the Spanish legends of St James. We have also established that Z was copied, about 1750, by or for the eighteenth-century Jesuit antiquarian and bibliophile P. Marcos Burriel, who was part of a group of scholars assembling a multi-volume legal and ecclesiastical history of Spain. Mariana's actual manuscript is now lost, so we have no direct evidence when it was written. The fact that it and VB both came from Zaragoza—VB is in part a palimpsest, with fourteenth-century Zaragoza documents underneath—suggests that Mariana's

manuscript, or its model, was in Zaragoza in the fourteenth century. Mariana's manuscript or its model must have been made at Ripoll, for R did not leave the monastery until the nineteenth century. But when between 1173 and the fourteenth century it was copied we cannot say.

Manuscripts of the Short Version: General Conclusions

One can draw a neat West/East line through Spain, dividing the patronage of the Short Version manuscripts (by individuals based in Ripoll, Zaragoza, Toledo) from those of the Long Version (Compostela, Seville, and probably Alcobaça). The pattern of collecting and readership does little to change this division, with the exception of the fourteenth-century wanderings of A to Avignon and then Peñiscola, and VA to the sacristy collection of the Basilica di San Pietro at Rome by the seventeenth century. It is surprising that the eager antiquaries working in the seventeenth and eighteenth centuries did not search for copies of Jacobean material in Galicia, or that, if they did, their searches were unsuccessful. Neither Mariana nor Burriel went, or sent, directly to Santiago to obtain their copies. What is even more surprising is that the ecclesiastical hierarchy of Compostela itself seems to have stayed out of the fray surrounding St James in the seventeenth and eighteenth centuries. No one produced C as authentic twelfth-century evidence.[63]

Several factors must have contributed to this situation. The late sixteenth century is the period when other cults were supplanting that of St James as foci for national devotion, such as those of St Theresa of Avila (1515-82), canonized in 1622, and St John of the Cross (1542-91), beatified in 1675, canonized in 1726. It would also seem that Ambrosio de Morales' negative judgements about C, written in 1572, though largely aimed at the rejection of the claimed authorship of Pope Calixtus and about the truth of the legends related in Book IV, *Pseudo-Turpin*, had the effect of condeming C as a whole to obscurity for several centuries.[64] It was notably absent from the manuscripts he selected for removal to Philip II's newly founded library at El Escorial. Not until the twentieth century were the *Codex Calixtinus* and its Long Version copies readily available to scholars.

III. The Lost Manuscripts of the 'Pilgrim's Guide'

We have discussed the relationships of the extant *Pilgrim's Guide* manuscripts, and what their provenance tells us about some of the readers and users of the text over eight centuries. Some of those arguments depended, for historical or textual reasons, on postulating further copies, now lost. We summarize here what this evidence adds to our knowledge of the origins and reception of the *Guide*. We also consider some manuscripts that contain selections from other Books of the *Codex Calixtinus* and which might have once included more, or might be based on models that were more complete and might possibly have included a copy of the *Guide*.

Twelfth-Century Copies at Compostela

C is the earliest extant manuscript of the *Codex Calixtinus* and the *Guide*. As we have suggested above, the collation of the *Guide*, taken in conjunction with what we know about the historical circumstances that governed the production of the extant copies, suggests that there may have been other twelfth-century copies of the *Guide*'s text; they are more likely to have occurred in the context of copies of the *Codex Calixtinus* as a whole, although, in the cases of the models for P and T, the case for the early existence of partial copies of the *Codex Calixtinus* can be argued.

A Version earlier than C Hand 1

If the stemma were neat and tidy, one might wish to reconstruct an earlier, completely accurate, version of C, used as an exemplar by Hand 1. If he was not the author/compiler of the *Guide* as well as the scribe of C, such a version must have existed. It would have had 12 solar signs, not 20 at VIII-171; *leva* or *sinistra* for *dextera* at VIII-232 and *ceteris* for *cetibus* at VIII-993 in addition to *cum* or *cum xl* for the dead soldiers of Roncesvalles at VII-262 and *getis* for the Geats at VII-340. It might also have had illustrations like those in S, or a more extensive picture cycle, and might have been written

in two columns; but those features might instead be the basis for postulating yet another copy, as we suggest below.

The textual basis for positing a copy in existence earlier than C Hand 1 is extremely slender, and depends largely on how the variants in P and T are interpreted in relation to the circumstantial evidence about the origins of each one. Both are late manuscripts, and at least one intermediate stage must come between any version of C and T; two stages seem likely between any version of C and P. We discuss those intermediary stages below.

A Version entirely by C Hand 1

Such a copy has been suggested by other scholars for the text of Books II and III, and could be argued from our collation. It would have contained the readings *cum xl* or *cum xl* for the warriors killed at Roncesvalles (VII-262)—correctly copied by Arnault but altered by C's Hand 2—and *getis* at VII-340 (miscopied as *gentis* by Arnault, who then erased the final 's'—or someone else did; correctly copied by C's Hand 2), and *fraglantibus* at IX-468 (correctly copied by Arnault and also by C's Hand 2); it probably had *in pueritia* at VIII-853. There is nothing to prove that what R copied from was anything other than a version entirely written by C's Hand 1, and not much to indicate that R could not have used the *Codex Calixtinus* as it now stands, in Hands 1 and 2. If the earlier version posited above was also in existence, R could equally well have copied from it, since the other variants in C Hand 2 are not in R.

Another Copy made before C Hand 2

It is possible to argue the existence of such a copy from the codicological, textual and artistic evidence in S. Readings would include *cum xl* at VII-262 and *gentis* at VII-340. Like C Hand 1, it probably also had *in pueritia* at VIII-853. It would be likely to have been written in two columns. Perhaps it was part of the two-column miscellany of saints' lives, Tortosa B. Cap. 197,[65] which we discuss separately below, or perhaps Tortosa 197 was based on it. S's illustrations do not seem likely to have been copied directly from those in C; it is probable that both depend on a common source.[66] Was that source also written in two columns, and distinct from the possible pre-C Hand 1 archetype discussed above?

It is also possible that R depended on this copy rather than on a complete copy by C Hand 1; but, if so, it is unlikely, on textual grounds, to have preceded C's Hand 1, as the *gentis* reading in R is wrong.

Another Short Version

Again, there is scant evidence. It depends primarily on the fact that Arnault de Munt's original sequence of books is preserved in VB, which suggests that VB was taken from a copy somehow related to Arnault's first plan for the arrangement of Books: he changed his mind in the course of copying, as we show in our Catalogue description of R, so it is unlikely that VB's sequence comes from R directly. But it is probably more likely that R was unbound, and arranged in the order of the quire numbering, when VB's scribe or the scribe of his direct model took his copy: he would then simply have rationalized the headings to omit the one that ends Book I and begins Book II in R. In addition, there is a single variant shared by VB (and Z) and P, which is an insufficient indicator on its own that a relationship existed between P's ultimate model, contemporary with, or earlier than, C, and the model of VB.

Twelfth and Thirteenth-Century Manuscripts outside Compostela which might indicate the existence of other Copies containing a full 'Codex Calixtinus'

Jerusalem and France

The preface to Book I of C claims that copies were sent to Cluny and Jerusalem, the latter perhaps because its patriarch, William, contributed prayers and hymns to the liturgy in Book I. This preface is ascribed to Pope Calixtus II, who died in 1124. This preface is likely to be part of the international aggrandizing thrust of the compilers who assembled C in the late 1130s; the probability is that no copies were actually sent. While we know little of western medieval manuscript collections in medieval Jersualem,[67] library catalogues and manuscripts from Cluny do survive,[68] and contain no evidence of a copy of the *Codex Calixtinus* or the *Guide*.

Spain (or France?)

Tortosa, Biblioteca Capitulare de la Catedral MS 197[69]

A late twelfth-century Miscellany, incomplete at the beginning and end. Measurements: binding (? box) : 524 × 370 mm, written space 400 × 230 mm; leaf 400 × 230 mm, 40 lines per page, written in two columns. Contains an account of the Translation of St James, beginning with the Epistle of Pope Leo (Book III, Ch. 2 of the *Codex Calixtinus*), and selections of the Miracles of St James in Book II, with a mention of the Feast on 25 July, and ending with the miracle of 1100, Ch. 22 in the *Codex Calixtinus*. The miracles have an incipit which indicates that a version of the *Codex Calixtinus* or the *Liber Sancti Jacobi* was their source: *Incipit lib. II sancti iacobi patroni gallecie de XX duobus miraculis*. There are eight miracles from Book II, in the following order: IV : Hubert of Besançon; VI: Calixtus, 1100; XII: Calixtus, 1106; XX: Calixtus, undated; III: Calixtus, 1108; V: Calixtus, 1109; XVII Hugh of Cluny/Anselm, undated; XXII: Calixtus, 1100. Thus they are in no discernible order, of date, or author, or type of miracle. The miracles of St James are preceded by the miracles of Pope Gregory (12 March) and Nicholas (6 December), and followed by the Feast of St John at the Latin Gate (12 May), so the volume is clearly not a lectionary in calendar sequence. The manuscript includes a note, pertaining to itself or its exemplar: *Quapropter precipimus ut codex iste iuter* [sic: obviously an error for *inter*] *ueridicos codices deputetur et in ecclesiis et refectoriis diebus festis eiusdem apostoli aliisque si placet diligenter legatur.* Presumably Tortosa's library had bound different categories of books by colour, and green books were for liturgical use.

The catalogue entry concludes with the following comment: *Dom Cebrían B. Obiols, del Monasterio de Montserrat, preguntaba en 1945 quen esos fragmentos relativos a Santiago habia referencias a itinerarios de peregrinos, y sugería la idea de confrontar este códice 197 de Tortosa con el del Archivo de la Corona de Aragón (Fons. Ripoll nº 99) copiado en 1173 del la Compostela.* Presumably what interested Dom C.B. Obiols was the closeness of date, and the fact that both were large books. It is possible that the miracles from Book II were indeed copied from R, which preserves a complete text of Book II with a *titulus* designating it so. Nothing, however, proves that the Tortosa MS ever had a complete *Codex Calixtinus* text; like Gloucester Cathedral MS 1, made in England in the early thirteenth century, it may have been simply a lectionary.[71]

England

Oxford, Balliol College MS 292[72]

Another large (388 × 133mm) compendium, written in the early thirteenth century, in two columns; the *Codex Calixtinus* section, ff. 107-117, has 40 text lines per column, and the hand looks early thirteenth-century. Writing occurs above the top line; round 's' is used only for capital letters, never initially, medially or finally in lower case; 2-shaped 'r' occurs only after 'o'; bitings occur frequently; and there are wedged ascenders, about the same height again as the body of the letter forms.

There is no monastic or cathedral *ex libris* or other identifying mark, but the front flyleaf records that the volume came to Balliol, like many others in the collection, from the library of William de Gray, Bishop of Ely (1416-78). Gray travelled on the Continent, and many manuscripts in his collection come from Italian sources, but the hand and decoration of Balliol 292 are English.

The main text (ff. 1-105) is the *Parabolis Salomonis* by Richard de Furnellis. Folios 105v and 106 are blank. The *Codex Calixtinus* section contains the initial letter of Calixtus from Book I, and the complete texts of the Book III, the Translation, and Book II, the Miracles, but with no indication of Book numbers:

f. 107 [from Book I]: Prefatory letter of Calixtus, complete.

ff. 107-109 [Book III, entire text] Translation of St James, including the prologue and letter of Pope Calixtus, the letter of Pope Leo, and Calixtus's explanation of the three feasts of St James.

ff. 109-117 [Book II], Miracles, complete, including the *Argumentum* of Calixtus, the 22-chapter Tabula, text of 22 miracles, identified in their rubrics by author, and the beginning of the 1139 miracle of Alberic of Vézelay. Expl. *...anxius Beati Iacobi auxilium*. The bottom three lines of the column, and the whole of the verso of the leaf are blank.

Gloucester Cathedral MS 1[74]

The manuscript is one volume of a three-volume *Legenda* set which was probably made at Reading for that monastery's cell at Leominster. The other two volumes are now in Lincoln Cathedral Library (see THOMSON, 1989). Articles 35, 36 and 46 of Gloucester Cathedral 1, as listed by KER, concern St James. But only parts of the texts are in the *Codex Calixtinus,* and all of those show considerable variation in wording.

Article 35: ff. 116-116v, An account of the Translation of St James Inc. *Postea vero discipuli eius collegerunt ossa apostoli…* Not in the *Codex Calixtinus.*

Article 36: ff. 116v-118. Three Miracles from Book II of the *Codex Calixtinus* which derive from the *Dicta Anselmi*: XVI, XVII, and XVIII.

Article 46 is far more complicated; its contents are listed here:

f. 164 *Codex Calixtinus,* Book I, Prefatory Letter of Calixtus, incomplete, and with an emended *titulus*; about the first two-thirds of the text, omitting remarks about knowledge of languages, and contents of the *Codex Calixtinus* volume. Inc. *Incipit prefatio beati Calixti pape in miraculis beati iacobi apostoli. Calixtus Episcopus servus servorum dei venerabilis filius Gilelmo patriarche ierosolimitano et didaco compostelenensi archiepiscopo…*expl. *summopere precium est beati iacobi miracula… ut tam peritis quam imperitis aperirentur* (Whitehill, pp. 1-2).

ff. 164-171v Preface and Miracles of Book II, omitting the chapter list and all attributions to authors, as well as miracles XVI, XVII, and XVIII, which appear at the end of the Translation, on ff. 116v-118. All these texts have variations in wording; the collection is differently ordered, and there are also interpolated miracles, usually concerning Englishmen.

f. 164-164v Argumentum; Miracles I, III, V.

f. 165 Interpolated miracle: Inc. *Anno incarnationis domini m^o c^o xx^o v^o. Quidam de anglia ascenderunt beatum iacobum ex voto…* Expl. *suspensum vitit. Benedictus es qui fecit mirabilia solus Christus.*

f. 165v Miracles VI-XV.

f. 165v Miracle XIX.

ff. 165v-167v Miracle XXII.

f. 167v Miracle from the end of Calixtus's Prologue to Book III, the Translation, about a cleric who had the price of a book about St James returned to him by the saint: Inc. *Clericus quidam mihi satis notus…*Expl. *extitit recompensationibus temporalibus.* (Whitehill, p. 290, lines 8-19.)

ff. 167v-168v Miracles XXI, XX, II, and IV.

ff. 168v-169 Two interpolated miracles. (i) Inc. *Quidam viri venerabiles ascendentes de anglia…*Expl. *in illa civitate* (Toulouse) *in omnibus qui audierant et viderant. Regi ergo regum sit laus et gloria in secula seculorum.* (ii) Inc. *Quidam peregrinus orationis cause…*Expl. *qui tam cito subvenit se diligentibus.*

f. 169-169v Book IV of the *Codex Calixtinus, Pseudo-Turpin,* Chapter 25, the miracle of Altamaior.

f. 169v Interpolated miracle. Inc. *Mirandis miranda mirabilibus mirabiliora subiungo. Quedam navis onerata peregrinis a jerosolimis rediens procellis…*Expl. *qui sibi acciderant mihi indicavit.*

f. 169v Miracle of 1139 (Whitehill, p. 400).

f. 169v Four Miracles from the first Sermon of Pope Calixtus, *Codex Calixtinus,* Book I, about the fates of those who worked on the feast of St James, interpolated between I and II with a brief summary of one of the Reading miracles which conclude item 46. The same four miracles are included in Vincent of Beauvais' collection (see PL 163, cols 1375-1376; Whitehill, pp. 20-21). (i) Inc. *Inter hispanos apud tudellionum die festo sancti iacobi triticum tota die…* Expl. *tanti festi exaltavit.*

ff. 169v-170 (ii) *Alter quidem in britannia in festo beati iacobi venatum ivit, qui eodem die post captionem venationis sue defluente in oculos eos tanquam sanguine sudoris statim excecatus et ita ut a nemore in domum suum non posset redire.* One of the Reading miracles, told at greater length below.

f. 170 (iii) *Vascones apud albinetum sancti iacobi festum colere contempnentes…* Expl. *sed divinitus visus fuit advenisse.*

f. 170 (iv) Inc. *In episcopatu bissontiensi bernardus de maiora karro…*Expl. *sed ultio divina boum oculos sero excecavit.*

f. 170 (v) Inc. *Inter gothos in provincia montis pessulanis iussu cuiusdam militis…*Expl. *magis ac magis sanguinem eiecit.*

f. 170-170v Interpolated miracle on the same theme. Inc. *Moneda opido alvernie vidua manebat, dampna defuncti mariti unico filio relevans… * Expl. *et habitum ibidem monachium susceipt. anno incarnationis dominice m⁰ c⁰ xiii⁰.*

ff. 170-171 Chapters 1, 2, 5, 7 (opening sentence omitted), 21 and the beginning of 22 (to Whitehill, p. 342, line 9) of *Pseudo-Turpin*. These include Charlemagne's vision of James, the Battle of Pamplona and Miracle of the lances, his victories in Spain, and Turpin's vision of Charlemagne's death. No Roland material is included.

f. 171-171v A brief prayer to St James, not from the *Codex Calixtinus: Domino docente dedicimus, quia seruus qui dominicam pecuniam sudario involvere et abscondere maluit, quam in lucrum expendere, non solum talentum amisit, quod habuit, verum et dampnationis sententie periculum declinere cupientes, divine largitionis talentum quod meritis beati iacobi percepimus vel alios percepisse cognovimus, modis quibus possumus posteritati porrigendum censuimus. tum ut spes audientium ex auditu roboretur, tum ut in glorioso apostolo suo christus glorificetur.*

ff. 171v-175v Miracles of the Hand of St James at Reading. Unedited, but translated, with extensive commentary, by KEMP, 1970.

The Gloucester manuscript includes material from Books I-IV of the *Codex Calixtinus*, arranged to include miracles from all possible sources. Did its exemplar have the *Guide* as well? The strongest argument against the availability of the *Guide* to the compiler is the lack of inclusion of the miracles from Chapter 11. Had he known them, surely he would have copied them as well.

Reading was a major cultural centre, with a rich library. The volume listed in its medieval catalogue as *Vita Caroli Magni* is not, however, the *Pseudo-Turpin*, but Einhard's *Life of Charlemagne*, which is now Cambridge, Gonville and Caius College, MS 177 (WATSON, 1987, p.57). See also Catalogue of Manuscripts under T, Provenance and History.

These are all liturgical volumes, whose compilers might have rejected the *Pseudo-Turpin* and the *Guide* as inappropriate for their purposes, even if they were available. Certainly the scribe of the Gloucester manuscript rejected large parts of the *Pseudo-Turpin*. The most we can say is that the existence of these three manuscripts certainly indicates interest in the cult of St James, and gives clear evidence for the presence of substantial material from the *Codex Calixtinus* wherever Tortosa 197 was made (probably somewhere in France), and also in Reading, England, where Gloucester Cathedral MS 1 was made. Unfortunately, neither the Reading nor the Balliol manuscript give any clear indication of the presence of a *Guide* manuscript in England by the early thirteenth century.

Dublin, Trinity College, MS 184 (B. 2. 17)

This manuscript is a twelfth-century letter-collection from St Albans.[78] In Letter XII, the writer, unable to visit a friend because he is completely shattered by a demoniac he encounters when he sets out, remembers another horrible journey. He recounts the tale *quod in Hispania multis testibus gestum est*, of the rich man who went on pilgrimage to St James with his son. At their lodging, an envious host planted a cup in the boy's belongings, then had them arrested as thieves. The son insisted on being hanged for the father, who continued his pilgrimage. Returning after a year, the father found the boy, still hanging, but alive, because St James supported his feet, and kept him nourished. In the *Codex Calixtinus*, this miracle (Book II, no. V) is dated 1090, and is told about Germans passing through Toulouse. It is among the miracles ascribed to Pope Calixtus.[79] The version in the Dublin manuscript is about three times as long, and embellished with moral apostrophes (*O cupiditas!…O dolositas!…O auaritia!*), passages in verse, and longer speeches by all the characters. There are no striking verbal correspondences with the *Codex Calixtinus* version, and there is no mention of Pope Calixtus. Clearly the writer is retelling a story he remembered, not looking one up in a book. It could be something he remembered from a sermon, or a lection. But the fact that the story appears in a letter collection compiled soon after 1146,[80] may indicate that at least Book II was available at St Albans by then.[81]

Letters 18-20 trace the career of a certain Benedict from his student days in France to his becoming chaplain to a papal legate, referred to only as A, after his own abbot was deposed. The papal legate to England who best fits the dates Colker suggests is Alberic of Ostia, signatory to the false bull of Innocent II in the *Codex Calixtinus*.[82] He was legate to England in 1138/39. St Albans was within easy

reach of the south coast where travellers from the continent landed. Could Alberic have brought a *Codex Calixtinus*, or a version of Book II, with him?

Exemplar of T (London, British Library, Cotton Titus A.XIX)

There is only one piece of evidence which suggests an independent circulation of Books IV and V of the *Codex Calixtinus* in England, and it is provided by T.

At least one manuscript must have intervened between C and T. The incomplete state of T's *Guide* text, which ends abruptly before the end of Chapter VII, suggests an incomplete exemplar; and T's *rogus* for *rotgerius* at Latin note V-12, which C writes out in full, is an unlikely misreading. And, while many pilgrims did go to Compostela in the fifteenth century, surely no one who had been in Spain long enough to copy even two books of the *Codex Calixtinus* from MS C would muddle as many place names as T. The issue is further complicated by the fact that T's text of *Pseudo-Turpin*, most fully discussed by MEREDITH-JONES,[83] is not from the same group as the *Codex Calixtinus* or any of its other surviving descendants, including those thought to come from Glastonbury, where T obtained some of his sources.[84]

Nothing else by the *Guide* hand in T indicates that the scribe travelled outside England. The account of Ogier the Dane which is interpolated in Chapter 24 of T's *Pseudo-Turpin* comes from Alexander Neckam, *De Naturis Rerum*, a text written between 1200 and 1204. If it was already in T's exemplar, that copy cannot be earlier than 1200, and must be English, since *De Naturis Rerum* had virtually no continental circulation. But, as discussed fully in the description of T, it is possible that T inserted the Ogier passage, and the brief account of Charlemagne's *Iter* to the Holy Land, from copies of Alexander Neckham and Helinand he found in the library of the Austin Friars at York. Where he got his *Pseudo-Turpin* and *Guide* texts, and when exactly they were written, remains unclear.

T was compiled at Kirkstall, but, with the exception of a quire with Glastonbury material, and some Grosseteste legends which emanate from Lincoln, most of its source material came from York. There is no medieval catalogue of the manuscripts at York Minster library, but it may be worth mentioning that Archbishop Thurstan, a long account of whose Life is also in T, held the see from 1114 to 1140, and was consecrated by Calixtus II, whose friend he remained. Some correspondence between the two survives. It is possible that an early, and perhaps partial copy of the Long Version of the *Guide*, accompanied by a *Pseudo-Turpin*, was acquired by Thurstan as a Calixtine work.

No crucial readings suggest that T's exemplar of the *Guide* was other than a copy of C; but the sheer number of errors suggests that several stages may have intervened, since T is quite careful in copying place and personal names in his Glastonbury material.

Italy

Exemplar of P (Pistoia, Archivio di Stato, Documenti vari 27) and its Source

P's immediate exemplar is most likely to have been Pistoia, Archivio di Stato, Doc. vari 1, a thirteenth-century manuscript that can be identified with one of the entries in the inventory of the sacristy of St James at Pistoia dated 1 January 1261.[85] The collation of P's text for the *Guide* can be argued either to depend on C's Hands 1 and 2, or, and more likely because of the circumstances of the Pistoia relic's acquisition, negotiated in 1138, it can be argued to depend only on Hand 1 of C. Just possibly the relationship with C may have been inverse, with C's Hand 1 depending on P's exemplar. The strongest argument for this is that, in P itself, only a few components of Book I are included, suggesting that perhaps C's Book I was not yet available for copying. But as P could equally well reflect a revised liturgy, based on local miracles and sermons, and put together between the twelfth and the sixteenth centuries, nothing can be proved.

The inventory of the sacristy of St James at Pistoia dated 1 January 1261 lists *duos libros de legenda sancti Jacobi*. One of them can, in all likelihood, be identified with Pistoia, Archivio di Stato, Doc. vari 1, which has been ascribed to the middle of the thirteenth century. In its current state, it is incomplete. It cannot be proven that it once contained the *Guide*, but the analogies between its other texts and those of Pistoia Doc. vari 27, our P, which we discuss in detail in the Catalogue of Manuscripts for P, make it a likely supposition.[86]

Did the other manuscript mentioned in the 1261 inventory also include the *Guide*? There is no independent corroboration. The grouping of the two under one *titulus* suggests but does not prove that they were two copies of the same material. Either or both could well have been an earlier version of the Lectionary of St James, Pistoia, Doc. vari 2, which was written, decorated, and donated to the Cathedral of Pistoia in 1486 by Girolamo Zenoni.[87]

The Fourteenth-Century Spread of the 'Codex Calixtinus' in Spain

Manuscripts A, VA, and S all indicate that there was a definite interest in the *Codex Calixtinus* in the fourteenth century. There may have been other copies.

'Exemplarium Hispaliensis' of SV (Madrid, Biblioteca National, 7381)

No antique manuscript damaged by damp, such as that described by the scribe of SV on f. 1 (*ill. 84*), (*COPIA De un libro MS. dela Santa Iglesia de Sevilla escrito en pergamino de letra mui antigua, i esta por algunas partes podrido con la umedad*), survives in Seville; but the lettering he draws for the incipit and explicit is similar to that in A and VA, which were written in Santiago *c.* 1325; and some of the readings of the *Guide* also suggest a fourteenth-century, or very late thirteenth-century, exemplar.

As we have deduced above, SV's exemplar was a small volume, smaller than anything that is extant, with only 17 lines to a page. If his *pagina* meant a column rather than a page, the exemplar could have had 34 lines per page, as C does, but in a two-column format like S. Could it have been the model for S as well as for SV? The lack of readings common to both argues against it, and suggests a single-column rather than a two-column format for SV's model.

Heavily Abbreviated Model of S (Salamanca, Biblioteca Universitaria, 2631)

As we argue under S in the Catalogue of Manuscripts, it is unlikely that S's errors could originate in a display copy with elaborate illustrations, since such a book would be likely to be clearly written, particularly if, as is possible, it was a twelfth-century manuscript. Was there another copy, also with the illustrations, but made in the thirteenth-century and heavily abbreviated, from which S's errors derived? Or did the illustrations and text derive from different copies?

If such an abbreviated version existed, it is possible that M could have used it for certain readings, such as his emendation of *gentis* to *gentibus* at Latin note VII-340. But, as discussed above, M also worked directly from C.

Later copies: Seventeenth-century Spain

The Morlanes/Mariana Manuscript

Bartholomé de Morlanes, jurist of Zaragoza, had a manuscript in his possession in Zaragoza *c.* 1606, as we learn from the note on f. 101 in Z. We argue above that it is not likely to have been VB, because the collation requires an intermediary between VB and Z. Since VB also has Zaragoza connections, it is most probable that the lost intermediary (sent by de Morlanes to Mariana) came from Zaragoza as well. It provided the exemplar for Z, which was compiled for Burriel in the 1750s.

Peter of St Caecelian's Copies

In the colophon at the end of SV, dated 1632, Peter, Redemptorist monk of St Caecelian, mentions two exemplars, one *Autographo,* which is presumably the wretched Seville copy, probably of the thirteenth century, described above (*ill. 85*).[88] He also worked, *ex alio transumpto ex ipsomet Exemplari Ms.,* from another copy made from the same Exemplar; he worked in his cell in Granada, not in Seville. There is no evidence for dating this second copy except that it must obviously have been written between the date of the *Exemplar Hispalensis* and 1632. As the text of SV is still full of gaps, one might assume that the copy was made after the *Exemplar Hispalensis* had already suffered considerable damage. He does not tell us who made the second copy, or how he acquired it (but see below under Sandoval). It is just possible that SV's scribe may himself be Peter: if so, he is adding the date of 1657 at the beginning and end of a manuscript he had copied much earlier, in 1632. This

seems rather unlikely, particularly as there seems to be a scribal signature, VS, in addition to Peter's PC monogram.

If our scribe is not Peter, then the 1632 copy is a third lost manuscript in this line of transmission.[89]

The Sandoval Copy and Velasco's Edition

A note in SV, f. 91, states that Ambrosio de Morales, in *Las Relacions del Viage quæ hizo a Galizia y Asturias*,[90] says that the monastery of Sandoval had an old book of the Lives of Saints, in which Pope Calixtus is cited as the author of the Life of St James. The scribe of SV doubts the ascription. If the manuscript were indeed a collection of Saints' Lives, it might contain only a translation and miracles, as for instance Tortosa 197, Gloucester Cath. MS 1, or Balliol 292, discussed above.[91]

The name 'Sandoval' occurs a second time in relation to material about St James. Juan de Mariana, in a letter of 8 November 1605,[92] mentions having been sent a text about the arrival of St James in Spain from Cardinal D. Bernardo de Rojas y Sandoval. The text, entitled *Dos discursos en que se defien de la venida y predicacion del Apostol Santiago en España*, was printed by the Constable of Castille, Juan de Velasco, in 1605.[93] Mariana's views on the authenticity of the account were far from complimentary. The account in fact depends heavily on local tradition, whereas Mariana was influenced by the complete lack of reference to James in Spain in the early sources, of which his knowledge was far more profound and detailed than that shown in *Dos discursos* of 1605. That volume, however, contains a reference to a *libro de Calixto segundo*,[94] and another to sources in Granada.[95] But since Mariana was complaining in 1606 that he had no copy of Calixtus's complete works on St James, and was overjoyed when Morlanes sent him one, it seems hardly possible that what Peter says about his second model, copied in SV, refers either to *Dos discursos* itself or to the sources in Granada on which *Dos discursos* drew.

Cornelius Lerche's Quarto Manuscript

Lerche was the Danish ambassador to Spain from 1650-53 and 1658-62. He then returned to Denmark, where he died in 1681. His library was sold the following year. He had acquired manuscripts in Spain; those which survive are almost all late sixteenth and early seventeenth-century works, or late paper copies of earlier works. He was interested in Spanish history, and the collection included no. 23, the Chronicon of Roderick, Archbishop of Toledo; no. 28, the *Coronica de los Reyues de Navarra por Mosen Diego Ramiosez d'Aualos*; no. 33, *Historia del Monasterio real de Najara*. Among the quartos were no. 15, Visigothic Laws and no. 16, *Coronica del Rey Don Enrique IV de Castilla, por Diego Henrique del Castillo su Chronista*. There were volumes from Vich, Seville, Madrid and Zaragoza. The two volumes of particular interest to us are folio no. 8: *Historia Compostellana*, and quarto no. 1, *Calixtus Papa de S. Jacobo Apostolo Zebedeo, Ao. 1124. MS. Ariæ Montani, in Pergameno*. GIGAS, 1909 could not trace either of these volumes in the Aarne Magnusson collection in Copenhagen, where nine other items from Lerche's thirty-two manuscripts are preserved. Those manuscripts passed from Lerche to the Danish historian Jens Rosenkrantz, who died in 1695. From there, some volumes went to Magnussen, who died in 1730, but whose collection had partly been devastated by the great fire which swept through Copenhagen in 1728. We have, however, no list of Rosenkrantz's specific acquisitions from the Lerche sale, nor of Magnussen's specific acquisitions from Rosenkrantz.

Arias Montanas, who had owned Lerche's manuscript, died in 1591. He was a Spanish humanist scholar, who moved in the same circle as Ambrosio de Morales. He also owned a manuscript commentary on the Apocalypse by Apringius of Béja, which was owned by the Danish collector Holger Parsberg in 1680, and is now Magnussen MS 795.[96] Could Lerche have brought it to Copenhagen, and given or sold it to Parsberg before his death? Both Montanas and Lerche seem to have acquired manuscripts from a variety of places, though Gigas suggests 'la grande collection dilapidée d'Olivares' as a likely source.[97]

Lerche's manuscript is described as on parchment, and it seems possible that it was an earlier copy than the sixteenth century. It is, however, unlikely to be the only manuscript of *Pseudo-Turpin* now in Denmark, MS Thott 519 quarto, a thirteenth-century manuscript now in the Royal Library at Copenhagen.[98] It came there as part of the vast collection (60,000 volumes) of the noted bibliophile and statesman Otto Thott (1703-85). Thott 519 is a Libellus manuscript, part of Hämel's Group 10, no. 94; he says its text is close to London, BL, MS Cotton Nero A.XI, which is English.[99] This is the group deriving ultimately from St Denis, but containing many English manuscripts. The only

Pilgrim's Guide text it may contain are the miracles from Chapter XI. The *incipit* agrees, but the *explicit* differs: *Peregrini, siue pauperes, siue diuites X operemur bona in his sacris sollempnis. Prestante Domino.* The problem with identifying Lerche's manuscript with Thott 519 is that the first two items in Thott are not ascribed to Pope Calixtus. He is first identified as an author on f. 9, and even there, his death date is not given, as it is in Lerche's copy.

Neither REILLY, 1971, nor FALQUE REY, 1985 and 1988 list any manuscript of the *Historia Compostelana* now in Denmark. It is possible that copies of both the *Codex Calixtinus* and the *Historia* reached Denmark, but perished in the 1728 fire, which devastated numerous libraries, including some of Magnussen's manuscripts.

The Lost Manuscripts of the 'Pilgrim's Guide': General Conclusions

From the textual evidence, we therefore arrive at a minimum of 8 or 9 lost manuscripts (one of which was certainly a Short Version copy), and the likelihood of three or four more. Together with the twelve that have survived, the likely total is somewhere between 19 and 23 or 24, of which at least four contained the Short Version. For a range in date from the second quarter of the twelfth century to the mid eighteenth century, the total is larger than has been thought. But it is still hardly sufficient to allow its text to have been common reading or listening among pilgrims on the journey through France and Spain to Santiago de Compostela. If the lost intermediaries have cleared several paths between the surviving copies, the network of routes still requires the collation of more Books of the *Codex Calixtinus* than the *Guide* alone to lay it open.

Notes

1. SHORT, 1969, pp. 6-7, sees a model earlier than C for the late 14th or 15th-century Galician translation of Book IV (ed. PENSADO, 1958), on the grounds that, of three crucial instances in which the Galician translation differs from C in its present state, two instances show that C Hand 2 and R agree, against the Galician version. This means that the Galician version should derive not from C Hand 1, with which R is in other instances in agreement (as per HÄMEL, 1950) but from an earlier version altogether. HERBERS, 1986, p. 102, n. 8, cites the variant about the Geats as evidence that R's model for the *Guide* is C Hand 1, see below. But the instances discussed by Herbers and Short can be interpreted in other ways, as we show below. HORRENT, 1975 thinks C's version is preferable.

2. HÄMEL, 1950; the other scribes who participated in later alterations to C did not tamper with the *Guide*, which, in its present state, is written entirely by the first and second scribes. See our Catalogue of Manuscripts for a table of the relationship between text and scribes in C.

3. Our collation sequence puts T next to SV at the end of the list of Long Manuscripts because it is incomplete, and L at the end of all because its selection is unique.

4. C, A, and VA begin with the inscription *EX RE SIGNATUR IACOBUS ISTE LIBER VOCATUR*. SV's version is slightly different: *EX RE + GNATUR IACOBUS LIBER ISTE [CHI RHO* on its side]. Its exemplar was probably a 13th or early 14th-century manuscript; see Catalogue of Manuscripts. One can speculate as to whether or not P's exemplar also belonged to this group; P itself has selections from the *Codex Calixtinus* Books I and III preceding its miracles, but not organized under the heading 'Book'; *Pseudo-Turpin* and the *Guide*, however, are entitled, respectively, *Liber Quartus* and *Liber Quintus*. Two earlier Pistoia manuscripts are listed in the 1261 inventory as *Libri sancti Jacobi*. The surviving fragments that may be identified with one of the earlier copies, Pistoia Doc. vari 1, lacks the opening page. See *SANTIAGO DE COMPOSTELA*, 1985, no. 43.

5. There is another textual component in A, but copied in a different hand; see Catalogue of Manuscripts.

6. For a more complete textual description and full bibliography, see Catalogue of Manuscripts.

7. HÄMEL, 1950, pp. 12-21, noting that his foliation dates from before the restoration of Book IV to the Codex in 1966. We give both foliations in our Catalogue of Manuscripts. See also HERBERS, 1984, pp. 22-30; DÍAZ Y DÍAZ, 1988a, pp. 271-296. DÍAZ Y DÍAZ divides the work of the first scribe into two: one for Book I (Scribe 1A), a second, closely similar but different largely in spacing, for the rest of the Codex (Scribe 1B). Since Scribe 1A did not participate in the writing of the *Guide* we concentrate here on the distinction between the two scribes who did write the *Guide*, calling them simply Scribes (or Hands) 1 and 2. See the Catalogue of Manuscripts for our presentation of the relationship between the quire structure, division of hands, and textual components in C.

8. HÄMEL, 1950, and the Catalogue of Manuscripts under C for analysis of the scripts.

9. See the discussion in the Introduction to the Manuscripts above, STONES, 1992 and STONES/KROCHALIS, 1995.

10. For a table of their distribution see STONES, 1981.

11. He appears on f. 155 in the 20th quire and is present in quires 20, 21, 22, 23, 25, and 26, but not in quires 23a, 24, 27, 28, nor the additional singletons at the end of the Codex. See Catalogue of Manuscripts for a breakdown by quire, hand, and text.

12. Because of the *termini* in the text: *c.* 1130 for Book I, after 1135 for Book II, between 1130 and 1145 for Book IV, after 1137 for Book V.

13. See his discussion of modules (1988a, pp. 278-296), noting his distinction, on this basis, between the scribe of Book I (Scribe 1A) and the other scribe of the first phase (Scribe 1B); this is also the basis for his rejection of ff. 221-222 from the first campaign (p. 308).

14. This kind of spreading out of text is what characterizes the layout of the script on ff. 186-187 on the bifolium containing the Liberal Arts text that possibly replaced an illustrated quaternion (HOHLER, 1972, p. 35), although no surviving illustrative tradition reflects such a set of pictures (STONES, 1981, p. 200, nn. 30-33, and STONES, 1992.

15. See the Catalogue of Manuscripts for the layout of C. The first quire (written by Scribe 1A) is exceptional in that it has 9 leaves, with the first half of the first bifolium missing—might it have once contained miniatures of the Life of St James? The other quire that is irregular is no. 23a, a bifolium written by Scribe 3, containing the description of the Liberal Arts. Possibly it may have replaced an original quaternion with miniatures (HOHLER, 1972, p. 35). There are also arguments that it was nothing more than a later addition to the text (STONES, 1981, p. 200). The Liberal Arts passage is present in the Pistoia text of *Pseudo-Turpin*, which argues for its presence in C by 1138-45. It is also in L, which was copied from C before the end of the 12th century. See Catalogue of Manuscripts. Quire no. 23 includes a central bifolium written by Scribe 4 which is enclosed by three bifolia by Scribe 2, again preserving the structure of the quaternion.

16. HÄMEL, 1950, pp. 21-28.

17. For the artistic context of C see STONES, 1992. For the links with R see also below.

18. As the result of Ambrosio de Morales' visit in 1572 and Mariana's negative views on the legends of Charlemagne, published in 1603 and 1608, and his negative opinions on the *Guide*, published in 1609, p. 21. See HÄMEL, 1943, pp. 232-233; SHORT, 1969, p. 3; DÍAZ Y DÍAZ, 1988a, p. 322.

19. See STONES in WILLIAMS/STONES, 1992).

20. Unless it is deliberate; see the 'deliberate error' arguments advanced by HOHLER, 1972 for this reading, *dexteris* and *cetibus*. Could this error be a reflection of the Anglo-Saxon counting practice whereby, for instance, 120 would be hundtwelftig (i.e. a hundred and twelve). See BRIGHT, 1891/1971, p. 86. We thank Mary Elizabeth Meek for this suggestion.

21. See previous note.

22. See English note IX-135 for a discussion of meanings and sources.

23. See also the note to this passage in the English translation for a discussion of the numbers of warriors mentioned in the account of the battle in the *Pseudo-Turpin*, Book IV of the *Codex Calixtinus*.

24. The reference is probably to the Geats among whom Ovid spent his exile; see English note VII-44.

25. HERBERS, 1986, p. 102, n. 87.

26. HÄMEL, 1950, p. 14: Book II in C (ff. 140-155) is largely written by Scribe 1, but f. 155 is by Scribe 2; Book III (ff. 155v-162) is largely by Hand 2, but ff. 161 and 162 are by Hand 1 (see our Catalogue of Manuscripts). The variants in R that Hämel notes are all on leaves copied, in C, by Scribe 2: *editum* for *conscriptum* (f. 155), *permaneat* for *permanet* (f. 155v), *haberet* for *habeatur* (f. 157v); *pedissequi* for *pedissece* (f. 159). They therefore constitute an argument for R having copied a version prior to C Hand 2's version (or an earlier archetype, such as SHORT, 1969 posits for the Galician version of Book IV). DÍAZ Y DÍAZ, 1988a, p. 273, follows Hämel. HÄMEL, 1950, pp. 24-25, also noted that R incorporates into its text passages about the feast of the Miracles which are in the margins on ff. 20, 152v, 161 in C, although the added half-leaf, f. 128 in C, with the Mass of the Feast of Miracles (3 October) is omitted in R.

27. See below and Catalogue of Manuscripts.

28. Hohler's 1972 argument, that they are deliberate errors, does not seem very convincing in view of the small number of them. The other three significant readings in Hand 1, *citra*, *dimii*, *Wicarto*, cannot really be called errors. See note 20.

29. See note 26 above.

30. SHORT, 1969, p. 6. We note that the *nomen/sanguinem* reading occurs in Hand 4 of C (f. 181 [*olim* 19] W p. 331), the *a terra elevatus* omission is made by C's Hand 2 (f. 179 [*olim* 17] W p. 327), and the spelling *Naaman dux Baioarie* is also by C's Hand 2 (f. 170 [*olim* 8] W p. 312). Of these, both of C Hand 2's readings occur in R; however R includes the *sanguinem* reading which C Hand 4 omits. C's Hand 4 dates to the early 14th century and did not participate in the copying of the *Guide*, so it does not concern us here. See Catalogue of Manuscripts, however, for the complete division of scribal hands in C.

31. See the discussion of C above, p. $$.

32. STONES, 1981, p. 200 and Catalogue of Manuscripts, under A, VA, S.

33. For comparative measurements see Catalogue of Manuscripts, C, A and VA, and above; see also note 47 below. Díaz y Díaz made these suggestions in discussion at the Pittsburgh Conference on the *Codex Calixtinus* in November 1988. Neil Ker has noted that English manuscripts adopted a two-column format gradually in the century after the Norman Conquest of 1066: '…soon for big books, later for medium-sized books, and towards the end of the century for small books'. S, in Ker's terms, would count as a middle-size book. KER, 1960, p. 42) No comparable study exists for Spain, but we mention here a parallel for the use of the two-column layout in Tortosa,

Cathedral, Biblioteca Capitolare MS 197, attributed to the end of the 12th century, containing, after miracles of SS. Gregory and Nicholas, selections from the *Codex Calixtinus* Books III (Ch. 2 and Prologue to Book III) and II (Miracles 4, 6, 12, 20, 3, 5, 17, 22, in that order, date range 1100-1109). See BAYERRI BERTOMEU, 1962, pp. 353-355, and DÍAZ Y DÍAZ, 1988a, p. 138. A full investigation of the two-column layout in manuscripts that include parts of the *Codex Calixtinus* but not the *Guide* might be fruitful in relation to the problems raised by S. For other parallels to Tortosa 197 see also the discussion below under T. The two-column layout was, of course, not uncommon by the date of S; most court manuscripts under Alfonso el Sabio in the previous century were written in two columns, regardless of size.

34. For the same reading in R, see discussion of the Short Version manuscripts.

35. See English note IX-116 on the altar-cloth.

36. See Introduction to the Manuscripts, pp. 28-30.

37. See p. 30.

38. See Catalogue of Manuscripts.

39. He also includes the last part of C's Chapter IX at the end of his Chapter XI, see Table of Chapters on p. 52. The other manuscript that adds its own chapter headings is Z; it ends up with XV chapters for the *Guide*. The numbering system is also important for determining the relationship between Z and Mariana's manuscript. See Catalogue of Manuscripts, VB.

40. See Catalogue of Manuscripts for mention of which components of the *Codex Calixtinus* are in P, and the significance of the omissions, some of which support the idea that the model was copied before 1139, shortly after our *terminus post quem* for C.

41. Discussed in Catalogue of Manuscripts under P.

42. See pp. 227ff.

43. See the discussion of C above. We have emended to *leva*, which is C's usual word for left, but *sinistra* was far more common in the 16th century.

44. The misbinding was noted by WHITEHILL, 1944, p. 52. See Catalogue of Manuscripts. We thank Elizabeth Peterson for working out this relationship between C and M. The misbinding is not copied in A, VA or S, nor is it reflected in P or SV; it must therefore have occurred between c. 1325 and 1538. P's direct model, Doc. vari 1, we know for historical reasons to be earlier than 1325, and this is another factor in confirming that SV's earlier model dated before the misbinding.

45. See previous note.

46. See Catalogue of Manuscripts.

47. C has 34 lines to a 295 × 212 mm page, A has 36 lines and measures 222 × 155; VA has 32 lines and measures 375 × 260 mm; S has 39 lines per column and measures 337 × 245 mm; P has 27-30 lines and measures 290 × 205 mm; M has 29 lines and measures 210 × 155 mm; T has 52-61 lines and measures 215 × 140 mm; R has 26 lines and measures 286 × 185 mm; VB has 36 lines per page and measures 217 × 144 mm; Z has 25 lines and measures 317 × 217 mm; L has 30-31 lines and measures 347 × 230 mm; SV itself has 28-32 lines per page and measures 314 × 217 mm.

48. HÄMEL, 1950 classified it D10 with reservations; for MANDACH, 1961, p. 383, it is HA80-Carmen, and also T37-Carmen because of its unique Latin Roland poem; see Catalogue of Manuscripts.

49. See Catalogue of Manuscripts for a more complete description of the problematical version of *Pseudo-Turpin* and related texts in T.

50. See above under P.

51. See Catalogue of Manuscripts.

52. Discussed above under Context, pp. 3-14.

53. DÍAZ Y DÍAZ, 1988a, pp. 247-261.

54. C does not seem to have been on general view, however. William Wey, the Fellow of Eton who went to Compostela in 1456, listed the indulgences and the relics, described the services, and made inquires about the number of cathedral clergy (WEY, 1857, pp. 153-161). He mentions the 'gold or gilt' crown of the captured king of Granada recently presented by King Henry, and displayed on the head of St James. Among the relics was the head of St James the Less, kept in the treasury, which would have been the logical place to display C. But Wey does not mention seeing C, and clearly did not consult it. He reports, for instance, that there are eighty canons, whereas the *Guide* makes a point of there being seventy-two, the number of Christ's disciples (see English note X-1). What Hieronymous Münzer of Nuremberg saw at Santiago while staying with the archbishop's chaplain, John Ramus in 1494, was probably C itself—not a duplicate copy, as suggested by PFANDL, 1917, pp. 586-608 and SHORT, 1972, p. 128. Münzer saw it in the Archives, still the home of C today. From it he transcribed part of the introduction, and selections from Books IV and I. PFANDL, 1917 edits Münzer's selections from Munich, Bayerische Staatsbibl., MS Clm 431, ff. 174-180, a copy of Münzer by the humanist Hartmann Schedel, and compares the *Pseudo-Turpin* excerpts with the 1880 edition by CASTETS. Pfandl wonders whether Münzer's section entitled *De Crusillis, id est muscheln* is from the *Guide*; in fact it is from the sermon *Veneranda dies*, Chapter XVII in Book I of the *Codex Calixtinus* (WHITEHILL, 1944, p. 153), and Münzer did not include the *Guide* in his selection. Pfandl later edited Münzer's account of his travels, including Schedel's copy of his drawing of the cathedral, 1920, pp. 1-79. For further discussion and English translation of Münzer's account of his visit to Compostela, see KROCHALIS, 1996.

55. See Catalogue of Manuscripts for descriptions, the table in DÍAZ Y DÍAZ, 1988a, pp. 327-333, for which selections are included, and our Table of Chapters on p. 52 for which sections of the *Guide* are in Short Version manuscripts.

56. DÍAZ Y DÍAZ, 1988a, p. 77, is cautious; but if R is not Arnault's copy it must have been made very soon afterwards, and the addition of a comment about the Benedictine abbey of St Pelayo in the same or a closely similar hand suggests a Benedictine scribe. A rather tenuous argument can be constructed, on the basis of VB, for the existence of a second Short Version copy in Arnault's time; see below.

57. STONES, 1992, and above at note 17.

58. See Introduction, p. 30.

59. See p. 52.

60. HÄMEL, 1950, pp. 21-28 and note 22 above.

61. See p. 201.

62. See discussion of S in the Long Version. S, writing *c.* 1325, could not have used a C Hand 1 version though P1's ultimate exemplar could have.

63. See KENDRICK, 1960.

64. See MORALES, 1765/1985, pp. 130-131. Among the few books he saw at Santiago were the *Historia Compostelana* and the *Codex Calixtinus*. Of the latter he made the following remarks: 'El otro Libro que tienen está entero, y fuera harto mejor que no lo estuviera: es el libro de los Milagros del Apostol Santiago, que dicen escribió el Papa Calisto II. Es buen libro en muchas cosas, mas no lo escribió aquel Sumo Pontifice, como claramente se puede demostrar. Aquel Original que alli tiene la santa Iglesia, tiene al cabo un tratadillo que entre otras cosas buenas de la descripcion de la Ciudad, y su Templo, tiene un aviso para los Peregrinos, con discurrir por todo el viaje. Quien quiera que fue el Autor, puso alli cosas tan deshonestas y feas, que valiera harto mas no haberlo escrito. Ya lo dige alli al Arzobispo Valtodano, que haya gloria, y à los Canonigos, para que no tuviesen alli aquello: no sé si lo remediarian, y es lo peor que no muestran aquel Libro sino à personas honradas, que son las que mas se ofenderán con aquello, y les hará mas lastima'. See also DÍAZ Y DÍAZ, 1988a, pp. 321-322. He appears to have been sufficiently impressed to have a copy of the *Historia Compostelana* made: in all probability the one which is now Madrid, Biblioteca Nacional 1512 (REILLY, 1971, p. 140).

65. See note 33 above and note 69 below.

66. See pp. 203, 204, 227.

67. BUCHTHAL, 1957, p. 135 notes a simiarilty in the script of the Sacramentary of the Holy Sepulchre, now Rome, B. Angelica, MS D.7.3, and the Rule and Obituary of St-Gilles, London, BL, Add. 16979. For the latter, see our English note VIII-21. Devotion to St James (even St James the Less, whose relics were in Jerusalem) is notably absent in the liturgical books of the Latin Kingdom discussed by Buchthal, nor does he refer to any copy of the *Codex Calixtinus* there.

68. For Cluny manuscripts, see the list under Cluny in GENEVOIS *et al.*, 1987. DAVIES/DAVIES, 1982, p. 42, n. 7 list Paris, BN, MS lat. 12 as a manuscript containing the *Codex Calixtinus*; this is an error.

69. BAYERRI BERTOMEU, 1962, pp. 353-355; DÍAZ Y DÍAZ, 1988a, p. 138, and note 32 above. The manuscript is of uncertain provenance; it is not impossible that, like the *Historia Pontificalis* of Peire Guilhem also at Tortosa, B. Cap. 246, Tortosa 197 is French in origin. For MS 246 see English note VIII-21. As this was in press, we received information about another Tortosa manuscript that has interesting implications for the CC tradition: Tortosa, Biblioteca Capitulare de la Catedral MS 106 (BAYERRI BERTOMEU, pp. 259-261; ZINK, 1972, 1974, cited in JACOMET, 1993, pp. 61, 76-77). The manuscript is a late 12th or early 13th-century Sermon collection, the first part of which contains the Sermons of Gregory the Great (ff. 1-106), the second part (ff. 106v-135), of interest here, is Sermons in Provençalo-Catalan, including (ff. 117v-125v or 126), one for the Feast of St James. The volume of 135

ff. measures 207 × 130 mm, written space 160 × 100 mm, text on 17 lines, precluding its ever having been part of the Tortosa Miracles discussed above. But JACOMET (1993, p. 117, n. 221) has observed that the St James Sermon opens with a quote in Latin from Calixtus's *Versus* for the Feast of St James and the Feast of the Translation (W 218). The text of the sermon emphasizes James as Apostle of Galicia, and the role of his tomb in the West as opposed to that of St John in the East, and it describes the translation of his relics to Galicia. What is especially interesting is that this Sermon cannot derive from the only manuscript that has survived from late 12th-century Catalunya, R, because the passage of text at W 218 was not included among the selections from MS C that Arnault de Munt copied into R. Tortosa 106 would therefore seem to be a sole witness to the existence of a Long Version manuscript available in Catalunya in the late 12th century independently of R. Might it have been a copy acquired from Santiago by bishop Oldoinus of Barcelona? If so, it would have been part of Diego Gelmirez' first efforts to circulate the *Codex Calixtinus*, an effort to which T's model, and the ultimate model of P, may also have belonged. The language of the vernacular sermons has been identified by ZINK (1974, 1976) as containing words in Catalan dialect, and so Oldoinus is the most obvious channel through which the model might have arrived in Catalunya; but it might also be worth considering a link between the model of Tortosa 106 and the other important figure whose name has surfaced in relation to St James and the *Guide*, who also lived in the Languedoc region—Peire Guilhem, librarian of St-Gilles, author of the Life and Miracles of St Giles (written in Latin), the other potentially interested figure, whose *Liber Pontificalis* is Tortosa MS 246. An examination of the script and decoration of Tortosa 106 is needed before the question of its origins can be pursued further; and the study by MORAN I OCERINJAUREGUITES, 1990 was not available to us. We thank Humbert Jacomet for drawing the manuscript, and his work on it, to our attention.

70. For the distinctions see Introduction, note 5.

71. See p. 230.

72. MYNORS, 1963, pp. 311-312.

73. Not to be confused with the *De penitentia Salomonis* attributed to Augustine in R; see Catalogue of Manuscripts.

74. See KER, 1977, pp. 934-939.

75. It appears to be unpublished.

76. SOUTHERN, 1969, pp. 196-209, cited by KER, 1977, p. 938.

77. KER, 1977, p. 939.

78. COLKER, 1975, pp. 70-71, 81, and 114-120. Not in THOMSON, 1982.

79. WHITEHILL, 1944, pp. 267-268; reprinted with emendations by COLKER, 1975, pp. 162-163.

80. COLKER, 1975, p. 71.

81. As GAIFFIER, 1943 points out, the hanging man saved is a miracle that exists in many different versions, and had an extensive iconographical tradition, much of which is earlier than the *Codex Calixtinus*; but the details here clearly do derive from the *Codex Calixtinus* account. Of interest in the context of the *Guide* is that this miracle is

also told in relation to SS. Eutropius and Foy; pilgrim badges of St-Eutrope, Saintes, recovered from the Seine, show the miracle (FORGEAIS, 1983, p. 172, cited by GAIFFIER, 1943, pp. 131-132 and plate facing p. 132). Later variants on this miracle add chickens and place the occurrence at Sto Domingo de la Calzada; see English note VIII-191.

82. See Catalogue of Manuscripts under C.

83. MEREDITH-JONES, 1936/1970, p. 16.

84. See the Catalogue of Manuscripts for T and the Introduction to the Manuscripts above.

85. Gai in *SANTIAGO DE COMPOSTELA*, 1985, no. 43, with previous bibliography.

86. Doc. vari 1 contains 34 surviving leaves from a longer compilation. The leaves which survive contain the entire correspondence between Rainerius, canon and schoolmaster of Santiago, Archbishop Diego Gelmírez, and the eyewitness account by the Pisan chancellor Cantarinus of the consecration of the Pistoia chapel of St James in 1144. This occupies ff. 1-16v. Folios 17-24 were originally numbered LXIII, LXXIIII, LXV, LXVI, LXXVII-LXXX. Assuming that the manuscript was quired in eights throughout, and that these were originally a quire, 63 and 65, 66 are mistakes for 73, 75 and 76, and this quire was originally 72-80. It contains the lections for the octave of the Feast of St James. The current fourth quire, leaves 25-32, has no original numbering, but continues the lections for the octave. The current leaves 33-34 are numbered LXXXVI and LXXXVIII; they contain part of the passion of St Felicity and her seven sons, and were part of the quire which originally preceded the current 25-32. Folio 34v contains a miracle of James, not otherwise recorded. The last two leaves are loose, and come from another manuscript. Presumably the volume originally contained miracles of James, probably the Pistoia local miracles now found in Doc. vari 27. There would have been space for those and for other texts in the missing 56 folios, but not for the entire *Codex Calixtinus*. If the original contents were like those in Doc. vari 27, it contained liturgy for at least one Feast of St James, and perhaps the 22 Miracles of Book II, and possibly the Translation, Book III.
The result would be a compilation like the Reading manuscript, Gloucester Cathedral MS 1, mentioned above; it would also resemble the surviving Pistoia manuscript Doc. vari 2, compiled for the Feast of St James in the mid 15th century. But, if the manuscript had further leaves after f. 88, it might well have contained all five books of the *Codex Calixtinus*. The fact that Pistoia Doc. vari 27 has the correspondence, the local miracles, its own local liturgy, and *Codex Calixtinus* Books I-V, if in a different sequence, supports the theory that its exemplar did as well.

87. GAI *et al.*, 1984, no. 8. The overlap of its texts with P is discussed in the Catalogue of Manuscripts.

88. *Et quia ego frater petrus a sancto cæcilio, monachus ex familia excalciasorum sacri ordinis redemptorum beate marie de marcede hoc transumptum bene et fideliter transcripsi* (something cancelled) *partim ex Autographo, partim ex alio transumpto ex ipsomet Exemplari Ms. sumpto. Ideo me subscriptsi. Granate in camera mee solite residentie apud sacrum cenobium B. Marie Virginis de Bethleem, pridie Nonas Decembris anno domini M Dc xxxii.* [signed] *Fr. Petrus a Sancto*

239

Cæcilio (monogram: PC?). margin: *Aubelor copias en Estepa. 22. de Julio. 1657* [with another signature? VS]

89. SV's—or Peter's—second copy of Book IV of the *Codex Calixtinus*, *Pseudo-Turpin*, seems to have been a printed book. In a note towards the end of PT, ff. 67-68, the scribe compares two copies of PT, one with 32 chapters and one with 26. The 32-chapter version he refers to on f. 65v: *cum typis edita inter scriptores Veteres Rerum Germanicarum vulgo circumferatur*. We reproduce the manuscript underlining. (The various 16th and 17th-century editions of this compilation, which was indeed, as Peter says, widely circulated, and commonly available, are discussed by CIAMPI, 1822. The version of Ch. 26 is *in nostro Calixti codice*. The 32-chapter version (which breaks down the lengthy Ch. 21) is also in our MSS L, T and M. It is interesting that Peter's desire was to copy exactly what was in the exemplar, however incomplete and inadequate, even when another text was at hand. It gives further evidence of Peter's—or SV's—concern for recording all available evidence to establish the best possible text.

90. Written in 1572, published in 1765, reprinted 1985.

91. See p. 230.

92. Cited by CIROT, 1905, p. 66.

93. Ibid., p. 65, n. 4.

94. *Dos discursos*, published in Mainz, 1605, p. 19, cited by CIROT, 1905, p. 67, n. 6.

95. *Dos discursos*, p. 21, cited by CIROT, 1905, p. 67, n. 8.

96. GIGAS, 1909, p. 430, n. 1.

97. GIGAS, 1909, p. 438.

98. JØRGENSEN 1926, p. 189, with no indication of provenance.

99. HÄMEL, 1953, p. 80; MANDACH, 1961, A7-Da, p. 308; not in MEREDITH-JONES.

ILLUSTRATIONS

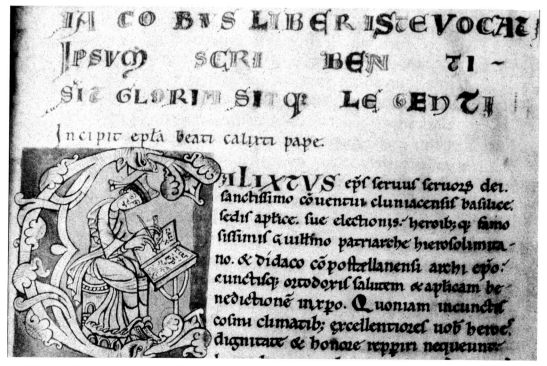

1. Calixtus writing, f. 1. Santiago de Compostela, Archivo de la Catedral

2. Initial S, f. 24v

5. Initial A, f. 31v

3. Initial S, f. 71v

4. Initial S, f. 95v

6. Initial P, f. 48v

7. Initial A, f. 53v

9. Initial D, f. 44v

8. Initial V, f. 74

10. Initial G, f. 164

11. Initials I and Q, f. 65v

12. Initial E, f. 67

13. Initial A, f. 94

nube cerrificum in monte chabor audierunt hic est filius meus

dilectus ipsum audite. ev o ae. P Laudate d. decet. capitlo. Iacob; di & dnu nr̃. vt

V. N. s. iacobi a dr̃o fulberto karnotensis supra,

Sanctissime o iacobe fr̃ q̃ es ingenere. iohis epo edit

euangeliste. p nob ora sedule; Qui supplantator diceris. sub

planta nos a uiciis ut tuis sacris pcib; ungamur poli ciuib?

Zelus patris; f Iacob; fuit magnus. Sedm nom suũ alta; sero io

oyarei ca atus. v iii.

Ascendens ihesus in montem uocauit adse ia cobum tohñ

& iohan nem et imposu it eis nomina boanerges al leluia.

evo ae. P Benedictus adp̃oñ. a Imposuit ihs. ad tecia. a vocauit ihs.

capto. Iacob; indieb; suis; R Ora p nobis beate iacobe alle

luia alleluia. vt digni efficiamur promissionib; xp̃i. alta alta. Gta

patri. ora p nob. Imposuit ihs. vt svp; ad u i. a Sicut eni. capto.

In uita sua fecit monstra vt svp. R Imposuit ihs iacobo iohi alta

alta. Nomina boanerges; alta alta. Gta patri. Occidit autem he

rodes iacobum. fratrem iohis gladio. alta. ad iii. a Recte filii. capto.

nomi ore quasi mel. vt svp; R Occidit autem herodes iacobũ

14. Book I, f. 103

letemur in secula a$\overline{\text{m}}$ens; Sec. S. evangtu.s. marcu;

N illo tpr· Accesserunt ad dnm ihm filij zebedei
iacob; ⁊ iohs· dicentes; Magister· uolum⁹ ut q̊ c$\overline{\text{u}}$q;
pecierimus tibi· facias nobis; At ille dixit eis; Quid
uultis ut faci$\overline{\text{a}}$ uobis, Et dixerunt; Da nobis ut un⁹
ad dexteram tuam· & alius ad siniftram sedeamus in
gloria tua; Ihs autem ait illis; Nescitis quid petatis;
Potestis bibere calicem quem ego bibo, Aut baptis
mo$\overline{\text{m}}$ quo ego baptizor baptizari· At illi dixer$\overline{\text{u}}$t
ei; Possumus; Ihs autem ait eis; Calicem quidem qu$\overline{\text{e}}$
ego bibo bibetis· & baptismo quo ego baptizor bab
tizabimini· sede aut$\overline{\text{e}}$ ad dexteram meam ut ad sinis
tram non $\overline{\text{e}}$ meum dare uobis· $\overline{\text{s}}$; quib; paratum eft;
Et audientes dece$\overline{\text{m}}$ ceperunt indignari· de iacobo et io
hanne; Ihs autem uocans eos· ait illis; Scitis quia hii
qui uidentur principari gentib; dominant$\overline{\text{ur}}$ eis· & principes
eor$\overline{\text{u}}$ potestatem habent ipsor$\overline{\text{u}}$; Non ita $\overline{\text{e}}$ autem in
uobis; S; q̊ c$\overline{\text{u}}$q; uoluerit fieri maior· erit ur minister;
Et q̊ uoluerit in uobis prim⁹ $\overline{\text{ee}}$ erit omniu$\overline{\text{m}}$ seruus;
Nam & fili⁹ hominis non uenit ut ministraret ei $\overline{\text{s}}$; ut
ministraret; Et daret anim$\overline{\text{a}}$ sua$\overline{\text{m}}$ redempcion$\overline{\text{e}}$ p multis;

Credo minor. $\overline{\text{V}}$.
marc. off. A s cendens ihesus in mon

tam uoca uit ad se iacobum

zebe dei ⁊ iohannem fratrem iaco bi et impo

suit e is no mi na boaner

Calixt̄ P̄ de festiuitate miraclo̧ʒ S. Iacobi. que s̄, die Nonar̄
estiuitate miraclo̧ʒ sc̄i iacobi qualit̄ uiru q̄ se ip̄ soctob colit̄
su diabolo suadente inicecerat sustentauit. d̄i genetrice maria au
riliante: ce q̄m xx uiuos a captione moabitaru potenti uirtute d̄i
eripuit: ce mortuu a portib; cisere usq; ad c̄ompostellana urbe una nocte
p bissenas dietas ad sepeliendu deportauit. cetaq; miracla fec̄: y die
nonariu octobris beat̄ a̧sel̄m olim colere p̄cepit: ce nos hoc ide corro
boramꝰ; s̄. die Nonariu octobris. missa miraclo̧ʒ sc̄i iacobi;

n̄ uocauit. p̄ Collenariam. ut sup̄

D̄s q̄ beatu iacobu aplm tuu ad laude tui nominis in numeris
fecisti miraclis coruscare: concede nob ei miraclo̧ʒ festa celebra
tib; ipso intecedente uirtutu floub; uite. ce ad gaudia paraclisi p̄ ue
nire. p̄ l c̄o. Iacob̄ inuel̄ fu. s̄. ut sup̄. R̄. Misit herodes. s̄. Occidit au.
Alla. uocauit ih̄c. p̄sa Clemens seruulo̧ʒ. eua⟨n⟩⟨g⟩liu. Conuocatis ih̄r duodeci.
off̄ Ascendens ih̄c. O

penitenciā: inuent̄ e p̄fect̄ iustus: ce in t̄pore ire fact̄
est reconciliacio; caplo̧ ad matutina de libro sapientie.
agnus pater multitudinis genciu. ce non e inuent̄
similis illi in gl̄a: qui c̄oseruaret lege excelsi; caplo̧
ad terciao̧. de libro sapientie;
uit d̄ns in testamento cu ipso. in carne ei fecit sta
re testamtu: ce in temptacione inuentus e fidelis;
caplo̧. ad sexta̧, de libro sapientie;
gnouit eu d̄ns in benedictionib; suis. ce dedit illi he
reditate: ce diuisit ei parte in tribub; duodecim;
caplo̧. ad nona. de libro sapiencie;
ilect̄ a d̄o ⁊ hominib; beatꝰ iacobus: cuiꝰ memoria

16. Book I, f. 12 (damaged)

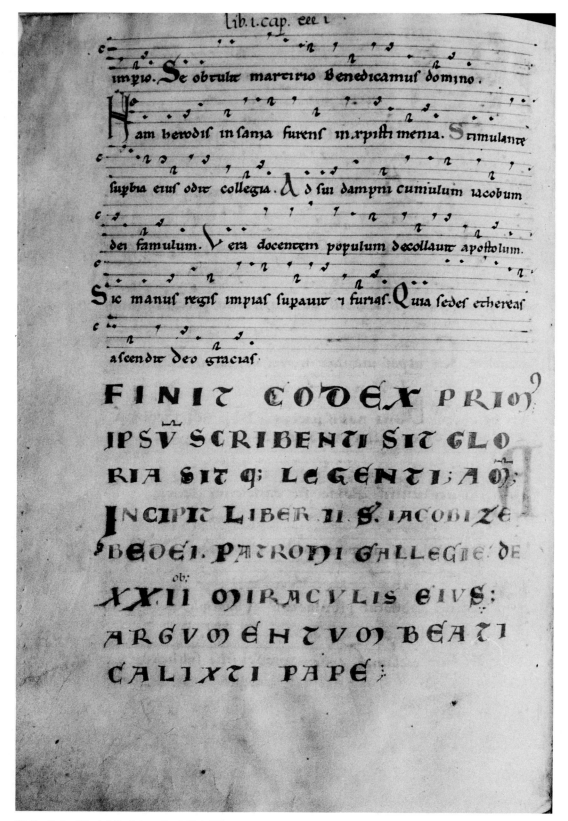

lib. i. cap. eee i

impio. Se obtulit martirio Benedicamus domino.

Ham herodis in sania furens in xpisti menia. Stimulante

supbia eius odit collegia. Ad sui dampni cumulum iacobum

dei famulum. Vera docentem populum decollauit apostolum.

Sic manus regis impias supauit et furias. Quia sedes ethereas

ascendit deo gracias.

FINIT CODEX PRIOS
IPSU SCRIBENTI SIT GLO
RIA SIT Q LEGENTI: AO;
INCIPIT LIBER II. S. IACOBI ZE
BEDEI. PATRONI GALLEGIE DE
XXII OMIRACVLIS EIVS;
ARGVMENTVM BEATI
CALIXTI PAPE;

17. Explicit of Book I; Incipit to Book II, f. 139v

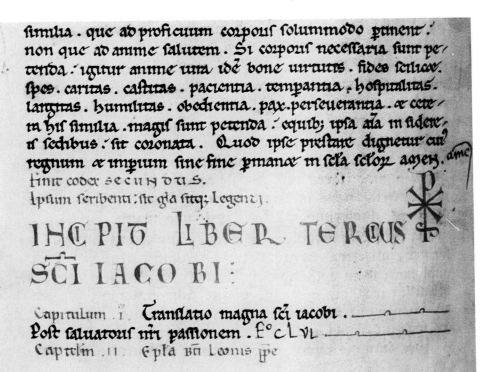

18. Incipit of Book III, f. 155v

19. Dream of Charlemagne, f. 162

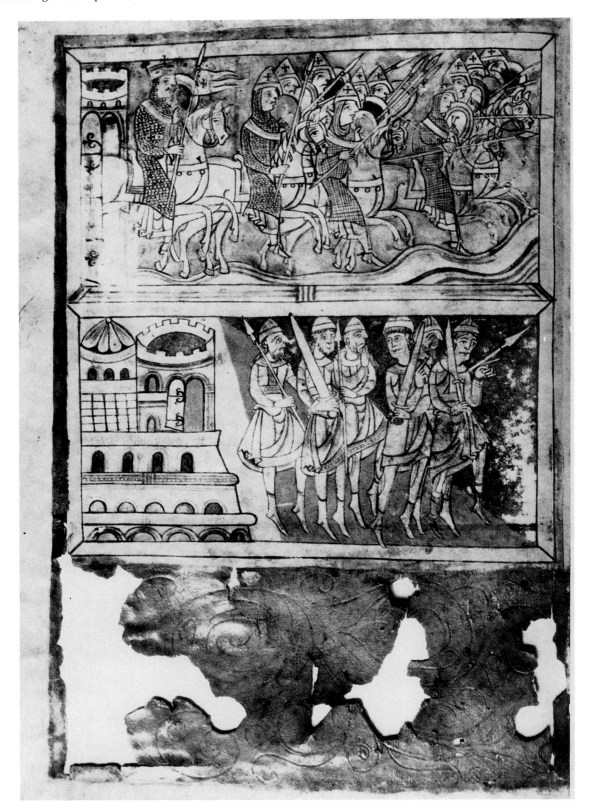

20. Charlemagne and his army set out from the city, f. 162v

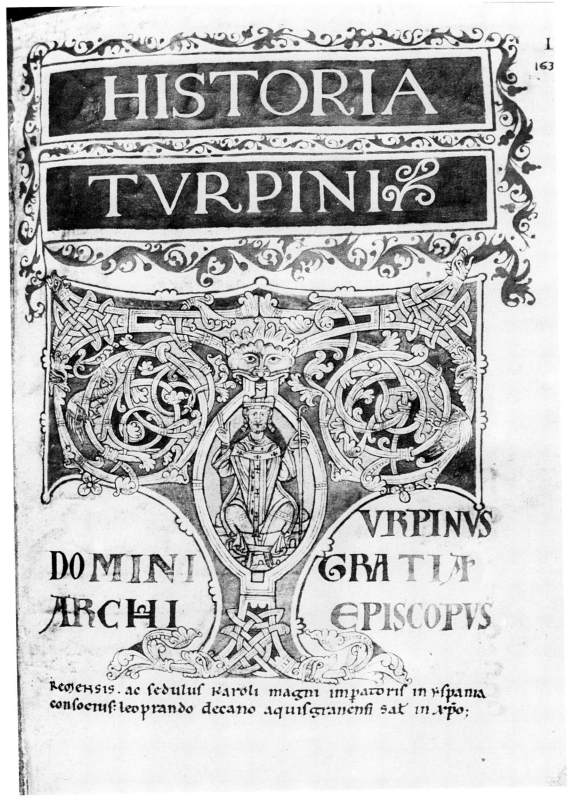

HISTORIA

TVRPINI

DOMINI

ARCHI

VRPINVS

GRATIA

EPISCOPVS

Regensis. ac sedulus karoli magni impatoris in yspania consocius: leoprando decano aquisgranensi sal in xpo;

21. Preface to Book IV, Turpin blessing, f. 163

cenorū gladio pēmptī sūnt. Capitlm̄ . X.

Inde aigolandus uenit scōnas. que tūc sarracenoꝝ impiis
subiacebat. ⁊ ibi cum suis commoratus est. karolus uero sub
secutus est illum. ⁊ mandauit illi ut redderet urbem. Ipse uero
noluit reddere. s; exiliuit ad bellum contra eum: tali conue
nientia ut illius esset urbs qui uinceret alium. Sexto uero an
die belli. castris ⁊ aciebꝫ ⁊ turmis preparatis. in pratis scilicet
que sunt inter castrum quod dicitur talaburgus ⁊ urbē. iuxta
fluuium nūc charanta. infixerunt xp̄iani quīdā hastas suas
erectas infra corā castris. Crastina u̅ die hastas suas scortitibꝫ
⁊ frondibꝫ decoratas inuenerunt: hii scilicet qui in bello presen
ti accepturi erant martirii palmā pro xp̄i fide. Qui etiam tāto
dei miraculo gauisi. abscisis hastis suis de terra. insimul coadu
nati primitus in bello ferierunt. ⁊ multos sarracenos occide
runt: sed tandem martirio coronantur. Erat enim illorum
exercitus. quattuor milibus. Et equus etiam k a r o l j
ibi occiditur. k a r o l ꝰ ꝰ uero oppressus fortitudine pa
ganoꝝ. resumptis uiribus cum suis exercitibus peditus inter
fecit multos illorum. At illi ferre eius bellum non ualentes:

22. Hand 2, f. 169

euemadmodum tame poſt deuotatione tellum gauecie
ab yspania rediit ad gallia: nob breuit est dicendum;

oſt quam Capitulum . X X i.

karolus magnus impator famosissi
mus totam yspaniā diebꝫ illis ad do
mini ⁊ ap̄li eiꝰ sc̄i iacobi decus adqui
siuit: rediens ab yspania pampiloniū
cum suis exercitibꝫ hospitatus est.
⁊ erant tunc tempous commoran
tes aput cesaraugustam duo reges
sarraceni marsirus scilicet ⁊ belli
guandus frater eiꝰ. ab admirando
babilonis depfide ad yspaniā missi: q̄

23. Initial P, Hand 2, f. 179

Deinde proprio cornu cepit altis sonis tonitruare. si iam
aliqui ex xpianis qui p nemora timore sarracenozum
latitabant: ad se uenirent. uel si illi qui portus iam transie-
rant. forte ad se redirent: suoqz funeri ad essent: spatam qz su-
am et equum acciperent. et sarracenos causa telli persequere-
tur. Tunc tanta uirtute tantaqz fortitudine tubam suam
eburneam sonuit: quod uento oris eius tuba illa p medium
scissa. et uene colli eius et nerui rupti fuisse feruntur. Cui9
uox tunc usqz ad Karoli aures qui erat hospitatus cum pro-
prio exercitu in ualle Karoli. loco scilicet qui distabat a ro-
tolando .viij. miliarijs uersus gasconiam. angelico ductu p-
uenit. Ilico K a r o l u s. uoluit ad eum causa au-
xilij redire. sed ganalonus passionis rotolandi conscius di-
xit ei. Noli retro comine mi rex redire: quia ro t ol
a n d u s pro minimo tubam cotidie usus est sonare.

24. Hand 4, f. 181v

qz ad refocilandam sitim suam ultra quam dici fas est de-
sideraret: superuenienti balduino ut sibi limpham preteret
minuit. Qui cum aquam huc illucqz quereret nec inuen-
ret. uidens eum morti proximum ilico benedixit ei: et for-
midans ne in manus sarracenozum incurreret: equm eius
ascendit. et Karoli exercitum precedentem relicto eo immita-
uit. Quo recedente: ilico aduenit tedricus. et cepit ualde
super eum lugere. dicens ei. ut animam suam fide confessio-
nis muniret. Acceperat ipse r o t o l a n d u s die
eodem eucaristiam et delictozum suozum confessionem a-
quibusdam sacerdotibus. antequam ad bellum properaret.
Erat enim mos ut oms pugnatozes. eucaristia et confessio-
ne pmaniis sacerdotum. episcopozii. et monachozum. qui ibi
aderant. animas suas munirent. illo scilicet die qua sciebat
se ituros ad bellum antequam ad pugnam properarent.
Tunc eleuatis ad celum occulis. rotolandus xpi martir:
alt.

25. Hand 4, f. 182

meritorum annexa.

Non decet hunc q̃ uacuis deflere querelis.
Quem letum summi nc tenet aula poli.
Nobilis antiqua decurrens ple parentum
Nobilior gestis nunc sup astra manet.
Egregius nulli denobilitate seds
Moribus excellens culmine primus erat.
Templorum cultor recreans modulamine ciues
Vulneribus patrie fida medela fuit.
Spes cleri. tutor uiduarum. panis egentium
Largus paupib; prodigus hospitibus.
Sic uenerabilibus templis. sic fudit egenis
Mittere ut celis. quas sequerentur opes.
Dogmata corde tenens. plen' uelut arca libellis
Quisquis quod uoluit fonte fluente bibit.
Consilio sapiens. aio pius. ore serenus
Omibus ut plis esset amore parens.
Culmen honoratum. decus almum. lumẽ opimum
Laudibus in cuius. milite omne decus.
Pro tantis meritis hunc ad celestia uectum
Non premit urna rogi sed tenet aula dei.

Quid plura Dum beati rotolandi miris anima exiret a
corpore ex ego turpinus in ualle K A R O L I.

26. Hand 2, f. 183

tur. ꝭ decoratur designant.

Dialectica in aula regis depingitur. que docet uerum a
falso discernere. disputare. de uerborum ingeniis tractare.
stultos concludere. scientes uerbis abundare. Inqua si pe
dem firmiter posueris ex inde trahere non poteris.

Rethorica que scienter et conuenienter. placide ꝭpulchre
ꝭ recte docet loqui. Rethos grece dicitur facundus. Ver
bis enim facundum ꝭ eloquentem. scientem se ars reddit.

el V
187

Geometria ibi depingitur. que
mensuratio terre dicitur. Ge enim grece dicitur glis.
metros mensura. hec ars terrarum. montium. uallium
ꝭ manuum spacia ꝭ miliana ꝭ leugas mensurare docet. Quam
qui adplenum intelligit cum spacium cuiuslibet regionis. uel
terre. uel loci. uel campi. uel prouincie. uel urbis uidet. quan

27-28. Hand 3, ff. 186v and 187

lib. iiii. cap. 1.

C lc. iiii.
192

INCIPIT LIBER V. SCI. JACOBI. Aptiss

ARGUMENTUM BEATI CALIXTI PP.

Si ueritas apud lectore nostra uoluminib; requirat. in hui codicis serie. amputato estracionis scrupulo secure intelligat; Que eni in eo scribuntur. multi ad huc uiuentes uera ee testantur;

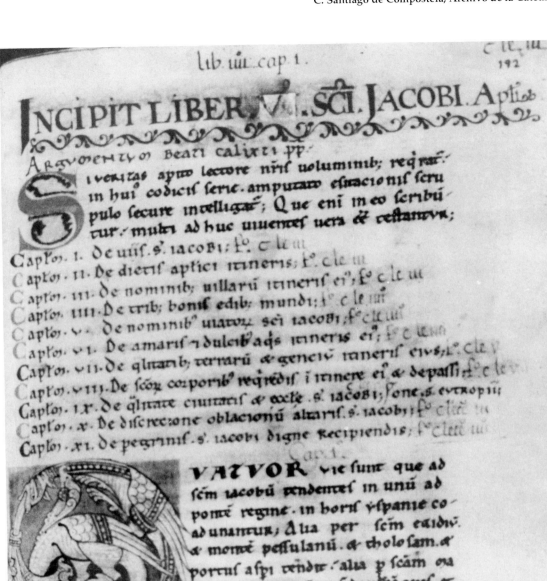

Cap. 1.

QVATVOR uie sunt que ad scm iacobu tendentes in unu ad pontem regine. in horis ispanie coadunantur; Alia per scm eaidiu. & monte pessulanu. & tholosam. & portus aspi tendit. alia p scam mariam podii. i scao fidem coqs. et scm petru de moissaco incedit. alia p scam mariam madalena vizilaci. i scm leonardu lemouicensem. & urbe petragoricensem pgit. alia p scm mariam tyronense. i scm ylariu pictauensem. & scm iohem angliacensem. & scm eutropiu sconensem. & urbe burdegalensem nadit; Illa que p scam

29. Incipit of Book V, f. 192

30. Hand 1, f. 193v

31. Hand 1, f. 197v

quendā paupem hospitati essent : ecce eni diuina opante
ulcione. totū uicū uelocissimus igs. incipiens ab ede q̃
prius hospiciū pecierant. usq; ad illa q̃ hospitati erāt noc
te illa cōbussit ; Et erant edes circiŧ mille ; Jlla ū do
mus q̃ serui di hospitati erāt : dei gia illesa remansit ;
Qua ppŧ sciendū qd̄ sci iacobi pegrim siue paupes si
ue diuites. iure ĥ recipiendi. & diligenŧ procurandi ;

EXPLICIT CODEX
Q.VART' S. IACOBI
APOSTOLI ;

Ipsum scribenti sit gŀa. sit q; legenti ;
HVNC CODICẼ PRI ECCLIA ROMA
NA DILIGENER SVSCEPIT: SCRIBIŦR
ENI IN CŌPLVRIBVS LOCIS IN ROMA
SCILICET: IN HIEROSOLIMITANIS HO
RIS: IN GALLIA IN YTALIA IN THEVTO
NICA. ET IN FRISIA. ET PRECIPVE ARD
CLVNIACV M ;

32. Explicit of Book V and Colophon, f. 213v

[Musical notation with staff lines]

do

ideo dyoardus

mi no **Bene** di ca mus do mi

aymericº picadi prb de partu jaco

no

ad honorem regis summi qui condidit omnia

Venerantes iubilemus iacobi magnalia

De quo gaudent celi ciues in supna curia

Cuius sacta gloriosa meminit ecclesia

Supra mare galilee omnia postposuit

Viso rege ad mundana redire non uoluit

Set post illum se uocantem pergere disposuit

Et precepta eius sacta predicare studuit

G· mocrepi

iacobu~ nobis inuitauit· fac nos qs me̅ sede add dexteram
parte regni tui· qs eu de calicis participes fieri uoluisti· peundem.
Innocentius eps seruus seruorum di· **Epistola domini papae INNOCENTII**
uniuersis ecce filiis sal· & aplica~ bn̅ in xpo· Hunc codice~ A d̅no pp̅·
calixto p̅ multis editu~· que~ pictauensis aymericꝰ picaud· de parriaco
uet̅· q etiam oliueꝝ d iscam· uilla sce marie magdalene deuziliaco
di̅ & bptga flandrensis· sotia eiꝰ p diaru~ suaꝝ redeptoe̅ sco iacobo gal
leciauensi declar· ub uerissimu~· acctione pulcherrimu~· ab hereca
& apocfa p̅urate Altenu~· 7 un̅ ecclasticos codices autengon~· 7 caru~
fore Auctoritas n̅ra nob̅ testificat· ex comunicas 7 Anathematizans·
Auctoytate di patis oipotentis 7 filii 7 sp̅c s̅ci· illos qui eiꝰ labores
intenere Sci Iacobi forte inquietauerint· ut q ab eide Apt̅i basilica
post q ubi oblatus fuerit· inste illu~ abstulerit· ut fraudauerit· ual·

Ego aimericus cancellariꝰ hunc libru~ autenticu~ et ueracem
fore· ad honorem sci iacobi in manu mea scribendo affirmo.

Ego byard d sca̅ †ce· cardinat· he̅ codice~ p̅rofessꝰ ad dec̅ sci
Iacobi· penna mea scribendo corroboro.

Ego Guido pissauꝰ cardinat· q d̅ni pp̅· I· testificat· affirmo.

Ego Iuo cardinat· qd d̅ni pp̅· I· auccorias affirmat· laudare
non recusư o;

Ego gregoriꝰ cardinat· nepos d̅ni papę· I· hunc codice~ obtimu~
ad honore̅ beati iacobi· laudo.

Ego guido lumbardꝰ cardinat· libru~ istu~ bonu~ 7 pulcherrimu~· ad
dec̅ sci iacobi gtifico;

Ego gregoriuſ in betsia· cardinat· he̅ codice~ obtimu~ similem
ad dec̅· sci Iacobi L A v d o.

Ego Albicꝰ legatꝰ p̅sul hostiensis· ad decꝰ sci Iacobi· cuiꝰ seruuſ su̅· he̅ codice~ legale̅
& carissimu~· 7 pora laudabile̅ fore p̅dico.

34. Book V, f. 221

Miraculu. s. iacobi. a domno Albico virzhacensi abbate atq;
epo hostiensi. & rome Legato editum.

Anno dominice farnatois. co. c. xxx. ix. Ludouico
rege francorum. regnante. ynnocentio. pp. psidente. uir
quidam nomine brunus deuizhaco. uilla. s. marie mag-
dalene a sco iacobo rediens: numis sib; deficientib; cepit
egere. Q uicum non haberet. unde solam panis numma-
tam emere posset: die quadam circa nonam ad huc ie-
iunus. midicare erubescens. ualde anxius. beati iacobi au
xilium toto corde ymplorando. sub arbore quadam solusq;
euit. Ibi u paulisp dormiens: somniabat quod beatus
apls iacob; cibo illum pascebat. Cuuigilatus namq; sub
ciner igium pane ad cap suu inuenit. ex quo. x v. dieb;
uixit. quo usq; ad propria uenit. Per unum quemq;
diem ex eo sufficient bis comedebat: & altera die eunde
panem integru sacculo inueniebat. O admirabile factum
che prophe renouatu. a domino factum est istud. & est
mirabile in oclis nris. E rgo regi regum sit decus & gla.
in secla selov amen. i. atta igreco.

Alleluia Vocauit ihc. v. Efonisen o yssys iacobon
tu se be zeum kc io an nin azelfon ap tu ke
kales sen apus o nomata BOANERGES pion
pragma estui oy osusuronitis. Chorus. Vo est filii. cauталдина

36. Book V, f. 222

84

Hac urbe dece̅ eccl̅e solet e̅. q̅r̅u̅ p̅ma de eccl̅iis u̅ a̅ b̅ s̅.
gt̅oiosissimi ap̅ti iacobi zebedei i̅ mdio sita refulget gt̅osa. Sc̅da
bi pet̅ ap̅ti. que monachoz̅ e̅ abbacia. uirta uia̅ f̅acigena̅ sita;
t̅c̅ia sc̅i michael que d̅r̅ cist̅na; uiii. sc̅i martini ep̅i que d̅r̅ de
pinario. q̅ e̅ monachoz̅ e̅ abbacia; v. sc̅e t̅nitatis q̅ e̅ peg̅noz̅
septi̅a; vi. sc̅e susane uirginis. q̅ e̅ uirta uia̅ pet̅ni; vii. sc̅i felicis
m̅ris. octaua sc̅i benedicti; nona sc̅i pelagii m̅ris. q̅ e̅ ret̅o bi iaco
bi basilica̅. decima sc̅e marie u̅ginis. que e̅ ret̅ eccl̅a sc̅i iacobi= ha
bet̅ it̅uu̅ i eade̅ basilica̅ i̅ altare sc̅i nicholay i sc̅e crucis. dealtarib; ba

Altaria hui̅ basilice= hoc ordine habet̅ur. In p̅mis uirta porta̅ silice
f̅acigena̅ que e̅ isinist̅iali parte. e̅ altare sc̅i nicholay; ide̅ e̅ altare
sc̅e crucis; ide̅ e̅ i costa sc̅ altare sc̅e fidis u̅ginis; ide̅ altare sc̅i ioa̅is
ap̅ti i eug̅le. f̅ris sc̅i iacobi; ide̅ e̅ altare sc̅i saluatoris. i maiori sc̅t capi
te; ide̅ e̅ altare sc̅i pet̅ ap̅ti; ide̅ e̅ sc̅i andree altare ap̅ti; ide̅ e̅ altare
sc̅i martini ep̅i; ide̅ e̅ altare sc̅i sc̅i ioh̅is baptiste. I̅nt̅ altare sc̅i iaco
bi. i altare sc̅i saluatoris= e̅ altare sc̅e marie magdalene ubi de
cantat̅ uisse matutinales peg̅nis. Sursu̅ i̅palacio eccl̅e. si̅t t̅ia
altaria. mai̅. g̅oz̅ e̅ sc̅i michaelis arcangeli; i aliud altare e̅ i dex
t̅alis parte sc̅t sc̅i benedicti; et aliud e̅ altare isinist̅iali parte.
sc̅oz̅ sc̅t pauli ap̅ti. i sc̅i nicholay ep̅i; ubi solet e̅ archi. ep̅i
capella. decorpore ie altare sancti iacobi. Hec q̅d̅e de
q̅litate eccl̅e acte̅i t̅tauim̅; n̅c de ap̅tico altar̅ uenerabili n̅b
e̅ t̅ctadu̅. In p̅fata siqd̅e uenerabili basilica. bi iacobi corp̅ uenent̅
d̅u̅ sub altari maiori q̅d̅ sub e̅ honore fabricat̅. honorifice ut
fert̅ iacet. archa marmorea reg̅diu̅ i̅obumo archuato sepulc̅o=
q̅d̅ miro op̅e ac magnitudie p̅decenti̅ op̅t̅. Q̅d̅ e̅ corp̅ immobile

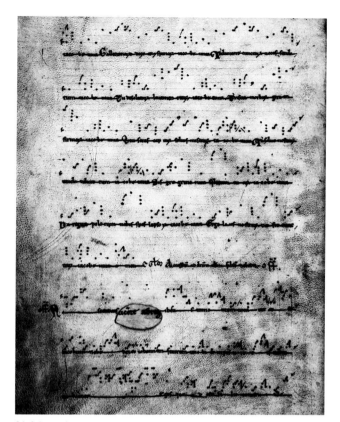

38. Musical Notation, f. 32v

39. Explicit of Book IV, opening of Book V, f. 80

40-41. Dedicatory letter of Arnaldus de Monte, f. 84v-85

ce maximi. Sollempnitate hodierna. XVj. Capłm. Sermo bñ calixti ṕp.
Venenda diei. XVij. Capłm Omilia bñ gregorii ṕp. Iudicis frs kñt
qa. XViij. Capłm. Expositio bñ calixti ṕp. Sollempnia sacra ṕfecta.
XiX. Capłm. Expositio scoꝝ Jeronimi aug̃. gregorii. ce calixti.
Festiuitate electionis ce translationis. Sermo uenabil bede prbri.

Quoniam bñ iacobi uigilia dilctm frs desidat obse-
quiis ce dignis ieiuniis iam recolim. dignu e ut ad
eiꝰ dec ꝯ laudes nrarum linguarum pconia ñ sileant.
Jacob di ce dñi nrī ihu ꝯ seruu inpmordio
epłe sue se asserit. ce salutem fidelibꝰ pmittit. ut demonstret
quia qsqs in di seruicio usqꝫ infine pseuauit. pculdubio inp-
permim saluus erit. Dixe de hoc iacobo. apłs paul. Jacobus
cephas ce iohns q uidebant columne ce. dextꝝ dede ꝫ ce bar-
nabe societatis. ut nos ingentibꝰ. illi aut mcircuncisione tantu
pauperum memores eem. Ca q̃ mcircuncisione ordinat erant apłs
cauuit eos q̃ mcircumcisioe erant sic ṕsentes colloquendo disce.
sic ce absentes p epłam consolari. instruere. increpare. corrige.
Duodeci mqt tribubꝰ q̃ st indispsione. Legim occiso a iudeis
bto stepho. qa facta e in illa. die psecucio magna inecclia. q̃ erat
ierosolimis. ce omis dispsi st p regiones iudee ce samarie. ptꝫ apło.
hiis q̃ dispsis q̃ psecucione passi st ꝯpe fiucia. mittit bñ iacobus
epłam. Nec solu hiis. uerum etiam illis q̃ pcepta fide ꝯ. necdu opibꝰ p-
fecti ce curabant. Sic sequencia epłe ṕsentis restant. Nec ñ ce eis
q̃ etiam fidei ex fontes durabant. q̃ ce ipsam mcredentibꝰ q̃tum ua-
luere pseꝗ ac pturbare studebant. Q ̃ tam oīs indispsioe fuere ua-
riis casibꝰ patria. pfugi. ce iniuriis cedibꝰ mortibꝫ atqꝫ erumnis
ubicunqꝫ erant ab hostibꝰ pressi. sic hystoria ecclastica sufficiet
exponit. S; ce inactibꝰ apłoꝝ legim eos tempore dñice passionis
longe lateqꝫ iam fuisse dispsos. Dicente luca. Erant aute inierłm
habitantes iudei uiri religiosi. ex omī natione que sub celo e.

42. f. 105

43-44. Book IV, ff. 213v-214

215

45-46. Excerpt from Book V, ff. 214v-215

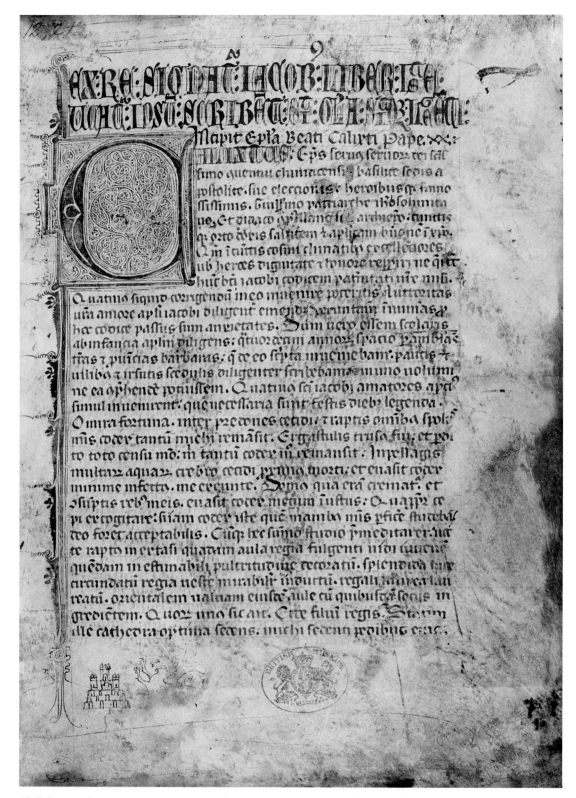

47. Title-page, f. 1

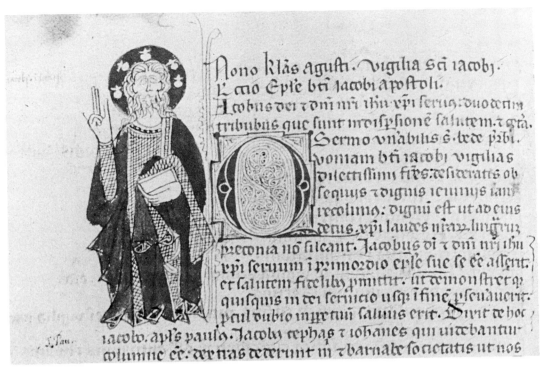

48. St. James, f. 3v

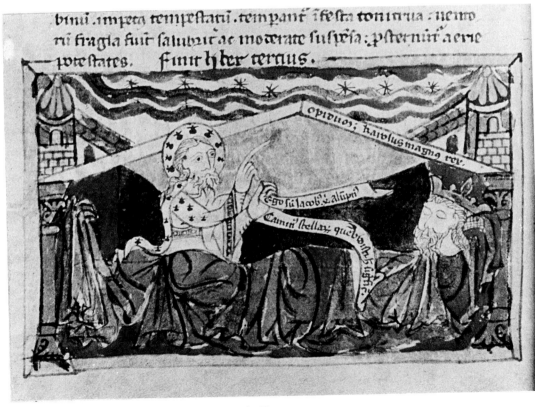

49. St. James appears to Charlemagne in a Dream, f. 132v

suis gentibus laicis renuderint. Qd si litteras fecerint: in cede pa
rum pgentiu illuc remunent in celis. Et quicumque hanc epl'am
inscripta de loco ad locu ut de ecclia ad eccliam plataurit. oi
bque pala' predicaurit: ph'enni glia remunetur. Igit' hec an
nunciantibus huic. 7 pgentibus illuc. sit pax gtinua. 7 cm 7 len
cia. expugnaaui uictoria. fortitudo 7 uita pluxa. sal' et glia.
Qd ipe prestare dignet'. ih's xp's dns n'r: cui regnu 7 impi
um sine fine ymanet in scl'a sclo2 am'. fiat. fiat fiat. Data
latam'. letare ih'rl'm: ad stantibus. e. ep'is ingalio. A pascha
usque ad festu sci io'h'nis bbte. ista epl'a p unu quemque die dni
cu omnib' ecclijs. audientib' laicis. post euanglium salti lega
t'. 7 exponatur: A'Danu mie sue magne huiu'codias sep'to2 et
lecto2 clemiter porrigat ih's xp's dns n'r: qui cu patre 7 sp'u sco
uiuit 7 regnat de's: p infinita scl'a sclo2 ame'. finit codex q'rtus.
Incipit liber .v. sci iacobi apl'i. Argumtu b'ti calixti. p̄.
Cu ueritas apud lecto2e n'ris uoluminibus requirat': in hui'
codias serie. ampputato esitacionis scrupulo secure intelliga
tur. Que eni in eo secuntur: n'm adhuc iuuentes uera ee restat.

Capitl'm .i. De uijs sancti iacobi.
Capitl'm .ij. De dietis apl'ici itineris.
Capitl'm .iij. De nomib; uilla2 itineris ei'
Capitl'm .iiij. De tribus tot9 edilt5 mundi.
Capitl'm .v. De nomibus uiato2 sci iacobi.
Capitl'm .vj. De amaris 7 dulcibus aquis itineris eia.
Capitl'm .vij. De q'litatib; terra2, 7 gentiu itineris eius.
Capitl'm .viij. De sco2 corpo2ibus requirendis in itinere ei7 7 de passio
Capth'.ix De q'litate ciuitatis 7 ecclie .s. iacobi. 7 ne sci eutropij.
Capitl'm .x. De discretione oblacionu altaris sci iacobi.
Capitl'm .xj. De pegrinis sci iacobi digne recipiendis.
Quatuo2 uie sunt que ad scm iacobu tendentes iu'm
ad ponte irgine. in ho2is uspanie coadunant'. Alia p

secula seculorum amen. ~

Deinde ap̃ blauui in maritima bri romani psidia peten̄da st̃: cuius basilica requiescit corpꝯ beati rotolandi mris. Qui cum eet gene nobilis. comes sel' karoli magni regis. & numo vii. pugnatorꝯ: ad expugnandas gns psidas zelo fidi septꝫ yspaniã ingssꝯ e. Hic tanta fortitudie repletꝯ fuit: qd petroniu que dam ut fert in runcauualle. a summo usqꝫ deorsum. sua framea p medium trino ictu sel' scidit: et tuba sonando. oris sui uento simul p̃ medium diuisit. Tuba ū eburnea sel' scissa aput burd galem urbẽ. in basilica brī seuerini habetr: et sup petronu sancta ualle quedã ecclia fabricat. Post ꝗ ū rotolandꝯ inista tella re gi & gentiliu deuicit: fame. frigore. caloribꝫ nimijs fatigat. alapis inmanissimis & uerberibꝫ crebris p ruuini numinis a more cesus. sagiteisqꝫ lanceis uulnatus: tandem siti fertur inp̃fata ualle. xp̃i mr p̃ciosꝰ obisse. Cui sacitissimū corp̃ in brī romani basilica ap̃ blauui ipiꝯ socii digna uenaacóe sepe

Deinde ap̃ burdegalem urbẽ beati seuerini epi & [hieri gfessoris corp̃ uisitandū e. Cui sollēpnitas .x. kl' nouēbꝫ. colit̃ tem in landis burdegalensibꝰ uilla que dr̃ telino. uisitanda st̃ corpa scorꝯ mr̃m. Oliueri. gandelbodi regis frisie. Oggeri re gis dacie. arastagni regis bretannie. Garini ducis lothari gie. & aliorꝯ plimorꝯ sel' karoli magni pugnatorꝯ: ꝗ deuictis eua tibꝫ paganorꝯ in yspania trucidati p xp̃i fide fue. Quorꝯ p̃cio sa corpa usqꝫ ad telinū socii illorꝯ detulert: et ibi studiosissi me sepelier. Jacent eni os una in uno tumulo. er ꝗ suauis simꝯ odor flagrat: unde colinui sanantur.

Deinde uisitandū e in yspania beati dnici gfessoris cor p̃: ꝗ calciatã que e int nagera urbẽ & radicellas fe cit: ubi ipse requiescit. Item uisitanda st̃ corpa brorꝯ mr̃ꝫ. facundi sel' & p̃mitiui: quorꝯ basilicā karolꝯ fecit: iuxta ꝗꝫ

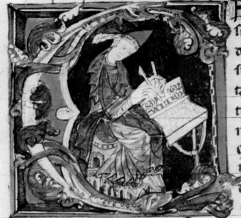

52. Calixtus writing, f. 1

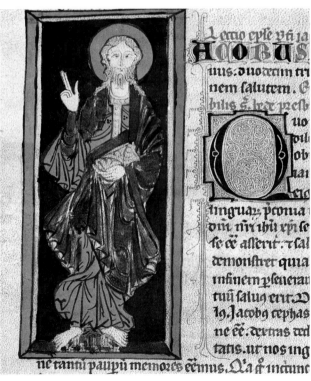

53. St. James, f. 3v

54. Initial B, f. 118

55. Initial S, f. 21

56. Initial A, f. 27

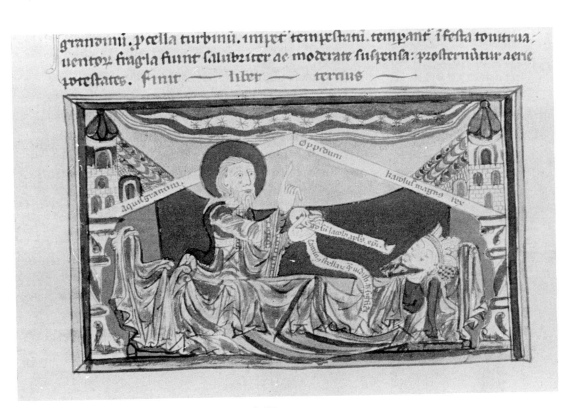

57. St. James appears to Charlemagne in a Dream, f. 133v

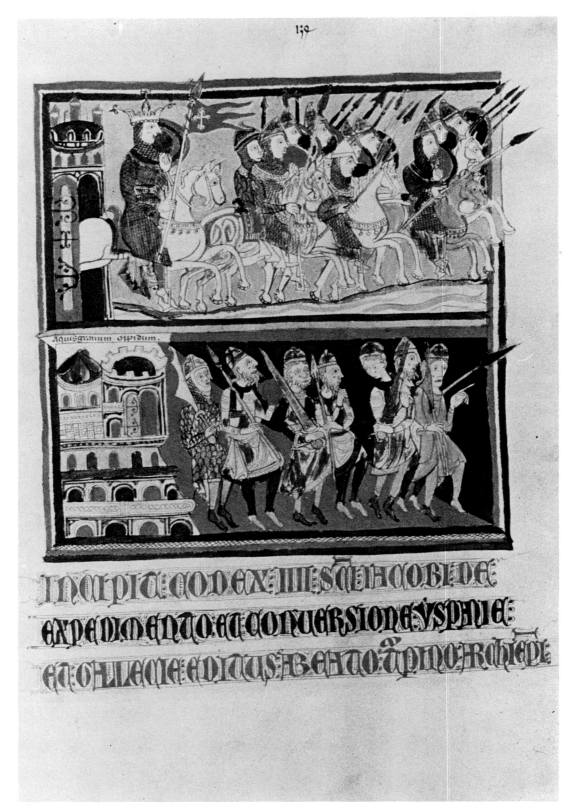

58. Charlemagne and his army set out from the city, f. 134

59. Opening to Book IV, Turpin blessing, f. 134v

aplica mandata precipue annuciare no desinat. pribus suis etia exortates: ut in ecclijs suis gentibus laicis renuciet. Qd si litteris fecerit: mercede pariter pgenciu illue remunerent i celis. Et qcuq hac eplam trascpta de loco ad locu ul de eccla ad eccliam platauit. omibq pala predicauerit: phenni gla remuneret. Igit per annuciatibus hunc. pgentibus illue: sit par gtinua. deus z lecicia. expugnacu uictoria. fortitudo z uita plica. salus z gla. Qd ipe prestare dignet. ihs xps dns nr. cui regnu z impium sine fine pma net in secla seclo. amen. fiat. fiat fiat. Data laterani. letare ihlm: adstantibus. e. epis iocilio. Pascha usq ad festu sci iohnis baptiste ista epla per unu queq die dnicam omibus ecclijs. audientibus laicis. post euangliu saltim legat z exponatur. Manu misericordie sue magne huius codicis scriptor z lectori clementer porrigat ihs xps dns nr: qui cu patre z spu sco uiuit et regnat ds: p infinita secla seclo amen. finit codex quartus.

Incipit liber v. sci iacobi apli. Argumentum bti calixti pape: —

Si ueritas apito lectore nris uoluminibus requiratur: in huius codicis serie. amputato esitacionis scrupulo secure intelligatur. Que eni in eo scribuntur: multi adhuc uiuentes uera esse testantur.

Quatuor

61. Opening of Book V, f. 157

62. Book V, f. 166

63. St James, f. 2v

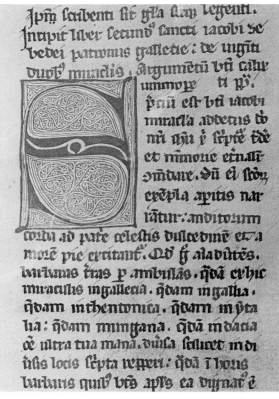

64. Initial S, f. 77v

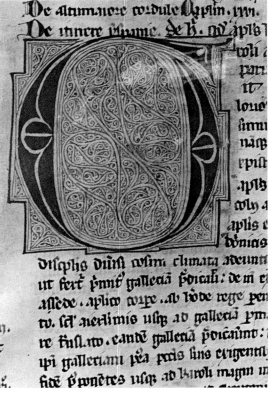

65. Initial O, f. 91

66. Book I, page with space for music, f. 65

67. Opening of Book V, f. 107

68-69. Book V, ff. 115v-116

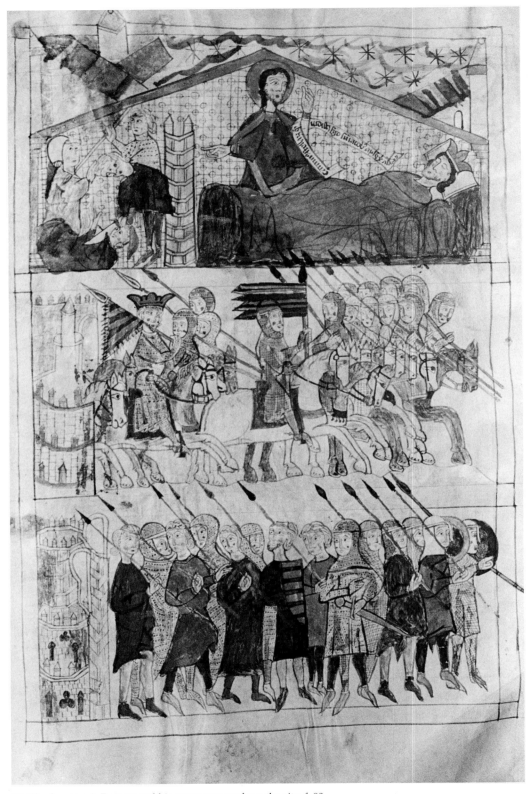

70. Charlemagne's Dream; and his army sets out from the city, f. 90

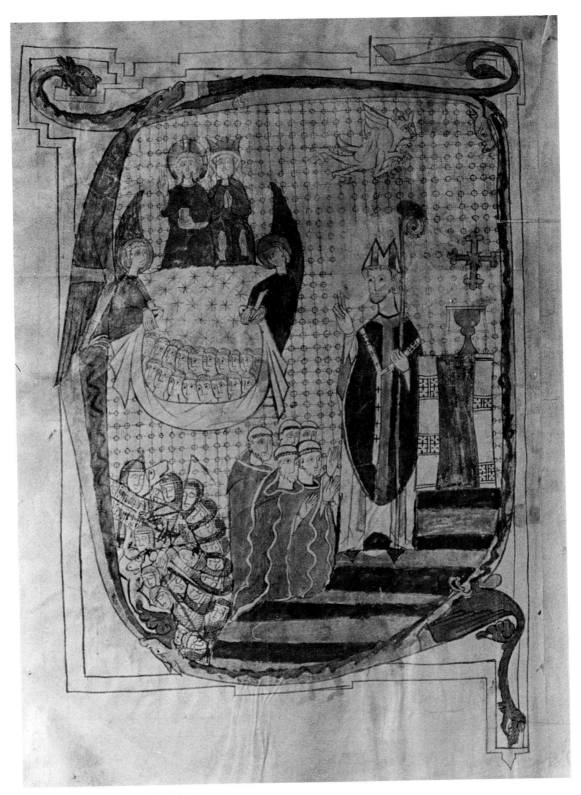

71. Opening of Book IV, initial T, f. 90v

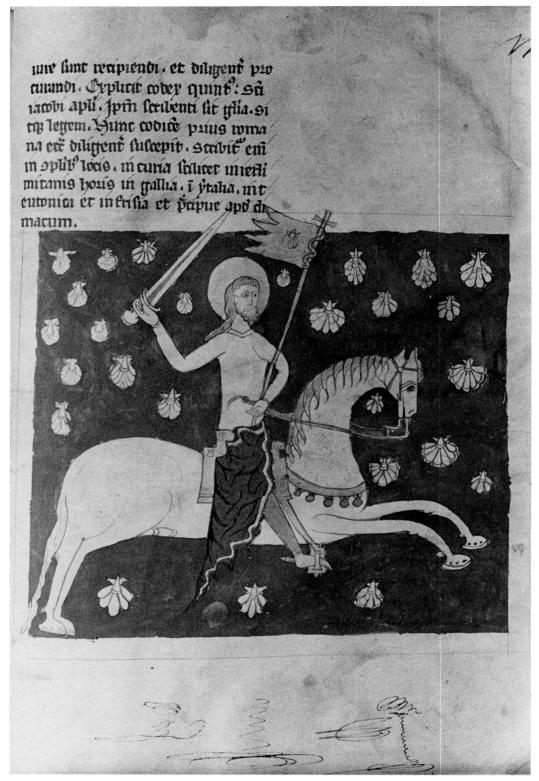

inre sunt recipiendi. et diligent pro
curandi. Oxplicit codex quint: sci
iacobi apli. Ipm scribenti sit gloria. si
tri legtem. Hunc codice prius roma
na eccr diligent suscepit. scribit em
in opltis locis. in curia scilicet romi
mitanis horus in gallia. i ytalia. mt
eutronica et in frisia et prcipue apo di
macum.

72. St. James Matamoro, f. 120

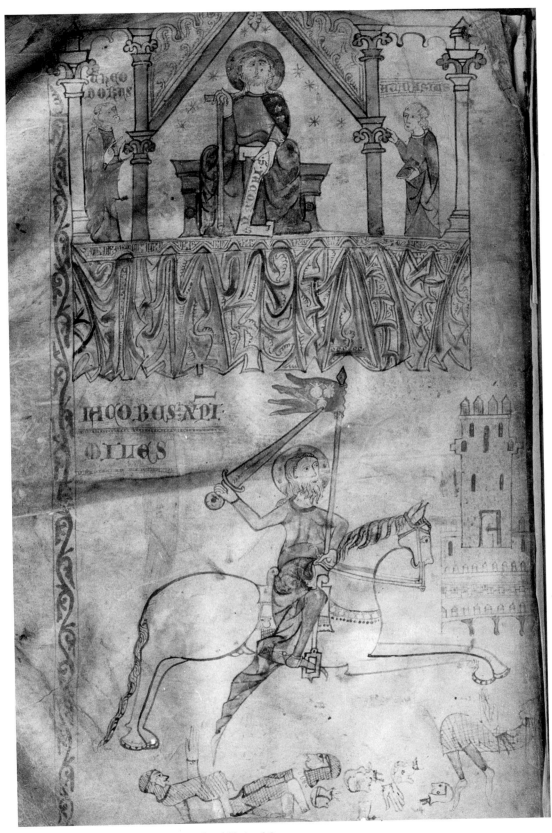

73. St. James enthroned; St. James, Knight of Christ, f. 2v

nisset . rapuit . qcqd i ea inuenit . et uillam similit deuasta
uit. Cuq; i eade; uilla eu suis excitib; hospitat° eet . q
da dux exercituum ei igress° eade; basilica; uidit colu
pn pulcherimas lapides q eide; eccle tecta sustetabat .
q i sumitate de argetate et deaurate erat . neq; e
et i uidie stimulo tact°. qnda cuneu fereu i bases
cuisda colupne et eade; coliumna ifixit. Cu itaq; cuneu
illu malleo fereo fortit magis i ictib; feriret . totaq;
basilica seruire teptaret diuino opate iudicio ide;
ho lapis efficit. Ot i lapis usq; hodie ieffigie hois i
eade basilica pstitit . huius tales colores . qles eide saraceni
tunica tuc gerebat. Solet i pegrini narare q il
luc ea pcu tedut qd lapis ille fetore emictit . Os i
altus maior uidit . ait domesticis suis . magn° e reuela
ta et glificao de sanon q tales hit aluinos q eu ab
hac uita mignauerut tam sibi uiuos rebellos ita
puniut . qd aliis oclor lumen auferut . d alio lapide
mutu; facit . Jacob° lume oclor a me abstulit . ro
man° dnone lapide fecit. Sz magn° iacob° clemetissim°
e q iste roman°. Jacob° e oclos meos redidit m mihi
sz hores meu redere no uult roman°. fugiam q ab
his oris. Luc cofus asceffit pagan° cu suis excitib°
n fuit postea p mltu tps q bti iacobi patria debellare
audret . Sciat q se dampnados i euu . q ei tellure q
pti i egetauerit . Ot i apotestate saracenor uilla cu
rodierit . celesti muere remuerabut :~
Fuit codex ait° argumetu bti calixti .

Si uitas aperito lectore intus uoluinib° regrat°
si huic codicis serie amputo escitatois scrupulo se
cure itelligat° . Que e ieo scbut° . mlti adhuc uide
tes uera ee testat°. Incip° libe qnt° de itine bti iacobi .

Quatuor uie st q ad scm iacobu tedetes i unu ad po
 te regie i horis yspanie coaduat° . alia p sca egidiu
et mostre fesulanu et tolosa; et port° aspi tedit . alia p sca;
mariã podii et sca; fide de coctis et sca; petru de moy
siaco . alia p sca; mariã madalena; uurelia; et sca;

. leonadus .

76. Inscription on front cover

77. Incipit of Book V, f. 138v

78. Explicit ofBook V, f. 182v

Incipit liber quintus calixti pp̄ de itineribꝯ ⁊ ecclesia
beati Jacobi apostoli. · Argumentum ·

Si veritas aperito lectore nostris voluminibꝯ ⁊ requiratur
inhuius codicꝯ serie amputato hesitationis scrupulo secure
Intelliget̄ que in eo scribuntur multi adhuc viuentes vera
esse testantur.

Quatuor sunt vie que ad sanctuz Jacobū tendentes in vnuz
ad pontem Regine in horis hispanie coadunantur. Alia
per Santuz Egidiuz ⁊ mōtē pesulanum ⁊ Tolossam ⁊
a portis spiꝰ tendit. Aliam per Santā Mariaz podii ⁊ sā
tam fidez de aquis ⁊ sanctuz petrū de morsiaco Incedit. Alia
per Santaz Mariaz Madap_lenā viziliari ⁊ santuz leonarduz
lemouicensez ⁊ vrbem petragoricensez pergit. Alia persantꝯ
tuz Johanē anglicensem ⁊ santuz ilariuz pitauiensem ⁊ sā
⁊ vrbem Burdegalensez vadit. Illaque per santaz fidez
⁊ aliā per santuz leonarduz ⁊ aliā per santuz Martinuz
tendit ad hostabaluz coadunātur ⁊ transitu portu ciserec
ad pontez Regine soriant̄. viaꝗ per portꝯ asperi trāsit
similit̄ ad pontez Regine coadunatur ⁊ vnasimul exide
via efficiat̄ vsꝗ ad sanctuz Jacobum.

Capituluz secunduz de dietꝯ Itinerꝯ sti Jacobi ipā ca
lixto contractꝯ

A portibꝯ asperi vsꝗ ad pontē Regine tres parnehentur
diete. Prima est aborcia que est villa in pede montis
asperi sita aduersus gasconiaz vsꝗ ad Jaccaz. Secundaest
a Jacca vsꝗ ad montez reluz. Terciaest arelo vsꝗ ad
pontez Regine. A portibꝯ ꝯo ciserecis vsꝗ adsanctuz
Jacobuz. tredecim dietꝯ h̄ent̄. Prima est abilla sti
Michaelis q̄ est in pede porte ciserec ꝯsus filz gasconiaz
vsꝗ ad vis carctuz ⁊ ipsa est parua. Secundaest abiscar

A·q̄·

80-81. Explicit and Colophon of Book V, ff. 207v-208

82. Excerpt from Prologue of Book I, f. 209v

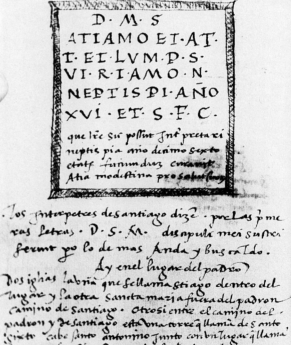

D·M·S
ATIAMO ET·AT·
T·EI·LVM·P·S·
VI·R·IAMO·N
NEPTIS·PI·AÑO
XVI·ET·S·F·C·

83. Drawing of Roman stone with inscription, f. 211v

84. Title and excerpts from Book I, f. 1

85. Explicit and colophon of Book V, f. 90v

Z. Madrid, Biblioteca Nacional, 13118

86. Table of Contents and excerpts from Book II, f. 101

eadem Solemnia evenirent, indigne dimitteret. Multo
pius B. Mariæ Annunciatio, quæ octavo Kalend. Et
prius excoli debet, vel inter Ramos Palmarum, et
Pascha, vel in Hebdomada Resurrectionis evenit, et
nullatenus celebrari potuit. Festum Miraculorum B.
Jacobi, quod quinta Die Nonarum Octobris colitur,
qualiter hominem, qui ve ipsum, amonente Diabolo,
occiderat, B. Apostolus suscitavit, cæteraque Miracu-
la, quæ fecit, B. Anselmus prius colere præcepit,
et nos hic idem affirmamus. Prætur quod Transla-
tionis B. Jacobi Celebritatem tertia Die Kalend. Ja-
nuarij inclitus Imperator Hispanus Aldefonsus, bo-
næ Memoriæ dignus celebrare intra Galeciam ante nos
instituit, priusquam nostra Aucthoritate corroboraretur.
Non minus Translationis Solemnitatem, quam Pas-
sionis credebat esse celebrem, quia in ea Alumnum
Domini, Corporale Volatium Plebs Galeciana gau-
dens suscepit.

Argumentum Beati Calixti

Si veritas à perito lectore in nostris voluminibus requira-
tur in hujus Codicis serie amputato hæsitationis scrupu-
lo secure intelligatur, quæ enim in eo scribuntur multi
ti adhuc viventes vera esse testantur &c.

LIST OF ILLUSTRATIONS

PHOTO CREDITS

Photographs for reproduction have been made available from the following sources:

Illustrations 1, 29, 79-87 – Paula Gerson
ills. 2-28, 30-36, 63-73 – Alison Stones
ills. 37-41 – Barcelona, Arxiu de la Corona de Aragó
ills. 42-46 – Lisbon, Biblioteca Nacional
ills. 47-51, 75 – London, British Library
ills. 52-62, 74 – Vatican, Biblioteca Apostolica Vaticana
ills. 76-78 – Jeanne Krochalis

CONTENTS OF VOLUME TWO

Contents of Volume 2
Pilgrims Guide
Critical edition

The Pilgrimage Routes to Santiago de Compostela

——	Principal Routes
-·-·-	Alternate Routes
*	Places mentioned in the 'Pilgrim's Guide'
-·-·-	Modern International Boundaries

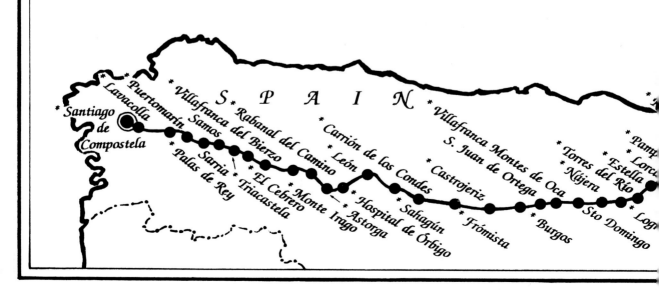

S P A I N

* Santiago de Compostela
* Lavacolla
* Puertomarín
* Villafranca del Bierzo
* Samos
* Rabanal del Camino
* Sarria
* El Cebrero
* Palas de Rey
* Triacastela
* Monte Irago
* Astorga
* Hospital de Órbigo
* León
* Carrión de las Condes
* Sahagún
* Castrojeriz
* Frómista
* S. Juan de Ortega
* Villafranca Montes de Oca
* Burgos
* Sto Domingo
* Nájera
* Torres del Río
* Estella
* Logroño
* Loreto
* Pamplona

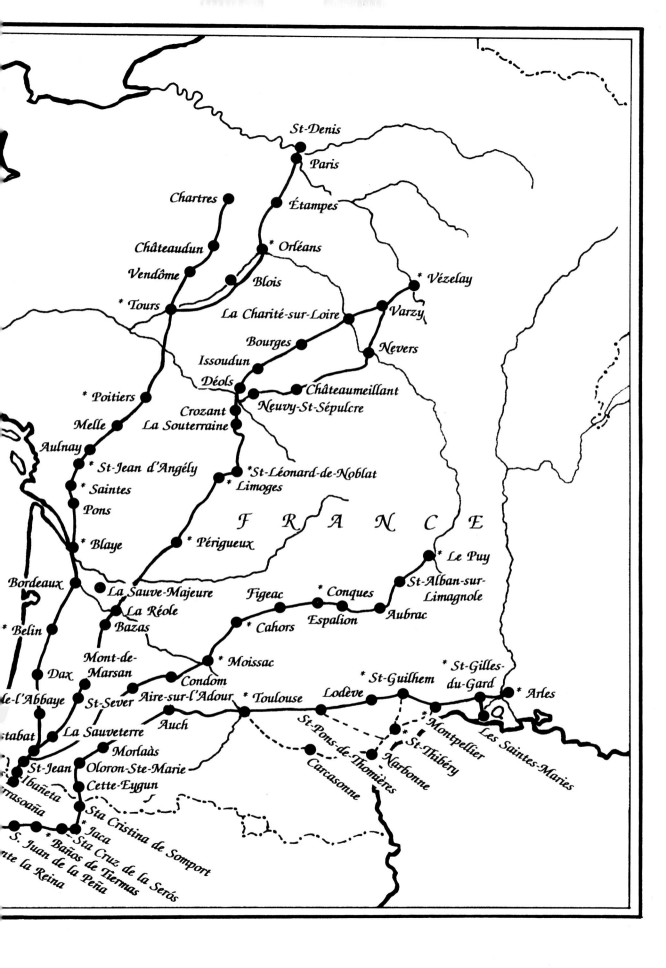